Dictionary
of
Victorian Painters

CHRISTOPHER WOOD

ANTIQUE COLLECTORS' CLUB

Dictionary
of
Victorian Painters

CHRISTOPHER WOOD

WITH GUIDE TO AUCTION PRICES

300 ILLUSTRATIONS

AND INDEX TO ARTISTS' MONOGRAMS

ANTIQUE COLLECTORS' CLUB

Printed in England by
Baron Publishing, Church Street, Woodbridge, Suffolk

CONTENTS

INTRODUCTION

Although there are several good books on Victorian painting, there is as yet no dictionary of Victorian painters, except for Graves, *Dictionary of Artists,* published in 1884, which is little more than a check list. The larger dictionaries, such as Benezit and Thieme-Becker, often leave out interesting minor Victorian artists, or simply list their names and dates, telling one practically nothing about their work. It is this gap which I have tried to fill with my Dictionary. Obviously I have not been able to include every single painter working in the very prolific Victorian period. To do so would need many years of research and fill many volumes. Using Graves's *Dictionary* as my starting point, I have selected artists on the basis of my own knowledge of the period, combined with research into all the books on Victorian painting which are at present available. In addition I have included many minor artists whose works I have seen in exhibitions or sale-rooms, who have not yet found their way into any books. The result will, I hope, be useful to collectors and dealers, perhaps also to museums and scholars.

The designation 'Victorian' I have taken to mean any artist who was working during Victoria's reign, 1837-1901, although in borderline cases my selection has been based on artistic rather than purely chronological considerations. It is obviously impossible to leave out many artists working in the 1820s and 30s, such as Wilkie, Collins and Mulready, whose work belongs to what we understand as the Victorian age. Some artists, on the other hand, who were working in the 1830s and even '40s, such as Thomas Barker of Bath, seem to belong to an earlier tradition, and have therefore been left out. At the other end of the century, the problem is even more delicate. In most cases I have included artists working in the 1880s and '90s whose careers extended well into this century, even if their later work was not Victorian. There are also many Victorians who carried the styles of the nineteenth century well into the twentieth.

The Price Guide

After the entry for each artist I have included, in italics, records of the most recent auction prices for the artist's work. This is based on the recently published *Connoisseur Art Sales Annuals 1968-70* and on auction records for about the last ten years. Where no auction records are available, I have mentioned the 'probable price range' into which I consider the artist's work might fall. If the artist was both painter and watercolourist, I have tried to indicate prices for both mediums, as oils are usually more expensive than watercolours. If the artist was purely a painter, then the prices apply to oils only. These estimates should not be taken as any more than rough guesswork. based on my experience of saleroom prices. Also it is important to remember that prices for every artist vary according to the size, subject and quality of each picture. It is hoped in a few years to reprint the Dictionary, bringing the price guide up to date.

Bibliographies

One of the great advantages of a dictionary over a book is that it can list comprehensive bibliographies of each artist, thus showing the reader where to look if he should wish to do further research. For this reason I have taken trouble to make the bibliographies very detailed, excluding only a few books and periodicals which are either unobtainable or out of date. A list of bibliographical abbreviations is at the front of the book.

Monograms

Victorian artists were very fond of using monograms, and often went to great pains to make them as elaborate and obscure as possible. The monograms of Millais and Rossetti, and the best-known artists, are fairly common knowledge, but many minor artists have deprived themselves of immor-

tality by using such esoteric combinations of letters as to be indecipherable to the modern connoisseur. I have therefore included an index of monograms at the back of the book. If any readers know of other monograms, the author would be glad to hear of them.

Acknowledgements

All the illustrations in the Dictionary are reproduced by kind permission of their owners or, in the case of museums, by permission of the trustees and curators concerned. I can only record my gratitude and thanks for their help, as they are too numerous to list individually. My greatest debt is to my research assistant, Margaret Richardson, whose industry and scholarship have been of incalculable value. I would also like to thank Jeremy Maas for his help and advice, particularly by allowing us to use his excellent library. Finally, my thanks to my wife, Sarah, without whose gentle, but persistent, nagging the book would never have been finished.

Christopher Wood 1971

EXHIBITIONS AND GALLERIES

AG Art Gallery

BI British Institution 1806-67. Established as a rival to the RA at Boydell's Shakespeare Gallery in Pall Mall. Aimed 'to encourage and reward the talents of the artists of the United Kingdom'. Organized loan exhibitions of old masters for students to copy

BM British Museum

FAS Fine Art Society, Bond Street. Held many important one-man shows in the 1880s and 90s

GG Grosvenor Gallery 1878-90. Founded in Bond Street by Sir Coutts and Lady Lindsay, both amateur artists. Focus of the Aesthetic movement of the 1880s, caricatured by Du Maurier, Gilbert and Sullivan — 'greenery-yallery Grosvenor-Gallery' &c. Closed soon after the opening of the rival New Gallery in 1888. Favourite of Burne-Jones and his Pre-Raphaelite followers

Nat. Gall. National Gallery, London

NEAC New English Art Club. Founded 1886 by a group of young artists as a kind of Salon des Réfusés on the French pattern. The pictures were selected by the artists themselves, not by a committee. Among its members were W.J. Laidlay, T.B. Kennington, H.H. La Thangue, George Clausen, Whistler and Wilson Steer. Centre for French influence and Impressionism

NG New Gallery. Founded in 1888 by C.E. Hallé and J. Comyns Carr in Regent Street as a breakaway from the Grosvenor Gallery. After the closing of the GG in 1890, most of its artists transferred to the NG. Also held big winter loan exhibitions, and the exhibitions of the International Society of Painters, Sculptors and Gravers.

NPG National Portrait Gallery, London

NWS New Watercolour Society. Founded in 1832 to rival the monopoly of the more prestigious Old Watercolour Society. Changed name to the Institute of Painters in Watercolours in 1863, and later became Royal. Members style themselves RI. Still holds annual exhibitions at 195 Piccadilly

OWS Old Watercolour Society. Founded in 1804 at 5a Pall Mall East by Dr Monro and a group of watercolourists who felt that their work was not properly shown at the RA. Became Royal 1881. Members styled RWS. Now at 26 Conduit Street, W1

RA Royal Academy. Founded 1768. Members first have to become Associates (ARA) then full Members (RA). In spite of its many rivals, the RA was during the Victorian period at the zenith of its power and prestige, and its exhibitions were the high point of the artistic season

RSA Royal Scottish Academy. Founded 1826; modelled closely on the RA. Not until the 1850s, under the Presidency of Sir William Allan, did it achieve anything like the power and prestige of its London counterpart. It remained somewhat provincial, and most good Scottish artists exhibited mainly in London. Moved in 1855, and again in 1911 to its present location on Princes Street, Edinburgh

SS(SBA) Society of British Artists, Suffolk Street. Founded in 1824 by a rebel group of artists including B.R. Haydon, John Martin, John Glover and Thomas Heaphy (first President). Became Royal in 1887 while under the Presidency of Whistler. Members styled RBA

Other Victorian Galleries, not included in this list, which held less important exhibitions, were the Portland (1848-61) the Dudley (1865-82) the Institute of Oil Painters (founded 1883) and the Society of Portrait Painters (founded 1891)

LETTERS AFTER ARTISTS' NAMES

ARA Associate of the Royal Academy
ARCA Associate of the Royal Cambrian Academy
ARHA Associate of the Royal Hibernian Academy
ARPE Associate of the Royal Society of Painters and Etchers
ARSA Associate of the Royal Scottish Academy
ARSW Associate of the Royal Scottish Watercolour Society
ARWS Associate of the Royal Watercolour Society
H Honorary
P President
RA Royal Academician
RBA Member of the Royal Society of British Artists, Suffolk Street (SS)
RBSA Member of the Royal Birmingham Society of Artists
RCA Member of the Royal Cambrian Academy Manchester
RHA Member of the Royal Hibernian Academy, Dublin
RI Member of the Royal Institute of Painters in Watercolours (formerly NWS)
ROI Member of the Royal Institute of Painters in Oil-Colours
RPE Member of the Royal Society of Painters and Etchers
RSA Member of the Royal Scottish Academy
RSW Member of the Royal Scottish Watercolour Society
RWS Member of the Royal Watercolour Society (formerly OWS)
VP Vice President

BIBLIOGRAPHICAL ABBREVIATIONS

The following essential reference books have been consulted in nearly every case, and are not therefore quoted in the bibliographies:

Benezit,	*Dictionnaire des Peintres, Sculpteurs &c,* 8 vols
Graves, Algernon,	*A Dictionary of Artists 1760-1893,* first published 1884, reprinted 1895, enlarged 1901, reprinted 1969 by Kingsmead Reprints
Graves, Algernon,	*A Century of Loan Exhibitions 1813-1912,* 5 vols 1913-15 (rep. 1971)
Graves, Algernon,	*The British Institution* (1806-67), 1908 (reprinted 1969)
Graves, Algernon,	*Royal Academy Exhibitors 1769-1904.* 8 vols, 1905-06 (reprinted 1970)
Thieme-Becker, (TB)	*Algemeines Lexicon der Bildenden Kunstler,* Leipzig 1927 (37 vols)

Periodicals

Periodicals have been listed first in the bibliographies, before other references:

Academy Notes:	1876-1906. ed. Henry Blackburn
Apollo:	*Apollo Magazine 1925-*
AJ:	*Art Journal 1849-1912*
AU:	*Art Union 1839-1848*
Athenaeum:	*Athenaeum 1828-1912*
Burlington Mag:	*Burlington Magazine 1925-*
Connoisseur:	*Connoisseur Magazine 1901-*
Country Life:	*Country Life Magazine 1897-*
Frazers Mag:	*Frazers Magazine for Town and Country 1830-69*
L'Art:	*L'Art 1877-1900*
Mag. of Art:	*Magazine of Art 1878-1904*
OWS Journal:	*Journal of the Old Watercolour Society 1923-39*
Portfolio:	*Portfolio 1870-1893*
RA Pictures:	*Royal Academy Pictures 1888-1915,* an illustrated supplement to the *Magazine of Art*
Studio:	*The Studio 1893-*
Walkers Quart.:	*Walkers Quarterly Magazine 1920-32*

Books

The list of books is given here in alphabetical order, but in the text they are, where possible, listed in chronological order, starting with the earliest references, working up to the most recent:

Bate:	Percy H. Bate, *The English Pre-Raphaelite Painters,* 1899
Binyon:	L. Binyon, *Catalogue of Drawings by British Artists in the British Museum,* 1898-1907
Birmingham Cat.:	City of Birmingham Art Gallery, *Catalogue of the Permanent Collection of Paintings &c* 1930, with supps. to 1950
Boase	T.S.R. Boase *English Art 1800-1870,* 1959
BM:	British Museum
Bryan:	M. Bryan, *Dictionary of Painters and Engravers,* 1903
Caw:	Sir J.L. Caw, *Scottish Painting 1620-1908.* 1908
Clayton:	E.C. Clayton, *English Female Artists,* 1876
Clement & Hutton:	Clement & Hutton, *Artists of the 19th Century,* 1879
Clifford:	D. Clifford, *Watercolours of the Norwich School,* 1965
Cundall:	H.M. Cundall, *History of British Watercolour Painting* 1908, 1929
DNB:	*Dictionary of National Biography*
Fredeman:	William Fredeman, *Pre-Raphaelitism, A Bibliocritical Study,* 1965
Gleeson White:	Gleeson White, *English Illustration, The Sixties* 1908 (repr. 1970)
Hardie:	M. Hardie, *Watercolour Painting in Britain,* 3 vols, 1967-69
Hughes:	C.E. Hughes, *Early English Watercolours,* 1913, 1950
Hutchison:	S. Hutchison, *History of the Royal Academy 1768-1968,* 1968
Ironside & Gere:	R. Ironside & J.A. Gere, *Pre-Raphaelite Painters,* 1948

Maas:	J. Maas, *Victorian Painters*, 1969
Marillier:	H.C. Marillier, *The Liverpool School of Painters*, 1904
Nat. Gall.:	National Gallery, London
NPG:	National Portrait Gallery, London
Ottley:	H. Ottley, *A Biographical and Critical Dictionary*, 1866
Pavière, Landscape:	S.H. Pavière, *A Dictionary of Victorian Landscape Painters*, 1968
Pavière, Sporting Painters:	S.H. Pavière, *Dictionary of British Sporting Painters*, 1965
Redgrave, Cent.:	S. & R. Redgrave, *A Century of British Painters*, 1866
Redgrave, Dict.:	S. Redgrave, *A Dictionary of Artists of the English School*, 1878
Reynolds, VP:	G. Reynolds, *Victorian Painting*, 1966
Reynolds, VS:	G. Reynolds, *Painters of the Victorian Scene*, 1953
Roget:	J.L. Roget, *History of the Old Watercolour Society*, 1891
Ruskin, Academy Notes:	J. Ruskin, *Academy Notes 1855-59*, 1875
Sparrow:	W.S. Sparrow, *British Sporting Artists*, 1922, repr. 1965
Strickland:	W.G. Strickland, *A Dictionary of Irish Artists*, 1913 repr. 1971
Tate Cat.:	Tate Gallery, London, *The Modern British Paintings, Drawings and Sculpture*, 2 vols (by Mary Chamot, Dennis Farr & Martin Butlin), 1964
VAM:	Victoria & Albert Museum, *Catalogue of Watercolour Paintings*, 1927; supp. 1951
Williams:	I.O. Williams, *Early English Watercolours*, 1952 (repr. 1971)
Wilson, Marine Painters:	A Wilson, *Dictionary of British Marine Painters*, 1967

PRICE REVIEW

1st September annually

There will be a review list issued annually in which the major
price changes will be recorded; it will also include a discussion
of price changes generally in the Victorian picture market.

Price £1.50 by Bankers' Order from the
Antique Collectors' Club,
Clopton,
Woodbridge,
Suffolk

An asterisk indicates that there is an illustration of a work by the artist. Illustrations are in alphabetical order.

ABBEY, Edwin Austin RA 1852-1911
Painter and illustrator of historical subjects, usually medieval or Shakespearian. Born in Philadelphia, USA. Studied at Pennsylvania Academy 1869-71; employed by Harper Brothers 1871-91, and sent by them to England in 1878, where in 1880 he settled permanently. Visited Holland 1885, the first of several Continental tours. First exhib. at the RA 1885. Painted a series of large decorative panels for the Boston Library USA, 1890-1901; reredos for the American Church in Paris 1904; the official picture of the Coronation of Edward VII 1903-04; a mural for the Royal Exchange 1904; and a series of murals for the Pennsylvania State Capitol, completed in 1910. His illustrations to Herrick's poems, Goldsmith and Shakespeare won him a great reputation. ARA 1894, RA 1898. A memorial exhibition was held at the RA in 1912.

Although popular and expensive at the turn of the century, Abbey's works are too large and rhetorical for modern taste, and find little favour. His pictures rarely come on to the market, and would not be likely to make more than £100-300.

Bibl: *Studio*, Winter Number, 1900-01; XXXI, p.151, E.V. Lucas, *E.A.A. Royal Academician, The Record of his Life and Work*, 2 vols. 1921; Tate Cat; Maas 231-232.

ABORN, John fl.1885-1899
Landscape painter; lived in Dolwyddelan, N. Wales and Milford, Surrey. Exhib. at RA 1885-99 and SS. Subjects mainly winter landscapes, often in Wales.

Probable price range £30-70

ABSOLON, John 1815-1895
Painter of landscape, seascape and genre in both oil and watercolour, and book illustrator. Began career as painter of theatrical scenery at Covent Garden. First exhib. at SS in 1832 at age of 17. Went to Paris 1835, and on his return in 1838 became a member of the NWS, of which he later became Treasurer. In 1850 he helped T. Grieve and Telbin to produce the first diorama, 'The Route of the Overland Mail to India'. Absolon exhib. mainly at the NWS (660 works), also at RA, BI and SS. Hardie praised his watercolours for their 'fresh and breezy manner'.

Average prices for watercolours £50-150, oils £100-500.

Bibl: Clement & Hutton; VAM; Cundall; Hardie III 79-80 (pl.101).

ADAM, Joseph fl.1858-1880
London landscape painter; father of Joseph Denovan Adam (q.v.) Exhib. at RA 1858-1880, and BI and SS. Subjects mainly Scottish or north of England. Very little known.

Probable price range £30-100

ADAM, Joseph Denovan RSA, RSW 1842-1896
Glasgow landscape and animal painter. Studied under his father, Joseph A. (q.v.) and at S. Kensington Schools. In the 1870s he went to live in the Crieff district, and in 1887 he settled near Stirling, founding a school of animal painting at Craigmill. Specialized in painting highland cattle. Exhib. at the RA 1860-92, BI, SS and also in Paris and Munich, where he won a gold medal. Like Farquharson's, Adam's pictures have been prevented from achieving popularity because of their often bleak and wintry subjects.

Price range £100-200

Bibl: Caw, 206, 338-339, 480

ADAMS, Albert G. fl.1854-1887
London landscape painter. Exhib. mainly at SS; also at BI and RA 1854-87. Subjects mainly views of Devon and the southern coast, and occasional genre scenes — e.g. 'A Mendicant Friar'. Very little known.

Probable price range £30-70

ADAMS, Charles James 1859-1931
London landscape painter; also lived in Leicester, Horsham and Midhurst. Exhib. at RA from 1882, SS and NWS. Also painted animals, genre and historical subjects. Very little known.

Probable price range £30-100

ADAMS, Douglas fl.1880-1904
London landscape painter. Exhib. at RA 1880-1904, SS, GG and NG. Subjects mostly Scottish, including loch and coastal views. Very little known.

Probable price range £30-70

***ADAMS, John Clayton 1840-1906**
Surrey landscape painter; lived in Edmonton and Guildford. Exhib. at RA 1863-93, SS, NWS, GG and NG. Subjects mainly views in Surrey and the southern counties. His landscapes, painted in a rich broad technique, are natural and realistic, and full of feeling for light and colour. Adams is one of the most individual and least recognized of late Victorian landscape painters.

Usual price range, £50-300, but large works have sold at auction for as much as £800.

ADDISON, William Grylls fl.1875-1893, d.1904
London landscape painter and watercolourist. Exhib. at RA 1876-95, SS, NWS and GG. Titles at RA 'Calm Decay', 'Waste Lands', 'A Sunny Border' & c.

Probable price range £30-70

AGLIO, Agostino 1777-1857
Landscape painter; born in Cremona, Italy. Came to England with William Wilkins RA in 1803. A versatile artist; produced theatrical scenery, church decoration, and prints. Exhib. at RA 1807-46, BI and SS. His son Augustine also a landscape painter. Neither of their works are often seen, possibly because many of Agostino's pictures were for large-scale decorations.

A landscape by Aglio sold at Christie's 21.3.69 for £504.

Bibl: Redgrave, Dict; DNB; VAM; Hardie III, 291

ALDRIDGE, Frederick James fl.1884-1901
Landscape and seascape painter; worked in Worthing, Sussex. Exhib. at RA 1896-1901 and SS. Very little known.

Probable price range £20-50

ALEXANDER, Edwin RSA 1870-1926
Scottish painter and watercolourist of flowers, birds, animals and

Arabian subjects. Son of Robert Alexander RSA. At the age of 17 he visited Tangier with his father and Joseph Crawhall (q.v.) who had a great influence on his artistic career. Studied in Paris 1891. Visited Egypt 1892-96. Married in 1904 and settled near Inverness. Elected ARSA 1902, RSA 1913, member of the RWS 1910. Many of Alexander's watercolours are painted on silk, linen or textured paper. His style reflects the decorative ideas of the Glasgow school and the influence of Japanese art.

A group of watercolours by Alexander sold at Christie's sale in Glasgow, April 1969, for prices ranging from £200-300.

Bibl: *Who's Who* 1906; Caw, 304, 438-440, 450; Cundall; J. Patterson, 'E.A.', OWS Annual IV (1926); Hardie II, 207-209 (pl.240).

*** ALKEN, Henry 1785-1851**
Sporting painter and watercolourist; best known of the Alken family of sporting artists. Henry's father, Samuel Alken Senior, of Danish extraction, was a landscape and sporting painter. Henry was born in London and first studied with J.T. Barber, a painter of miniature portraits. The only works ever exhib. by H.A. at the RA, in 1801 and 1802, were portrait miniatures. In 1809 he married Maria Gordon in Ipswich. A keen huntsman, Alken showed a real knowledge and love of hunting in his pictures and prints. At first, he produced his hunting prints anonymously, signing them Ben Tally Ho, but it was not long before the secret was out. Although a prolific painter and watercolourist of hunting, coaching and shooting scenes, Alken became well known through his many sporting prints, which were mostly published by Fores. For example, the series 'The Midnight Steeplechase' were very popular, and produced in large numbers. After 1820 the quality of Alken's work declined; it became dull and repetitive, and he died in poverty in Highgate in 1851. He is known to have had at least two sons, Henry Jnr. and Seffrien, who imitated his style closely. The work of Henry Jnr. who signed H. Alken as well, has never been satisfactorily distinguished from the late work of his father. He probably used the signature H. Alken in order to pass his pictures off as his father's. Seffrien Alken signed S. Alken, and is usually confused with Samuel Alken Snr. Two other Alkens, George and Samuel Junior, are recorded, but practically nothing is known about them.

Sporting and coaching pictures by Alken can now be worth about £2,000-5,000 each; drawings £100-500; sets of aquatints up to £1000.

Bibl: DNB; Redgrave Dict; M. Hardie, 'The Coloured Books of H.A.', *Queen* CXVIII (1905), p.194; W.S. Sparrow, *Henry Alken*, 1927; VAM; Paviere, Sporting Painters (pl.1); Hardie III; Maas 71-72, 74-75 (pl. on p.74).

ALLEN, Robert Weir RWS RSW 1852-1942
Glasgow *plein-air* landscape and seascape painter and watercolourist. Subjects mainly landscapes of N.E. coast of Scotland, fishing villages and cliffs. Worked first near Glasgow, exhib. at Glasgow Institute in 1873 and at the RA from 1875 onwards. Later went to Paris and worked under Julian and Cabanel. From Paris he sent many *plein-air* landscapes to English exhibitions. Settled in London 1881. Sketched much in Holland, Belgium, France and Italy; toured India 1891-92 and Japan 1907. His seascapes and harbour scenes similar in feeling to those of Colin Hunter (q.v.), but his foreign scenes reflect his Paris training.

Price range £50-300

Bibl: AJ 1904, p.197; *Studio* XXIII, p.229-237 (monograph with illustrations by Mrs. A. Bell); Caw, 329-331; VAM; FAS, 1924; Hardie III, 193 (pl.229)

ALLAN, Sir William RA, PRSA 1782-1850
Scottish painter of history and scenes of Russian life. Apprenticed as a coach painter; studied under Graham at the Trustees' Academy with Wilkie, John Burnet and Alexander Fraser. Later he entered the RA Schools in London. In 1805 he went to Russia and spent several

years in the Ukraine, travelling to Turkey, Tartary etc. studying the Cossacks and Circassians, and collecting subjects for many future pictures. In 1814 he returned to Edinburgh and in 1815 exhib. 'Circassian Captives' which was subscribed to by Sir W. Scott and his friends. Later he painted scenes of Scottish history suggested by Scott's novels, which proved more popular than his Russian subjects. Exhib. at the RA 1803-49. Elected ARA 1825, RA 1835, PRSA 1838. In 1843 he exhib. 'The Battle of Waterloo from the English Side', bought by the Duke of Wellington. In 1844 he again went to St. Petersburg and there he painted for the Czar 'Peter the Great Teaching his Subjects the Art of Shipbuilding' (Winter Palace). Also painted portraits. Not only was Allan one of the first to paint oriental subjects, he was also one of the pioneers of Scottish history painting.

'Tartar Horsemen' sold Christie's 3.4.69 for £294.

Bibl: AJ 1849, p.109; 1850, p.100; 1903, p.53; Clement & Hutton; Redgrave, Dict; DNB; NPG Cat; Caw, passim (pl. opp. p.105); Binyon.

ALLBON, Charles Frederick fl.1874-1892
Croydon landscape and seascape painter. Exhib. at RA 1885, 1888, 1892 and SS. Subjects mainly views of the French and Dutch coasts. Very little known.

Probable price range £30-70

ALLEN, John Whitacre fl.1859-1886
Bath and Cheltenham landscape painter. Exhib. at RA in 1864, 1879 and SS. Visited Italy. Very little known.

Probable price range £30-50

ALLEN, Joseph William 1803-1852
Prolific London landscape painter and watercolourist. Drawing Master at the City of London School. Secretary to the Society of British Artists, and regular Exhibitor there (329 works). Also exhib. at RA 1826-1833 and BI. Subjects mainly idealized views in N. Wales, Cheshire, Yorkshire and other Midland counties. The *Art Journal* of 1852 cites 'The Vale of Clwyd' (1847) as a really fine work, but criticizes Allen's work for "unequivocal marks of haste and want of finish".

In October 1968 a landscape by J.W.A. sold at auction for £200; in March 1969 another sold for £330.

Bibl: AJ 1852, p.316 (obit); Redgrave; Dict.; DNB; Cundall; VAM; Hardie II, 154-155 (pl.140).

ALLEN, Thomas William fl.1881-1902
Landscape painter, working in London and Surrey. Exhib. at RA 1882-1902 and SS. Subjects mainly in Surrey, Oxfordshire and Wales, or ideal landscapes e.g. 'At Eventide' (RA 1886). Very little known.

Probable price range £30-70

ALLINGHAM, Mrs. Helen RWS 1848-1926
(Miss Helen Paterson)
Watercolour painter of rural scenes, sunny gardens and children. Educated at the Birmingham School of Design and the RA Schools. Strongly influenced by Birket Foster and Frederick Walker. In 1874 she married William Allingham, the Irish poet, thus entering a literary circle where she met Ruskin, who became an admirer of her work. In *Art of England* (1884), he linked her with Kate Greenaway (q.v.) and praised her representation of 'the gesture, character and humour of charming children in country landscapes'. She was elected ARWS in 1875, and member in 1890. Exhib. almost entirely at the OWS (221 works).

Probable price range £50-150

Bibl: Clement & Hutton; Clayton II, pp.1-5; Ruskin, *Academy Notes,* 1875; and *Art of England,* 1884; Studio, Summer No. (1900); H.B. Huish, *Happy England as painted by H.A. with memoir,* 1903; FAS, 1886, 87, 91, 94, 98, 1901, 1913; VAM; Cundall; Hardie III, 112-113 (pl.34); Maas, 231.

ALLOM, Thomas 1804-1872

Architect and topographical watercolourist. Articled to Francis Goodwin. Founder member of RIBA. Produced perspectives for Sir Charles Barry of 'the new Houses of Parliament and completed the hall in Barry's Highclere, Hants. Employed by Virtue & Co. and Heath & Co. he made drawings for *Cumberland and Westmorland, Devonshire and Cornwall, Scotland, France, Constantinople, Asia Minor and China.* He is chiefly known today for his topographical drawings — mostly views of buildings. He travelled extensively on the Continent and in the Far East. Exhib. at the RA 1827-1871 and SS.

Price range £50-150

Bibl: AJ, 1863, pp. 36, 77, 123, 162, 205, 228, 250; 1872, p.300; *Builder,* 1872, 26 Oct; DNB; Binyon; Redgrave, Dict.; *RIBA Drawings Cat.* Vol. A; Hardie III, 29 (pl.38).

ALMA-TADEMA, Anna fl.1885-1903

Painter of landscape, classical genre and flowers. Daughter of Alma-Tadema (q.v.). Exhib. at RA 1885-1903, NWS, GG and NG. Usually signed A. Alma-Tadema. Her pictures are painted with great delicacy and poetry, but her reputation has always been overshadowed by that of her father and mother.

Price range £50-200

Bibl: Shaw Sparrow, *Women Painters of the World.* 1905.

ALMA-TADEMA, Lady Laura (Laura Epps) 1852-1909

Painter of children (usually in Dutch 17th c. costume) portraits in pastel, domestic scenes, classical subjects and small landscapes (generally Italian). Daughter of Dr. George Napoleon Epps and second wife of Alma-Tadema (q.v.). Her sister Mrs. Edmund Gosse and her daughter Anna also painters. Exhib. at RA from 1873, and GG and NG. Her classical subjects are often confused with those of her husband; she signed L. Alma-Tadema, but did not use opus numbers. In 1878 she was one of the two women artists invited to contribute to the International Exhibition in Paris.

Price range £50-300

Bibl: Alice Meynell in the AJ, 1883, pp.345-347 (mono. with plates); Clayton, II, p.6.

* ALMA-TADEMA, Sir Lawrence OM RA 1836-1912

Painter of Greek and Roman subjects, set in scenes of remarkable archaeological and architectural accuracy. His paintings are always recognizable for their brilliant luminosity, and exquisite rendering of marble, silver, gold, bronze and silks. Born in Dronryp, Holland. In 1852 entered the Antwerp Academy, where Louis de Taye, the Professor of Archaeology, much influenced his work. In 1860 became assistant and pupil to Baron Leys. Settled in London 1870. His output was prolific. He numbered all his works with Roman numerals, his first work painted when he was 14 being opus I 'Portrait of my Sister'. His last work, opus CCCCVIII, 'Preparations', was painted two months before his death. His first picture painted in London was Opus LXXXVI, 'From an Absent One'. Some quite finished pictures do sometimes appear without opus numbers. In 1906 he was awarded the Royal Gold Medal by the RIBA for his promotion of architecture in painting. His own house in St. John's Wood was designed in the style of a Pompeian villa. He also produced stage designs for Sir Henry Irving's *Coriolanus* 1901 and *Cymbeline* 1896 and for Sir Herbert Beerbohm Tree's *Julius Caesar* and *Hypatia.* Exhib. at the RA from 1869, OWS, GG and NG. He had many followers and imitators, e.g. Edwin Long and J.W. Godward (q.v.). His wife Laura and his daughter Anna (q.v.) were also painters, who closely followed his style. Forgeries of his work do exist, many of which are falsely signed and numbered CCCXXXVIII.

Two works by A-T sold at Sotheby's 4.6.69 for £3,000 and £4,600.

Bibl: George Ebers Lorenz, *A-T,* 1886; Percy Cross Standing, *Sir L.A-T,* 1905; William Gaunt *Victorian Olympus,* 1952; Reynolds, VP, 120, 123, 180, 193 (pl. 89-90); Mario Amaya, 'The Roman World of A-T'. *Apollo,* Dec. 1962 (with additional bibliography); Mario Amaya, *Sunday Times Magazine,* 18 Feb. 1968; Maas, pp.182-183 (pl. on p.182-183).

ALMOND, W. Douglas b.1866 fl.1886-1904

London genre and historical painter. Member of the Langham Sketching Club. Exhib. at RA from 1893 and at SS. Subjects often of Cavaliers and Roundheads, e.g. 'In Council' (RA 1899). Little known.

Probable price range £30-50

Bibl: AJ, 1895, p.54; Studio XXXII, p.286.

AMPHLETT, Miss Kate fl.1878-1890

London landscape painter. Exhib. at SS and RA 1884-89. Titles 'A Swamp'. Very little known.

Probable price range £30-70

ANDERSON, John fl.1858-1884

Coventry landscape painter. Exhib. at SS, BI and RA 1858-84. Subjects views around Coventry and the Midlands e.g. 'A Bit of Warwickshire', 'Green Pastures on the Avon' etc. Another landscape and flower painter called John Anderson exhib. at the RA 1827-39, but neither are well known.

Probable price range £30-70

* ANDERSON, Mrs. Sophie 1823-c.1898

Genre, landscape and portrait painter. Born in Paris, where she studied under Steuben. Her father being French, her early years were spent in France, but with the outbreak of the 1848 Revolution, she and her family left for America. There she established herself as a successful portrait painter and married an English artist, Walter Anderson. In 1854 they came to England, and in 1855 she began to exhibit genre pictures at the RA. While in England she lived in London, Dalston (Cumberland), and Bramley, near Guildford, but around 1871 she moved to Capri because of ill-health. Eventually she returned to England and lived in Falmouth. At present she is known only for one outstanding work, 'No Walk Today' (Reynolds VP on cover), but more pictures by her may well come to light. She exhib. at the RA 1855-96, BI, SS and GG.

Price range £200-500, but a work of the quality of 'No Walk Today' would obviously be worth more.

Bibl: Clayton II 7-9; Reynolds VP 113 (pl. 73 and cover).

ANDRE, James Paul Jnr. fl.1823-1867

Prolific London landscape painter. Exhib. at RA 1823-59, BI and SS. Subjects at RA views in Surrey, Kent, Devon and elsewhere. Little known.

Probable price range £50-200

ANDREWS, Henry fl.1830-1860

London genre and historical painter. Exhib. at RA 1830-58, BI and SS. Now best known for his imitations and adaptions of Watteau, who he is also said to have forged. Redgrave says that 'he fell into the hands of unscrupulous dealers'. Although derivative, his Watteau-style pictures are popular for their decorative appeal.

Price range £500-1,000; more for an exceptional example.

Bibl: Redgrave, Dict.

ANELAY, Henry 1817-1883
Landscape painter; lived at Eyre Cottage, Blackheath. Exhib. mainly at SS, showing 5 works at the RA between 1858 and 1873. Some of the titles are coastal views, e.g. 'Coast near Fairlight' (1872); Ruskin commented on 'Anstey's Cove' (RA 1858) "....though not an altogether successful effort, is a most earnest one to render the mingling of transparency with reflection in pure and perfect sea".

Probable price range £50-200

Bibl: Ruskin, *Academy Notes,* 1858

ANGELL, Mrs. John b.1847 fl.1875-1882
Flower painter and watercolourist. Specialized in small studies of fruit, flowers and birds in the manner of Hunt, Clare and Cruickshank. William Hunt (q.v.) regarded her as his successor. Exhib. at OWS, NWS, GG and at RA 1876-78. A Miss Maude Angell of Hendon also exhib. flower pieces at the RA 1869-1904.

Price range £20-100 for watercolours, £50-200 for oils.

Bibl: AJ 1884, p.127; Clayton II, 261; Cundall; VAM.

*** ANSDELL, Richard RA 1815-1885**
Liverpool sporting and animal painter. Began studying painting in 1836; by 1840 he was exhibiting at the RA. Following the vogue for Highland subjects, he painted many Scottish subjects in the popular Landseer manner — stags in glens, moorland scenes, sheep-dipping, cattle, shooting parties etc. He also painted battles and historical scenes. In 1856 he went to Spain with John Phillip (q.v.), and again in the following year by himself. Phillip and Ansdell collaborated on several Spanish pictures, and from this time many Spanish genre scenes and landscapes appear in Ansdell's work. He is also said to have often collaborated with Thomas Creswick (q.v.) and W.P. Frith (q.v.). Exhib. at the RA 1840-85 (149 works) and BI. Elected ARA 1861, RA 1870. President of the Liverpool Academy 1845-46. Many of his pictures were engraved and became very popular. His studio sale was held at Christie's on 19 March 1886. Although best known for his Landseer-type works, some of Ansdell's large portrait groups, such as 'The Caledonian Coursing Club' sold at Christie's on 25 April, 1969 show him to have been an artist of considerable ability.

Average price for large pictures £400-1,000, smaller examples £100-300. 'The Caledonian Coursing Club' sold at Christie's on 25 April, 1969 for 34,000 gns. was an exceptional price for an exceptional picture.

Bibl: Ruskin, *Academy Notes,* 1857; AJ 1860, 233; 1885, 192; 1904, 217; Clement & Hutton; Redgrave, Cent. 385; Marillier, 51-55 (pl. opp. p.52); Pavière, Sporting Painters (pl.2); Maas 53, 83, 96.

ANTHONY, George Wilfrid 1800-1860
Landscape painter and art critic. Studied under Ralston in Manchester and Barber in Birmingham. Exhib. at RA 1831-32, BI and SS. Became a drawing master, and wrote for the *Guardian.* Cousin of Henry Mark Anthony (q.v.).

Price range £30-70

Bibl: AJ 1860 p.10 (obit).

ANTHONY, Henry Mark 1817-1886
Landscape painter, born in Manchester. Much influenced by the Barbizon painters Corot and Dupré, with whom he studied in Paris and Fontainebleau 1834-40. Later he settled in London where he was in contact with Ford Madox Brown, Goodwin and other Pre-Raphaelites. Exhib. at the RA 1837-84, BI and SS. Travelled in France and Spain. As well as landscapes, he painted many small studies of trees, ponds and foliage. Cousin of George Wilfred

Anthony (q.v.).

Price range £50-200

Bibl: Bryan; Clement & Hutton; Exhib. Catalogue of the Leathart Collection, Laing Art Gallery, Newcastle, 1968.

*** ARCHER, James RSA 1823-1904**
Scottish painter of genre, portraits, landscapes and historical scenes (mostly medieval). Studied at the Trustees' Academy in Edinburgh under Sir William Allan (q.v.). At first painted chalk portraits, but in 1849 he exhib. his first historical picture 'The Last Supper' at the RSA. Elected ARSA 1850, RSA 1858. Exhib. at the RA 1840-1904 (108 works), BI and SS. About 1859 he began to paint a series of Arthurian subjects, e.g. 'La Morte d'Arthur', 'Sir Launcelot and Queen Guinevere' etc. which show Pre-Raphaelite influence. In 1862 he settled in London, and turned mainly to sentimental historical scenes and portraits. He was the first Victorian painter to do children's portraits in period costume. Often signed with monogram JA, punningly transfixed by an arrow.

Price range £100-500. In April 1969 Christie's sold 'Rose Brawardine' by JA for 140gns. His Pre-Raphaelite pictures would make the highest prices, but his portraits are now largely forgotten.

Bibl: AJ 1871 pp.97-99 (3 plates); Ruskin *Academy Notes,* 1875; Clement & Hutton; Caw, 170-171; Maas, 231 (pl. on p.256).

ARMFIELD, George fl.1840-1875
London painter, of dogs, especially terriers chasing birds, cats or mice. Exhib. at RA 1840-62, BI and SS. Also painted landscapes; dead game birds and other wild animals. His small dog pictures often passed off as Landseer. Graves says his real name was Smith. An Edward Armfield also painted some similar dog pictures, and may have been related to George A.

Prices usually under £50, but £50-100 for sporting subjects.

Bibl: AJ 1859 p.121

*** ARMITAGE, Edward RA 1817-1896**
London painter of biblical and historical subjects and allegories. Pupil of Paul Delaroche in Paris and assisted him in the decoration of the hemicycle in the Ecole des Beaux Arts. Won a £300 prize in the Westminster Hall Competition in 1843 for his 'Landing of Julius Caesar'. Executed two frescoes in the Houses of Parliament. In 1845 he won a £200 prize for his cartoon 'The Spirit of Religion'. In 1847 his 'Battle of Meance' won a £500 prize and was bought by the Queen. Exhib. only at the RA 1848-93. In Rome 1849-51. Painted 'Inkerman' and 'Balaclava' after a visit to the Crimea during the Russian war. Other major works by him are 'Retribution', a large allegory in the Leeds Town Hall, and frescoes in Marylebone Parish Church and the St. Francis Chapel of the RC Church of St. John in Islington. Elected ARA 1867, RA 1872. His style is similar to that of Edwin Long (q.v.); their ideas both derive basically from Alma-Tadema.

Large-scale biblical and allegorical works by Armitage find little favour today and rarely appear on the market; probable price range £50-300.

Bibl: AJ 1863 pp.177-180; 1896 p.220; Ruskin, *Academy Notes,* 1875; Clement & Hutton; J.P. Richter, *Pictures & Drawings Selected from the Work of E.A.* 1897; DNB; T.S.R. Boase, *English Art* 1800-1870, pp.210, 215-16, 291 (pl.900); Maas, 22, 27.

ARMSTRONG, Miss Elizabeth A. See under FORBES, Mrs. Stanhope

ARMSTRONG, Thomas 1835-1911
Manchester decorative figure painter. Studied under Ary Scheffer in Paris and was one of the 'Paris Gang' in Du Maurier's novel *Trilby* with Whistler, Poynter and T.R. Lamont (q.v.). Unlike the other

members of the group, Armstrong remained a lifelong friend of Du Maurier's. Exhib. at the RA 1865-77 and GG. Armstrong's decorative style and subjects similar in feeling to Albert Joseph Moore (q.v.). In addition to his easel pictures, he also painted several decorative schemes for interiors. In 1881 he was appointed Director of Art at the S. Kensington Museum, and practically gave up painting.

Armstrong's work rarely appears on the market; probable price range £100-300.

Bibl: Clement & Hutton; Reynolds VP, 119, 123-124, 151, 194 (pl. 136); Maas, 184; Leonee Ormond, *George du Maurier*, 1969, *see* Index.

ARNOLD, Mrs. (Miss Harriet Gouldsmith) 1787-1867
London landscape, portrait and genre painter. Exhib. at RA 1840-54 and BI. Subjects at RA views around London, on the Thames and in Wales. One of the few 19th c. woman painters to gain any distinction in landscape painting.

'Richmond Bridge, with a Regatta' sold at Christie's 2.7.71 for £1,575.

Bibl: AJ 1863, p.53; Clayton I, 397.

ARUNDALE, Francis 1807-1853
London architect, topographical painter and traveller. Studied with Pugin. Travelled in the Middle East and spent many winters in Rome. Exhib. at RA 1830-52 and BI. Pictures all of buildings, classical ruins, temples, archaeological sites etc. Published and illustrated several books on architecture. Married to a daughter of Francis Pickersgill (q.v.).

Probable price range £50-200

Bibl: AJ 1854, p.50 (obit); Redgrave, Dict; Binyon.

ASCROFT, William fl.1858-1886
London landscape painter. Exhib. at RA 1859-86, BI and SS. Titles also include genre scenes, e.g. 'Thou Busy, Busy Bee'. 'Is it a Hogarth' etc. Little known.

Probable price range £30-100

ASHBY, H.P. fl.1835-1865
London landscape painter. Exhib. at RA 1835-65. Subjects all English views, especially around Wimbledon, where Ashby lived. Very little known.

Probable price range £30-100

ASHTON, Julian R. fl.1871-1879
London genre painter. Exhib. mainly at SS, also RA 1873-78. Titles at RA 'Mother's Darling'. 'Thinner she Might Have Been' etc. Very little known.

Probable price range £30-100

ASTON, Charles Reginald RI fl.1855-1893
Birmingham landscape painter and watercolourist. Exhib. at RA 1862-78, BI, SS and NWS. Subjects at RA views in Wales, Cornwall and Italy.

Probable price range £30-70

ATKINS, Miss Catherine J. fl.1871-1894
London genre painter. Exhib. at RA 1877-94, BI, OWS, NWS, GG and NG. Titles at RA 'The Dowager', 'Happy Thoughts'. 'Age is a Time of Peace' etc. Very little known.

Probable price range £30-70.

Bibl: *The Year's Art* 1880-97

ATKINSON, George Mounsey Wheatley fl.1806-1884
Irish marine painter. Started life as a ship's carpenter; later held a naval post at Queenstown, Co. Cork. Exhib. at the RHA. A little known but very attractive marine artist.

'A Harbour Scene' sold at Christie's in May 1967 for 450gns.

ATKINSON, John Gunson fl.1849-1879
Prolific London landscape painter. Exhib. mainly at SS (108 works), also at BI and RA 1854-74. Titles at RA mostly views in Wales and north of England. Little known.

Probable price range £30-70

ATKINSON, W.A. fl.1849-1867
Little-known London genre and historical painter. Exhib. only a small number of works at the RA (1849-62), BI and SS. Now only known for one exceptional picture, 'The Upturned Barrow' (Reynolds VS, pl.65), but more of his work may come to light.

Price: owing to the rarity of his work, very difficult to estimate. A fine example of the same quality as 'The Upturned Barrow' might be worth £500-1,000, his historical scenes less.

Bibl: Reynolds VS, 26, 85 (pl.65)

AUMONIER, James RI 1832-1911
Painter of quiet pastoral landscapes and animals, in oil and watercolour. Born at Camberwell, London; studied drawing at the Birkbeck Institution, Marlborough House and South Kensington Schools. At first worked as a designer of printed calicoes, but about 1862 took up landscape painting under the influence of Lionel Smythe and W.L. Wyllie. Exhib. at RA from 1870, BI, SS, NWS, GG and NG. Member of the NEAC, ROI, RA. Awarded medals at many international exhibitions.

JA's landscapes are sometimes rather empty and featureless, which keeps his prices down. 'Summer from the Hill Slopes', a landscape 24 x 36in. sold at Christie's 11.7.69 for £333. Price range £100-400; small works and sketches £20-50.

Bibl: Studio 20 (1900) p.141

AUMONIER, Miss Louisa fl.1868-1900
London flower painter. Exhib. at RA 1885-1900, SS, NWS and GG Very little known; presumably related to James Aumonier (q.v.).

Probable price range £20-50.

AYLING, Albert RCA fl.1853-1892
Landscape and portrait painter; lived in Chester and Liverpool. Exhib. at RA 1853-92, SS, NWS. Subjects portraits, Welsh landscapes, fruit and occasional genre. Also painted watercolours.

A watercolour sold at Christie's Jan. 1969 for £105.

AYLMER, T.B. fl.1834-1856
London landscape painter. Exhib. at RA 1838-55, BI, SS. Titles at RA mostly continental views — Italy, Belgium and Germany. Very little known.

Probable price range £30-100.

BACON, John Henry F. ARA 1868-1914
London domestic and genre painter. Exhibited at RA from 1889. Titles at RA mostly romantic – 'A Confession of Love' etc. Occasionally painted portraits. Sometimes signed 'J.H.F.B. His best known work is 'The City of London Imperial Volunteers Return to London from South Africa on Monday 29th October, 1900' in the Guildhall, London. His studio sale was held at Christie's on April 27, 1914.

'His own Poems' sold at Christie's 19.12.68. for £336.

Bibl: Studio Vols. 22,23,25 (illustrations).

BAILEY, Albert E. fl.1890-1904
Landscape painter, lived at Northampton and Leicester. Exhibited at the RA from 1890, subjects mainly idyllic and evening landscapes. Very little known.

Probable price range £30-70

BAILEY, Henry fl.1879-1907
London landscape and genre painter. Also lived in Chelmsford. Exhibited at RA from 1880. Titles 'The Dart near Staverton' 'Cornfield by the Sea' 'On the Cliffs' etc. Very little known.

Probable price range £30-50

BAIRD, William Baptiste fl.1872-1899
London domestic genre painter. Born in Chicago; exhibited in Paris, and at the RA 1877-1899. Titles at RA mostly family scenes – 'The Cares of a Family' 'The Cottage Door' etc.

'Hens with their Broods' sold at Sotheby's 26.2.69 for £160.

BAKER, Alfred 1850-1872
Birmingham landscape painter, son of S.H. Baker (q.v.). Studied art under his father and at the Birmingham School of Art. Exhibited mainly at Birmingham Society, showing only 4 works at SS in London. Subjects largely open-air landscapes in the Midlands and N. Wales.

'A Lane at Streatley, Berkshire' sold at Sotheby's 14.5.69 for £110.

Bibl: Birmingham Catalogue

BAKER, Miss Blanche fl.1869-1901
Bristol landscape painter. Exhibited at RA 1869-1901. Titles 'Lingering Twilight' 'The Evening Tide' 'The Forester's Garden' etc. Very little known.

Probable price range £30-70

BAKER, Henry 1849-1875
Birmingham landscape painter, known as 'Harry' Baker. Eldest son of S.H. Baker (q.v.), and brother of Alfred Baker (q.v.). Studied in his father's studio. Did not exhibit at the RA; only at SS and the Birmingham Society. Subjects mostly landscapes in N. Wales, Devon and Ludlow. Often signed HB in monogram.

Price range £50-150

Bibl: Birmingham Catalogue

BAKER, Samuel Henry RBSA 1824-1909
Birmingham landscape painter and watercolourist. Worked first with a magic lantern slide painter; then studied at the Birmingham School of Design, the Birmingham Society, and with J.P. Pettitt. Exhibited from 1848 at the RBSA, of which he became a member in 1868, and later trustee and treasurer. Also exhib. at the RA 1875-1896, and at SS. Subjects mainly N. Wales and Midlands. Shared Cox's reverence for the Welsh countryside, but employed a stipple technique foreign to Cox's vigorous and free brushwork. Often signed with the initials S.H.B. His two sons, Henry and Alfred B. (q.v.), both artists, and also his brother.

Price range £50-150

Bibl: Birmingham Catalogue

***BAKER, Thomas 1809-1869**
Midlands landscape painter and watercolourist, known as "Baker of Leamington". Exhibited at the RA in 1831, 1847 and 1858, but more frequently at the BI and RBSA. Best-known and probably the most accomplished painter of the numerous Baker family of artists. Subjects mainly landscapes in Warwickshire and the Midlands, with sheep and cattle. His diaries and notes, which contain a complete list of his works, are in the Birmingham City Art Gallery. Usually signed T. BAKER and numbered each picture on the back.

The average price at the moment is £500-1,000, but an example was sold by Christie's in April 69 for £1,260. Two others at Sotheby's 18.2.70 made £2,200 and £2,600.

Bibl: Binyon; RBSA, *Retrospective Exhib.* Cat. 1968.

BALDOCK, James Walsham fl.1867-1887
Worksop animal and sporting painter. Exhibited at SS and NWS. Subjects mainly cows, but also painted horses and hunting scenes in a style derived from J.F. Herring Senior.

A hunting scene sold at Christie's in April 1969 for £168; another in the same sale made £158.

Bibl: Pavière, Sporting Painters, 14 (pl.3).

BALDWIN, Samuel fl.1843-1858
Little known Halifax genre painter, who exhibited at S.S. 1843-1858. Almost his only known work is 'Sketching Nature' reprd. in Maas, who notes 'he combined a Ruskinian eye for landscape with figure painting'.

Probable price range £70-150

Bibl: Maas 238 (pl. on p.244).

BALE, C.T. fl.1868-1875
London still-life painter. Exhibited at the RA in 1872, and at SS. Subjects mainly fruit and flowers, painted in a repetitive style derived from George Lance and William Duffield.

Price range £100-200

BALL, Wilfred Williams 1853-1917
London landscape and marine painter, etcher and watercolourist; lived in Putney. Exhibited at the RA 1877-1903 (mainly etchings) also at SS, NWS and GG. Many of his paintings and etchings were views on the Thames in the style of Whistler. Also travelled in Holland, Germany, Italy and Egypt.

Probable price range £50-150

Bibl: AJ 1905 p.219,
Studio Vol. 16 p.3 ff (monograph with illustrations); vol. 31, pp 72-3.
Hardie III p.82.

BALLANTYNE, John RSA 1815-1897
Scottish portrait and historical genre painter. Studied in Edinburgh; came to London 1832. Exhib. at the RA 1835-1883. Teacher at the Trustees' Academy. Specialised in portraits of artists in their studios. The NPG has one of Sir Edwin Landseer at work on the lions in Trafalgar Square.

Probable price range £100-200

Bibl: NPG Cat. 1903; Caw, p.230-31; Studio 1907.

BALMER, George 1805-1846
Newcastle landscape and marine painter and watercolourist. Worked in North Shields, exhibiting at the Blackett St. Academy in Newcastle. Friend and rival of J.W. Carmichael (q.v.), with whom he collaborated on several pictures. Toured the Continent, visiting Holland, Germany and Switzerland, after which he settled in London. In 1836 he started work on *The Ports, Harbours, Watering Places and Coast Scenery of Great Britain* which contained engravings of some of his best drawings, but was never completed. The first volume appeared in 1842. He also exhib. rural and architectural subjects from 1830-41 at the BI and SS. Balmer's watercolours are often attributed to the better-known and more expensive Charles Bentley (q.v.).

Probable price range £100-200

Bibl: AU 1846 pp.280-81 (obit); Binyon; DNB; Hardie III p.78 (pl.95).

BANCROFT, Elias Mollineaux RCA fl.1869-1893
Manchester landscape painter; also worked in London, exhibited at the RA from 1874. Subjects mainly views in Wales, Germany and Switzerland. Very little known.

Probable price range £30-70

BANKS, J.J. fl.1860-1874
York landscape painter. Exhibited 26 works between 1860 and 1874 at SS and BI. Another York artist, Thomas J. Banks, is also recorded as a landscape painter, and is probably of the same family. Both are very little known.

Probable price range £50-100

BANKS, J.O. fl.1856-1873
London painter of rustic genre. Exhibited at RA 1856-1873. Subjects usually pretty girls and children in landscapes.

Price range £100-300.

BANNATYNE, J.J. RSW fl.1866-1891
London landscape painter and watercolourist. Exhibited at the RA 1869-1886, also at SS and NWS. Subjects mostly views of Scottish lochs. Little known.

Probable price range £30-70

BARBER, Charles Burton 1845-1894
London sporting and animal painter. Exhibited at the RA 1866-93. Specialised in portraits of dogs, often with children. Painted Queen Victoria with her dogs, and many other royal dogs e.g. 'Fozzy', the Prince of Wales's Dog.

Price range £100-200

Bibl: H. Furniss *The Works of C.B.B.* 1896

BARBER, Charles Vincent 1784-1854
Birmingham landscape painter and watercolourist. Eldest son and pupil of Joseph Barber (1758-1811), the teacher of David Cox. One of the founders of the first Society of Birmingham Artists in 1809, which developed into the Birmingham Academy of Arts, Barber was a friend of David Cox and accompanied him on sketching tours in Wales. By 1818 he was working in Liverpool as a drawing master and was exhibiting at the Liverpool Academy by 1822. He later became its treasurer, secretary and president (1847-1853). Exhibited at the RA in 1829 and 1849, also at SS and the OWS.

Price range £50-150

Bibl: AJ 1854 p.50 (obit); Hardie II p.192; *Cat. of Early English Watercolours and Drawings in Walker Art Gallery, Liverpool, 1968.*

BARBER, Joseph Moseley fl.1858-1889
Leicester landscape and genre painter. Worked in Birmingham, later in Chelsea. Exhibited at RA 1864-1878, also at S.S. and B.I. Subjects mostly rustic genre 'Granddad's Darling' 'Cottage Pets' etc. Not to be confused with Joseph Vincent Barber (1788-1830) or his father Joseph Barber (1758-1811), teacher of David Cox.

Probable price range £50-150

Bibl: AJ 1859, p.121
Roget I, pp.331-2.

BARCLAY, Edgar fl.1868-1893
London landscape and genre painter. Studied in Dresden and Rome. Exhibited at the RA from 1869, also at the GG and NG. Subjects usually landscapes or scenes of peasants working in fields, showing the influence of J.F. Millet.

'Dairy Time' signed and dated 1869, sold Christie's 9.6.61 for £105.

Bibl: AJ 1894, p.266 (illustration).

BARKER, Thomas 1769-1847
Bath landscape painter; one of the 'indefatigable family of Barkers of Bath', many of whom were painters. His brother was Benjamin Barker of Bath (1776-1838). Exhib. at the RA and SS, but mostly at the BI. Barker was much influenced by Gainsborough, and their pictures and drawings are often confused.

Price range £100-400

Bibl: Hardie I. pp.95-96

BARKER, Thomas Jones 1815-1882
London historical and battle painter. Studied under Horace Vernet in Paris. Exhibited at the RA 1845-1876, also at SS and BI. Subjects mainly historical battle scenes, especially of the Napoleonic and Crimean Wars.

'The Meeting of Wellington and Blucher' sold at Christie's 21.3.69 for £263.

Bibl: AJ 1878 pp.69-72; 1882, p.159; Clement and Hutton

BARLAND, Adam fl.1843-1875
London landscape painter. Exhibited at the RA 1843-63, and at the BI and SS. Subjects views in England and the Scottish Highlands.

A landscape sold at Bonham's 6.2.69. for £130.

BARNARD, Frederick 1846-1896
London painter of genre, mainly domestic scenes. Studied under Léon Bonnat in Paris. Worked in London, and at Cullercoats, on the coast of Northumberland. Exhibited at the RA 1858-1887, and at SS Worked as illustrator for *Punch, Illustrated London News* and other magazines. Chiefly known for his illustrations reinterpreting the novels of Dickens. His paintings and watercolours are done in bright, pure

colours, and usually contain much period detail of Victorian interiors.
A watercolour 'Breakfast Visitors' sold at Christie's in June 1969 for 50 gns. Average price range for watercolours £50-150, oils £100-300.

Bibl: The Year's Art 1897 p.309; DNB 1908; Reynolds VS p.90 (pl.77).

BARNARD, George fl.1832-1890
London landscape painter and watercolourist. Pupil of J.D. Harding (q.v.). Exhibited at the RA 1837-1873, and at the BI, but more often at SS. Subjects views in Switzerland, Wales, Devon etc. and some sporting scenes.

Price range £50-150

Bibl: Roget II p.179.

BARNARD, J. Langton b.1853 fl.1876-1902
London domestic genre painter. Exhibited at the RA, SS and the NEAC. His wife Mrs. Barnard (Miss Emily Cummins) a landscape painter. Both very little known.

Probable price range £30-70

BARNES, E.C. fl.1856-1882
London painter of domestic scenes and interiors, especially of children. Exhib. mainly at SS, but also at the RA 1856-1882 and the BI. His work mainly of two types, small genre and domestic scenes, and larger Frith-type scenes of Victorian life. He also painted some Spanish subjects in the manner of John Phillip and J.B. Burgess.

'Fisherwoman with Prawns' sold at Bonham's 7.8.69 for £125.

BARNETT, James D. fl.1855-1892
Landscape painter, working at Crouch End. Exhibited at the RA 1855-1872, and at the BI, but mostly at SS. Painted views on the Rhine, in Normandy and Burgundy, and also town views in England.

Probable price range £30-70

BARNICLE, James fl.1821-1845
London landscape painter. Exhibited mainly at SS and the BI, also at the RA 1821-1843. Subjects views on South Coast, Channel Islands, Wales and Scotland. Very little known.

Probable price range £30-70

BARRABLE, George Hamilton fl.1873-1887
London painter of genre scenes, mainly interior and domestic subjects. Exhibited at the RA 1875-1887, and at SS. Titles at RA 'April Showers' 'The Coquette' 'After the Dance' etc.

Probable price range £50-150

BARRATT, Thomas fl.1852-1893
Sporting and animal painter, worked at Stockbridge. Exhib. at the RA 1852-1893, and at the BI and SS. Titles at RA 'The Farmyard' 'Riding the Herd from the Wounded Buck' 'The Sick Lamb' etc.

Probable price range £30-100

BARRAUD, Allan F. fl.1872-1893
Landscape painter and etcher; lived in Watford. Exhib. at the RA 1873-1900, mostly etchings, and also at SS. Titles at the RA 'A Winter Afternoon' 'Collecting the Flock' 'At the Ford' etc.

Probable price range £30-70

BARRAUD, Charles James fl.1871-1893
London landscape painter and watercolourist. Exhib. mainly at SS but also at the RA 1877-1894. Titles at RA 'Waiting' 'Close of Day' etc. Very little known.

Probable price range £20-50

*BARRAUD, Henry 1811-1874
London portrait, sporting and genre painter, brother of William Barraud (q.v.), with whom he often collaborated on sporting pictures. Exhib. at the RA 1833-59, also at the BI and SS. Subjects mainly historical, e.g. 'Robert Bruce and the Spider' 'The Theory of Gravitation suggested to Sir Isaac Newton by the Fall of an Apple' etc. Henry and William B. exhibited joint pictures on which they both worked at the RA from 1836-1849. These were mostly portraits with horses and dogs, and historical scenes, e.g. 'Border Law' 'The Annual Benediction of the Animals at Rome'. Henry B. probably painted the figures, William the animals.

'A Man on a Bay Hunter' sold Christie's 16.7.65 for £945, but the more usual price range is £200-400

Bibl: Sir W. Gilbey, *Animal Painters*
Pavière, *Sporting Painters*, p.15 (pl.4).4).

*BARRAUD, William 1810-1850
London sporting painter, brother of Henry B. (q.v.), with whom he often collaborated. Pupil of Abraham Cooper. Exhib. at the RA 1829-1850, also at the BI and SS. Subjects sporting, portraits with horses and dogs, animals, and some historical. Apart from their separate output, William and Henry B. exhib. several joint pictures at the RA between 1836-1849 (see Henry B.).

'A White Horse in a Landscape' sold Sotheby's 12.10.66 for £1,600. The more average range of prices is £200-500. A picture of 'The Old Surrey Foxhounds' by Henry and William B. sold Christie's 17.6.66 for £1,890.
Bibl: AJ 1850, p.339, and as for Henry Barraud.

BARRETT, Jerry 1814-1906
Brighton historical and genre painter. Exhib. at the RA 1851-1883 and at SS. Titles at RA 'Meeting of Queen Victoria with the Royal Family of Orleans' 'Lady Mary Wortley Montague in Turkey' 'Nature and Art' etc. Barrett's two most famous works were 'Florence Nightingale receiving the Wounded at Scutari in 1856' and 'Queen Victoria visiting the Military Hospital at Chatham.' Because of the patriotic feelings aroused by the Crimean War, both these pictures were enormously popular through engravings.

Price range £100-300

Bibl: AJ 1861, p.191; 1858, 191; The Year's Art 1907; Reynolds VP 112, 115 (pl.65).

BARTHOLOMEW, Valentine 1799-1879
Prolific London flower and still-life painter and watercolourist. Exhibited mainly at the OWS, of which he was a member; also at the RA 1826-1854 and SS. Appointed Flower Painter in Ordinary to Her Majesty and to HRH The Duchess of Kent. His wife, Mrs. Valentine Bartholomew (Mrs. Turnbull, formerly Miss Anne Charlotte Fayermann 1800-1862) painted miniatures and domestic scenes.

A still-life in watercolour sold Sotheby's 13.3.69 for £170.

Bibl: AJ 1879 p.109; Roget II. p.245; Clement and Hutton

BARTLETT, William H. b.1858 fl.1874-1904
London painter of domestic scenes and interiors. Not to be confused with William Henry B. (q.v.). Studied under Gérôme in Paris. Exhib. at SS., also at the RA from 1880, and at the GG and NG. As well as genre, painted continental views, and according to Pavière, sporting subjects.

Probable price range £50-150

Bibl: RA Pictures 1891

BARTLETT, William Henry 1809-1854
London topographical watercolourist and illustrator. Articled, when

fourteen, to John Britton who sent him to make topographical drawings for his *Cathedral Antiquities of Great Britain,* and the *Picturesque Antiquities of English Cities.* About 1830 he visited the Continent, and then Syria, Egypt, Palestine and Arabia; he went four times to America. Nearly a thousand of his drawings — as Hardie notes — 'effective as to topography, but slight and uninspiring in workmanship', were engraved in many of his illustrated works such as *Walks about Jerusalem,* 1845; *Pictures from Sicily,* 1852; *The Pilgrim Fathers,* 1853. He exhibited at the RA in 1831 and 1833, and also at the NWS. Not to be confused with William H. Bartlett (q.v.).

Price range £100-200; much more for American views.

Bibl: AJ 1855, 24-6. W. Beattie *Brief Memoir of W.H. Bartlett,* 1855; J. Britton *A Brief Biography of W.H. Bartlett,* 1855; Fine Art Society, 1892; Binyon; DNB; Hughes; VAM; *Country Life* 1968, 15th Feb; Hardie III 29-30, pl.41.

***BARWELL, Frederick Bacon fl.1855-c.1897**
London genre painter. Friend of J.E. Millais (q.v.), who painted most of 'The Rescue' and other pictures in his studio. Exhib. at the RA 1855-1887, and a few pictures at the BI and SS. Subjects mainly small domestic scenes and interiors, but occasionally attempted bigger scenes of Victorian life, such as 'Parting Words - Fenchurch Street Station', his best known work (Reynolds V.S. pl.72). Ruskin praised F.B's 'The London Gazette' (RA 1855) and 'Adopting a Child' (RA 1857), describing the latter as 'a well-considered and expressive picture'.

Price range £200-500

Bibl: Ruskin, Academy Notes, 1855 and 1857; The Year's Art 1880-1897; Reynolds VS p.88 (pl.72).

BATEMAN, James 1815-1849
London sporting painter. Exhib. at the RA 1840-48, also at the BI and SS. Subjects hunting, shooting and fishing.

'Flyfishing', a pair of fishing scenes, sold at Sotheby's 1.2.61 for £160.

Bibl: AJ 1849 p.161; Shaw Sparrow, *Angling in British Art.*

BATEMAN, Robert b.1841/2 fl.1865-1889
Very little known minor Pre-Raphaelite painter. Entered RA schools in April 1865. Exhib. 6 works at RA 1871-1889, 14 at the GG, and 10 elsewhere. One of his RA pictures 'The Pool of Bethesda' (1876) was recently rediscovered and published by Basil Taylor in *Apollo.* It shows Bateman to have been a very original artist, with a style compounded of Burne-Jones and eclectic study of early Italian Renaissance painters.

Owing to the rarity of his works, prices are impossible to estimate.

Bibl: Basil Taylor, *A Forgotten Pre-Raphaelite,* Apollo, Notes on English Art, August 1966.

BATES, David fl.1868-1904
Midlands landscape painter, worked in Birmingham and Worcester. Exhib. at the RA from 1872, also at SS and the GG. Style and subjects similar to other artists of the Birmingham school, such as Joseph Thors and S.H. Baker (q.v.). Also made many small oil sketches of hedges and plants, which he usually inscribed and signed on the reverse.

Price range £100-250

BATES, W.E. fl.1847-1872
London marine and seascape painter. Exhib. mainly at SS, but also at the BI and RA 1847-1864. Titles at RA 'On the Beach at Fécamp, Normandy' 'Pegwell Bay' etc.

Probable price range £50-100

BATTEN, John Dickson 1860-1932
London painter, book illustrator and etcher. Exhib. at the RA 1891-98, and at the GG and NG. Subjects mainly themes from fairy tales or mythology e.g. 'Thetis Saves the Argonauts from Scylla' (RA 1898). Batten often painted in tempera, and was influenced by late Quattrocento painters such as Crivelli, and also by Burne-Jones.

'Diana and the Infant Perseus' sold at Sotheby's 12.3.69 for £280.

Bibl: Studio, Vol. 23, p.158; Vol.35, p.295; Vol.38, pp.64, 67.

***BAXTER, Charles RBA 1809-1879**
London painter of fancy portraits and charming pretty girls in 'The Keepsake' tradition. Exhib. at the RA 1834-1872, but more often at SS. Subjects also included poetic and rustic subjects. Invented the Baxter print, which made his works widely popular. Started his career as a bookbinder and miniature painter. Elected member of the Society of British Artists in 1842. His studio sale was held at Christie's March 15, 1879.

'Study of a Young Girl' sold Sotheby's 26.6.69 £160.

Bibl: AJ 1864 p.145-7 (Biog); 1879 p.73 (obit); VAM; Maas p.107 (pl.106, 111).

BAYLISS, Sir Wyke PRBA FSA 1835-1906
London painter and architect. Exhib. almost only at SS; exhib. at RA in 1865 and 1879. Specialised in Gothic church interiors. Also a prolific writer on art and aesthetics.

Price range £30-50

Bibl: AJ 1906 p.192

BAYNES, Frederick T. fl.1833-1864
London still-life painter and watercolourist. Exhib. at the RA 1833-1864, and at SS. Subjects small fruit and flower pieces in the manner of Oliver Clare, and occasional figure subjects.

Price range £30-50

BEALE, Miss Sarah Sophia fl.1860-1889
London genre, portrait and marine painter. Exhib. mainly SS; also at RA 1863-1887. Titles at RA 'The First Violet' 'The Pleasures of Art' 'The Funeral of an Only Child—Normandy' etc. Very little known.

Probable price range £30-70

BEARNE, Edward H. fl.1868-1892
London landscape and rustic genre painter. Exhib. at the RA 1869-1895. Views in Devon, Italy and Germany, and rustic genre, e.g. 'The Peasant's Cottage'. Very little known.

Probable price range £30-70

BEAVIS, Richard RWS 1824-1896
Prolific painter, in oils and watercolours, of landscape, and especially atmospheric coastal scenes, e.g. 'Fishermen Picking up a Wreck at Sea', 'Threatening Weather' etc. rustic genre, eastern subjects, animals, and military scenes. Born at Exmouth; entered RA Schools 1846; worked as an artist for the firm Messrs. Trollope, upholsterers and decorators, until 1863. With him as designer the firm competed successfully for three international competitions. He exhibited some of these interior designs at the RA in 1855, '58 and '60. Later he worked for them only part time. In 1867-8 Beavis lived in Boulogne, visiting Holland. He was influenced by Millet and the Barbizon painters. In 1875 he travelled via Venice and Brindisi to Alexandria, Cairo, Jaffa and Jerusalem, the trip providing him with subject matter for many of his later paintings. In all he exhibited from 1852-96 at the RA, SS, BI, OWS, NWS, GG, NG, and also on the Continent. Elected

A of the Institute, 1867; member 1871; ARWS, 1882; RWS, 1892. His studio sale was held at Christie's Feb. 17, 1897.

'Stacking Oats' sold Bonham's 6.3.69 for £100

Bibl: AJ 1877 p.65-68; 1897 Jan (obit); Studio 1905 The Old Watercolour Society; Bryan.

BEDFORD, Miss Ella M. fl.1882-1902
London genre and decorative painter. Exhib. at RA 1885-1902, and at SS. Titles at RA 'Poetry — Design for Decoration' 'A Breton Maid' 'Isabella, the Pot of Basil' etc. Very little known.

Probable price range £30-50

BEECHEY, Capt. Richard Brydges 1808-1895
London marine painter; son of Sir William Beechey, the portrait painter. Made the navy his career, and eventually rose to the rank of Admiral. Exhibited at the RA 1832-1877, and at the BI and SS. Specialised in rough weather, shipwrecks and storms, which has prevented his work from achieving popularity.

'The Sea is His and He made it' sold at Christie's in Feb.66 for 12 gns. Average prices now probably £30-100.

BELL, Miss Ada fl.1878-1903
London flower painter and landscapist. Exhib. at the RA 1880-1903 (mostly flowers); also at SS, GG and NWS. Very little known.

Probable price range £20-50

BELL, Arthur George fl.1875-1893
London genre and landscape painter. Exhib. at the RA from 1879, and more often at SS. Subjects often of New Forest. Very little known.

Probable price range £30-70

BELL, Edward fl.1811-1847
Worcester painter of dead game, fish, still-life, landscapes, rustic genre and historical subjects. Also an engraver and mezzotinter. Exhib. at the RA 1811-1847, and at the BI and SS.

Price range £50-150

Bibl: J. Challoner Smith, *British Mezzotint Portraits*, 1878 I. p.55; Binyon.

BELL, John fl.1847-1861
Landscape painter. Very little known, but appears to have worked at Bettws-y-Coed in Wales. Exhib. at the RA, BI and SS.

A landscape sold at Christie's in 1968 for £73. Average price range £50-150

BELL, John Zephaniah 1794-1883/4
Scottish domestic and historical painter. Studied with Archer-Shee, and Gros in Paris. Worked in Edinburgh, Rome, Lisbon, Oporto, and Manchester. Won a prize in the competitions for the Westminster Hall decorations. Exhib. at the RA 1824-1861, and at the BI and SS. Subjects 'Cartoon for Ceiling at Muir House' 'Richard II Giving the Charter to the Goldsmith's Company' 'Circassians reconnoitring Polition' etc.

Probable price range £30-100

BELL, Robert Anning RA 1863-1933
Figure painter, sculptor of reliefs, illustrator and designer of mosaics and stained glass. Articled to an architect. Studied at the RA schools in 1881 and at Westminster School of Art. Worked in Paris under Aimé Morot and in London with George Frampton, then visited Italy. Exhib. at RA from 1885; elected ARA 1914, RA 1922. Member of

NEAC 1892-1902; ARWS 1901; Art Worker's Guild (Master in 1921). Taught at Liverpool University from 1894 and Glasgow School of Art from 1911. Professor of Design at RCA 1918-24. Designed mosaics for Westminster Cathedral. Memorial exhibition at the FAS 1934. His wife was Laura Anning Bell (1867-1950), the portraitist.

Price range £30-100

Bibl: Tate Cat.; Studio, see index.

BENHAM, Thomas C.S. fl.1878-1893
London landscape, portrait and genre painter. Lived in Portsmouth. Exhib. at RA 1878 onwards. Titles at RA 'Poachers' 'Toilers of the Sea' 'Washed Ashore' etc. Very little known.

Probable price range £30-70

BELL, Stuart Henry 1823-1896
Marine painter, worked in Newcastle, Gateshead and Sunderland. Not known to have exhibited, although his pictures were admired by Queen Victoria in 1886. Bell was also a theatrical scenery painter, and impresario. He leased the Theatre Royal, Newcastle, and the Drury Lane, Sunderland, but his theatrical speculations ended in bankruptcy. The Sunderland Art Gallery has a collection of his pictures.

'The Road to the Village' sold Bonham's 7.8.69 £260.

BENTLEY, Charles 1806-1854
London marine watercolourist. Apprenticed as an engraver to Theodore Fielding and worked with him and his two engraver brothers. Engraved a number of Bonington's watercolours and much influenced by his style. In 1827 set up on his own as an engraver and produced drawings for illustrated publications. Elected A of the OWS 1834, member 1843. Exhib. mainly at OWS from 1834-54 (209 works), also at SS and NWS. Did not exhib. at the RA. Subjects generally coast and river scenes, with varying effects of sunset, evening, storm and calm, on the British and Irish coasts, Normandy and the Channel Islands. A lifelong friend of William Callow (q.v.) with whom he made many trips to Normandy and Paris. His studio sale was held at Christie's April 16, 1855.

'A Brig Beating out of Harbour' sold Sotheby's 17.10.68 for £150.

Bibl: DNB; Binyon; Roget; F.G. Roe, *Walker's Quart.* 1, No.3. 1920; VAM; Hardie III p.76-8.

BENTLEY, Joseph Clayton 1809-1851
London landscape painter, watercolourist and engraver. Born in Bradford. Pupil of Robert Brandard the engraver. Exhib. from 1833-1851 at the BI, from 1846-52 at the RA, and at SS. His watercolours often confused with those of Charles Bentley (q.v.).

'Yorkshire River Landscape' sold Sotheby's 18.6.69 £500.

Bibl: AJ 1851 p.280; 1852 p.15 (obit); Redgrave, Dict.; VAM; Cundall; DNB; Hughes; Hardie III 77.

BERKELEY, Stanley fl.1878-1902 d.1909
London animal, sporting and historical battle painter. His wife, Mrs. Edith Berkeley, painted genre and landscapes, and also exhib. at the RA 1884-1891. Stanley B. exhib. at the RA 1881-1902, also at SS and NWS. Titles at RA 'On the Thames' 'For God and the King' 'The Sunken Road of Ohain; an Incident in the Battle of Waterloo'.

Price range £50-150

Bibl: Maas, p.206 (Reprd: detail from 'For God and the King').

BERRIDGE, William Sidney
Animal painter. Very little known. Probably working c.1880-90.

'A Tiger Drinking' sold at Christie's in Dec. 1968 for £26. Average price range £20-40.

BEVERLY, William Roxby **1811-1889**
Landscape painter and watercolourist. Son of William Roxby, an actor and theatrical manager. As a boy Beverly studied with Clarkson Stanfield, but devoted most of his career to painting and designing stage scenery. Worked in Manchester and London, and was scenic director of Covent Garden 1853-1884. In spite of the demands of his work, B. found time to paint pictures and watercolours, mainly coastal scenes, especially at Scarborough, Sunderland, Eastbourne and Hastings. He also visited the Lake District, Paris and Switzerland. His output was not large, but Hardie says 'there can be no doubt that if there were wider knowledge of his radiant and limpid watercolours, Beverly would have a much higher place than he has hitherto occupied in any history of watercolour.'

'Scarborough Castle' a watercolour, sold Christie's 11.3.69 for £115.

Bibl: F.L. Emannal, *W.R.B.*, Walkers Quarterly I, No.21; Clement & Hutton; Binyon; VAM; Hughes; DNB; Hardie II 188-9 (pl.182).

BINGLEY, James George **fl.1871-1891**
Godalming landscape painter. Also lived at Wallington and Midhurst. Exhib. at RA 1871-91. Mainly views of Kent, Surrey and the South Coast. Titles at RA 'A Bit of Old Kent' 'Gathering Primroses' 'The First Brood' etc.

Probable price range £30-50

BINKS, Thomas **1799-1852**
Hull marine painter. Painted merchant ships in and around Hull, and also scenes of arctic exploration. Not known to have exhibited in London. Pictures by him are in the Ferens AG and the Maritime Museum in Hull.

'A View of Hull' sold Christie's 2.4.65 for £924.

BIRCH, Downard **1827-1897**
Landscape painter. Exhib. only 5 works at the RA (1858-61 and one in 1892) and 3 at the BI. His early works show interesting Pre-Raphaelite influence, but his output was very small, and he lived for many years in Italy. The AJ says in his obituary that the promise of his early years 'was scarcely fulfilled'.

'A River Landscape' sold at Christie's 10.7.70 for £294.

Bibl: AJ 1897 350 (obit).

BIRD, Samuel C. **fl.1865-1893**
London painter of coastal and genre scenes. Exhib. at the RA 1866-83, and at the BI and SS. Titles at RA 'Who Killed Cock Robin' 'The Many Twinkling Smile of Ocean' etc.

Probable price range £20-50

BIRTLES, Henry **fl.1859-1892**
Birmingham landscape painter. Also lived in Regent's Park, Hampstead and Arundel. Exhib. at the RA 1861-78, more often at SS. Titles at RA 'Sheep in the Meadows' 'A Dewy Morning' etc. Very little known.

Probable price range £30-70

BISHOP, Walter Follen **1856-1936**
Liverpool landscape painter. Also lived in London and Jersey. Exhib.

at RA 1882-1902, more often at SS. Specialised in woodland scenes. Titles at RA 'A Woodland Pool' 'In the Heart of the Forest' etc.

Probable price range £20-50

BLACK, Arthur John **1855-1936**
Nottingham landscape and figure painter. Studied in Paris under B. Constant. Exhib. at the RA from 1882, and at the NG. Subjects mainly romantic landscapes, sometimes with figures. Titles at RA 'Young Fishermen - Wollaton Canal' 'A Fairy Swirl' 'Lobster Fishers'. His coastal scenes show stylistic influence of the Newlyn School.

A coastal scene sold at Christie's in July 1968 for £47. Average price range £30-100

BLACKBURN, Mrs. Hugh **fl.1850-1875**
(Miss Jemima Wedderburn)
Painter of animals. Married to the Professor of Mathematics at Glasgow University. Exhibited only 3 works at RA, but much admired by Ruskin, who praised her *Illustrations of Scripture* in 1855.

Probable price range £20-70

Bibl: Mary Lutyens, *Millais and the Ruskins*, 1967, p.113n

BLACKLOCK, Thomas Bromley **1863-1903**
Scottish painter of landscapes and children. Later became a painter of fairy tales. e.g. 'Red Riding Hood' 'Bo-Peep' 'The Fairies Ring' etc. Studied in Edinburgh, and worked in East Linton and Kirkcudbright. Exhib. at the RA in 1901 and 1903.

Price range £30-100

Bibl: Caw, 406

BLACKLOCK, William James **1816-1858**
London landscape painter. Exhib. at the RA 1836-55, also at the BI and SS. Born in Carlisle, B. specialised in landscape views in the north of England, especially in Cumberland.

'A Mountain Lake in the Scottish Highlands' sold Christie's 29.3.63 for £126.

Bibl: AJ 1858 p.157; DNB 1908 II 591; Redgrave Dict.; Binyon.

BLAIKLEY, Alexander **1816-1903**
London portrait and figure painter. Born in Glasgow. Exhib. at the RA 1842-67 (mainly portraits) and at the BI and SS. At Birmingham AG is 'The First Ragged School, Westminster' 1851.

'The Interior of Crystal Palace' sold Sotheby's 26.7.61 for £150.

Bibl: Birmingham Cat.

BLIGH, Jabez **fl.1863-1889**
London and Peckham still-life painter. Exhib. at RA 1867-1889, also at SS. Titles at RA 'Mushrooms' 'Fungus' 'Nest & Primroses' etc. Very little known.

Probable price range £30-70

***BLINKS, Thomas** **1860-1912**
London sporting and animal painter. Exhib. at the RA from 1883, and at SS. Titles at RA mainly hunting scenes and dogs.

'Refreshment at the Hunt Stables' sold Sotheby's 4.6.69 £250.

Bibl: Pavière, *Sporting Painters*, p.19 (pl.5).

BLUNDEN, Miss Anna (Mrs. Martino) **b.1829 fl.1854-1877**
Figure and landscape painter; worked in London & Exeter. Exhib. at the RA 1854-1872, but more often at SS. At first a figure

painter, Miss B. turned to landscape at the encouragement of Ruskin, who admired her pictures 'Past and Present' (1858) and 'God's Gothic' (1859) at the RA. A.W. Hunt & Holman Hunt were also among her admirers, and David Roberts bought one of her pictures. 'Mr. Roberts might learn something by that picture, if he would but study it,' was Ruskin's comment. Miss B. visited Italy, married in Hamburg, and settled near Birmingham.

Probable price range £100-300.

Bibl: Ruskin, *Academy Notes,* 1858, 1859; Clayton II p.196-226.

BODDINGTON, Edwin H. **fl.1853-1869**
London landscape painter, son of Henry John Boddington (q.v.). Exhib. at the RA 1854-1866, but more often at the BI and SS. Subjects mainly views on the Thames. Boddington developed a very personal and recognisable style. His river scenes are usually painted in a calm evening light, using a range of very dark greens and browns.

Boddington's works frequently appear at auction. Price range £100-400.

***BODDINGTON, Henry John** **1811-1865**
London landscape painter; second son of Edward Williams (q.v.) After his marriage to Clara Boddington in 1832, he used the name Boddington so as not to be confused with other members of the Williams family. Exhib. at the RA 1837-1869, at the BI, but mainly at SS where he showed 244 works. Subjects mainly views on the Thames and in Wales. Ruskin praised his pictures for their honesty and true love of countryside.
'On the River Lynn, N. Devon' sold at Christie's 19.11.70. for £2,205. Usual range £400-800.
Bibl: AJ 1865 p.191 (obit); DNB 1908 II p.752; Ruskin, *Notes on the SBA,* 1857, 1858; Redgrave, Dict.

BODICHON, Madame Eugene (Miss Barbara Leigh Smith) 1827-1891
Amateur landscape painter and watercolourist. Wife of a French diplomat; travelled widely in Canada, America, France, Spain & N. Africa, painting views wherever she went. Also a famous philanthropist, and one of the founders of Girton College, where some of her pictures hang. Exhib. at RA 1869-1872, mainly coastal scenes, e.g. 'Stormy Sea near Hastings'. Much influenced by the Barbizon painters; the French critics called her the 'Rosa Bonheur of landscape.' Madame Bodichon was a friend of Rossetti, who often stayed at her house in Sussex, Scalands. Rossetti described her as 'Blessed with large rations of tin, fat, enthusiasm and golden hair.' She also knew many of the other Pre-Raphaelites.

Probable price range £20-50

Bibl: Clayton II 167, 374, 383; Hester Burton, *Barbara Bodichon,* 1949; Fredeman, see index; Rosalie Glynn Grylls, *Portrait of Rossetti,* See index.

BODKIN, Frederick E. **fl.1872-1902**
London landscape painter. Exhib. at the RA 1874-1902, and at SS. Subjects poetic landscapes, or views in the south of England. Titles at RA 'Down by the Old Mill Wheel' 'Full Summer Time' 'A Lowland Hill' etc.

Probable price range £30-70

BOLTON, William Treacher **fl.1857-1881**
London landscape and flower painter. Exhib. mainly at SS. also at RA 1859-1881. Titles at RA 'Apple Blossom' 'A Beech Wood - Surrey' etc. Very little known.

Probable price range £30-70

BONAVIA, George **fl.1851-1876**
London painter of portraits and romantic genre. Exhib. at RA 1851-1874, and at the BI and SS. Genre titles at RA 'A Recluse "For Thee I Panted" 'The Heart has Tendrils Like the Vine' etc.

Probable price range £30-50

BOND, Richard Sebastian **1808-1886**
Midlands landscape painter; distant relation of W.J.J.C. Bond (q.v.). Born in Liverpool, where studied with Samuel Austin. Lived at Bettws-y-Coed in Wales, where he was friendly with David Cox and W.J. Muller (q.v.). Exhib. at the RA 1856-72, and at the BI and SS, but chiefly exhibited in Birmingham and the Liverpool Academy, of which he was an associate from 1836-42. Subjects mainly coastal scenes and Welsh landscapes.

Probable price range £50-150

Bibl: The Year's Art 1887 p.229; Marillier, p.69-70; Birmingham Cat.

***BOND, William Joseph J.C.** **1833-1926**
Liverpool landscape painter. Apprenticed to Thomas Griffiths, a picture dealer and restorer. Lived in Carnarvon, then in Central Chambers, South Castle St. Liverpool. Worked mainly for northern patrons. Exhib. at SS, but only twice at the RA, in 1871 and 1874. Elected associate of Liverpool Academy 1856, member 1859. An eclectic artist — the influences of Davis, Huggins, and especially Turner are visible in his work. His pictures have often been passed off as Turners. Came under Pre-Raphaelite influence in the 1850's. Subjects landscapes, coastal and harbour scenes, mainly in Cheshire, Wales and Anglesey. Also fond of painting old buildings. Visited Antwerp.

Price range £30-100

Bibl: Marillier p.71-78 (plates opp. pp.72 and 76)

BONNAR, William RSA **1800-53**
Edinburgh painter of historical and genre scenes, and portraits. Exhib. mainly in Edinburgh; showed only 4 works at SS. Caw states that his 'pastoral pieces and children' were better suited to his talent than his ambitious historical pieces. His genre subjects showed marked Wilkie influence.

'The Deserter' sold at Sotheby's 4.6.69 £100.

Bibl: AJ 1853 p.76; DNB; Caw 120.

BOOT, William Henry James RBA **fl.1872-1903**
London landscape painter. Exhib. mainly at SS, also at RA 1874-1903. Travelled in Germany, France and N. Africa. Titles at RA views in Derbyshire, Surrey, Devon, and on the continent. Also painted domestic genre and interiors.

Probable price range £30-100

BOOTH, Edward C. **fl.1856-64**
Leeds landscape painter. Exhib. at the RA 1856-64. Very little known, except that Ruskin admired 'The Roadside Spring' exhib. at the RA in 1856, praising its honesty and attention to detail.

'The Rocky Stream' sold Christie's 11.10.68 £100

Bibl: J. Ruskin *Academy Notes* 1856

BORROW, William H. **fl.1863-93**
London marine painter; also lived at Hastings. Exhib. at the RA 1863-1890, and at SS. Subjects mainly coastal scenes in Devon and Cornwall. Very little known.

Probable price range £30-70

BOTTOMLEY, John William 1816-1900
London sporting and animal painter. Studied in Munich and Dusseldorf. Exhib. at RA 1845-75, and at SS, BI. Titles at RA show that he painted shooting scenes, dogs, deer, sheep & cattle, and a few pure landscapes. Thought to have painted many of the cattle in Creswick's (q.v.) landscapes.

Probable price range £50-150

***BOUGH, Samuel RSA 1822-1878**
Scottish landscape painter. Born in Carlisle, son of a shoemaker. Worked as a theatre scenery painter in Manchester and Glasgow Encouraged by James Macnee to take up painting. In Glasgow 1848-1855; often worked with Alexander Fraser (q.v.) in Cadzow Forest. Moved to Edinburgh, elected ARSA, and in 1875 RSA. Exhib. 15 works at the RA 1856-76. Subjects chiefly Scottish or north of England. B's early style is minute and detailed; after 1860, his handling became broader and more confident. Caw praises his 'feeling for air and atmosphere and movement, and for broad and scenic effects' but warns that his works are at times 'deficient in intimacy of sentiment and depth of feeling'. Bough was also a good watercolourist. Often signed SB in monogram.

Bough's works sell fairly often at auction. Price range £100-500.

Bibl: R. Walker, *S.B. & G.P. Chalmers;* Caw p.188-90 (plate opp. p.190); Sidney Gilpin, *S.B.* 1905; DNB II 912; Cundall; VAM; Binyon; Maas p.46 (with plate).

***BOUGHTON, George Henry RA 1833-1905**
London painter of genre, figure subjects, portraits, landscape, sporting pictures and historical scenes. Lived in America, studied in Paris, and came to London in 1862. Exhibited from 1863-1904, at the RA, BI, GG and NG. Painted views in England, Scotland, France and Holland. 1879 ARA; RA 1896. Many of his paintings are very decorative, but often the figures tend to become too pretty and the subjects over-sentimental. The single figures, especially, usually portraits of women, often veer too closely to the chocolate-box, eg. 'Rosemary' and 'Black-eyed Susan'. Ruskin, who did not like Boughton's technique, described it as 'executed by a converted crossing sweeper, with his broom, after it was worn stumpy'. The sale of his studio was held at Christie's June 15, 1908.

Probable price range £100-300

Bibl: AJ 1904 367; AJ Christmas Annual 1904, full monograph with plates; The Portfolio 1871 69; J. Ruskin *Academy Notes* 1875.

BOUVIER, Miss Agnes Rose — see NICHOLL, Mrs. Samuel Joseph

BOUVIER, Gustavus A. fl.1866-1884
London genre painter. Exhib. mainly at SS, also at RA 1869-1881. Titles at RA 'The Orange Girl' 'Miss in her Teens' 'A Fisher's Wife' etc. Very little known.

Probable price range £30-50

BOUVIER, Joseph fl.1839-1888
London genre and historical painter. Exhib. chiefly at SS, also at BI and RA 1839-1856. Titles at RA 'Little Red Riding Hood' 'Cleopatra' 'The Little Romany Maid' etc. Painter of pretty Victorian girls and children in the tradition of Baxter and Birket Foster.

'At the Cottage Door' sold Bonham's July 69 for £52.

***BOWKETT, Miss Jane Maria (Mrs. Charles Stuart) fl.1860-1885**
London painter of domestic scenes, usually of mothers and children. Exhib. mainly at SS, also at RA 1861, 1881 and 1882. Subjects 'Preparing for Dinner' 'Sally in our Alley' etc. Several other Miss Bowketts are recorded, Miss E.M.B., Miss Jessie, Miss Kate & Miss

Lily, all very little known, and presumably of the same family.

'At the Seaside' sold Christie's 9.6.67 for £294.

Bibl: Reynolds VS, p.85 (pl.64).

***BOWLER, Henry Alexander 1824-1903**
London landscape & genre painter. Like Redgrave, Dyce, Moody and many other Victorian painters, Bowler devoted most of his life to teaching, and so did not have much time to paint. Headmaster of Stourbridge School of Art 1851-1855. Professor of Perspective at the RA 1861-1899. Exhib. at the RA 1847-1871, mostly landscapes, and a few works at BI, SS and NWS. His best known work is 'The Doubt — "Can These Dry Bones Live?" ' an illustration to Tennyson, shows Pre-Raphaelite influence both in subject and style.

Probable price range £200-500

Bibl: AJ 1908 p.108; Reynolds VS 17, 81 (pl.1 'The Doubt'); Maas 133.

BOWNESS, William 1809-1867
London portrait and genre painter. Mainly self-taught artist. Born in Kendal. Exhib. at RA 1836-1863, more often at SS & the BI. Titles at RA 'The Grecian Mother' 'The Fair Falconer' 'Consulting the Glass' etc. Married to the eldest daughter of John Wilson (q.v.) the marine painter.

Probable price range £30-70

Bibl: AJ 1868 p.34 (obit); DNB II 983; Redgrave Dict.

BOXALL, Sir William RA FRS 1800-1879
London portrait painter of the literary, artistic and ecclesiastical establishment. Exhib. portraits at RA 1818-1880, and also religious subjects and landscapes. Also exhib. at BI & SS. Ruskin criticised his portrait of Mrs. Coleridge (RA 1855) for 'excess of delicacy and tenderness.' His studio sale was held at Christie's June 8, 1880.

Probable price range £50-100; more for an important sitter.

Bibl: Ruskin, *Academy Notes,* 1855; DNB II, 995.

BOYCE, George Price RWS 1826-1897
Landscape and topographical painter and watercolourist. Educated as an architect, and made many architectural studies on the Continent. In 1849 he met David Cox (q.v.) at Bettws-y-Coed, who encouraged him to give up architecture for painting. Exhib. at the RA 1853-1861, and at SS. Titles at RA 'Edward the Confessor's Chapel, Westminster' 'St. Mark's, Venice' 'At Lynmouth, N. Devon' etc. Exhib. mainly at the OWS (218 works) of which he was A in 1864, member 1877, retired 1893. Friend of D.G. Rossetti (q.v.) and one of the founders of the Hogarth Club. Ruskin praised B's 'At a Farmhouse in Surrey' (RA 1858) as 'full of truth and sweet feeling'. Boyce's Diaries, published by the OWS in 1941, are a valuable source of information on the Pre-Raphaelites. His studio sale was held at Christie's July 1, 1897.

Price range £100-500

Bibl: J. Ruskin *Academy Notes,* 1858, 1859; A.E. Street *Arch. Review* 1899; OWS XIX 1941; Bryan; VAM; Roget; Birmingham Cat: Fredeman, See Index; Hardie III 127-9 (pl.191).

BOYCE, William T.N. 1838-1911
Marine painter and watercolourist, lived at South Shields, Co. Durham. Did not exhibit in London. Subjects mainly shipping scenes off the north east coast. Works by him are in the Laing Art Gallery, Newcastle, and the Sunderland AG.

Price range £5-25

BRABAZON, Hercules Brabazon 1821-1906

Landscape and still-life watercolourist. Born in Paris. Educated at Harrow and Trinity College, Cambridge, where he read Mathematics. Studied in Rome for 3 years, and took lessons from J.H. d'Egville and A.D. Fripp. Travelled with Ruskin and Arthur Severn; toured Spain, Egypt, India etc. Original member of NEAC. In 1892, Sargent persuaded H.B.B. to exhibit some of his drawings at the Goupil Gallery, as up to then he had practised as an amateur. Since then his rapid, colourful sketches have been popular with collectors.

Brabazon's watercolours frequently appear on the market, and make about £50-250.

Bibl: Goupil Gallery Exhibition Cat. 1892 (Preface by Sargent); AJ 1906, 1907; Studio Vol.35 p.95-98; Hardie III 202.

BRADLEY, Basil RWS 1842-1904

Landscape and genre painter & watercolourist. Studied at Manchester School of Art. Exhib. mainly at OWS, also S S and RA 1873-99. Subjects at RA chiefly English and Scottish landscapes, some sporting.

'Peat Carrier, Connemara, Ireland' sold Christie's 18.10.68 £147.

Bibl: Clement & Hutton; Cundall; Pavière, *Sporting Painters* (pl.7).

BRADLEY, Edward fl.1824-1867

London landscape & still-life painter. Exhib. at RA 1824-44, more often at BI and SS. Titles at RA views in Hampshire, Surrey, Scotland and Italy. Very little known.

Probable price range £30-70

BRADLEY, John Henry b.1832 fl. 1854-1884

Landscape and topographical painter and watercolourist. Pupil of David Cox and James Holland, both of whose influence can be detected in his work. Lived in Leamington and London, and travelled in Italy. Exhib. at RA 1854-79, and at BI and SS. Subjects landscapes, views in Italy, and some flower pieces. His views of Venice similar in style to James Holland.

Price range £100-300

Bibl: Clement & Hutton

***BRAMLEY, Frank RA 1857-1915**

Genre and portrait painter. Member of the Newlyn School, with Stanhope Forbes and Henry Tuke (q.v.), at Newlyn, Cornwall. Like those of Forbes, Bramley's works combine the social realism of Courbet and Millet, with the *plein-air* landscape of the Barbizon painters. B. exhib. at the RA from 1884. Elected ARA 1893, RA 1911. 'A Hopeless Dawn' (RA 1888) bought by the Chantrey Fund and now in the Tate (Reynolds VP pl.131). One of the founder members of the NEAC; exhib. at GG and NG. After 1897 turned increasingly to portrait painting.

Price range £100-300, major works more.

Bibl: Tate Cat.; Reynolds VP 188, 194, 195 (pl.131); Maas 249-50.

BRANDARD, Robert 1805-1862

Landscape engraver and watercolourist, brother of E.P. Brandard, an engraver. Their sister Annie Caroline B. also a landscape painter. Robert B. came to London from Birmingham in 1824, and studied with Edward Goodall (q.v.). Exhib. oils at the RA in 1838, 1842 and 1852, but concentrated on engraving. Employed by Turner, Callcott, Stanfield and others. Engraved plates for Turner's *England* and *English Rivers*.

Price range for oils £50-150

Bibl: Redgrave Dict.; DNB II 1124; Bryan; Binyon; VAM; Cundall; Hughes.

BRANGWYN, Sir Frank RA 1867-1956

Painter, watercolourist, etcher and lithographer. At first a self-taught artist; worked under William Morris, and then went to sea. Exhib. at the RA from 1885, also at SS, GG and NG. Subjects at RA mainly marines, scenes of life on board ship, and subjects inspired by his travels. At first his colours were grey and subdued; after his return from abroad his style became richer and more colourful. Brangwyn's long career extends well beyond the Victorian period, so for the remainder of his career after this period, see Bibl.

'Fisherman on Jetty at Calais Harbour' (1889) sold Christie's 23.5.69 £420.

Bibl: P. Macer-Wright, *Brangwyn - a Study of Genius;* Vincent Galloway, *Oils and Murals of Brangwyn;* Walter Shaw-Sparrow, *Frank Brangwyn & his Work,* 1910, 1915 (with appendix by B. of list of paintings, sketches and etchings up to 1914). Tate Cat; Maas 67.

BRANWHITE, Charles 1817-1880

Bristol landscape painter and watercolourist. Pupil of William Muller (q.v.) Exhib. mainly at the OWS (265 works); also at RA 1845-56, and at the BI. Subjects mainly views in the West Country, Wales, Scotland, and on the Thames. His studio sale was held at Christie's on April 15, 1882. Style shows influence of Muller. The AJ says he was particularly noted for his 'frost scenes'.

'View of the River Severn' sold at Bonham's 8.5.69 for £440. Watercolours £70-200.

Bibl: Ruskin, *Notes on OWCS* 1857, 58; AJ 1880 p.208 (obit); Clement & Hutton

BREANSKI, see under de Breanski.

BREAKSPEARE, William A. (1855/6-1914)

London genre painter. Foundation member of the Birmingham Art Circle. Studied in Paris and influenced by Thomas Couture. Member of the Newlyn School in Cornwall. Exhib. at the RA 1891-1903, and at SS and GG. Subjects mainly genre, or 18th century costume pieces.

'Interior with Women Disrobing' sold Phillips Son & Neale 16.6.69. £170.

BRENNAN, Michael George 1839-1874

Irish landscape and genre painter. Trained in Dublin and at the RA; settled in Rome. Exhib. at RA 1865-1870. Subjects scenes of Roman life, and Italian views around Capri, Naples and Pompeii.

Probable price range £30-100

BRETLAND, Thomas W. 1802-1874

Nottingham animal and sporting painter. Never exhibited in London; travelled round the country working for his patrons, who included the Dukes of Buccleuch and Montrose. As a painter of horses he was competent, if uninspired. Pictures by him are in the Nottingham AG.

'A Racehorse and Jockey' sold at Christie's 22.11.68 for £336. Other auction prices range from £100 to £400.

***BRETT, John ARA 1830-1902**

London painter of coastal scenes and landscapes. Attracted the attention of Ruskin with 'The Stonebreaker' at the RA in 1858. Encouraged by Ruskin, Brett visited N. Italy, and painted 'The Val d'Aosta' which he exhibited at the RA in 1859. Ruskin devoted several pages of his *Academy Notes* for that year to praising the picture, although he did comment 'it is Mirror's work, not Man's'. Under Ruskin's influence, Brett's style developed away from his earlier Pre-Raphaelitism, towards subjects of geological and botanical interest. For the next forty years, Brett exhibited at the RA a succession of highly detailed, geological coast scenes of a rather

repetitive formula, but which often show great beauty and observation.

'View of St. Ives, Cornwall' sold Christie's 17.1.69. £179. Usual price range £100-200, but a good Pre-Raphaelite work would make more.

Bibl: Ruskin, *Academy Notes* 1858, 1859, 1875; AJ 1902, p.87; Bate 87f; Tate Cat; Ironside & Gere p.45 (pls.77-79); Reynolds VS 17, 76 (pl.III); Fredeman, see index; Reynolds VP 65, 68, 69, 154, 155; Maas 63, 67, 133-4 (pls. on p.65, 68, 136, 137).

BRETT, Miss Rosa **fl.1858-1881**
Landscape painter; sister of John Brett (q.v.). Exhib. at RA 1858-81, and occasionally elsewhere. Although really an amateur, she painted many charming studies of fruit, flowers, foliage, and animals, as well as landscapes.

Her pictures hardly ever appear on the market, as they are mostly in the possession of the Brett family. Probable range would be £50-150.

BREWER, Henry William **fl.1858-1897 d.1903.**
London painter of churches, details of church interiors and tombs. Exhib. at RA 1858-1897 and at SS. Travelled in England, France, Germany and Italy in search of subjects. Style similar to Samuel Prout.

Probable price range £50-150

Bibl: AJ 1881 p.257 - 261 (illustrations).

BRICKDALE, Eleanor Fortescue RWS 1871-1945
Book illustrator and painter, in oil and water-colour, of homely genre, historical and imaginative subjects. Educated at Crystal Palace School of Art and the RA Schools. In 1896 she won a £40 prize for a design for the decoration of a public building – a decorative lunette 'Spring' for one of the lunettes in the RA Dining Room. She first exhibited at the RA in 1896 and onwards. Member of the Royal Society of Painters in Watercolours. Amongst books she illustrated are: *Poems by Tennyson*, 1905 (Bell Endymion series); Browning, *Pippa Passes* and *Men and Women*, 1908; Browning *Dramatis Personae* and *Dramatic Romances and Lyrics*, 1909; Tennyson, *Idylls of the King*, 1911; W.M. Canton, *Story of St. Elizabeth of Hungary*, 1912; *Book of Old English Songs and Ballads*, 1915; *Eleanor Fortescue Brickdale's Golden Book of Famous Women*, 1919; *The Sweet and Touching Tale of Fleure and Blanchfleure*, 1922; *Carols*, 1925; Palgrave, *Golden Treasury of Songs and Lyrics*, 1925; Calthorp, *A Diary of an Eighteenth Century Garden*, 1926. Her paintings are in the Walker Art Gallery, Liverpool, Birmingham, Leeds, etc; she also designed stained glass windows for Bristol Cathedral, Brixham etc.

Price range £100-200

Bibl: AJ 1905 p.387, plate; Studio, Vol.13, 103-8; Vol.23, 31-44; W.S. Sparrow *Women Painters* 1905 p.73; *Who Was Who 1941-50;* Hartnoll and Eyre Ltd., Catalogue III.

***BRIDELL, Frederick Lee 1831-1863**
Landscape painter. Born Southampton. Apprenticed to an art dealer, he travelled round Europe painting copies for him. After visiting Italy, returned to England and settled at Maidenhead. Exhib. at the RA 1851-62, also at BI and SS. Subjects all continental views, esp. Italy. Returned to Rome, where he married Eliza Florence Fox, also a painter, who exhib. portraits, genre and historical subjects at the RA 1859-1871. B. suffered from poor health, and died of consumption aged 32. His last and best-known picture, 'The Coliseum by Moonlight', exhib. at the International Exhibition in 1862, is a romantic and individual work; had Bridell lived longer he might have

become a considerable artist, but his output was too small for him ever to achieve lasting fame. The sale of his studio was held at Christie's on Feb. 26, 1864.

'Cypress Trees' sold Christie's 9.6.67 for £136

Bibl: AJ 1864 p.12 (obit); Redgrave Dict.; DNB 1909 II 1220; Tate Cat; Reynolds VP 155 (pl.III); Maas 228.

BRIDGES, James fl.1819-1853
Oxford landscape and portrait painter. Lived at same address as John Bridges (q.v.), so presumably they were brothers. Exhib. at RA 1819-1853, and at BI and SS. Subject portraits, and landscape views around Oxford, and in Italy and Germany.

'View of Oxford from Hinksey' sold Sotheby's 20.11.68 £320

***BRIDGES, John fl.1818-1854**
Oxford portrait and genre painter, presumably brother of James Bridges (q.v.) Exhib. at RA 1818-1854, also at BI and SS. Subjects portraits, genre, and some historical and religious scenes. His portrait groups have great period charm, and are full of detail of Victorian interiors.

'Three Sisters Seated at a Table' sold Christie's 11.7.69 £578.

BRIDGMAN, Frederick Arthur b.1847 fl. 1871-1904
American landscape and historical painter. Studied with Gérôme in Paris. Exhib. at RA 1871-1904. Subjects chiefly views in Egypt, Algeria, N. Africa, and scenes from Egyptian history.

'Arab Street Scene' sold at Parke-Bernet 20.2.69 for £272.

Bibl: AJ 1879, p.155 (with illustration).

***BRIERLY, Sir Oswald Walters RWS 1817-1894**
London marine painter and watercolourist. Decided at an early age to be a marine painter. Studied at Sass's Academy and at naval college in Plymouth. 1841-1851 went on his first trip round the world, during which he took an exploratory expedition round the Australian coasts. Went to the Crimea as reporter on naval affairs, after which he was employed as marine painter to the royal family. 1867-8 around the world again in the Duke of Edinburgh's suite. 1868-9 up the Nile with Prince of Wales. Exhib. at RA 1839-1871, and at OWS (192 works). In 1874, when Schetky died, B. was appointed Marine Painter to the Queen. Knighted 1885. In his later years, turned to historical naval scenes, many of the Armada and other patriotic themes. Spent much time in Venice, with his friend Edward Goodall (q.v.). A full-scale exhibition of his work was held at the Pall Mall Gallery in 1887.

'The Colonial Whaler Fame' sold Sotheby's 17.2.65. (Ingram Collection) for £170.

Bibl: J.L. Roget in AJ 1887 p.129-134; DNB; Bryan; Cundall; Wilson, Marine Painters p.18 (pl.4); Maas 65 (pl. on p.64).

BRIGGS, Henry Perronet RA 1791-1844
London historical and portrait painter. Studied at RA Schools 1811; in 1813 went to Cambridge. Exhib. at RA 1814-44 (132 works) and at the BI (1819-35). Elected ARA 1825, RA 1832. After about 1835, B. gave up historical painting (mainly subjects from Shakespeare or English history) in favour of portraits. Among his many famous sitters were Charles Kemble, the Duke of Wellington, and the Earl of Eldon. As with many Victorian portrait painters, his sketches and drawings have more charm and spontaneity than his finished works. As 'Baron Briggs' he was placed first by Thackeray in his 'List of

Best Victorian Painters' (Fraser's Magazine 1838). His studio sale was held at Christie's April 25-27, 1844.

Probable price range £100-300, depending on the importance of the sitter.

Bibl: AU, 1844, p.62; Redgrave Dict. and Cent; Bryan; Binyon; NPG 1907 Cat; Maas pp.22, 110, 215.

BRIGHT, Henry 1814-1873

Norwich School landscape painter and watercolourist. Trained as a chemist, and became dispenser at Norwich hospital. Studied with J.B. Crome and John Sell Cotman. Exhib. at RA 1843-76, at the BI, SS, and NWS, of which he was elected a member in 1839. Subjects at RA mainly views in East Anglia, also views in Holland and on the Rhine. After living in London for over 20 years, B. retired due to ill-health to Ipswich, where he died. Although better known as a water-colourist, B. was also an able painter, working in a style similar to Alfred Vickers and other second generation Norwich painters.

'Bolton Abbey, Yorkshire' sold by Christie's in Glasgow 2.4.69. for £1,365. This was a large important work; average prices usually £200-700; watercolours £100-300.

Bibl: AJ 1873, p.327; Redgrave Dict; DNB 1909 II 1238; Binyon; F.G. Roe, *H.B. of the Norwich School*, Walker's Quart. 1, no.1. 1920; Bryan; VAM; Cundall; Clifford; Nettlefold; Maas p.57 (with pl.). H.A.E. Day *East Anglian Painters* 1968 II 214-26.

BRISTOW, Edmund 1787-1876

Sporting and animal painter. Lived at Windsor, where he was patron-ised by the Duke of Clarence, later William IV, and other members of the court. Exhib. only 7 works at the RA between 1809 and 1829; also exhib. at BI and SS. Painted sporting scenes, animals, portraits, rustic genre and landscapes in a style which belongs more to the era of Morland and Ibbetson than to the Victorian period. B. was a recluse by nature, and disliked patronage so much that he would often refuse to sell his pictures. He died in such complete obscurity at the age of 88 that the *Art Journal*, writing his obituary, could dis-cover nothing to say about him.

'Two Stallions Fighting' sold 23.7.69 at Sotheby's £250. Other auc-tion prices £150-180.

Bibl: AJ 1876 p.148 (obit); Redgrave Dict; Paviere, *Sporting Painters* (pl.7); Maas 48.

BRITTEN, William Edward Frank fl.1873-1893

London decorative painter, mainly of Grecian figures. Exhib. at RA 1884-1888, but after that mainly at the GG and NG. Titles at RA 'Boy and Dolphin' 'A Frieze' etc. His style shows the influence of Leighton and A.J. Moore.

Price range £20-70

Bibl: AJ 1883 p.236 (illustration)

BROCKY, Charles 1807-1855

Hungarian painter of portraits and classical figure subjects. Lived in Vienna and Paris in great poverty; brought to London by the collec-tor Munro of Novar. Exhib. at RA 1839-1854, also at BI and NWS. Titles at RA portraits, also 'Psyche' 'Music and Art Instructed and Crowned by Poetry' etc. By the end of his career, B. had established himself as a very successful portrait painter, with Queen Victoria among his sitters.

Probable price range £20-50

Bibl: Norman Wilkinson, *Sketch of the Life of C.B. the Artist*, 1870 Redgrave Dict.; Binyon.

BRODIE, John Lamont fl.1848-1881

London painter of portraits, coastal scenes, landscapes, and historical genre. Exhib. at RA 1848-1881. Titles also include some Italian scenes, and fishing subjects. Very little known.

Probable price range £30-70

BROMLEY, Clough W. fl.1870-1904

London landscape and flower painter. Imitator and copyist of Vicat Cole RA (q.v.), and engraver of some of his works. Exhib. mainly at SS, also at RA from 1872. Titles at RA 'Wild Roses' 'On a London Common' 'Cherry Orchard, Fittleworth' etc.

Price range £50-150

Bibl: AJ 1894, p.194 (engr. after V. Cole)

BROMLEY, John Mallard RBA fl.1876-1904

Landscape painter; lived in London, Rochford and Saint Ives. Exhib. mainly at SS (92 works), also at RA from 1881. RA titles views in Wales, Yorkshire, Derbyshire and Cornwall. Very little known.

Probable price range £30-100

BROMLEY, Valentine Walter 1848-1877

London historical painter and watercolourist. His wife, Alice Louisa Maria Atkinson, was a landscape painter, and also his father, William Bromley III (q.v.). Exhib. at S.S. and NWS, also at RA 1872-77. Titles at RA 'The False Knight' 'Queen Mab' etc. B. was frequently art correspondent of the *Illustrated London News,* and also a prolific book-illustrator. In 1875 he travelled in N.America with Lord Dunraven, illustrating his *The Great Divide.* Died suddenly aged only 30.

Probable price range £50-100

Bibl: AJ 1877 p.205; Redgrave Dict; DNB 1909 II 1311.

BROMLEY, William III fl.1835-1888

London historical & genre painter, grandson of William Bromley, the engraver. Exhib. at SS (187 works), the BI, and RA 1844-70. RA titles 'Preaching of the Covenanters' 'Rural Courtship' 'Jacob and Rachel at the Well' etc.

'Waiting for a Nibble' sold Sotheby's 16.10.68 for £400.

Bibl: Clement & Hutton; Redgrave, Dict.

*BROOKER, Harry fl.1876-1889

Painter of domestic genre, especially of children. Exhib. one picture at the RA, and 4 at SS. His Victorian interiors and figures are full of period charm, and follow the tradition of Webster and F. D. Hardy.

'Feeding the Pigeons' sold Phillips Son & Neale 12.5.69 for £280.
'The Dancing Lesson' sold Bonham's 5.2.70 for £230.

BROOKS, Henry Jermyn fl.1884-1904

Portrait painter, who exhibited from 1884-1900 at the RA and NG. His best known work is the large 'Private View of the Old Masters' Exhibition, 1888, RA.' painted in 1889, (NPG), which is very similar in conception to Frith's 'Private View of the RA, 1881'. In 1904 the Graves' Gallery held an exhibition of 11 of his paintings, including portraits of the King and Queen, and a portrait of Gladstone — said by *The Studio* to be the best thing in the exhibition:- 'It is very small, but the sensitive handling gives it a distinction lacking in some of the larger paintings'.

Probable price range £50-100

Bibl: Studio 31 (1904) 151.

BROOKS, Miss Maria fl.1869-1890
London portrait painter. Exhib. at RA 1873-1890, and at SS. Titles at RA also include some figure subjects 'Miss Mischief' 'News of Home' 'A Love Story' etc. Very little known.

Probable price range £20-50

Bibl: Blackburn, *Academy Notes*, 1877-79

***BROOKS, Thomas** 1818-1891
Genre painter, born in Hull, Pupil of H. P. Briggs (q.v.). Exhib. at the RA 1843-1882, and at BI and SS. Painted many pictures of dramas connected with the sea, eg. 'The Missing Boat' (1869) 'A Story of the Sea' (1871) 'Launching the Lifeboat' (1868). Also sentimental Victorian scenes such as 'The Sister's Grave' 'Consolation' etc. usually involving a wistful heroine. Influenced by the Pre-Raphaelites in the 50's and 60's, which was the period of his best works.

'The Sister's Grave' sold at Christie's 17.1.69 for £252.

Bibl: AJ 1872, p.197 f (monograph, with illustrations); Clement & Hutton.

BROWN, Alexander Kellock RSA 1849-1922
Glasgow landscape and flower painter. Exhib. at the RA 1873-1902, and at SS, NWS, GG and NG. RA titles mostly views in Scotland, the Highlands and the Hebrides.

Price range £30-70

Bibl: AJ 1901 p.101; 1904 p.172, 174; 1909 p.153; Caw p.300-301 (with illust.); Studio 1917-18 p.16.

***BROWN, Ford Madox** 1821-1893
Painter of historical, literary and romantic genre, landscape and biblical subjects. Born in Calais. Studied in Bruges, Ghent, and Antwerp, under Baron Wappers 1837-39. In Paris 1841-44. Competed for the Westminster Hall Decorations 1844-5. Visited Rome 1845, where he came under the influence of the German Nazarene painters. Returned to England in 1846. In 1848, D.G. Rossetti wrote F.M.B. a letter expressing admiration for his work, and shortly afterwards became his pupil. Although never a member of the Pre-Raphaelite brotherhood, Brown was familiar with their aims and ideals, and under their influence, painted some of his best works, such as 'Work' and 'The Last of England.' Exhib. at the RA and BI 1841-67. In his later period, Brown reverted to the historical and romantic subjects of his youth, painted predominantly under the influence of Rossetti, often in watercolour. Although he never achieved the fame or popularity of the Pre-Raphaelites, Brown was the most important artist to be closely associated with them.

The last important work sold was 'Jacob and Joseph's Coat' at Sotheby's 12.7.67 which made £2,300. Minor works have been sold in the £100-300 range.

Bibl: Ironside & Gere, p.22 (pls. 7-17); Reynolds VS 3, 18, 65, 66, 75 (pl. 32); Reynolds VP 60, 61, 64, 65, 68 (pl. 49); Maas 88, 124, 125, 131-32, 182, 198, 216 (pls. p.130, 131, 132, 198, 199); For full bibliography, see Fredeman, p.151-143 and index.

***BROWN, Frederick** 1851-1941
Landscape and genre painter, watercolourist and teacher. Studied at the RCA 1868-77 and in Paris under Robert - Fleury and Bougereau 1883. Taught at Westminster School of Art 1877-92, and succeeded Legros as Slade Professor, 1892-1918, during which time he turned out many talented pupils. Exhib. at RA from 1879, and at SS. Titles at RA 'Carlyle's Chelsea' 'Candidates for Girton' 'Rural England' etc. Played large part in the foundation of the NEAC in 1886.

Price range £100-300

Bibl: AJ 1893 p.29; Studio Vol.37, p.29-32; Vol.44, p.136-138; Burlington Magazine LXXXII 1943; Tate Cat.; Recollections by F.B. in *Art Work* 1930, Nos. 23 & 24.

BROWN, Sir John Arnesby RA 1866-1955
Landscape painter. Pupil of Hubert Herkomer (q.v.) and much influenced by the Barbizon and Impressionist landscape painters. Exhib. at RA from 1891. 'Morning' was bought by the Chantrey Bequest in 1901 and is in the Tate Gallery. Most of B's work falls outside the Victorian period.

'Cattle Resting in Moorland Landscape' sold Bonham's 6.2.69 £180.

Bibl: Studio 1898 pp.118-122; AJ 1902 p.214; 1903 p.86, 175; 1905 p.169, 184; Tate Cat.

BROWN, Lucy Madox (Mrs. W.M. Rossetti) 1843-1894
Pre-Raphaelite watercolourist. Daughter of Ford Madox Brown (q.v.). Began exhibiting in 1868 at the Dudley Gallery, where she showed most of her work. She only exhibited one picture at the RA — 'The Duet' in 1870. Her best work was 'Romeo & Juliet' exhib. at the Dudley in 1871. Visited Italy 1873-4. Married William Michael Rossetti, brother of D.G. Rossetti (q.v.) in 1874.

Her output was extremely small (8 exhibited works) and her watercolours rarely appear on the market. Prices therefore impossible to estimate.

Bibl: Clayton II 116-24; DNB; Bate 22-3 (pl. opp. p.23); Other references see Rossetti, and also Fredeman index.

BROWN, Thomas Austen RI.ARSA 1857-1924
Scottish landscape and domestic genre painter. Exhib. at RA 1885-1898, and at NWS and GG. Titles at RA 'Sabbath Morning' 'Potato Harvest' 'Hauling Ashore the Sail' etc. Very little known.

Probable price range £30-70

Bibl: Caw, 446; Glasgow Cat.

BROWN, William Beattie RSA 1831-1909
Edinburgh landscape painter. Exhib. at RA 1863-99, all Scottish views. B. used a dark palette, painting sombre Highland scenes in a style similar to Peter Graham (q.v.).

Price range £30-100

Bibl: Clement & Hutton; Caw 298; AJ 1904 p.138; 1909 p.180

BROWNE, Hablot Knight ("Phiz") 1815-1832
Artist and book-illustrator, who assumed the pseudonym "Phiz". Apprenticed to Finden, the engraver; then started as a painter in water-colour with a young friend; at the same time attended a 'life' school in St. Martin's Lane, where Etty was a fellow-pupil. 1832, won the Silver Isis medal offered by the Society of Arts for the best illustration of an historical subject. 1836, first became associated with Dickens in Dickens's *Sunday as it is by Timothy Sparks*. Later illustrated *Pickwick Papers*, using the pseudonym "Nemo" for the first two plates, and then "Phiz". The association of Browne and Dickens continued through many novels. Exhibited water-colours at the BI and SS. He also painted in oils but these were imperfect technically. Fifteen years before his death he was struck with paralysis, but continued to work.

Price range for watercolours and drawings £20-50

Bibl: Forster, *Life of Charles Dickens*, III, 1874; Clement & Hutton; Fitzpatrick, *Life of Charles Lever*, 1879; F.G. Kitton, *Phiz, A. Memoir*, 1882; D.C. Thompson, *Life & Labours of H.K. Browne*, 1884; Bryan; Binyon; DNB, III.

BROWNE, Philip fl.1824-1865
Shrewsbury landscape, sporting and still-life painter. Exhib. at RA 1824-61 (70 works) and SS. Subjects mainly views around Shrewsbury, in Wales and Holland. Very little known.

Probable price range £50-150.

BROWNING, Robert Barrett 1846-1912
Painter and sculptor; son of Robert and Elizabeth B. Studied in Antwerp and Paris. Exhib. at RA 1878-1884, and at GG. Subjects domestic and genre subjects, mostly in Antwerp and Belgium. In his early career he was helped by his parents' friend, Millais (q.v.).

Probable price range £50-150

BROWNLOW, Miss Emma fl.1852-1869
London domestic genre painter. Worked in Belgium and N. France. Exhib. at RA 1852-67, and at BI and SS. Titles at RA 'Granny's Lesson' Repentance and Faith' 'Lullaby' etc. Very little known.

Probable price range £30-70

BRUNNING, William Allen fl.1840-1850
London landscape painter. Exhib. at RA 1840-1850, and at BI & SS. Exhibited works mainly views on the Thames, in Kent and Normandy, and street scenes. Very little known.

Probable price range £30-100

BUCKLER, John Chessel 1793-1894
London architectural painter and draughtsman, son of John Buckler, an architect and antiquarian draughtsman. Exhib. at RA 1810-1844, also SS & OWS. Mainly views of churches, ruins, and country houses.

Price range £50-200

Bibl: AJ 1894 p.125; Redgrave Dict; Binyon; DNB; Bodleian Library, Oxford; *Drawings of Oxford by J.C.B.* 1951; RIBA Drawings Cat.

BUCKNER, Richard fl.1842-77
London portrait painter. From 1820-40 he lived in Rome, where he was friendly with Leighton, and exhibited Italian genre subjects. Returned to London about 1845, and concentrated on portrait painting. Became a very successful painter of elegant and fashionable Victorian ladies. Exhib. at RA 1842-77, also at BI and SS. A sale of his works was held at Christie's Feb. 22, 1873.

'Drummer Barber, The Balaclava Drummer Boy' sold Christie's 20.11.64 for £1680. This was an exceptional work, the usual range being £200-300.

Bibl: AJ 1859 p.81, 142, 163; 1860 p.80; Binyon; Maas 212 (pl. p.213).

BULLOCK, G.G. fl.1827-1859
London portrait painter. Exhib. at RA 1827-55, also BI and SS. Titles at RA also include some still-life and genre pictures. Little known.

Probable price range £20-50

BUNCE, Kate Elizabeth 1858-1927
Birmingham decorative painter; youngest daughter of John Thackray Bunce, editor of the *Birmingham Post.* Studied at the Birmingham Art School under Edward R. Taylor. Influenced by Rossetti and the later Pre-Raphaelites. Exhib. 1887-1901, four works at RA. Titles at Birmingham include 'Melody' and 'The Keepsake'. Most of her later work altar-pieces and church murals. Elected associate of RBSA 1888. Signed KB in monogram.

Probable price range £50-200

Bibl: Birmingham Cat.

BUNDY, Edgar RI, RBA 1862-1922
London historical and genre painter and watercolourist. As a boy spent much time in the studio of Alfred Stevens; otherwise self-taught. Exhib. at RA from 1881 and at the Paris Salon from 1907. Subjects mainly historical costume pieces. Painted 'The Landings of the Canadians in France 1915' for the Canadian War Memorial.

'The Argument' sold Sotheby's 4.6.69. £300. Other auction prices £100-600

Bibl: AJ 1897 p.170, 182; 1900 p.176, 183; 1905, p.176; 1909 p.174, 334f. Studio, Summer No.1900, p.23; Tate Cat.

BURBANK, J.M. fl.1825-1872 d. 1873
London animal painter and watercolourist. Exhib. at RA 1825-1847, and at BI, SS and NWS. Travelled in N. America. Very little known.

Probable price range £30-100

Bibl: Cundall p.190

BURCHETT, Richard 1815-1875
London historical and landscape painter, and teacher. Assistant master at Government School of Design at Somerset House; and later in charge of training art teachers at the Department of Practical Art. Because of his official duties, B. was not able to devote much time to painting. Exhib. 5 works at the RA 1847-1873. Worked on several decorative schemes, including some in the House of Lords. 'A Scene in the Isle of Wight' (Reynolds VP pl.103) shows him to have been a landscape painter of considerable ability. It is a pity he did not devote more time to this instead of his now forgotten historical works.

Probable price range £100-300

Bibl: AJ 1875 p.232 (obit); Redgrave Dict.; DNB; Reynolds VP 152-3 (pl.103); Maas 228

***BURGESS, John Bagnold RA 1830-1897**
Painter of Spanish genre. Son of H. W. Burgess, landscape painter to King William IV and grandson of portrait painter William Burgess. Pupil of J.M. Leigh. Exhib. at RA 1850-1896, and at BI and SS. Specialised in Spanish, Gipsy & North African subjects of the type popularised by John Phillip (q.v.), although in his earlier years he painted some charming pure genre pieces. Travelled frequently in Spain with his friend Edwin Long (q.v.) His studio sale was held at Christie's March 25, 1898

'Saints' Day' sold Christie's 3.4.69 £137

Bibl: Ruskin, *Academy Notes,* 1875; AJ 1880 p.297-300; 1898 p.31; Clement & Hutton.

BURKE, Augustus Nicholas RHA c.1838-1891
Irish painter of landscape, genre and historical subjects, and occasionally portraits. Began his career in London, and from 1863-91 exhibited at the RA, SS and elsewhere; titles at the RA include views in Ireland, England, Holland, France and Italy. 1869, settled in Dublin and elected ARHA in July 1871, member in August 1871. 'The Feast Day of Notre Dame de Tremala, Brittany' is in the Council Room of the RHA, and a 'View of Connemara' in the National Gallery of Ireland. In 1882, after the murder in Phoenix Park of his brother, Thomas Henry Burke, Under-Secretary for Ireland, he left Dublin and settled in London.

Price range £100-300

Bibl: Strickland; Pavière, Landscape.

***BURNE-JONES, Sir Edward Coley, Bt. ARA 1833-1898**
Painter, watercolourist, designer and leader of the second phase of the Pre-Raphaelite movement. Born in Birmingham; in 1852 went to Exeter College, Oxford, where he became a friend of William Morris. Intended to enter the Church, but was so impressed by the work of Rossetti that in 1856 he left Oxford, deciding to become a painter instead. He later met Rossetti, and in 1857 they worked together on the Morte d'Arthur wall paintings in the Union Debating Society's Room at Oxford. Went to Italy in 1859; went again in 1862 together with Ruskin. As a partner in the firm of Morris & Co. Burne-Jones produced many designs for stained glass and tapestries. Elected Associate of the OWS in 1864, member 1868, but resigned in 1870 following criticism of one of his works. Elected ARA 1885, but only exhibited once at the RA in 1886, and resigned his Associateship in 1893. He exhibited 5 works at the opening exhibition of the Grosvenor Gallery in 1877, which quickly established his reputation as England's most influential artist. Thereafter he exhibited mainly at the GG & NG, also occasionally at the OWS. Created baronet 1894. In the '80s and '90s became an international figure — awarded the Legion of Honour, and many other European honours. Burne-Jones's consciously aesthetic and unworldly style, which combined the romanticism of Rossetti with the medievalism of Morris, became steadily more abstract towards the end of his life. Most of his subjects are taken from the Arthurian legends. He rarely painted either in pure oils or watercolours, preferring to experiment with mixed media. He had many pupils & imitators, including Marie Stillman, Frederick Sandys, Simeon Solomon, J. M. Strudwick, T. M. Rooke, J. R. Spencer Stanhope, Charles Fairfax Murray, Evelyn de Morgan and others, who carried his ideas well into the 20th century. The sale of his studio was held at Christie's July 16 and 18, 1898.

'Laus Veneris' a large and important work, sold at Sotheby's 17.3.71 for £33,000. This is the auction record by a long way, as previously his usual price range was £1,000-£3,000. Smaller watercolours and figure studies can still be found for under £1,000.

Bibl: Reynolds VP 65, 69, 70, 121, 142 (pls. 46, 51, 52, 57); Hardie III, 121-123 and passim (pls. 140-143); Maas 135-146 and passim (plates on p.138, 141, 144-5); For full bibliography see Fredeman.

BURR, Alexander Hohenlohe 1835-1899
Scottish genre and historical painter, brother of John Burr (q.v.). Pupil of John Ballantyne (q.v.) in Edinburgh. Exhib at RA 1860-1888, and at BI, SS, and GG. Titles at RA 'King Charles I at Exeter' 'Grandad's Delight' and 'Blind Man's Buff' etc. Fond of painting children. Worked on some of the illustrations for an edition of Burns's poems. Many of his works were engraved.

'The New Toy' sold at Bonham's March 1969 for £90

Bibl: AJ 1870 p.309-11 (Monograph with plates); Clement & Hutton; Caw 262.

***BURR, John RBA, ARWS 1834-1893**
Scottish genre painter, brother of A.H. Burr (q.v.) Studied at Trustees' Academy in Edinburgh. Began by exhibiting at RSA, and in 1861 both he and his brother came to London. Exhib. at the RA 1862-82, and at SS and OWS. Subjects at RA mainly domestic scenes with children, similar in style to his brother's. A sale of his works was held at Christie's April, 23, 1883.

'The Peepshow' sold at Christie's Hopetoun sale 15.10.69 £315.

Bibl: AJ 1869 p.272 (pl.) 337-39 (Monograph, with plates); Clement & Hutton; Caw 262.

BURT, Charles Thomas 1823-1902
Midlands landscape painter. Born in Wolverhampton. Pupil of Samuel Lines in Birmingham, and also a friend and pupil of David Cox (q.v.), by whose style he was influenced. Exhib. at RA 1850-92, BI, SS, and elsewhere. Member of the Birmingham Society of Artists, 1856. Specialised in Highland and moorland landscapes.

'Landscape with Figures' sold King and Chasemore, Sussex, 1.4.69. £225.

Bibl: Birmingham Cat.

BURTON, Sir Frederick William RHA 1816-1900
Irish landscape painter and watercolourist. Although Director of the National Gallery of Ireland 1874-94, B. still found time to paint portraits, genre, and historical scenes, as well as landscapes, which he exhibited at the RA 1842-74, OWS and elsewhere.

Probable price range £30-100

Bibl: AJ 1859 p.173; NPG Cat.; VAM; DNB; Cundall.

BURTON, William Paton 1828-1883
Landscape painter. Born in India, travelled in Egypt and on the Continent. Lived at Witley, and exhib. at RA 1862-83, SS and elsewhere. Titles at RA 'A November Sunset' 'Gloaming' 'The Lone Mill' etc.

Probable price range £30-70

Bibl: DNB

***BURTON, William Shakespeare 1824-1916**
London historical painter. Student at the RA schools. Now solely known for 'The Wounded Cavalier' (Maas plate on p.156) one of the finest works ever painted in England under the Pre-Raphaelite influence' (Bate). The picture was at first rejected by the RA Hanging Committee, but noticed by C.W. Cope (q.v.) who withdrew one of his own pictures to make room for it. Hung without artist or title, on the line next to Holman Hunt's 'Scapegoat', the picture caused a sensation at the 1856 Academy, and Ruskin hailed it as 'masterly.' Dogged by ill-health and lack of recognition, Burton practically abandoned painting during the 80's and 90's, but was persuaded to take it up again around 1900. His later works, such as 'A London Magdalen' 'The Angel of Death' 'Faithful unto Death' 'The King of Sorrows' 'The World's Gratitude' etc. never fulfilled the expectations of 'The Wounded Cavalier'. Exhib. at RA from 1846.

Owing to the rarity of B's works, any estimate of price is virtually impossible. His late religious works are probably worth £100-300, but any Pre-Raphaelite works more.

Bibl: Ruskin, *Academy Notes*, 1856; Bate, p.81-2 (pls. opp. pp.80, 82); William Gaunt, *The Lesser Known Pre-Raphaelite Painters*, Apollo Annual 1948, pp.5-9; Maas 156 (pl. 'The Wounded Cavalier').

BUSS, Robert William 1804-1874
London historical, genre and portrait painter. Pupil of George Clint. At first painted theatrical portraits, later turned to historical scenes and humorous genre. Exhib. at RA 1826-1855, BI, SS, and NWS. Exhib. at House of Lords competition 1844-5. Editor of *The Fine Art Almanack* and *English Graphic Satire* with etchings by himself.

'The Shabby Traveller' sold Sotheby's 16.10.68 £150.

Bibl: AJ 1874 p.300; 1875 p.178; Redgrave Dict.; DNB 1908 III 492; Binyon.

***BUTLER, Lady Elizabeth Southerden 1846-1933**
(Miss Elizabeth Thompson)
Painter of patriotic battle scenes and episodes of military life. Sister of Alice Meynell, the poet and essayist, she was brought up mostly abroad, particularly in Italy, and educated by her father. Entered S. Kensington Art Schools in 1866; in 1869 became a pupil of Guiseppe Belluci in Florence, and she also studied in Rome. First exhibited at the RA in 1873 with 'Missing', and in 1874 she became famous when she exhibited 'The Roll Call' at the RA, (full title 'Calling the Roll after an Engagement, Crimea'), which was bought by Queen Victoria. After this she painted almost entirely military subjects, and among her best known paintings are 'Quatre Bras', 1875 (Melbourne), 'The Remnants of an Army', 1879 (Tate Gallery), 'The Defence of Rorke's Drift', 1880 (Windsor Castle), and 'Scotland for Ever', 1881, Leeds. Ruskin described 'Quatre Bras' as 'Amazon's work' and as 'the first fine pre-Raphaelite picture of battle that we have had'. The precision of her painting was prized by the army for its faithful recording of regimental actions and dress, and few artists have equalled her drawing of horses. In 1877 she married Major (afterwards Lieutenant-General Sir) William Francis Butler.

Probable price range £100-300; important historical battle scenes more.

Bibl: AJ 1874 146, 163; 1876, 190; 1905, 322; Clayton II, 139; Clement & Hutton; Lady Butler, *Letters from the Holy Land*, 1903; Lady Butler, *From Sketchbook and Diary*, 1909; Lady Butler, *An Autobiography*, 1923; Viola Meynell, *Alice Meynell*, 1929; DNB, 1931-40.

BUTLER, Mildred Anne 1858-1941
Irish painter and watercolourist of genre, landscape and animals. Studied at Westminster School of Art and under Frank Calderon (q.v.) Exhib. at RA 1889-1902, NWS and elsewhere. Elected ARWS 1896. 'The Morning Bath' (RA 1896) was bought for the Chantrey Bequest, and is in the Tate.

Probable price range £50-150

Bibl: Tate Cat; Who's Who 1911, 300.

BUTLER, Richard fl.1859-1886
Sevenoaks landscape painter. Exhib. at RA 1859-86. Subjects views in the south of England, many of them of Knole Park. Very little known.

Probable price range £30-70

BUTLER, Samuel 1836-1902
Best-known for his books *(Erewhon, The Way of All Flesh etc.)* Butler took up painting after his return from sheep-farming in New Zealand. His first efforts were rather crude, but study with J.M. Leigh improved his style. Exhib. at RA 1869-76; titles 'Mr. Heatherley's Holiday' 'Don Quixote' etc.

Probable price range £50-150

Bibl: Reynolds VS, pp 1, 21, 89-90, 100 (pls. 75, 76).

BYRNE, Miss Letitia fl.1799-1848
London landscape painter. Exhib. at RA 1799-1848. Mainly views in Derbyshire and Wales. Very little known.

Probable price range £20-50

BYWATER, Mrs. Elizabeth fl.1879-1888
London flower painter. Exhib. at RA 1879-1888, SS and GG. Miss Katharine Bywater, who exhib. genre scenes at the RA 1884-90, also lived at 5, Hanover Square, was presumably her sister. Both very little known.

Probable price range £30-70

CADOGAN, Sidney Russell fl.1877-1895
London landscape painter. Exhib. at RA from 1877-1895 mainly Scottish views. Exhibited 'In Knowle Park' 1877; 'Rohallion, Perthshire' 1884; 'Loch of the Lowes, Dunkeld' 1890. Also exhib. at GG & NG. Little known.

Probable price range £30-70

CAFE, Thomas Watt RBA 1856-1925
Educated at King's College, London and at the RA Schools. Exhib. at the RA from 1876 onwards. For some time a member of the Dudley and Cabinet Picture Society, and wrote occasional articles on art subjects in daily press. Graves lists his speciality as 'landscape' but subjects include: 'Shrine of Edward the Confessor, Westminster Abbey' 1876; 'Wreaths of Welcome', 'Nydia', 'The Favourite', 'Summer Idleness', 'The Gift', 'Laurels for the Victor', 'The Valley of the Shadow', etc. His pictures are usually classical figures in Graeco-Roman interiors, and show the influence of Albert Joseph Moore (q.v.). James Cafe, Thomas S. Cafe, and Thomas Cafe (Junior) were also exhibiting at the same period, and may have been of the same family.

'The Gift' (RA 1889) sold at Christie's 11.7.69 for £116.

Bibl: Who Was Who 1916-1928

CAFFIERI, Hector RI RBA 1847-c.1911
Born in Cheltenham, living in 1911. Landscape painter and watercolourist. Pupil of Bonnat and J. Lefebvre in Paris. Worked in London and Boulogne-sur-Mer. Member of NWS. Painted fishing scenes of English and French ports, flowers, landscapes and some sporting subjects. Exhib. at the RA from 1875-1901, and in Paris at the Salon des Société des Artistes Français from 1892-3 with 'Attente' and 'Départ des Bateaux de Boulogne'. Typical titles are 'A fishing Party' & 'Mussel Gatherers'. Exhib. mainly at SS & NWS.

Usual price range £30-70 for watercolours; £50-150 for oils.

CAFFYN, Walter Wallor fl.1876-1898 d.1898
Landscape painter; lived in Dorking, Surrey. Exhib. at RA 1876-97, and SS. Painted views in Surrey, Sussex and Yorkshire; also painted landscapes for the angling painter H.L. Rolfe (q.v.).

'A River Scene with Eel-Traps' sold at Christie's sale in Tokyo for £584, May 1969. This was an exceptional price, the usual range being £100-300.

Bibl: Pavière, Landscape (pl.10).

CALDECOTT, Randolph RI 1846-1886
Illustrator and watercolourist. Educated at King's School, Chester, where he took two prizes for drawing from the Science and Art Department, S. Kensington. Worked as a bank clerk at Whitchurch, Salop, and later at Manchester, where he studied at the Art School, and from 1868 drew for the local papers. He contributed to *London Society* from 1871 and *Punch* from 1872, in which year he settled in London where he studied at the Slade School. He also drew for the *Graphic*, and illustrated numerous books, his children's picture books being published 1878-85 (e.g. *The House that Jack Built* and *John Gilpin*). Exhibited at the RA (from 1872-1885), and at the RI, etc. In 1882 he became Member of the RI, and in 1880 of the Manchester

Academy of Fine Arts. He also made bronze models and terracotta busts. He made his name by his illustrations to Washington Irving's *Old Christmas* 1875 and *Bracebridge Hall* 1876. His world was the "fresh, vigorous scenes of the English squirearchy in manor-house and hunting field" (Hardie), and, in his own words, he studied the "art of leaving out as a science". The BM and VAM own a wide variety of his watercolours, pen drawings and coloured proofs.

Price range £30-100

Bibl: Redgrave Cent.; VAM MSS, R.C. letter to Edmund Evans, 1884; H.R. Blackburn, *R.C.* 1886; C. Phillips, *R.C., Gaz des B. Arts*, XXXIII, 1886; *R.C.'s Sketches* 1890; Bryan; Binyon; Cundall; DNB; VAM; M.G. Davis, *R.C.* 1946; Hardie III 144-5 (pl.170).

***CALDERON, Philip Hermogenes RA 1833-1898**
Painter of domestic and historical scenes and leader of the St. John's Wood Clique. Born in Poitiers; educated by his father, a renegade Spanish priest, who was Professor of Spanish Literature at King's College, London. 1850 entered J.M. Leigh's art school in Newman St. 1851. Studied under Picot in Paris. In 1853 he began to exhibit at the RA, and in 1857 made his name with 'Broken Vows' (Tate Gallery). This picture, which shows marked Pre-Raphaelite influence, was engraved in 1859 and became widely popular. In 1867 'Her most High, Noble and Puissant Grace' won him a medal at the Paris International Exhibition, the only gold medal awarded that year to an English artist. In 1891 his version of 'The Renunciation of St. Elizabeth of Hungary' (Tate Gall.) gave great offence to Roman Catholics owing to the representation of Saint Elizabeth kneeling naked before the altar. After 1870 he turned mainly to Portrait painting. 1887 elected Keeper of the RA, and managed the RA Schools. Calderon's success, like that of Millais, was due to his ability to invent and portray an incident in a way which appealed to popular taste. He usually signed with initials P.H.C. For his part in the St. John's Wood Clique, see article by Bevis Hillier listed below.

'Spanish Ballads' sold Christie's 7.10.1966 for £126. More important works would make more than this.

Bibl: Ruskin, *Academy Notes*, 1858-59; DNB; Bevis Hillier, Apollo, June 1964, *The St. John's Wood Clique*; Reynolds VP 111-12, 179, 180, 196 (pl.121); Maas 234-5, 13.

CALDERON, William Frank ROI 1865-1943
Painter of portraits, landscapes, figure subjects and sporting pictures. Third son of P.H. Calderon (q.v.). Educated at the Slade School under Professor Le Gros. Founder and Principal of the School of Animal Painting, 1894-1916. He was a regular exhibitor at the RA from 1881-1921. His first RA painting, 'Feeding the Hungry' was purchased by Queen Victoria. His principal works are: 'John Hampden, Mortally Wounded, Riding from Chalgrove Field'; 'Flood'; 'Market Day'; 'A Son of the Empire'; 'Showing his Paces' (Hamburg), etc. and many portraits. He published *Animal Painting and Anatomy*, 1936.

'Village Scene and Children at Play' sold Bonham's 3.10.68 for £280.

Bibl: Who Was Who, 1941-1950

CALLCOTT, Sir Augustus Wall RA 1779-1884
Painter of landscapes, seascapes, and historical genre. Studied at RA Schools, and with John Hoppner. His first exhibited works mainly portraits. Travelled in Holland, the Rhine and Italy. His romantic classical landscapes earned him the title of the 'English Claude'. Exhib. at RA (129 works) and BI. Elected ARA 1806, RA 1810. For many years Keeper of the Royal Collection, for which he was knighted in 1837. Ruskin was of the opinion that Callcott 'painted everything tolerably, nothing excellently', but he was very popular and expensive in his lifetime, though his reputation did not last. His best-known works were 'Mouth of the Tyne' 1818 'Milton Dictating Paradise

Lost to his Daughters' 1840 and 'Raphael and his Fornarina' 1837. The sale of his studio was held at Christie's on May 8-11, 1845, and on June 22, 1863.

Pictures sold during the 1968-9 season ranged from £116 to £200. A large important seascape might be worth considerably more.

Bibl: AU 1845 p.15 (obit); AJ 1856 p.9 ff; 1866 p.99 ff; 1896 p.334 ff; Portfolio 1875 p.161 ff; J. Dafforne, *Pictures by Sir Augustus Wall Callcott* 1878; Redgrave Dict.; Roget; Bryan; Cundall; DNB; Hughes; VAM; Reynolds VP 12; Hardie II 153-4 (pl.139) III 272-3; Maas 22, 54.

CALLCOTT, William J. fl.1843-1890
London marine painter, and of storm and coastal scenes. Titles at RA 'Fishing Craft, Scarborough Harbour' and 'The Breakwater at Gorleston, Great Yarmouth'. Greenwich Maritime Museum has 2 examples. Exhib. at RA 1844-96, BI, SS, and NWS.

Probable price range £30-100

CALLOW, John 1822-1878
Marine and landscape painter. Pupil of his elder brother William Callow (q.v.) who took him to Paris in 1835 where he studied for several years. In 1844 he returned to England and started up as a landscape painter in watercolours. In 1855 he was appointed Professor of Drawing in the Royal Military Academy at Addiscombe, and six years later he took the post of Sub-professor of Drawing at Woolwich. Some years later he retired and painted for exhibitions as well as taking pupils. He excelled in marine painting more than landscapes and his brother said that teaching impeded his development. He exhibited yearly at the OWS (352 works), and at RA, BI, SS and NWS.

'An Extensive Coastal Scene with Shipping and Figures at Low Tide' sold at Bearne's Torquay 17.12.68 for £340.

Bibl: Roget; DNB; Hardie III 36, 217, 221 (pl.249).

CALLOW, William RWS 1812-1908
Painter of landscapes, buildings and sea pieces, mainly in watercolour but some in oil — the Victorian heir of the picturesque, topographical school epitomised by Prout. Articled at the age of eleven to Theodore and Thales Fielding. Went to Paris in 1829, where he worked under Newton Fielding, and later established himself there as a teacher. Thomas Shotter Boys much influenced his style. In 1831 he exhibited 'View of Richmond' at the Salon, and as a result was appointed drawing-master to the family of Louis Philippe. From 1838-40 he toured Europe making sketches. He left Paris in 1841 for London, and in 1838 was elected A of the OWS, member in 1848, and secretary from 1866-70. He exhibited over 1,400 works. In 1848 he took to oil-painting. In 1855 he left London and settled in Great Missenden where he died. His work became somewhat mannered and after a time ceased to attract. About 2 years before his death he turned out his portfolios of early works and these sold so well that he held an exhibition of them at the Leicester Galleries in 1907. His studio sale was held at Christie's on March 21, 1910.

During the last few years, pictures and watercolours have been sold at auction for prices varying from about £100-500.

Bibl: DNB; Roget William Callow, *An Autobiography*, ed. H.M. Cundall, 1908; Martin Hardie, *William Callow*, OWS, XXII; Walker's Quarterly XXII, 1927; VAM; Reynolds VP 25; Hardie III passim (pls. 51-54); Maas 64, 88, 97-8.

CALTHROP, Claude Andrew 1845-1893
London genre and historical painter. Pupil of John Sparkes. Exhib. at RA 1867-93, BI, SS, and also at the Salon des Société des Artists Français in Paris, where he lived for a time. Titles at RA include a few portraits. Ruskin said of his picture 'Getting Better' (RA 1875) that

"it deserves close attention, much praise, and a better place than it at present occupies".

Probable price range £100-200

Bibl: Gazette des Beaux-Arts 1873 II 248; Ruskin, *Academy Notes,* 1875.

CALVERT, Edward 1799-1883

Friend and disciple of William Blake and Samuel Palmer and member of the Shoreham Group. Entered the Navy at an early age, but abandoned it to study painting. He studied under James Ball and Ambrose B. Johns at Plymouth, and afterwards moved to London where he worked at the RA Schools. He exhibited at the RA from 1825-36, and met Palmer there in 1826, looking "a prosperous stalwart country gentleman redolent of the sea, and in white trousers". During the years of the Shoreham Period 1827-31 he produced a series of remarkable wood-engravings — Arcadian visions —, such as 'The Cyder Feast' and 'The Chamber Idyll', and he is best known for these. From then on he painted mainly to please himself, in oil and watercolour, mostly mythological subjects, destroying a great deal and leaving much unfinished. He was greatly interested by Greek Art and the mysticism of a pagan antiquity, and visited Greece, bringing back many studies. He aspired to a "beautiful ideal" and took his subjects from mythology.

Recent auction prices £100-300

Bibl: Redgrave Cent.; Roget; S. Calvert, *Memoir of Edward Calvert,* 1893; Bryan; DNB; E. Calvert, *Ten Spiritual Designs* (H.P. Horne, Brief notice of Edward Calvert) 1913; L. Binyon, *The Followers of William Blake,* 1925; A.J. Finberg, *The Engravings of Edward Calvert,* Print Collector's Quarterly, XVII, No.2, 1930; A. Grigson, *A Cornish Artist E.C.,* 'West Country Mag.' 1946; Arts Council, *Samuel Palmer and His Circle,* 1957; R. Lister, *Edward Calvert,* 1962; Reynolds VP p.141-2 (pl.94); Hardie II 169-171 (pls. 159-160); Maas 39, 41-2, 167 (pls. on p.41-2).

CALVERT, Edwin Sherwood RSW 1844-1898

Scottish landscape painter, working mainly in Glasgow. Disciple and follower of Corot. He began by painting coast and fishing scenes, but his later work, much of which was in watercolour, was pastoral in subject and idyllic in character. He often painted in the N. of France, in grey and pensive colour schemes, and closely followed Corot in the general balancing of foliage and shepherdesses and sheep. Exhibited at the RA from 1878-1896, and occasionally at the NG.

Probable price range £100-200

Bibl: Caw p.310.

CALVERT, Henry fl.1813-1861

Painter of sporting pictures, born in Manchester. Titles of paintings exhib. at the RA from 1826-1854 include 'A Brood Mare', 'The Wynnstay Hunt', 'The Royal Pair of the Jungle'. Although little known, Calvert was a very competent animal painter whose work can be compared, at its best, with H.B. Chalon and R.B. Davies. He worked mainly in Wales.

'Gentleman on a Hunter' sold Christie's 25.4.69 for £231.

Bibl: Pavière, Sporting Painters, 24 (pl. 9).

CAMERON, Sir David Young RSA RA RWS 1865-1945

Scottish painter, watercolourist and etcher. In the '90's he became famous for his etchings; his early paintings and watercolours are eclectic, and show a variety of influences — Velasquez, Whistler, the Barbizon painters, and M. Maris. Later his style matured, and he concentrated on Highland landscapes, painted around his home at Kippen. Using romantic and dramatic colour combinations, he tried to express the mystical grandeur of Highland scenery. Elected ARWS 1904, RWS 1915; ARA 1911, RA 1920. Also RSA and RSW; knighted 1924.

Prices during the 1968-9 season ranged from £270 to £1,365, the last figure probably being the present auction record.

Bibl: Studio, *The Paintings of Sir D.Y.C.,* 1919; D. Martin, *The Glasgow School of Painting,* 1908; Caw; Who's Who 1911; VAM; D. Meldrum, *Watercolours of the Highlands by DYC,* Apollo 1929; Caw, Sir D.Y.C. OWS XXVII; *Catalogue of Sir D.Y.C. Centenary Exhib.* Scottish Arts Council, 1965; Hardie III 65, 211 (pl. 245).

CAMERON, Duncan fl.1871-1900

Scottish landscape painter working in Stirling and Edinburgh. Exhib. at RA 1872-1900, and at SS. Titles at RA 'The Druid Stones in Arran' 'A Harvest Field in Perthshire' 'Glencoe' etc.

A pair of landscapes sold Christie's 23.5.69 for £105.

Bibl: Caw 303.

*CAMERON, Hugh RSA RSW 1835-1918

Scottish painter of genre and portraits. Studied under Scott Lauder in the Trustees' Academy in 1852. His work developed parallel with that of G.P. Chalmers and McTaggart, but has its own individuality, a little gentler than theirs. Apart from portraits his favourite subjects were homely genre, especially with an accent on childhood or old age; and some of his early works are painted with Pre-Raphaelite finish. He settled in London from 1876-1888, but later spent the summers at Largs and the winters in Edinburgh: about 1880 he visited the Riviera and painted, exceptionally, a few Italian subjects. ARSA, 1859; RSA 1869; RSW 1878; Edinburgh (National Gallery of Scotland) has several of his best works including "Going to the Hay", 1858, and "A Lonely Life", 1873. Exhib. at RA 1871-92.

'The Young Student' sold Christie's 3.4.69 for £147.

Bibl: Caw 259-61 and passim (plate opp. p.260); Who Was Who, 1916-1928; Cat. National Gallery of Scotland.

*CAMPBELL, James c.1825-8—1893

Liverpool genre and landscape painter; strongly influenced by the Pre-Raphaelites in the 1850's. Spent most of his working life in Liverpool; studied at RA schools in 1851. Began exhibiting at Liverpool Academy in 1852; elected Associate 1854, member 1856. 'Eavesdroppers' noticed by Ruskin at SS in 1856; he praised several of Campbell's later pictures at the SS and RA. Campbell only exhib. twice at the RA, in 1859 and 1863, and 13 works at SS. He was supported mainly by Northern patrons, such as John Miller, James Leathart and George Rae. His genre scenes of the 1850's are painted with "minute finish, pale tonality, and Dickensian characterisation" (Bennett), but according to Marillier he lacked "the gift of combining figures with scenery". About 1862 he changed to a broader style of painting, and the quality of his work declined. After a period in London, he returned to Liverpool, and was forced to give up painting because of failing eyesight.

Owing to the rarity of C's work, his pictures hardly ever appear on the market. Probable price range for Pre-Raphaelite works £200-500, other examples less.

Bibl: Ruskin, *Notes on SS* 1856, 1858; *Academy Notes* 1859; Marillier 81-84 (pl. opp. p.84); Mary Bennett in the Liverpool Art Gallery Bulletin, Vol.12, 1967; Catalogue of the Leathart Collection Exhibition, Laing AG Newcastle, 1968.

CAMPOTOSTO, Henry fl.1861-1880 d.1910

Belgian painter of rustic genre; worked in Brussels, and came to London about 1870-71. Exhib. at RA 1871-74 and SS, and at Paris Salon. Titles at RA 'The Happy Mother' 'The Child's Caresses' etc. His sister Octavia Campotosto was also a painter, and exhib. at the RA 1871-74. 'Italian Fisher Children' by Henry C. is in the Leeds AG. Sometimes collaborated with the Belgian painter Eugene Verboeckhoven.

Usual range for Henry C. £100-300. 'A Peasant Girl', by Octavia C. sold Christie's 18.10.68 for £147.

Bibl: Gazette des Beaux Arts 1860, p.320; AJ 1871 80; 1872, 156.

CARLISLE, 9th Earl of. See under HOWARD, George

CARLISLE, John fl.1866-1893
London landscape painter. Exhib. mainly at SS, also RA (1881-89) and NWS. Travelled in Italy. Titles at RA 'Glen Cloy, Arran' 'Hayes Common, Kent' etc.

Probable price range £30-70

***CARMICHAEL, John Wilson 1800-1868**
Newcastle marine painter. Graves, and all later writers mistakenly call him James. Friend and pupil of T.M. Richardson (Senior) (q.v.). Exhibited mainly at the Northern Academy of Arts in Blackett St. Newcastle, which was next door to his studio. Travelled in Holland, Italy, and also in the Baltic. Recorded the Crimean War for *Illustrated London News*. Also painted landscapes and watercolours. He coloured the figures and buildings in many of John Dobson's architectural drawings, and also did a series of railway drawings. Lived in London for a time, but retired due to ill-health to Scarborough, where he died. Exhib. at the RA 1835-59, BI and SS. The recent centenary exhibition of Carmichael's work at the Laing Art Gallery, Newcastle, (Nov-Dec 1968) was the most comprehensive ever devoted to him. The catalogue contains a detailed account of his career. Works by Carmichael can be seen at Greenwich, Newcastle, Gateshead and Sunderland art galleries. His studio sale was held at Christie's on Nov. 24-5, 1870.

Two works by J.W.C. sold at auction in 1969 for over £3,000. The average range for his works is still £1,000-2,000, but a major work, up to £5,000. Drawings and watercolours £50-200.

Bibl: AJ 1868 128 (obit); Redgrave Dict; Cundall; DNB; Hughes; VAM; Wilson, Marine Painters, pl.7; Catalogue of J.W.C. Centenary Exhibition, Laing AG, 1968; Hardie III 68, 72 (pl.87); Maas 63.

CARPENTER, William 1818-1899
Painter of figure subjects, historical and mythological subjects and portraits, who exhibited at the RA from 1840-66. He lived in London but after 1862 in Boston, U.S.A. In 1855 he accompanied the Punjab Irregular Force to Afghanistan, and exhibited several Eastern subjects as a result of his journey. Titles at the RA include, among portraits, 'Thetis Bathing Achilles in the Styx', 'Charles II in Holland before the Restoration'.

Probable price range £30-100

Bibl: VAM.

CARRICK, J. Mulcaster fl.1854-1878
Landscape painter, and painter of figure subjects who exhibited at the RA from 1854-1871, and occasionally at BI and SS. Member of the Hogarth Club, which sympathised with Pre-Raphaelite ideas. Little known, except that Ruskin praised his 'The Village Postman' (RA 1856) and 'Rydal' (RA 1857). Travelled in France, Switzerland and Spain. His pictures are usually small, detailed, and of high quality, but in his later period he painted a number of rather repetitious coastal scenes.

'Between Nice and Monaco', and 'Villefranche' a pair, sold at Phillips Son and Neale 12.5.69 for £230. Another pair of views on the Thames sold at Christie's 11.7.69 for £441.

Bibl: Ruskin, Academy Notes 1856-57.

CARRICK, Robert RI fl.1847-93 d.1895
Painter of genre and landscapes who exhibited at the RA from 1853-1880, titles including 'A Day in the Fields', 'The Widow's Cares', 'The Cottage Door', 'Saved from the Wreck'. Ruskin admired his 'Thoughts of the Future' (RA 1857) and 'Weary Life' (RA 1858).

Probable price range £100-200

Bibl: AJ 1859, 162; 1869, 302; Ruskin, *Academy Notes*, 1857-58.

CARRINGTON, James Yates fl.1881-91 d.1892
Genre and landscape painter who exhibited at the RA from 1882-1889, titles including 'So Sinks the Day to Eventide', 'Steerage Passengers', 'An Out-patient at King's College Hospital'. Graves, Dict., gives his speciality as "animals".

Probable price range £30-70

Bibl: AJ 1892, 224.

CARTER, Samuel John 1835-1892
Norfolk animal and sporting painter. Born in Swaffham, and studied in Norwich. Lived in London and Swaffham. Specialised in sentimental pictures of dogs and puppies. Exhib. at RA, BI, SS, GG. Ruskin, always sentimental about animals, praised Carter's 'The First Taste' (RA 1875) as "exemplary in its choice of a moment of supreme puppy felicity as properest time for puppy portraiture". Pictures by S.J.C. are in the Tate and Preston AG.

'A Bay Hunter' sold Sotheby's 12.3.69 for £1,200. Pictures of dogs could be worth less, probably £200-400.

Bibl: Ruskin, *Academy Notes*, 1875.

CARTER, William 1843-1864
London landscape painter and topographical artist, who exhibited at the RA from 1843-1864; in 1843 'Sketch on the Spot of Jacob's Island, Southwark, mentioned by Boz in *Oliver Twist*'.

Probable price range £30-70

CARTWRIGHT, Frederick William fl.1854-1889
London painter of landscapes, portraits and rustic genre who exhibited at the RA from 1854-1889. He lived in London. Brixton and Dulwich and the landscapes he exhibited at the RA were of views in Devon, N. Wales, Hastings and Haslemere. TB also calls him a "marine" artist.

Probable price range £30-70

CARY, Francis Stephen 1808-1880
Genre and historical painter who exhibited at the RA from 1837-1876, titles including illustrations of scenes from Shakespeare, 'Abelard and Heloise', 'Escape of Eliza', 'St. Valentine's Day', 'The Village Well' etc. A pupil of Henry Sass in Bloomsbury, he also went to the RA Schools and for a short time was in Lawrence's studio. 1829, in Paris and Munich; 1833-35, on foreign travel. In 1842 he took over the management of Sass's art school in Bloomsbury, and is best known for this. This school was modelled on the school of the Carracci in Bologna and many prominent painters went there — Cope, Millais, Rossetti etc. Through his father, the Rev. Henry Francis Cary, (1772-1844), the translator of Dante, he enjoyed much of the literary society of the day. He painted an interesting portrait of Charles and Mary Lamb (NPG). He retired to Abinger Wotton in 1874.

Probable price range £100-200

Bibl: AJ 1880 108; DNB; Bryan.

CASSIE, James RSA RSW 1819-1879
Aberdeen painter of landscapes and coastal scenes. Exhib. at RA 1854-79, BI and SS. Subjects usually calm sea at dawn or sunset, but titles at RA include several domestic genre subjects also. Elected ARSA 1869, RSA 1879.

Probable price range £50-150

Bibl: Caw 324.

CATTERMOLE, George 1800-1868

Architectural draughtsman and topographer of the romantic movement, illustrator, and painter of historical genre. Placed about 1814, with John Britton, to study architecture, and began his career as a topographical draughtsman, making illustrations for Britton's *Cathedral Antiquities of Great Britain.* Elected A of the OWS, 1822, and Member, 1833, but resigned in 1852 when he took up oil painting, although he later returned to the practice of watercolour. Abandoning purely architectural for figure subjects, he became a painter of historical genre, of great spirit and originality. He exhibited 1819-50, 105 works at the RA (from 1819-27), BI, and OWS, (97 works). He worked much for publishers, making illustrations for Roscoe's *Wanderings in N. Wales,* the *Waverley Novels,* several of Dickens's novels, a history of the Civil War by his brother Richard, etc. He was a close friend of Dickens and Thackeray, Macready and Maclise. Ruskin *(Modern Painters),* admired him : "The antiquarian feeling of Cattermole is pure, earnest, and natural; and I think his imagination originally vigorous, certainly his fancy, his grasp of momentary passion considerable, his sense of action in the human body vivid and ready". But at the same time Ruskin felt his later work was ruined by a lack of study of nature, and was "tending gradually through exaggeration to caricature." His studio sale was held at Christie's on March 8, 1869.

Price range £30-150

Bibl: AJ 1857 July; 1868 Sept; 1870 March; J. Ruskin, *Modern Painters,* I, 1843; Redgrave, Cent. and Dict.; Clement & Hutton; Roget; Binyon; Cundall; DNB; Hughes; VAM; R. Davies, *George Cattermole,* OWS, IX, 1932; Hardie III passim (pl.113).

CAUTY, Horace Henry 1846-1909

Genre and historical painter who exhibited at the RA from 1870-1904, titles including 'The Inspection of the Watch', 'The Vagabond', 'Tramps', 'Little Sunshine', etc. He was Curator of the RA Schools.

Probable price range £30-70

Bibl: The Year's Art 1910 387.

CHALMERS, George Paul RSA RSW 1833-78

Painter of domestic genre, portrait and landscapes. The son of the captain of a coasting vessel, and apprenticed to a ship chandler, he eventually came to Edinburgh and at the age of twenty became a student at the Trustees' Academy under R. Scott Lauder. Settling in Edinburgh, he led a quiet and uneventful life in the practice of art, varied by occasional painting trips to Ireland, the Continent, Skye and Glenesk. He was elected A of the RSA in 1867, and member in 1871. His genre paintings and portraits are usually of single quiet figures seated in dimly-lit interiors, usually placed in strong light and shade, and are similar to those of R. Scott Lauder. The Edinburgh National Gallery has several examples, e.g. 'A Quiet Cup' (an old woman taking tea), and 'The Tired Devotee' (a child dozing in church).

'The End of the Day' sold at Christie's 2.4.69 for £168.

Bibl: AJ 1897 83-8; 1878 124 (obit); Portfolio 1887 189; 1877 192; 1880 39f; A. Gibson and J. Forbes White, *Memories of G.P.C. and the Art of his Time* 1879; Edward Pinnington, *G.P.C. and the Art of his Times* 1897; Holmes *R. Scott. Academy,* Studio 1907; Caw 244-7 (pl. opp. 244); DNB.

CHALON, Alfred Edward RA 1780-1860

Painter of portraits and of contemporary and historical genre. Younger brother of John James Chalon (q.v.) He was the most fashionable painter of portraits in watercolour – usually about 15 ins. high, and also miniatures on ivory, and was the first to paint Queen Victoria on her accession to the throne, and thereby received the appointment of Portrait Painter to H.M. the Queen. Among his best known subject pictures are 'Hunt the Slipper', 1831; 'John Knox Reproving the Ladies of Queen Mary's Court', 1837; 'Sophia Western', 1857. He was

clever at imitating the styles of other painters and particularly Watteau. He also painted a vast number of works in oils, and exhibited at the RA from 1801-1860. ARA, 1812; RA, 1816.

Price range for watercolours £50-100; Oils £100-300

Bibl: VAM, MS letters to and from John Constable, 1822-51; Redgrave, Cent. and Dict.; AJ 1860 337; 1862 9 (article by James Dafforne); *Autobiographical Recollections of C.R. Leslie,* ed Tom Taylor, 2 vols, passim, 1865; Roget; Bryan; Binyon; Cundall; Hughes; VAM; A.P. Oppe – *English Drawings at Windsor Castle* 1950; DNB; Hardie II 149 (pl.135).

CHALON, Henry Bernard 1770-1849

London sporting and animal painter, and lithographer. Son of Jan Chalon, a Dutch engraver (1738-95). Animal painter at the Prince Regent's Court and to the Duke of York. Mainly painted horses and dogs, in the Ben Marshall – Abraham Cooper tradition. Exhib. at the RA 1792-1847 (198 works) BI and SS.

Prices during the 1968-9 season ranged from £170 to £336.

Bibl: AJ 1849 271; Redgrave Cent.; Pavière, Sporting Painters, (pl.9).

CHALON, John James RA 1778-1854

Painter of landscape, genre and animals, both in oil and watercolour. Brother of A.E. Chalon (q.v.). Born at Geneva of French parents; came to England in 1789, when his father became French professor at Sandhurst. Entered the RA Schools in 1796. Exhib. 1801-1854, 86 works at the RA, 48 at the BI, and SS at the OWS. Elected ARA 1827, and RA 1841; A of the OWS 1805, and Member 1807-1812. In 1816 he exhibited an important work at the RA, 'Napoleon on Board the Bellerophon', and 'The Gravel Pit' at the International Exhibition in 1862, said to be one of his best works. Redgrave Cent. notes that "in his early days much of his time was given up to teaching, and although he was an exhibitor for fifty years his works are comparatively few". He was a friend of C.R. Leslie who wrote of him that few painters "had so great a range of talent" – he painted landscapes, figure and animal subjects, and marine pictures with equal facility and success. He published in 1820 *Sketches from Parisian Manners.*

'Summer Landscape' sold at Sotheby's 18.6.69 for £300.

Bibl: C.R. Leslie in AJ 1854 375; 1855 24; Redgrave, Cent, Dict.; Roget; Binyon; Cundall; DNB; Hughes; VAM.

CHAMBERS, George RWS 1803-1840

Marine painter and watercolourist. Born at Whitby, the son of a fisherman. Worked as a sailor until he was 17, when he set up as a house and ship painter. Came to London, and began to practise as a ship painter. Also worked as a scenery painter at the Pavilion Theatre. He was much patronised by naval officers; in 1830 was commissioned by King William IV to paint four pictures, which are still in the Royal Collection. Exhib. 1827-40 at RA, BI, SS, OWS and NWS. Elected ARWS 1834, RWS 1835. Both his oils and his watercolours are lively and spirited, and show a real knowledge of ships and the sea.

'Shipping at Portsmouth Harbour' sold Christie's 9.5.69 for £473.

Bibl: AU 1840 186 f (obit); AJ 1859 332; Portfolio 1888 127; *Memoir of G.C.* 1837; J. Watkins, *Life and Career of G.C.* 1841; Redgrave Dict.; Roget; Binyon; Cundall; DNB; Hughes; VAM; Wilson, Marine Painters; Hardie III 72-5 (pls. 89-90); Maas 62-3.

CHAMBERS, George, Junior fl.1848-1862

Marine painter, son of George Chambers (q.v.). Exhib. at RA 1850-61, BI and SS. Subjects at RA river and coastal scenes, e.g. 'Lord Mayor's Day' 'Schooner Ashore near Whitby' etc. His work is often confused with that of George (Senior).

Probable price range £50-150

CHAPMAN, George R. fl.1863-1874
Portrait painter who exhibited at the RA from 1863 to 1874. During the early 1860's was associated with Rossetti, Arthur Hughes and Madox Brown.

Probable price range £50-100, depending on interest of sitter.

Bibl: AJ 1895 p.344; Leathart Collection Catalogue, 1968, no.32.

***CHAPMAN, John Watkins** fl.1853-1903
Genre painter and engraver. Exhib. mainly at SS (112 works) also RA 1853-1903, BI and NWS. Titles at RA include still-lives of birds and flowers, portrait engravings after Reynolds and Hoppner, and genre scenes, e.g. 'The Mischievous Model' 'Wooed but not Won' etc.

'A Private Box, Drury Lane'; and 'The Gallery, Drury Lane' sold at Christie's 11.10.68 for £577.

Bibl: Cat. of Engr. Brit. Portraits BM, 1908, I, 174, 228.

CHAPMAN, R.W. fl.1855-1861
Little-known London genre and historical painter. Exhib. at the RA in 1855 and 1856, and also at SS. Titles at RA 'At Length the Tumult Sinks, the Noises Cease' 'The Lollard Discovered'.

Probable price range £100-200, but more for scenes of Victorian life.

***CHARLES, James** 1851-1906
Painter at first of portraits, later mainly of landscape and rustic genre. Studied at Heatherley's School, at the RA Schools from 1872, and in Paris at the Académie Julian, where he was influenced by the *plein-air* movement. Exhib. at the RA, 1875-1906, the NG and at the Paris Salon 1897-1905, Member of the NEAC 1886-87, and continued to exhibit there until the end of his life. Visited Italy 1891 and 1905. Memorial exhibition at the Leicester Galleries, 1907. Reynolds, V.S., says that he was "one of the first to practise *plein-air* painting in England. His unpretentious and often charming studies of country life in England have never attained the reputation they deserve".

Probable price range £100-300

Bibl: AJ 1905 185; 1906 350; 1907 135; 1908 145 f; Studio, 40 (1907) 43-49; vol. 38, 229 f; vol. 39, 62; Reynolds, V.S., 40, 97 (pl.92); Tate Catalogue; Reynolds, V.P., 194, 199 (pl.137).

CHARLTON, John RBA fl.1870-1904 d.1917
Born in Bamburgh, Northumberland, Charlton studied at the Newcastle school of art and at South Kensington. Painted portraits, sporting subjects, and battles. Exhib. at the RA 1870-1904, SS, NWS, GG and NG. 'God Save the Queen' (RA 1899), a picture of Queen Victoria arriving at St. Paul's for the Diamond Jubilee Service, was commissioned by the Queen herself. In his later years Charlton turned increasingly to military and battle scenes.

'A Boy on a Pony, with 3 dogs' sold at Christie's 25.4.69 for £788.

CHATTOCK, Richard Samuel RE 1825-1906
Birmingham etcher and landscape painter. Exhib. from 1869-1891 at the RA – all landscapes – but generally was better known and was very popular as an etcher. He contributed to *The Etcher* (Second Series, folio, dating from 1880), and to *The Portfolio* (from 1873-1884), where his landscapes were liked very much. Some of his best things are his 14 plates of *Views in Wensleydale*, 1872, and he also published a reproduction of Crome's *Woodland Road*, and *Practical Notes on Etching*, 1883.

Probable price range for oils £30-100

Bibl: *The Portfolio*, III, 81; *Rugby School Register*, 1901, I, 309; *Cat. of Mod. Brit. Etchers*, VAM, 1906, 28; *The Times*, 3.2.1906, 10; W. Shaw Sparrow, *A Book of British Etching*, 1926, 186-7, 192.

CHESTER, George 1813-1897
Landscape painter. He rejected the Governorship of Sierra Leone, and turned to painting. He was largely self-taught, but was encouraged by Augustus Egg and Ansdell, to whom his wife was related. Through Ansdell he met many of the leading painters, Frith, Elmore, H. O'Neil, John Phillip, Creswick, Bridell and Lee. He exhibited at the RA from 1849-1889 — landscapes, titles including 'Starting for Market', 1853, 'The Woodland Glade', 1861, and 'The Fisherman's Haunt', 1862. His paintings were usually large and in the style of Constable.

Probable price range £30-70

Bibl: AJ 1897 255; Studio II (1897) 100-106 (five illustrations).

CHILDS, George fl.1826-1873
Painter of landscapes and rustic genre, and lithographer. Exhib. at the RA from 1833-71; 1836 at BI; 1826-73 at SS. Titles at the RA include 'The Village Coquette', 'The Pride of the Village', 'Shall I Fight or Not'. He drew lithographs for a volume on trees and published: *A New Drawing-Book of Figures; The Little Sketch Book; Child's Drawing-book of Objects; English Landscape Scenery and Woodland Sketches*.

Probable price range £100-200

CHRISTIE, James Elder 1847-1914
Scottish painter of pictures of childhood, scenes from Burns, moralising allegories and portraits. Trained at the Art Schools, Paisley and at South Kensington, and won two gold medals at the RA in 1876 and 1877. But then he went to Paris and returning joined the N.E.A.C. and "disappointed the prophets by producing work in the best opposition style". In 1893 he went to Glasgow, but his best work was done before he returned there. Exhib. at RA from 1877-1900.

'Vanity Fair' sold at Christie's 2.4.69 for £420.

Bibl: David Martin, *The Glasgow School of Painting*, 1902, p.3-6; Caw 274; DNB; Who's Who 1912; Studio II (1897) 121 (reprd. 'Vanity Fair'); Catalogue of The Glasgow Boys' Exhibition, Scottish Arts Council, 1968.

CLACY, Miss Ellen fl.1870-1900
Historical and genre painter. Exhib. 1870-1900 at SS and RA, 1872-1900 at RA. Titles at RA 'The List of Conspirators' 'A Hunted Jewess, France 1610' 'The Letter' etc. 'Will Myers, Ratcatcher and Poacher' (RA 1885) is in the Walker Art Gallery, Liverpool.

Probable price range £50-150.

CLARE, George fl.1860's
Birmingham fruit and flower painter. Exhib. 1864, 1866 and 1867 at RA, also BI and SS. Imitator, with his brother Oliver, of W. H. Hunt's small, detailed pictures of fruit, flowers, blossom and birds' nests. Another member of the family, Vincent Clare, painted in the same vein, but no details of his career are known.

Single pictures can make £50-200; during the 1968-69 season several pairs sold for between £100 and £525.

CLARE, Oliver fl.1880's
Painter of fruit and flowers; brother of George Clare (q.v.). Exhib. 1 picture at RA in 1883, two at SS. Like his brother, probably worked mainly in Birmingham. Oliver Clare's pictures are very similar to those of George Clare's, but not of such good quality.

During the 1968-9 season prices for single pictures ranged from £125-175, pairs £120-170

CLARK, Dixon fl.1890-1902
Animal painter from Blaydon-on-Tyne. Exhib. at RA from 1890-1902,

but worked mostly in the north-east. Subjects usually cattle or sheep in pastoral landscapes, in the style already popularised by T.S. Cooper. Pictures by him are in the Sunderland Art Gallery.

Price range £20-70

*CLARK, Joseph 1834-c.1912
Painter of domestic genre of a tender and affecting nature (usually of children), and a few biblical subjects. Studied at J.M. Leigh's. Exhib. at the RA from 1857-1904. Received a medal and award at Philadelphia in 1876 sending there his 'Sick Child' and 'The Bird's-Nest'. Among his more important works are 'The Wanderer Restored' (1861), and 'Early Promise'. Graves, R. Acad. lists him as "Joseph Clarke."

Probable price range £100-300

Bibl: AJ 1863 49 ff. (reprd. 'The Return of the Runaway', 'The Wanderer Restored' and 'Hagar and Ishmael'); AJ 1859 165; 1860 78; 1869 296; Clement and Hutton; Ruskin, *Academy Notes,* 1875; Who's Who 1912.

CLARK, Thomas ARSA 1820-1876
Scottish landscape painter. First exhib. at RSA when 20 years of age. ARSA in 1865. At that period he lived in Edinburgh. Painted both in oil and watercolour: his subjects were chiefly scenes in Scotland, but were sometimes scenes in England as a few years before his death he used to winter in the South. Among his better works are: 'Waiting for the Ferry', 'A Quiet Morning on Loch Awe', 'Spring', 'Summer' and 'The Farm Yard, Woodside, Surrey'. Exhib. at RA 1830-70, BI and SS.

Probable price range £100-200

Bibl: AJ 1877 20, 38 (obit); Clement and Hutton; DNB.

CLARK, William, Senior and Junior fl.c.1830-1970
Both little-known ship painters, probably working mostly in Glasgow c.1830-70. Although both unrecorded, two pictures by these artists sold at Christie's in May 1967, reveal them to be very competent and sensitive artists. The Clark (Senior) sold for 550 gns, the Junior for 580 gns. Wilson records a W. Clark, who may be the same artist as William Clark,(Senior).

CLARKE, Joseph. See CLARK, Joseph

CLARKE, Samuel Barling fl.1852-1878
Domestic genre painter of humorist themes, titles including 'The Stolen Bite', 'Toothache', 'A Modern Friar Tuck', 'Fun', 'Lighting Grandfather's Pipe', 'Up in the Clouds, Down in the Dumps' etc. Exhib. at the RA 1854-74, BI and SS.

Probable price range £30-100

CLATER, Thomas 1789-1867
Painter of domestic genre and portraits. Exhib. at the RA from 1819-1859 (in 1819 'The Game of Put or the Cheat Detected'). Titles include 'Reading the Letter', 'Dressing the Bride', 'Luncheon' 'Scandal!!! Only think!!' 'The Music Lesson'. His paintings were usually of scenes from domestic and provincial life, in a manner based on that of Dutch genre, usually of a quietly humorous character that was easily appreciated at the time. 'A Chief of Gipsies Dividing Spoil with his Tribe' is in the Walker Art Gallery, Liverpool.

Probable price range £100-200

Bibl: Redgrave; DNB; Gent. Mag. new series III 667.

*CLAUSEN, Sir George RA 1852-1944
Plein-air figure and landscape painter of scenes of rural life, both in oil and watercolour. He also painted portraits, some nudes, town interiors and still life, and made occasional decorations and engravings.

Born in London, the son of a Danish sculptor, he studied at the South Kensington Schools. He visited Holland and Belgium in 1876, exhibiting his first picture at the RA in that year' 'High Mass at a Fishing Village on the Zuyder Zee'. He worked under Bouguereau and Tony Robert-Fleury in Paris, but then returned to London and began to paint the life of the agricultural labourer. Strongly influenced by Bastien-Lepage, he worked out of doors and was preoccupied with the effects of light, but at the same time retained solidity of form. He was especially interested in figures seen against the sun. He spent much of his time in Essex sketching agricultural life. His 'Labourers after Dinner', 1884, brought him wide repute, and 'The Girl at the Gate', 1889 was purchased by the Chantrey Bequest (now in the Tate). He was an original member of the NEAC., in 1886, ceasing to exhibit there when elected ARA in 1895. 1904-6, Professor of Painting at the RA Schools; 1908 RA; knighted in 1927. He also published *Six Lectures on Painting,* 1904, and *Aims and Ideals in Art,* 1906.

In the 1968-9 season prices ranged from £147-462.

Bibl: F.G. Roe, *George Clausen,* OWS, XXIII; Who's Who, 1912; Dyneley Hussey, *George Clausen,* (Contemporary British Artists), 1923, (no work earlier than 1904 reproduced; VAM; DNB 1941-50; Tate Catalogue; Maas 250 (pl. p.250).

CLAXTON, Marshall 1812-1881
Painter of historical and biblical subjects, portraits, and scenes in India, Australia, Jerusalem, Egypt, etc. Pupil of John Jackson RA, and also studied at the RA Schools. In 1843 he won a prize at the Cartoon competition at Westminster Hall, for his 'Alfred in the Camp of the Danes'. Due to lack of success he went to Australia in 1850, hoping to sell his own work and that of others and to found a school. He held the first exhibition of paintings in Australia. But had little success, so he went to India where he disposed of most of his paintings. He also visited Egypt and the Holy Land, and in about 1858 returned to England. While in Australia he had received a commission from the Queen to paint a 'General View of the Harbour and City of Sydney', and he also painted a portrait of the last Queen of the Aborigines. His best work was thought to be his 'Sepulchre' which he sent to the International Exhibition of 1862 and later gave to the RA. He exhibited at the RA from 1832-1876.

Probable price range £50-150

Bibl: AJ 1869 368; Athenaeum 13.8.1881 216 (obit); Ottley; Bryan; DNB.

CLAY, Sir Arthur Temple Felix, Bt. 1842-1928
Painter of historical and domestic subjects and also of portraits. An amateur painter, educated at Trinity College, Cambridge. Exhib. at the RA from 1874-1890 and also SS, NWS, GG and NG. Pictures by Clay are in the London Law Courts (Court of Criminal Appeal), the War Office and the London Museum.

Probable price range £30-70

Bibl: Who Was Who 1916-28

CLEMINSON, Robert fl.1865-1868
Sporting painter. Subjects deer, dead game, dogs, shooting etc. Exhib. at BI and SS 1865-68.

'The Timber Waggon' sold Bonham's 3.7.69 for £100.

*CLIFFORD, Edward 1844-1907
Painter of portraits and biblical genre. Born in Bristol, where he first studied. Later moved to RA Schools. Exhib. at RA 1867-92, SS, NWS, GG, NG and elsewhere. All Clifford's RA pictures were conventional Victorian female portraits, but at the GG and elsewhere he showed biblical scenes, such as 'Israelites Gathering Manna', and other genre pieces. His religious pictures show the influence of Holman Hunt. Clifford was himself a religious man, and later in life he

worked for the Church Army. A portrait drawing of General Gordon is in the NPG.

A watercolour copy after Burne Jones by C. sold at Christie's in Jan. 1970 for £84.

Bibl: Ruskin, *Academy Notes* 1875; Clement and Hutton; The Times 20.9.1907.

CLINT, Alfred 1807-1883
Son of George Clint, ARA. (q.v.). Painter of landscapes, coastal scenes and portraits. President of the Society of British Artists. Exhibited landscapes at the RA for over 40 years, 1829-1871. "He could devise fine effects, at times rivalling Danby in the red glow of the sunsets" (Maas). He was also a prolific exhibitor at SS (406 works) and the BI. His studio sale was held at Christie's on Feb. 23, 1884.

'Harbour Scene on the South Coast' sold at Christie's 6.3.70 for £2,100. This is a record price. Usual price range £100-500.

Bibl: AJ 1854 212; 1868 92; Redgrave Dict; Maas 48 (reprd. p.49, 'Landscape with Mountains and Rocks' VAM.

CLINT, George ARA 1770-1854
Portrait painter, engraver and miniature painter. He began his career as a miniature painter and then took up engraving. His studio, No.83 Gower St., was the rendezvous of the leading actors of the day, a popularity due to a series of theatrical portraits he painted, e.g. 'W. Farren, Farley and Jones as Lord Ogleby, Canton and Brush in the Comedy *Clandestine Marriage'*, 1819. He exhibited at the RA, from 1802-1845, and was elected ARA in 1821, but resigned in 1836 as he was disappointed in never becoming an RA. His son Alfred Clint (q.v.) was also a painter.

'Portrait of Harriet Smithson' sold at Christie's 21.3.69 for £578.

Bibl: AJ 1854 212 (obit.); Redgrave, Dict.; Clement and Hutton; Williamson, *History of Portrait Miniatures*, 1904; DNB.

CLIQUE, The
Group of early Victorian rebels, consisting of P.H. Calderon, A.L. Egg, John Phillip, Richard Dadd, H.N. O'Neil, and W.P. Frith (all q.v.). They had no coherent policy, beyond general dissatisfaction with the RA. Flourished during the late 1830's, after which the artists went their very separate ways.

COBBETT, Edward John RBA 1815-1899
Genre and landscape painter. Trained under the landscape painter, J.W. Allen (q.v.). Exhib. at the RA from 1833-1880. Titles include 'The Proposal' 1863, 'The Ballad' 1864, 'A Rustic Confabulation' etc. Two of his RA exhibits were of dead game and angling. At York Art Gallery is 'A Welsh Interior (1856). Of 'Heather Bells' exhib. at SS in 1859, the AJ said:- "A company of colliers' daughters with such (!) petticoats for colour and texture, and standing on a piece of hillside bottom, rich in grasses, and fragrant with the sweet heath-bloom. The figures are made to tell powerfully against the sky and distances".

'Mother and Child in a Landscape' sold Bonham's 8.5.69 for £180.

Bibl: Ottley; AJ 1859 141; 1860 80; Clement and Hutton.

COCKERELL, Samuel Pepys b.1844 fl. 1875-1903
Son of Charles Robert Cockerell, the architect. Painter of historical scenes, portraits, mythological and genre pictures, decorative artist, and sculptor. As a sculptor he produced the mural monument to James Stewart Hodgson in Haslemere Church, (exhib. at RA 1903), and the decorative reliefs inside and out at Lythe Hill, Haslemere. Exhib. at the RA from 1875-1903, SS and GG. Titles at RA 'Pilate Washing his Hands before the People' 'Orpheus and Eurydice' 'Our Lady of the Ruins' etc.

Probable price range £30-100

Bibl: Ruskin, *Academy Notes,* 1875; Blackburn, *Acad. Notes,* 1882 80 n.1624; G. Ulick Browne, Studio, 30 (1904) 116-122 (sculpture).

COCKRAM, George RCA 1861-1950
Liverpool landscape painter in watercolour, especially of mountain and coast scenes. Studied at the Liverpool School of Art, 1884, and in Paris, 1889; then decided to devote himself entirely to painting in watercolour. RCA 1891. Exhib. at the RA from 1883-1924. 'Solitude' (RA 1892) was purchased by the Chantrey Bequest and is in the Tate Gallery.

Probable price range £100-200

Bibl: Tate Cat; R. Acad. Pictures, 1892, 153 (reprd. 'Solitude').

COLBY, Joseph fl.1851-1886
Painter of genre, portraits, historical and mythological subjects. Exhib. at the RA from 1851 ('Asiatic Indolence') to 1886. In 1860 he exhib. at the BI 'Olivia': "Not one of those Olivias whom we all know so well — yet a study of rare excellence". (AJ).

Probable price range £30-70

Bibl: AJ 1860 80.

COLE, George 1810-1883
Portrait, landscape and animal painter. Self-taught, and began by painting several large canvas advertisements for the proprietor of a travelling circus (tiger hunts etc. exhib. at Weyhill Fair). This success led him to study animal painting more seriously and he went to Holland to study the Dutch Masters. He devoted himself for some years to animal painting in Portsmouth, exhibiting for the first time in London at the BI in 1840. His 'Don Quixote and Sancho Panza with Rosinante in Don Pedro's Hut' attracted much attention there in 1845. From 1849-1882 he exhibited at the RA, turning to landscapes, mainly in Hampshire, Surrey, Cornwall, Wales, Sussex etc. His son George Vicat Cole (q.v.) was also a landscape painter, and their work is sometimes confused.

Prices in the 1968-9 season ranged from £110-290

Bibl: AJ 1883 343; Ottley; Clement and Hutton; DNB; Pavière, Landscape (pl. 12).

***COLE, George Vicat RA 1833-1893**
Landscape painter, eldest son of George Cole (q.v.). Born in Portsmouth; in 1852, he sent his first pictures for exhib. to London to the Society of British Artists. He exhibited at the RA from 1853-1892 becoming A in 1869, and RA in 1880. His work was highly popular. Maas notes that he "achieved almost the popular success of Leader, and was capable of grand effects — as in 'The Pool of London' ". His subjects were taken from England, Wales and Scotland, but he was especially fond of views along the Thames. His studio sale was held at Christie's on June 16, 1893.

Prices during the 1968-9 season ranged from £100 to £1,100, the last being an auction record.

Bibl: AJ 1870 177 ff; 1893 33; 1909 294; Chignell, *Life and Works of Vicat Cole,* 1897; Pavière, Landscape, (pl. 13); Maas 228-9 (pl. 229).

COLE, John H. RCA fl.1870-1892
Landscape painter from Llanbedr, Carnarvonshire. Exhib. at RA from 1870-1892, and SS. Subjects mainly Welsh landscapes, with children.

'Street Scene' sold Sotheby's 28.11.68 for £150.

COLEMAN, Edward fl.1813-1848 d.1867
Born at Birmingham towards the end of the 18th C.; son of James Coleman, a portrait painter. Painter of portraits, dead game and kin-

dred subjects; he also decorated papier-mâché ware. Exhibited 16 works at the RA, 1813-1848, and was a contributor to the R. Birmingham Society of Arts from 1827. Elected member of RBSA, 1826.

Probable price range £30-100

Bibl: Birmingham Cat.

COLEMAN, Miss Helen Cordelia. See ANGELL, Mrs. John

COLKETT, Samuel David 1800/6-1863
Landscape painter, engraver and lithographer of the Norwich School, working both in oil and watercolour. Pupil of James Stark. From 1828-1836 he lived in London, exhibiting at the RA in 1830 and 1831, but then returned to Norwich as a dealer, restorer and drawing master, where he stayed for seven years before transferring his business to Yarmouth, and eventually, for the last ten years of his life, to Cambridge. His work was often been attributed to Thomas Churchyard (1798-1865), and until recently his watercolours were very scarce. Clifford says he is a more individual watercolourist than has been supposed, especially for his rural scenes "painted very wetly in bright fresh colours". "His was a slight talent, but he deserves to be remembered for it rather than as a poor imitator and copyist of Stark and an over-painter of Cotman's canvasses, which is all Dickes could say of him".

'Rustics by a Cottage' sold Sotheby's 20.11.68 for £280.

Bibl: Dickes, *The Norwich School of Painting,* 318, 572; Clifford, 49, 50, 61, 72, 82, 84 (plates 54b, 55 a-b); H.A.E. Day *East Anglian Painters* 1968 II 91-7

COLLIER, Arthur Bevan fl.1855-1899
Landscape painter; lived in London and Cornwall. Exhib. at RA 1855-99, BI and SS. Subjects mainly Scottish and Welsh landscapes, also views in Devon and Cornwall. 'Trebarwith, near Tintagel, Cornwall' (RA 1872) is in the Birmingham AG.

'River Landscape' sold at Phillips Son & Neale 16.6.69 for £140.

***COLLIER, The Hon. John 1850-1934**
Painter of portraits, dramatic subject pictures and occasional landscapes. Younger son of the judge Robert Collier (afterwards first Lord Monkswell). Educated at Heidelberg. Studied art under Poynter at the Slade School, in Paris under J.P. Laurens and in Munich; encouraged by Alma-Tadema and Millais. Exhib. at the RA from 1874-1934. Published *The Primer of Art* 1882; *A Manual of Oil Painting,* 1886; *The Art of Portrait Painting,* 1905. One-man exhibition of landscapes at the Leicester Galleries, 1915; retrospective exhibition at Sunderland Art Gallery, 1921-2. Titles include: 'The Last Voyage of Henry Hudson' 1881 (Tate Gallery), reprd: *The Art Annual,* 1914, p.19; 'Marriage de Convenance', 1907 and 'A Glass of Wine with Caesar Borgia', 1893, both exhib. at RA Bicentenary Exhibition, 1969. Collier's subject pictures, like those of Orchardson, catered for the vogue for psychological dramas of upper-class life.

No recent auction prices available – probable price range £100-400.

Bibl: W.H. Pollock in AJ 1894 65-69; Tate Cat; W.H. Pollock, *Art Annual,* 1914.

COLLIER, Thomas RI 1840-1891
Landscape watercolourist. Occasionally painted in oils. Attended Manchester School of Art, first exhib. at SS when 23 – 'On the Llugwy, N. Wales' (1863). Lived from 1864-69 at Bettws-y-Coed then in Hampstead. Influenced by David Cox. In the 19th c. his work was confused with that of James W. Whittaker. Little known about his life and career and under-appreciated until Adrian Bury's monograph in 1944. Hardie calls him "One of the supreme watercolour painters of England". Exhib. 4 works at the RA 1869 and

1870; and 80 at the RI, of which he was elected A 1870, and Member, 1872.

Probable price range £50-200

Bibl: Ruskin, *Academy Notes* 1857; Cundall; VAM; Nettlefold; Adrian Bury, *Thomas Collier,* 1944; Hardie III 150-156 (pls. 175-176).

COLLINGWOOD, William RWS 1819-1903
Landscape painter, mainly in watercolour. Born in Greenwich, son of an architect. Pupil of J.D. Harding and Samuel Prout. Exhib. at RA 1839-60, BI, SS, OWS (732 works) and NWS (108 works). In 1856 Ruskin praised his watercolour of the 'Jungfrau at Sunset' and thereafter Collingwood was chiefly known for his Alpine subjects. Many of his pictures are in Liverpool and its vicinity, where most of his professional life was spent. He was intensely religious, a lay preacher, and member of the Plymouth Brethren. He was a friend of A.W. Hunt (q.v.). Died in Bristol.

'Conway Castle' sold Sotheby's 23.7.69 for £200.

Bibl: J. Ruskin, *Notes on the OWS* 1856; Clement and Hutton; Marillier 87-91

COLLINS, Charles fl.1867-1903
Painter of rustic genre and figure subjects. Dorking address. Exhib. at the RA from 1867-1903, SS and NWS. Titles include 'An English Cottage' 1867; 'When March Winds Blow' and 'His First Attempt' 1903.

Probable price range £30-70

***COLLINS, Charles Allston 1828-1873**
Painter of historical genre. Studied at RA schools. Came into contact with the Pre-Raphaelites, and his paintings of the 50's show their influence, especially 'Convent Thoughts' (Ashmolean) his best-known work. Very friendly with Millais, with whom he made several painting expeditions. Their drawing styles are very similar, and are sometimes confused. Never a facile artist, Collins gave up painting about 1858 to pursue writing. He wrote two novels, two very observant and amusing travel books and periodical essays. His father was William Collins (q.v.), his brother Wilkie Collins, and he was married to a daughter of Dickens. Exhib. at the RA 1847-55, and at BI in 1848-9.

Owing to the scarcity of his work, prices are impossible to guess at. Small sketches and drawings perhaps £50-200, finished works more.

Bibl: AJ 1904 281-4 (Smetham & C.A.C); 1859 122; 1873 177; Ruskin, *Academy Notes* 1855; Forster, *The Life of Charles Dickens,* 1893; Bate 79-80 (plates opp. p.10, 79); Bryan; DNB; S.M. Ellis, *Wilkie Collins, Le Fanu and others* 1931; Fredeman, see Index; Reynolds VP 68; Maas 127, 193

***COLLINS, William RA 1788-1847**
Painter of landscape, coastal scenes and rustic genre. Although really a pre-Victorian figure, Collins is important because he established the tradition of picturesque rustic landscape carried on by Shayer and many others. Father of C.A. Collins (q.v.) and Wilkie Collins, the novelist. His father, William C., was Morland's biographer, and it was from Morland that young William received his first lessons. Entered RA Schools 1807, and began exhibiting in that year. Also exhib. at BI. Elected ARA 1814, RA 1820. In 1822 married a daughter of the Scottish painter Andrew Geddes. Encouraged by his friend Wilkie (q.v.) he travelled in Holland and Belgium (1828), Italy (1836-38), Germany (1840). Although Collins's landscapes are contrived, and his figures sentimental, his pictures were enormously popular. His colours are fresh and his technique pleasingly fluid, but many of his pictures have now discoloured because of his use of experimental pigments. His studio sale was held at Christie's from May 31 – June 5, 1847.

Recent auction prices range £100-400

Bibl: AU 1847 137; AJ 1855 141-144; 1859 44; 1899 139 f; W. Wilkie Collins,

Memoirs of the Life of W.C. 1848; Redgrave, Cent. 346-350; DNB; Reynolds VP 16 (pl. 5); Maas 54-5.

***COLLINSON, James 1825-1881**
One of the original founder members of the PRB. Fellow student with Holman Hunt and D.G. Rossetti at R.A. Schools. In 1847 exhib. at RA 'The Charity Boy's Début'. which attracted Rossetti's attention for its painstaking detail,who induced him to become one of the original 7 brothers of the PRB. He was engaged to Christina Rossetti from 1849-1850. 1851 he exhibited at the Portland Gallery a PRB picture "An Incident in the Life of St. Elizabeth of Hungary". He was fiercely R.C., and after 1851 left the PRB and retired to Stonyhurst. About 1854 he emerged again and resumed the profession of an artist. He confined himself to small subjects of domestic and humorous character, e.g. 'For Sale and To Let', 'Good for a Cold', 'The New Bonnet', and of all the original PRB's his reputation dwindled the most rapidly. However, his paintings are extremely pretty and show his great dexterity in painting objects and the surfaces of materials. "He seems to have been chiefly remarkable for his habit of falling asleep on all occasions, which made him something of a butt among his friends, who treated him with a kind of contemptuous kindness". (Ironside and Gere).

'Italian Image Makers at a Roadside Alehouse' an important PRB work, sold at Christie's ll.7.69 for £1,995. Another picture of 'A volunteer' sold Sotheby's 16.10.68 for £260.

Bibl: DNB; Thomas Bodkin, *Apollo*, XXXI, 1940, May, 128-133; Ironside and Gere, 26; Fredeman, (for full bibliography); Maas 117 (pl.140).

COLLINSON, Robert b.1832 fl.1854-1890
Genre painter who exhibited at the RA from 1858-1890, titles including 'Stray Rabbits' 1858, 'Summer Ramble' 1880. Also exhib. at BI and SS. Ruskin praised his 'Sunday Afternoon' at the RA in 1875.

'Mother and Child in an Interior' sold at Christie's 11.7.69 for £294.

Bibl: Ottley; Ruskin, *Academy Notes*, 1875; V & A Cat. I. 1907.

COMPTON, Edward Thomas b.1849 fl.1879-1881
Landscape painter. A self-taught artist, he first painted English scenery, then travelled to Germany and Switzerland. He became one of the first artists to devote himself to painting the remote and inaccessible heights of the Alps. For this reason he has always been more appreciated in Switzerland than in England. He also travelled in Spain, Corsica, North Africa and Scandinavia. Exhib. at RA, SS, NWS, GG and elsewhere. Many of his pictures and drawings were used in Guide books to the Alps.

A large and dramatic Alpine scene sold at Christie's 5.2.70 for £892.

Bibl: AJ 1907 247; E.W. Bredt, *Die Alpen und ihre Maler* 1910; Dreyer, *Der Alpinismus und der Deutsch-Osterr, Alpenverein* 1909.

CONDER, Charles 1868-1909
Painter of landscapes and portraits in oil, best known for his watercolours on silk, usually done as panels for wall decoration or fans. Also a lithographer. Spent early years in India and Australia. Studied art in Melbourne and Sydney. Went to Paris in 1890; after 1897 lived mainly in England. Exhib. at Leicester Galleries, Grafton Gallery, and NEAC. One of the founders of the Society of Twelve. His subjects like those of Beardsley, are vague and fragile, tinged with *fin de siècle* morbidity and decadence. An exhibition of his work was held at the Graves AG Sheffield in 1967.

'May Day' sold at Sotheby's 9.7.69 for £1,700. Another of 'The Bay of Newquay' sold at Christie's 18.3.69 for £840.

Bibl: VAM; Cundall; F.G. Gibson, *Charles Conder*, 1914; J. Rothenstein, *The*

Life and Death of Conder, 1938; Hardie III 170-1 (pl.200); Maas 20, 169, 252 (plates on pp. 252, 255).

CONDY/CUNDY, Nicholas 1793?-1857
Landscape painter. Born in Torpoint, Cornwall. Served in the Peninsula War, 1811-1818. From 1818 he studied art and became a professional painter in Plymouth. He chiefly produced small watercolours on tinted paper, about 8ins. x 5ins. which he sold for about 15/- to 1 guinea each. Between 1830 and 1845 he exhib. landscapes at the RA, BI and SS. At the RA in 1843 and 1845, 'An interior of an Irish cottage at Ballyboyleboo, Antrim', and 'The Cloisters of Laycock Abbey'. His best known painting 'The Old Hall at Cotehele on a Rent-day' is at Mount-Edgcumbe (DNB, 1908). He published *Cotehele on the Banks of the Tamar, the Ancient Seat of the Rt. Hon. the Earl of Mount-Edgcumbe,* 17 plates with descriptive account.

'Yachting Race' sold Sotheby's 18.6.69 for £700

Bibl: DNB

CONDY, Nicholas Matthew 1818-1851
Son of Nicholas Condy (q.v.) Marine painter. Became a professor of painting in Plymouth. He exhibited 3 sea pieces at the RA from 1842-45, which gave hopes of his becoming a distinguished artist, but he died prematurely.

Probable price range £100-300

Bibl: DNB; Redgrave, Dict.

***CONOLLY, Miss Ellen fl.1873-1885**
Genre painter. Sister of Francis Conolly, a sculptor, fl.1849-70. Exhib. at RA, SS and elsewhere. Titles at RA 'Darby and Joan' 'Chelsea Pensioners' 'A Village Genius' etc.

COOK, Ebenezer Wake b.1843 fl.1874-1910
Landscape water-colour painter, mainly of views of the Thames, in Yorkshire, Venice, Florence and Switzerland. Studied under N. Chevalier and worked in London. Exhib. at the RA from 1875-1910, SS and NWS. Titles include: 'Mussel sorters,, Conway', 1875; 'The Thames near Great Marlow', 1876; 'Sunset on the Lake of Geneva' 1892; 'The Loggia die Lanzi, Florence', 1900; 'The Earthly Paradise', 1902. His drawings illustrating 'The Quest of Beauty' and 'Real and Ideal' were exhib. at the Fine Art Society, 1903 — of which was said (*Studio*) . . . "he fails sometimes to bring the many details of his design into proper relation". 'S. Georgio in Venice' 1896 is in Melbourne, and 'The Wye and the Severn from the Windcliff' 1881, and 'The Last Days of the Campanile, Venice' 1906, are both in Sydney.

Prices for the 1968-9 season ranged from £220 to £1300, the last probably being the present auction record.

Bibl: Studio Vol.28 135

***COOKE, Edward William RA 1811-1880**
Painter of river and coastal scenes in oil and watercolour. Son of George Cooke, an engraver. Because of his detailed knowledge of ships and their rigging, Cooke was employed by Clarkson Stanfield (q.v.) to make studies of details of ships for him. Under Stanfield's influence, he took up painting in oil, and travelled in France, Scandinavia, Holland and Egypt. Exhib. at RA 1835-79 (129 works) BI and SS. Elected ARA 1851, RA 1863. A sale of his works was held at Christie's on June 19. 1861; his studio sale was on May 22, 1880.

Prices during the 1968-9 season ranged from £100-1,000, the majority being in the £200-400 range. Three views of Venice sold at Christie's 10.7.70 for £683, £840 and £998.

Bibl: AJ 1869 253; Redgrave, Cent; Ruskin, *Academy Notes*, 1856, 57, 58,

75; Clement and Hutton; Hughes; Bryan; Cundall; DNB; VAM; Wilson, Marine Painters (plate 10); Maas 62-63 (2 plates).

COOPER, Abraham RA 1787-1868

London sporting, battle and historical painter. Largely self-taught except for a few lessons from Benjamin Marshall. Employed at the age of 13 by Astley's Circus which was managed by his uncle. He turned his attention at an early age to painting horses, in which he became very proficient. His first picture, 'The Battle of Waterloo' was purchased by the Duke of Marlborough from BI in 1816; and in 1817 he was elected ARA for 'The Battle of Marston Moor', his first picture exhib. at the RA. Elected RA 1820. Among his works are 'Rupert's Standard', 'The First Lord Arundel taking a Turkish Standard at the Battle of Strigonium', 'The Battle of Bosworth Field', 'The Gillies' Departure' etc. 'A Donkey and Spaniel' and 'A Grey Horse at a Stable-door' are in the VAM (both 1818). As a painter of battle-pieces he stands pre-eminent — holding an analogous position to Peter Hess in Germany and Horace Vernet in France. He also painted many of the celebrated race-horses of the day. John Frederick Herring, (Senior) (q.v.) was one of his pupils, and their painting of horses is very similar. William Barraud (q.v.) also studied with Cooper. In the BM Print Room is a folio volume containing many engravings after Cooper.

The demand for sporting pictures has made this side of Cooper's work much more popular than his historical scenes. A small pair sold at Sotheby's in Nov. 68 for £1,100; price range usually £500-£1,000. Historical works less – £100-300.

Bibl: AJ 1869 45; Ruskin *Academy Notes* 1856, 1858; Clement and Hutton; DNB; Sparrow, Sporting Artists, passim (pl.73); Pavière, Sporting Painters (pl.12); Maas 74.

COOPER, Alexander Davis fl.1837-1888

Son of Abraham Cooper, RA (q.v.) London painter of landscape, portraits, genre and scenes from Shakespeare. Exhib. at RA from 1837-1888, BI and SS. Titles at RA 'Spaniel and Game', 'Milking Time', 'Imogen entering the Cave', 'Abraham Cooper Esq. RA' etc. Mrs. Alexander Davis Cooper was also a painter of children, fruit and flowers, and exhib. at RA 1854-68, BI and SS.

'Lord Nelson and Admiral Collingwood' sold Christie's 5.2.65 for £199.

Bibl: Cat. NPG 2 (1907) 91.

*COOPER, Thomas George fl.1868-1896

London painter of landscapes, pastoral scenes and rustic genre. Exhib. at RA 1868-96, BI and NWS. Titles at RA 'Harvest Time in Berkshire' 'Waiting for the Ferry' 'The Golden Age' etc. Son of Thomas Sidney Cooper (q.v.)

'Hop Picking in East Kent' sold Christie's 2.4.65 for £399.

Bibl: Ruskin, *Academy Notes* 1875; Portfolio 1884 226.

*COOPER, Thomas Sidney RA 1803-1902

Animal painter. Encouraged by Abraham Cooper (q.v.), no relative, and Sir Thomas Lawrence. Entered RA Schools. In 1827 became a teacher in Brussels, and friend of the Belgian animal painter Verboeckhoven who greatly influenced his style, as did the Dutch School of the 17th c. In 1831 he settled in London, and first exhib. at SS in 1833. Exhib. 48 pictures at BI between 1833 and 1863. 'Landscape and Cattle', RA 1833, was the first of a series of 266 exhibits shown there till 1902, without a break — a record for continuous exhibiting at the Academy. Sheep or cattle were his constant subjects but in 1846 he attempted a large historical painting 'The Defeat of Kellermann's Cuirassiers at Waterloo'. This and 'Hunting Scene' (RA 1890) were his only figure studies. Between 1848 and 1856 he painted the cattle in numerous landscapes by Frederick Lee (q.v.), and also the animals

in landscapes by Thomas Creswick (q.v.). After about 1870 his commissions were so constant and lucrative that he was tempted to yield to facile repetition of his favourite themes, but the quality and competence of his style only began to decline in the 1890's, by which time he was an old man. His studio sale at Christie's lasted three days April 12-15, 1902.

Prices in the 1968-9 season ranged from £100 to £546, the majority being in the £100-200 range.

Bibl: AJ 1849 336-7; 1861 133-5; 1902 125 (obit); Clement and Hutton; T. Sidney Cooper, *My Life,* 1890, 2 vols; DNB; Maas 53 (pl. on p.50).

COOPER, W. Sidney fl.1871-1908

Landscape painter, who exhib. from 1871-1908, at RA (1881-91) and SS. Titles include 'Springtime; Isle of Wight', 1881; 'The Avon at Ringwood' 1889; 'Twilight on the Thames' 1884. Does not appear to have been related to T.S. Cooper. A 'View on the Thames' is in the Reading Museum.

'A Travelling Stallion' sold Sotheby's 18.6.69 for £480.

COPE, Sir Arthur Stockdale RA 1857-1940

Prolific portrait painter. Son of Charles West Cope (q.v.). Painted: Marquis of Hartington, 1889; General Lord Roberts, 1894; Duke of Cambridge, 1897; Lord Kitchener, 1900; Archbishop of Canterbury, 1904; H.M. The King, 1907; Prince of Wales, 1912. His treatment could alternate between strong and realistic — Rev. William Rogers 'Hang Theology Rogers', (Studio V 118), and soft, weak, and pretty as in the portrait of Mrs. Joseph Prior, Jun. (RA Pictures, 1891). He exhib. at the RA from 1876.

Probable price range £100-300, depending on importance of sitter.

Bibl: RA Pictures (1891-1907); Studio Vol.5, 118; Vol.29, 42; Vol.35, 43; Vol. 41, 31; Vol.44 43.

*COPE, Charles West RA 1811-1890

Painter of historical, literary and biblical subjects; contemporary and historical genre; illustrator and engraver. Studied at Mr. Sass's Art School in Bloomsbury and became a student at the RA in 1828. In 1831 he went to Paris and studied the Venetian pictures in the Louvre. In 1833 he first exhibited at the RA, 'The Golden Age', (he continued to exhibit until 1882), and from 1833-5 he travelled in Italy. In 1843 he took part in the competition for the decoration of the Houses of Parliament, and won a prize of £300 for a cartoon of *Trial by Jury,* and in the next year obtained a commission to paint a fresco of 'Edward III investing the Black Prince with the Order of the Garter', which was followed by a second of 'Prince Henry acknowledging the Authority of Judge Gascoigne', and 'Griselda's First Trial of Patience'. ARA in 1843; RA in 1848. He retired in 1883. He is now best remembered for his small cabinet pictures of contemporary genre, especially his sympathetic studies of mothers with children. In 1969 a large number of his watercolours and drawings appeared for sale at Christie's, from the estate of one of Cope's grand-daughters.

Prices for pictures in the 1968-9 season ranged from £63 to £199; the range for drawings and watercolours usually £20-70.

Bibl: AJ 1859, 264; 1869, 177ff (with plates); 1890, 320 (obit); Ottley; C.H. Cope, *Reminiscences of C.W. Cope RA,* 1891; Richard Redgrave, *A Memoir,* 1891, pp 32, 46, 51-2; Bryan; DNB; T.S.R. Boase, *The Decoration of the New Palace of Westminster,* Journal of the Warburg and Courtauld Institutes 1954, Vol 17, pp 319-358 (figs 46b, 49d, 50 b-c); Reynolds VP 36 (p.21); Hutchison, 108, 122, 139 (pl.47); Maas 28, 216, 238 (pls. on pp 217, 241 243).

CORBAUX, Miss Fanny RI 1812-1883
(Marie Françoise Catherine Doetter)

Miniature portrait painter and biblical critic. Forced to earn her own living at the age of 15, she first won success in 1827 at the Society

of Arts, obtaining the large silver medal for an original portrait in miniature; in 1828 the silver Isis medal, and in 1830 the gold medal — again for a miniature portrait. In 1830 she was made an hon. member of the Society of British Artists and for a few years she used to contribute oil pictures to its gallery. Later she turned entirely to miniature painting as it was more immediately lucrative. She was also elected a member of NSW, and hardly ever failed to contribute to its annual exhibitions. She exhib. at the RA from 1829-54 — all portraits. She designed the illustrations for Moore's *Pearls of the East* 1837 and for *Cousin Natalia's Tales* 1841.

Probable price range £30-70

Bibl: Clayton II 68ff; DNB.

CORBAUX, Miss Louisa b.1808 fl.1828-1881

London painter, watercolourist and lithographer; sister of Fanny Corbaux (q.v.) Exhib. at RA 1833, 1834 and 1836, SS and NWS. Subjects chiefly children and pet animals, e.g. 'A Child with a Kitten', 'Portrait of a Favourite Cat', 'The Bird's Nest' etc.

Probable price range £30-70

Bibl: Clayton II 70.

CORBET, Matthew Ridley 1850-1902

Landscape and portrait painter. Educated at Cheltenham College, the Slade, under Davis Cooper, and the RA Schools. His first exhibits at the RA were portraits, but apart from a few, from 1883 onwards he painted almost entirely landscape. Pupil, for 3 years in Rome, of Giovanni Costa, Italian landscape painter, and much influenced by him. Corbet was at his best painting in Italy, and produced the type of poetic-pastoral landscape: a title for a landscape of 1890 suggests the mood he chose to adopt 'A Land of Fragrance, Quietness, and Trees and Flowers (Keats)'. He exhib. at the RA from 1875-1902. After 1880 he also sent several works to the GG and later to the NG. ARA 1902. 'Morning Glory' (RA 1894) and 'Val D'Arno' (1901) were both bought by the Chantrey Bequest, and are in the Tate Gallery.

Probable price range £100-300

Bibl: Bryan; AJ 1902 92 f. (Reprd: 'Val D'Arno') 164 (obit); Studio (1902) 133; 25 (1902) 133; Magazine of Art XXVI 1902 236; DNB.

CORBOULD, Alfred fl.1831-1875

London sporting painter. Exhib. at RA 1835-75, BI and SS. Subjects mainly dogs and shooting scenes, with occasional landscapes. Another painter of horses and dogs, Alfred Hitchens Corbould, was working c.1844-63, probably a relation of Alfred C.

Probable price range £100-300.

CORBOULD, Aster R.C.

Painter of rustic genre, portraits and horses. Exhib. at RA 1850-74, BI and SS. Titles at RA 'The English Farmer' 'Mrs. Craven on her Favourite Mare' 'Madras Hunt' etc.

Probable price range £100-200, more for sporting subjects.

CORBOULD, Edward Henry RI 1815-1905

Watercolour painter. Pupil of Henry Sass, and student at RA Schools. His main work was in watercolour, in which he produced a large number of subjects illustrating literature, (chiefly Chaucer, Spenser, and Shakespeare), history, biblical subjects, and daily life. Only a small proportion of his pictures are in oil (e.g. 'The Canterbury Pilgrims', RA 1874). In 1842 his watercolour of 'The Woman Taken in Adultery' was bought by Prince Albert and 9 years later he was appointed "instructor of historical painting" to the Royal Family. For 21 years he continued to teach various members of the Royal

Family and many of his best works were acquired by Queen Victoria and Prince Albert and his royal pupils. He also produced a large number of designs for book illustration. Exhib. at the RA from 1835-1874, BI, SS and NWS (241 works).

Probable price range £50-150

Bibl: AJ 1864, 98 (Reprd: 'The Lesson of the Passover'); 1905, 286, 379; Ruskin, *Notes on NWS*, 1858-59, DNB; Gleeson White.

COTMAN, Frederick George RI 1850-1920

East Anglian painter of portraits, landscape, genre and historical subjects — both in oil and watercolour — who exhib. at the RA from 1871 onwards. Nephew of John Sell Cotman, being the son of Henry Cotman, John Sell's younger brother. Born and educated at Ipswich, in 1868 entered the RA Schools, where his 'The Death of Eucles', won him the gold medal for historical painting, 1873, (now Town Hall, Ipswich). His early watercolours were purchased by both Leighton and Watts, and he was engaged by Leighton to assist in painting 'The Daphnephoria', 1876, and by H.T. Wells to do similar work. He at first started as a portrait painter (for example the large portrait group of The Marchioness of Westminster, Lady Theodora Guest and Mr. Guest playing dummy whist), but later also painted landscape and genre. Walker Art Gallery has 'One of the Family', and Oldham 'Her Ladyship's First Lesson'. In 1882 he was elected RI.

'Peterborough Cathedral' a watercolour, sold Christie's 21.1.69 for £126.

Bibl: *Studio* 47 (1909) 167-77 (plates); *Who Was Who*, 1916-1928

COTMAN, John Joseph 1814-1878

Landscape water-colourist. Second son of John Sell Cotman. He studied under his father, and after a short stay in London as an aide to his father at King's College School, which did not suit him, he returned to Norwich in 1834. Here he struggled, between bouts of heavy drinking and periods of mental instability, to maintain the paternal teaching practice in Norwich for the rest of his life. Exhib. eight works at the BI, 1852-56, and one in 1853 at the RA. His water-colours are very individual, being freer and more passionate than those of his father or brother, and outstanding for their highly personal range of colour — bright blues and yellows, gold and indian reds. In his foliage paintings there is a similarity to Samuel Palmer's Shoreham period. Clifford writes: "His range is not wide nor are his drawings all equally successful, but he is one of the most remarkable and least appreciated watercolourists of the third quarter of the century."

'Evening on the Yare' sold Sotheby's 20.11.69 for £500. Average auction prices £50-200.

Bibl: AJ 1878 169 (obit); Roget; Cundall; DNB; VAM; 'Sprite' pseud., *Norwich Artist Reminiscences*, J.J. Cotman, 1925; A. Batchelor, *Cotman in Normandy*, 1926; Clifford, *passim* (pl.VII figs. 736, 74, 75 a-b, 76a); Hardie II 94, 97 (pls.82-3); H.A.E. Day *East Anglian Painters* 1969 III 55-70.

COTMAN, Miles Edmund 1810-1858

Eldest son of John Sell Cotman (1782-1842), whose work he closely imitated. He started to exhibit at Norwich at the age of 13. Came to London, 1835, and assisted his father as drawing-master at King's College School, succeeding him for a short time after his death. In 1852 he returned to Norfolk, teaching at North Walsham for some years before going to live with his brother in Norwich until his death in 1858. Exhib. from 1835-56 at the RA, BI and SS. He collaborated very closely with his father, to such an extent that John Sell often put his name to his son's work, so that many drawings of this period cannot with certainty be attributed to Miles or to his father. However his work has its own personal qualities — a decisive line, strong colour

and a certain tightness of finish. He worked in both oil and water-colour.

Recent auction prices range £100-250

Bibl: Redgrave, Dict; Roget; Binyon; Cundall; DNB; VAM; C.F. Bell, *Miles Edmund Cotman*, Walker's Quarterly, 1927; S.D. Kitson, *Life of J. Sell Cotman*, 1937; Clifford, passim (pls. 69a, 69b, 70a); Hardie II 93, 96-7 (pls.80-81) III 204 n; H.A.E. Day *East Anglian Painters* 1969 III 39-54

COULDERY, Horatio Henry b.1832 fl.1861-1893

Animal painter. Exhib. at RA from 1861-1892, BI and SS. Ruskin, *Academy Notes* 1875, comments upon 'A Fascinating Tail' — "Quite the most skilful piece of minute and Dureresque painting in the exhibition — (it cannot be rightly seen without a lens); — and in its sympathy with kitten nature, down to the most appalling depths thereof, and its tact and sensitiveness to the finest gradations of kittenly meditation and motion, — unsurpassable." Other titles at RA 'The First Mouse' 'The End of a Tail' etc.

Probable price range £50-200

Bibl: Ruskin, *Academy Notes* 1875

COUTTS, Hubert Herbert fl.1874-1893

Landscape painter working in Ambleside. Exhib. 'Early Summer, near Grasmere, Westmorland' at RA, 1876; and continued to exhib. at RA until 1903, also SS and NWS. Subjects mainly landscapes around the Lake District, also Wales and Scotland.

Probable price range £30-70.

COWEN, William 1797-1860/1

London landscape painter who exhib. views in Ireland at BI in 1823 and sent landscape views in Switzerland, Italy and France to the RA from 1823-39. In 1824 he published a series of six Italian and Swiss views and in 1848 *Six Weeks in Corsica* with etchings by himself.

Probable price range £30-70

Bibl: DNB; Cundall 200; Bryan.

COWPER, Frank Cadogan ARA b.1877 fl.1899-1910

Painter of portraits, historical and fantasy scenes; also decorator and watercolourist. Studied at St. John's Wood School; also with Edwin Abbey (q.v.) and J. S. Sargent. Exhib. at RA from 1899 and at RWS. Although his career falls mostly outside the Victorian period, Cowper was strongly influenced by Burne-Jones and Pre-Raphaelitism, and carried its ideas and style well into the twentieth century. His 'St. Agnes in Prison' was the last work bought by the Chantrey Bequest. In 1910 he was commissioned by the Earl of Carlisle (q.v.) to paint six walls in the Houses of Parliament.

Probable price range £100-500

Bibl: AJ 1904 144; 1905 31 f, 348; Studio 27 (1903) 58-9; 41 (1907) 61; 44 (1908) 75; Who's Who 1912, Record of Art 1912; Times 24.1.1912; Illust. London News 25.5.1912.

COX, David RWS 1783-1859

Painter of English and Welsh scenery — landscapes, coastal scenes and rustic genre — chiefly in water-colour, but in oils as well; highly prolific. Born in Deritend, Birmingham; son of a whitesmith and worker in small iron wares. Sent at an early age to the evening drawing school of Joseph Barber; later apprenticed to a miniature painter named Fieldler, who committed suicide. He then worked at scene-painting at the Theatre Royal, Birmingham. Went to London in 1804 and absorbed himself in the task of learning to be a painter; received a few lessons in water-colour from John Varley (q.v.). In 1808 he married Mary Ragg and settled in Dulwich where he supplemented his earnings with teaching. Exhib. in 1809 at the Associated Artists in Water-colours, of which he became President, 1810, and remained member until its collapse, 1812. Elected A of the OWS, 1812, and Member 1812, and exhib. 849 works there, from 1813-59; 13 works at the RA, 1805-44; exhib. also at the BI, SS, and elsewhere. Appointed drawing master at the Military Academy at Farnham in 1813, but quickly resigned and went to Hereford, 1815, as drawing master at Miss Croucher's School. In 1814 he published his *Treatise on Landscape Painting and Effect in Watercolours,* which made his ideas on painting known to a much wider circle. He also published *Progressive Lessons in Landscape for Young Beginners* 1816 and *The Young Artist's Companion* 1819-21. He lived in Hereford until 1827 when he returned to London. In 1836 Cox made a technical discovery that was to give his work a distinctive character — he started to use a rough textured wrapping paper, made in Dundee, which well suited his rapid strokes and his representation of windswept landscapes with rough atmospheric effects. However, he only ordered a ream and when it was finished was never able to obtain the same quality of paper again. A similar paper today is always known as "David Cox" paper. From 1812 onwards Cox had occasionally painted in oils, but it was not until 1840 that he began to think of the medium seriously, and then he took lessons from William Müller (q.v.). In 1841 he moved to Harborne where he died in 1859. Member of the Birmingham Society of Artists from 1842, he made many sketching tours in England and Wales, visiting the latter for the first time in 1805. He visited France, Holland and Belgium in 1826, and France again in 1829 and 1832. Cox's early style was hard and dry, based on the work of the topographical painters (e.g. 'Old Westminster' 1805). From about 1820-40 he showed a broader outlook and used broken colour for rendering transient effects (e.g. 'Lancaster Sands', Mellon Collection). After this he produced works which are the most popular today — "large generalized aspects of nature, very vigorous in their touch" (Hardie, II), e.g. 'Rhyl Sands'. His works were immensely popular in the nineteenth century and many of his pupils' paintings were sold as authentic works, often with a fake signature. His studio sale was held at Christie's on May 3-5, 1873.

Cox's work frequently appears on the market, and the range of prices is very wide — from £50 to £500 is not too great an exaggeration.

Bibl: AJ 1860 41 ff; 1859 211; 1898 65 ff; 1909; J. Ruskin *Modern Painters* 1843; Redgrave Cent; N. Neal Solly *A Memoir of the Life of David Cox* 1873; F. Wedmore *David Cox* Gent Mag March 1878; W. Hall *Biography of David Cox* 1881; G. R. Redgrave *David Cox and Peter de Wint* 1891; Roget; A. L. Baldry Studio Summer Number 1903; Studio 34 (1905) 38 ff; Whitworth Wallis 'David Cox Forgeries' Connoisseur May and July 1905; Binyon; Cundall; DNB; A. J. Finberg *The Drawings of David Cox* 1909; Hughes; F. Gordon Roe *David Cox* 1924 (contains list of paintings by Cox which may be seen in galleries open to the public); A. P. Oppé *The Water-colours of Turner, Cox and de Wint* 1925; VAM; B. S. Long 'David Cox' OWS X 1933 (with list of his exhibited works at OWS); F. Gordon Roe *Cox the Master* 1946 (contains an appendix of list of works by David Cox exhibited in London during his lifetime); Sir Trenchard Cox *David Cox* 1947, also by him a Birmingham Museum and Art Gallery publication on Cox published after 1952; C. A. E. Bunt *David Cox* 1949; Windsor; Williams; Sir Trenchard Cox *David Cox* 1954; Hardie II 109-209 and passim, plates 183-190, III passim; Maas 44-6 plates p. 45 53.

COX, David, Junr. ARWS 1809-1885

Only child of David Cox, (Senior) (q.v.). Studied art under his father, whose style he imitated in his water-colours. Exhib. 1827-84, 3 works at the RA, 579 at the OWS, 87 at NWS, and 1 at SS. Elected A of the NWS, 1841; member 1845; resigned 1846; A of the OWS, 1848. Maas notes that, although he imitated his father, "some of his fairly large landscapes display a certain character and distinction of their own". His studio sale was held at Christie's on April 14-15, 1886.

Price range £50-200

Bibl: DNB; AJ 1886 29 (obit); Maas 46.

CRANBROOK COLONY, The

Group of artists who congregated during the summer at Cranbrook in

Kent. Leader was Thomas Webster, (q.v.) who lived in Cranbrook from 1856-86. Other followers included F.D. Hardy, A.E. Mulready, G.B. O'Neill, and J.C. Horsley, (all q.v.). Their aim was to paint simple, unaffected scenes of country life, especially children, following both the techniques and the traditions of Wilkie. This group had many imitators, who carried its ideas right through the nineteenth century, and even into the early twentieth century.

*CRANE, Walter RWS 1845-1915

Painter of portraits, figure subjects and landscapes; he also designed numerous illustrations for children's books and other publications, 1863-96 (e.g. *Song of Sixpence, The Fairy Ship* 1869, *Baby's Opera* 1877, *Floral Fantasy* 1899); also made many designs for textiles, wall papers etc., and executed interior decoration. Born in Liverpool; apprenticed to W.J. Linton, wood engraver in 1859. Influenced by Burne-Jones and the PRB's; associated with William Morris in the Socialist League. His first illustrations appeared in a series of sixpenny toy-books between 1864 and 1869. Exhib. from 1862 at the RA, OWS, NWS, GG, etc. Member of the RI 1882-86; elected A of the OWS, 1888, member 1899. Principal of the RCA 1898-99. Signs in monogram with the initials 'WC' and a crane.

'St. George and the Dragon' an important work, sold at Sotheby's 20.11.68 for £2,100.

Bibl: AJ 1901 79 f; 1902 270f; etc. (TB for full list); P.G. Konody *The Art of Walter Crane* 1902; VAM Press cuttings and MS notes relating to Walter Crane, 1903; W. Crane *An Artist's Reminiscences* 1907; Cundall; DNB; VAM (book illustrations and landscape studies, etc.); Anthony Crane *My Grandfather, Walter Crane,* The Yale University Library, Vol. XXXI, no.3 (1957); Reynolds VP 65, 69, 70, 71 (pl.54); Hardie III 142-143 (pls. 167-168); Maas 16, 146, 183 (pl. on p.142).

*CRANSTONE, Lefevre J. fl.1845-1867

Little-known genre painter. Lived in London and Birmingham. Exhib. at RA 1845-54, BI and SS. Titles at RA 'A Country Fair' 'Waiting at the Station' and 'Cheap Jack'. Cranstone appears to have specialised in Frith-type scenes of Victorian life. Although very little is known of his life or the amount of his output, 'Waiting at the Station' shows that he was a competent and charming artist.

'Waiting at the Station' sold Sotheby's 20.11.63 for £400.

CRAWFORD, Edmund Thornton RSA 1806-1885

Scottish landscape painter. Studied at Trustees' Academy, Edinburgh. 1831 paid the first of many visits to Holland, to study the painters of the 17th c. Exhib. mostly at the RSA; only once at the RA in 1836. Elected ARSA 1839, RSA 1848. Painted Scottish landscapes, coastal scenes, and harbours. The predominant influence on his style was Dutch — Van de Velde in seascape, and Hobbema in landscape. His work is similar in spirit and period to that of Patrick Nasmyth (q.v.)

'Figures in a Boat in an Estuary' sold at Christie's 17.1.69 for £683. Another landscape sold 3.4.69 for £252.

Bibl: W. Armstrong in Portfolio 1887 178 f; Caw 161-2; DNB; L. Baldry *Royal Scottish Academy* Studio 1907 7 f.

CRAWHALL, Joseph 1861-1913

Painter and watercolourist of landscapes and animals. Born Morpeth, Northumberland; studied in London; spent much of his early life in Scotland, where he was closely associated with the Glasgow School. He worked at Brig o' Turk with James Guthrie, E. A. Walton and George Henry. Most of Crawhall's work is in watercolour on silk or linen; his favourite subjects were horses, dogs, animals and birds. His rapid wash drawings are often compared with Oriental calligraphic art. Crawhall lived many years in Tangier, which he visited with Edwin Alexander (q.v.). Later he settled at Brandsby, Yorkshire. Crawhall's

output was small; he exhib. once at the RA 1883; most of his work was bought by a few Scottish collectors.

In the 1968-69 season, two works were sold by Morrison McChlery of Glasgow, one of a huntswoman for £260, the other of butterflies and bees for £850.

Bibl: AJ 1905 121; 1906 118 186; 1911 71-76; Studio Vol.3 166 ff; Vol.47, 180; Vol.56. 65; Caw; Cundall; VAM; A.S. Hatrick *A Painter's Pilgrimage* 1939; M. Hardie *J.C.* OWS XXIII 1945; Adrian Bury *J.C.* 1958; Hardie III 204-7, (plates 237-9); Maas 85-7 (plates on p.19, 84-5).

*CRESWICK, Thomas RA 1811-1869

Landscape painter, of a narrow range of scenery chiefly in Wales and the north of England, usually with streams or water. Studied under John Vincent Barber in Birmingham and in 1828 moved to London. Exhib. from 1828, 266 works at the RA, BI, SS, and elsewhere. ARA, 1842; RA, 1851. As his themes were limited in scope he frequently varied his pictures by introducing figures and cattle, painted by his friends, Ansdell, Bottomley, Cooper, Elmore, Frith, Goodall and others. Reynolds notes that he liked to maintain an overall brown tone and that his work stands out by "its integrity and power of construction". His work was a great success and a Memorial Exhibition was held after his death. He was also favourably criticized by Ruskin in *Modern Painters*, 'On the Truth of Vegetation'. At the London International Exhibition of 1873, 109 of his works were collected together, with a catalogue by T. O. Barlow, RA. He was also a book illustrator. His studio sale was held at Christie's on May 6, 1870.

Prices in the 1968-69 season ranged from £120-200

Bibl: AJ 1856 141f (mono. with plates); 1870 53 (obit); 1906 333; 1908 104; Ruskin *Academy Notes* 1855-57; Redgrave, Cent and Dict.; DNB; VAM; Reynolds VP 152 (pl.159); Maas 49 (pl. on p.49).

CROCKFORD, George fl.1835-1865

London landscape painter, honorary exhibitor at the RA from 1835-1865 — landscape views in Switzerland and Scotland. Also exhib. at BI and SS.

Probable price range £30-70

Bibl: VAM

CROFT, Arthur fl.1865-1893

Landscape painter. Exhib. at RA 1868-93, SS and NWS. Views in Wales, the Alps, Algeria, and New England, USA.

Probable price range £30-70.

Bibl: VAM

CROFTS, Ernest RA 1847-1911

Painter of battle-pieces and disciple of Meissonier. He chiefly painted the English Civil War, the Napoleonic War and the Franco-Prussian War. Among his more famous works are 'The Evening of the Battle of Waterloo' (Walker Art Gallery, Liverpool), 'The Morning of Waterloo', 'Napoleon's Last Attack', and 'Charles II at Whiteladies after the Battle of Worcester'. He achieved more success as an illustrator. His studio sale was held at Christie's on December 18, 1911.

Prices in the 1968-69 season ranged from £110 to £945

Bibl: Clement and Hutton; AJ 1882, 22; 1893, 286; 1898, 180; 1902, 143; Magazine of Art XIX 1896, 134; XXII 1898, 627; DNB.

CROME, Vivian fl.1858-1883

Painter from Norwich, son of William Henry Crome. A painting of 'The White Dog', 1883, was exhibited at the Maas Gallery, May, 1969. He exhib. at the RA in 1867 'Zoe', and at the BI in the same year,

'The White Rose' and 'The Sage'. His address is given as 35 Cheyne Walk. Graves, Dict, gives his speciality as "flowers".

Probable price range £50-150.

***CROWE, Eyre ARA 1824-1910**
Painter of historical subjects, domestic genre, and portraits. Elder brother of J.A. Crowe, who wrote with G.B. Cavalcaselle the *History of Painting in North Italy,* etc. He was a pupil of Paul Delaroche, with whom he went to Rome in 1843, and a life-long friend of Gérôme. He became secretary to Thackeray, who was his cousin, and went with him on a lecture tour to America in 1852. This provided him with the subject of his painting of 'The Sale of Slaves at Richmond, Virginia' (exhib. 1861), which was basically a study of negroes and a foretaste of the Civil War. (The AJ commented: "However skilfully painted such pictures may be, the subjects do not commend themselves either to the eye or the mind. Neither the colour nor the features of the negro race can be associated with European notions of aesthetic beauty.") As befits a pupil of Delaroche the majority of his paintings tend to be themes from history, but occasionally, and only too rarely in his work, are scenes of contemporary social comment — like the Richmond Slaves and a scene from industrial life 'The Dinner Hour, Wigan' 1874, and simple genre scenes like 'The Bench by the Sea' (Reynolds VP fig. 72). He exhibited at the RA from 1846, and became ARA in 1875.

Prices in the 1968-69 season ranged from £147 to £880.

Bibl: AJ 1864 205-7; 1868 28; 1904 166; RA Pictures, 1891-1896; 1905-1907; DNB; Reynolds VS 92 (pl.80); Reynolds VP 112 (pl.72); Maas 238.

CROWLEY, Nicholas Joseph RHA 1813-1857
Irish painter of portraits and domestic genre who exhib. at the RA from 1835-58. He worked in Dublin and Belfast, coming to London in 1838. Titles at RA 'What's her History?' 'Expectation' 'The First Step' etc.

Probable price range £30-100

Bibl: DNB; Redgrave, Dict.

CRUIKSHANK, William fl.1866-1879
South London painter of genre, still life, fruit, game and birds. Imitator of W. Henry Hunt (q.v.). Exhib. from 1866-79 at the RA and SS.

Price range £30-100

Bibl: Maas 173 (pl.172 — 'Still life with Bird, Bird's Nest and Blossom').

CURNOCK, James Jackson RCA 1839-c.1889
Bristol landscape painter who exhib. at the RA from 1873-1889 — all landscapes and chiefly Welsh views. Ruskin in *Academy Notes* 1875, highly praised 'The Llugwy at Capel Curig'; "I find this to be the most attentive and refined landscape of all here; too subdued in its tone for my own pleasure, but skilful and affectionate in high degree; and one of the few exceptions to my general statement above made; for here is a calm stream patiently studied. The distant woods and hills are all very tender and beautiful." Also exhib. at SS and NWS.

Probable price range £100-300

Bibl: Ruskin *Academy Notes* 1875; Clement and Hutton.

DADD, Frank RI ROI 1851-1929
Painter and illustrator of romantic historical genre in oils and watercolour. Studied at the RCA and RA schools. Worked for the *London Illustrated News,* 1878-84, and later for *The Graphic.* Exhib. at RA occasionally between 1878 and 1912, titles including 'Life or Death' 'Teaching the Young Idea how to Shoot'. Member of RI, 1884 and ROI 1888; also exhib. at the RBA.

'The Bill' sold Christie's 15.3.68 for £231.

Bibl: Tate Cat.

***DADD, Richard 1819-1887**
Following his youthful ambition to paint "works of the imagination", Dadd studied at the RA schools, and became a member of the clique with Egg, Phillip, H.N. O'Neil, and Frith, 1842-3 travelled with Sir Thomas Phillips in Italy, Greece, the Middle East, Italy and France. On his return he began to show symptoms of madness which got steadily worse. In 1843 he murdered his father at Cobham, fled abroad, but was soon caught and confined to Bedlam, insane. Spent the rest of his life there and in Broadmoor, where he died. His style underwent a complete metamorphosis from the promising academy work of his youth to the allegorical, surrealistic style for which he is now best known. His intense, crowded, obsessive pictures have the look of embroidery, and are almost unique in Victorian art. To us he is a fascinating psychological phenomenon; to the Victorians he was merely mad. Before 1843 he exhib. only a few works, 4 at the RA from 1839-1842, 16 at Suffolk Street.

The last two important works to be sold were 'The Gardener' and 'Contradiction — Oberon and Titania' at Sotheby's March 1964 for £2,400 and £7,000. Range for smaller works and drawings £200 to £500.

Bibl: AU 1843 p.267-71, 295; 1845 p.137; AJ 1864 p.130; Bryan; Binyon; VAM; Cundall; Reynolds, VS p.10-11, 56 (pl.16); John Ricketts, *Richard Dadd, Bethlem and Broadmoor,* Sotheby's Year Book 1963-4 (with plates); Reynolds, VP 29, 31-2, 141 (pl.18); Hardie III 129 (pls. 153-4); Maas 150-152 (2 pls.).

DADE, Ernest fl.1887-1901
Scarborough marine painter. Exhib. 1887-1901 at RA, and at SS. Titles at RA mostly coastal scenes in Yorkshire, or imaginary, e.g. 'Ashore' 'Solitude' 'A Wreck' etc.

Probable price range £30-70.

DAFFARN, William George fl.1872-1904
London painter of genre and landscape who exhib. at the RA from 1872 onwards; also at SS and GG. Titles at RA 'The Village Maiden' 'The Duck Pond' 'Early one morning' etc.

Probable price range £30-70.

DALBY, David fl.1780-1849
Sporting painter, lived at York and Leeds. Did not exhibit in London, but worked for private patrons, painting racehorses, equestrian portraits, and hunting scenes. Often called Dalby of York because he signed 'Dalby York'. Sometimes copied John Ferneley, Senr., by

whom he might have been influenced. Many of his pictures are to be found in private houses in Yorkshire.

Prices during the 1968-69 season ranged from £116 to £368. 'Edinburgh to London Mail Coach' sold at Sotheby's 19.11.69 for £850.

Bibl: Pavière, Sporting Painters, 30 (plate 14)

DALBY, John fl.1826-1853
York sporting painter; possibly the son of David Dalby (q.v.). Mostly known for hunting scenes, which like those of David D., are of very good quality.

'General Chasse, a Bay Racehorse with Owner' sold Sotheby's 20.11.68 for £1,300. Average price range is still £200-400.

***DANBY, Francis ARA 1793-1861**
Bristol landscape painter, born in Ireland. Studied in Dublin Royal Society Schools, and with the landscape painter James O'Connor. Lived in Bristol 1813-1823, then moved to London. Exhibited at the RA 1821-1860, mostly poetical and imaginary landscapes, especially with effects of sunset or early morning. Also exhibited some religious and historical subjects. In his later years moved to Exmouth, where he concentrated chiefly on mythological subjects e.g. 'The Departure of Ulysses from Ithaca'. Some of his large and dramatic pictures, such as 'The Delivery of Israel out of Egypt' (1825) were painted in emulation of the work of John Martin. Danby was never made a full R.A., which was a great disappointment to him, and led to public criticism of the academy election procedures.

Major works have not appeared recently. In 1964 at Christie's 'Winter Sunset, a Slide' made £1,785; in June 1965 'The Wood Nymph's Hymn to the rising Sun' made £945, also at Christie's. Prices for minor works have ranged from £130-840.

Bibl: AJ 1855, p.77-80; 1861, p.118; Redgrave Dict.; DNB; Reynolds VP p.15, 142 ('Liensford Lake' pl.9); Arts Council, Danby Exhibition Cat. 1961 (many illustrations); Hardie II, 47; Maas, p.36-7 (pls. p.36 and 38).

DANBY, James Francis 1816-1875
Eldest son and pupil of Francis Danby (q.v.), brother of Thomas Danby (q.v.). Exhibited at the RA 1842-1876, also at the BI and SS. Painted landscapes in oils and watercolours, chiefly views in Wales, Scotland and on the north-east coast, often scenes of sunrise or sunset "resembling his father's in execution, but not emulating his ideality' (DNB). Travelled in France, Switzerland and North Italy.

'River Scene' sold at Bonham's 5.12.68 for £170.

Bibl: AJ 1859 pp.142, 171; 1876, p.47; DNB.

DANBY, Thomas RWS 1817(18?)-1886
Younger son and pupil of Francis Danby (q.v.), and brother of James Francis Danby (q.v.) Travelled with his brother in France, Switzerland and Italy. In Paris he was much impressed by the landscapes of Claude Lorraine, whose aerial effects he tried to imitate. Exhibited at the RA 1843-1882, and also exhibited over 200 watercolours at the RWS. Like his brother's pictures, they were mostly views in Wales, Scotland and Switzerland. Also painted occasional rustic genre subjects e.g. The Shepherd's Home (1861). Close friend of Paul Falconer Poole (q.v.) with whom he shared a romantic feeling for nature. In his latter years he devoted himself chiefly to watercolour painting. His studio sale was held at Christie's June 17, 1886.

'A wooded landscape' sold Sotheby's 15.3.67 for £140.

Bibl: AJ 1886 p.157; DNB; Hardie II 47.

***DANIELS, William 1813-1880**
Liverpool portrait, historical and genre painter. Working as an appren-

tice bricklayer, he developed a talent for modelling portraits in clay. These were seen by Mosses, a local portrait painter, who encouraged him to take up painting. He soon became popular in Liverpool as a portrait painter, and exhibited at the RA in 1840 and 1846. He also painted genre and historical works, many of Shakespearian subjects, e.g. 'The Prisoner of Chillon' 'Shylock' 'Macbeth' 'The Recluse' etc. Daniels' style is vivid and bold, and he was fond of strong chiaroscuro effects of light and shade. Unfortunately, says Marillier ":a taste for low life and convivial associations spoilt his chances and destroyed his excellent promise". Several pictures by him are in the Walker Art Gallery, Liverpool.

'The Goldfish Bowl' sold at Christie's 14.3.69 for £378.

Bibl: Redgrave, Dict.; Marillier, pp.95-98 (plate opp. p.96).

DAVIDSON, Charles Topham b.1848 fl.1870-1902
Landscape painter, son of the watercolourist Charles Davidson. Exhibited at RA 1872-1902 mostly coastal views in Cornwall and Wales. Also exhib. at SS, NWS, GG and elsewhere.

Probable price range £30-100.

DAVIDSON, Thomas fl.1863-1893
London historical genre painter. Exhibited at RA 1863-1903, and at SS. Subjects mostly medieval, but from 1894-1899 he produced a series of pictures of scenes from the life of Admiral Nelson.

Probable price range £30-70.

DAVIES, Edward 1843-1912
Leicester landscape painter and watercolourist. Exhibited at the RA 1880-1904. Chiefly views in Scotland, Wales and the Isle of Man.

Probable price range £30-70.

DAVIS, Edward T. 1833-1867
An almost forgotten painter of genre scenes who worked in Worcester and came into prominence when an album of his drawings was sold at Christie's in 1951. He entered the Birmingham School of Design under J. Kyd; exhibited at the RA from 1854-67. Among his best works are 'On the Way to School', 'Granny's Spectacles', 'Words of Peace', and 'The Little Peg Top'. His 'A Game of Marbles' was in the 1962 Arts Council exhibition of Victorian Paintings.

'Granny's Spectacles' sold at Christie's 6.3.70 for £252.

Bibl: DNB; Cat. of 1962 Arts Council Exhibition of Victorian Paintings.

***DAVIS, Henry William Banks RA 1833-1914**
London landscape and animal painter, and occasional sculptor. Exhib. over 100 works at RA 1852-1904, also at BI, SS and NG. His subjects were mostly landscapes with animals in Wales, Scotland and Northern France. In the 1850's and early 60's he was much influenced by the Pre-Raphaelites, and his works of this period show a high level of observation and detailed technique. Later he broadened his style and turned to larger size works of the Landseer and Rosa Bonheur type. His pictures were immensely popular, and made high prices at auction in his lifetime. Two works were bought by the Chantrey Bequest in 1880 and 1899. Elected ARA 1873, RA 1877.

'Towards Evening in the Forest' sold at Christie's 6.3.70 for £840. This was a Pre-Raphaelite style picture of 1853. The average price for his later works is still £100-300.

Bibl: AJ 1901 p.174; Clement and Hutton; Who's Who 1913; RA Pictures see Index 1893-1914.

***DAVIS, John Scarlett 1804-1845(6?)**

Painter of landscapes, portraits and architectural studies in oils and watercolours. Born the son of a Hereford shoemaker, Davis studied at the RA Schools, and travelled widely on the continent, where he found most of the subject matter for his works. Because he only exhibited very few works, mainly at the RA between 1822 and 1841, Davis is still a neglected and underrated artist today. The brilliance of his watercolours is comparable to the work of Bonington. Specialised in the interiors of buildings, libraries and picture galleries "reproducing the Old Master paintings on their walls with extraordinary fidelity" (Maas).

'The Main Gallery of the Louvre, Paris' sold Sotheby's 18.2.70 for £1,800.

Bibl: DNB 1908 V (under Davies); Connoisseur, 1912, p.215; Hardie II 187-8; Maas, 94 ('The Art Gallery of the Farnese Palace, Parma' p.94).

DAVIS, J. Valentine RBA b.1854 fl.1875-1893

Landscape painter. Born in Liverpool, son and pupil of William Davis. Studied with Ford Madox Brown and settled in London. Exhibited mostly poetical landscapes at the RA from 1875 to 1912, and occasional genre interiors e.g. Five O'clock in the Studio, 1908.

Probable price range £50-200

Bibl: Studio 1904, 32, 284; Who's Who 1913 p.512; RA Pictures 1905.

DAVIS, Lucien RI b.1860 fl.1878-1893

Son of William Davis of Liverpool. Younger brother of J. Valentine Davis (both q.v.). Exhibited at RA 1885-1913. Mostly historical genre, some flower pieces. Worked as illustrator for *The Graphic, The Illustrated London News,* and illustrated books. Titles at the RA 'Musical Chairs' 'The Ghost Story' 'Ping-Pong' etc.

Probable price range £50-200

Bibl: Who's Who 1913 p.511; The Year's Art 1913 p.491.

DAVIS, Richard Barrett RBA 1782-1854

London sporting artist. A competent and prolific painter, Davis exhibited 141 works at Suffolk Street, as well as a good number at the RA from 1802-1853 and BI. His father was Huntsman to the Royal Harriers, and King George III patronised Davis, as did George IV, William IV, and Victoria. Studied with Sir Francis Bourgeois and Sir William Beechey. Nearly all Davis's pictures are hunting scenes, in a style similar to Cooper and Herring. At his best he can nearly equal the brilliance of Marshall, but he produced a lot of mediocre work.

'Two Bay Racehorses near a Barn' sold Christie's 27.2.69 for £525. 'A Hunting Scene' sold Parke-Bernet 24.9.69 for £462.

Bibl: DNB 1908 V; Pavière, Sporting Painters, 31 (pl.14).

***DAVIS, William 1812-1873**

Liverpool landscape painter. Born Dublin. Studied at Dublin Academy; at first painted portraits. Moved to Liverpool, and joined the Liverpool Academy in 1854. Exhibited at the RA 1851-1872, mostly landscapes and still life. Landscape studies usually taken along the Cheshire coasts and in the woods around Wallasey. Helped to organise Pre-Raphaelite exhibitions in Liverpool; friendly with Hunt, Rossetti and Madox Brown. Member of Old Hogarth Club. Madox Brown thought Davis an unlucky and underrated artist. Ruskin wrote Davis a letter of advice, which he never received. Little appreciated in his lifetime, he was kept occupied by a handful of Liverpool patrons, such as Miller and Rae. Several fine Pre-Raphaelite landscapes by him are in the Walker A.G. Liverpool.

Owing to the great rarity of his work, prices are impossible to estimate exactly. A good Pre-Raphaelite work could perhaps make £500-1,000, a smaller work or sketch £200-500.

Bibl: AJ 1873 p.177; 1884, 325; 1903, 225, 228; Marillier 99-113, 259; Cat. of Leathart Collection, Laing A.G. Newcastle 1968; Maas 227-8.

DAWSON, Alfred fl.1860-1893

Landscape painter and etcher, son of Henry Dawson, younger brother of Henry Thomas Dawson. Exhibited at RA 1860-1889, mostly pen drawings and etchings. Titles 'A Page from Gray's Elegy' 'Leaving the Plough'. Also exhibited at SS and BI.

Probable price range £50-200

Bibl: Portfolio 1884 p.1, 28.

DAWSON, Mrs. B. (Miss Elizabeth Rumley) fl.1851-1876

Painter of fruit and flowers, who exhibited as Miss Elizabeth Rumley from 1851-58, and as Mrs. B. Dawson from 1859-76, at the RA, BI, SS and elsewhere.

Probable price range £30-100

***DAWSON, Henry 1811-1878**

Marine and landscape painter. Born in Hull. Lived in Nottingham until 1844, when he moved to Liverpool. Studied with J.B. Pyne (q.v.), but mainly self-taught. Exhib. at the Liverpool Academy; elected Associate 1846, member 1847. In 1850 he moved to London. Exhib. at the RA 1838-74, also at BI, SS, the Portland Gallery. His work, mostly marine and coastal scenes, was not popular with the RA Hanging Committee, who placed them badly. He also painted landscapes, and some very large views of London e.g. 'The Pool from London Bridge' which made £1,400 at Christie's in 1876. His two sons Alfred and Henry Thomas Dawson were also marine painters (q.v.)

'London from Greenwich' sold at Christie's 6.3.70 for £2,100. This was a particularly large and fine work. The range of prices in the 1968-9 season was £175-733.

Bibl: AJ 1879 p.48; Portfolio 1879 p.24; Marillier 114-18, 259 (pl. p.116); DNB; A. Dawson The Life of Henry Dawson Landscape Painter 1891; Hardie III 159.

DAWSON, Henry Thomas fl.1860-1878

Marine painter, son of Henry Dawson, and elder brother of Alfred Dawson (q.v.). Exhibited at the RA 1866-73 and the BI 1860-67.

Probable price range £100-300

Bibl: Portfolio 1885 p.91; Cat. of Walker Art Gallery, Liverpool, 1884 p.72.

DAWSON, Nelson RBA 1859-1941

Marine painter. Exhibited at RA 1885-93. Subjects mostly of Cornish Coast. His wife, Edith B. Dawson, was also a painter. After 1895 they abandoned painting for metal and enamel work, which they studied under Alexander Fisher. From then on they exhibited caskets, bronze figures, medallions and enamel work together at the RA. In addition to this, they both continued to exhibit pictures and watercolours.

Probable price range £50-200

Bibl: M.H. Spielmann: British Sculptors, 1901, p.170-171; Studio 22, 169-74; 28, 124; 40, 182-90; Hardie III 83-4.

DEACON, Augustus Oakley fl.1840-1862

London landscapist, and painter of churches. Exhibited at the RA 1841-55, and at SS and BI. Teacher in a school in Derby 1849-61. Titles at RA 'Western Doorway – Tintern Abbey', 'Windsor Castle',

'Stapenhill Ferry, Burton-on-Trent' etc. Works by him are in Derby AG.

Probable price range £30-100

DEAKIN, Peter fl.1861-1884

Landscape painter, worked in Harborne, near Birmingham. Moved to Birmingham and later to London. Exhibited at RA 1855-1878. Chiefly views in Wales, Worcestershire, and Salop.

Probable price range £30-70

DEALY, Miss Jane M. (later Lady Lewis) fl.1879-1903

Genre painter, lived in Blackheath. Married Sir Walter Lewis 1887. Exhibited at the RA 1881-1903 genre scenes, mostly studies of children. Titles 'Mary, Mary, Quite Contrary', 'Watching the Fairies' 'A Wee Bit Doleful' etc. Also illustrated several children's books.

Probable price range £30-70

Bibl: Shaw Sparrow: Women Painters of the World 1905. p.144
Who's Who 1913 p.1200

DEAN, Frank b.1865 fl.1885-c.1907

Landscape painter, born Headingley, near Leeds. Studied with Legros at the Slade, and in Paris. Returned to Leeds 1887, and exhibited at the RA from then until about 1907. Also travelled in Egypt and the Sudan, which provided him with many subjects. Titles at the RA 'On the Sand Dunes' 'A Son of the Soudan' 'Tilling on the Nile Banks' etc.

Probable price range £20-50

Bibl: Studio 39 (1907) p.164; 49 (1910) 47-51; Year's Art 1913 p.491.

DEANE, Charles fl.1815-1851

London landscape painter. Exhibited at the RA 1815-1851 and at the BI. Chiefly views on the Thames, and around Bristol. Also travelled in Holland, on the Rhine, and the Moselle, painting views.

'Twickenham Ferry' sold at Christie's 6.3.70 for £420

DEANE, Dennis Wood fl.1841-1868

Historical genre painter, elder brother of William Wood Deane (q.v.) Exhibited at the RA 1841-1868, also at the BI and SS. Subjects mostly Shakespearian. Also travelled in Spain and Italy, which provided inspiration for some of his genre scenes. Titles at RA 'Don Quixote' 'The Despair of Claudio' 'Van Dyck and Frans Hals' etc.

Probable price range £20-50

Bibl: AJ 1859 p.81, 165, 166; 1860 p.78

DEANE, William Wood ARWS 1825-1873

London architect, painter and watercolourist. Younger brother of Dennis Wood Deane (q.v.) Exhibited at the RA 1844-1872, at the SS, OWS and NWS. Subjects architectural studies, interiors and landscapes. Travelled in Belgium, France and Italy. Much of his best work done in Spain, travelling with F.W. Topham. Studied watercolours with David Cox. Associate member of OWS.

Probable price range £30-70

Bibl: AJ 1873 p.80 (obit); Roget II 383-6; Hardie III, 21.

DEARLE, John H. b.1860 fl.1853-1891

Glassmaker, tapestry worker and designer of carpets, textiles etc. for Morris and Co. Pupil of William Morris. Became partner in the firm and manager of the works at Merton Abbey. Designed stained glass windows at Glasgow University, Troon Church and Rugby School Chapel. Was responsible for designing many of the wallpapers for Morris and Co. although many have since been attributed to Morris himself.

Bibl: AJ 1905 p.84-9, 380; 1906, 54, 56; Studio 28 (1903) 40, 119; 45 (1909) 13.24; See also books on William Morris.

DEARMAN, John fl.1824-1856

Landscape painter, lived in London and Guildford. Exhibited at the RA 1824-1856; also a regular exhibitor at SS and the BI. Subjects invariably landscapes with cattle, sheep, horses and figures.

Auction prices from 1966 to 1969 have ranged from £180 to £650 for a pair. The highest recorded price for a single work is £400, paid at Sotheby's 8.2.67.

DEARMER, Thomas fl.1840-1867

London landscape painter. Exhibited at the RA 1842-66, SS 1840-67, and the BI. Views mostly in the south of England, and Wales. Travelled in Wales and Italy.

Probable price range £20-50

DE BREANSKI, Alfred fl.1869-1893

Landscape painter, exhibited at RA 1872-1890, and at SS. Specialised in Welsh mountain landscapes, and Highland scenery, but also painted views on the Thames. Gustave de Breanski (q.v.) who painted similarly, was probably his son. Another Breanski, who signed A.F. de Breanski, is also recorded, but little is known about him, and he may have been synonymous with Alfred.

Prices during the 1968-9 season ranged from £120-360

DE BREANSKI, Gustave fl.1877-1892

Landscape painter, exhib. mainly at SS, and at RA. Like Alfred de Breanski, presumed to be his father, he painted Highland views, coastal scenes, and Thames views, but his work is of coarser quality.

A pair of Coastal Scenes sold at Phillips Son and Neale 20.10.69 for £105. Another pair at Knight Frank and Rutley 30.10.69 made £120.

DE FLEURY, J.V. fl.1847-1868

London landscape painter. Exhibited at RA 1847-1868, at BI and SS. Travelled in Brittany, Switzerland, Venice and North Italy painting views.

'A Venetian Canal Scene' sold at Phillips Son and Neale 28.7.69 for £135.

Bibl: AJ 1860 p.78

DELAMOTTE, William Alfred 1775-1863

Landscape painter, watercolourist and lithographer. Born in Weymouth of a French refugee family, he studied at the RA under Benjamin West. Drawing master at Sandhurst Military Academy. Exhibited at RA 1793-1851; also at BI and OWS. Views in Wales, Oxford, on the Thames, Belgium, France, on the Rhine, Switzerland, and north Italy. He also illustrated topographical books, especially about Oxford. His son Philip Henry Delamotte was also an artist and early photographer.

Probable price range £50-200

Bibl: Roget I 211, 231-2

DELL, John H. 1830-1888

London landscape and rustic genre painter. Exhibited at the RA 1853-1875, the BI 1851-1867, and at SS. Titles at RA 'A Rustic Nursery' 'A Farmyard Corner' and 'Cottage Cares'.

Probable price range £50-200

Bibl: Years Art 1889 p.256

DE MORGAN, Mrs. Evelyn (nee Pickering) 1855-1919

Pre-Raphaelite painter. Pupil of her uncle, R.Spencer Stanhope (q.v.) and wife of the potter William de Morgan (q.v.) who she married in 1887. Studied at Slade 1873; visited Italy 1875-77. Exhib. mostly at GG and NG. A large number of her works can be seen at Old Battersea House, London. Her pictures are mostly large and somewhat lifeless imitations of Burne-Jones, but her drawings show great sensitivity.

Probable price range for oil paintings £200-500, drawings £50-150.

Bibl: The Studio Vol.19 (1900) p.220-32; 26, p.292; 79 (1920) 28-31; Connoisseur 63 (1922) 133f; Bate 115 (pl. opp. p.111); Mrs. A.M.W. Stirling, *William de Morgan and his Wife*, 1922; Catalogue of E. de M. Drawings, Hartnoll and Eyre Gallery, London 1970.

DE MORGAN, William 1839-1917

Painter and designer of stained glass, pottery, tiles and ceramics. Began career designing stained glass; later began to make pottery in his own kiln at his house in Cheyne Row, Chelsea. Although not a partner of Morris and Co., de Morgan's works supplied them with tiles and designs. In 1881 he moved his works to Merton with Morris and Co. De Morgan painted a few Pre-Raphaelite pictures, but did not regard this as a serious side of his output. His wife Evelyn (q.v.) who he married in 1887, was better known as a painter. As a result of ill-health, and de Morgan's lack of business sense, the factory was closed in 1905, after which de M. embarked on a very successful career as a novelist.

Bibl: Portfolio 1876 p.114 ff; Studio 70 (1917) 88; Burlington Mag. 31 (1917) 77.83; 91-97; Connoisseur 63 (1922) 183 f; Mrs. A.M.W. Stirling, *W. de M. and his Wife*, 1922.

DERBY, Alfred Thomas 1821-1873

Painter of portraits and historical genre. Son of the water-colour painter William Derby (1786-1847). Exhibited at RA 1848-1872. BI and SS. Studied at RA Schools. For a few years he painted portraits, in oil, and pictures of scenes from Scott's novels, but his father's ill-health made it necessary for him to help him in the production of watercolour copies from Landseer and others. From that time he worked in watercolour, sometimes producing originals, but mostly copies.

Probable price range £20-50

Bibl: AJ 1873 p.208; DNB 1908 V.

DESANGES, Louis William b.1822 fl.1846-1887

Naturalised Frenchman, born in Bexley. Travelled in France and Italy. Settled in London in 1845. His first pictures were historical, but he turned to the more lucrative business of painting portraits of ladies and children. Exhibited at the RA 1846-1887, at BI and SS. In 1872 he began to paint contemporary military scenes, and travelled in India. In 1859 many of these were exhibited in an exhibition entitled 'Victoria Cross Gallery' which was later shown in the Crystal Palace.

Probable price range £50-150

Bibl: Acad. Notes 1877-8; AJ 1864 p.41-43.

DESVIGNES, Herbert Clayton fl.1833-1863

London landscape and animal painter. Exhibited at the RA 1833-61; also at BI and SS. Titles 'Landscape and Cattle' 'A Kentish Farm' etc. His daughter Emily Desvignes (later Bicknell) was also a painter of animals, especially sheep, who exhibited at the RA 1855-72.

Probable price range £50-150

***DEVERELL, Walter Howell 1827-1854**

Pre-Raphaelite painter. Born in Charlottesville, U.S.A. where his English father was a schoolmaster. Returned to London with his father in 1829, and studied at Sass's Drawing School, where he became friendly with D.G. Rossetti. From Jan. to May 1851 he and Rossetti shared the studio at 17 Red Lion Square later used by Burne-Jones and Morris. Appointed assistant master at Government School of Design. Although never a member of the PRB, he was friendly with its members, and influenced by their ideas. After the resignation of Collinson in 1850 he was nominated for membership, but it was never confirmed. His promising career was cut short by illness and poverty, and he died aged only 27 in 1854. He exhib. only 4 works at the RA 1847-53, one at BI (1853), 2 at SS, and 2 elsewhere. His best known work is 'The Pet' (Tate Gallery). The rarity of his work has inevitably prevented him from enjoying the reputation he deserves.

Owing to rarity, the price of his work is impossible to estimate exactly. All his best works are in museums. The only things likely to come on the market are small sketches and drawings, which might make anything from £100-500

Bibl: Bate 54; Ironside and Gere 27-8 (pls. 23-4); Fredeman, see index; Reynolds VS passim (pl.43); Reynolds VP 65, 68; Maas 133.

DICKINSON, Lowes Cato 1819-1908

Highly successful portrait painter to the Victorian establishment. Exhibited portraits at the RA 1848-91. Sitters included many famous politicians, soldiers, dons and aristocrats — Gladstone, General Gordon etc. His pictures tend to be large and sombre, and mostly in private collections. For these reasons they do not appear on the market frequently.

'Portrait of Lady East' sold at Christie's 5.6.70 for £105

Bibl: Cust NPG 1902 p.202

***DICKSEE, Sir Frank PRA 1853-1928**

Genre and portrait painter. Son and pupil of Thomas Francis D. (q.v.) Exhib. at the RA from 1876, achieving success with his picture 'Harmony' in 1877, which was bought by the Chantrey Bequest. His subjects were often romantic genre pictures e.g. 'The Magic Crystal' in a very personal style compounded of Watts, Burne-Jones and late Pre-Raphaelite influences. He also painted social dramas in the Orchardson manner e.g. 'Reverie' (1895), and many elegant society portraits. Elected ARA 1881, RA 1891. Although a strong opponent of modernity in art, he was elected PRA in 1924 at the age of 71; Knighted 1925; KCVO 1927.

'Portrait of Lady Hillingdon' sold at Christie's 22.3.68 for £178

Bibl: AJ 1897 p.326-7; 1901, 160; 1902, 213; 1904, 181; 1905, 331-2; 1906, 10; 1908, 318; 1909, 167; Art Annual 1905 Christmas Number 1-32; Studio 23 (1901) 185; RA Pictures 1891-1907 etc; Mag. of Art 1887 p.218; Tate Cat; Reynolds VP passim (pl.59); Hutchison passim; Maas 231 (pl. p.15)

DICKSEE, Herbert Thomas b.1862 fl.1881-1893

Painter of animals and historical genre. Son of Thomas Francis Dicksee. (q.v.). Exhibited at the RA 1885-1904. Subjects mostly of lions, and other animals, historical genre, and copies after Millais and Frank Dicksee. Titles 'The Dying Lion' 'After Chevy Chase' 'The Little Gipsy' etc.

Probable price range £50-150.

Bibl: Studio Summer No.1902; Who's Who 1911.

DICKSEE, John Robert 1817-1905

Painter of portraits and genre scenes. Brother of Thomas Francis Dicksee, uncle of Herbert Thomas D. (both q.v.). Exhibited at the RA 1850-1905, and at the BI and SS. Genre titles at RA 'Fluttering the Fan' 'A Dream of Chivalry' 'Sophia Western' etc.

Probable price range £50-150.

Bibl: Guildhall Cat. 1910

DICKSEE, Thomas Francis 1819-1895
Painter of portraits and historical genre. Pupil of H.P. Briggs, the portrait painter. Exhibited at the RA 1841-1895, BI and SS. Subjects mostly Shakespearian, some historical, some pure genre. Titles 'Ophelia' 'Crotchet Work' 'Lucretia' 'Antigone' etc. Father of Sir Frank, Herbert Thomas, Margaret, and James, all painters.

Probable price range £50-150.

Bibl: AJ 1872 p.5-7; 1896 p.31; The Year's Art 1895.

DILLON, Frank RI 1823-1909
Topographical painter in oil and watercolour. Pupil of James Holland. Like Lewis and Lear, he travelled abroad continually, visiting Spain, Italy, Egypt and the Far East. Exhibited at the RA 1850-1903, the BI and OWS. Subjects mostly views of temples, ruins, etc. the majority Egyptian. He also painted Moorish interiors in the manner of J.F. Lewis, but not as brilliantly. His studio sale was held at Christie's Jan. 21. 1911.

'A View of Stirling Castle' sold at Christie's 3.2.67 for £315

Bibl: AJ 1909 p.223; DNB 1901-1911

DITCHFIELD, Arthur 1842-1888
Painter, watercolourist and traveller. Exhibited at the RA 1866-1886, and at BI and SS. Painted views in France, Spain, Germany, Algeria, and Egypt.

Probable price range £50-150

Bibl: AJ 1908 p.261

DOBBIN, John fl.1842-1884
Landscape and topographical painter. Exhibited at the RA 1842-1875, and also exhibited over 100 works at SS. Travelled in Holland, France, Spain and Germany. Specialised in architectural studies of cathedrals, churches and buildings. Titles at RA also include some Scottish landscapes.

Probable price range £50-100

DOBSON, Henry John RSW b.1858 fl. 1881-1892
Scottish genre painter, worked in Edinburgh. Exhibited a few works at the RA and SS; mostly exhibited at the RSA. Subjects homely scenes of Scottish life – titles at RA 'The Gloamin'' 'The New Toy' 'Burns Grace' etc.

'A Critical Move' sold at Christie's 6.6.69 for £116

Bibl: Caw 468; Reynolds VS (pl.104).

DOBSON, William Charles Thomas RA RWS 1817-1898
Painter of religious and historical scenes, genre subjects, and portraits. Master of the Society of Arts and School of Design in Birmingham. Exhib. 107 works at the RA between 1842 and 1894. His genre subjects mainly of children. Titles at RA include 'Prosperous Days of Job' 'Nursery Tales' 'Christmas Carols' 'Bethlehem'.

'A Woman and Child with a White Horse' sold at Bonhams 3.7.69 for £120

Bibl: Clement and Hutton; AJ 1859 p.212; 1860 p.137; 1898 p.94; DNB.

DOCHARTY, James ARSA 1829-1878
Glasgow landscape painter. Served his apprenticeship as a pattern designer for calico printing. About 1862 he abandoned designing for landscape painting. His studio was in Glasgow and he exhib. at the Edinburgh Academy, the Glasgow Institution, and 13 works at the RA, 1865-77. Elected ARSA, 1877. In the spring of 1876, his health

failing, he went to Egypt, through Italy and France, and died shortly after his return in 1878. His paintings are all Scottish views, and his style is realistic, natural and truthful to nature. The AJ of 1874 notes: " 'The Fishing Village' and 'The Cuchullin Hills' leave nothing to desire; for James Docherty lays his hand, not metaphorically, like Byron, but materially, upon Nature's elements, and shows us many secrets of her witchery."

Probable price range £100-300

Bibl: AJ 1878 p.155; Clement and Hutton; DNB; Caw 193-4; Birmingham Cat.

DOCKREE, Mark Edwin fl.1856-1890
Landscape painter, exhib. mainly at SS, also at RA. Subjects views in Wales, Surrey and Kent.

Probable price range £20-50

DOLLMAN, John Charles RI b.1851 fl.1871-1893
Historical genre painter. Exhib. at RA 1872-1904, and at SS. Titles include 'Table d'hôte at a Dogs' Home' 'Your Humble Servant' 'Saint Anthony' 'Kismet'.

'English Setters, Justice and Royalist' sold at Christie's 3.4.69 for £147

Bibl: RA Pictures 1892, 1894, 1895, 1905-12

DONALDSON, Andrew Benjamin b.1840 fl.1861-1898
Painter of historical and religious genre, and landscapes. Exhib. at RA 1862-1898, but was a more regular contributor at SS. Titles include 'The Garden of Faith' 'Flight from the Danes' 'The River Dee at Chester'. In some books referred to as Andrew Brown Donaldson.

Probable price range £50-100

DOUGLAS, Edwin b.1848 fl.1869-1892
Scottish sporting, animal and genre painter. Imitator and successor of Edwin Landseer. Exhib. at the RA 1869-1900. Titles include 'The Highland Hearth' 'Mountain Shooting' 'Milking Time – Jersey' 'The Dog in the Manger'. He studied at the RSA School, living in Edinburgh until 1872 when he came to London. He first exhib. at the RSA in 1865.

'Christmas Morning' sold at Edmistons, Glasgow 19.2.69 for £180

Bibl: AJ 1885 p.193, 213; Clement and Hutton; Caw 340.

***DOUGLAS, Sir William Fettes PRSA 1822-1891**
Scottish painter of landscape and historical genre. Took up painting in 1847 after ten years as a bank clerk. Mainly self-taught. Elected RSA 1854. His earliest works mostly portraits, which he soon gave up in favour of genre subjects. After visiting Italy in 1857 he became a keen antiquarian and collector of books, coins, medals, manuscripts, ivories, enamels, and antiquities, which he used as accessories in his pictures. Although he painted landscapes and historical scenes, he was most fond of painting interiors of studies, with antiquarians poring over books, manuscripts and other objects. The detail and quality of his still life painting has often been compared with the Pre-Raphaelites, but being more interested in accessories, his figures are rather weak and lifeless. Elected Curator of the National Gallery of Scotland 1877-1882, and PRSA 1882-1891. Exhib. at the RA 1862-75 Typical titles 'The Rosicrucian' 'The Alchemist' 'The Conspirators'. Used the Douglas Heart as his monogram, usually in red.

'Two Scholars in a Library' sold at Christie's 9.6.67 for £42.

Bibl: Clement and Hutton; John M. Gray, *Sir William Fettes Douglas PRSA*, 1885; AJ 1891, p.288; Caw 172-174; DNB; Hardie III 189-90

***DOWNARD, Ebenezer Newman fl.1849-1889**

London genre and landscape painter. Exhib. at the RA 1849-1889, also at the BI and SS. Also painted biblical scenes and portraits. Some of his landscapes show Pre-Raphaelite influence, particularly of Holman Hunt. Titles at RA 'Gulliver Diverting the Emperor of Lilliput' 'Cheap Jack at a Country Fair' 'The Tethered Goat'.

'A Mountain Path at Capel Curig, Wales' sold at Christie's 11.7.69 for £525. This was a Pre-Raphaelite style work — pictures of his later style would be worth less.

Bibl: AJ 1883 p.248

DOWNES, Thomas Price fl.1835-1887

London portrait painter, working 1835-1887. Exhib. mainly at the RA. He also occasionally painted landscapes, and historical genre. Titles at RA 'Italian Peasant Girls' 'Queen Eleanor Obliging Fair Rosamund to Take Poison' 'Last Moments of Princess Elizabeth'. Later he turned almost entirely to portraits.

Probable price range £50-150

DOYLE, Charles A 1832-1893

Youngest son of the caricaturist John Doyle (1797-1868), and brother of Richard Doyle (q.v.). Entered the Civil Service and spent most of his life in the Edinburgh Office of Works. In his leisure hours he painted many strange fantasies with elves, horses and figures. He also illustrated John Bunyan's *Pilgrim's Progress*. His son was Sir Arthur Conan Doyle.

Because of the rarity of his work, and the demand for fantasy and fairy pictures of the Victorian period, price range could be £200-£500. or more.

Bibl: Univers. Cat. of Books on Art (VAM 1870), I, 189 (under Bunyan) Maas, p.155 (pl. 159)

***DOYLE, Richard 1824-1883**

Son (with Charles) of John Doyle (1797-1868), a well-known caricaturist. Primarily a book illustrator of themes from everyday life and fairy subjects, and painter of a number of highly original fairy pictures. In 1843 he joined the staff of *Punch* and designed the famous cover in 1849. In 1851, after he had left *Punch*, he did some of his first fairyland illustrations for Ruskin's *The King of the Golden River*. He also illustrated Thackeray's *The Newcomes*, Leigh Hunt's *Pot of Honey*, William Allingham's *The Fairy Land,* and many others. He painted both in oil and in watercolour, and exhib. at the RA in 1868 and 1871, and at the GG. Some of his pictures were very large and peopled with hundreds of fairies. He also did landscapes but these were never very popular.

The highest recorded auction price is 'The Fairy Minuet' sold at Sotheby's 21.11.68 for £1,700. Other auction prices for pictures and drawings have ranged from £100 to £945

Bibl: Clement and Hutton; DNB; Daria Hambourg *Richard Doyle* 1948; Maas 155-60 (pls. on p.16, 156)

***DRAPER, Herbert James 1864-1920**

Neo-classical painter of mythological and historical genre. Also painted portraits and mural decorations. 'An Episode of the Deluge' at the RA in 1890, won him a gold medal and a travelling scholarship, which he spent in Paris and Rome. 'The Lament for Icarus' was bought by the Chantrey Bequest in 1898. His style combined the classical severity of Leighton with the simpering Victorian nudes of J.W. Waterhouse. Although popular and successful in his day, his work is now largely forgotten, and rarely appears on the market. Studied at St. John's Wood School of Art and at the RA Schools from 1884; worked in Paris at the Academie Julian and in Rome 1890-91. Exhib. at the RA from 1887 and elsewhere. Decorated the Nurses' Canteen, Guy's

Hospital, 1887, and the ceiling at Drapers' Hall, 1903. Retrospective exhib. at Leicester Galleries 1913.

Probable price range £100-300

Bibl: Studio: Art in 1898 p.52; AJ 1898 p.182; 1900 p.184; 1901 p.165, 179; Sir Claude Phillips — Daily Telegraph 21.3.1913; Who's Who 1913; Tate Cat; Maas 232 (Reprd: 'The Lament for Icarus')

DREW, J.P. fl.1835-1861

London painter of rustic genre and portraits 1835-1861. Exhib. 18 works at the RA between 1835 and 1852; exhib. more frequently at the BI and SS. Titles at RA 'A Cottage Girl' 'Wild Flowers' 'Girl and Rabbits'.

Probable price range £30-100

Bibl: Glasgow A.G. Cat. 1911.

DRUMMOND, James RSA 1816-1877

Scottish historical genre painter. Worked in Edinburgh, and exhib. mostly at the RSA. Sent only a few works to the RA, BI, and SS. Two of his smaller works 'Peace' and 'War', exhib. at the BI in 1850, were purchased by Prince Albert. They are now at Osborne and were reproduced in the AJ in 1860 and 1861. Most of his subjects were taken from Scottish history. His great knowledge of Scottish arms, costume and customs enabled him to make his pictures very accurate, but he lacked the ability to breathe dramatic life into his figures and groups. Caw criticises him for this — "if capacity for taking pains would have made a history painter, then Drummond should have been one". In 1868 he was appointed Curator of the Edinburgh National Gallery.

'The Smugglers' sold at Sotheby's 4.6.69 for £280.

Bibl: AJ 1877 p.336 (obit); Redgrave Dict.; DNB; Caw 118-19.

***DUFFIELD, William 1816-1863**

Still life painter, born in Bath. At first a self-taught artist, Duffield moved to London and studied under George Lance (q.v.). He also studied in Antwerp for 2 years with Baron Wappers. Eventually returned to Bath. Specialised in fruit, vegetables, meat, and dead game. Occasionally included figures, mostly portraits of his wife and son. Exhib. only a few works at the RA and BI, but preferred SS, where he exhib. 38 works. Died suddenly aged 47 at the height of his powers. His wife, Mary Ann Rosenberg, whom he married in 1850, was a flower painter, and they presumably worked together. William L. Duffield, a landscape and figure painter, who exhib. very few works, was probably his son.

'Still Life of Flowers' sold at Sotheby's 12.2.69 for £600. The average for his works is still less than this about £200-400.

Bibl: AJ 1863 p.221 (obit); Redgrave Dict.; Maas 174.

DUFFIELD, Mrs. William b.1819 fl.1848-1893
(Miss Mary Ann Rosenberg)

Flower painter and watercolourist. Daughter of the painter Thomas Elliot Rosenberg. Married the still life painter William Duffield in 1850. Exhib. at the RA 1857-1874, BI, NWS, GG and elsewhere.

Probable price range £100-300

Bibl: Clayton II 172-3; Who's Who 1913.

DUFFY, Patrick Vincent RHA 1836-1909

Dublin landscape painter. He studied at the schools of the Royal Dublin Society, and while still a student was elected A. of the R.H.A., and three months later full member. In 1871 he was elected keeper of the R.H. Academy, a post he held until his death. A good example

of his art, 'A Wicklow Common' is in the Irish National Gallery. "His pictures are very unequal in merit", notes the DNB.

Probable price range £50-200

Bibl: DNB

***DUKES, Charles fl.1829-1865**

Landscape and rustic genre painter, working in London 1829-65. Although little known, he exhib. over 100 works at the RA, BI and SS. Subjects cottage or country scenes, and views in Wales and Ireland. Titles at RA 'Interior of an Alehouse' 'Country Courtship' 'A Welsh Peasant Girl'. A work by him is in the Burton Collection, York City A.G.

Probable price range £100-300

Bibl: AJ 1859 p.80, 121-2

DU MAURIER, George Louis Palmella Busson 1834-1896

Artist and cartoonist in black and white, and novelist. Born in Paris where he was educated. Studied chemistry at University College, London, 1851, and art under Gleyre in Paris, 1856-7, and under De Keyser and Van Lerins at Antwerp, 1857-60. Worked on book illustrations in London, 1860. Contributed occasional drawings to *Punch* in 1860 and joined the staff in 1864 as successor to John Leech, and began literary contributions in verse and prose in 1865. Illustrated stories for *Cornhill Magazine*, 1863-83. He published, in the first instance serially, in *Harper's Magazine*, three novels, *Peter Ibbotson*, 1891, *Trilby*, 1894, and *The Martian*, 1896. Trilby was a transcript of his own experiences in the Quartier Latin during his year in Gleyre's studio and contains portraits of T.R. Lamont, Thomas Armstrong and Poynter. It was dramatised and produced at the Haymarket in 1895. His drawings for *Punch* chiefly satirized middle-class society in the spirit of Thackeray.

In London galleries, his drawings are selling at the moment around an average of £30-70.

Bibl: DNB, supp. II; Leonee Ormond, *George Du Maurier,* 1969, with full bibliography.

DUNCAN, Edward RWS 1803-1882

London marine painter and watercolourist. Began his career as a copyist and engraver in the studio of Robert and William Havell. Set up his own engraving business, working mainly for Fores of Piccadilly on sporting subjects and for William Huggins on shipping subjects. After marrying Huggins's daughter, he branched out as a marine painter. Most of his marine works are in fact coastal and port scenes, as Duncan did not have enough knowledge of the sea to paint pure marine pictures. He also continued to paint landscapes and animals. Although he exhib. about 40 works at the RA, BI and SS, he was a far more frequent exhibitor at the OWS and NWS, where he exhibited over 500 watercolours and drawings. A prolific, competent, if uninspired artist. Hardie rates him as "a painstaking, skilful painter of a class below Stanfield, Chambers and Bentley".

'A River Estuary' sold at Christie's 15.11.68 for £577. 'A Mill near Tenbury' also at Christie's 20.2.70 made £840

Bibl: AJ 1882, p.159; 1883 p.400; Hardie III p.75-6; Maas pp.48, 64.

DUNCAN, Thomas ARA RSA 1807-1845

Scottish historical and portrait painter. Studied at Trustees' Academy in Edinburgh under William Allan. Exhib. at RA 1836-46; elected ARA and RSA 1843; in 1846 headmaster of the Trustees' Academy. Took his subjects mostly from Scottish history, especially the '45 Rebellion. Although his style and subjects are typical of his period, Duncan painted with remarkable freedom of technique, and strong

sense of colour. His promising career was cut short by his early death at the age of 38.

Probable price range £100-300

Bibl: AU 1847 p.380; Portfolio 1887 p.179; Redgrave, Dict.; Caw 110-112.

DUNN, Miss Edith See HUME, Mrs. T.O.

DUNN, Henry Treffry 1838-1899

Pre-Raphaelite painter, and studio assistant to D.G. Rossetti (q.v.) for 20 years. Born in Truro, Cornwall. Studied at Heatherley's. Recommended as assistant to Rossetti by Howell. Produced replicas, and also assisted Rossetti on many of his pictures. When Rossetti became ill and lived mostly out of London, Dunn became his general factotum at Cheyne Walk. After Rossetti's death, Dunn's career ran downhill into poverty and alcoholism, but he was rescued by the charitable Clara Watts-Dunton, who looked after him at The Pines in Putney, as she had previously looked after Swinburne. Although Dunn is mentioned in most books on Rossetti, the most complete account of his career is *Life with Rossetti* by Gale Pedrick.

His work rarely appears on the market, and is probably very often dismissed as "Rossetti School". Probable price range £100-200.

Bibl: Gale Pedrick, Life with Rossetti, 1964
Fredeman, see index; See references in Rossetti literature.

DUVAL, Charles Allen 1808-1872

Portrait and historical genre painter, born in Ireland, worked mainly in Manchester. Exhib. 20 works at RA from 1836 to 1872, mostly portraits, also some religious and historical genre. Titles 'Columbus in Chains' 'The Dedication of Samuel to the Lord' 'Moonlight on the Sea'. Did several group portraits — one containing one hundred portraits of the leading Wesleyans in the U.K., another is of the chief members of the Anti-Corn-Law League. One of his best known works is 'The Ruined Gamester' which was engraved and became so popular that a cartoon in *Punch* caricaturing Sir Robert Peel, was drawn from it.

Probable price range £50-100

Bibl: Redgrave Dict.; DNB.

DUVAL, John fl.1834-1881

Ipswich animal and sporting painter, working 1834-1881. Exhibited 77 works, 49 of them at the SS. Titles at the RA 'Lambing Time' 'Shooting Pony and Setters' 'The Master's Cob'.

'View of Ipswich from Crane Hill' sold at Sotheby's 18.3.69 for £130
Bibl: H.A.E. Day *East Anglian Painters* 1968 I 153-167.

***DYCE, William RA HRSA 1806-1864**

Scottish painter and decorator. Son of an Aberdeen doctor, he studied art against his father's will. Sir Thomas Lawrence was so impressed with his talent that he persuaded Dyce to take up painting professionally. He made several trips to Rome, where he was deeply impressed with the aims and ideals of the Nazarenes Overbeck and Cornelius, and also by Italian Renaissance painting. These influences persisted throughout his career. He painted portraits and religious subjects, and several fresco cycles in the House of Lords, Lambeth Palace, Buckingham Palace, Osborne House, and several churches. He was one of the few artists to sympathise with the Pre-Raphaelites. His own works, such as 'Pegwell Bay', and 'Titian's first Essay in Colour' show PRB influence in the realistic detail and bright colours. The latter picture drew praise from Ruskin in 1857 – "Well done, Mr. Dyce! and many times well done!' As he was kept busy by public duties in Government Schools, he did not exhibit a great many pictures. Most were exhibited at the RA and RSA, and some at the

BI. His style is highly individual, a blend of Nazarene and Pre-Raphaelite ideas, and is always characterised by an innate religious feeling. His studio sale was held at Christie's on May 5, 1865.

Major works rarely appear on the market. The last was 'St. John Leading Home his Adopted Mother' at Christie's 11.5.62 for £787.

Bibl: AJ 1860 p.293; 1864, 90, 113, 153, 320, 321; 1865, 333-4; Redgrave, Cent.; DNB; Caw 128-135 (pl. p.132); Dyce Centenary Exhibition, Aberdeen AG 1964; Reynolds VS 23, 66-7 (pl.33); Reynolds VP 37-8 and passim (pls. 31-2); Fredeman see index; Maas 25-6 and passim (pls. p.25, 135-6, 237).

EARL, George fl.1856-1883

London sporting and animal painter. Exhibited at Royal Academy 1857-1883, also at the BI and SS. Titles at RA 'Deer Stalkers Returning' 'Polo Match at Hurlingham' 'Finding the Stag' 'Grouse Driving on Bowes Moor, Yorkshire'. His daughter Maud Earl (q.v.) also an animal painter.

'Two Terriers in a Landscape' sold Sotheby's 22.1.69 for £190. Another of 'Bulldog Champions' sold Christie's 25.4.69 for £158.

EARL, Miss Maud fl.1884-1908

London animal painter; specialised in sentimental or dramatised pictures of dogs. Exhibited at the RA 1884-1901, and once at SS. Titles at RA 'Old Benchers' 'The Dog of War' 'Dogs of Death' etc. Painted Queen Victoria's and King Edward VII's dogs, and many pedigree and prizewinning dogs. Her work very popular through engravings. Twelve of her compositions were engraved in 1908 for 'The Sportsman's Year'. Her father was George Earl (q.v.) the sporting painter.

'Study of Two Terriers' sold Bonham's 19.3.70 for £170. 'Japanese Fine Feathers' a picture of pekinese, sold Christie's 14.11.69 for £399.

Bibl: Who's Who 1914

EARL, Thomas fl.1836-1885

London animal painter; specialised in dogs and rabbits. Exhibited at the RA 1840-1880, also at the BI and SS, where he exhibited over 100 works. Titles at RA 'Cat and Dog Life' 'The Dream of the Hound' 'The Rabbit Family' etc. Occasionally painted the animals in Henry Bright's landscapes.

Probable price range £100-200; more for sporting subjects.

EARL, William Robert fl.1823-1867

London landscape painter. Exhibited at RA 1823-1854, but more frequently at the BI and SS. Subjects mainly views of Sussex, the Isle of Wight, and other places on the English Coast. Also travelled in Germany and along the Rhine.

Probable price range £50-100

EARLE, Charles RI 1830/1-1893

London landscape painter and watercolourist. Exhibited at RA 1857-1890, also at SS and NWS. Subjects mainly views in England and Wales; also travelled in Germany and Italy.

Probable price range £30-70

EAST, Sir Alfred RA RI PRBA RPE 1849-1913

Landscape painter and watercolourist. Born Kettering, Northants. Studied at Glasgow School of Art, then in Paris under Tony Fleury and Bougereau. Settled in London about 1883. One of the earliest members of the Society of Painters-Etchers. Elected ARA 1899, President of the RBA 1906, knighted 1910, RA 1913. Exhibited at the RA from 1883, also at the BI and NWS. Travelled in Japan, France, Spain, Italy and Morocco. Landscape style much influenced by the Barbizon painters, Corot, Daubigny and Rousseau, particularly in his use of distinctive pale browns and greens. His landscapes are generally romantic and idealised, but carefully composed, as East believed in applying the principles of decorative design to landscape. In his day East enjoyed a great reputation, but since his death has been completely neglected. Recently there have been signs of a revival of interest in his work.

Prices during the 1968-9 season ranged from £100-137.

Bibl: Who's Who 1913; Chron. des Arts 1913, p.225 (obit); Studio 7 (1896) 133-42; Vol.37, 96-102; and Gen. Index; Hardie III 163; VAM; Connoisseur 37 (1913) 186 f; RA Pictures 1891-1913.

EASTLAKE, Sir Charles Lock PRA 1793-1865

Painter of biblical scenes, Italian genre, historical genre and portraits; writer and critic. Born Plymouth; studied under Prout and at RA schools. Returned to Plymouth as portrait painter, his most famous sitter being Napoleon, who was brought into port on the *Bellerophon*. Settled in Rome 1818-1830, where he painted many of his best works (e.g. Pilgrims Arriving in Sight of Rome 1828). Elected ARA 1827, RA 1830. Exhibited at the RA 1823-1855, also at the BI. After his return to London in 1830, official duties gradually forced him to give up painting. He was secretary to the Royal Commission for the Decoration of the Houses of Parliament, PRA 1850, and from 1855-65 Director of the National Gallery. Eastlake's biblical and historical works tend to be rather dry and academic; his Italian genre subjects are undoubtedly his best. Dubbed 'Archbishop Eastlake' he ranked sixth in Thackeray's Order of Merit (Fraser's Magazine, 1838).

Two Greek subjects sold at Sotheby's 18.6.69 for £750 and £900. These early genre scenes are his most attractive works, and can make up to £1,000. His historical and biblical works are worth much less.

Bibl: Lady Eastlake, *A Memoir of Sir Charles L. Eastlake*, 1869; W. Cosmo Monkhouse, *Pictures by Sir Ch. L. Eastlake,* with a biographical sketch, 1875; DNB; Redgrave, 435-6; AJ 1855, p.277 f; 1866, p.60 (obit); Reynolds VP 35, 37, 38, 61, 119, 151.

EBURNE, Miss Emma see under OLIVER, Mrs. William

EDDIS, Eden Upton 1812-1901

Portrait painter; worked in London, and after 1886 at Shalford, near Guildford. Exhibited over 100 works at the RA between 1834 and 1883; also a few at BI and SS. Painted occasional landscapes and biblical scenes. Among his many sitters were Sir Francis Chantrey, Lord Macaulay, Lord Coleridge, and many other public figures of the day. Many of his portraits were engraved.

'A Little Man' sold Sotheby's 18.12.68 for £220

Bibl: DNB. 2 Supp. I. 545; NPG Cat. II (1902).

EDEN, William fl.1866-98

Landscape painter; worked in Liverpool, and later in London. Exhibited at the RA, SS, and the NWS. Subjects all English views, but appears to have travelled in Germany. Titles at RA 'Flatford Mill' 'Staffordshire Uplands' 'Walberswick Pier'. Often confused with the watercolourist Sir William Eden. His son Denis William Eden (b.1878) was also a painter.

Probable price range £50-150

EDGAR, James H. fl.1860-70
Liverpool portrait and genre painter. Exhibited a small number of pictures at the RA, BI and SS. Title at the BI 'The Spinning Wheel — a Galway Interior.' Very little known artist.

'The Flower Maker' sold Christie's 6.3.70 for £179

EDWARDS, Miss Catherine Adelaide see under SPARKES, Mrs. J.
EDWARDS, Miss Mary Ellen, see under STAPLES, Mrs. John C.

EDWARDS, Edwin 1823-1879
Landscape painter and etcher; lived in Sunbury and London. Exhibited at the RA 1861-1879. Subjects mainly views in the south of England, especially Devon and Cornwall. Under the influence of Legros, Whistler, Fantin and Jacquemart he turned mainly to etching.

Probable price range £30-70.

Bibl: Beraldi, Graveurs du 19.s. VI (1886); Tate Cat; Portfolio 1872, 113; 14 f.

***EGG, Augustus Leopold RA** 1816-1863
London historical genre painter. The son of a rich goldsmith, Egg studied at Sass's and the RA schools. In the 1840's and 50's was a member of the clique with Phillip, Dadd, H.N. O'Neil, and Frith (all q.v.). Elected ARA 1849, RA 1861. Subjects taken from English history and literature, especially Shakespeare, Scott and Le Sage. This was a genre which had already been popularised by Leslie and Newton, but Egg's technique was more robust and colourful, and his treatment less sentimental. In his later period Egg was influenced by the Pre-Raphaelites, to whom he gave advice and encouragement. 'Travelling Companions' painted in 1862 (Reynolds VP. plate 16) shows an awareness of Pre-Raphaelite techniques, and an interest in painting scenes of contemporary life. Owing to poor health, Egg was forced to live abroad much of his life. He travelled in France and Italy, and died aged 47 in Algiers. The sale of his studio was held at Christie's May 18. 1863.

Auction prices between 1961 and 1968 ranged from £100-650;

Bibl: AU 1847, 312; AJ 1863, p.87 (obit); DNB; Reynolds VS. 3.10.11.18.56. 77-8 (plates 48-50); Reynolds VP.29.31.32.62.66.142 (plates 16, 27); Maas, pp.13,133 (Reprd: 'Past and Present', No.3, and Scene from 'The Winter's Tale')

***EGLEY, William Maw** 1826-1916
London historical genre painter. Son of William Egley (1798-1870) the miniaturist. Exhibited at the RA 1843-1898, also at the BI and SS. Egley's work can be divided into three phases. In the first period, which lasted from about 1843 until 1855, he painted literary illustrations mainly taken from Moliere and Shakespeare. In 1855 Egley turned to painting scenes of contemporary life. The fact that he was a friend of Frith, and painted several backgrounds in his pictures, must obviously have influenced his style in this direction. The works of this period, which lasted only until about 1862, are undoubtedly Egley's best, and are now the most sought after. In his last period, Egley turned to eighteenth century costume and historical pieces in the manner of Marcus Stone. Egley was a slow worker but in his diaries, which are in the V and A Museum, he lists over 1,000 paintings done between 1840 and 1910. Like many successful Victorian artists who lived too long, Egley's work is of very uneven quality.

On 12.2.69 Sotheby's sold 'The Talking Oak' by Egley for £3,000. This picture, dated 1856, was a good example of his best period. Lesser pictures of the historical genre type would make much less, probably £100-300.

Bibl: Reynolds V.S. 25, 85 ('Omnibus Life in London' plate 66); Reynolds VP 96, 109, 111 (plate 63); Egley's MSS diaries and lists, V and A Museum; Maas 104, 239.

ELEN, Philip West fl.1838-1872
London landscape painter. Exhibited at the RA 1839-1872, also at the BI and SS. Subjects mainly views in Yorkshire and North Wales.

Probable price range £30-70

ELLERBY, Thomas fl.1821-1857
London portrait and genre painter. Exhibited at the RA 1821-1857, also at the BI, and occasionally SS. Apart from official portraits, titles at the RA include 'An Italian Female' 'A Spanish Lady' 'A Roman Woman Selling Flowers'. Many of his portraits were engraved.

Probable price range £30-70

***ELLIOTT, Robinson** 1814-1894
Newcastle painter of genre, religious scenes, portraits and landscapes. Exhib. at RA 1844-81, BI, SS, NWS and elsewhere. Titles at RA 'Children in the Wood' etc. and several views in Northumberland and around South Shields. He also painted some charming pictures of children. 'In School' is in the Sunderland AG.

'The Race' sold at Christie's 10.7.70 for £105.

ELLIS, Edwin 1841-1895
London marine and landscape painter. Born in Nottingham, where he first worked in a lace factory. Studied under Henry Dawson (q.v.) and settled in London in the 1860's. Exhibited at the RA, but more often at SS, where he showed nearly 100 works. Subjects mostly coastal views in Yorkshire, Wales and Cornwall. His rich colouring and broad technique similar to the late style of Charles Napier Hemy (q.v.) In 1893 a comprehensive exhibition of his work was held at the Nottingham Museum.

'Ship Foundering off a Harbour' sold Christie's 11.7.69 for £126.

Bibl: AJ 1895 p.84, 191; Manchester Catalogue

ELLIS, Tristram J. fl.1868-1893
London landscape painter and watercolourist. At first an engineer on the District and Metropolitan railway, Ellis studied under Bonnat in Paris, and travelled widely, visiting Cyprus, Asia Minor, Egypt and the Middle East. His travels in these countries furnished him with the subject matter of most of his pictures and drawings, which he exhibited at the RA, NWS, and GG.

Probable price range £50-100

Bibl: Who's Who 1914; The Portfolio 1879 p.144; The Studio, Summer Number, 1902; AJ 1884 (illustrations).

***ELMORE, Alfred W. RA** 1815-1881
London genre and historical genre painter. Born Clonakilty, Cork; came to London at the age of 12. After learning to draw from the sculptures in the British Museum, Elmore entered the RA schools in 1832. In 1834, aged only 19, he exhibited his first picture at the RA 'Subject from an Old Play'. From 1833-39 he lived mainly in Paris; in 1840 he studied in Munich, and then settled in Rome until 1842. After his return he was elected ARA 1845, and RA 1857. Elmore exhibited at the RA from 1834-1880, and also at the BI and SS. His exhibited works were almost all subjects from English, French or Italian history, and Shakespeare. Only occasionally did he attempt scenes of modern life, such as 'On the Brink' in 1865, (Reynolds VP. plate 61) which scored a great success with the public. These few contemporary works are now much more sought after than Elmore's historical pictures. Elmore was also an excellent watercolourist, compared by Hardie to Bonington and Delacroix. Of his historical works Hardie says "Elmore's romantic medievalism is sometimes sentimental, but never cheap it reveals a sincere emotional quality". Redgrave

also praised his pictures as being "varied in idea, and exceedingly well thought out and composed". A sale of his studio was held at Christie's May 5, 1883.

'The Origin of the Guelph and Ghibeline Quarrel' sold at Christie's 6.3.70 for £252. Another historical work in the same sale made £231.

Bibl: AJ 1857 p.113; 1865 p.68; 1866 p.172, 204; 1881 p.95; The Portfolio 1881 p.54, 104; Redgrave Cent.; Strickland, Vol. I; Reynolds VP 32, 64, 110, 11, ('On the Brink' plate 61); Hardie II 186-187 (plates 177-178).

EMMERSON, Henry H. 1831-1895
Newcastle genre painter. Born in Chester-le-Street, Co. Durham, Emmerson studied in Newcastle with William Bell Scott. Except for occasional visits to London, he lived in and around Newcastle all his life, at Ebchester, Bywell, Whickham, Morpeth, and finally Cullercoats, where he died. Between 1851 and 1893 he exhibited 54 works at the RA. Subjects mainly scenes of country life in his native Northumberland — titles at RA 'The Maid of Derwent' 'Gamekeeper's Daughter — Twilight' 'The Calf Yard'. Emmerson once enjoyed a great reputation in the north-east, but is now very little known. His works may be seen in the York Art Gallery, and the Laing Art Gallery in Newcastle, and in many family collections in the north. He also illustrated children's books. One of his patrons was the 1st Lord Armstrong.

'The Harvest Song' sold at Christie's 10.10.69 for £42.

Bibl: The Year's Art 1896 p.297; AJ 1859 p.166; Catalogue of Laing Art Gallery, Newcastle; M. Girouard *Entertaining Victorian Royalty* Country Life Dec. 4, 1969.

EMMS, John 1843-1912
London sporting and animal painter. Also lived in Lyndhurst, Hants. Exhibited at the RA 1866-1903, also at the BI, SS, and the NWS. Titles at the RA 'The Bird's Nester' 'Clumber Kennels' 'Digging Out', Emms particularly specialised in painting foxhounds.

'Dreaming of the Chase' sold at Christie's 7.5.71 for £1,260. Other prices ranged from £150-683.

EMSLIE, Alfred Edward ARWS b.1848 fl.1867-1889
London genre and portrait painter. Son of John Emslie, an engraver, and brother of John Phillip Emslie. His wife Mrs. Rosalie Emslie a well-known miniaturist. Emslie exhibited at the RA 1869-1897, also at SS and the Grosvenor Galleries; he also showed watercolours at OWS, NWS, and NG. Titles at RA include 'Binding Sail After a Gale' 'Early Spring' 'Lead Kindly Light' 'Love amongst the Roses'. Travelled in Japan. In his later years turned increasingly to portrait painting. 'Dinner at Haddo House' is in the NPG.

Probable price range £100-300.

Bibl: AJ 1900, p.192; Studio Vol.20, 47, 48; Vol.32; 153 ff; Reynolds VP 193 (pl.133).

ENSOR, Mrs. Mary fl.1871-1874
Very little known painter of birds and flowers; lived at Birkenhead, Cheshire. Exhib. 7 works at SS, but not known to have exhibited elsewhere. Her pictures are usually small, colourful and highly detailed renderings of birds and flowers, in the tradition of Hunt, Clare and Cruikshank.

A study of flowers sold Christie's 11.7.69 for £189

*ETTY, William RA 1787-1849
Painter of classical and historical subjects. Born in York, the son of a baker, Redgrave says that "he demonstrated his love for art very early by defacing every plain surface". After a strict Methodist schooling, he worked as a printer's apprentice from 1798-1805. In 1807 he entered the RA schools, and in 1808 studied under Lawrence. Success was slow in coming to Etty; only in 1811 did the RA finally accept

one of his works, and it was not until 1821, with "Cleopatra's arrival in Sicily", that "one morning, he woke famous" (Leslie). Lived in Rome 1821-23. Elected ARA 1824, RA 1828. Between 1811 and 1850 he exhibited 138 works at RA, as well as a good number at the BI. Etty devoted himself to the painting of the female nude, and was a familiar figure at the RA life classes all his life. His luscious, sensual sketches of female nudes frequently scandalised the Victorian public, but his large-scale machines in the manner of Rubens, Titian and Veronese were more acceptable. Etty's subjects were mostly episodes from classical or mythological history, as these enabled him to use the maximum number of female nude figures. In 1848 he retired to his native York, where he died in 1849. The same year, an exhibition of his work was held at the Society of Arts. In May 1850 Christie's sold the remaining sketches and drawings in his studio for over £5,000.

The record auction price in recent years was 'Leda Reclining' which made £3,675 at Christie's 20.11.64. During the 1968-9 season prices ranged from £147-420.

Bibl: A. Gilchrist, *Life of W.E.* 1844; W.C. Monkhouse, *Pictures by W.E.* 1874; W. Gaunt, *E. and the Nude,* 1943; Dennis Farr, *W.E.* 1958; Redgrave, Cent. 257-262; Reynolds VP. 13, 119 (plate 4); AJ 1849 p.13, 37-40 (autobiog.), 378 (obit); DNB; Maas 166-167.

EVERSHED, Dr. Arthur ARPE b.1836 fl.1855-1900
London landscape painter and etcher. Pupil of Alfred Clint. Exhibited at RA 1857-1900, also at SS and the OWS. Subjects mainly views on the Thames or of southern England; also travelled in Italy.

Probable price range £50-200

Bibl: Beraldi Graveurs du 19.s. Vol. VI (1887); Who's Who 1914 p.666.

EWBANK, John Wilson R.S.A. 1779-1847
Scottish landscape and seascape painter. Born in Gateshead, Ewbank worked for a house painter named Coulson. Later he moved to Edinburgh and studied with Alexander Nasmyth. His technique and subject matter strongly influenced by the Dutch seventeenth century, particularly Van der Velde. His best work is from his early years, as after about 1810 his style deteriorated badly. Elected RSA 1823. Died in Edinburgh in great poverty.

'Edinburgh from the Firth of Forth' sold Christie's 2.4.69 for £116.

Bibl: Caw 160 ff, 322; AU 1848, p.51.

*FAED, John RSA 1820-1902
Scottish genre and historical painter. Elder brother of Thomas Faed (q.v.). Exhibited at the RA 1855-1893, and at SS. At first a miniature painter in Galloway, Faed settled in Edinburgh about 1841. Elected ARSA 1847, RSA 1851. Joined his brother in London 1862-1880, and then retired to his native village. His subjects included historical and biblical genre, as well as domestic and Highland scenes. Many of his and Thomas's compositions were engraved by the third brother, James Faed. Prior to his retirement from London in 1880, a sale of his works was held at Christie's on June 11th of that year.

'Dr. Rochecliffe in his Study' sold Phillips Son & Neale 20.1.69 for £500. Other prices 1968-9 season £180 and £240.

Bibl: AJ 1871 p.237-239 (Biog.); Clement and Hutton; Caw 166; DNB 2, Supp. II, 1912.

***FAED, Thomas RA HRSA 1826-1900**
Scottish painter of domestic genre and Highland scenes. Younger brother of John Faed (q.v.). Born in Burley Mill, Kircudbrightshire; Studied with his brother John in Edinburgh, and then with Sir William Allan and Thomas Duncan. Elected ARSA 1849. Settled in London 1852. In 1855 he established his popularity with 'The Mitherless Bairn' which became widely known through engravings. Elected ARA 1859, RA 1864. Exhibited nearly 100 works at the RA between 1851 and 1893. Subjects mainly sentimental scenes of Scottish peasant life — e.g. 'Cottage Piety (1851) 'Highland Mary (1856) 'My Ain Fireside' (1859) — or pretty Highland girls. Sometimes collaborated with J.F. Herring Senr. (q.v.).

Prices during the 1968-9 season ranged from £100 to £273

Bibl: AJ 1871 p.1-3; Mag. of Art 1878, p.92 f; Clement and Hutton; Caw p.164-166 (plate 'The End of the Day').

FAIRLESS, Thomas Kerr 1825-1853
Landscape painter, born in Hexham, Northumberland. Studied for a time under Bewick's pupil, Nicholson, a wood engraver, at Newcastle. Came to London and practised landscape-painting. From 1848-51 he exhibited landscapes at the RA, and also at BI and SS. "His works were executed in a broad and vigorous manner, with a fine idea of colour and exquisite feeling for the beauties of country scenery, gathered during the summer days among the woods and pastures of England" (L.Cust. DNB). He also painted sea views and shipping.

Probable price range £30-100

Bibl: AJ 1853, 215 (obituary); DNB.

FAIRLIE, William J. fl.1850's-60's
Carlisle landscape painter who painted views in the Lake District, and exhibited at the RA in 1853, 55, 57 and 65. Subjects Lake District, or country around Carlisle.

Probable price range £30-100

***FARMER, Mrs. Alexander fl.1855-67**
Genre and still-life painter, wife of Alexander Farmer, whose sister Emily was also a watercolourist. Lived at Porchester, Hampshire. Exhibited at the RA 1855-67, also at the BI and SS. Titles at RA 'A Bird's Nest' 'An Anxious Hour' 'The Remedy Worse than the Disease' etc. Mrs. Farmer, like Sophie Anderson and many other minor female painters of the Victorian period, produced a small body of extremely competent, if sentimental pictures.

A pair of sentimental genre scenes sold Christie's 11.7.69 for £315.

FARQUHARSON, David ARA ARSA RSW 1840-1907
Scottish landscape painter. Born in Blairgowrie, Perthshire, and lived there until he came to Edinburgh about 1872. He was, to a great extent, a self-taught artist. Exhibited at the RSA for the first time in 1868, and in 1882 was elected A, but in 1886 he settled in London until 1894. He then removed to Sennen Cove, Cornwall, but often re-visited Scotland. His landscapes attracted considerable attention and led to his election as ARA in 1905 at the age of 66. He exhibited at the RA from 1877-1904. He painted the Highland hills and moors and peat mosses, river valleys and views in England and Holland in all sorts of atmospheric conditions, and in a tonal palette reminiscent of early Corot landscapes.

Prices during the 1968-9 season ranged from £105 to £578

Bibl: DNB; Caw 306-7; AJ 1907, 197, 283, 360; 1908, 231; Studio, Vol.38, 10; R.A. Pictures, 1891-96, 1906-8.

FARQUHARSON, Joseph RA 1846-1935
Scottish landscape painter, noted for winter subjects, especially snow-storms, snowy landscapes and winter woods. He occasionally painted Oriental mosques and eastern market places, social and rustic genre, and portraits. Born in Edinburgh, he studied first under Peter Graham, RA, then at the Board of Manufacture School in Edinburgh, and the Life School at the RSA. In 1859 he first exhibited at the RSA; he exhibited at the RA from 1873 onwards, and was elected ARA in 1900. In 1880 he studied in Paris under Carolus Duran. In 1885 he visited Egypt. Sickert wrote an essay comparing him to Courbet, and preferring Farquharson:- "Farquharson's extraordinary virtuosity has been developed by experience, but it arises certainly from the fact that he is thinking of telling his story. The arrest of the fox in the snow of the picture called 'Supper Time' is a breathless moment. The subject is the very *raison d'etre* of the picture. Bloomsbury will perhaps tell you that it is wrong to paint a live fox. Fortunately the writ of Bloomsbury does not run in the North of Scotland." Not related to David Farquharson (q.v.). An exhibition of his work was held at the FAS in March, 1887.

'Borderland' sold Christie's 3.4.69 for £200

Bibl: AJ 1890, 158; 1893, 153 (monograph); 1905, 175; Studio Art in 1898, Index; RA Pictures, 1905-8, 1910-12; Caw, 306; The Globe, 5.8.1908; W.M. Sinclair, *The Art of J.F.*, Art Annual, Christmas-Number, 1912; Connoisseur, XXXVI, 59 ff; W.R. Sickert, *A Free House, ed.* Osbert Sitwell, 1947, 204-6, (essay first published with the title "Snow Piece and Palette-Knife", in the Daily Telegraph, 7th April, 1926).

FARRIER, Robert 1796-1879
Painter of genre and portraits who exhibited at the RA from 1818-1859, titles including 'The Prophecy — You'll Marry a Rich Young Lady'.

Probable price range £30-70

FERGUSON, William J. fl.1849-86
London landscape painter, who exhibited at the RA from 1850-78, mostly landscape views of glades of oaks, beeches etc., and often views of buildings.

Probable price range £30-70

FERNELEY, Claude Lorraine 1822-1891
Melton Mowbray sporting painter; son of John Ferneley (q.v.), by his first wife Sarah. Exhibited only one picture of horses at the RA in 1868. Painted horse portraits and hunting scenes for local patrons in a style similar to his father's. Works by him can be seen in the Leicester Art Gallery.

Prices during the 1968-9 season ranged from £170 to £290

Bibl: Guy Paget, *Sporting Pictures of England,* 1945; Guy Paget, *The Melton Mowbray of John Ferneley,* 1931; Shaw-Sparrow, *A Book of Sporting Painters.*

***FERNELEY, John E., Senior 1782-1860**
Melton Mowbray sporting painter. Born at Thrussington, Leicestershire, the son of a wheelwright. Worked for his father until he was 21, painting only in his spare time, and occasionally painting panels on coaches and waggons. Encouraged by the Duke of Rutland and other local patrons, he was sent to London to study under Ben Marshall. Worked in Dover and Ireland, before settling in Melton Mowbray. Married Sarah Kettle in 1809, by whom he had four sons, including John and Claude Lorraine (q.v.), who both became painters. Sarah F. died in 1836; Ferneley married Ann Allan, who died in 1853. Although Ferneley exhibited at the RA, BI and SS, he worked mostly for private patrons. Within the patterns laid down by the current Marshall - Herring tradition, he developed a very recognisable personal style.

'The Ferneley Family' sold Christie's 20.6.69 for £29,400. This is

still the record price, but the usual range is £1,000 — £5,000, or even under £1,000 for less saleable subjects.

Bibl: Guy Paget, *The Melton Mowbray of John Ferneley*, 1931; Shaw-Sparrow, *A Book of Sporting Painters;* Shaw-Sparrow, *British Sporting Artists*, 9, 179, 180, 181, 185-194, 216, 217, 234 (plate 59); Pavière, *Sporting Painters*; Maas 72 (pl. p.71).

FERNELEY, John, Junior c.1815-1862

Melton Mowbray sporting painter, eldest son of John F. Senior (q.v.), by his first wife Sarah. Very little is known of his life, except that he worked in Manchester, York, and died in Leeds. His work is often confused with his father's, and they probably collaborated on many pictures. John Junior usually signed 'John Ferneley', and his father 'J. Ferneley', but the son's work is noticeably coarser and less competent than his father's.

Prices during the 1968-9 season ranged from £150 to £480

Bibl: Guy Paget, *The Melton Mowbray of John Ferneley*, 1931; Shaw-Sparrow, *A Book of Sporting Painters;* Shaw-Sparrow, *British Sporting Artists*, p.193.

FIELDING, Anthony Vandyke Copley 1787-1855

Marine and landscape painter in water-colour and oil. Second son of Nathan Theodore Fielding. Studied under his father and John Varley. In 1910 he began to exhibit at the RWS, where he exhibited most during his career, often sending 40 or 50 a year. He became a full member of this society in 1813, secretary in 1813 and president from 1831 to his death. He exhib. only 17 paintings — all oils — at the RA, from 1811-42, landscapes and views of buildings. He was one of the most fashionable drawing-masters of his day. In 1824 he was awarded a medal at the Paris Salon, with Constable and Bonington. His best subjects were views of the Sussex Downs, but also storm scenes at sea, and drawings of lake and mountain scenery in Scotland, Wales and the N. of England. He also painted a few Italian scenes, but these were from the sketches of others. He never went abroad. He was championed by Ruskin:- "No man has ever given, with the same flashing freedom, the race of a running tide under a stiff breeze, nor caught, with the same grace and precision, the curvature of the breaking wave, arrested or accelerated by the wind". (Modern Painters). Many of his watercolours have faded, because of the use of indigo.

'Near Cuckfield, Sussex' sold Sotheby's 23.7.69 for £550. Usual range for watercolours £100-200.

Bibl: DNB; S.C.K. Smith, OWS, III, 1925; Roget; Redgrave, 407; AJ 1855, 108 (obituary); 1906, 298-9; Burlington Magazine, 19 (1911), 331-2; Ruskin, Modern Painters, see Index; Binyon; VAM, Cat. of Oil Paintings, 1907; A.L. Baldry, The Wallace Coll., 1904, 117, 119; Maas, 64; Hardie III passim.

*FILDES, Sir Luke. RA 1843-1927

Painter of genre and portraits. Born in Liverpool. Fildes studied first at a local Mechanics Institute. After 3 years at Warrington School of Art, he came to London in 1863 to study at the South Kensington schools. Fildes then worked for several years as an illustrator on magazines such as *Once a Week* and *The Graphic*. Through a recommendation from J.E. Millais, he was commissioned by Dickens to illustrate his last novel, *Edwin Drood*. In the 1870's Fildes turned from illustration to painting; and in 1874 his large picture of 'Applicants for Admission to a Casual Ward' brought him fame overnight. The picture, which is now in Royal Holloway College, was praised for its Dickensian realism, honesty and lack of affectation. Fildes's subsequent output was of three types — firstly, social documentary subjects, such as 'The Widower' (1876) and 'The Doctor' (1891) which became enormously popular through engravings — secondly, Venetian genre scenes, such as 'Venetians' (1885) and 'An Alfresco Toilet' (1889), painted in a style similar to Van Haanen, Eugene de Blaas and Henry Woods (Fildes's brother-in-law) — and

thirdly, portraits. It was as a portrait painter that Fildes found the fame and fortune he so earnestly pursued. In 1894 he painted the Princess of Wales, which led to a series of royal commissions, including the State portraits of Edward VII in 1902, and George V in 1912. Fildes was elected ARA 1879, RA 1887, and knighted 1906. The fullest account of his life is the biography recently published by his son. His studio sale was held at Christie's on June 24, 1927.

'Venetian Fruit Seller' sold at Sotheby's 6.3.68 for £220.

Bibl: Clement and Hutton; AJ 1877, p.168; 1895, p.179, 181; 1897, p.168, 338f; 1898, p.167, 177; 1900, p.177; 1901, p.180; 1902, p.184, 1909, p.166; Art Annual 1895, p.1-32 (mono. with plates); Who's Who 1914; Reynolds VS 27, 28-30, 33, 40, 94-5 (plates 84, 85); Reynolds VP 15, 120, 141, 180; L.V. Fildes, *Luke Fildes RA. A Victorian Painter*, 1968; Maas 237-8 (pl. on p.239).

FINCH, Francis Oliver 1802-1862

Landscape watercolour painter. Worked for five years under John Varley, and became an associate of the Society of Painters in Watercolours in 1822 and a member in 1827. He exhibited at the RA from 1817-1832. He painted many views of Scottish and English landscapes in "rather stilted classical compositions, using the 'hot' colours which affected watercolour painting at the time" (Maas).

'A Shepherd - Evening - Bucks' sold at Sotheby's 19.3.70 for £100. The more usual range is £30-70.

Bibl: Mrs. Eliza Finch, *Memorials of F.O. Finch*, 1865; Roget; DNB; VAM, Cat. of Oil Paintings, 1907; Watercolour Paintings, 1908; Binyon, BM Catalogue; AJ 1862, 207 (obituary); 1893, 44; Maas 44; Hardie II 171-2 (pls. 161-2).

FINNIE, John 1829-1907

Liverpool landscape painter, engraver and etcher. Born Aberdeen. Worked in Newcastle, where he met W.Bell Scott; in London 1853-56. He then became Headmaster of the Mechanics Institute and School of Art in Liverpool, and held the post until 1896. Finnie, whose landscapes were broad and naturalistic in style, was also a mezzotinter and etcher. He exhib. at the RA 1861-1902, BI, SS and the Paris Salon, where he once received honorable mention.

Probable price range £50-100

Bibl: AJ 1907; Studio Vol.7, 167; Vol.24, 136; Vol.28, 208; Vol.42, 148; Art in 1898. 66; Summer No.1902; Marillier 119-121 (plate opp. 120); DNB.

FISHER, William Mark RA 1841-1923

Landscape painted, considered by George Moore in 1893 to be "our greatest living landscape painter". Born in Boston, USA. Studied at the Lowell Institute, Boston, and under George Innes. Started as a genre and portrait painter. Went to Paris about 1861; studied under Gleyre and was influenced by Corot. Returned to Boston, but not finding success, came to England in 1872. Exhibited at the RA, from 1872, ARA, 1911; RA, 1919. Member of NEAC. He chiefly painted landscapes.

Prices during the 1968-9 season ranged from £130 to £336, but 'The Gardener Mowing the Orchard' sold Christie's 18.7.69 for £998.

Bibl: Who's Who in America, VII; Clement and Hutton; George Moore, *Modern Painting*, 1900, 249-51; AJ 1910, 15-20; 1896, 97; 1900; 1905; 1908; Studio, Vol.2, 23, 30, 35, 44, 47, 58; Burlington Magazine, XII, 278, 286; Connoisseur Vol.29, 56; RA Pictures, 1905-13; VAM MSS: Letters to H.M. Cundall from M.F. with biog. inform. 1878; V. Lines, *Mark Fisher and Margaret Fisher Prout*, 1966; VAM.

*FITZGERALD, John Austen 1832-c.1908

Painter of fairy scenes and dreams (sleeping people surrounded by goblins) — all highly imaginative works. Very little is known of his life and only very few of his paintings exist. Four of his best are reproduced in Maas, 'The Captive Dreamer', 'The Chase of the White Mice', 'The Dream', and 'Standing Nude'. He is known to have belonged to the Maddox St. Sketching Club, and he exhibited at the RA from 1845-

1902, the last title being 'Alice in Wonderland', 1902. His death date is unknown but his name last appears in *The Year's Art* for 1909. Works by him can be seen in the Guildhall, London, and The Walker Art Gallery, Liverpool.

'World of Dreams' sold Sotheby's 2.4.69 for £220.

Bibl: AJ 1859, 82, 121, 141, 162; 1860, 80; Index Printsellers' Assoc. 1912; Maas, pp.153-4 (pls. p.154-5, 159, 166).

*FORBES, Stanhope Alexander RA 1857-1947

Painter of realistic genre, frequently in the open air, historical subjects and landscapes. Born in Dublin. Studied at Lambeth School of Art, the RA Schools, 1874-8, and for two years in Paris under Bonnat. Influenced by Bastien-Lepage; painted in Brittany with La Thangue (q.v.) 1880. Settled in Cornwall, 1884 and became a leading member of the Newlyn School. Foundation member of the NEAC, 1886. Began exhibiting at the RA in 1878. ARA 1892, RA 1910. Married Elizabeth Armstrong, ARWS, painter, in 1889, and founded with her the Newlyn School of Art 1899. (See under Mrs Stanhope Forbes). Most of his paintings are large, realistic scenes of life in the fishing villages of Cornwall, painted in a robust *plein-air* style, using the muted colours so typical of Bastien-Lepage and his followers. His best known work is the Courbet-like 'Health of the Bride' in the Tate Gallery.

Probable price range £100-500; more for major works.

Bibl: L. Birch, *Stanhope A. Forbes and Eliz. S. Forbes*, 1906; C.L. Hind, *The Art of S.A. Forbes*, AJ Christmas No.1911; W. Meynell in AJ, 1892, 65-69; 1889, 98-101; Studio, vol.23 (1901), 81-88 – also vols. 26, 29, 32, 35, 41, 49, 53, 63; RA Pictures 1891-1914; Who's Who, 1914, 725; Tate Catalogue.

*FORBES, Mrs. Stanhope ARWS 1859-1912
(Miss Elizabeth Armstrong)

Painter of rustic genre; wife of Stanhope Alexander Forbes (q.v.), who she married in 1889. Exhib. at RA from 1883, SS, NWS, GG, NG and NEAC. Her style and subjects very similar to those of her husband. She also exhibited flower pieces and a few etchings. Founded the Newlyn Art School with her husband in 1899.

A chalk and watercolour drawing 'Ora pro Nobis' sold for £136 at Christie's 9.7.68. Apart from this no prices over £100 recorded.

Bibl: AJ 1889; 1896; 1904 p.382 ff; Studio 4 (1894) 186-192; 18 (1900) 25-34; 23 (1901) 81-8; also vols. 26, 38, 44, 56; Studio *A Record of Art in 1898* Special No; Who's Who 1912-13; Also see under Stanhope Alexander Forbes.

FORD, Henry Justice fl.c.1888-1903

Illustrator of children's books, and also a painter, (though weak), in oils, of romantic and historical subjects. Friend of Burne-Jones. His most famous series of designs were the volumes of *Fairy Tales and True Stories (Blue, Red, Green, Pink, Grey, Yellow, Violet etc.)*, edited by Andrew Lang for Longmans. He also illustrated *Aesop's Fables*, 1888, and *The Arabian Nights' Entertainment*, 1898, and many others. He exhibited at the RA from 1892-1903; and an exhibition of his watercolours – chiefly for *The Yellow Fairy Book*, 1894 – was held at the FAS in May, 1895. Sketchley says that he "represents (with J.D. Batten and H.R. Millar) the modern art of fairy-tale illustration at its best", and Gleeson-White notes that he was "a prime favourite with the small people".

Probable price range £50-150

Bibl: AJ 1899, 1900, 1901, 1905; Studio, Special Winter Number, 1897, Gleeson-White, Children's Illustrated Books, p.46; R.E.D. Sketchley, *English Book Illustration of Today*, 1903, 109, 110, 165.

FORTESCUE-BRICKDALE, Eleanor See BRICKDALE, Eleanor Fortescue

*FOSTER, Myles Birket RWS 1825-1899

Painter, chiefly in watercolour, of landscape and of rustic scenes in Surrey and elsewhere, peopled with children and milkmaids; illustrator and engraver. Born in North Shields; came to London when he was five, and apprenticed when about sixteen to Peter Landells, a leading wood engraver who had been a pupil of Bewick. There he first cut blocks and then produced drawings of topical scenes and current events for *Punch*, the *Illustrated London News* and other magazines. He was then employed as a draughtsman under Henry Vizetelly and illustrated Longfellow's *Evangeline* and Rogers's Italy. In 1846 he set up on his own, illustrating books and producing illustrations for the *Illustrated London News*. About 1859 he turned to painting chiefly in watercolours, elected A of the OWS in 1860, RWS 1862; and from that date contributed some 400 drawings to its exhibitions. Also exhib. at the RA from 1859-81. In 1852, 1853 and 1861 he travelled about the Continent, chiefly up the Rhine, making many colour sketches and pencil studies; in 1866 he went abroad again, and in 1868 visited Venice with W.Q. Orchardson and Fred Walker, who was a very close friend. He also made many later visits to Italy – largely on the commission from Charles Seeley to make fifty Venice drawings for £5,000. In 1863 he built a house at Witley near Godalming, and it is for his watercolours of the Surrey countryside that he is best known today. Hardie notes: "As a painter, he worked with meticulous finish and with astounding technical skill. At his best he showed a fine sense of composition and command of colour. Under all the rather sugary surface of sentiment and prettiness lies a hard core of sound and honest craftsmanship. We may deplore the sentiment, but we shall be narrow-minded if we fail to respect the artistry."

One of the few artists whose prices have, if anything, gone down since the war. Current price range at auction £100-500.

Bibl: AJ 1871, 157 ff; 1863, 10 ff; AJ Christmas No.1890, M.B. Huish *Birket Foster, his life and work*; The Portfolio 1891, 192 ff; J. Pennell *Modern Book Illustrators* 1895; The Studio 1902 'English Watercolour'; Bryan; Cundall; H.M. Cundall *Birket Foster* 1906; DNB; W.R. Sickert 'Fathers and Sons' *The Art News* April 7, 1910; Hughes; VAM; L. Glasson, *Birket Foster*, OWS XI 1933; Reynolds VP 156, 173, (pl.113); Hardie III 109-112 and passim, (pl.133); Maas 231 (pl. p.230).

FOSTER, William 1853-1924

Painter of landscapes and interiors, still life and genre in watercolour, and illustrator in black and white. Second son of Birket Foster (q.v.); followed his father's methods in painting, and exhibited at the RA from 1872 onwards. He was a fellow of the Zoological Society and supplied colour illustrations to several books on birds.

Probable price range £30-100

Bibl: Hardie III 112.

FOSTER, William Gilbert RBA 1855-1906

Painter of landscape and rustic genre, who for a long time lived and worked in Leeds. Born in Manchester, son of a Birkenhead portrait painter. He studied under his father and worked with him until 1876, when he first exhibited at the RA from a Leeds address. He exhibited from 1876-1906, at the RA, SS and elsewhere. He is listed under William Gilbert Foster (1876-1893) and Gilbert Foster (1895-1904) in Graves Dict. Titles at the RA include 'Eventide', 'The Girl with the Geese', and 'Driving the Ducks'. For some years he was art master at Leeds Grammar School. Two of his works are in Leeds Art Gallery, and one in Hull. He painted in oil, watercolour and charcoal. RBA in 1893.

Probable price range £100-200

Bibl: AJ 1906 286; Studio 30 (1904), 155; RA Pictures 1892, 1895, 1898, 1900, 1901, 1903; Cat. of Leeds City Art Gallery, 1909.

FOWLER, Robert R.I. b.1853 fl.1876-1903
Liverpool decorative painter, of myth and allegory — figures treated decoratively in pale colours, in the style of Albert Moore, Leighton and Fernand Khnopff. Also influenced by Japanese artists. Born in Anstruther, he studied in London, but moved to Liverpool where his chief work was done. He stayed there until 1904 when he returned to London. His studio in Liverpool was a chief centre for artistic life. His work at first was chiefly in watercolour, the subjects from classic myth or romantic poetry. Later he worked in oils, in which he was more successful. In 1902 he started in landscape painting. He exhib. at the RA from 1876-1903. In 1891 became a member of the RI. He also designed posters -- some for the Walker Art Gallery.

Probable price range £100-300

Bibl: Who's Who, 1914; Caw, 355, 407-11; RA Pictures; 1897-1913; Studio 9 (1897), 85-98 (with many illustrations); 32, (1904), 161; Art in 1898; Summer No.1900, 35.

FOWLES, A.W. fl.1840-1860
Little known marine painter, born on the Isle of Wight. Not known to have exhibited in London, so presumably he worked entirely for local patrons. Pictures by Fowles are in the Bury Art Gallery, Ryde Town Hall, and the Maritime Museum, Greenwich.

'Queen Victoria Reviewing the Fleet'(a pair) sold at Christie's 9.5.69 for £1,155. These were an exceptionally fine pair; the average price is usually £200-300.

Bibl: AJ 1876 p.30; Wilson, Marine Painters, p.35.

FOX, Henry Charles RBA b.1860 fl.1879-1913
London landscape painter, working c.1880, c.1913, exhibiting at the RA (1880-1902), SS and NWS.

Probable price range £20-50

FOX, Robert 1810-fl.1868
London painter of genre and eastern portraits, who exhib. at the RA from 1853, titles including: 'Head of a Hindoo', 'As She Looked in the glass', 'After the Opera', etc.

Probable price range £30-70

Bibl: Strickland, 1.

FRASER, Alexander, Junior RSA. 1828-1899
Landscape painter, son of Alexander George Fraser (q.v.). He studied at the Trustees Academy. Until 1857, a year before he was elected ARSA (RSA 1862), his subjects were principally Scottish, but in that year he visited Wales, and for some time Welsh landscape engaged him. But he returned to paint some of his finest pictures in Scotland in Cadzow Forest and on Loch Lomond. 1868-9 he painted in Surrey, and for the last fifteen years of his life, in Scotland. He exhib. at the RA from 1869-1885. He especially liked summer and high noon in the forest and resembled the PR's in the attention he gave to detail.

'Thomas William Coventry' sold at Christie's 27.10.61 for £147.

Bibl: DNB; Caw 190 ff. (Reprd. opp. p.192 'On the Avon-Haymaking time'; AJ 1904, 375-379; 1906, 154 ff. 1873, 101; Portfolio, 1887, 208; Armstrong, Scottish Painters, 1888.

FRASER, Alexander George, Senior ARSA 1786-1805
Painter of domestic and historical genre. Assistant to Wilkie, and for about twenty years he is said to have painted the still life and accessories in Wilkie's paintings. He exhibited at the RA from 1810-1848, and in 1842 his "Naaman cured of the Leprosy" obtained the premium at the BI for the best picture of the year. In taste, and subject his paintings were very like Wilkie's, and in the fashionable brown-tone. Caw says that "most of his pictures deal with social or convivial situations conceived in the Spirit of comedy".

'Collecting funds for the Regiment' sold 16.10.68 for £270.

Bibl: AJ 1865, 125; Gent. Mag. 1865 XVIII, 652; Portfolio, 1887, 109; DNB; Caw, 104f. (Reprd: opp. p.104, 'Tam and the Smith'.); Cunningham, *Life of Sir David Wilkie.*

FRASER, John RBA b.1858
London marine painter. Exhibited at the RA 1879-1893, also at the SS, and NWS. Titles at the RA 'North Sea Herring Boats' 'Anchovy Boats in the Straits of Gibraltar' etc. Several works by Fraser are in the Greenwich Maritime Museum.

Probable price range £50-150

Bibl: Wilson, Marine Painters, p.36.

FRASER, Robert W. fl.1874-92
Bedford landscape painter who exhibited from 1876-1892 at the RA. Subjects mostly views in the South of England. Titles "It was on April Morning" "Honey Hill, Bedford" "Near Pickhurst, Kent" etc.

Probable price range £30-70

FREEZOR, George Augustus fl.1861-1879
Genre and portrait painter. Lived in London. Exhib. at RA 1861-68, and once at BI and SS. Titles at RA mostly female portraits, of the keepsake type. A work by him is in the Graves Art Gallery, Sheffield.

Probable price range £50-100

FRIPP, Alfred Downing RWS 1822-1895
Born in Bristol, the younger brother of George Arthur Fripp (q.v.). At the age of 18 he went to London, and studied at the BM and RA. Like his brother he exhib. regularly at the RWS from 1844, when he sent his 'Poacher's Hut'. His early works were British and Irish landscapes and rustic genre. Then in 1850 he went to Rome, and from then to 1854 his subjects were Italian — views and studies of peasants. After his return to England he again reverted to Welsh and English scenes and genre. He exhib. at the RA in 1848, 'Sad Memories'.

Probable price range £30-100

Bibl: see under FRIPP, George Arthur.

FRIPP, George Arthur RWS 1813-1896
Landscape painter, mainly in watercolour, but also occasionally in oil. Born in Bristol and taught by James Baker Pyne, and Samuel Jackson. In 1834 he made a foreign tour — through Germany to Venice — with his Bristol friend W.J. Muller. In 1841 he came to London, and was elected an A. of the RWS in that year, and member in 1845. He exhib. there regularly and at the RA in 1838, 43, 44 and 48. In 1860 he was commissioned by the Queen to visit Balmoral to make sketches of it and the neighbourhood — and these were added to the Royal Collection. His landscapes were highly regarded, and met with a ready sale. His subjects were mainly: river scenes of the Thames, foreign scenery, rustic and agricultural subjects, ruined castles and scenes on the isles of Skye and Sark, and elsewhere in the North.

'River Scene near Tyrolean Cathedral Town' sold Bonham's 3.10.68 for £260.

Bibl: AJ, 1877, Feb; Roget, ii, 264-8 (George), 291-3 (Alfred); DNB; H.S. Thompson, *G.A. and A.D. Fripp,* Walker's Quarterly, XXV, XXVI, 1928; Clement and Hutton.

***FRITH, William Powell RA 1819-1909**
Painter of historical genre and scenes of Victorian life. Born near

Ripon, Yorkshire, Frith was forced by ambitious parents to take up painting against his will. This perhaps explains his materialistic and commercial attitude to art, which persisted throughout his life. Studied at Sass's Academy and RA Schools. Elected ARA 1845, RA 1852. During the 1840's a member of the Clique, with Richard Dadd, A.L. Egg, H.N. O'Neil, and John Phillip (all q.v.). Early subjects all historical and literary scenes, painted in a very sentimental style, the subjects being taken from such sources as Shakespeare, Moliere, Scott, Goldsmith, Dickens and Sterne. In his autobiography Frith claims that he was always "strongly drawn towards illustration of modern life". It was not, however, until the Pre-Raphaelites had made modern genre acceptable that Frith tried his hand at this type of subject. A visit to Ramsgate in 1851 gave him the idea for his first panorama of Victorian life, 'Ramsgate Sands', exhibited at RA in 1854. The picture was an enormous success, and was bought by Queen Victoria. Encouraged by this, Frith went on to paint a succession of similar panoramas, for which he is now best known – 'Derby Day' (1858), 'The Railway Station' (1862), 'The Salon d'Or, Homburg' (1871), 'Private View Day at the Royal Academy' (1883). He also painted several moralistic series such as 'The Road to Ruin' (1878), and 'The Race for Wealth' (1880). In addition to these, he continued to paint historical and sentimental subjects, becoming steadily more repetitive, his colours growing thinner and dryer. Frith exhib. at the RA for sixty years, from 1840-1902, and also at the BI and SS. A self-portrait is in the MacDonald Collection at the Aberdeen Art Gallery. A sale of works from his own collection was held at Christie's on June 14, 1884.

The last important works by W.P.F. to be sold were the 'Road to Ruin' series, a set of five pictures, sold at Sotheby's 14.11.62 for £7,200. The average price for minor works has ranged from £200 to about £600.

Bibl: W.P. Frith, Reminiscences, 1888 (Autobiog.); The Times 4.11.1901 (obit); AU, 1849; AJ 1910, p.14 (obit); AJ 1854 p.161; 1856 p.237 ff; 1858 p.93; 161; 1864 p.64; 1854 p.157, 167; 1866 p.116; 1867 p.137, 172; 1878 p.166; Clement and Hutton; DNB 2 Supp. II 1912; Jonathan Mayne, Catalogue of Frith Exhibition, Whitechapel Art Gallery 1951; Reynolds VS4, 8, 10, 11-13, 18, 23, 14, 56, 57-62, 78 (Plates 18, 19, 20, 21, 22, 23, 25-7); Reynolds VP 29, 32-4, 95, 96, 111, 113, 117, 123, 141, 173 (Plates 23-5); Maas 110-113 (plates on pp. 112, 113, 114, 118).

***FROST, William Edward RA 1810-1877**

Painter of portraits, mythological and historical subjects. He was an early protégé of Etty's, and there is a reflection of Etty's style in his work. In 1829 he became a student at the RA, and exhibited there from 1836 to 1878, and was awarded the gold medal in 1839 for his 'Prometheus Bound by Force and Strength'. In 1843 he won a £200 prize in the Houses of Parliament competition for 'Una alarmed by the Fauns and Satyrs'. These successes led him to leave portraiture for subjects of a sylvan and bacchanalian character, drawn chiefly from Spenser and Milton. 'Diana and Actaeon ' led to his election as an associate in 1846. 'Una', from Spenser's *Faerie Queen* was bought by Queen Victoria in 1847. He became an RA in 1870, his diploma work being a 'Nymph and Cupid'. His studio sale was held at Christie's on March 14, 1878.

Prices during the 1968-9 season ranged from £105 to £380.

Bibl: Sandby, History of the RA 1862, 11, 219 ff; AJ, 1849, 184; 1856, 4; 1857. 5 ff; 1858, 4; 1866, 76; 1877, 234, 280; DNB; Maas, 168.

FULLEYLOVE, John RI 1845-1908

Leicester painter of landscape and views of buildings in Greece, Rome, Venice, Jerusalem, etc., and genre. Also a book illustrator for A. and C. Black. A friend of Thomas Collier (q.v.). He exhib. in London from 1871-1904, at the RA (1873-1904), SS, and at the RI, and other galleries.

'The Acropolis, Athens' sold at Sotheby's 27.6.68 for £300.

Bibl: Studio Vol. 7, p.77 ff; Vol. 25, 199; Summer No. 1900; Sketchley, *English Book Illustration of Today,* 1903; DNB

FURSE, Charles Wellington ARA 1868-1904

Painter of portraits and figure subjects, influenced by Whistler and Sargent; lecturer and writer on art. His brother was the sculptor John H.M. Furse. Studied at the Slade School under Legros, 1884, in Paris at the Academie Julian, and at the Westminster School of Art under Fred Brown. Exhib. at the RA from 1888; NEAC and New Gallery from 1891; member of NEAC 1892. Painted decorations in the Town Hall, Liverpool, 1899-1901. ARA, 1904. Died of tuberculosis. Memorial exhibition at the Burlington Fine Arts Club, 1906. 'The Return from the Ride', 1902, and 'Diana of the Uplands', 1903-4, are in the Tate Gallery.

'A Scene in the Boer War' sold at Christie's 29.7.66 for £168.

Bibl: AJ 1893, 158; 1904, 79, 182, 189, 381, 396; 1905, 143, 353; 1906, 37; 1908, 144, 146; 1909, 82 (plates); Studio Vol. 1, 33, 124; Vol. 6, 215 (plates); 62 (1914) 96, 102; 65 (1915) 128, 204; Magazine of Art, 1904, 438; Burlington Fine Arts Club, D.S. MacColl, *Illustrated Memoir of Charles Wellington Furse, ARA,* 1908; DNB, Suppl. II; *Illustrated London News,* 1914, vol. 145, 65 (plate); Dame Katharine Furse, *Hearts and Pomegranates,* 1940; Tate Cat.

GADSBY, William H. RBA fl.1869-1893

London painter of domestic genre, who exhibited from 1869-93, mainly at the BI (73 works), and at the RA from 1869-1880, 5 works - titles including 'A Girl and Kitten', 'In the Apple Room', etc.

Probable price range £50-150

*** GALE, William 1823-1909**

London painter of historical and biblical genre. Also painted portraits, mythological subjects, and scenes of life in the Orient. Student of the RA schools. Travelled in Italy 1851, Syria 1862, Palestine 1867, and Algeria 1876-7. Exhib. at RA 1844-93, BI, and SS. A work by him is in the Glasgow AG. In his early period he also painted several charming genre scenes in Pre-Raphaelite style. A typical one of this type is in the Tate.

Probable price range £100-300

Bibl: J. Dafforne in AJ 1869, p.373ff (mono, with illustrations); 1859, p.162, 163, 166; Clement and Hutton.

GALLON, Robert fl.1868-1903

London landscape painter, who exhibited from 1868-1903 in London, at the RA (32), (from 1873-1903), and at the BI (27), titles being generally landscapes in England, Wales and Scotland.

Prices in the 1968-9 season ranged from £160 to £290.

GALLON, Robert Samuel Ennis fl.1830-1868

London genre and portrait painter, and lithographer. Father of Robert Gallon (q.v.). Exhib. at RA 1830-68, BI and SS. In 1847, he drew a lithograph portrait of the opera singer Marietta Alboni.

Probable price range £50-100

Bibl: B.M. cat of England Brit. Portraits 1908 IV 287.

GARLAND, Charles Trevor　　**fl.1874-1901**

London painter of genre and children, portraits and landscape, who exhibited from 1874-1901, at the RA (19), and from 1875-1901 at the BI (19), titles including 'In Heart-thrilling Meditation Lost', 'Sunny Days', 'Good-bye sweetheart' (in 1885 and 1901). The AJ illustrates 'The Rivals' — children in Cromwellian costume.

'Children in the Snow' sold at Bonham's 6.3.69 for £100.

Bibl: AJ, 1884, 264 (plate)

***GARLAND, Henry**　　**fl.1854-1890**

Painter of landscape and genre. Lived in Winchester and London. Exhib. at RA 1854-90, BI and SS. Works by him are in Leicester, York and Sunderland Art Galleries. Also recorded as living in Winchester are T. Valentine, Valentine Thomas and William Garland, all painters of domestic genre. Graves's Dictionary lists T. Valentine, Valentine Thomas (q.v.) and T.W. Garland separately, but it seems probable that they are all the same artist.

Probable price range £100-300

GARLAND, Valentine Thomas　　**fl.1884-1903**

Painter of animals; lived in Winchester and London. Exhib. at RA from 1868, SS and NWS. Titles at RA 'Forty Winks' 'A British Workman' 'The Sunshine of Life' etc. Graves's dictionary also lists a T. Valentine and a T.W. Garland; these are both probably mistakes for Valentine Thomas.

'Puppies at Play' sold at Christie's 7.11.69 for £105.

GASTINEAU, Henry G.　　**c.1791-1876**

Landscape and topographical water-colourist, his work "technically accomplished but not particularly original" (Hardie). Student at the RA; began his career as an engraver but soon gave this up, first starting painting in oils, and then turning exclusively to watercolour. Exhib. 26 works at the RA, 1812-30; elected A. of the OWS, 1821, and Member 1823, exhibited 1,310 drawings there, 1818-75; also 3 works at the BI, 1816, 1819, 1841. Spent much time in teaching. From 1833 many of his drawings were engraved for books on English topography. He was one of the last artists to work in the old school of picturesque topography and his landscapes are mainly stock picturesque subjects in England, Scotland and Wales. He also visited Belgium, Switzerland and the Italian Lakes, and after 1838 painted a number of subjects in Ireland, notably the coast of Antrim. ('Near Trim, Co. Meath') VAM.

Probable price range £50-100

Bibl: AJ, 1876, 106 (obituary); Builder, 1876, 108; Redgrave Dict; Year's Art, 1885; Roget; Cundall; DNB; Hughes; VAM; Hardie III, 40, 150, 160 (fig. 182).

GASTINEAU, Miss Maria G.　　**fl.1855-1889, d.1890**

Landscape watercolourist. Daughter of H.G. Gastineau (q.v.).

Probable price range £20-50

GAULD, David　RSA　　**1865-1936**

Glasgow painter of cattle and landscape, decorative portraits and allegorical subjects. Apprenticed to a Glasgow lithographer; first attracted attention through a series of clever pen drawings illustrating stories and verses, which appeared in the *Glasgow Weekly Citizen* in the late 1880's, then he turned to designing stained glass. As a painter he produced paintings of wood-nymphs, dryads or girls loitering by streams or wandering in summer woodlands, and also decorative portraits of girls' heads with flowers or wavering leaves as a setting. But he first made his mark as a painter of cattle and landscape, and developed into a specialist in painting Ayrshire calves. Gauld

himself said that the two main influences on his work were Rossetti and James Maris.

'Dutch Landscape with Cows' sold at Morrison McChlery, Glasgow, 6.12.68 for £110.

Bibl: AJ, 1909, 153; Studio, Vol. 25, 207 (plate); Vol. 29, 298; Vol. 31, 163; Vol. 63; 117; Vol. 66, 103, 105; Martin, *The Glasgow School of Painting*, 1902, p.14ff; Caw, 442, 450-1.

GENDALL, John　　**1790-1865**

Topographer, landscape painter and engraver. Born on Exe Island, Exeter, he became servant to Mr. White of Exeter. Recommended by White to Sir J. Soane, he was introduced by Soane to Ackerman who employed him for some years as a draughtsman, lithographer and manager. Among works which Gendall himself illustrated were 'Picturesque Views of the Seine', 1821, and 'Views of County Seats', 1823-8. He exhibited at the RA from 1818-63, all landscapes in Devon.

'A View of the City of London' sold at Christie's 15.5.64 for £756. A watercolour of 'Chelsea Hospital from the River' sold at Christie's 3.3.70 for £336.

Bibl: Redgrave, Dict; G. Pycroft, *Art in Devonshire*, 1883; Binyon; Cundall; DNB; VAM; Prideaux, *Aquatint Engraving*, 1909, 375, 377; Hardie, III, 28 (fig. 36)

GIBB, Robert　RSA　　**1845-1932**

Painter of romantic, historical and military subjects, who became famous for his painting 'The Thin Red Line' (an infantry line facing a cavalry charge). His earlier paintings are more romantic, eg. 'Death of Marmion', 1873; 'The Bridge of Sighs', 1877; in 1878 he started upon military themes: 'Comrades', 'The Retreat from Moscow', and in 1881, 'The Thin Red Line' which was a great success at the RSA. He painted especially the infantry. He exhibited 5 works only at the RA, from 1882-93. He also painted portraits. His elder brother was William Gibb, (1839-1929), watercolourist and lithographer, who painted with great clarity — relics, goldsmith's work etc. — his work being the counterpart of Jacquemart's etchings in France.

Probable price range £100-200; or more for an important military subject.

Bibl: AJ, 1897, 25ff. (with plates); Studio Vol. 65, 204; Caw, 214, 266-7, 289, 474, 480 (fig. opp. p.266); Who's Who, 1914; Hardie, III, 195.

GILBERT, Arthur　　**1819-1895**

London landscape painter, who exhibited from 1838-94, at the RA (48), from 1842-1894, at the BI (51), and at SS (111). Titles at the RA include river scenes, moonlight and twilight scenes, (and from 1874 a few Egyptian landscapes.) Like Henry J. Boddington (q.v.) A.G. Williams changed his name to Arthur Gilbert, to avoid confusion with other members of the Williams family. He was the fourth son of Edward Williams (q.v.).

'Pastoral River Landscape' sold at Christie's 10.10.69 for £105.

Bibl: *The Williams Family*, Exhib. at N.R. Omell Gallery, London April 1971

*** GILBERT, Sir John　RA PRWS**　　**1817-1897**

Painter and watercolourist of historical genre, successor to the sentimental and romantic tradition of George Cattermole (q.v.). In 1836 he gave up his career as an estate agent to take up painting. At first he worked mainly as an illustrator, at which he was immensely prolific. He illustrated about 150 books, and contributed nearly 30,000 illustrations to *The Illustrated London News*. After 1851 he devoted himself mainly to watercolours. Elected Associate of OWS 1852, member 1854, President 1871. Knighted 1872, and elected ARA, RA 1876. Gilbert exhib. oils at the RA 1838-97, and at BI and SS, but his oil paintings fall far short of his watercolours in quality. In

spite of the enormous bulk of his output, his works display an extraordinary facility and fertility of pictorial invention.

'Dirk Hatteraick and the Gipsies' sold at Sotheby's 12.2.69 for £120.

Bibl: Ruskin, *Notes on the OWS*, 1856; Roget; Binyon; Cundall; DNB; VAM; R. Davies, *Sir John Gilbert*, OWS Vol. X; Richard Ormond in Country Life, August 18-25, 1966; Hardie III, 94-6 (pl. 115-116); Maas 232.

GILBERT, John Graham RSA 1794-1866
Glasgow portrait, biblical, and genre painter. Born John Graham. Studied at RA schools; travelled in Italy for two years. Settled first in Edinburgh, and after 1834, in Glasgow. Exhib. at RA 1844-64. President of the West of Scotland Academy, and one of the founders of the Glasgow Art Institute. His portraits follow the tradition of Raeburn. He also painted biblical and genre scenes, which show the influence of the Italian Old Masters, of which he was a notable collector.

'Crossing the Brook' sold at Morrison McChlery (Glasgow) 6.12.68 for £130.

Bibl: Portfolio 1887 p.139; DNB; AJ 1886 p.217; Redgrave, Dict; Caw 85-87 (plate opp. p.86).

GILBERT, Miss O.P.
Genre painter, living in Blackheath, who exhibited from 1862-91 at SS. Very little known.

Probable price range £30-70.

GILES, Godfrey Douglas 1857-c.1914
Newmarket painter of horses, military scenes, and battles. Born in India. Served with army in India, Afghanistan and Egypt. Studied in Paris with Carolus Duran. Exhib. at RA 1884-88 and elsewhere.

Probable price range £50-150

Bibl: AJ 1901 p.38; Who's Who 1914.

GILES, James William RSA 1801-1870
Aberdeen landscape, sporting and animal painter. Specialised in angling scenes, and pictures of fish; also in studies of deer in Highland landscapes. Travelled in Italy. Exhib. mainly at BI and SS, only twice at RA in 1830 and 1854. Many of his works are in the Aberdeen AG.

Probable price range £50-200

Bibl: AJ 1870 p.343; Caw 146, 198; DNB XXI (1890).

GILL, Edmund 1820-1894
London landscape painter. Often mistakenly called Edward Gill. Lived in Ludlow and Hereford. In 1841 met David Cox (q.v.) in Birmingham, whose work had a lasting influence on him. Exhib. at RA 1842-86, BI and SS. Subjects mainly Wales and Scotland. Especially fond of painting waterfalls, which earned him the nickname of Waterfall Gill.

'Lake District View' sold at Sotheby's 4.6.69 for £380.

Bibl: AJ 1874 p.41 ff (mono. with plates); Binyon.

GILL, William fl.1826-1869
Portrait and genre painter, living in London and Leamington, who exhibited from 1826-69, at the RA (18), from 1827-54, at the BI (22), and at SS (46). Titles at the RA include 'Listening to the Violin', 'Blowing Bubbles' etc. Gill's work, like that of Webster and the Cranbrook Colony, was a continuation of the genre tradition of David Wilkie.

'The Dead Bird' sold at Christie's (Glasgow Sale) 3.4.69 for £210.

GILL, W.W. fl.1854-1867
Ludlow landscape painter who exhibited from 1854-67, at the BI (5), and at SS (4). Titles at the BI are mostly of topographical views of castles.

'Woodland Scene near Dounton Castle, near Ludlow' sold at Christie's 14.3.69 for £168.

GILLIES, Miss Margaret 1803-1887
Painter of genre and miniature portraits. Niece of Lord Gillies, an Edinburgh judge, and brought up by him in an artistic and literary society, meeting Sir Walter Scott, Jeffrey and Lord Eldon. Then she resolved to try to be an artist in London, and received instruction from Frederick Cruickshank in miniature painting. Before she was 24, she was commissioned to paint a miniature of Wordsworth, and she also painted Dickens, and from 1832-61 contributed portraits to the RA. In 1851 she went to Paris and studied under Ary Scheffer. On her return she exhibited from time to time portraits in oil, but soon turned exclusively to painting in water-colour, usually domestic, romantic or sentimental subjects, and it is on these that her chief distinction rests. In 1852 became an A of the OWS and was a constant exhibitor there till her death. Hardie illustrates a charming watercolour, 'June in the Country', signed MG.

Probable price range £50-100

Bibl: Clayton, II, 87 ff; The Times, 1887, 26 July; Mary Howitt, *An Autobiography*, 1889, ii; Roget; Cundall; DNB; VAM; BM Cat. of Drawings, II, 1900; Cust., NPG, II, 1902; BM Cat. of Engr. Brit. Portr., II, 1910, 670; III, 1912, 178; IV, 1914, 542; Hardie, III, 199-1, (fig. 124).

GLASS, James W. 1825-1857
American military and portrait painter who exhibited at the RA from 1848-55, at the BI, and at SS. In 1845 he became a pupil of Huntington in New York, going to London in 1847 where he studied and painted for some years. He returned to America in 1856. His 'Last Return from Duty', an equestrian portrait of the Duke of Wellington, first brought him to the public's notice in England. It was bought by Lord Ellesmere and a duplicate was ordered by the Queen. Among his works are 'The Battle of Naseby', 'The Royal Standard' and 'Puritan and Cavalier'. He was particularly good at drawing horses. Graves (R.Acad.) lists two exhibits of 1847 and 1859 as being by a J. Glass of Edinburgh, but this is probably a different artist.

Probable price range £100-200

Bibl: Tuckerman, Book of the Artists, 1867, 421; Clement and Hutton.

GLENDENING, Alfred Augustus fl.1861-1903
London landscape painter, who began life as a railway clerk. Exhib. at RA 1865-1903, BI and SS. Titles include views on the Thames, in the southern counties, Wales and Scotland. His son and pupil was Alfred G. junior (q.v.).

Prices in the 1968-9 season ranged from £110-377.

Bibl: Pavière, *Landscape Painters* (plate 24)

GLENDENING, Alfred, Junior RBA fl. 1881-1905 d.1907
London landscape and genre painter, son of Alfred G., Senior (q.v.). Exhib. at RA 1881-1904 and SS. His picture of 'Haymaking' (RA 1898) was bought by the Chantrey Bequest. Later worked as a theatrical scenery painter.

'In Nature's Garden' sold at Sotheby's 4.6.69 for £120.

GLENNIE, George F. fl.1861-1882
London landscape painter who exhibited from 1861-1882, at the RA from 1861-74 (6), at SS (10) elsewhere (75).

Probable price range £30-70

GLINDONI, Henry Gillard RBA ARWS b.1852 fl.1872-1904
London genre and historical painter, who exhibited from 1872-1904, at the RA, (1873-1904) SS, and the OWS. His genre scenes are usually costume pieces of the 17th and 18th centuries. Also painted Cardinals.

'The Broken Contract' sold at Bonham's 21.11.68 for £210.

Bibl: RA Pictures, 1900, 1902-4.

GODDARD, George Bouverie 1832-1886
Sporting and animal painter. Born in Salisbury. Received no training, but came to London in 1849 and spent about two years making studies of animal life at the Zoological Gardens. During this time he supported himself mainly by drawing sporting subjects for 'Punch' and other periodicals. He then returned to Salisbury, where he received many commissions, but finding his sphere of work too limited he settled in London in, 1857. He began to exhibit at the RA in 1856 with 'Hunters', and continued to exhibit until 1886. His first work of note was 'The Tournament' in 1870. In 1875 he exhibited a large picture, 14 ft. long, representing 'Lord Wolverton's Bloodhounds', which was highly praised in Whyte-Melville's, *Riding Recollections*. In 1879 he sent in 'The Struggle for Existence' which is now in the Walker Gallery, Liverpool.

Probable price range £50-200

Bibl: AJ, 1886, p.158 (obit); Times, 18 and 29 March, 1886; DNB.

GODDARD, James fl. 1800-1855
London flower painter who exhibited at the RA from 1800-55, and also at the BI and SS. His brother, J. Goddard, was a miniature painter, who exhibited at the RA from 1811-42.

Probable price range £30-70

GODET, Julius fl.1844-1884
London landscape painter who exhibited from 1844-84, at the RA (16) from 1852-1876, at the BI (40), and at SS (51).

Probable price range £30-70

GODWARD, John William RBA fl.1887-1905
London painter of classical genre scenes; imitator of Lawrence Alma-Tadema (q.v.), with whom his work is sometimes confused. Exhib. at RA from 1887 and SS. Subjects usually pretty girls wearing filmy robes, reclining in marble interiors e.g. 'A Pompeian Bath' etc.

Prices in the 1968-9 season ranged from £100-300

GOFF, Frederick E.J. fl.1890-1900
London topographical painter, mostly in watercolour. Exhib. at RA in 1900, and NWS. Best known for his small watercolour views of London, which catch the mood of the late-Victorian city.

Average prices are usually around £10-30

GOLDIE, Charles fl.1858-1879
London painter of genre and historical subjects, who exhibited at the RA from 1858-79, titles including 'Joan of Arc', 'The Trial of St. Perpetua', 'Louis XVII and the Sparrows in the Temple'. In 1859 he exhibited 'The Monk Felix', (a single figure of a monk) upon which the AJ commented "A figure picture without a face is usually considered an impossibility; yet this is one". He also exhibited at the BI (6) and SS (11).

Probable price range £50-150

Bibl: AJ, 1859, 81, 166-7

GOLDSMITH, Walter H. fl.1880-1898
Landscape painter, living in Maidenhead, who exhibited from 1880-98 at the RA (15), and at SS (24). Very little known.

Probable price range £30-70

*** GOOD, Thomas Sword 1789-1872**
Berwick painter of domestic genre. Pupil of Wilkie. Exhib. at RA 1820-33, BI 1823-1834, and SS. Fond of painting fisherfolk and coastal scenes around Berwick. In 1830 he inherited a legacy, and soon after gave up painting.

'Coachmen in a Tavern' sold at Christie's 2.4.69 for £294

Bibl: AJ 1852 p.94; 1901 p.293; Redgrave, Dict.; DNB XXII; Poynter, The National Gall. 1899-1900 III; Cust., The Nat. Portr. Gall. 1901-2 II 12.

GOODALL, Edward Alfred RWS 1819-1908
London painter and watercolourist of continental views and battle scenes. Son of Edward Goodall, an engraver, and brother of Frederick Goodall (q.v.). Accompanied the Schomburgh Guiana Boundary Expedition in 1841; in 1854 visited the Crimea as artist for the *Illustrated London News*. Travelled in Morocco, Spain, Portugal and Italy. Exhib. at RA 1841-1884, BI SS and OWS. Elected associate 1858, member 1864 of OWS. Hardie calls him Edward Angelo G. His studio sale was held at Christie's on Nov. 30, 1908.

A watercolour 'View of Venice' sold at Sotheby's 23.10.69 for £110

Bibl: AJ 1859 p.173; 1908 p.187; Redgrave, Dict.; Clement and Hutton; Roget; Cundall; VAM; Huish; Hardie III 164 (plate 195).

*** GOODALL, Frederick RA 1822-1904**
London painter of landscapes, genre and Egyptian subjects. Son of Edward Goodall, an engraver, and brother of Edward Alfred G. (q.v.). Won a silver medal at the Society of Arts in 1837, at the age of 14. In 1843 he toured Ireland with F.W. Topham (q.v.). His early works are mainly genre and peasant scenes in the Wilkie tradition, but later he specialised in views of Egypt, scenes of Egyptian life, and biblical genre. Elected ARA 1852, RA 1863. Two of his sons, Frederick Trevelyan and Herbert H. Goodall, were painters.

Prices in the 1968-9 season ranged from £100-350. An early Pre-Raphaelite style work would be worth more.

Bibl: AJ 1850 p.213 (autobiog.); 1855, p.109 ff (Biog.); 1850 p.167; 1862 p.46; 1895 p.216; 1904 p.301 f.303; Ruskin, Academy Notes 1859, 1875; Roget; Binyon; Reminiscences of Frederick Goodall, 1902; Cundall; VAM; Reynolds VP 111, 144, 180 (plates 67, 98); Hardie III 164; Maas 97, 155, 184 (plates on p.97, 160).

GOODALL, Thomas F. fl.1875-1901
London painter of landscapes, coastal scenes and rustic genre. Not apparently related to the other Goodalls. Exhib. at RA 1879-1901, SS, GG and NG. A picture by him is in the Walker A.G., Liverpool.

Probable price range £100-200

GOODE, Miss Louise See JOPLING, Mrs. J.M.

GOODEN, James Chisholm fl.1835-75
Marine and landscape painter. Friend and sketching companion of W.J. Muller (q.v.) on trips down the Thames and elsewhere. He painted landscapes but was chiefly interested in marine subjects, and compiled the *Thames and Medway Admiralty Surveys*, 1864. Hardie notes that "he drew boats with much skill and his sketches made among the tidal waters of estuaries have considerable charm". He exhibited from 1835-65, at the RA (3) from 1835-46, at the BI (9) and at SS (17).

Probable price range £50-100

Bibl: Roget, II, 234-7, 314; VAM; Hardie, III, 59-60, 62, 81 (fig. 77).

GOODERSON, Thomas Youngman fl.1846-1860
Portrait and genre painter, who exhibited from 1846-60 at the RA
(21), at the BI (14), and at SS (24). Very little known.

Probable price range £30-70

Bibl: AJ, 1859, 167; Cust. NPG, II (1902).

GOODMAN, Miss Maude (Mrs. Scanes) fl.1874-1901
London painter of genre and humorous pictures of children. Exhib. at
RA 1874-1901, BI, NWS and GG. Titles 'A Little Coquette' 'Don't
Tell', 'Like this, Grannie' etc.

'The Critics' (RA 1895) sold at Christie's 11.7.69 for £231.

Bibl: AJ 1889 p.200; RA Pictures 1892, 1893.

*** GOODWIN, Albert RWS 1845-1932**
Painter in oils and water-colour of landscapes, and of biblical, alle-
gorical and imaginative subjects. Ardent follower of J.M.W. Turner.
First exhibited at the RA in 1860, aged 15, with an oil painting
'Under the Hedge'. For a short time in the early 60's, was a pupil of
Arthur Hughes and Ford Madox Brown, and was introduced by the
former to Ruskin who took him on a trip to Italy in 1872, with
Arthur Severn, and employed him to copy objects. He travelled widely
in Europe, India, Egypt and the South Sea Islands. In 1871 he was
elected A. of the OWS, and in 1881 a full member. One-man shows of
his work were held at Messrs. Leggatt's Gallery in 1912, at the Vicars
Gallery in 1925; and at the Birmingham Art Gallery in 1926. He paid
great attention to effects of light and atmosphere, and Hardie notes
that "he can be counted as one of those who have successfully dealt
with twilight and sunset". He experimented with methods of sponging
and stippling and was one of the first to use a pen-line in combination
with watercolour wash. His early work was at first in oil, but later was
almost entirely in watercolour. Reynolds writes that "he painted in a
comparable stippling manner (to Birket Foster), but reached a higher
plane of poetry, even a hint of mystery". Often signed AG (in
monogram).

Prices during the 1969-70 season ranged from £100-578

Bibl: W.M. Rossetti in Portfolio, 1870, 118; 1886, 124; Studio, vol. 49 (1910),
84-97; vol. 31 (1904), 252 ff; vol. 35, 155; Redgrave, Dict.; Bryan; Caw; DNB;
VAM; The Diary of Albert Goodwin, 1934; Reynolds, V.P., 173, 177 (fig. 169);
Cat. of Paintings by A. Goodwin, RWS, Seal Galleries, Seal, Kent, June, 1968;
The Leathart Collection Cat. Exhibition at Laing AG Newcastle 1968; Hardie, III,
162-3 (fig. 188); Maas, 230-1.

GOODWIN, Harry fl.1867-1902
Maidstone landscape and genre painter who exhibited from 1867-1902,
at the RA (15) from 1868-1902 SS (27), and NW (17). Titles at the
RA include 'Arundel Castle', 'The First Spring Day', 'Venice in June',
and 'Old Servants of the State'.

Probable price range £20-50

GORDON, Sir John Watson RA PRSA 1788-1864
Scottish portrait painter. Studied at Trustees Academy. At first he
attempted genre and historical subjects, but soon discovered that his
talent was for portrait painting. His early style was closely modelled
on Raeburn, a friend as well as teacher. After Raeburn's death he
assumed the mantle of leading Scottish portrait painter. A prolific
worker, he exhib. 123 works at the RA, and many more at the RSA.
Elected ARA 1841, RA 1851, PRSA 1850. Later he evolved a more
personal style, and was a great admirer of Velasquez. "His portraiture,
whatever it lacks in brilliance, is simple, sincere, and, at its best, gravely
beautiful." (Caw).

'Portrait of Sir Archibald Alison' sold at Christie's 2.4.69 for £158.

Bibl: AJ 1850, p.373; 1864, 215; 1903, 301-4; Portfolio 1887, 138 f; Studio see
index; Redgrave; Dict.; Bryan; DNB; Caw 80-3 and passim (pl. p.82); Cat. of
Engraved Brit. Portraits BM VI (1925) 489; Reynolds VP; Maas.

GORDON, Robert James RBA fl.1871-1893
London genre painter who exhibited from 1871-93 at SS (88) and the
RA (22), titles including 'Souvenirs', 'Pet Parrot', 'Lady Teazle', and
'Good-night'.

Probable price range £30-70

GOSLING, William W. RBA 1824-1883
London painter of landscape and rustic genre who exhibited from
1849-83, at the RA (13) from 1851-83, at the BI (23), and at SS (176).
Member of the Society of British Artists. Titles at the RA include
'Grandad — a Rustic Incident', 'On the Thames', and 'A Hot Day in
the Harvest Field'. The AJ (1873) commented: "By William Gosling is
a landscape of remarkable power, when we look back and consider his
earlier performance. It is entitled 'Harvest Time at Hennerton'
(SS 1873) and shows a field of corn already yielding to
sickle. The expanse of golden grain is bounded by a dense wood; and
altogether the work is so much superior to others that have preceded
it, that this artist must be estimated among those who have greatly
advanced."

Probable price range £50-150

Bibl: AJ, 1873, May; Clement and Hutton; Bryan.

GOTCH, Thomas Cooper RBA RI 1854-1931
Painter of portraits, landscape and allegorical and realistic genre.
Studied at Heatherley's School; the Ecole des Beaux Arts, Antwerp;
the Slade School, and in Paris under J.P. Laurens. Visited Australia
in 1883. Lived first in London, then settled in 1887 at Newlyn, Corn-
wall, where he belonged to the Newlyn School of *plein-air* painters.
Exhibited at the RA from 1880, and at SS OWS NWS GG NG, Munich,
Paris and Chicago. Original member of NEAC, 1886; RBA, 1885;
RI, 1912. Founder of the Royal British Colonial Society of Artists,
1887 and President 1913-28. Retrospective exhibition at the Laing
Art Gallery, Newcastle, 1910. Chantrey Purchase, 'Alleluia', 1896.
His earlier work was naturalistic in the style of the Newlyn School.
After his visit to Italy in 1891, he turned to more symbolistic and
allegorical subjects, and a more decorative treatment, e.g. as seen in
'Alleluia'.

Probable price range £100-300

Bibl: AJ, 1889, 138; 1902, 211; 1903, 167; 1905, 356; Studio Vol. 13, 73-182
(monograph); Vol.26, 38; Vol.42, 55; Studio, Summer No., Art in 1898;
Portfolio, 1888, 103; Tate Cat.

GOULDSMITH, Miss Harriett (see Mrs. Arnold) 1786-1863
London landscape painter. Exhib. up to 1839 as Miss Harriett G.,
thereafter under her married name of Arnold.

GOW, Andrew Carrick RA RI 1848-1920
Painter of historical and military subjects, genre and portraits.
Exhibited at the RA from 1867 onwards, and at SS (3), NWS (48),
and GG (1), titles at the RA including 'The Tumult in the House of
Commons' March 2nd, 1629', 1877, 'Algerian Gossip', 1886, and
'Washington's Farewell to the Army', 1902. Elected ARA 1880;
RA 1890. Ruskin wrote of 'Loot, 1797' — "It is an entirely fine
picture of its class, representing an ordinary fact of war as it must
occur without any false sentiment or vulgar accent. Highly skilful
throughout, keenly seen, well painted." A large picture of Queen
Victoria at St. Paul's Cathedral on Diamond Jubilee Day is in the
Guildhall AG.

Probable price range £100-£200.

Bibl: Ruskin, Academy Notes, 1875; Clement & Hutton; RA Pictures, 1891 ff. Who's Who, 1914.

GOW, James RBA fl. 1852-1885

Painter of genre and historical subjects who exhibited from 1852-1884, at the BI (5) and at SS (60). Member of Society of British Artists. Titles at the RA include 'Rehearsing the School Task,' 'Preparing the Ark for the Infant Moses', and 'A Volunteer for Cromwell.'

Probable price range £30-£70.

GRACE, Alfred Fitzwalter RBA 1844-1903

Landscape and portrait painter. Studied art at Heatherley's and the RA School, where he won the Turner gold medal. Exhibited from 1865, at the RA (from 1867), at the BI (6), SS (81), NWS (10), GG (5) and NG (3). Member of the Society of British Artists. He lived at Steyning, Sussex, and his landscapes were particularly views of the South Downs. His portraits were often miniatures. Author of *A Course of Landscape Painting in Oils,* 1881. Friend of J.M. Whistler. His wife was Emily M. Grace, an enamel painter, who exhibited portraits at the RA from 1881-1888.

Probable price range £50-£150.

Bibl: AJ, 1904, 381.

GRACE, James Edward RBA 1851-1908

Landscape painter and illustrator, who exhibited from 1871-1903; at the RA from 1876-1903, at SS (158), at NWS (14), at GG (16) and at NG (16). Member of the Society of British Artists.

Probable price range £30-£100.

Bibl: Cundall, 215.

GRAHAM, Peter RA 1836-1921

Scottish painter of landscapes and coastal scenes. Pupil of the naturalistic school of R.S. Lauder in Edinburgh. Leapt to fame in 1866 with his first picture at the RA, 'A Spate', but his later work did not fulfil this early promise. In spite of this his desolate moorland scenes and stormy coastal scenes remained very popular. Exhibited at RA from 1866-1904. Elected ARA 1877, RA 1881. Titles 'After Rain' 'Seagirt Crags' 'Lonely sea-cliffs Where the Gannet Finds a Home' etc. Sometimes signed with a symbol (see monogram index).

'The Angry Sea' (1888) sold at Edmistons (Glasgow) 19.2.69 for £130.

Bibl: Portfolio 1887 Nov; Mag. of Art II 144; AJ Christmas Art Annual 1899; Caw 255-6 (plate opp. p. 254).

*GRAHAM, Thomas Alexander Ferguson HRSA 1840-1906

Scottish painter of fishing and country life, and later, of portraits. Entered the Trustees Academy in 1855, and soon took a prominent place in the brilliant group trained by R.S. Lauder — Orchardson, Pettie, Chalmers and McTaggart. He began to exhibit at the RSA in 1859, but in 1863 he joined Orchardson and Pettie in London. He spent more time abroad than his associates: in 1860 he went to Paris with McTaggart and Pettie and in 1862 visited Brittany. In 1864 he was in Venice, and in 1885, in Morocco where he painted 'Kismet' and other oriental subjects. But the wild west coast of Scotland, and the Fifeshire fishing villages were his favourite sketching grounds. 'A Young Bohemian', 1864 (Nat. Gall. of Scotland) is an example of his early work, and shows the influence of the PR's, and especially Millais, which is in his work of the 1860's. He exhibited at the RA from 1863-1904; and was made an Hon. member of the RSA in 1883. He was exceptionally handsome and was the model for the angry husband in 'The First Cloud'. and also appears in Pettie's 'The Jacobites'. Reynolds notes that "although of a finer sensibility than his fellow students in Edinburgh, he did not achieve the same official

successes. Yet, as 'The Landing Stage' shows, he was capable of combining the observation of human emotion with a purely painterly approach to its physical setting."

No important works have appeared recently at auction. The probable range would be £100-300 for a minor work; perhaps more for a major one.

Bibl: AJ: 1873, 208 (plate); 1874, 356 (plate); 1901, 92 (plate); 1902, 216 (plate); 1907, 36 (obit.); Studio Vol. 40, 87 (plates); Portfolio, 1887, 233; 1896, No. 14, 6 (plate); VAM, Cat. of Oil Paintings, 1907; Caw, 244, 258-9, 479; DNB; Reynolds, V.P., 193, 194 (pl. 128); Maas, 252, (fig. 253).

* GRANT, Sir Francis PRA 1803-1878

Painter of portraits and hunting scenes. Born the younger son of the laird of Kilgraston, Perthshire, Grant at first painted as an amateur. In the 1830's he took up painting as a profession. His social connections and flattering portrait style ensured a quick success, and in 1840 his portrait of Queen Victoria and Melbourne riding in Windsor Park made him the most fashionable portrait painter of the day. Among his other sitters were Palmerston, Macaulay, and Landseer. His wife was a niece of the Duke of Rutland, and he spent much time painting around Melton Mowbray. His pictures of the Melton Hunt became well-known through engravings. Exhib. at RA 1834-79, BI and SS. Elected ARA 1842, RA 1851, PRA 1866. His studio sale was held at Christie's on March 28, 1879.

The highest recent auction price was 'Lt. Gen. James Keith Fraser as a Young Man on a Pony' sold at Christie's 16. 7. 65 for £2,730. Average prices are usually in the £200-500 range.

Bibl: Portfolio 1887 p. 139 f; AJ 1878 p. 232; Redgrave, Dict., 1878 Supp; Caw 176-7; DNB XXII, 386; John Steegman, Sir F.G. PRA. Apollo Jun. 1964; Reynolds VP 94, 173 (plate 171); Maas 72-3, 213, 215 (plates on p. 73, 218).

GRANT, William James 1829-1866

London historical genre painter. Studied at RA schools. Exhib. at RA 1847-66, and BI. Titles 'The Last Trial of Madame Palissy' 'A Legend of the White Rose' 'Katherine Parr' etc. His works showed considerable talent, but his career was cut short in 1866 when he died at the age of 37.

'The Tower, February 1553: Last Relics of Lady Jane Grey' sold at Christie's 11.10.68 for £157.

Bibl: AJ 1864 p. 233-35; 1866 p. 217 (obit.); Redgrave, Dict.

GRAVES, Hon. Henry Richard fl.1846-1881

Portrait painter who exhibited at the RA from 1846-1881. His sitters included many of the aristocracy, and he also painted several members of the Royal Family, Princess Louise and Princess Beatrice, by Royal Command.

Probable price range £30-100

Bibl: Cat. Exhib. Portr. Min., London 1865; Cat. Engr. Brit. Portr. BM, II, 168; III, 587; Cat. Milit. Prints, London, 1914 (T.H. Parker Bros.).

GRAY, H. Barnard fl.1844-1871

Landscape and sporting painter who exhibited from 1844-71, at the BI, RA (from 1845-63), at SS and elsewhere. Titles at the RA include, in 1850, 'The Britannia Tubular Bridge across the Menai Straits,' from sketches made on the spot.

Probable price range £50-150

Bibl: AJ, 1859, 121, 171

* GREAVES, Walter 1846-1930

Painter of landscape and river scenes. Son of a Chelsea boat-builder who used to ferry Turner across the river; Walter and his brother Harry

also performed this service for Whistler, and in about 1863 became his unpaid studio assistants and pupils. They adored Whistler, accompanied him where he went, imitated his dress and manner, made the frames for his canvases, bought his materials and prepared his colours. Walter said: "He taught us to paint, and we taught him the waterman's jerk." Most of Greaves' paintings were imitations of Whistler's, but his remark "To Mr. Whistler a boat is always a tone, to us it was always a boat" shows that he recognised their difference in outlook. His reputation was established by an exhibition at the Goupil Gallery in 1911. In 1922 he was admitted to the Charterhouse, where he died.

'Battersea Bridge from Chelsea Reach' sold at Sotheby's 23.4.69 for £280.

Bibl: Studio Vol. 53, 1911, 65, 144-8, plates; E.R. and J. Pennell, *The Life of James McNeill Whistler*, 1908, 1, 88, 106-8, 126, 137, 138, 164, 165, 168, 171, 175-6, 179, 185, 188, 204; Cat. Toledo Museum (USA), 1914; W.R. Sickert, *A Free House*, 1947, p. 28-32 (essay first appeared in *The New Age*, 15th June, 1911); Reynolds, VS, 101-2 (fig. 103); Maas, 247.

GREAVES, William fl.1885-1900
Leeds landscape painter, who exhibited from 1885-1900 at the RA — landscapes and woodland scenes, some in Sherwood Forest. Very little known.

Probable price range £30-70

GREEN, Benjamin Richard RI 1808-1876
Water-colour painter and illustrator. Son of James Green, the portrait painter. Studied at the RA schools, and painted both figures and landscapes, mostly in water-colour. 1834 elected member of the Institute of Painters in Water-colours. He was also employed as a teacher and lecturer. Exhibited at the RA from 1837-58 (all miniature portraits), NWS (243), and SS (38). In 1829 he published a numismatic atlas of ancient history, executed in lithography; he also published works on perspective, a lecture on ancient coins, and a series of heads from the antique.

Probable price range £20-50

Bibl: AJ, 1877, 20; Arnold's Magazine of Fine Arts, 1, 1833, 532; Redgrave Dict.; Univ. Cat. of Books on Art, V & A, 1870; Bryan; DNB; BM Cat. of English Book Sales, 1915.

GREEN, Charles RI 1840-1898
Watercolour painter of genre and historical subjects, and illustrator. Starting under Whymper, he worked for *Once a Week* and other periodicals, and became one of the most successful of the b. and w. draughtsmen of his time, especially in his illustrations to Dickens. Some of these were turned into watercolours (e.g. 'Little Nell,' VAM, Hardie, fig. 163). As a watercolour painter he became A of the RI in 1864 and member in 1867. He exhibited from 1862-83 at the RA, all genre titles — 'The Rivals', 'The Letter Bag', 'Ruin', and 'The Girl I left Behind me', and at NWS (150). His elder brother was H. Towneley Green (1836-99), who also drew in black and white and painted in watercolour. (A of RI in 1875, member in 1879). A sale of both their works was held at Christie's on Jan. 13, 1900.

'Ruin' a large work, sold at Christie's 14. 11. 69 for £683.

Bibl: AJ, 1873, 141; 1908, 90-1; Studio Vol. 32, 286 (plate); Bryan; Cundall; Gleeson White; VAM Cat. of W.C. Painting, II, 1908; Hardie, III, 82, 96, 140, 152 (fig. 163)

GREEN, David fl.1879-1898
Landscape watercolourist, who exhibited from 1879-1898 at the RA, and also at SS (40), NWS (15), GG (4) and NG (1).

Probable price range £20-50

GREEN, H. Towneley, see under GREEN, Charles

GREGORY, Charles RWS fl.1877-1897
Painter of genre and historical subjects who exhibited from 1877-97 at the RA, and at SS (11), and OWS (94). Titles at the RA included 'Pensive Thoughts', 'The Conversion of Ancient Britons', and 'England, Home and Baby'.

'The Present' sold at Christie's 13.11.69 for £126.

Bibl: AJ 1882, 80 (plate); Portfolio 1887, 248

GREGORY, Edward John RA RI 1850-1909
Illustrator and painter of genre and portraits. Born in Southampton. Entered the drawing office of the P & O Steamship Co., but decided to become an artist, met Herkomer and came to London in 1869. Studied at the RCA and later at the RA Schools. Was employed on decorations at the V & A and from 1871-75 worked for *The Graphic*. Exhibited at the RI (A, 1871, Member 1876, PRI 1898-1909), NWS (55), GG (14), and at the RA from 1875 (ARA 1879, RA 1898). Visited the Continent and in 1882 stayed in Italy. 'Marooned', 1887, is in the Tate Gallery. His most famous work is 'Boulter's Lock: Sunday afternoon', 1898, which obtained for him his election as RA (now Lady Lever Art Gallery, Port Sunlight).

'The Pose' sold at Christie's 22.12.69 for £78.

Bibl: AJ 1895, 176; 1897, 162; 1905, 259; 1908, 292; 1909, 255; Studio 32 (1904) 61; Vol. 43, 311; Vol. 48, 87 ff; Magazine of Art, VII, 353; Gaz. des B. Arts, 1878, II, 314, 644, 727; 1879, II, 372, 374; Portfolio 1878, 161, 1883, 64; RA Pictures, 1891-5; 1897-1901; 1905; 1907-8; DNB; Reynolds, VS 105-6, (fig. 110); Tate Catalogue.

GREIFFENHAGEN, Maurice William 1862-c.1921
Painter and illustrator. Studied at RA schools. Began to exhib. at RA in 1884, also SS and elsewhere. Titles at RA mostly portraits, also allegorical figures in late Pre-Raphelite style e.g. 'An Idyll' 'The Mermaid' 'The Judgement of Paris' etc. He was also a prolific illustrator, best known for his illustrations of the novels of Rider Haggard. He also worked for such magazines as *The Lady's Pictorial* and *The Daily Chronicle*. After about 1900 he turned increasingly to portrait painting. In 1906 he taught at the Arts School in Glasgow. Between 1901 and 1912 he exhib. at many of the big international exhibitions, in Munich, Venice, Pittsburgh, etc.

'Naples', a gouache, sold at Christie's 18.7.69 for £126

Bibl: AJ 1890, p. 150; 1894, 225 f; Studio 9 p. 235 f; 63 p. 131, 260; 68 p. 40, 122, 69 p. 71; J. Pennell *Modern Illustration* 1895; R. Sketchley *English Book Illustration of Today* 1903; Who's Who 1921.

GRIMSHAW, Arthur 1868-1913
Very little-known son of Atkinson Grimshaw (q.v.). Painted moonlight scenes and winter landscapes in his father's style, but without the same technical mastery or poetic feeling. Not known to have exhibited in London. With the revival of interest in Atkinson Grimshaw, Arthur's work now occasionally appears on the London art market. He probably only painted around 1890-1900; he was also a composer, and organist at the Roman Catholic Church in Leeds.

Probable price range £50-150

* GRIMSHAW, John Atkinson 1836-1893
Leeds painter of landscapes, town views and dockyards, especially at sunset or by moonlight. Born the son of an ex-policeman, Grimshaw first began painting while working as a clerk for the Great Northern Railway. He encountered bitter opposition from his parents, but after his marriage in 1858 to Theodosia Hubbarde, a cousin of T.S. Cooper (q.v.), he was able to devote himself to painting. By 1870, he was successful enough to rent Knostrop Old Hall, a 17th century mansion near Temple Newsam, which features in many of his pictures. Later in the 70's he built a house near Scarborough, and in the 80's rented a

studio in Chelsea. Grimshaw painted mostly for private patrons, and exhib. only 5 works at the RA between 1874 and 1886, and one at the GG. The towns and docks that he painted most frequently were Glasgow, Liverpool, Leeds, Scarborough, Whitby and London. Grimshaw's style and subject matter changed little during his career; he strove constantly to perfect his own very individual vision. He was interested in photography, and sometimes used a camera obscura to project outlines on to canvas, enabling him to repeat compositions several times. He also mixed sand and other ingredients with his paint to get the effects he wanted. Although he established no school, Grimshaw's pictures were forged and imitated in his lifetime, notably by Wilfred Jenkins and H. Meegan. Even Whistler had to admit "I considered myself the inventor of Nocturnes until I saw Grimmy's moonlit pictures". Although his moonlit town views are his most popular works, his early pure landscapes are generally considered to be his finest. During his early period he signed "J.A. Grimshaw" but c.1867 dropped the John, and signed himself Atkinson Grimshaw. He usually signed his pictures on the front and the reverse, inscribed with the title. Two of his sons, Arthur and Louis, were also painters.

The record auction price for Grimshaw is £3,255 for a moonlit view of Scarborough sold at Christie's 5. 3. 71. Smaller pictures range from £500-£1,000, larger and more important works £1,000-£2,000. Moonlight pictures are usually more expensive than the 'autumn sunset' type.

Bibl: Reynolds VP 155 (plate 99); Catalogue of the Grimshaw Exhib. Ferrers Gallery 1964; Maas 202-3, 229-30 (plates on p. 204, 205, 229); J. Abdy *A.G.* 1970.

*** GRIMSHAW, Louis H. 1870-1943 (?)**
Son of Atkinson Grimshaw (q.v.). Painted moonlight town views in his father's style. Collaborated with his father on many pictures, Atkinson painting the sky and backgrounds, and Louis the figures. In 1905 Louis gave up painting for good, and became a cartographer for the *Manchester Guardian*. His work is consequently very rare. Most of his pictures are views of London, which were commissioned by a dealer called Jackson, but he also painted in other towns. About 1902 he painted a series of views of London, as it was decorated for the Coronation of King Edward VII.

'A View of the Royal Mile, Edinburgh,' by Louis G. sold at Christie's 11.7.69 for £683. Because of his rarity, an important work could be worth up to £2,000.

Bibl: see J.A. Grimshaw.

GRITTEN, Henry fl.1835-1849
London landscape and topographical painter who exhibited from 1835-49, at the RA from 1835-45, and also at BI (30) and SS (14).

'Calais Sands with Fort Rouge' sold at Phillips Son & Neale 16.6.69 for £280. 'A View of Tasmania' sold at Sotheby's 16.10.69 for £600. This higher price was obviously due to the Australian interest.

GUSH, William fl.1833-1874
Portrait painter, whose portraits were painted in the "keepsake" tradition — "aptly named" (Maas). He exhibited at the RA from 1833-74, titles including 'A Portrait — when She Speaks, her Soul is Shining through her Earnest Face', 1858, and at the BI (4), and SS (2). His female types are very similar to those of Charles Baxter (q.v.).

Probable price range £50-200

Bibl: L. Cust, NPG, II, 1902; Cat. Engr. Brit. Port, BM, 1908 ff., I-IV, passim; Cat. Art Museum, Nottingham, 1913, 59; Maas, 108, (fig. 109).

GUTHRIE, Sir James PRSA HRA RSW 1859-1930
Glasgow landscape and portrait painter. Gave up law in 1877 to take up painting. Met John Pettie and other Scottish painters in London 1879. After a visit to Paris in 1882, his work was strongly influenced by the *plein-air* ideas of Bastien-Lepage. Returning to Scotland, Guthrie continued to paint landscapes, together with George Henry, Crawhall, and others of the Glasgow School. In 1885 he took up portrait painting, at which he was very successful. President of Glasgow Art Club 1896-98, ARSA 1888, RSA 1892, PRSA 1902-1919, Knighted 1903. Member of NEAC and RSW.

'Study of a Cob' sold at Christie's 18.7.69 for £137.

Bibl: AJ 1894, 1903, 1909, 1911; Studio Vol. 54 (1912); Connoisseur 1930, Vol. 86; Catalogue of The Glasgow Boys Exhibition, Scottish Arts Council, 1968.

HAAG, Carl RWS 1820-1915
Painter and watercolourist of landscapes, portraits and Eastern subjects. Born at Erlangen, Bavaria. Studied Nuremberg and Munich. Worked in Brussels as miniature painter. Came to England 1847. Continued to paint miniature portraits, but in 1853 painted Swiss views, and then worked at Balmoral on two large pictures of stag-shooting. 1854 visited Dalmatia and Montenegro; 1858-60 travelled in Egypt and the Middle East, with Frederick Goodall (q.v.). His pictures of Eastern subjects brought him fame and prosperity. Elected ARWS 1850, RWS 1853. Exhib. at RA 1849-81, BI and OWS.

'House of Cards' sold at Christie's 11.10.68 for £157.

Bibl: AJ 1883 p.71; Portfolio 1878, p.81; 1882, 224; 1885, 245; Mag. of Art 1889 (Biog. with plates); Roget; VAM; Hardie III 67, 164.

HACKER, Arthur RA 1858-1919
Painter of portraits, genre and historical scenes. Studied at RA schools and with Bonnat in Paris. Exhib. at RA from 1878, BI, GG and NG. His early works mostly genre scenes e.g. 'Her Daughter's Legacy', but he soon became a very popular society portrait painter, to which he devoted most of his energies. He continued to paint occasional romantic genre subjects, such as 'Circe' 'Leaf Drift' etc. and views of London at night. His picture of 'The Annunciation' (RA 1892) was bought by the Chantrey Bequest.

'Evening' sold at Christie's 21.11.69 for £147.

Bibl: Studio Vol. 29, 45; Vol. 32, 39; Vol. 38, 16; Vol. 41, 43; Vol. 43, 26; Vol. 44, 33, 39; Vol. 46, 175-82; Vol. 68, 40, 50; Connoisseur Vol. 28, 207; Vol. 36, 58; Tate Cat.

HAGHE, Louis HPRI 1806-1885
Painter and watercolourist of continental views and historical genre. Born Tournai, Belgium. His right hand was deformed, and he worked with his left. Studied lithography; came to London and worked for Day and Son, who published lithographs for David Roberts. From 1840-52 Haghe published many volumes of his own lithographs, all topographical views. After 1852 he devoted himself completely to watercolours. Exhib. at BI and NWS; President of NWS 1873-84. His favourite subjects were scenes in the old towns of Belgium and Germany, and cathedral interiors.

'Interior of Church of St. Anne, Bruges' — a watercolour — sold at Christie's 6.5.66 for £52.

Bibl: AJ 1859, p.13ff; Redgrave, Cent.; Binyon; Cundall; DNB; Hughes; Hardie III 93 (plate 114).

HAGUE, Anderson RI RBA PRCA b.1850 fl.1873-1893
Landscape painter and watercolourist. Studied at Manchester Art School. Lived mostly in N. Wales, exhib. at RA from 1873, SS, NWS, GG and NG. President of the Royal Cambrian Academy. Hague's landscapes, which are similar in feeling to those of Aumonier (q.v.), are quiet, pastoral scenes, painted in a broad technique. His works can be seen in Manchester and Liverpool A.G.

'Children and Cattle in a Pasture' sold at Christie's 17.1.69 for £147.

Bibl: AJ 1895 p.284

HAINES, William Henry 1812-1884
London genre painter. At first a picture restorer, Haines exhibited genre scenes, landscapes, and views of London and Venice at the RA 1848-81, BI and SS. He often used the pseudonym William Henry. He is also known to have painted views of Venice in the manner of Canaletto and Guardi, which were passed off as originals.

'Saint Mark's Square, Venice' sold at Sotheby's 12.2.69 for £550.

Bibl: VAM; Cundall.

HAITE, George Charles RBA b.1855 fl.1883-1894
Painter, illustrator and writer. Son of a designer, Haite was a self-taught artist. Exhib. first at the Crystal Palace, later at RA 1883-1904, BI and NWS. Exhibited works mainly English landscapes, and Moroccan scenes. Later became first President of the London Sketch Club and the Institute of Decorators and Designers. He designed the cover of the *Strand Magazine*.

Probable price range £50-100

Bibl: Studio Vol. 25, 193f; Vol. 30, 21f.

HALE, Edward Matthew b.1852 fl.1875-1893
Genre painter; lived in London and Godalming. Studied in Paris 1873-75 with Cabanel and Carolus-Duran. 1877-8 worked as war artist for the *Illus. London News* with the Russian Army, and later in Afghanistan. Most of his genre scenes are of army life, or the sea. Two works are in Leeds AG. Exhib. at RA, SS, GG, NG and elsewhere.

Probable price range £30-70

HALE, William Matthew RWS 1837-1929
Painter and watercolourist of landscape and seascape. Pupil of J.D. Harding (q.v.) and Collingwood Smith (q.v.). Exhib. at RA 1869-96, SS and OWS. Elected RWS 1871. Subjects England, Scotland, Norway and Spain.

Probable price range £20-50

HALFNIGHT, Richard William fl.1878-1907
Sunderland landscape painter. Worked a time in London, exhibiting landscapes and Thames views at the RA 1884-89, SS and NWS. Later moved to Newcastle. Two works are in Sunderland AG.

Probable price range £30-70

Bibl: Cat. of Sunderland AG 1908.

HALL, Frederick 1860-c.1921
Painter of landscape and rustic genre. Studied at Lincoln School of Art and at Antwerp under Verlat. From 1883-98 he was a member of the Newlyn School in Cornwall, with Stanhope Forbes (q.v.),

Bramley (q.v.) etc. His pictures show identification with their ideas about social realism and *plein-air* painting, but Hall also pandered to the popular taste for storytelling pictures e.g. 'The Result of High Living' (RA 1892). exhib. at RA from 1887, SS, GG and NG. Also exhib. in Paris and Venice. Hall was also known for his caricature drawings.

Probable price range £100-300

Bibl: AJ 1889, p.102; 1890, 365; 1891, 25f; 1905, 356; Cat. of Leeds AG. 1909.

***HALL, Harry fl.1838-1886**
Sporting painter; worked in London and Newmarket. exhib. at RA 1838-64, BI and SS. Painted racehorses, hunters and occasional sporting scenes, in a style similar to J.F. Herring Senior (q.v.).

'William Henry, with Earl Poulett' sold at Sotheby's 12.3.69 for £6,000. This was probably a record price. Range during the 1968-9 season was £280-£2,400.

Bibl: Pavière, Sporting Painters, 45 (pl.18).

***HALL, Thomas P. fl.1837-1867**
London genre and historical painter. Exhib. at RA 1854-67, BI 1837-67, and SS. Titles 'Cavalier and Puritan' 'Dean Swift and the Peasant' etc. A genre scene of children picnicking was in Agnew's exhibition of Victorian Painting 1961.

'Mother and Children with Rabbits' sold at Bonham's 5.12.68 for £150.

Bibl: Smith, Recollection of the Brit. Institution 1860.

HALLE, Charles Edward 1846-1914
Painter of portraits and decorative figure compositions. Son of Charles Hallé, the musician. Pupil of Baron Marochetti and L. von Mottez. Exhib. at RA 1866-82, mostly portraits; in 1876 he joined the group of artists of the "Secession" at the newly-founded Grosvenor Gallery. After 1887 he was also involved with the New Gallery. A close friend of Burne-Jones, Watts, Herkomer and Alma-Tadema, Hallé was more important as an organiser than for his own paintings, which are mostly imitations of Burne-Jones. After the 1880's he exhib. entirely at the GG and NG.

'Autumn of Life' sold at Sotheby's 4.6.69 for £130.

Bibl: C.E. Hallé *Notes from a Painter's Life* 1908

HALLIDAY, Michael Frederick 1822-1869
Amateur painter. Son of a naval captain. Held an official post in the House of Lords, and late in life began to take an interest in painting. Exhib. at RA 1853-66, and occasionally elsewhere. He painted land-scapes, views in the Crimea, genre and Italian scenes. Shared a studio for a time with Holman Hunt (see bibl.).

Probable price range £30-70

Bibl: AJ 1869, p.272; Redgrave, Dict.; DNB; Diana Holman Hunt, *My Grand-father, His Wives and Loves* 1969, see index.

HALPEN, M. Francis fl.1845-1868
London genre and landscape painter. Exhib. at RA 1845-57, and BI Graves lists a W.F. Halpen, a G.F. Halpen, an F. Halpen and an F.H. Halpen, but it seems probable that these all refer to the same artist. Several of his RA pictures were unfinished sketches.

Probable price range £20-50

HALSWELLE, Keeley RI ARSA 1832-1891
Genre and landscape painter. At first worked as an illustrator, for the

Illus. London News, and for the Edinburgh publisher Nelson. He exhib. at the RSA, and was elected ARSA in 1866. Many of the pictures of this early period were scenes of fishing life at Newhaven. In 1868 he went on the first of his visits to Rome, which was to provide him with Italian subjects for many years. Typical titles at the RA were 'Contadine in St.Peter's, Rome' 'A Roman Fruit Girl' 'Lo Sposalizio' etc. In the 1880's he abandoned figure painting, and turned almost entirely to Highland landscapes and views on the Thames. Exhib. at RA 1862-91, SS, NWS, GG and NG.

'Queen Victoria's Visit to Dunkeld in 1842' sold at Christie's Hopetoun Sale 15.10.69 for £472.

Bibl: AJ 1879, p.49-52; 1884, 59f; 1891, 192; 1893, 132; Portfolio 1884 p.24; Mag. of Art IV, 406; Clement and Hutton; Cundall; DNB 1890; Gleeson White, 45, 127, 140.

HAMILTON, Charles fl.1831-67
Painter of genre, oriental scenes, and sporting subjects. Exhib. at RA 1831-38, BI and SS. Titles 'The Egyptian Emir' 'Arabs Migrating' 'The Kensworth Harriers' etc. Hamilton lived in London, and at Kensworth, Herts.

Probable price range £30-70; more for sporting subjects.

HAMILTON, Vereker Monteith fl.1886-1914
Painter of military scenes, mainly of the Afghan and Napoleonic Wars. Exhib. at RA 1886-1914, and GG. His wife Mrs. Lilian H. was a sculptress, also exhib. at RA from 1889.

Probable price range £30-70

HAMMERSLEY, James Astbury 1815-1869
Manchester landscape painter. Pupil of J.B. Pyne. Born Burslem, Staffordshire. Lived mainly at Nottingham, where he was teacher in the local Art School. Exhib. at RA 1846-48, BI and SS. Works are in the Manchester AG., and the Royal Collection. Hammersley's work, with its pale and delicate colouring, plainly shows the influence of Turner and Pyne.

Probable price range £40-100

Bibl: DNB; Manchester A.G. Cat. 1910

HANCOCK, Charles 1795-1868
Sporting and animal painter; worked at Marlborough, Reading and Tattersall's in London. Exhib. at RA 1819-47, BI, SS and NWS. Pictures usually small in scale, and of horses, dogs and sporting scenes. Also very occasional portraits and rustic genre scenes.

'Chestnut Hunter in Extensive Landscape' sold at Sotheby's 12.3.69 for £450.

HANKES, J.F. fl.1838-59
London genre, historical and biblical painter. Exhib. at RA 1838-59, BI and SS. Very little known.

Probable price range £20-50

HANNAH, Robert 1812-1909
London historical and genre painter. Born Creetown, Kirkcudbright. Exhib. at RA 1842-70, BI and SS. Also exhib. in Liverpool and Rome. Titles 'The New Frock' 'The Countess of Nithsdale petitioning George I' 'Sisters of Charity' etc. Also painted portraits. Works are in the V & A, and Glasgow AG. Two works by him were in the collection of Charles Dickens.

Probable price range £50-100

Bibl: VAM 1907 Cat.; Glasgow A.G. Cat. 1911.

HARDEN, Edmund Harris fl.1851-1880
London painter of historical and biblical genre. Exhib. mainly at SS 1851-80, also at RA 1851-59, and BI 1851-62. Titles also include some pure genre scenes and studies of heads.

Probable price range £20-50

HARDING, James Duffield 1798-1863
Landscape and topographical painter, mainly in watercolours, but also in oils; engraver and lithographer. Received 10 or 15 lessons in watercolours from S. Prout; in 1816 or '18 gained the Society of Arts Medal for an original landscape. Apprenticed to John Pye, the engraver. Exhibited in London from 1811-64, at the RA (1811-58), at BI, SS, OWS (143 works); became an A of the OWS in 1820; member 1821; resigned in 1846 to become a candidate for the RA, as a painter in oil, but failed, and was re-elected, 1856. He was a small exhibitor as he spent much time in teaching lithography. He was a pioneer in the movement for art instruction in schools and for the training of art masters. Published many books on teaching drawing — all supporting direct observation of nature rather than tricks. (For details of his publications *see* Roget, II, 178-187). He taught Ruskin, among others, and when the first volume of *Modern Painters* appeared in 1843, many of Harding's old pupils recognised his lessons "on skies", "on water", "on mountains" etc, and especially his theory that tree-drawing should be based upon the laws of tree growth. Ruskin said that, next to Turner, Harding was "unquestionably the greatest master of foliage in Europe". Visited Italy, 1824; went frequently to the Continent after that date; visited Verona, Venice and Mantua with Ruskin in Sept. 1845. His illustrations in the *Landscape Annual,* (he supplied 24 lithographs for each of the 3 volumes, 1832-4, two dealing with Italy, one with France), made him one of the best-known artists of his day.

Harding was a prolific artist and his watercolours frequently come on the market. The usual price is £50-200.

Bibl: AJ 1864, 39ff (obit.); J. Ruskin, *Modern Painters,* Vols. I-V, 1843-60, Index, passim; Ottley; Redgrave, Cent.; J. Ruskin, *Academy Notes,* 1875; VAM, *Universal Catalogue of Books on Art,* Supp. 1877; Redgrave, Dict.; *The Portfolio,* 1880, 29ff; J. Ruskin, *Praeterita,* 1885-9, II, chp. VII; Roget, I & II; Binyon; Cundall; DNB; Hughes; VAM; F.J. Nettlefold Collection Catalogues. 1933-38; H. Lemaitre, *Le Paysage Anglais a l'Aquarelle,* 1760-1851, 1954; Hardie III, 24-27 and passim, plates, 32-4; Maas, 55.

HARDWICK, John Jessop ARWS 1832-1917
Painter and watercolourist of fruit and flowers in the manner of William Hunt (q.v.). Like Hunt, he was praised and encouraged by Ruskin. Worked as illustrator for the *Illustrated London News* 1858. Exhib. at RA, SS, OWS (172 works) and GG.

Probable price range £30-70

Bibl: Studio Vol.70, 88 (obit); Hardie III 109 (plate 180).

HARDWICK, William N. RI fl.1829-64 d.1865
Painter and watercolourist of landscapes, usually on a small scale. Exhib. mainly at NWS (member 1834), also RA 1830-58, BI and SS. After 1838 lived in Bath.

Probable price range £20-50

Bibl: VAM 1908 Cat. Vol. II

HARDY, Mrs. Deric. See SMALL, Miss Florence.

HARDY, Dudley RBA 1866-1922
Painter, watercolourist and illustrator, born in Sheffield. Studied first with his father T.B. Hardy (q.v.), then in Dusseldorf, Antwerp and Paris. Began exhibiting at the RA in 1884, but his first notable success was 'Tramps in Trafalgar Square at Dawn'. Hardy also worked as an

illustrator and cartoonist for many magazines, including *The Pictorial World, The Lady's Pictorial, The Sketch, Black and White* etc. He did fashion drawings, and his cartoons of cockney humour became widely popular. He also designed theatre posters. In addition to all this, Hardy still found time to exhibit at the RA, SS, NWS and GG. His output was varied, and included biblical scenes, oriental views, landscape and seascape, and genre, in both oil and watercolour.

'Folies Bergeres' sold at Sotheby's 15.10.69 for £110.

Bibl: AJ 1187 p.353-7; Studio 30 (1904), p.42f; 48 (1910), p.236, 58 (1913), p.56; 69 (1917), p.98; Fincham, *Art and Engraving of Britain* 1897; Sketchley, *English Book Illustration*, 1903, p.93; A.E. Johnson, *D. Hardy*, 1910; Who's Who 1914.

*HARDY, Frederick Daniel 1826-1911

Painter of genre scenes, especially interiors with children. Son of a musician. Studied under Thomas Webster (q.v.). Exhib. at RA 1851-1898, and BI 1851-56. Member of the Cranbrook Colony in Kent, with Webster, A.E. Mulready, G.B. O'Neill and J.C. Horsley (all q.v.). His studio was in Webster's house in Cranbrook. Like Webster, Hardy painted humorous scenes of children, usually in detailed Victorian interiors, but his range of subjects sometimes included drawing-room scenes and portraits. He lived in Cranbrook from 1854-75, and died there in 1911. Hardy's brother George H. (1822-1909) was also a painter; exhib. at RA 1846-92, BI and SS. He painted in a similar style to Frederick Daniel, but was much less prolific, and is not as well known.

'Monks Building a Stained Glass Window', sold at Sotheby's 22.1.69. for £340. Other prices in the 1968-9 season ranged from £150-£231.

Bibl: AJ 1875 p.73ff (Biog. with plates); Mag. of Art 1889; Ottley; DNB 2nd Supp. 1912; Reynolds VS 54, 67 (pl.11); Reynolds VP36, 58 (plates 28-9); Maas 234.

HARDY, George See under Frederick Daniel HARDY.

*HARDY, Heywood ARWS RPE 1843-1933

Painter and watercolourist of animals, sporting subjects, and genre. Studied in Bristol; settled in London 1870. Exhib. at RA, BI, SS, OWS, GG and NG. Some of Hardy's animal studies are very sensitive, but he also painted genre pieces, in 18th century costume, often of people riding. Collaborated with Frank Walton. Among his many patrons were the Sitwells of Renishaw.

Price range during the 1968-9 season £130-1,300.

Bibl. AJ. 1875 p.296; Portfolio 1881 p.57; 1885, 194f; Pavière, Sporting Painters, p.46 (plates 19 and 20).

HARDY, James, Junior RI 1832-1889

Bristol painter and watercolourist. Exhib. at RA 1862-86, BI, SS, and NWS (Member 1877), subjects landscapes with rustic figures, hunting scenes, and still life. Now best known for his pictures of dogs with game. Sales of his work were held at Christie's on March 9, 1878, and after his death on April 4, 1889.

'A Lady Painting with her Child' sold at Sotheby's 4.6.69 for £220.

Bibl: Cundall, p.218; Paviere, Sporting Painters, p.46 (plate 21).

HARDY, Thomas Bush RBA 1842-1897

Marine painter and watercolourist; born in Sheffield. Travelled in Holland and Italy. Exhib. at SS 1871-97 (elected RBA 1884), RA and NWS. Hardy's prolific coastal scenes, painted in fresh and vivid colours, achieved enormous popularity. His later work tended to become hasty and repetitive, which is perhaps why his reputation is much smaller today. His son Dudley Hardy (q.v.) was a painter and illustrator.

A pair of coastal scenes with fishing boats sold at Bonham's 7.11.68 for £200.

Bibl: Studio, 1919, British Marine Painting, p.30, 77; Bryan; Binyon; Cundall; VAM, Hardie III 82 (plate 107).

HARE, St. George RI ROI 1857-1933

Painter of genre, portraits (particularly group portraits of children), historical pictures exploiting the nude, and fluffy Edwardian "keepsake" beauties. Born and studied in Limerick under N.A. Brophy, the son of an Englishman; came to London in 1875 and entered the RCA. In 1882 and 83 exhibited at the Dudley Gallery; 1883 and 1884 at SS, and in 1884 for the first time at the RA with 'The Little Mother'. In 1885 at the RA, 'Natural Instincts' (a study of a child before a looking glass), achieved immediate popularity. In 1890 at the RA he exhibited his first important painting of the nude – 'The Victory of Faith' (a white skinned girl and a young negress sleeping side by side in a cell below the arena). Other titles include 'The Death of Attila', 'Miserere Domine', and 'The Adieu'. He painted in oil, watercolour and pastel.

'Golden Wedding at Chelsea Old Church' sold at Sotheby's 25.2.70 for £150.

Bibl: AJ, 1908, 345-9 (with plates); Studio, 22 (1901), 45; 35 (1905), 68; 38 (1906), 15; 44 (1908), 53; 68 (1916), 40; RA Pictures, 1902-4-6-8 (plates); Who Was Who, 1929-40.

HARGITT, Edward RI 1835-1895

Scottish landscape painter, born in Edinburgh and a pupil of Horatio MacCulloch. He exhibited from 1852-93, at the RA (1853-81), at BI, SS, NWS (255), and elsewhere. He was elected an associate of the RI in 1867 and member in 1871. Hardie thinks his 'Leixlip on the Liffey, nr. Dublin' (VAM) extremely good – "like a Harpignies, it has breadth and subtle refinement in its low-toned scheme of grey and green". He was also well known as an ornithologist.

'An Extensive View of the Firth of Forth from Stirling Castle' 1864 sold at Christie's 12.7.68 for £210.

Bibl: Ottley; Bryan; Binyon; Cundall; VAM; Hardie III, 163 (plate 190).

HARPER, Henry Andrew 1835-1900

London landscape and genre painter who exhibited from 1858-93, at the RA (1865-88), at SS, NWS, GG, and elsewhere. From 1873 onwards he began to exhibit landscapes of views in Jerusalem, Mount Sinai, Dead Sea, and Cairo. Two of his watercolours are in the Wallace Collection.

Probable price range £30-70

Bibl: Wallace Collection Cat. 1908.

HARRIS, George Walter fl.1864-93

Painter of fruit who exhibited at the RA from 1864-93, at SS, and elsewhere.

Probable price range £20-50

Bibl: Guildhall Catalogue.

HARRIS, James fl.1846-1876

Swansea marine painter. Exhib. at BI and SS. Very little known.

Probable price range £100-300.

Bibl: Wilson, Marine Painters, 40 (plate 15)

HARRISON, George Henry 1816-1846

Landscape and genre painter. Born in Liverpool where his mother was a flower painter (q.v.). They moved into Denbighshire and then, when he was fourteen, came to London. He started by making anatomical

and other medical drawings, and in studying anatomy at the Hunterian School in Windmill St. Later Constable became his friend and continually encouraged him to study nature. He specialized in landscape, often with luxuriant foliage, and practising as a teacher, he always preferred to teach in the open air. He exhibited at the RA from 1840-46, and also at BI, SS and OWS, titles at the RA including 'The Days when we went gypsying', 'The first born', 'Lane scene' etc. He was elected a member of the OWS.

Probable price range £50-100.

Bibl: AU, 1847, 44 (obituary); Clayton, I, 411-3; American Art Review, II, 1, 1881, 174; Roget; Bryan, VAM Cat., II, 1908; Cat. of Engr. Brit. Portr., BM, II, 1910, 10.

HARRISON, J. fl.1845-1865
Little-known York portrait painter and miniaturist. Exhib. a few pictures at the RA between 1846 and 1856, but worked mostly in the north. A portrait of a girl dated 1845, sold by Christie's on July 11, 1969, shows him to be an artist of considerable charm and talent.

'Portrait of a Lady', sold 11.7.69 for £357. Price range therefore likely to be £200-400, but Harrison's works rarely appear on the market.

HARRISON, Mrs. (Miss Mary P. Rossiter) 1788-1875
Fruit and flower painter, 'one of the most graceful of modern times' (Clayton). Born in Liverpool; married in 1814; her husband lost most of his money fifteen years later, and with twelve children to support, she turned to painting. Moved to London where she joined some friends in establishing a new Society of Painters in Water-colours (the Institute) of which she remained a member till her death. In France, during the reign of Louis Philippe, when she met George Sand and many celebrities, she was much sought after and called the 'Rose and Primrose' painter. In 1862 she painted 'The History of a Primrose', in three compartments: 'Infancy', 'Second Maturity' and 'Decay'. Exhibited from 1833-75, at the RA, BI, SS and NWS (322 works). Two of her paintings are in the Walker Art Gallery, Liverpool, and in her lifetime two of her works were purchased by the Queen. Her second son was George Henry Harrison (q.v.) who died young in 1846.

Probable price range £50-100.

Bibl: *See* HARRISON, George Henry

HART, Solomon Alexander RA 1806-1881
Painter of historical and biblical genre, and portraits. Born in Plymouth. Came to London in 1820 with his father, a Jewish goldsmith. At first a miniaturist, then began to exhibit paintings at the BI and SS. Encouraged by success, Hart went on to paint many large and ambitious historical canvases. Many of his works were painted on a huge scale, which partly accounts for the neglect into which they have now fallen. He also painted many official portraits, and views of Italian churches. Exhib. at RA 1826-81, BI and SS. Elected ARA 1836, RA 1840. In 1855 he succeeded Leslie as teacher of painting at the RA schools, and later became Librarian. After his death two sales of his works were held at Christie's, on July 29, 1881, and August 2, 1881.

Probable price range: £100-300

Bibl: AJ 1881 p.223; Studio, 1916, Shakespeare in Pictorial Art, Spring Number; Ottley; Ruskin, Academy Notes 1857, 1858; A. Brodie, *Reminiscences of A.S. Hart RA* 1882; G. Pycroft, *Art in Devonshire,* 1883; Cundall p.219.

HARTLEY, Alfred RBA ARPE b.1855 fl.1885-1900
Painter of landscape and genre, etcher, in line and aquatint, and portrait painter of considerable success. Pupil of Sir Frank Short and C. J. Watson, etcher; studied at S. Kensington Art Schools and at Professor Brown's class at Westminster Art School, with Frampton

and Anning Bell as fellow pupils. Exhibited from 1885 onwards at the RA SS NWS GG NG and elsewhere. Between 1889 and 1899 he painted many notable portraits, amongst them portraits of Lord Randolph Churchill, Lord Russell of Killowen and the Prime Minister. Titles at RA include 'Spring', 'Maternity', 'Hen and Chicks', 'Wayfarers', 'Twilight'; he also did decorative paintings, e.g. Studio, 1901, 'A Decorative Panel for a Rosewood Piano, a Pastoral Scene'.

Probable price range: £50-150

Bibl: Studio, Vol.23, 22; Vol.28, 61; Vol.64, 1915, 99 ff; Vol.67, 115, 252; 70 (1917) 55, 111; Special numbers; Art in 1898; Summer No. 1902; Die Graph, Kste, XXI, 1898, 48 ff; Cat. Exhib. Carnegie Institute, Pittsburgh, 1907, 1911-13; Holme, *Modern Etching,* 1913; Salaman, *Modern Woodcuts,* 1919.

HARTLEY, Thomas fl.1820-1860
Painter of genre and portraits who exhibited from 1820-60, at the RA from 1821-59, at the BI SS and OWS. Titles at the RA include 'Portrait of a Lady', 'A Girl at Embroidery', 'Memory, thy pleasure most we feel when Most Alone'. In the BM is an engraving of a portrait of William Lockwood (engr. 1836).

Probable price range £30-70

Bibl: Cat. of Engr. Brit. Portr., BM, III, 1912, 82.

HARVEY, Sir George PRSA 1806-1876
Scottish painter of genre, scenes of Scottish history, and landscape. Studied at Trustees Academy in Edinburgh (1823) under Sir William Allan. Elected ARSA 1826, RSA 1829. Harvey established his reputation with a number of patriotic scenes from Scottish history, which appealed to the taste of the day. Many of them depicted scenes during the Covenant period. Owing to his use of bitumen, many of these works are now obscured. When painting genre, observing the everyday life of the people, Harvey's work could be much more spontaneous and charming. He was also a masterful painter of Scottish landscape – "he realized the pensive charm and pastoral melancholy of the Highland straths and the Lowland hills with an insight and sympathy which make recollection of his landscapes a precious possession" (Caw). On the death of Sir John Watson Gordon (q.v.) elected PRSA, knighted 1867. Exhib. at RA, BI and SS, but mostly at Scottish Academy.

'Examination at a Village School' sold at Sotheby's 13.11.63 for £190.

Bibl: AJ 1850 p.341; 1858, 73-5; 1876 (obit); 1904; 392; Portfolio 1887 p.152; A.L. Simpson, *Harvey's Celebrated Paintings,* 1870; Redgrave, Dict; W.D. McKay, *The Scottish School of Painting,* 1906; Caw, see index (plate opp. p.150); DNB XXV

HARWOOD, Edward b.1814 fl.1844-1872
Irish painter of genre and historical subjects. Elder brother of J.J. Harwood (q.v.). Originally in business with his father as a housepainter, but became a painter, first of portraits and landscapes, and moved to Dublin where he studied in the Dublin Society's School. Exhibited at the RHA from 1844-8, such subjects as 'Study of a Girl reading', 'Conrad and Gulnare', 'The Pet' etc. c.1851 he went to London and exhibited 'A Winter Scene at Rugby School, Football', at the RA in 1859, (the only time he exhibited there). He was then living at Rugby and was still there in 1872.

Probable price range £30-70

Bibl: Strickland

HARWOOD, John James 1816-1872
Irish painter of portraits, genre and historical subjects. Born in Clonmell, he appears to have studied in Italy; but was following his profession in Clonmell in 1836. He was in London in 1839, and in Bath 1841-4. For the rest of his life he lived in London, visiting Ireland occasionally. Exhibited in London from 1839-71, at the RA (1840-1871), BI, SS and elsewhere; and at the RHA in 1836, 42, 44, 47-8,

50, 53, 56, 58 – portraits, genre and historical subjects, e.g. 'Francesca and Paolo of Rimini', 1853, and 'Children feeding the Birds', 1845. The National Gallery of Ireland has two portraits by him, 'Field-Marshal Gough', 1851 and 'Samuel Lover', 1856.

Probable price range £30-70

Bibl: Strickland

HARWOOD, Robert 1830-living 1879

Painter of landscape, portraits and genre. Younger brother of James and Edward Harwood (q.v.). Lived with his brothers at Clonmell and afterwards at 2 Percy Street, London. Exhibited from 1855-79, at the RA, from 1855-76, BI, SS and elsewhere, chiefly Welsh landscapes; and at the RHA in 1856 and 1858.

Probable price range £30-70

Bibl: Strickland

HASSELL, Edward RBA fl.1830-1852

Painter and watercolourist; son of John Hassell, also a watercolourist and engraver. Exhib. regularly at SS; elected RBA 1841, and later became secretary. Also exhib. at RA and BI. Painted landscapes, and interiors of gothic churches and buildings.

Probable price range £20-50

Bibl: Redgrave, Dict: DNB XXV under John Hassell; BM Cat. of Drawings by British Artists, 1900, II

HASTIE, Miss Grace H. fl.1874-1903

London fruit and flower painter who exhibited from 1874-1903, at the RA (1878-1903) at SS, NWS, GG, NG and elsewhere. A member of Society of Lady Artists.

Probable price range £20-50

HAVELL, Edmund, Junior 1819-1894

Genre and portrait painter; son of Edmund, Senior, a landscape painter, and nephew of William Havell. Lived in Reading 1835-42, and London. Exhib. at RA 1835-95, BI and SS. Also a lithographer, mainly of portraits. Titles at RA also mainly portraits, and some genre, e.g. 'Spring Flowers' 'Italian Boy' 'Crochet' etc. He visited the United States and exhibited in Philadelphia.

'Crochet' sold at Sotheby's 18.2.70 for £200.

Bibl: Catalogue of William Havell Exhibition, Reading Mus., Feb.-Mar. 1970.

HAVERS, Miss Alice Mary (Mrs. Frederick Morgan) 1850-1890

Genre and landscape painter. Born in Norfolk; married Frederick Morgan (q.v.) in 1872. Studied at the S. Kensington Schools, and became a clever and popular painter. Exhibited from 1872-89, at the RA (1873-89), SS, the Paris Salon and elsewhere, titles at the RA including 'A Knotty Subject', 'A Montevidean Carnival', 'Goosey, Goosey Gander' and 'Peasant Girls, Varengeville'. She was a member of the Society of Lady Artists. 'Blanchisseuses' is in the Walker Art Gallery, Liverpool, and 'The Annunciation' in the Norwich Castle Museum.

'A Girl Standing by a Wall' sold at Christie's 10.7.70 for £115.

Bibl: H. Blackburn, *Academy Notes* 1875 34; 1876 53, 55, 65; 1877-83; The Portfolio 1890 Art Chronicle pXX; Bryan (under Morgan); W. Shaw-Sparrow *Women Painters of the World* 1905 ('Blanchisseuses').

HAY, William M. fl.1852-1881

London painter of portraits, genre and biblical scenes. Exhib. at RA

1855-77, BI and SS. Titles at RA mostly portraits; also some genre, e.g. 'A Funny Story' 'A Pleasing Story' etc.

'A Labour of Love' sold at Phillips Son & Neale 1.12.69 for £150.

Bibl: AJ. 1860 p.80.

HAYDON, Benjamin Robert 1786-1846

Painter of large-scale historical subjects, and genre. Born Plymouth; came to London 1804. Worked for Hoare, Northcote and Fuseli, and studied at RA schools, where he befriended Wilkie. His first picture, 'The Flight into Egypt', was bought by Thomas Hope for 100 guineas in 1806. Haydon was deeply impressed by the Elgin marbles, which he studied at Elgin's house in Park Lane. Inspired by the idea of promoting historical painting in England, he produced a series of huge and grandiose canvases – 'Judgement of Solomon' (1814), 'Christ's Entry into Jerusalem' (1820), 'The Raising of Lazarus' (1823) etc. Unfortunately his technique was inadequate to cope with the scope of his ambitions. A turbulent and quarrelsome character, Haydon alienated clients by failing to complete compositions, and antagonised the Academy and his critics by his scathing attacks on them through pamphlets. He was imprisoned for debt three times. Bitterly disappointed by his failure to win any of the Westminster Hall competitions, he organised in 1846 an exhibition of his own work at the Egyptian Hall in Piccadilly. It was a complete failure, and Haydon committed suicide on June 22nd of the same year. He also painted a number of popular genre works, such as 'Mock Election', and 'Chairing the Member', for which he is now best remembered. He exhib. at the RA, BI, SS (of which he was one of the first supporters when founded in 1823) and OWS.

Haydon's output was not large, and his work very rarely comes on the market. 'The Duke of Wellington Musing on the Field of Waterloo' was sold at Christie's 27.10.61 for £420.

Bibl: AU 1846 p.235 f (obit); Mag. of Art IV 250, 501; T. Taylor, *Life and Art of B.R.H.* 1853; *Correspondence and table talk of B.R.H.* edited by I.W. Haydon 1876; Redgrave, Dict; DNB XXV 283 ff; E. George, *The Life and Death of B.R.H.* 1948; Boase, see index (plate 63); References in literary biographies of Hazlitt, Lamb, Scott, Reynolds, Keats, Wordsworth, Southey, etc.

HAYES, Claude RI ROI 1852-1922

Landscape and portrait painter. Born at Dublin; son of Edwin Hayes (q.v.). He ran away to sea, serving on *The Golden Fleece,* one of the transports used in the Abyssinian Expedition of 1867-8. Spent a year in America; studied art at Heatherley's School and for three years at the RA Schools, and at Antwerp, under Verlat. Exhibited from 1876 at the RA, and also at SS, NWS, GG, NG, and elsewhere. He first practised as a portrait painter in oil, but soon abandoned portraiture for landscape, first in oil and then with watercolour as his favourite medium. In 1884 he first exhibited at the RI, of which he was elected member, 1886. He worked in Hampshire, meeting James Aumonier, and in Surrey with William Charles Estall whose sister he married. He was influenced by Cox and Thomas Collier. Hardie writes "Maintaining worthily and without imitation their breezy, open-air style, he had the power of following broken ground into receding distance with able indication of form and colour values. His transparent use of fresh and untroubled colour allowed the sparkle of white paper to play its part in the general scheme. He has never quite received the recognition which he deserves."

'Canal Scene with Horsedrawn Barge' sold at Bonham's 5.2.70 for £180.

Bibl: Studio 33 (1905) 290-97 (plates); 67 (1916), 79-90 (plates); RA Pictures, 1896-1907, 1912, 14, 15; Holme, Sketching Ground, Studio Spec. No.1909, 23ff (plates). VAM; E.P. Reynolds, 'Walker's Quarterly', 7 (describing palette and method of work); Hardie, III, 156, 157-159 (plate 178).

HAYES, Edwin RHA RI 1820-1904

Marine painter, principally in watercolour, but also in oil. Born in Bristol, he exhibited prolifically, at the RA from 1855-1904, at BI, SS, NWS, GG, NG, and elsewhere, and made his name by his marine subjects. He became an associate of the NWS (RI) in 1860 and member in 1863. He was also a member of the Royal Hibernian Academy and of the Institute of Oil Painters. His 'St. Malo' (1862) (Bethnal Green Museum) is a typical work. His studio sale was held at Christie's on Jan. 21, 1905.

'Fishing Boats off the Coast' sold at Sotheby's 18.3.69 for £200.

Bibl: VAM Mss: 47 letters to H.M. Cundall, 1850-1912; RA Pictures, 1891-1904 (plates); Poynter, Nat. Gallery of British Art, 1900, I; DNB, Supp. II, 1912; Benezit, II, 1913; Marine Painting Studio Special No. 1919; VAM; Hardie, 157, 159.

HAYES, John 1786-1866

London painter of portraits and historical genre. Exhib. at RA and BI, 1814-51. Specialised in portraits of military and naval officers. Later turned to historical genre. Also a lithographer. Many of his own portraits were engraved.

Probable price range £50-100

Bibl: DNB XXV 1891; Cust., NPG. Cat. 1900 II; BM., Cat. of engraved British Portraits; India Office, Cat. of Paintings, 1914.

*HAYLLAR, Miss Edith fl.1881-1897

Still life and genre painter; sister of Jessica, Kate and Mary Hayllar, all probably daughters of James Hayllar (q.v.). Exhib. at RA 1882-97, SS and elsewhere. Titles at RA 'The Sportsman's Luncheon' 'The First of October' 'Five O'Clock Tea' etc.

'A Summer Shower' sold at Christie's 10.7.70 for £588.

*HAYLLAR, James RBA b.1829 fl.1850-1898

Painter of portraits, genre and landscape. Born in Chichester. Came to London 1848. Studied with F.S. Cary and at RA schools. Travelled in Italy 1851-53. Exhib. at RA 1850-98 and BI, but mostly at SS, of which he was a member. At first Hayllar painted mainly small oil portraits and heads, but in the late 50's he came under the influence of the Pre-Raphaelites, and painted some charming and humorous genre scenes, in a more detailed style. Later his technique broadened, and the quality of his work declined. He turned to the more profitable pursuit of historical painting — 'The Progress of Queen Elizabeth' etc. Works by him are in the V & A, and Nottingham AG. His later work is often confused with that of Jessica Hayllar, probably his daughter, who exhib. genre scenes at the RA 1880-1915 and SS. Also recorded are Miss Kate, Miss Edith, Miss Mary Hayllar, probably her sisters, whose work is very little known.

'The Cook Children' sold at Sotheby's 15.5.63 for £420

Bibl: Ottley; Clement and Hutton; BM Cat. of Engr. Brit. Portraits IV (1914) 8; Reynolds VS 21, 83 (plate 60).

HAYLLAR, Miss Jessica See under HAYLLAR, James.

HAYNES, John William fl.1852-1882

London genre painter. Exhib. at RA 1852-67, BI, SS. Titles at RA 'Kept In' 'A Little Entanglement' 'Tuning the Fiddle' etc. Lived in Cambridge and London. 'The First, the Only One' is in York AG.

'The Musical Evening' sold at Christie's 27.10.67 for £273.

Bibl: AJ 1864; City of York AG Catalogue; Reynolds VS84 (pl.61).

HAYTER, Sir George 1792-1871

Painter of portraits and historical genre; son of Charles Hayter, also a portrait painter and miniaturist. Studied at RA schools. In 1815 awarded a premium of 200 guineas by the British Institution. Appointed the same year painter of miniatures to Princess Charlotte and the Prince of Saxe-Coburg. Studied in Italy 1815-18. In 1825 his picture of the 'Trial of Lord William Russell' became widely known through engravings. He is best known today for his large portrait groups, such as the 'Trial of Queen Caroline' and 'The Meeting of the First Reformed Parliament'. In Italy again 1826-31. On the accession of Queen Victoria in 1837, he was appointed her portrait and history painter. He painted a large picture of her Coronation, and in 1836, her state portrait, for which he was knighted in 1842. He exhib. at the RA 1809-38, his portrait of Victoria being his last exhibited work. Thereafter he enjoyed a lucrative practice as a fashionable portrait painter. His younger brother John (q.v.) was also a painter. Sir George's studio sale was held at Christie's on April 19, 1871.

'Portrait of Queen Victoria' sold at Sotheby's 23.7.69 for £260.

Bibl: AJ 1871 p.79 (obit); 1879, 180; 1902, 192; Redgrave, Dict; DNB XXV; Cust., NPG. Cat. II; BM Cat. of Engr. Brit. Portraits I-IV; Boase, 164, 209, 315 (pl. 62b); Reynolds VP 12; Maas 23, 213.

HAYTER, John 1800-1891

London portrait and genre painter; younger brother of Sir George Hayter (q.v.). Exhib. at RA 1815-79, BI & SS. At the RA he exhib. mostly portraits; at the BI mostly historical genre scenes. His portrait sketches and drawings were popular, and many were engraved.

'George Graham and his Wife Margaret' — a drawing — sold at Sotheby's 20.3.62 for £180.

Bibl: DNB XXV; BM Cat. of Engr. Brit. Portraits I-IV passim; Studio, 1916, Shakespeare in Pictorial Art, Spec. Spring No.

HEAPHY, Miss Elizabeth See MURRAY, Mrs. Henry John

HEAPHY, Thomas Frank 1813-1873

Painter of portraits, and historical and genre subjects. Eldest son of Thomas Heaphy (1775-1835), watercolour painter. Started as a portrait painter in watercolour, and for many years enjoyed an extensive patronage but branched off into the painting of subject pictures in oil. Exhibited at the RA from 1831-73, and at the BI, but mostly at SS (68 works). In 1850 exhibited his first subject picture at the RA, 'The Infant Pan Educated by the Wood Numphs'. Among his most successful works which followed were 'Catherine & Bianca', 1853; a series of peasant girls of various countries (1859-62); and 'Lord Burleigh showing his Peasant Bride her New Home', 1865. In 1867 he exhibited at SBA (SS) 'General Fairfax and his daughter pursued by the Royal Troops,' and in that year was elected a member of the society. He spent many years in an investigation of the traditional likeness of Christ, and published his research in the AJ in 1861 in a series of 8 articles. After his death these were re-issued in a volume, *The Likeness of Christ*, edited by Wyke Bayliss, 1880. (Drawings and oil sketches for this work are in the BM.) He travelled widely to do this, and especially spent much time in Rome. In 1844 he was commissioned to paint an altar-piece for the Protestant church at Malta, and he also executed one for a church at Toronto, Canada. At an early period Heaphy assumed the additional name "Frank", to distinguish his work from his father's, but dropped it before 1850.

Probable price range £100-200

Bibl: AJ 1873, 308; Athenaeum, No. 2390, 16 Aug. 1873; Redgrave Dict; Roget; Binyon; Cat. VAM, 1907; DNB; H. Hubbard, OWS XXVI, 1948; Hardie, III, 99-100

HEARD, Joseph fl.1839-1856

Very little known ship painter; did not exhibit in London. Works by

him are at Greenwich and Liverpool; his pictures now appear quite often on the London market.

Prices in the 1968-9 season ranged from £293-755

Bibl: Wilson, Marine Painters, 41 (pl.15).

HEDLEY, Ralph 1851-1913
Newcastle genre painter. Born Richmond, Yorks. Studied at Newcastle Art School. President of Bewick Club and Northumbrian Art Institute. Exhib. at RA from 1879. The subjects of his pictures are usually scenes of the working life of ordinary people in his native north-east. Sailors, labourers, recruits, veterans feature most often, usually observed in a gently humorous way. His work can be seen in Sunderland AG.

His pictures often sell at auction; the usual price range is £30-70

Bibl: AJ 1904 p.308; RA Pictures 1892-1900, 1905, 1907, 1913; Cat. of Sunderland AG 1908; Who's Who 1913, 1914; The Years Art 1914, p.445.

HELCKE, Arnold fl.1865-1898
Guernsey landscape and seascape painter. Exhib. at RA, SS, NWS, GG & NG. Subjects mostly views on the English and French coasts. Also exhib. in Paris at the Soc. des Artistes Français 1894-98.

Probable price range £20-50

Bibl: RA Pictures 1891; VAM 1907 Cat.

***HEMSLEY, William RBA b.1819 fl.1848-1893**
London genre painter. Son of an architect. At first Hemsley followed his father's profession, teaching himself painting in his spare time. Travelled in Germany and Holland. Exhib. at RA, BI, and especially at SS, of which he was a member, later vice-president. Hemsley's genre scenes of everyday life, which are usually painted on a small scale, follow the gentle tradition of Webster and F.D. Hardy. He was, like them, fond of painting children at play.

'Rustic Genius'; and 'Young Crabcatchers' – a pair – sold at Sotheby's 4.6.69 for £650. Other prices in 1968-9 season ranged from £110-£252.

Bibl: AJ 1853 p.85; 1866, 178; Ottley; Clement and Hutton

HEMY, Bernard Benedict fl.1875-1877
North Shields marine painter, little known outside the North-east. Presumably related to the better-known Charles Napier Hemy (q.v.). Exhib. only 2 pictures in London, at SS in 1875-1877.

'Entering Harbour' – a pair – sold at Bonham's 2.10.69 for £125.

***HEMY, Charles Napier RA RWS RI 1841-1917**
Painter and watercolourist of landscape and seascape; brother of Thomas Hemy (q.v.). Studied at Newcastle Art School. Worked on church decoration in Newcastle and Lyons, France. In 1863 he began to exhibit in London. In this early period he painted coastal scenes showing strong Pre-Raphaelite influence, particularly in the detailed painting of rocks. It is these works which are most admired today. Hemy then studied with Baron Leys in Antwerp, and under his influence began to paint historical scenes, mostly in 16th century costume. About 1880, Hemy turned to marine painting, to which he was to devote the rest of his career. Settling in Falmouth, where he died, he spent much time sailing. His marine and coastal scenes of this period, painted in a broad, swirling style, show that he had an intimate knowledge and love of the sea. Exhib. at RA from 1865, also at BI, SS, OWS, NWS, GG & NG.

'The Fisherman's Harbour' sold at Sotheby's 16.10.68 for £260.

Bibl: AJ 1881 p.225-7; 1901; 1905; 1907; Studio 72 (1918) 73 (obit); 1919, Brit. Marine Painting, Special Number; RA Pictures 1894-1903, 1906-8, 1910-15; Poynter, Nat. Gal. of Brit. Art 1900 II; Wilson, Marine Painters, p.41 (plate 16). Maas 67, 194 (plates on p.193).

HEMY, Thomas Marie Madawaska 1852-1937
North Shields marine painter, brother of Charles Napier Hemy (q.v.). Studied in Newcastle and under Verlat in Antwerp. Exhib. at RA from 1873; also at SS, NWS & GG. Fond of painting shipwrecks. His work can be seen at Sunderland AG and the Laing AG, Newcastle.

Probable price range £20-50

Bibl: The Graphic, Pictures of the Year, 1914, p.10, 167. Sunderland A.G. Cat. 1908, p.11.

HENDERSON, Charles Cooper 1803-1877
Little known painter of coaching scenes in oils and watercolours. Exhib. only twice in London, at the RA in 1840 and 1848. Worked entirely for private patrons. Like J.C. Maggs (q.v.) Henderson carried on the coaching tradition of Pollard long after coaches had begun to disappear from English roads. Many of his pictures were engraved by Fores and Ackermanns. As a boy Henderson first studied law, and then took lessons from Samuel Prout (q.v.).

'Dover – London Mail Coach at Night' sold at Christie's 25.4.69 for £2,890. Average prices usually in £100-300 range.

Bibl: DNB XXV (1891) 396; Maas 75 (pl.).

HENDERSON, W.S.P. fl.1836-1874
London genre and portrait painter who exhibited from 1836-74, at the RA (1839-1863), at BI and SS, titles at the RA including "The Last Look of Home", "A Cottage scullery", etc.

'A Hard Word' sold at Sotheby's 20.11.63 for £125.

HENLEY, Lionel Charles RBA c.1843-c.1893
Genre painter who exhibited from 1862-93, at the RA (1862-88), at BI, and SS (124), titles at the RA including 'Private & Confidential', 'A Vexed question', etc. He studied first in Dusseldorf and exhibited in Magdebourg before returning to London. A painting by him is in Leeds Art Gallery.

Probable price range £50-150

HENRY, George RSA RA RSW 1858/60?-19433
Glasgow school landscape and decorative painter. Studied at Glasgow School of Art, Met Guthrie, Crawhall and Walton, with whom he worked at Brig O'Turk and Roseneath, and later at Eyemouth and Cockburnspath. Began to exhibit at Glasgow Institute in 1882. In 1895 he met E.A. Hornel (q.v.). The two painters found their ideas so *en rapport* that they shared a studio, and produced two large works together – 'The Druids' and 'The Star in the East'. The former was very successful at the Grosvenor Gallery show in 1890. In 1892 Henry was sent abroad to convalesce, and he and Hornel visited Japan together. This had a great effect on Henry's work, and painted many Japanese subjects on his return, striving constantly for pleasing decorative effects. Member of the NEAC 1887. President of Glasgow Art Club 1901-2. Elected ARSA 1892, RSA 1902; ARA 1907, RA 1920.

'Girl Reading' sold at Edmiston's (Glasgow) 8.10.69 for £195.

Bibl: Studio Vol. 24, 117; Vol. 31 3 ff; Vol. 68, 73 ff; 95 ff; Vol. 83, 33; AJ 1904-07; 1909; D. Martin, *Glasgow School of Painting* 1902; Caw 399-404; George Buchanan, The Scottish Art Review, Vol. 7 No. 4; Scottish Arts Council, The Glasgow Boys Exhib. Glasgow 1968.

HENRY, James L. 1855-c.1904
Landscape painter who exhibited from 1877 at the RA, SS, NWS, GG and elsewhere. *The Studio*, 1908, wrote regarding 'A West Coast Harbour', and 'Breezy Lowlands' – "they are particularly remarkable

for their power and interest, their sense of atmosphere and regard for beauty."

Probable price range £50-150

Bibl: Studio Spec. No. Art in 1898;
Studio 64 (1908) 36;
Manchester City Art Gallery, *Handbook to the Permanent Collection,* 1910;
Athenaeum, 1920, I, 375.

HENRY, William See HAINES, William Henry

*HENSHALL, John Henry RWS 1856-1928
Painter of genre and historical subjects, in oil and watercolour, the latter often very large, the subjects highly dramatic and full of sentiment. Educated at S. Kensington Schools and RA Schools. Exhibited from 1879 at the RA, SS, RSW, Salon and elsewhere. ARWS in 1883; RWS, 1897. His works include 'Adam Bede' 1894. 'The Stool of Repentance' 1895 (a naughty girl sitting on a high stool), 'Her Daughter's Legacy' 1897 (a grandmother holding her daughter's child, and comparing youth with old age). His paintings were purchased by Birmingham, Leeds, Hull, Manchester, Bristol, Preston and Blackpool, for permanent collections.

'The Interior of a Public House' sold at Christie's 12.10.62 for £110.

Bibl: AJ 1894, 123; 1895, 61; 1897, 104; RA Pictures, 1897, 1901, 1908, 1910, 1912; Benezit, II, 1913; Who's Who, 1922.

HENSHAW, Frederick Henry 1807-1891
Birmingham landscape painter. Pupil of J.V. Barber.Influenced by Turner. Travelled in Germany, Switzerland and Italy 1837-40. Exhib. in London 1829-64, at RA, BI, and SS; also at Birmingham Society of Artists. Apart from occasional continental views, his work is mostly English landscape, painted in the Midlands, Wales or Scotland. Works by him are in Birmingham and Glasgow AG. Occasionally collaborated with an artist called R.J. Hammond.

'A Wooded Lane' sold at Sotheby's 12.3.69 for £110.

Bibl: The Portfolio 1891; Art Chronicle p.XXIV.

HENZELL, Isaac fl.1854-1875
London genre painter. Exhib. 1854-75 at RA, BI, and especially SS. Also a landscape painter. Works by him are in Reading, Sheffield and York AG. Known to have collaborated with Henry Bright (q.v.).

'Coastal Scene with Girl and Dog' sold at Bonham's 5.6.69 for £180.

Bibl: AJ 1859 p.141-143

HERBERT, Alfred fl.1844-1860 d.1861
Southend marine painter and watercolourist. Exhib. at RA 1844-60, BI & SS. Subjects mainly coastal scenes of East Anglia, Devon, Kent, Holland and France. Works can be seen at Beecroft AG, Southend.

Probable price range £20-50

Bibl: AJ 1861 p.56
Wilson, Marine Painters, 41 (pl.16).

*HERBERT, John Rogers RA HRI 1810-1890
Painter of portraits, historical genre, biblical scenes and landscape. Studied at RA schools 1826-28. At first a painter of portraits, which he began to exhibit at the RA in 1830. He then tried his hand at romantic genre. His picture 'The Rendezvous' was engraved for one of the Keepsake books. Following a visit to Italy, he painted many Italian historical subjects. A keen admirer of Pugin, Herbert was converted to Catholicism about 1840. Thereafter his subjects were predominantly biblical, although he continued to paint some charming landscapes and genre scenes. Herbert's biblical scenes tend to be dry and academic,

and show familiarity with the work of Dyce and the Nazarenes. His picture of 'Our Saviour subject to his Parents at Nazareth' (Guildhall AG exhibited in 1847, seems to anticipate Millais's 'Christ in the House of his Parents', painted three years later, but Herbert used far more conventional Italian-style figures. Exhib. at RA, BI & SS; elected ARA 1841, RA 1846. His sons Arthur John, and Cyril Wiseman Herbert were also painters.

'A Coastal Scene' sold at Christie's 14.3.69 for £252.

Bibl: AJ 1865 p.162; T. Smith, *Recollections of the BI* 1860; Redgrave, Cent; W. Sandby, *History of the RA* 1862, II; Ottley; DNB XXVI (1891); BM. Cat. of Engr. Brit. Portraits II-IV; Studio, Shakespeare in Pictorial Art, Special Spring No. 1916; Reynolds VS 63, 67 (pl.28); Reynolds VP, 38, 58, 64 (pl. 30); Maas 16, 28 (pl. on p.28)

HERBERTE, E.B. fl. c.1870-1880
With the revival of interest in sporting pictures, works by Herberte now frequently appear on the art market, although practically nothing is known of his career. He never exhibited in London, painting hunting scenes for private patrons. His pictures are usually painted in pairs, or sets of three or four.

'Hunting Scenes' – a set of four – sold at Bonham's 3.7.69 for £825.

Bibl: Pavière, Sporting Painters, p.48 (plate 23).

HERDMAN, Robert RSA RSW 1829-1888
Scottish painter of genre and historical subjects, portraits, landscape and flowers. Born at Rattray, Perthshire, where his father was parish minister, he was educated in theology at St. Andrew's. A good Greek scholar, he retained a love for Classics throughout his life.However, he left University; exhibited for the first time at the RSA in 1850, and in 1852 entered the Trustees Academy as a pupil under Scott Lauder. In 1854 he won the Keith Prize for the best historical work by a student in the exhibition, and visited Italy the following year. Elected ARSA in 1858; RSA in 1863. Some of his early paintings illustrated Biblical subjects, but after his return from a visit to the Continent in 1855 which supplied him with several Italian subjects, e.g. his diploma work 'La Culla', 1864, his source of inspiration became Scottish, history and song: often patriotic subjects like 'After the Battle', 1870 (Edinburgh), showing a severely wounded soldier with his family. He also did portraits – e.g. 'Lady Shand', 1867 (Edinburgh), and single figures, often Scottish peasant girls. He did some charming work in watercolour, and many of the holiday sketches of wildflowers, boulders and seashores, made in Arran, are very beautiful. Caw remarks that, in his oils, his chief defects were "a want of solidity and richness of impasto, and a certain greasiness of touch". He was certainly the best educated and most highly cultured man of his group.

'The Young Bramble - Gatherer' sold at Morison - McChlery (Glasgow) 6.12.68 for £120.

Bibl: AJ, 1873, 376; W.D. McKay, *Scottish School of Painting,* 1906; Studio Special No. RSA, 1907, XLI (Plates); Caw, 60, 174-6, 204, 233, 475, 478; DNB.

HERDMAN, William Gawin 1805-1882
Liverpool landscape and topographical painter. Best known for his topographical studies of Liverpool and the surrounding area, such as 'Pictorial Relics of Ancient Liverpool' published in 1843 and 1856. Joined Liverpool Academy in 1836. Following a quarrel with the Academy in 1857 over the annual award to Millais for his 'Blind Girl', Herdman left and set up a rival society. The Institution of Fine Arts. He exhibited landscapes at the RA 1834-61, mostly views around the Liverpool area. He also wrote essays and pamphlets on a wide variety of subjects, including curvilinear perspective, and *Hymns and Ancient Melodies,* and published a book of poems.

'Royal Review on the Mersey, October 1851' was sold at Christie's 27.10.67 for £252.

Bibl: Walker AG. Liverpool, 1884 Cat; Marillier, 136-142 (plate opp. p.136); DNB XXVI

HERING, George Edwards 1805-1879

London landscape painter. Son of a bookbinder. Studied in Munich 1829. Travelled in Switzerland with his patron. Lord Erskine, and then studied two more years in Venice. After further travels in the Levant, he came to Rome, where he met John Paget, a publisher of travel books, for whom he worked on many illustrations. After seven years' absence, Hering returned to London in 1836, and became a regular exhibitor at the RA, BI & SS. For his subjects, he drew mostly on his travel sketches made on the continent and in the Middle East. His pictures are often small in scale, but painted with a delicate feeling for light and atmosphere. His wife was also a landscape painter. She exhibited at the RA in 1852 and 1858 under the name Mrs. G.E. Hering. After Hering's death, two sales of his works were held at Christie's on May 7, 1880 and April 25, 1881.

'Mountainous Landscape' sold at Bonham's 8.5.69 for £170.

Bibl: AJ 1861 p.73-5; 1880, 83 (obit.); DNB XXVI 244.

*HERKOMER, Sir Hubert Von RA RWS RI 1849-1914

Painter of social realism, portraits, historical subjects and landscapes; engraver. Born at Waal, Bavaria; son of a wood-carver, who settled in Southampton, 1857. Entered S. Kensington Schools in 1866 where he studied under Sir Luke Fildes (q.v.); influenced by F. Walker, (q.v.). From 1869 he received an income from *The Graphic* for engravings. Exhibited from 1869 at the RA, SS, OWS, RI, GG, NG and elsewhere. He first achieved great success with 'The Last Muster, Sunday at the Royal Hospital, Chelsea', 1875, which was bought for £1.200 by the Lady Lever Gallery. Among his outstanding social-genre paintings are 'Found', 1885, Tate Gallery, 'Hard Times', 1885, Manchester, 'On Strike' 1891, RA Diploma. As a portrait painter he had a very extensive clientele, his portraits including those of Wagner, Ruskin, Lord Kelvin and Lord Kitchener. He also made a speciality of large portrait groups, somewhat reminiscent of 17th c. Holland, e.g. 'The Chapel of the Charterhouse', (RA 1889), 'The Council of the RA', 1908 and 'The Firm of Friedrich Krupp', 1914. He composed music and wrote some operas, acted and designed stage scenery, even living to design sets for the cinema. He founded and directed the School of Art at Bushey, 1883-1904; Slade Professor of Fine Arts at Oxford, 1885-94; member of the Institute of Painters in watercolours, 1871; ARA, 1879; RA, 1890; ARWS, 1893; RWS, 1894; CVO, 1890; knighted, 1907; raised to noble rank by the Emperor of Germany in 1899, and afterwards assumed the prefix "von". Wrote an autobiography and on etching, etc. Maas writes: "Herkomer claimed to have learned in England that 'truth in art should be enhanced by sentiment'. He was rarely sentimental but his social realism is rather heavy handed and clogged with over-emphasis as can be seen in 'On Strike'."

'Street Scene' sold at Christie's 11.7.69 for £473

Bibl: For full bibliography and list of paintings and publications *see* TB, 1925 ed.
Selected Bibliography:- AJ, 1870, 86; Studio Vols. 29, (1903), 60, 63; 50, (1910), 15; 56, (1912), 17; Ludwig Pietsch, *Herkomer*, 1901; A.L. Baldry, *Hubert Von Herkomer, RA, a Study and a Biography*, containing a list of his works to 1901, 1902; Sir H. von Herkomer, *My School and My Gospel*, 1908; Sir H. von Herkomer, *The Herkomers*, 2 vols, 1910-11; Who's Who, 1913; DNB, 1912-21; J. Saxon Mills, *Life and Letters of Sir Hubert Herkomer, A Study in Struggle and Success*, 1923; Reynolds, VS, 27, 30-1, 96-7, 105, (pl.91); Maas 237, (pl.239).

HERRING, Benjamin, Junior 1830-1871

Painter of animals, sporting scenes and rustic genre. Lived in Tonbridge. Son of J.F. Herring Senior (q.v.), and often confused with Benjamin Herring Senior (q.v.). Exhib. at BI and SS 1861-63. It is possible that many of the forged J.F. Herring farmyard scenes now in circulation are by Benjamin Herring, Junior.

'Village Fair' sold at Christie's 21.3.69 for £1,260

HERRING, Benjamin, Senior 1806-1830

Animal and sporting painter; brother of J.F. Herring, Senior (q.v.). Did not exhibit in London. Painted hunting scenes, racehorses, and horse fairs. Very often confused with Benjamin Herring, Junior (q.v.). His style is similar, but not as good as J.F. Herring and Harry Hall.

'Alice Hawthorn' a racehorse and jockey, sold at Sotheby's 12.3.69 for £550.

Bibl: Sparrow; Pavière, Sporting Artists, p.48 (plate 23), (The picture illustrated here is dated 1867, and must therefore be by Benjamin Herring, Junior).

HERRING, John Frederick, Junior fl.1860-1875 d.1907

Sporting and animal painter and watercolourist. Son and imitator of J.F. Herring, Senior (q.v.). Exhib. mainly at SS (53 works), also at RA and BI. Herring Junior is said to have quarrelled with his father, and although a competent artist, he devoted his career to slavish copying and imitation of his father's work, particularly farmyard scenes. As both painters used the same name and initials, their work is constantly confused. Herring Junior's style is much coarser, and became more so as he got older.

The highest recorded price is £1,260 for a 'Farmyard Scene' at Christie's 22.11.68. Range during the 1968-9 season was £100-800. The general confusion about J.F. Herring Senior and Junior accounts for the wide variation in price.

Bibl: AJ 1907 p.160, 251, 360
Shaw Sparrow, British Sporting Artists, 222-3.

*HERRING, John Frederick, Senior 1795?-1865

Sporting and animal painter. At first a sign and coach painter. Worked as stable boy and coachman in Yorkshire until, with the help of patrons, he was able to study with Abraham Cooper(q.v.). Exhib. at RA 1818-46, and BI, but mostly at SS (82 works) of which he was a member 1841-52. Herring became a popular painter of racehorses. For many years he painted the winners of the Derby and the St.Leger, as well as many other famous horses and jockeys of the day. He also painted many charming small-scale studies of rabbits, ducks, goats, birds, and other animals. Towards the end of his career he turned increasingly to repetitious farmyard scenes, which were much copied and imitated by his son J.F. Herring, Junior (q.v.). He had two other sons, Benjamin, Junior (q.v.) and Charles, who died aged 28. Many of Herring's works were engraved. He held the appointment of animal painter to the Duchess of Kent. Sometimes collaborated with Thomas Faed (q.v.). A picture by both artists is in the City of York. A.G. Herring's studio sale was held at Christie's on Feb. 3, 1866.

At present, Herring's pictures of coaching scenes and racehorses make the highest prices. The current record is £24,500 at Sotheby's 18.3.70 for 'The Goodwood Cup 1833 – at the Start.' The range for farmyard scenes is usually £1,000-3,000, but many of the pictures sold as Senior are often by Junior. A single horse in a stable can sometimes make less – perhaps £500-1,000.

Bibl: AJ 1865 p.172, 328 (obit); *Memoir of J.F.H.* Sheffield, 1848; Redgrave, Dict; Bryan; DNB XXVI 258 f; Guy Paget, *Sporting Pictures of England; Sporting Magazine* Vol. 6; Shaw-Sparrow, British Sporting Artists, see Index (plates 76, 83); Pavière, Sporting Painters, 49; Maas 74, 78, 82 (plate on p.78).

*HICKS, George Elgar RBA b.1824 fl.1848-1905

London painter of genre, portraits and scenes of Victorian life. Studied to be a doctor, but changed to painting, entering RA Schools in 1844. Exhib. 1848-1905 at RA, BI, SS and GG. The success of 'Dividend Day at the Bank' (1859) led Hicks to attempt more scenes

of contemporary life, such as 'The Post Office' (1860) and 'Billingsgate' (1861), in the colourful style of Frith. These brought Hicks great popularity, but he turned later to portraits, and biblical and historical genre. As a society portrait painter, Hicks was much in demand, but his work in this field has none of the charm or quality of his genre scenes of the 1860's.

'Dividend Day at the Bank' a small version, was sold at Christie's 8.7.66 for £1,575. The more usual range is £100-300.

Bibl: AJ 1872, p.97-99; Clement and Hutton; Reynolds VS, 8, 13-14, 88-9 (plates 73-4); Reynolds VP, III; Maas, 117, 119, 121.

HILDER, Richard fl.1836-1851
London landscape painter. Exhib. 1836-51 at RA, BI and SS. Four drawings by him are in the Brit. Mus.. Perhaps brother of P. John Hilder, also a landscape painter, who lived at the same address. Subjects at RA mainly views in Kent and Sussex.

'Wooded Landscape' sold at Christie's 20.12.68 for £399.

HILDITCH, George 1803-1857
Prolific London landscape painter who exhibited from 1823-56, at the RA, BI and SS. Bryan writes "His style is original, with much of the power and truth to nature of Patrick Nasmyth, but pictures painted by him during a visit to France in 1836 have been mistaken for the works of Bonington." The subjects were selected chiefly from Richmond and its vicinity, N. and S. Wales, France and Germany.

'All Saints Church, Hastings' sold at Sotheby's 20.12.68 for £200.

Bibl: Bryan

HILDITCH, Richard H. fl.1823-1865
Landscape painter who exhibited from 1823-65, at the RA, BI and SS. Brother of George Hilditch (q.v.). Subjects Wales, the Thames, and Warwickshire. Also travelled on the Rhine and in Italy.

Probable price range £50-150

HILL, Arthur RBA fl.1858-1893
Painter of landscape, genre and portraits, working in Nottingham and London. Exhibited from 1858-93, at SS, at the RA (1864-93), at BI and elsewhere. Titles at the RA include 'Oak in Bradgate Park', 'Mariana', 'Andromeda' and 'The Foolish Virgins'.

Probable price range £30-70

HILL, David Octavius RSA 1802-1870
Scottish painter of portraits and landscape, who subsequently became known as one of the 19th c's outstanding portrait photographers. Born in Perth, he studied under Andrew Wilson at Edinburgh School of Art. He was Secretary to the Society of Artists in Edinburgh for eight years, before in 1838 it became the RSA, and occupied the post till his death. In 1841 he published *The Land of Burns,* a series of 60 illustrations engraved from his oil landscapes, and these became very well known. He first adopted photography to paint a large group portrait containing no less than 474 likenesses, called 'The Signing of the Deed of Demission', (to commemorate the first general assembly of the new congregation of ministers who had withdrawn from the established Presbyterian Church of Scotland). This was begun in 1843 and completed in 1865, and is now in the Free Church Assembly Hall, Edinburgh. Together with the chemist and photographer Robert Adamson, he began in 1843 to take calotype photographs of each person to appear in the painting, and at the same time opened a photographic business with Adamson, photographing many of the eminent Scots of the day, and often exhibiting these calotypes alongside his landscapes at the RSA, (e.g. in 1844, '45 and '46). After the retirement of his partner in 1847, Hill returned to painting. He exhibited from 1832-68, at the RA, 1852-68, BI, SS and elsewhere. He also helped in founding the N.G. of Scotland, 1850. In 1846 he published a series of calotype views of St. Andrews. In the 19th c. Hill's photographs were favourably compared with the work of earlier masters — Reynolds, Rembrandt and Murillo — and the painter Clarkson Stanfield, who Ruskin called 'the great English realist', found them superior to the work of Rembrandt.

Probable price range for oils and watercolours £50-100.

Bibl: AJ, 1869, 317-9; 1870, 203 (obit); Redgrave, Dict; Clement and Hutton; The Portfolio, 1887, 135; Ch. Holme, RSA, The Studio, p.XLI (plate); Cat. Engr. Brit. Portraits, BM, 1908, II, 178; IV, 239; Caw, 93, 145-6; DNB; Heinrich Schwarz, *David Octavius Hill,* 1932, and in Art Quarterly, Winter, 1958; Aaron Scharf, *Art and Photography,* 1968, 27, 29-31, 59, 260; Maas, 191.

HILL, James John RBA 1811-1882
Painter of landscape, rustic genre and portraits. Born in Birmingham, where he studied. Came to London 1839. Exhib. mainly at SS; elected RBA 1842. Also exhib. at RA 1845-68 and BI. His patroness was Lady Burdett-Coutts, for whom he painted many portraits, animal and dog studies. Hill also painted a few fantasy works, but his later work has a tendency to repeat the same formula — pretty, smiling peasant girls, either singly or in groups, with landscape backgrounds. Visited Ireland frequently. Hill's pictures were often reproduced lithographically for the *Illustrated London News* Sometimes painted figures for Henry Bright (q.v.).

'Mother and Child' — a pair — sold at Bonham's 6.2.69 for £180.

Bibl: DNB XXVI (1891); Bryan; BM Cat. of Engraved Brit. Portraits III 526.

HILLINGFORD, Robert Alexander b.1828 fl.1864-1893
Painter of historical genre. Born in London. Studied in Dusseldorf, Munich, and home. After marrying an Italian model, Hillingford spent many years in Italy, painting scenes of Italian life. In 1864, after 16 years absence, Hillingford returned to London, where he exhib. 1864-93 at the RA, BI and SS. Abandoning his early Italian subjects, he turned to historical genre, and battle scenes, especially of the Napoleonic Wars. He also painted some typical fancy-dress genre pieces, mostly in seventeenth century costume, which reflect his Munich training. Works by him are in Glasgow and Sheffield AG.

Price range in the 1968-9 season £121-683

Bibl: AJ 1871 p.213-15; 1908, 350; L'Art XLII (1890) 212-13; Clement and Hutton; Blackburn, RA Notes 1881-3; RA Pictures 1893, 1895, 1898-1902.

HINES, Frederick fl.1875-1897
London landscape painter, exhibiting from 1875-97, at the RA from 1879-97, at SS, NWS, GG and elsewhere. Titles at the RA include 'Silver Birches', 'The Reapers', 'The Woodland Solitude'. Brother of Theodore Hines (q.v.).

Probable price range £30-70

HINES, Theodore fl.1876-1889
London landscape painter who exhibited from 1876-89, at the RA (from 1880-89), SS, GG and elsewhere. Brother of Frederick Hines (q.v.). Titles at the RA include 'Spring', 'Lingering light', and 'Gloaming'.

'Stronachar, Trossachs' sold at Christie's 2.4.69 for £168.

HODGSON, John Evan RA HFRPE 1831-1895
Painter of genre, landscape, historical and eastern subjects. Born in London, he spent his early youth in Russia; educated at Rugby and afterwards began a commercial career in London. Then he entered the RA Schools in 1853. Exhibited from 1856-93, at the RA, BI, SS,

and elsewhere. From 1856-68 he exhibited at the RA historical or domestic scenes, e.g., 'Canvassing for a Vote', 1858, 'The Patriot's Wife', 1859, 'Margaret Roper in Holbein's Studio', 1860. In 1868 he visited Africa — Tunis, Tangier, Algiers and Morocco, and from that time his works were almost exclusively Eastern in subject matter, e.g. 'An Arab Story-teller'. Elected ARA 1872, RA 1879, his Diploma painting being 'A Shipwrecked Sailor Waiting for a Sail'. He was Librarian and Professor of Painting at the RA from 1882-95, and with Fred. A. Eaton wrote *The Royal Academy and Its Members, 1768-1830,* 1905. Hodgson was a member of the St. John's Wood Clique (see bibl.), whose members painted a series of frescos in his house.

Probable price range £100-200

Bibl: AJ, 1895, 256 (obit); *The Portfolio,* 1871, 17-19; *Gaz-des B.Arts,* 1873, II, 348; H. Blackburn, *Academy Notes,* 1876, 13, 24; Clement and Hutton; *The Year's Art,* 1896, 297; Bryan; Cat. Engr. Brit. Portr., BM, IV, 1914, 386; Hutchinson, 137, 143, 232, 233; Bevis Hillier, *The St. John's Wood Clique,* Apollo Jun. 1964.

HODSON, Samuel John RWS RBA RCA 1836-1908
Landscape and architectural painter, and lithographer. Studied at RA Schools. Exhib. 1858-1906 at RA, BI, SS and OWS. Subjects mainly romantic views of buildings in Italy, Spain, Germany, Belgium, and Switzerland, both in oil and watercolour. Elected ARWS 1882, RWS 1890; secretary of RI. Hodson worked for *The Graphic* as colour lithographer, engraving many well-known pictures by Millais, Leighton, Fildes and others.

Probable price range £30-70

Bibl: AJ 1901 p.207-2; Cundall p.159, 221; The Year's Art 1909 p.406; BM Cat. of Engraved Brit. Portraits V.27.

HOLDER, Edward Henry fl.1864-1917
Yorkshire landscape painter. Born in Scarborough. Exhib. 1864-93 at SS, also at RA 1872-3. Subjects mainly coastal views in Yorkshire. Lived in London, and Reigate, and then visited South Africa, where he carried out many commissions. In 1917 he exhibited a view of the Victoria Falls on the Zambesi at the RA. Several of his works are in York AG.

Probable price range £100-300

Bibl: City of York A.G. 1907 Cat. p.53

***HOLIDAY, Henry 1839-1927**
Painter of historical genre; also illustrator, glassmaker, enamellist and sculptor. Studied at Leigh's Academy, and RA Schools. Now best known for his 'Dante and Beatrice' exhibited at the Grosvenor Gallery in 1883, and now in the Walker A.G. Liverpool. In 1861, under the influence of Burne-Jones, Holiday began to design stained glass for Messrs. Powell and Sons. In 1890 he founded in Hampstead his own glassworks, which produced stained glass, mosaics, enamels, and sacerdotal objects. Exhib. at the RA from 1858, mainly cartoons and stained glass, although he did continue to paint occasional figure subjects e.g. 'Terpsichore' 'Cleopatra' 'Sleep' etc. in the Pre-Raphaelite style, and portraits. As an illustrator, Holiday is best known for his work on Lewis Carroll's *The Hunting of the Snark.*

Probable price range £100-300

Bibl: Studio vols.34 (1905) p.304; 46 (1909) p.106; 70 (1817), p.131; Studio Year Book of Decorative Art 1909 p.55; AJ 1859 p.169; 1884, 5; 1890, 31; 1901, 121; 1904, 23; 1906, 20-25; 1908, 83; H. Holiday, *Reminiscences of My Life,* 1914; Reynolds VP 65, 69. 71, 72, 85, 92 (plate 55); Maas 231.

***HOLL, Frank RA ARWS 1845-1888**
Painter of portraits and genre, and illustrator. Son of Francis Holl, an

engraver. Studied RA Schools 1860; won Gold Medal 1863. Began to exhibit at RA in 1864. In 1868 scored his first success with 'The Lord Gave and the Lord hath Taken Away.' For this he was awarded the Travelling Prize, which he spent in Italy 1869. In 1870 'No Tidings from the Sea' was bought by Queen Victoria. In genre painting, Holl's preference was for dramatic social realism. Most of his illustrations for *The Graphic* were scenes of working class life. His best known picture of this type is 'Newgate — Committed for Trial' exhibited at the RA in 1878, where it hung alongside Fidles's 'Applicants for Admission to a Casual Ward.' (q.v.). Elected ARA 1878, RA 1882. Exhib. at RA 1864-88, and GG, and occasionally BI, SS and NG. In 1877 Holl began to paint portraits, launching himself on a career which made him one of the most popular, and one of the best of all Victorian portrait painters. His portraits are painted in strong black and brown tones, with dramatic chiaroscuro, showing the influence of Dutch seventeenth century painting, especially the work of Rembrandt. Among Holl's sitters were Millais, John Bright, Joseph Chamberlain, Gladstone, Pierpont Morgan, The Duke of Cambridge and the Prince of Wales. In 1888 Holl fell ill on a visit to Spain, and died later the same year, aged 43.

'The Broken Crock' sold at Sotheby's 12.2.69 for £160. A good portrait or an important genre scene would make more than this.

Bibl: AJ 1876 p.9-12; 1889, 53-9; Portfolio 1888 p.183f; DNB XXVII (1891); Roget; Poynter N.G. Cat. 1900; BM Cat. Engr. Brit. Portraits Vols. 1-11; A.M. Reynolds, The Life and Works of F.H. 1912; India Office Cat. 1914 p.41; Reynolds VS 27-8, 33, 40, 93 (plate 83); Reynolds VP 37, 173, 180; Maas 213, 223, 237.

***HOLLAND, James RWS RBA 1799-1870**
Painter and watercolourist of landscapes and continental views, especially Venice. Born Burslem, Staffordshire. Taught by his mother, who painted flowers on porcelain. Came to London 1819. At first concentrated on flower painting, but changed gradually to landscape. In 1831 he went to France on the first of many tours he was to make all over Europe, gathering enough material to last a lifetime. Holland's early watercolours, much influenced by Bonington, are among the finest in the tradition of Victorian continental view painting, comparable to, sometimes even better than, Callow, Prout, Harding or Roberts. After about 1840, Holland's style began to decline. Like so many Victorian artists, he found it more profitable to turn out romantic, colourful views of Venice. These repetitive, travel-poster pictures still enjoy popularity, and are not without merit, but they represent a decline when compared with Holland's earlier work. Exhib. at RA 1824-65, BI, SS (108 works), OWS (194 works) and NWS. Elected ARWS 1835, RWS 1857. Member of SBA 1842-48. His studio sale was held at Christie's on May 26, 1870.

'A View of the Town of Torres Vedras' sold at Sotheby's 20.11.68 for £750. A fine Venetian view would probably make more than this.

Bibl: AJ 1870 p.104 (obit); Portfolio 1892 p.211; Connoisseur 1913 p.105; 1914, p.76, 82; Studio Spring No. 1915; Winter No. 1922-3; Ottley; Redgrave, Dict; Roget; Binyon; Cundall; DNB XXVII)1891) 146; Hughes; VAM; H. Stokes, *J.H.,* Walker's Quarterly XXIII, 1927; R. Davies, *J.H.,* OWS, VII, 1930; Reynolds VP 25; M. Tonkin, *The Life of J.H.,* OWS, XLII, 1967; Hardie III 31-5 and Index (plates 47-59); Maas 88, 98 (plates on p.98).

HOLLAND, John fl.1831-1879
Nottingham landscape painter. Exhib. landscapes and coastal scenes at SS. 1831-79 and BI 1865-6. Usually signed J. Holland, and his works are sometimes passed off as James Holland (q.v.). Works by him are in the Nottingham AG.

Two landscapes — a pair — sold at Sotheby's 16.10.68 for £130.

HOLLAND, Philip Sidney 1855-1891
Painter of genre and historical subjects, who exhibited from 1877-84,

at the RA, SS, NWS and elsewhere. Titles at the RA include 'Music of the Past', and 'The Trial of a Noble Family Before the Blood Council, Antwerp, 1567". One of his paintings is at Norwich Art Gallery (No. 113, Cat. 1913).

Probable price range £30-70

HOLLINGDALE, Horatio R. RBA fl.1881-1899
London landscape painter who exhibited from 1881-99, mostly at SS (55 works), and also at the RA and elsewhere.

Probable price range £30-70

HOLLINGDALE, Richard fl.1850-1899
Genre and portrait painter working in Stroud (Kent), who exhibited from 1850-99, at the RA (from 1854-99), BI and SS. Titles at the RA mainly portraits, and 'The Sister's Entreaty', and 'Let me Tell your Fortune, Fair Ladies'.

Probable price range £30-70

HOLLINS, John ARA 1798-1855
Painter of portraits, historical and genre subjects, and occasional landscapes. Born in Birmingham, where his father was a glass painter. Exhibited 2 portraits at the RA in 1819, 3 more in 1821, and settled in London in 1822, painting portraits in oil, and occasionally in miniature. From 1825-27 he travelled in Italy and on his return resumed his practice as portrait painter, though he also painted numerous historical subjects from the works of Shakespeare, Goethe and other writers. Later in life he also painted landscape and genre. Occasionally he painted group portraits: 'A Consultation Previous to an Aerial Voyage from London to Weiburg in Nassau on Nov. 7th 1836' (showing many noted people of the day), and 'Salmon-fishing on Loch Awe' (1854, with F.R. Lee RA), another celebrated group portrait. He was elected ARA in 1842.

'A Consultation Previous to the Aerial Voyage to Germany, 7th Nov. 1836' sold at Christie's 6.3.70 for £840, and is now in the N.P.G.

Bibl: Ottley; Redgrave, Dict; Cust., NPG, II, 1902, 70; DNB; VAM; Cat. Engr. Brit. Portr. BM, V, 1922, 87.

HOLLOWAY, Charles Edward RI 1838-1897
Landscape and marine painter, engraver and lithographer. Born at Christchurch, Hants. Fellow pupil of Fred Walker, Charles Green and Sir J.D. Linton at Leigh's Studio in Newman St.; subsequently associated with William Morris till 1866 in the production of stained glass. Then, devoting himself entirely to painting, he exhibited from 1866-94, at the RA (1867-94), SS, NWS (70 works), GG and elsewhere, showing many paintings of the Fen district, the Thames, and Suffolk and Essex coasts. At the RA he exhibited mainly topographical views, and his speciality is listed as "Churches" in Graves, Dict. Hardie notes that 'his watercolours show his acceptance of the Impressionist outlook and also a kinship with Whistler in their suave and subtle colouring". Elected A. of the RI in 1875, member in 1879.

Probable price range £50-150

Bibl: AJ, 1896, 12 (plate); 1897, 127 (obituary); Studio, 1906 (plate X); Bryan; Cundall; VAM; Studio Special No., *British Marine Painting*, 1919, 28, 68, (plate); Hardie, III, 82, 84 (plate 106).

HOLMES, Edward RBA fl.1841-1891
Landscape, marine and portrait painter, who exhibited from 1841-91, mostly at SS (159 works), and also at the RA (from 1855-91), and at BI (1847-67). Titles at the RA include 'Going to Market', 'The Prawn Fishers', 'In the New Forest', and 'The End of the Year'.

Probable price range £30-70

HOLMES, George Augustus RBA fl.1852-1909
Painter of genre who exhibited from 1852-1909, at the RA (from 1852-1900), BI, GG, Paris Salon (1906, 10-11), elsewhere, but mostly at SS (110 works). Titles at the RA include 'Isabella-Vide' 'Orlando Furioso' 'Feeding Time' and 'Forty Winks'

Probable price range £30-70

HOLMES, James RBA 1777-1860
Painter of genre, portraits and miniatures, engraver and lithographer. Apprenticed to an engraver; after that turned to painting in watercolour. Elected member of OWS, 1813, exhibiting 'Hot Porridge' and 'The Married Man'. 1819 exhibited 2 miniatures at the RA and at about the same time started to paint oils. In 1821 he ceased to be a member of the OWS, and actively worked to establish the Society of British Artists who held their first exhibition at SS in 1824. He became a member in 1829 and a constant exhibitor, chiefly in miniatures up to 1850 when he resigned. In the latter part of his career he became a fashionable miniature painter, and had many distinguished sitters — amongst them Byron. He varied his portraits with genre, liking the plain humour and pathos of domestic scenes, as is seen from such titles quoted above. His genial character and musical talents gained him the personal friendship of George IV and his 'Michaelmas Dinner' of 1817 was bought by the King. He was also a popular teacher. Hardie quotes Gilchrist's statement that Blake was indebted to Holmes and to Richter for "a greater fullness and depth of colour in his drawings than he, bred in the old school of slight tints, had hardly thought could have developed in watercolour art." In all, he exhibited at SS (142 works), RA (1798-49), BI, OWS, NWS and elsewhere.

Probable price range £50-150

Bibl: A full list of his paintings, portraits and engravings is in TB (ed. 1923); A. Gilchrist, *Life of William Blake*, I, 1863, 247; Redgrave, Cent; Redgrave, Dict.; Roget, I & II; A.T. Storey, *James Holmes and John Varley*, 1894; G.C. Williamson, *History of Portrait Miniatures*, 1904, I, 188 (plates); Cat. of Engr. Brit. Portr, BM, I, 1908, 132, 313; II, 1910, 62, 246, 315; III, 1912, 230, 431, 582; IV, 1914, 24, 338, 400, 489; Cundall; DNB; Connoisseur 30 (1911) 251 (plates); Hughes; Hardie, II, 152-3, 120.

HOLYOAKE, Rowland fl.1880-1907
Painter of genre, portraits, landscapes and interiors. Son of William Holyoake (q.v.). Exhib. from 1880-1907, at the RA (1884-1907), SS, NWS, GG, and elsewhere, titles at the RA including 'For the Banquet.' (Hamlet, Act III, sc. 4), 'Shall I Wear a White Rose?'.

'Waiting' sold at Christie's 10.7.70 for £94.

Bibl: RA Pictures, 1905.

HOLYOAKE, William RBA 1834-1894
Genre and historical painter. Member of the RBA where he exhibited 53 works; Vice P. of the RBA for many years, and was in that position when Whistler was elected for his brief career as President. Also exhibited at the RA, 1865-85, and at BI, 1858-67. Twice the Curator of one of the Academy Schools. Among his best known works are 'The Sanctuary' (which now hangs in one of the Chapels of Westminster Abbey), 'The Home at Nazareth', and 'The Broken Vow'. Reynolds, (VS), illustrates 'In the Front Row of the Opera', comparing the ladies to Rossetti's 'stunners'.

'Derby Day at Epsom' — a pair — sold at Sotheby's 13.7.66 for £440.

Bibl: AJ, 1894, 95 (obituary); H. Blackburn, *Academy Notes*, 1877, 1878, (plates); Cat. Engr. Brit. Portr. BM, I, 1908, 70; Glasgow Art Gallery Catalogue, 1911 (Biography); Reynolds, VS, 91, fig. 70.

HOOD, George Percy Jacomb See JACOMB-HOOD, George Percy

***HOOK, James Clarke RA HFRPE 1819-1907**
Painter of coastal scenes and seascapes, historical genre, and landscape.

Studied with the portrait painter John Jackson, and in 1836 at RA schools. In 1839 he made his début at the RA with 'The Hard Task'. 1844 won Gold Medal in Houses of Parliament Competition. 1845 won 3 year travelling prize, which he spent in France and Italy. He was much influenced by the rich colours of the great Venetian painters. On his return he settled down to a series of historical scenes, mostly from literary sources, and rustic genre. In 1859 the success of 'Luff Boy!' at the RA — it was much praised by Ruskin — encouraged him to turn to coastal scenes and seascapes, for which he is now best known. Elected RA 1860. Exhib. at RA 1839-1902, BI and occasionally elsewhere. Hook's brisk style and rich colours succeed admirably in capturing the effects of wind and sunshine by the sea.

'The Cider Makers' sold at Christie's 11.10.68 for £1365. The average is still £200-500

Bibl: AJ 1856, p.41, 44; 1907, 187; 1908, 58, 59, 61; Portfolio 1871 p.181 ff; Ruskin, *Academy Notes*, 1855, 57-9, 75; W. Sandby, *History of the RA*, 1862; F.G. Dumas, Biog. of Mod. Artists 1882-4; A.H. Palmer, *J.C.H.*, 1888; F.G. Stephens, *J.C.H. His Life and Work* 1890; DNB 2nd Supp. (1912), 293 f; Reynolds VP 94, 152, 153 (plate 105); Maas 66 (plate on p.68).

HOPKINS, William H. fl.1853-1890 d.1892

Landscape, animal and sporting painter. Exhib. at BI from 1853, and RA from 1858, and SS. Became a popular painter of horses, hounds, and hunting scenes e.g. 'Her Majesty's Buckhounds' (1877). Sometimes collaborated with Edmund Havell junior (q.v.) who painted figures. Hopkin's sister Hannah exhib. genre scenes at RA 1873-77.

'Forrard Away!' sold at Coe's (London) 16.7.69 for £300.

Bibl: Chronicle des Arts 1892, p.270.

*HOPLEY, Edward William John 1816-1869

Painter of genre, portraits, and in particular historical, allegorical and fairy subjects. He originally studied medicine, but later turned to art, gaining popularity as a painter of domestic genre and portraits. He first exhibited at the BI in 1845 'Love Not', and at the RA in 1851 with 'Psyche'. The subjects of some of his paintings were very diverse and strange: 1853 (BI), 'Puck and Moth, Two Treatments'. (Two small and very highly finished pictures, proposing to contrast the spirit of Pre-Raffaelism with that of Post-Raffaelism. The conceptions are ingenious and worked out with incomparable nicety); 1855 (RA) 'A Primrose from England', 1859 'The Birth of a Pyramid' (the result of considerable archaeological research). He also invented a trigonometrical system of facial measurement for the use of artists. Much of his life was passed in Lewes.

Probable price range £100-300; perhaps more for a good fantasy subject.

Bibl: AJ 1853, 88; 1869, 159, 216 (obit.); DNB XXVII, 1891, 340; Maas 155 (pl. 158).

HORLOR, George W. f.1849-1891

Animal and sporting painter. Worked in Cheltenham, Birmingham and Brentford. Exhib. at RA, BI, and SS. Specialised in shooting scenes in the Highlands, e.g. 'A Day's Sport in Perthshire' (1856) 'Denizens of the Moors' (1866) etc.

'A Man on Horseback by a Stream' sold at Sotheby's 4.6.69 for £220.

Bibl: AJ 1859, p.81, 122, 143, 167; 1860, 79.

HORLOR, Joseph fl.1834-1866

Landscape and coastal painter. Worked in Bath and Bristol. Exhib. at BI and SS 1834-66. Subjects mostly Welsh landscapes and coastal scenes. Two works by him are in Bristol AG.

'Cattle in a Glen' sold at Christie's 20.12.68 for £136.

Bibl: Building News 1910 II 490.

HORNBROOK, T.L. 1780-1850

Plymouth marine painter to Duchess of Kent and Queen Victoria. Exhib. at RA 1836-1845 and SS. Very little known, but his work shows a developed feeling for light and colour, particularly in his pictures of ships in calm water.

'British Men o' War in a Foreign Port' sold at Christie's 8.5.70 for £294.

Bibl: Wilson, Marine Painters, 44 (pl. 17).

HORNEL, Ernest Atkinson 1864-1933

Glasgow school genre and decorative painter. Born in Australia, but lived mostly in Kirkudbright. Studied Trustees. Academy, Edinburgh, and in Antwerp under Verlat. The works of this early period show strong Belgian influence; mostly landscapes with figures in the manner of Maris or Mauve. Through his long friendship with George Henry (q.v.) Hornel moved towards a more colourful, decorative style. Hornel's association with Henry, which lasted about ten years, produced a series of pictures which are regarded as the essence of the Glasgow school. Using low-keyed palettes, both tried to escape subject and local colour, concentrating on purely decorative colour arrangements. After Hornel's Japanese paintings of 1893-4, his work declined in quality, becoming sentimental, repetitive, and over-sweetly coloured.

Price range in the 1968-9 season was £700-1700

Bibl: AJ 1894 p.76, 78; 1905, 352; 1906, 383; 1909, 95; Studio, See Index 1901-14; Connoisseur 1911, 216; 1913, 111; RA Pictures 1910-15; D. Martin, *The Glasgow School of Painting*, 1902, p.30 ff; Caw 400-403 (plate opp. p.402); Who's Who; Scottish Arts Council, *Catalogue of the Glasgow Boys Exhibition*, Glasgow 1968.

HORSLEY, Hopkins Horsley Hobday 1807-1890

Birmingham landscape painter, worked in London, Birmingham, and Sutton Coldfield. Exhib. in London 1832-66 at RA, BI and SS. Subjects Staffordshire, Devonshire, Wales, the Swiss Alps and North Italy.

Probable price range £20-50

*HORSLEY, John Callcott RA 1817-1903

Historical genre painter. Nephew of Sir A.W. Callcott (q.v.) and brother-in-law of the engineer Brunel. Studied at RA Schools. His first RA picture in 1839, 'Rent Day at Haddon Hall in the Days of Queen Elizabeth' launched him on a long and successful career. Exhib. at RA 1839-96, and BI. Painted mostly historical subjects, but in the 50's and 60's he turned to contemporary subjects, usually "scenes of flirtation set in the countryside" (Reynolds) such as 'Showing a Preference' or 'Blossom Time'. The recipe for these pictures was described by a contemporary as "sunshine and pretty women". Was also a member of the Cranbrook Colony in Kent, with Thomas Webster, A.E. Mulready, G.B. O'Neill and F.D. Hardy (all q.v.). From 1875-90 he was rector of the RA, where his prudish objections to the use of nude models earned him the nickname of "Clothes-Horsley". He was the organiser of the first RA Old Master Winter Exhibitions. A keen musician, he was a friend of Mendelssohn-Bartoldy; he also contributed drawings to *Punch* for another friend, John Leech.

'Someone at the Door' sold at Bonham's 8.5.69 for £220.

Bibl: AJ 1857 p.181-4; Ottley; Ruskin, *Academy Notes* 1856-8; Sandby, *History of the RA*, 1862; Blackburn, *RA Notes*, 1875-83; RA Pictures 1891-3, 96; J.C. Horsley, *Recollections of an R.A.* 1903; DNB 2nd Supp (1912) 304; Studio, *Shakespeare in Pictorial Art*, Spring No. 1916; Reynolds VS 54-5, 70 (plates 12-13); Reynolds VP 36, 62, 64, 66 (plates 22, 26); Maas 27, 28, 164, 232-3 (2 plates on p.232).

HOUGH, William fl.1857-1894

Painter of still life and birds' nests. Exhib. from 1857-94, at the RA, BI, SS NWS and elsewhere. Worked at Coventry and subsequently for many years in London. Imitator of W.H. Hunt, closely following his

painting of flowers and fruit. He is represented (amongst other places) at Glasgow Art Gallery.

'Summer Fruits and Flowers', a watercolour – sold at Christie's 28.4.70 for £105.

Bibl: Cundall; VAM; Hardie, III, 102, 109, 114.

*HOUGHTON, Arthur Boyd 1836-1875

Book illustrator and painter of contemporary genre, both in oil and watercolour. Studied at Leigh's Art School, and became known for his brilliant illustrations to Dalziel's *Arabian Nights,* 1865, *Don Quixote,* 1866, *A Round of Days'*, 1866, for the many drawings he supplied to *The Graphic, Fun,* and other serials. He exhibited from 1859-74, at the RA (1861-72), BI, SS, OWS and elsewhere. He travelled to India, and to America (for *The Graphic,* making sketches of Shaker customs), and these trips supplied him with a taste for the exotic as is seen in such subjects as 'The Transformation of King Beder' and 'The Return of Hiawatha', 1871, (VAM), both watercolours, and rich in colour. His oil paintings were chiefly of contemporary genre and "reveal a refreshingly undoctrinaire approach to the everyday scenes of home life, and give a much less tragic view of Victorian domesticity than might be gleaned solely from Hunt's 'The Awakening Conscience' or Egg's 'Past and Present'. (Reynolds, V.P.). But his fame depends mainly upon his designs for books and he was outstanding in this field, even among his brilliant contemporaries of the 1860's. Elected A of the OWS in 1871. His studio sale was held at Christie's March 17, 1876.

'Baby's Toes' sold at Sotheby's 25.1.67 for £190.

Bibl: AJ, 1876, 47 (obit); Redgrave, Dict; Roget, II; L. Housman, *Arthur Boyd Houghton. A Selection from his work,* 1896; Gleeson White; VAM, Cat. *of Exhibition of Modern Illustrators,* 1901; Binyon; Cundall; DNB; A. Hayden, *Chats on Old Prints,* 1909; *Burlington Magazine,* XL, 1922, 203; Studio Special Number, *Drawings in pen,* 1922; Studio Special Winter Number, *British Book Illustrations,* 1023-4; 22 f; *Print Collector's Quarterly,* Vol. X, No. 1, 1923 Feb. No. 2, 1923 April; VAM; Reynolds VP, 109, 114, (figs. 97, 100); Hardie, III, 139-40, plate 162; Maas, 235, fig. 116.

HOUSTON, John Adam RSA RI 1812-1884

Scottish historical genre painter and watercolourist. Studied in Edinburgh, Paris and Germany. Returned to Edinburgh, elected ARSA 1841, RSA 1844. In 1858 moved to London, where he remained for the rest of his career. Exhib. at RA 1841-77, BI, SS and NWS. His treatment of historical scenes was romantic and imaginative rather than historically accurate, and he was especially fond of scenes from the Civil War period.

'Grouse on the Wing' a watercolour, sold at Christie's 15.10.69 for £315.

Bibl: AJ 1869 p.69-71; Portfolio 1887 p.136; The Year's Art 1885 p.229; Clement and Hutton; Caw 119.

HOWARD, George, 9th Earl of Carlisle HRWS 1843-1911

Amateur painter and watercolourist. His London house at 1, Palace Green was built by Philip Webb, and decorated by Morris and Burne-Jones. Studied at South Kensington School of Art under Costa and Legros. In 1868 he began to exhibit at the Grosvenor Gallery, which he continued to do until 1910, also at the New Gallery. His narrative pictures and watercolours were much influenced by the Pre-Raphaelites, who were mostly personal friends. The Howards had a wide circle of literary and artistic friends, which included Morris, Burne-Jones, Arthur Hughes, Crane, Leighton, Tennyson, Browning, and many other leading figures of the day, who all stayed with them at Naworth Castle in Cumberland. Howard was also widely travelled, and made continual sketches and watercolours wherever he went. In 1889, he inherited the title of 9th Earl of Carlisle. For 30 years he was Chairman of the Trustees of the National Gallery. In 1968 an exhibition of Howard's work was held at Carlisle Art Gallery.

Being an amateur, most of his best work is still in the possession of his family. Those that have come on the market have been unimportant, and made £30-50. His good works would be worth more.

Bibl: BM Cat. of Engraved British Portraits Vols. I and IV; DNB 2nd Supp. (1912); Catalogue of George Howard Exhibition, Carlisle Art Gallery, 1968; also many contemporary biographical references.

HOYOLL, Philipp b.1816 fl.1836-1875

Genre painter, miniaturist and lithographer. Born in Breslau; studied at Dusseldorf Academy 1834-39. Exhib. at Berlin Academy 1836-46. About 1864 moved to London, where he exhib. 1864-75 at the RA, BI and SS. His subjects genre scenes, especially of children, and occasional portraits.

'Children Watching a Procession from a Window' sold at Christie's 17.1.69 for £120.

Bibl: F. van Boetticher, Malerwerke der 19. Jahrh. Vol. 1 p.2 (1895); R. Wiegmann, Dusseldorf Academy Catalogues, 1856 p.234; E. Hintze, Schles. Miniaturmaler d.19. Breslau 1904 p.149.

*HUGGINS, William 1820-1884

Liverpool animal and landscape painter. Studied at Mechanics Institute, where he won a prize aged 15 for a historical subject. His devotion to animals soon began to show itself; he studied them at the Zoo, and kept a house full of pets. In 1847 he became an associate of the Liverpool Academy, and in 1850 a member. He also exhib. at RA 1842-75, BI and SS. Apart from his pure animal pictures – lions, horses, donkeys, poultry etc. – Huggins also painted historical subjects involving animals, such as 'David in the Lion's Den' and 'Una and the Lion', portraits and landscapes. He developed a very individual technique, painting with pale, transparent colours over a white ground. In 1861 he moved to Chester, and in 1876 took a house at Bettws-y-Coed. He later returned to Chester, where he died.

Price range in the 1968-9 season was £115-630.

Bibl: AJ 1904 p.219-21; Connoisseur 1913 p.150; Bryan; Marillier 143-153 (plates opp. p.146 and 150); DNB (1891) 159; Catalogue of Walker A.G. Liverpool; Reynolds VP 66; Hardie III 73, 75; Maas 81-2 (plates on p.81-2).

HUGGINS, William John 1781-1845

London marine painter. Served at sea with the East India Company. Exhib. at RA 1817-44, BI and SS. Painted merchantmen and warships, and naval actions. 1834 appointed marine painter to William IV. The compositions of Huggins's pictures are mostly conventional, but painted in a clear, pleasing style. A large group of his works can be seen at the Greenwich Maritime Museum.

'The Melton entering and leaving Tyneside' sold at Sotheby's 12.3.69 for £650.

Bibl: Redgrave, Dict; DNB (1891) 159; Cat. of Royal Gallery, Hampton Court, 1898; Wilson Marine Painters, 44 (plate 18); Maas 63 (plate on p.65).

*HUGHES, Arthur 1832-1915

Pre-Raphaelite painter and illustrator. Studied under Alfred Stevens. Entered RA schools 1847; began exhibiting at RA 1849. About 1850 converted to Pre-Raphaelitism by reading *The Germ.* Met Holman Hunt, Rossetti, Madox Brown, and later Millais. In 1852 he exhibited his first major Pre-Raphaelite picture 'Ophelia'. Throughout the 50's and 60's Hughes continued to produce a series of delicately poetic pictures, which hover on "the knife-edge between sentiment and sentimentality" (Fredeman) but are always redeemed by their brilliant colour and microscopic detail. Some of the best known are 'Home from the Sea' 'The Long Engagement' 'The Tryst' and 'April Love', which Ruskin thought "exquisite in every way". In 1857 he worked with other Pre-Raphaelites on the frescoes in the Oxford Union. He was also a member of the Hogarth Club. About 1858, Hughes retired

to live with his family in the suburbs of London. Being of a quiet and retiring nature, very little is known of his later career. After about 1870 his work lost its impetus, and became a lifeless parody of his earlier brilliance. Hughes illustrated Allingham's *Music Master* and many other novels, children's books and periodicals. Exhib. at RA, GG and NG. A sale of his works took place at Christie's after his death on November 21, 1921.

'The Lady of Shalott' sold at Sotheby's 18.6.69 for £1,100.

Bibl: For detailed bibliography see Fredeman, Index; other useful references – AJ 1904 p.237-8; Studio 67 (1916) 56; Vol. 72, 69; Portfolio 1870 p.132 ff; L'Art LIX, (1894) 399 f; Burlington Mag. XXVIII (1915-16) 204 ff (obit); Ruskin, *Academy Notes*, 1856, 1858-59; H. Blackburn, *Academy Notes* 1879-83; Bate 71 f (plates opp. p.71 and 72); DNB Supp. II 275-6; Forrest Reid, *Illustrations of the Sixties*, 1928, 83-95; Ironside and Gere, 41-4 figs. 9-10 (plates 63-70); Reynolds VS 79-81 (plates 52-4); Reynolds VP, 65, 67-70, 112 (plate 53); Maas 135, 230 (plates on p.133, 134, and 136).

HUGHES, Edward 1832-1908

London genre and portrait painter; son of George Hughes (q.v.). Exhib. at RA 1847-84, BI, SS and GG. Titles at RA 'Ruinous Prices' 'The First Tooth' 'After Confession' etc. also some portraits and historical scenes.

'The Letter' sold at Sotheby's 15.10.69 for £450.

Bibl: AJ 1859 p.83, 170;
DNB 2nd Supp. (1912) 319 f.

HUGHES, Edward Robert RWS 1851-1914

London historical genre painter. Studied at RA schools, also with Holman Hunt, and his uncle Arthur Hughes (q.v.). Exhib. at RA 1870-98, BI, OWS, GG and at International Exhibitions in Venice, Munich and Dusseldorf. ARWS 1891, RWS 1895. Painted mainly romantic genre, with subjects drawn from Boccaccio and novels. Hughes was a friend of Holman Hunt, and in his later years often worked as his assistant.

Probable price range £100-200

Bibl: F.W. Gibson in E.A. Seeman's *Meister der Farbe*, 1904, I, 55;
Studio 1914, p.57, 214;
References in Holman Hunt literature.

HUGHES, Edwin fl.1872-1892

Little-known London genre painter. Exhib. at RA 1872-92. Subjects usually children, domestic scenes or sentimental genre, painted on a small scale.

'Two Ladies Seated Reading a Letter' sold at Christie's 11.7.69 for £368.

HUGHES, George fl.1813-1858

Landscape painter; father of Edward Hughes (q.v.). Exhib. at RA 1813-58, BI and SS. Mostly views around London, and some portraits.

Probable price range £30-70

HUGHES, William 1842-1901

Still-life painter; father of Sir Herbert Hughes-Stanton (q.v.). Pupil of George Lance and W.H. Hunt (q.v.). Lived in London and Brighton. Exhib. at RA 1866-1901, BI, SS and GG. Titles at RA 'The Baron's Dessert' 'For the Feast of the Tournament' etc. His major work was a set of five large bird pictures for the hall of Lord Calthorpe's house in Grosvenor Square. A work by him is in Hull Museum.

'Grapes, Peaches and other Fruit' sold at Christie's 23.5.69 for £105.

Bibl: Bryan

HUGHES-STANTON, Sir Herbert Edwin Pelham RA PRWS 1870-1937

Landscape painter, son of William Hughes (q.v.). Self-taught, except for lessons from his father, and study of the old masters. In 1886 he began to exhibit at the Grosvenor Gallery, where he exhibited most of his work. He also exhib. at RA, RWS, NG and the Institute of Painters in Oil. Rather like his contemporary, Sir Alfred East (q.v.), Hughes-Stanton's landscapes are a romantic reinterpretation of the great English landscape tradition of the eighteenth and nineteenth centuries. His style and colours, however, were quite individual, and show more continental influence. Elected RA 1920, RWS 1921, although he had been PRWS since 1915. Knighted 1923. Hughes-Stanton's work enjoyed a big reputation in his day, but is now sadly out of fashion. His pictures are to be found in many museums in England; also in Rome, Florence, Barcelona, Buenos Aires, Tokyo, and Australia.

'Beside the River Dee, N.Wales' sold at Christie's 4.11.66 for £126.

Bibl: AJ 1910 p.77-82; 1904, 271; 1906, 180; 1907, 373; 1908, 171; 1909, 285; Studio 42 (1908) 269 ff; International Studio 33 (1908) 269 ff; RA Pictures 1907-8, 1910-15; Who's Who 1924.

HULK, William Frederick fl.1875-1906

Landscape and animal painter. Exhib. at RA 1876-98, SS and NWS. Lived at Shere near Guildford, and painted mainly in Surrey. Subjects rustic landscapes with cattle and sheep.

'River Landscapes' – a pair – sold at Sotheby's 7.5.69 for £130.

HULME, Frederick William 1816-18844

Landscape painter. Born Swinton, Yorkshire. Taught by his mother, who was a painter on porcelain. 1841 exhibited at Birmingham Academy. 1844 came to London, and worked as an illustrator and engraver. Exhib. at RA 1852-84, and BI. Subjects mostly Wales and Surrey. Also painted idyllic landscapes, with rustic figures and animals. Hulme's style is usually clear and fresh, similar in colouring to Shayer and Creswick (q.v.).

'Anglers Fishing on the Conway and the Llugwy' – a pair – sold at Bonham's 5.12.68 for £440.

Bibl: AJ 1858 p.101-3; Studio, Spring No.1915 p.26; Ottley.

HUME, J. Henry 1858-1881

Painter of landscapes, genre, portraits and flowers. Brother of Thomas O. Hume (q.v.). Exhibited from 1875-81 at the RA, SS and elsewhere, titles at the RA including 'Students Day at the NG', and 'Harvest Weather'. He died aged 23, "a young artist of promise – though chiefly a landscape painter, he had lately turned his studies with success to figure and portrait painting, showing a rich and refined feeling for colour" (AJ).

Probable price range £30-70.

Bibl: AJ 1881, 192 (obit).

HUME, Robert fl.1891-1903

Edinburgh painter of landscape and rustic genre who exhibited from 1891-1903 at the RA, SS and NWS. Titles at the RA include 'Midday', 'The Harvest is Come', and 'In the Land of Macgregor'. From 1894 he lived in London.

Probable price range £30-50

HUME, Thomas O. fl.1864-1893

Landscape painter who exhibited from 1864-93, at the RA (from 1871-93), at BI, SS and elsewhere. Brother of J.Henry Hume (q.v.).

Probable price range £20-50

HUME, Mrs. T.O. fl.1862-1892

Painter of genre — often fishing scenes — who exhibited under her maiden name Miss Edith Dunn, from 1862-67, at the BI and SS, and as Mrs. T.O. Hume from 1870-92, at the RA (from 1874-92, SS, NWS, GG, and elsewhere. Titles at the RA include 'Fishing on the Old Pier Head', 'Ripening Corn', 'Distant Thoughts', and 'Mending Nets'.

Probable price range £20-50

Bibl: H. Blackburn, *Academy Notes*, 1883 (plate)

***HUNT, Alfred William RWS 1830-1896**

Liverpool landscape painter and watercolourist. Studied at Oxford, where he won the Newdigate Prize for English Verse in 1851. From 1853 until 1861 he was a Fellow at Oxford; in 1861 he married and decided to devote his career to art. Elected associate of Liverpool Academy 1854; member 1856. Exhib. at RA 1854-88, SS, OWS (334 works) and elsewhere. Came to London 1862. ARWS 1862, RWS 1864. Hunt's watercolours, which combined Pre-Raphaelite detail with admiration for Turner, were highly praised by Ruskin. He painted in Scotland, the Lakes, and the Thames valley, but was especially fond of North Wales and Whitby. He also travelled in France and Switzerland. His daughter was Violet Hunt, author of *The Wife of Rossetti*, and other books. Hunt's work is often compared with that of Albert Goodwin (q.v.).

Probable price range £50-150

Bibl: AJ 1896 p.220 (obit); 1897, 93 f; 1903, 226 f; Portfolio 1876 p.155 f; 1884, p.44; Studio, Winter No. 1917-18 p.23; Ruskin, *Academy Notes* 1856, 57, 59, 75; DNB 2nd Supp. III (1901); Marillier, 156-68; Cundall; VAM; Hardie III 161-2 (plate 187); DNB 2nd Supp. III (1901); Marillier, 156-68; Cundall; VAM; Hardie III 161-2 (plate 187).

*** HUNT, Charles 1803-1877**

Painter of contemporary genre, often humorous, and historical subjects. Exhibited from 1846-91, at the RA (1862-73, and in 1891), BI and SS; titles at the RA including 'Vocal and Instrumental', 'The Banquet Scene — Macbeth', and 'Make Way for the Grand Jury'. He is singled out by Reynolds (VP), who illustrates 'In the Museum', as one of those "unknown artists who painted modern life in the 1850's, and attained a standard of achievement which ensures their continuing interest".

Price range in the 1968-9 season was £105-280.

Bibl: AJ, 1878, 76 (obit);
Reynolds, VP, 113, 116, (plate 108).

HUNT, Walter b.1861 fl.1881-1910

Animal painter; son of Charles Hunt (q.v.). Exhib. at RA 1881-1910, Titles 'Puss at Bay' 'Best of Friends' 'Twins' etc. 'Dog in the Manger' (RA 1885) was bought by the Chantrey Bequest.

'Terriers Ratting in a Stable' sold at Sotheby's 12.2.69 for £220.

Bibl: Mag. of Art 1901 p.433
Poynter, The Nat. Gallery III (1900).
RA Pictures 1891, 1901.

***HUNT, William Henry RWS 1790-1864**

Painter and watercolourist of fruit and flowers, rustic genre, and landscapes. Sometimes referred to as "Birds' Nest Hunt" or "Hedgerow Hunt". Although primarily a watercolourist, Hunt's works influenced many Victorian painters, as well as watercolourists. Because of a deformity in his legs which made it difficult for him to walk, Hunt's parents decided on an artistic career for him, and placed him with John Varley. In 1807 he began to exhibit oils at the RA; in 1808

entered RA schools. Elected ARWS 1824, RWS 1826. His early work mostly landscapes, rustic genre or architectural studies, much influenced by Varley. About 1827 he began to paint fruit and flowers, and candlelight scenes. His technique also changed. Usingbody-colour, he developed an individual method of hatching and stippling over a white ground, similar to that of Birket Foster. (q.v.). These pretty, enamel-like watercolours became enormously popular, and were also much admired by Ruskin. Hunt had a host of imitators, among whom were William Cruickshank, William Hough, William Hull, T.F. Collier, J. Sherrin, J.J. Hardwick, and George and Vincent Clare (q.v.). Hunt's studio sale was held at Christie's on May 16, 1864.

Due to the all-powerful influence of Ruskin, Hunt's watercolours sold in his own lifetime for as much as 750 guineas at Christie's. They are only now beginning to reach this level again. 'Charity Girl' sold at Christie's 14.10.69 for £630.

Bibl: Fraser's Mag. Oct. 1865; AJ 1895, p.12-14; Portfolio, 1888, 196-8; 1891, 9-16; Mag. of Art XXII (1898) 503-5; Studio 37 (1906) 192, 194; *Special Nos.* 1919, Winter 1922-3; Connoisseur 39 (1914) 78, 80, 82; Ottley; Redgrave, Cent. and Dict; Ruskin, *Notes on S. Prout and W.H.H.* 1879; Roget; DNB 1891 p.281 ff; Bryan; Binyon; Cundall; Hughes; VAM; F.G. Stephens, *W.H.H.* OWS, XII, 1936; Reynolds VP, 94, 173 (plate 120); Hardie III 104-9 and Index (plates 125-128 and 130); Maas, 108, 171-3, 246 (plates on p.109, 110, 172, 208).

***HUNT, William Holman ARSA RSW OM 1827-1919**

Pre-Raphaelite painter. Born in London, son of a warehouse manager. Against the wishes of his family, studied painting under Henry Rogers, a portrait painter, and copied at the National Gallery and British Museum. Entered RA schools 1844 and met Millais (q.v.) who became his greatest friend. Later met Rossetti (q.v.) and through him Madox Brown (q.v.). In 1848-9, Hunt, Millais and Rossetti, together with W.M. Rossetti, James Collinson (q.v.), F.G. Stephens and Thomas Woolner, formed the Pre-Raphaelite Brotherhood. In revolt against the Academy and its teaching, they aimed to paint nature with complete fidelity, combined with noble ideas. During the following years, Hunt painted some of his best-known works, such as 'The Hireling Shepherd', 'Valentine and Sylvia', 'The Light of the World', and 'The Awakening Conscience'. In 1854 he visited the Holy Land. where he painted 'The Scapegoat'. Visited the Middle East again in 1869 and 1873 to find the exact historical and archeological backgrounds for his religious pictures. Of all the Pre-Raphaelites, Hunt was the only one who remained faithful to its original principles. He exhib. at the RA 1846-74, OWS 1869-1903, GG and NG. Elected RWS 1869. Hunt's large pictures tend to be over-elaborate and crowded with detail, but he was also a masterly watercolourist. Awarded OM 1905. Buried in St. Paul's Cathedral.

The last major work to be sold at auction was 'The Lady of Shalott' at Christie's 16.6.61 for £9,975. Since then the average range for oils has been £1,000-3,000, and watercolours £100-500.

Bibl: Full Bibliography see Fredeman p.133-138 and Index;
More recent references: Reynolds VP 62-66, 69-71 and index (plates 39-41); Hardie III 54, 115-16, 118, 123, 125 (plates 147-8); Mary Bennett, *Catalogue of H.H. Exhibition*, Walker AG 1969; Maas 124, 126-8 (plates 124, 127, 128, 129, 218); Diana Holman Hunt, *My Grandfather, His Wives and Loves*, 1969.

HUNTER, Colin ARA RI RSW· 1841-1904

Scottish painter of seascapes and coastal scenes. Born in Glasgow. Studied with J. Milne Donald (q.v.) as a landscape painter, but in the 1860's took to seascape painting, on which his reputation is founded. Exhib. at RA 1868-1903, NG and elsewhere. ARA 1884. Moved to London 1872. In 1873 'Trawlers waiting for Darkness' was his first major success, and in 1879 'Their Only Harvest' was bought by the Chantrey Bequest. Hunter's pictures capture the moods of the sea rather than its purely visual effects. Although not technically as good a painter as J.C. Hook or Hemy (q.v.), Hunter's strong greeny-black colours and evening skies can be remarkably effective. Most of his

pictures were painted on the West Coast or in the Hebrides. His studio sale was held at Christie's on April 8, 1905.

'Fishing Boats on the West Coast of Scotland' sold at Christie's 2.4.69 for £126.

Bibl: AJ 1885 p.117-20; Portfolio 1887 p.209; Studio, Brit. Marine Painting No. 1919 p.29, 73; F. Blackburn, Academy Notes 1876 p.62; Caw 324-6 (plate opp. p.324); DNB 2nd Supp. II (1912) 328; RA Pictures 1893-6, 1901.

HUNTER, G. Sherwood RBA fl.1855-1893
Aberdeen painter of landscape and genre – mostly fishing scenes. Exhibited from 1855-93, mostly at SS, but also at the RA (1882-98). In 1887 he moved to London, and in 1898 to Newlyn, Penzance. In 1898 he exhibited at the RA, 'Jubilee Procession in a Cornish village, June, 1897'.

HURLSTONE, Frederick Yeates 1801-1869
Portrait and historical painter. Entered RA schools, 1820, and in 1823 won the gold medal for his 'Archangel Michael and Satan Contending for the Body of Moses'. Studied also under Beechey, Lawrence and Haydon. Exhibited at the RA 1821-45, and at the BI, 1821-46, but mainly at the SBA (SS), (326 works), of which he became member, 1831, and President 1835-69. His later works, which were much inferior to his earlier ones, consisted mainly of Spanish and Italian rustic and fancy subjects, the outcome of several visits to Italy, Spain amd Morocco made between 1835 and 54. He was very successful as a portrait painter. He was always much opposed to the constitution and management of the RA. Ruskin writes in *Academy Notes,* on his painting 'A Fisherman's Daughter of Mola di Gaeta' exhibited at the SBA in 1858: "Is it too late for Mr. Hurlstone to recover himself? He might have been a noble painter. Bad and coarse as it is, that bright fish is the best piece of mere painting in all the rooms."

Bibl: AJ, 1869, 216, 271, (obit); 1870, 86; Ottley, Dict. of Painters, 1866; Ruskin, Academy Notes, 1875; Redgrave, Dict; Bryan, DNB; Cat. Engr. Brit. Portr. BM, 1908, II, 41, 593; IV, 455.

HURT, Louis B. fl.1881-1908
Derbyshire landscape painter. Exhib. at RA 1881-1901 and SS. Subjects mostly Highland scenes with cattle. Titles at RA 'In a Northern Glen' 'The Silence of the Woods' 'By Peaceful Loch and Mist-wreathed Hill' etc. A work by Hurt is in Reading Museum.

Price range in the 1968-9 season was £100-420.

HUSKINSSON, H/L See Huskisson, Robert

*HUSKISSON, Robert fl.1832-1854 d.1854
Painter of genre, fairy pictures and portraits. Born in Langar, near Nottingham, and worked in Nottingham and then in London. TB equates him with H.Huskinson, a Nottingham portrait painter who exhibited at the RA in 1832, and who had a considerable reputation as a portrait painter in Nottingham. As R.Huskisson he exhibited at the RA, BI and SS from 1838-54, genre and fairy subjects, e.g. 'The Midsummer Night's fairies, There Sleeps Titania,' etc. 1847, and 'Titania's Elves Robbing the Squirrel's Nest', 1854. He illustrated Mrs. S.C. Hall's *Midsummer Eve: A Fairy Tale of Love,* 1848, and Maas illustrates the frontispiece of this, (Maas, 159). Frith describes meeting him and concedes that he "had painted some original pictures of considerable merit," although "he was a very common man, entirely uneducated. I doubt if he could read or write; the very tone of his voice was dreadful." It is possible that he was related to L.Huskisson, who exhibited at the RA from 1839-59, and who lived at the same address in London as he did, 39 Penton Place.

'Come unto these Yellow Sands' sold at Christie's 5.3.71 for £3,780.

Bibl: NB especially entry in TB; AU 1847; 1848 X (plate); William Powell Frith, *My Autobiography and Reminiscences,* 2 Vols, 1887; City of Nottingham Art Museum Cat. 1913 66; Maas 160-1 (pls. p.159, 161).

HUSON, Thomas RI RPE 1844-1920
Liverpool painter of landscape and genre, and engraver. Born and worked in Liverpool, and from c.1907 in Bala, N.Wales. Exhibited from 1871-89 at the RA, SS, NWS, GG and elsewhere. In 1903 he exhibited 'A Midsummer Day' at the Walker Art Gallery, and was referred to by *The Studio* as "another landscape painter held in high esteem." His wife also painted landscapes and exhibited at SS from 1877-8.

Probable price range £30-70.

Bibl: AJ 1904, 221 (plate); 1905, 353 (plate); 1907, 373 (plate); 1909, 335; The Studio 28 (1903), 207-8 (plate); 39 (1907); 66-8 (plate); The Studio Summer No. 1902, 'Modern Etching', (plates); Cundall, 172; The Year's Art, 1921, 344.

HUTCHISON, Robert Gemmell RSA RSW 1855-1936
Scottish genre and portrait painter. Born in Edinburgh where he studied at the Board of Manufacturers School of Art. Began to exhibit at RSA 1879, RA 1880, and GG. Using a broad and vigorous style, Hutchison painted children, sailors, workmen, homely domestic scenes and landscapes. His work shows influence of Dutch painters such as Israels and Blommers, and is anti-sentimental, literal and realistic. Elected RSW 1895, ARSA 1901, RSA 1911.

Price range in the 1968-9 season was £105-240

Bibl: AJ 1900, p.321-6; Who's Who 1924; Studio 1913, p.134, 136; 1915, 103; Caw 427-8; Hardie III 193

INCE, Joseph Murray 1806-1859
Landscape, marine and architectural painter, both in oil and watercolour. Born in Presteign, Radnorshire; pupil of David Cox in Hereford in 1823, and remained with him for three years before coming to London in 1826. Exhibited from 1826-58, at the RA, (1826-47), BI, SS (137 works), NWS and elsewhere. He painted pleasing landscapes on a small scale, such as 'Coasting Vessels, with Harbour', 1836 (VAM), and in 1832 was living at Cambridge, where he made many drawings of architectural subjects. Returned to Presteign c.1835 where he lived till his death. "His smaller works are the best, being well drawn and coloured" (VAM). VAM has 3 watercolours, BM 5, N. Gall. in Dublin 1.

'Drover Watering Cattle near a Windmill' sold at Bonham's 5.12.68 for £500.

Bibl: Redgrave, Dict.; Studio, 1902, English Watercolour; Bryan; Binyon; Cundall; DNB; Williams; Hardie, III, 19 (pl.26).

*INCHBOLD, John William 1830-1888
Landscape painter, who as a young man was influenced by the Pre-Raphaelites, and painted landscapes according to their principles. Born at Leeds; came to London and entered, as a draughtsman, the lithographic works of Messrs. Day and Haghe; about 1847, studied watercolour painting under Louis Haghe, and in 1847 entered the RA

Schools. Exhibited at SS in 1849 and 1850, at the BI, 1854, and 30 works at the RA from 1851-85. 'The Moorland' (RA 1855), painted in illustration of a famous passage in *Locksley Hall*, was highly praised in *Academy Notes* by Ruskin, who singled out his work for attention and acted as his host in Switzerland in 1857. Ruskin also bought his 'White Doe of Rylstone'. His best known works are probably 'The Jungfrau', 1857, 'On the Lake of Thun', 1860, 'Tintagel' 1862, 'Gordale Scar', 1876. In his later years, which were spent largely abroad especially in Spain and Italy, he gradually abandoned the minuteness of his earlier work for a freer style, but the poetic feeling in his art remained. A year or two before his death he returned from Algeria with a large collection of sketches. Through Ruskin he met Rossetti and members of the Pre-Raphaelite circle, and was friend of Coventry Patmore and Swinburne, who wrote him a beautiful funeral ode. Other admirers and supporters were Tennyson, Browning, Lord Houghton, Sir Henry Thompson and Dr. Russell Reynolds. He also was a poet, and published a volume of sonnets, *Annus Amoris* in 1877.

'Landscape with Figures in Spring' sold at Bonham's 7.5.70 for £700.

Bibl: AJ 1871, 264; Portfolio 1874, 180; 1876, 186; 1879, 187; J. Ruskin, *Academy Notes*, 1875; Athenaeum, 1888, 4th February; Bate, 90 (plate p. VIII); E.J. Poynter, *The National Gallery*, III, 1900; Bryan; DNB; VAM; Reynolds, VP, 154-5, 177, (pl. p.164); *Leathart Collection Catalogue*, 1968 Laing A.G. Newcastle; Maas 227 (pl. p.226).

INGRAM, William Ayerst RBA RI ROI 1855-1913
Landscape painter. Born in Glasgow, the son of the Rev. G.S. Ingram; pupil of J. Steeple and A.W. Weedon. He was a considerable traveller; exhibited from 1880 at the RA, SS (80 works), NWS at the Goupil Gallery, 1886, Fine Art Society 1888 and 1902, Dowdeswell Gallery 1911 and 1914. He was elected member of the RBA in 1883, of the RI in 1907, ROI in 1906, and in 1888 President of the Royal British Colonial Society of Artists. Hardie writes "Much of his work was in oil, but his watercolour drawings of subjects found on the coast and the open sea have a quiet, though not impressive accomplishment, but are lacking in bite and personality".

Probable price range £50-150 for oils, watercolours £20-50.

Bibl: RA Catalogues 1905, 07, 12; *Who's Who*, 1913; 1914; VAM; Hardie, III, 82 (pl.105).

INGLIS, Miss Jane fl.1859-1905
Painter of fruit and flowers, landscapes, and genre who exhibited from 1859-1905 at the RA, BI, SS, NWS and elsewhere, and in 1891 at the Paris Salon. Titles at the RA include 'Bird's Nest', 'A Milanese Girl', 'All on a Summer's Day'.

Probable price range £30-70.

Bibl: RA Cat., 1905.

INSKIP, John Henry RBA fl.1886-1910 d.1947
Scarborough painter of landscapes and interiors, who from 1886 onwards was a constant exhibitor at the RA, SS and elsewhere; hon. member of the Old Cheltenham FAS; and an occasional writer on art criticism. The Pannett Gallery, Whitby, has 'The Mill at Canterbury', and Rochdale Art Gallery two oils, 'Walmer' and 'Whitstable'.

Probable price range £50-100.

Bibl: RA Catalogues 1905, 7, 9, 11, 12; *Who Was Who* 1941-50.

INSKIPP, James 1790-1868
Painter of landscape, genre, portraits and game. Originally employed in the commissariat service, from which he retired with a pension and adopted painting as a profession for the remainder of his life. He began with landscapes, then turned to small subject pictures, and with

less success to portraits. His pictures were admired at the time and some were engraved. Drew a series of illustrations for Sir Harris Nicholas's edition of Izaak Walton's *Compleat Angler*, 1833-6. In 1838 he published a series of engravings from his drawings, *Studies of Heads from Nature*. Exhibited from 1816-64 at the RA, BI (83), SS and elsewhere, titles at the RA including 'Boy with Fruit', 'Père la Chaise', 'Market Girls'. He lived the latter part of his life in Godalming.

Probable price range £30-70

Bibl: Redgrave, Dict; DNB;
Connoisseur 39 (1914) 117 ff, 102.

IRELAND, Thomas fl.1881-1903
Landscape painter who exhibited from 1881-1903, at the RA, SS, NWS, GG, NG and elsewhere. T. Tayler Ireland, landscape painter, who exhibited at the RA in 1896 and 1902, has the same address as the above.

Probable price range £20-50

IRVINE, James 1833-1899
Scottish portrait painter. Born and educated at Menmuir, Forfarshire. Pupil of Colvin Smith, the painter, at Brechin; subsequently studied at the Edinburgh Academy and was afterwards employed by Mr. Carnegy-Arbuthnott of Balnamoon to paint portraits of the old retainers on his estate. Practised as a portrait painter for some years at Arbroath and then moved to Montrose. After a period of hard struggle he became recognised as one of the best portrait painters in Scotland, and received numerous commissions. He was a close friend of George Paul Chalmers (q.v.). Exhibited at the RA in 1882 and 1884. He also painted some landscapes.

Probable price range £50-200

Bibl: Catalogue of the National Portrait Gallery, Edinburgh, 1889;
Caw 289; DNB.

JACKSON, Miss Emily F fl.1878-84
Flower painter, exhibiting from 1878-84 at the RA & SS.

Probable price range £30-70

JACKSON, Frederick Hamilton RBA 1848-1923
London painter of genre, historical subjects and landscape; illustrator; designer. Student and first class medallist at the RA Schools. Exhibited from 1870 at the RA (1875-92), SS, NWS, GG, NG and elsewhere, the subjects decorative and Pre-Raphaelite in inspiration, eg. 'The Lady of Shalott' and illustrations for Morris's *Earthly Paradise;* also sketches for stained glass and mural paintings. Master of Antique School at the Slade School, under Poynter and Legros. Founder of the Chiswick School of Art in 1880 with E.S. Burchett. Member of the Art Workers' Guild 1887. He gave special attention to decoration and design, writing and lecturing also on technical and archaeological subjects; also specialized in ecclesiastical decoration, including the mosaic in the E. end of St. Bartholomew's, Brighton, and the apse of St. Basil's, Deritend, Birmingham. His publications include: *Handbooks for the Designer and Craftsman; Intarsia and Marquetry; Mural Decor-*

ation; True Stories of the Condottieri, A Little Guide to Sicily; The Shores of the Adriatic; Rambles in the Pyrenees.

Probable price range £50-200

Bibl: Cat. Loan Exhib. of Modern Illustrations, BM, 1901; RA Cats. 1907-9, 1916, 1919; Who's Who 1924.

JACKSON, Frederick William RBA 1859-1918
Landscape and marine painter. Born at Middleton Junction, Oldham; studied at the Oldham School of Art and the Manchester Academy, and although called a "Manchester" painter (where he often exhibited), he worked principally in Hinderwell, Yorkshire. He also studied under J. Lefebvre and Boulanger in Paris, and travelled in Italy and Morocco. Exhibited from 1880 at the RA, SS and elsewhere, titles at the RA including mainly landscapes, and 'Gossip', 'The Haven under the Hill', 'Sunny Days' etc. His watercolour sketches are very atmospheric with a great sense of breadth and light, eg. 'Early Morning, Florence, 1910'. He also did decorative sketches for tiles etc. His works are in Bradford Art Gallery and Manchester City Art Gallery.

'Fish-wives on a Quay' sold at Phillip's 2.6.69 for £125.

Bibl: Studio 30 (1904) 66; 44 (1908), 228 (plates); 47 (1909); 59; 50 (1910), 229 (plates) 230; VAM; Pavière, Landscape.

JACKSON, Samuel Phillips RWS 1830-1904
Landscape and marine painter. Born in Bristol, son and pupil of Samuel Jackson, (1794-1869), landscape watercolour painter. In 1851 his 'Dismantled Ship off the Welsh Coast' was shown at the BI, where he exhibited from 1851-7; at the RA from 1852-81. His earlier works, mainly in oils, were chiefly Devon and Cornish coast scenes and won the praise of Ruskin. In 1856 Ruskin wrote on "Two very interesting Studies of Sea — the breaking of the low waves in 167 is as true as can be; and both pictures are delicate and earnest in perception of phenomenon of sea and sky. The land is bad, in both". Elected A. of the RWS (OWS) in 1853, and after this confined himself mainly to watercolour, contributing annually to their exhibitions; elected member in 1876. In 1856 he moved to Streatley-on-Thames, and subsequently to Henley, and after this he chiefly painted views of the Thames, intermixed with inland scenes in Wales. He was interested in effects of sunlight, and skilful at handling grey mist and clouds. Hardie notes that "his work shows clean handling, and a pleasant feeling for moist and hazy atmosphere".

Probable price range £50-150

Bibl: AJ 1904, 103 (obit); Studio, 1905, Spring No., The 'Old' watercolour Society; J. Ruskin, Academy Notes, 1856; Roget, II, 379-81; Cundall; DNB, Supp. II, 1912; VAM; Hardie III, 161, 164 (pl.185).

JACOMB-HOOD, George Percy RPE MVO RBA 1857-1929
Painter of portraits, genre and historical subjects; illustrator; etcher; sculptor. Born at Redhill; son of an engineer and director of the London, Brighton and S. Coast Railway. Educated at Tonbridge School. Won a scholarship at the Slade School; studied also under J.P. Laurens in Paris. Exhibited from 1877 at the RA, SS, GG, NG, Paris Salon and elsewhere. Original member of NEAC; member of the RBA, and of the Society of Portrait Painters but later resigned his membership. Member also of the ROI, Vice-President of the Royal British Colonial Society of Artists, and served on the Council of the Royal Society of Painter-Etchers. Worked for *The Graphic*, which sent him to Greece, 1896; to Delhi for the Durbar, 1902; on the Indian Tour of the Prince and Princess of Wales, 1905; and on King George V's tour of India in 1911, when he was a member of his personal staff. MVO, 1912. Painted portraits in India and in England, and subject pictures. Exhibited two bronzes at the RA in 1891.

Probable price range £50-200

Bibl: For full bibliography see Thieme-Becker. Portfolio, 1881, 1, 37, 76, 92; 1882, 85; 1883, 56; 1888, 64, 189; RA Pictures, 1893, 97, 1900, 02, 05, 10, 11, Who's Who 1924; G.P. Jacomb-Hood, With Brush and Pencil, 1925 (reminiscences); Birmingham Cat., Supp. II, 1939.

JAMES, David fl.1881-1892
Marine painter. Exhib. at RA 1881-92 and elsewhere. Like Henry Moore (q.v.), James was more interested in pure studies of the sea, rather than topographical coastal views. He was especially good at painting waves. Much of his work was done on the coast of Cornwall. Titles at the RA 'A North Cornish Breaker' 'An Atlantic Roll' etc.

Prices during the 1968-9 season ranged from about £100 to £735.

Bibl: Wilson, Marine Painters, 46 (pl.18).

JAMES, Richard S fl.1860-1900
Painter of genre who exhibited from 1860-1900 at the RA, BI, SS, and elsewhere, titles at the RA including 'He Sang of all Sweet Things', etc. 'Dutch Courtship' and 'The Opening Rose'.

Probable price range £30-70

JAY, William Samuel RBA fl.1873-1913
Landscape painter who exhibited from 1873-1913 at the RA, SS, GG, NG, and elsewhere; titles at the RA including 'A Rich Corner', 'Cutting Rushes in Surrey', 'Old Boats. Dieppe'. Nottingham Art Gallery has one of his paintings of an autumn wood, 'At the Fall of Leaf, Arundel Park, Sussex', 1883.

Probable price range £30-70

Bibl: RA Cats., 1905, 1913; Nottingham Museum and Art Gallery Catalogue, 1913, p.67, 70 (plate).

JAYNE, Mrs. Charles (Mary) fl.1846-1878
Landscape painter who exhibited from 1846-78, at the RA (from 1846-64), BI and SS. Her husband Charles Jayne, fl.1838-1879, was also a landscape painter and exhibited from 1838-79, at the RA (from 1838-68), BI and SS.

Probable price range £20-50

JELLEY, James Valentine RBSA fl.1885-1918
Landscape and flower painter, working in Birmingham and Hampton in Arden, Warwicks, who exhibited at the RA, NWS and GG, from 1885-1918. 'River Scene' and 'The Lily Garden' in Birmingham Art Gallery.

'Sunshine at Whitby' sold at Christie's 11.7.69 for £137.

JENKINS, Joseph John RWS 1811-1885
Engraver and watercolour painter of domestic genre and single figures. Son of an engraver; engraved many portraits and illustrations for the annuals eg. *The Keepsake,* Heath's *Book of Beauty,* etc. Later he turned to watercolour, and exhibited from 1829-81, at the RA (once only, 1841), BI, SS, OWS (273 works) NWS (61) and elsewhere. In 1842 he was elected A. of the NWS and member in 1843. In 1847 he joined the OWS, and became A in 1849, member in 1850. He was its Secretary for ten years from 1854 and was a constant exhibitor; he was the first to introduce the system of private press views at picture exhibitions. He devoted the remainder of his life to collecting material for a history of the OWS and its members, and this was completed in 1891 by J.L. Roget.

Probable price range £20-50

Bibl: See TB for list of his works. Roget II; Reading Museum and Art Gallery Cat. 1903, 37; DNB; F.O'Donoghue, Cat. of Engr. Brit. Portr, BM 1, 1908; 31, 70, 221, 249, 300, 330, 339, 475, 541; II 1910; 63, 104, 254, 376, 474, 528,

584, 603, 630; III, 1912; 65, 86, 277, 428, 440, 586; IV 1914; 182, 234, 443, 469; T.M. Rees *Welsh Painters*, 1912; Cat. NG of Ireland, Dublin, 1920, 173; VAM.

JENKINS, Wilfred
Very little-known painter, whose dates are not known, and who did not exhibit in London. He painted moonlight street and dock scenes in imitation of the better-known Atkinson Grimshaw (q.v.), and for this reason his work is now beginning to arouse interest.

'Princes St., Edinburgh at Night' sold at Christie's 3.4.69 for £137.

JERÔME, Miss Ambrosini fl.1840-1871
Portrait painter to the Duchess of Kent (in 1843), and also of landscape, genre and historical subjects. Exhibited from 1840-71, at the RA (1840-62), BI, SS and elsewhere, titles at the RA including 'Sir John Falstaff and Mrs. Ford', 'Contemplation', and 'Cupid Defeated'.

'A Scene from the Taming of the Shrew' sold at Bonham's 10.4.69 for £130.

JOBLING, Robert 1841-1923
Painter of river and marine subjects, and genre, working in Newcastle-on-Tyne. Born in Newcastle; his father a glass-maker, he worked in the same trade until he was sixteen, and attended evening classes at the Newcastle School of Art under Mr. W. Cosens-Way. In 1899 he held a successful exhibition, and then turned entirely to painting. He exhibited in London from 1878 at SS, and from 1883 at the RA. He illustrated Wilson's *Tales of the Borders*. In 1910 elected P. of the Bewick Club. An exhibition of his work was held at King's College, Newcastle, 6 March, 1923. The AJ wrote of his work, "Jobling looks upon the sea when it is blue or grey, or when little wisps of white are fringing the processional waves; he looks upon the people with a poetic and sensitive eye, in their less intense moments. . . . a group of sailors gossiping by the side of a boat or on the headland. . . ."

'The Fisherman's Return' sold at Bonham's 15.1.70 for £125.

Bibl: AJ, 1904, 306 (plate) 308; RA Cats., 1905; 1911; 1912; Laing Art Gallery Cat. of Watercolours, Newcastle-on-Tyne, 1939, 112-113.

JOHNSON, Charles Edward RI ROI 1832-1913
Landscape painter. Born in Stockport; studied at the RA Schools; began his career as an artist in Edinburgh, moving to London in 1864. He conducted a school for landscape painting at Richmond. Exhibited from 1855 at the RA, BI, SS, NWS, GG, NG and elsewhere. His best known pictures are 'Glencoe, Ben Nevis in Winter', 'The Wye and the Severn', 'Gurth the Swineherd' (Tate Gallery, Chantrey Bequest in 1879), 'Fingal's Cave' and 'The Timber Wagon'. His paintings are in the Tate Gallery and in Rochdale, Derby and Sheffield Art Galleries.

Probable price range £100-300.

Bibl: AJ 1896; 170, 180; 1897; 172, 175; 1900; 173, 182; Studio 58 (1913), 224 (obit); 1914, p.XXII (list of works); RA Pictures 1891-1903, 1905-7, 1910-12; RA Cats., 1905, 1907, 1909-12; Poynter, National Gallery III 1909, 176 (plates); Who's Who 1913; VAM; Sale cat. 1927, Dec. 12-13 at Sheen of watercolours by CEJ (with prices).

JOHNSON, Cyrus RI RWS 1848-1925
Miniature portrait painter, and also painter of genre and landscape. Educated at Perse Grammar School, Cambridge. First exhibited at the RA from 1871-4, as "C. Johnson", genre and landscape, and then from 1877 onwards at the RA — all miniature portraits, in which field he had considerable success. His sitters included Sir John Duckworth, R.

Neville Granville, Rt. Hon. Edward Gibson, Lord Ebury, etc. He was also a member of the ROI.

Probable price range £50-150.

Bibl: RA Cats. 1905, 1909, 1912, 1917; Who's Who, 1924.

JOHNSON, Edward Killingworth RWS 1825-1896
Landscape and genre painter. Born in Stratford-le-Bow; self-taught and copied at the Langham Life School. Exhibited from 1846, at the RA (1846, 1858 and 1862), SS, OWS (176 works) and elsewhere, titles at the RA including 'Afternoon', 'A River Party' and 'Mending a Pen'. A of RWS in 1866, and RWS 1876. He lived in London until 1871 when he moved to N. Essex. His 'The Anxious Mother' 1876, was purchased by Birket Foster. His work was very popular in America, and amongst others he exhibited 'The Rival Florists' in New York in 1873, 'A Study' at Philadelphia 1876, and 'Intruders' in New York in 1876, of which the AJ said. . . . "it has been received with expressions of the highest praise. . . . its aim is so high and its motive so charming that it commands admiration in spite of any mere defect".

'The Victor' a watercolour — sold at Sotheby's 13.3.69 for £350.

Bibl: AJ 1876, 210; *Illustrated London News* 1868; Clement and Hutton; *The Year's Art* 1897, 309; Cundall 158, 255.

JOHNSON, Harry See JOHNSON, Harry John RI

JOHNSON, Harry John RI 1826-1884
Landscape painter. Born in Birmingham, eldest son of an artist, W.B. Johnson; studied at the Birmingham Society of Arts, under Samuel Lines, and after 1843 under William Müller (q.v.), whom he accompanied to the Levant on the Lycian expedition, 1843-4. Three volumes of sketches exist made in Lycia. On his return he worked in the Clipstone St. Studio in Müller's company. He was also a close friend of David Cox and went on sketching expeditions with him to Wales. He exhibited from 1845-1880 at the RA, BI, SS and NWS and is listed in Graves (RA & Dict.), as Harry and Harry John Johnson. Elected A of the RI in 1868, RI 1870. Hardie notes: "Both in pencil and colour work, Johnson retained the influence of Cox, but still more that of Müller throughout his life. He was an admirable draughtsman; his studies of boats in particular have high merit; and his sketches in general have a force and vitality not always displayed in his exhibition pieces". His studio sale was held at Christie's on March 5, 1885.

'Watermill in the New Forest' sold at Bearne's (Torquay) 28.7.70 for £390.

Bibl: Roget; Bryan; Binyon III 1902; Cundall, 170, 225; DNB; VAM; Hardie II 209, (pls. 195-6).

JOHNSON, Mrs. Patty Townsend fl.1877-1904
(Miss Pattie Townsend)
Nuneaton painter of landscape and genre, who exhib. from 1877-1904, at the RA (1881-1904), SS, NWS and elsewhere, from 1877-92 under her maiden name, and from 1897 onwards under Johnson. Titles at the RA include 'An Old Footbridge' 1881, 'The Children's Hour' 1900, and 'When Work Begins' 1904.

Probable price range £30-80

JOHNSTON, Alexander 1815-1891
Scottish historical, genre and portrait painter. Born in Edinburgh, son

of an architect. Student at the Trustees Academy from 1831-4; came to London with an introduction to Sir David Wilkie; entered the RA Schools under W. Hilton in 1836. Exhibited from 1836-86 at the RA, BI and SS, and little in Scotland. At the RA, in 1839, his picture 'The Mother's Grave' attracted good notices. In 1841 he exhibited his first historical painting, 'The Interview of the Regent Murray with Mary Queen of Scots', which was bought by the Edinburgh Art Union. Many of his works won premiums, and in 1845 his 'Archbishop Tillotson Administering the Sacrament to Lord William Russell in the Tower', was bought by Mr. Vernon for the Vernon Gallery and is now in the Tate. Caw notes that "his pictures, sometimes of the affections, and occasionally historical, are conceived in a somewhat similar spirit to those of Sir George Harvey. Austere and grave in feeling, and dwelling upon the pathos of life, his pictures, amongst which one may name 'The Mother's Grave', 'The Coventer's Marriage', and 'The Last Sacrament of Lord William Russell', are marked by sound drawing and expressive composition'.

'The Flight of the Queen of James II' sold at Bonham's 23.1.69 for £185.

Bibl: AJ, 1857, 57; 1862, 108; 1863, 236; 1865, 336; Ottley; Caw 120; DNB.

JOHNSTONE, George Whitton RSA RSW 1849-1901

Edinburgh landscape painter. Born in Glamis, Forfarshire, and came to Edinburgh as a cabinet-maker; became a pupil at the RSA's Life School, and during this period did genre and portraits. First exhibited at the RSA in 1872, and regularly afterwards; ARSA, 1883; Member 1895; RSW; exhibited at the RA from 1885-92. He painted mainly landscapes, many in Eskdale and Annandale, seaside scenes, streams and rivers. He also went to France and painted in the Fontainebleau forest. In his later years his paintings became more generalized — foliage and composition becoming more reminiscent of Corot. Caw notes a certain mannerism of touch, with results in a "rough hewn and unpleasantly marked surface".

Probable price range £50-200

Bibl: AJ, 1899, 146-9 (plates); Caw, 302.

JONES, Charles RCA 1836-1892

London painter of animals — sheep, cattle and deer in landscape settings. Of Welsh extraction, born near Cardiff. He was well known as an animal painter — generally known as "Sheep Jones" for his skilful painting of sheep — and exhibited from 1860-91, at the RA (from 1861-83), BI, SS, NWS and elsewhere. Member of the RCA, and c.1890 awarded a gold medal at the Crystal Palace.

'The Chertsey Meadows' sold at Christie's 20.12.68 for £105.

Bibl: AJ, 1892, 288; The Year's Art, 1893, 278; Cat. National Art Gallery, Sydney, 1906 (biography); Cat. Preston Art Gallery, 1907; T.M. Rees, *Welsh Painters*, 1912, 77.

JONES, Sir Edward Coley Burne-
See BURNE-JONES, Sir Edward Coley.

JONES, George RA 1786-1869

Painter of battlepieces and military subjects, portraits, genre historical subjects and views of towns. Born in London, son of John Jones, mezzotint engraver. Studied at the RA Schools in 1801, but his studies were considerably interrupted by his military ardour; he served in the Peninsular War, and in 1815 formed part of the army of occupation in Paris. When he resumed his career, his pictures were chiefly of a military character, and he painted many representations of the battles in the Peninsula and at Waterloo. In 1820 his picture of Waterloo with Wellington leading the British Advance was awarded the BI premium of 100 guineas, (Chelsea Hospital), and another Battle of

Waterloo again in 1822. Another of his well known works was 'Nelson Boarding the San Josef at the Battle of Cape St. Vincent' (Greenwich Hospital). He also painted historical events, such as 'The Prince Regent Received by the University and City of Oxford, June 1814', views of continental cities, e.g. 'Orleans' and 'Rotterdam', and in his later years did a great number of drawings in sepia and chalk of biblical and poetical subjects, and depicted the battles of the Sikh and Crimean Wars. Exhibited from 1803-70 at the RA (221 works), BI, SS, and OWS; 1822 ARA; 1824 RA; 1834-40 Librarian of the RA; 1840-50 Keeper of the RA. While Keeper he visited many foreign schools to see what improvements could be made, and it was on his recommendation that the draped living model was set in the Painting School. He was a close friend of Chantrey and Turner, and in 1849 published *Recollections of Sir Francis Chantrey*. He prided himself that he bore a certain resemblance to the Duke of Wellington, for whom he was said to have been once mistaken. This story, when repeated to the Great Duke, drew from him the remark that he had never been mistaken for Mr. Jones. The BM has many of his watercolours, and 11 volumes of academical studies, bequeathed by him.

'Study of an Officer of the 60th Rifles' sold at Christie's 28.11.69 for £168.

Bibl: A list of his works is given in TB. AJ 1869, 336 (obit); 1903, 372 f (plates); Ottley; Redgrave, Dict.; Binyon; DNB; L. Cust. NPG Cat. II; T.M. Rees *Welsh Painters* 1912, 84; T.H. Parker, Cat. of Military prints, 1914 No.2141; Hutchison.

JONES, Sir Thomas Alfred PRHA 1823-1893

Dublin portrait painter. After studying at the schools of the R. Dublin Society and the RHA, he entered Trinity College in 1842, but left without taking his degree and in 1846 went abroad. In 1849 he returned to Dublin, and became a painter of portraits and figures, exhibiting at the RHA in 1849, 1851 and 1856. His early works were small figure subjects, most of them drawings in watercolour and pastel, for which he found a ready sale; but he finally confined himself to portrait painting in oil, in which he achieved success; and after the death of Catterton Smith, he had almost a monopoly of portrait painting in Ireland. 1861 elected a Member of RHA, and was its President from 1869 till his death. 1880 he was knighted. Exhibited at the RA from 1872-9. Strickland writes: "His oil portraits are numerous, nearly everyone of note for many years sat to him; but his art was commonplace, and though his pictures satisfied his sitters as faithful likenesses, they are poorly painted, mechanical in execution, and without any artistic merit".

Probable price range £30-70

Bibl: Strickland; VAM.

JONES, William E. fl.1849-1871

Bristol landscape painter who exhibited from 1849-71 at the RA, BI and SS. Member of the Bristol Academy of Arts. Pavière illustrates his 'Panorama of the Thames from Richmond Hill'.

'An Old Mill near Bristol' sold at Bearne's (Torquay) 17.12.68 for £100.

Bibl: Pavière, Landscape, pl.39.

JOPLING, Joseph Middleton RI 1831-1884

Painter of historical subjects, genre, still life, flowers, portraits and landscape. Son of a clerk in the Horse Guards; occupied for some years a position similar to that of his father; was self-taught as an artist. Exhib. from 1848-1884 at the RA, SS, NWS (126), GG, and elsewhere. RI in 1859; resigned in 1876. Director of the Fine Art Section at the Philadelphia International Exhibition. An active volunteer and won the

Queen's Prize for rifle shooting at Wimbledon in 1861. Close friend of J.E. Millais. His studio sale was held at Christie's on Feb. 12, 1885.

Probable price range £30-100.

Bibl: Clement and Hutton; Walker Art Gallery Cat., 1884; Bryan; Binyon; VAM.

JOPLING, Mrs. J.M. (Louise)
(Mrs. Frank Romer, née Miss Louise Goode) RBA 1843-1833
Painter of portraits, genre and landscape. Born in Manchester; at seventeen she married Frank Romer, who in 1865 was appointed private secretary to Baron Rothschild in Paris. The Baroness discovered her talent and advised her to take lessons with M. Charles Chaplin, which she did, 1867-8, exhibiting two small red chalk drawings of heads at the Salon. In 1869 her husband lost his appointment, and died in 1873. In 1874 she married Mr. Jopling, watercolour painter. She exhibited as Romer from 1870-3 at the RA, and as Jopling from 1874 onwards, at the RA, SS, NWS, GG (32 works) and elsewhere. She was the first woman to be elected RBA. Her portrait of Samuel Smiles is in the NPG. A list of her best known pictures is given in Clayton — they are mainly portraits.

Probable price range £30-70

Bibl: Clayton II 107; Clement and Hutton; RA Pictures, 1891, 98; 1892, 136; 1894, 72; 1896, 158; 1897; 1902-3; W.S. Sparrow, *Women Painters*, 1905.

JOSI, Charles RBA fl.1827-1851
London painter of sporting and animal subjects, and landscape. Exhibited from 1827-51 at the RA (from 1838-47), BI and SS.

Probable price range £30-100

Bibl: Pavière, Sporting Painters, 54.

***JOY, George William 1844-1925**
Irish painter of highly dramatic historical subjects, genre and portraits. Brother of Albert Bruce Joy RHA (sculptor). Educated at S. Kensington and RA Schools. In 1868 he went to Paris where he studied under Jalabert, who had been a pupil of Delaroche. In 1878 he exhibited 'Laodameia' at the RA — his first serious picture, which was singled out for praise. In 1881 his 'Joan of Arc' was sold on opening day. His range extended from military and patriotic subjects to the nude, including historical subjects (eg. 'The King's Drum shall Never be Beaten for Rebels', Russell Cotes Museum, Bournemouth) and genre. He is now best known for 'The Bayswater Omnibus' (1895, in the London Museum), a delightful genre painting which shows an attempt at social realism in the way the different social types of passenger are contrasted on the bus. He exhibited from 1872 at the RA, SS and elsewhere.

Probable price range £100-300 for historical works; more for scenes of Victorian life.

Bibl: AJ 1900, 17-23 (plates); Studio 66 (1915) 195 (plates); *The Work of George William Joy,* with autobiographical sketch, 1904; RA Pictures 1892-5, 1897-9, 1905-6, 1908, 1910, 1913; RA Cats. 1905, 1907-8, 1910, 1913-4; Reynolds VS, 25, 95 (pl.86); Maas, 232, 239 (pl.240).

***JOY, Thomas Musgrove 1812-1866**
Painter of portraits, historical, genre and sporting subjects. Born in Boughton Monchelsea, Kent; studied under Samuel Drummond, ARA. Exhibited from 1831-67, at the RA (an honorary exhibitor from 1831-64), BI, SS and NWS. Patronised by Lord Panmure, who placed John Philip with him as a pupil. In 1841 he was commissioned by the Queen to paint portraits of the Prince and Princess of Wales. He was best known for his subject pictures, eg. 'Le Bourgeois Gentilhomme', 'A Medical Consultation' and 'Prayer'. In 1864 he painted 'The Meeting of the Subscribers to Tattersall's before the Races', which

contained portraits of the most noted patrons of the Turf. His studio sale was held at Christie's on June 18, 1866.

'Portrait of a Child' sold at Christie's 21.3.69 for £179.

Bibl: AJ 1866, 240 (obit); Redgrave Dict; DNB; Cat. of York Art Gallery; Cat. of Engr. Brit. Portr. BM II 1910, 235; Pavière, Sporting Painters, 1965.

JOY, William 1803-1867 and CANTILOE, John 1806-1866
Marine painters. William was born in Yarmouth; John in Chichester. Most of their pictures and drawings were joint productions. About 1832 they moved to Portsmouth, where they were employed by the Government to make drawings of various types of fishing boats. Later they worked in London and Chichester. William exhib. at RA in 1924 and 1832, BI and SS, John at SS 1826-7. Works by them are in Birmingham, Sheffield, Norwich and VAM.

'The Arrival of the 'Victoria and Albert' off Spithead sold at Sotheby's 2.4.69 for £170.

Bibl: Wilson, Marine Painters 47 (pl.19).

JUTSUM, Henry 1816-1869
Landscape painter. Born in London; educated in Devon. In 1839, became a pupil of James Stark. Exhibited from 1836-69, at the RA (1836-68), BI, SS, NWS and elsewhere. For some time he devoted himself to watercolour, and in 1843 was elected a member of the NWS. However, he preferred to paint in oil and in 1848 resigned his membership, afterwards painting mainly in oil. His works were always much admired: 'The Noonday Walk' is in the Royal Collection and was engraved for the AJ, and 'The Foot Bridge' is at the V & A. Many of his works were sold at Christie's 17th April, 1882; his studio sale was also held there on February 19th, 1870.

'Harvest Time' sold at Bonham's 4.12.69 for £1,600. This is an exceptional price; the usual range is £200-500.

Bibl: AJ, 1859, 269 (monograph with plates), 1869, 117 (obit); Ruskin, *Academy Notes;* Redgrave, Dict.; DNB; VAM; Pavière, Landscape Painters (pl.40).

KEARNEY, William Henry 1800-1858
Painter and watercolourist of landscapes, genre and portraits. Exhib. in London 1823-58, mainly at NWS (170 works) of which he was a founder member and later Vice President; also at RA and SS. Unlike most of his contemporaries, Kearney continued to paint watercolours in the traditional eighteenth century style, scorning the use of bodycolour.

Probable price range £20-50.

Bibl: AJ 1858 p.253 (obit);
DNB XXX (1892);
Cat. NG of Ireland 1920 p.173.

KEARSLEY, Miss H. fl.1824-1858
London portrait and genre painter. Exhib. 1824-58 at RA, BI and SS. Apart from portraits, her genre subjects include titles such as 'Florentine Peasant Woman' 'A Woman of Antwerp' and 'A Woman of Sorrento'.

Probable price range £20-50

KEENE, Charles Samuel 1823-1891
Cartoonist and illustrator, best known for his work in *Punch*. Also worked on *Illustrated London News, Once a Week,* and many books, such as Reade's *The Cloister and the Hearth.* Member of the Langham Sketching Club. Nearly all Keene's work was done in pen and ink, a technique of which was complete master. He produced few watercolours and no oil paintings to speak of, but his genius and importance as a recorder of the period qualifies him for inclusion in any Victorian Dictionary.

'The Prison Doctor' sold at Christie's 11.6.68 for £136.

Bibl: AJ 1891 p.92f; Studio, See Index 1902-22; G.S. Layard, *The Life and Letters of C.S.K.* 1892-3; S.W.L. Lindsay, *C.K.* 1934; F.L. Emmanuel, *C.K.* 1935; D. Hudson, *C.K.* 1947; Binyon; Cundall; DNB XXX (1892) 302 f; Hardie III 148-9 (plates 173-4).

KEITH, Mrs. L.M. See under PARSONS, Miss Letitia Margaret

KEMM, Robert fl.1874-1885
London genre painter. Exhib. 13 works at SS between 1874 and 1885. Specialised in Spanish subjects in imitation of John Phillip and J.B. Burgess (q.v.) 'Sleeping Priest' by Kemm is in the Sunderland AG.

'After the Bullfight' sold at Christie's 13.6.69 for £315.

Bibl: Cat. of Sunderland AG. 1905, p.6.

KEMPE, Miss Harriet fl.1867-1892
London genre painter. Exhib. at RA, SS and elsewhere. Her pictures are mostly humorous. Titles at RA 'Return from the Ramble' 'The Cottage Door' 'The Torn Frock' etc.

Probable price range £20-50

KENNEDY, Charles Napier 1852-1898
Painter of portraits, genre and mythological scenes. Studied at the Slade School, and at University College under E.J. Poynter (q.v.) who was to influence his work. Exhib. in London 1872-94 at RA, SS, GG, NG and elsewhere. At first exhibited mostly portraits and domestic scenes; later he turned to mythological and imaginative subjects, which he exhibited at the GG and NG. Typical titles 'Boy and Dryad' 'Neptune' 'Peace' etc. Works by Kennedy are in many provincial museums, including Leeds, Sheffield, Liverpool and Manchester. His wife Lucy (nee Marwood) was also an artist.

Probable price range £50-150

Bibl: AJ 1890 pl.30; 1892, 188; Strickland Vol. 1.

KENNEDY, Edward Sherard fl.1863-1890
London genre painter. Exhib. at RA, SS, NWS and elsewhere; also at the Paris Salon in 1880. Titles at RA include some historical genre — 'Louis XI, his One Good Deed' 'The Wolf in the Fold' 'Darby and Joan' etc.

Probable price range £30-70

KENNEDY, William Denholm 1813-1865
Scottish history, genre and landscape painter. Born in Dumfries; came to London in 1830. Friend and pupil of William Etty (q.v.). Entered RA schools 1833. Won Gold Medal for historical painting 1835. Travelled in Italy 1840-42. Exhib. from 1833 at RA, BI and SS. At first a painter of historical scenes, Kennedy changed after his Italian journey to Italian genre and historical subjects. He also painted literary subjects from Byron, Spenser, Tasso etc, domestic scenes, and landscape.

'The Soothsayer' sold at Morison McChlery (Glasgow) 22.5.69 for

£100. *'Raffael correcting the Proofs of Marc Antonio' sold at Sotheby's 18.3.70 for £550.*

Bibl: AJ 1865 p.235 (obit); Redgrave, Dict.; DNB XX (1892) 437; Bryan; Caw 120; Cat. of NG of Ireland 1920 p.64.

KENNINGTON, Thomas Benjamin RBA fl.1880-1916
London portrait and genre painter. Member of the SBA and also the Royal Institute of Painters in Oil. Exhib. 1880-1916 at the RA, also at SS, NWS and GG. Also exhib. at international exhibitions in Paris and Rome. Most of Kennington's subjects are scenes of upper-class life, especially mothers and children. Like John Collier (q.v.) he also painted psychological dramas of society life, with titles like 'Disillusioned.'

'Girl in a Striped Dress on a Beach' sold at Christie's 9.6.67 for £420

Bibl: AJ 1893 p.66; Connoisseur 42 (1915) 253; RA Pictures 1891, 93-95, 1897-1903, 1905-16; Poynter, The Nat. Gall. III.

KERR, George Cochrane fl.1873-1906
London marine and seascape painter. Exhib. 1873-93 at RA, SS and NWS. Titles at RA 'The Cliffs of Dover' 'The Busy Thames' 'Greyhounds of the British Navy' etc.

Probable price range £50-100

KIDD, William RSA 1790-1863
Scottish genre painter. Studied under J. Howe, an animal painter, but was more influenced by the work of Wilkie and Alexander Carse. Came to London and between 1817 and 1853 exhib. at RA, BI and SS. In 1849 he was elected H.R.S.A., and thereafter began to exhibit most of his work in Edinburgh. His scenes of Scottish life, pathetic or humorous, are in the Wilkie tradition — e.g. 'The Highland Reel' (1842) 'The Cottar's Saturday Night' (1845) and 'The Jolly Beggars' (1846). He also painted animals, portraits and still-life. Although a prolific and talented artist, Kidd was "quite unable to manage his wordly affairs" (Redgrave) and lived in continual poverty. Towards the end of his life he was supported by an Academy pension and the charity of his friends.

'A Tavern Scene' sold at Christie's 16.7.65 for £294.

Bibl: Portfolio 1878 p.151 f; Redgrave, Dict; DNB XXXI (1892) 95; Caw

KILBURNE, George Goodwin RI RBA 1839-1924
London genre painter, watercolourist and engraver. Studied for 5 years with the Dalziel brothers, the engravers and illustrators. 1863 began to exhibit at RA. Elected member of NWS 1866. Exhib. at RA 1863-1918, SS, NWS, GG and elsewhere. Kilburne's work is mostly genre set in seventeenth century costume. Many of his pictures became popular through prints. His work is in the Walker AG. Liverpool, and the Sheffield AG.

'Fairy Tales, an Interior at Knole' sold at Christie's 11.10.68 for £252.

Bibl: Connoisseur 70 (1924) 58 (obit).

KINDON, Miss M.E. fl.1879-1918
Painter of domestic genre, portraits and landscapes. Lived in Croydon and Watford. Exhib. at RA 1879-1918, SS, NWS, and also at the Paris Salon of the Société des Artists Francais 1904-14. Titles at RA 'Free Seats' 'A Cosy Party' 'The Song Went to her Heart' etc.

Probable price range £20-50

***KING, Haynes RBA 1831-1904**
London genre and landscape painter. Born in Barbados. Came to London in 1854. Studied at Leigh's Academy. In 1857 began to

exhibit at SS, of which he became a member in 1864. Also exhib. at RA 1860-1904, BI and NWS. King shared a house with Thomas Faed (q.v.), who had a considerable influence on his style. Later he lived with Yeend King (q.v.) who was no relation. His genre scenes are usually cottage interiors with figures, in the manner of Faed e.g. 'The Lace Maker' 'Jealousy and Flirtation' etc. He also painted landscapes and coastal scenes. Works by King are in the V and A, Bethnal Green Museum, and Leeds AG.

'Cottage Interior' sold at Bonham's 5.12.68 for £160.

Bibl: AJ 1904 p.272; DNB 2nd Supp. II 401; H. Blackburn, *Eng. Art in 1884,* p.288; RA Pictures 1892, 1893, 1896; Academy Notes, London, 1879, 1880, 1881; The Times 21.5.1904; Reynolds VP (pl.132).

KING, John 1788-1847

Painter of biblical and historical genre, and portraits. Exhib. at RA 1821-84, BI 1814-45, and SS. Worked in London, and also in Bristol, where he painted several religious works for churches, as well as portraits of local notables.

Probable price range £20-50

Bibl: AU 1847 p.413 (obit); Redgrave, Dict; DNB XXXI (1892) 141; Cust, *NPG* II (1902) 161;

KING, Captain John Duncan 1789-1863

Landscape painter. Entered the army in 1806, and served in France, Spain and Portugal. After the peace of 1815 turned to painting. Exhib. at RA 1824-58, BI and SS. Studied with Horace Vernet in Paris 1824. Subjects mostly views in Germany, Spain, Portugal and Ireland. Also known to have copied Claude Lorraine. After 1852 lived at Windsor as a 'Military Knight'.

Probable price range £30-70

Bibl: AJ 1863 p.198 (obit);
Redgrave, Dict.;
DNB XXXI (1892) 141.

KING, John Yeend RBA RI ROI 1855-1924

London landscape and rustic genre painter. Worked for 3 years in a glassworks. Studied under William Bromley (q.v.), and also with Bonnat and Cormon in Paris. Exhib. 1874-1924 at RA, SS, NWS, GG and elsewhere. Elected RBA 1879, RI 1886, later Vice-President. Also member of Royal Institute of Oil Painters. In 1898 his picture of 'Milking Time' was bought by the Tate Gallery. Yeend King was a typical late Victorian painter of rustic genre, often garden scenes with pretty girls, but his robust *plein air* technique and bold colours reflect his Paris training. Works by him are in the Tate, the Walker A G, Reading, Rochdale and Sheffield Galleries.

Prices in the 1968-9 season ranged from about £100 to £260.

Bibl: AJ 1897, p.374; 1898, p.182; RA Pictures 1892-5, 1897-1904, 1906-8, 1910-15; Cat. International Exhibition, Rome, 1911; Who's Who 1924.

KINGSLEY, Albert RBA ARCA RI b.1852 fl.1882-1896

Landscape painter, born in Hull. Worked in London, later moved to Leeds. Exhib. at RA 1882-1914, SS, NWS, and NG. Member of SBA 1890; RI 1896; Associate of the Royal Cambrian Academy in Manchester 1890. His preference in landscape was for moorland, woodland or river scenes, painted in broad, fresh style. A picture of 'Burnham Beeches' by him is in Leeds City AG.

Probable price range £30-70

Bibl: AJ 1896, p.158; 1900, 185;
Leeds City AG Cat. 1909;
Who's Who 1926.

KITCHEN, T.S. fl.1833-1852

London landscape painter. Exhib. 1833-52 at RA, BI and SS. Mostly views on the Thames, or in Kent and Essex.

Probable price range £20-50

*KNELL, William Adolphus c.1805-1875

London marine painter, probably father of William Callcott Knell (q.v.). Exhib. mainly at BI (1825-67), also at RA 1825-66, and SS. Most of his subjects are views on the English coast; he also painted the French, Belgian and Dutch coasts. In 1847 his 'Destruction of Toulon 1793' won a 2nd prize in Westminster Hall competitions. For Queen Victoria he painted 'The Landing of the Prince Regent at Dover' and 'The Review of the Fleet at Spithead'. He also illustrated a book on naval history. Works by Knell are in the NG Edinburgh, Derby and York AG.

'H.M.S. Queen in Portsmouth Harbour' sold at Christie's 12.5.67 for £1,470. This is still a record price, the more usual range being £200-400.

Bibl: AU 1847 p.269; AJ 1857 p.269; 1860, p.80; Redgrave, Bryan; DNB XXXI (1892), 240; S.T. Prideaux, *Aquatint Engraving*, 1919, p.152, 376; Wilson, Marine Painters, 49 (pl.20).

KNELL, William Callcott fl.1848-1865

London marine painter, probably son of William Adolphus Knell (q.v.). Exhib. 1848-65 at RA, BI, and SS. W.C. Knell's output was smaller than that of his father, and of poorer quality.

'Dutch Fishing Boats' sold at Sotheby's 30.10.68 for £260.

Bibl: Wilson, Marine Painters, 49 (pl.20).

KNEWSTUB, Walter John 1831-1906

Genre painter and watercolourist. Met. D.G. Rossetti in 1862 and became his first studio assistant. Through Rossetti met Ford Madox Brown, W.M. Rossetti and Theodore Watts-Dunton. Worked on twelve frescos in Manchester Town Hall 1878-93. Exhib. 1865-81 at RA and SS. In his early days Knewstub also did humorous drawings and caricatures. His daughter married William Rothenstein.

Probable price range £50-200

Bibl: Studio 38 (1906), 238 (obit); W.M. Rosetti, *Some Reminiscences,* III (1906); John Rothenstein, *W.J.K.* Artwork, Vol.IV (1930), 87; References in Rosetti Literature.

KNIGHT, Charles Parsons 1829-1897

Bristol landscape and marine painter. At an early age was making drawings of ships in Bristol harbour. Went to sea as a sailor, and on his return, studied at the Bristol Academy. Exhib. in London 1857-95 at RA, BI, SS and NG. Subjects coastal landscapes, and studies of sea and sky. Several of his works are in Bristol AG.

'Fishermen and Vessels on a Shore' – a pair – sold at Sotheby's 18.12.68 for £180.

Bibl: Bryan; Poynter, Nat. Gall. Cat. III; Studio Special No. 1919, *British Marine Painting,* 28, 65; Bristol AG Cat. 1910.

KNIGHT, John Prescott RA 1803-1881

London portrait and genre painter. Born in Stafford, son of an actor. Studied at Sass's Academy, and with George Clint. Exhib. at RA 1824-78 (227 works), BI and SS. Elected ARA 1836, RA 1844. Member of RA Council, and later Professor of Perspective and Secretary. Knight painted many of the leading men of the Victorian age, many large portrait groups, and institutional portraits. His genre pictures were usually of literary subjects, or rustic scenes, smugglers etc. Many

of his portraits were engraved. His wife was a genre painter, exhib. 1832-37. His studio sale was held at Christie's on July 2, 1881.

Probable price range £50-150.

Bibl: AJ 1849 p.209; 1881, 159 (obit); W. Sandby, *History of the RA,* 1861, II; Bryan; Poynter, *Nat. Gall. Cat.* 1899, III; R.L. Poole, *Cat. of Portraits of Oxford* 1925, II; B.M. *Cat. of Engr. Brit. Portraits* III-V; L. Cust, *NPG,* 1901, II; Hutchison see index (pl.29).

KNIGHT, John William Buxton RBA RCA 1843-1908
Landscape painter and watercolourist. Although his father William Knight was a landscape painter, Buxton Knight was virtually self-taught. Painted in the woods and parks around Sevenoaks, Kent. Exhib. at RA 1861-1907, SS, GG, NG and NEAC. Also at Berlin and Paris Internationals. Knight's landscapes are a fusion between the English landscape tradition of Constable, Cox and de Wint, and the techniques of the Barbizon School. One of his finest works 'December Landscape' was bought by the Tate Gallery in 1908.

'Harwich Landing Stage' sold at Christie's 8.11.68 for £147.

Bibl: Mag. of Fine Arts II (1906) 159-168; Studio 42 (1908) 278-92; AJ 1907 p.43; 1908, 120; Burlington Mag. 31 (1917) 9; Connoisseur 58 (1924) 47; The Years Art 1909 p.406; RA Pictures, 1892-1907; Cundall; Morning Post 17.2.1908.

KNIGHT, Joseph RI RCA ARPE 1837-1909
Manchester landscape painter. Self-taught artist. Exhib. in London 1861-1908 at RA, NWS, GG and elsewhere. Exhib. mainly at Society of Painters and Etchers, and in Manchester. Subjects usually rather sombre Welsh landscapes, with titles such as 'Cloud and Crag' 'Conway Marsh' etc. 'A Tidal River' was bought by the Tate Gallery in 1877.

Probable price range £30-70

Bibl: AJ 1909, p.94 (obit); RA Pictures 1897, 1905, 1908; Poynter, Nat. Gall. III (1900).

KNIGHT, William Henry 1823-1863
Genre painter. Gave up career as a solicitor to become a painter; came to London in 1845, and entered RA schools. At first a portrait painter. Exhib. at RA 1846-62, BI and SS. Later turned to humorous and pathetic genre scenes, usually of children. His pictures are mostly of small size. Some of his best works were 'Boys Snowballing' (1853) 'The Young Naturalist' (1857) and 'The Lost Change' (1859).

'Indoor Games' sold at Sotheby's 15.5.68 for £480.

Bibl: AJ 1861, p.195; 1863, 113-15; 1865, 240; Redgrave, Dict.

KNOWLES, Davidson RBA fl.1879-96
London genre painter. Exhib. mainly at SS, where he was a member; also at RA and elsewhere. Titles at RA include 'My Mother' 'The Tea Girl' 'Private and Confidential' etc.

Probable price range £30-70

**KNOWLES, George Sheridan RI RBA ARCA
b.1863 fl.1885-1893**
London genre painter and watercolourist. Exhib. 1885-1893 at RA, SS and NWS, and at RCA in Manchester. Subjects mostly sentimental genre scenes set in the middle ages, the eighteenth century, or the Empire. Titles at RA 'The Wounded Knight' 'The Love Letter' 'Home Again' etc. Works by Knowles are in Oldham and Nottingham AG.

'The Curlers' sold at Christie's 7.11.69 for £105.

Bibl: AJ 1901, p.177; RA Pictures 1891-2, 1894-8, 1903-7, 1914-15; Cundall, P.173.

KOBERWEIN, Georg. See TERRELL, Mrs. Georgina

KOBERWEIN, Miss Georgina F. See TERRELL, Mrs. Georgina

KOBERWEIN, Miss Rosa See TERRELL, Mrs. Georgina

LADBROOKE, John Berney 1803-1879
Norwich School landscape painter and lithographer. Third son of Robert Ladbrooke, 1770-1842, Norwich watercolourist, (see Clifford, passim). Said to have been the pupil of his uncle John Crome, although Clifford thinks this unlikely as the Cromes and Ladbrookes quarrelled when he was thirteen. Exhibited from 1821-72, at the RA (1821-2, 43), BI, and SS. He was largely an oil painter, but did produce several water-colours.

'Wooded Landscape with Cattle' sold at Sotheby's 12.2.69 for £1,600.

Bibl: DNB; Clifford 22-3, 44, 73, 75, (pls. 62b-63b); Pavière, Landscape; Maas p.56 (pl.); H.A.E. Day *East Anglian Painters* 1968 II 142-158.

***LADELL, Edward fl.1856-1886**
Still life painter. Lived in Colchester, Essex. Exhib. at RA 1856-86, BI and SS. Ladell's pictures are always easily recognisable, as he used the same 'props' over and over again — fruit, flowers, and sometimes a bird's nest, a casket, or carved mug and other objects, on a marble ledge draped with an oriental rug. Although Ladell is now very popular, and his work frequently comes on the market, practically nothing is known of his life. His wife, Ellen Ladell, also painted in a style almost identical to her husband's. She usually signed with her full name, whereas Edward used the EL monogram back-to-back. They must undoubtedly have collaborated on many pictures. Works by Ladell are in Sheffield and Reading AG.

The present auction record is £3,350 – Sotheby's 21.10.70 – but the usual range is £500-1,000 for small works, £1,000-2,000 for larger ones.

Bibl: Maas 174 (with pl.)

LADELL, Ellen See under LADELL, Edward.

LAIDLAY, William James 1846-1912
Landscape painter. Studied in Paris 1879-85 with Carolus Duran and Bouguereau. Exhib. at the Société des Artists Français in Paris 1880-1912, also at RA, SS, GG and NG. One of the founders of the NEAC, about which he wrote a book. *The Origin and First Two Years of the New English Art Club.* Laidlay was one of the strongest opponents of the RA. His pictures show French Impressionist influence.

Probable price range £100-200.

Bibl: AJ 1890 p.156; 1907; 154; Caw 308; Who's Who 1913; Maas 248.

LAMBERT, Clement 1855-1925
Brighton painter of landscapes, shore scenes and genre. Exhibited from 1880, at the RA (from 1882), SS, NWS, GG, NG and elsewhere, titles at the RA including 'Ebb Tide', 1882, 'The Hayfield', 'A Wayside Chat'. For many years he was on the Brighton Fine Art Committee.

Probable price range £30-70.

Bibl: Connoisseur 71 (1925) 180 (obit).

***LAMONT, Thomas Reynolds ARWS fl.1861-1893**

Scottish genre painter and watercolourist. Studied in Paris with George du Maurier, E.J. Poynter, Thomas Armstrong and Whistler (q.v.). Du Maurier used Lamont as model for the character of the Laird in his novel *Trilby,* which he wrote many years later. Lamont also appears in some du Maurier cartoons. Also studied in Spain. Exhib. only 4 works at the RA, and after 1880, lived a quiet life in St.John's Wood, and on his estates near Greenock in Scotland. He continued to exhibit watercolours at the OWS. Little is known of Lamont's later career, and it seems probable that he gave up painting seriously in the 1880's.

'The Pawnbroker' sold at Christie's 14.3.69 for £210.

Bibl: Cundall, p.229; Leonee Ormond, *George Du Maurier,* 1969, see index.

LANCASTER, Hume RBA fl.1836-1849 d.1850

Painter of marine subjects and coastal views, especially of Dutch scenery.. Born in Erith in Kent; in 1841 became a member of the SBA; exhibited from 1836-49 at the RA, BI and SS. The AJ notes: "Had circumstances permitted him the free exercise of his talents, he would doubtless have reached considerable eminence but it is painful to know that a man of education, and of unquestionable ability in his profession, should from domestic troubles, have been compelled to pass the prime of his life in obscurity and to paint for picture-dealers at prices barely sufficient to afford him subsistence " Not to be confused with Rev. Richard Hume Lancaster (1773-1853), landscape painter, who was an hon. exhibitor at the RA from 1800-27.

Probable price range £50-150

Bibl: AJ 1850, 240 (obit).

***LANCE, George 1802-1864**

Still life painter. Studied under B.R. Haydon (q.v.). Exhib. in London 1824-64, mainly at BI (135 works), also RA, SS and NWS. Also exhibited regularly at the Liverpool Academy, of which he was an honorary member. In 1836 he won the Liverpool prize for a historical picture, 'Melancthon's First Misgivings of the Church of Rome.' In addition to his many fruit and still life pictures, Lance also painted occasional historical genre scenes. His favourite pupil and imitator was William Duffield (q.v.). After Lance's death a sale of his works was held at Christie's on May 27, 1873.

Prices during the 1968-9 season ranged from £260 to £630.

Bibl: AJ 1857 p.305 ff; 1864, 242 (obit); Redgrave, Dict; Marillier 169; Reynolds VP 173, 178 (pl.119); Maas 23, 174.

LANDELLS, Robert Thomas 1833-1877

Illustrator, military and ceremonial painter, and special war correspondent. Eldest son of Ebenezer Landells, 1808-1860, wood engraver and originator of *Punch.* Educated principally in France and afterwards studied in London. In 1856 sent by the *Illustrated London News* as special artist to the Crimea, and contributed some illustrations of the close of the campaign. After the peace he was sent to Moscow for the coronation of the Czar, Alexander II, and contributed illustrations of the ceremony. He was present as artist throughout the war between Germany and Denmark in 1863, and again in the war between Austria and Prussia in 1866, when he was attached to the staff of the Crown Prince of Prussia. In 1870, on the outbreak of the Franco-German war, he was again attached to the staff of the Crown Prince. His war sketches were always much admired. He was also successful as a painter, and exhibited from 1863-76 at SS (45 works),

and elsewhere, but not at the RA. He was employed by the Queen to paint memorial pictures of various ceremonials which she attended.

Probable price range £100-400

Bibl: Redgrave, Dict; DNB

LANDER, Henry Longley fl.1864-1887

Landscape painter who exhibited in London from 1864-87, at the RA (1867-81), BI, SS, NWS and elsewhere. Titles at RA 'Spring' 'Streatley on Thames' 'Beda Fell, Cumberland' etc.

Probable price range £20-50.

LANDSEER, Charles RA 1799-1879

Genre and historical painter, elder brother of Edwin Landseer (q.v.). Studied with his father John Landseer, an engraver; with B.R. Haydon (q.v.) and at RA schools. Exhib. at RA 1828-79, BI and SS. Elected ARA 1837, RA 1845. Keeper of the RA from 1851 to 1873. Subjects mainly of a semi-historical nature e.g. 'The Eve of the Battle of Edgehill' 'Queen Margaret of Anjou and the Robber of Hexham' 'The Death of Edward III' etc. The AJ says of his works that they are "distinguished by careful execution, appropriate accessories and costumes, rather than by striking effects and grandeur of character." His studio sale was at Christie's on April 14, 1880.

'An Investiture at Windsor Castle by Queen Victoria' sold at Sotheby's 23.5.62 for £170.

Bibl: AJ 1879 p.217 (obit);
DNB XXXII;
BM Cat. of Engraved Brit. Portraits VI (1925).

***LANDSEER, Sir Edwin Henry RA 1802-1873**

London animal, sporting and portrait painter, and sculptor. Son of John Landseer, an engraver. As a boy, Landseer was fond of drawing animals; entered RA Schools at age of 14. Encouraged by B.R. Haydon, he studied dissection and anatomy to perfect his knowledge of animals. Elected ARA 1826, RA 1831. In 1834 paid first of many visits to Highlands, with C.R. Leslie (q.v.). His many pictures of Highland animals and sporting scenes helped to establish the vogue for Scottish subjects. Queen Victoria was a great admirer of Landseer's work. She owned a large number, and also commissioned him to paint her dogs. Also painted portraits, and designed sculpture; commissioned to model the bronze lions in Trafalgar Square. Exhib. 1815-73 at RA, BI, SS and OWS. Knighted 1850. Among his best-known works are 'The Old Shepherd's Chief Mourner' 'Dignity and Impudence' 'Monarch of the Glen' and 'The Stag at Bay'. Enormous numbers of engravings were made after his works, which greatly increased their popularity. Although a brilliant painter of animals, Landseer pandered to the Victorian taste for monkey pictures, comical dogs, and excessive sentiment. For this reason many of his pictures find little favour today, but his sketches and drawings are much appreciated for their wonderful observation and superb brushwork. Landseer's last years were marred by depression and illness. In 1865 he was offered the Presidency of the RA, but refused. In 1874 an exhibition of his work was held at Burlington House, and another in 1961. After his death, his studio sale was held at Christie's on May 8, 1874.

'Queen Victoria and the Duke of Wellington reviewing the Life Guards' sold at Christie's 22.7.66 for £13,650 – the current record price. Over the last ten years prices for average works have ranged from £500-2,000; small works and sketches £100-500.

Bibl: AJ 1873 p.326 f (obit); 1874, 55 f; 1875-77, see index; 1879, 178, 201, 245; 1905, 59; 1908, 248; Portfolio 1871; p.165 ff; 1876, 18 f; 1885, 32; 1872, 127; 1873, 144; C.S. Maun, *The Works of E.L.* 1843; A. Graves, *Cat. of the Works of the late Sir E.L.* 1876; F.G. Stephens, *Sir E.L.* 1880; F. G. Stephens, *Life and Works of Sir E.L.* 1881; C. Monkhouse, *E.L. Works, ill. by Sketches*

from the Collection of Her Majesty 1888; J.A. Manson, Sir E.L. 1902; L. Scott, Sir E.L. 1904; A. Chester, The Art of E.L. 1920; J. Ruskin, Modern Painters; J. Ruskin, Academy Notes, 1856-58; Redgrave, Dict.; Roget, Binyon; Cundall; DNB XXXII; Hughes; VAM; Pavière, Sporting Painters, (pl. 26); Reynolds VP 14-15, 61, 173, (pl.8); Maas 79-81, (plates on pp.79-81 and 89).

LANE, Samuel 1780-1859

Suffolk portrait painter. Born in King's Lynn, died in Ipswich. He was deaf and partially dumb from childhood. Studied under Joseph Farington, and afterwards under Sir Thomas Lawrence, who employed him as one of his chief assistants. Friend of Constable. Exhibited from 1804-57 at the RA (217 works), and at BI and SS. He built up a very successful practice and many of his portraits were engraved. Among his works are Lord George Bentinck (NPG), Admiral Lord Saumarez (United Services Club), and Captain Murray (V & A).

Probable price range £50-200

Bibl: Redgrave, Dict.; DNB; Cat. Scottish NPG, Edinburgh, 1889; Cat. Engr. Brit. Portr., BM, VI, Index, 510; Cat. Dulwich, 1914; Poole, Cat. of Portr., Oxford, II, 1925, No.44, plate IV.

LANGDALE, Marmaduke A. fl.1864-1904, d.1905

Landscape painter, working in Staines and Brighton. Studied at the RA Schools, and in his third year won the Turner Gold Medal. Exhibited from 1864-1904, at the RA, (1866-1904), BI, SS and elsewhere. He worked in N. Wales, S.Wales, N.Devon and finally settled in Brighton. His favourite medium was oil, but he sometimes used watercolour and pen and ink. The Studio considered his best picture to be 'The Wye near Tintern Abbey', and commented "He may well be remembered as one who strove sincerely after the simplicity of the everyday of nature".

Probable price range £30-70

Bibl: Studio, 37 (1906), 163-4, (plates).

LANGLEY, Walter RI 1852-1922

Genre painter. Born in Birmingham. Studied at S. Kensington Art School 1873-75. After his return to Birmingham, devoted himself more to watercolours. In 1882 settled in Newlyn, Cornwall, and became part of the Newlyn School, which included Stanhope Forbes, Frank Bramley and others (q.v.). Exhib. in London 1890-1919 at RA, SS and NWS. Elected RI 1883. Subjects mostly scenes of fisherfolk and life in fishing villages.

Probable price range £100-300

Bibl: AJ 1889, p.137 f;
RA Pictures, 1892-96.

LAPORTE, George Henry RI 1799-1873

Animal and sporting painter. Son of John L. (1761-1839) also an artist. Exhib. at RA 1821-1850, BI, SS and NWS. Animal-painter to the Duke of Cumberland, later King of Hanover. He painted hunting scenes, dogs and equestrian portraits. Worked in Hanover, where some of his pictures can be found in museums. His sister Mary Ann L. was also an artist, who exhib. 1813-45 at BI, RA, NWS etc.

'A Racehorse with Jockey up' sold at Sotheby's 22.1.69 for £150. An important sporting work could make much more than this.

Bibl: AJ 1859, 175; 1874, 26;
Redgrave, Dict.; DNB; Cundall;
Pavière Sporting Painters 57 (pl. 26).

LARA, George fl.1862-1871

Painter of farmyard scenes. Exhib. once at BI, 16 works at SS. Nothing is known about his life, but he painted rather naive farmyard and village scenes. His works are sometimes attributed to William Shayer (q.v.), a much superior artist, who painted similar subjects. Lara's work can often be recognised because of his tendency to put large numbers of small, doll-like figures into his canvases.

'Farmyard Scenes' – a pair – sold at Sotheby's 7.1.70 for £1,000.

*LA THANGUE, Henry Herbert RA 1859-1929

Painter of landscape and scenes of rustic life. Studied at South Kensington, Lambeth, and RA Schools. Won Gold Medal 1879, and studied with J.L. Gérôme in Paris for three years. While in Paris he came more under the influence of the Barbizon and plein-air painters, such as Bastien-Lepage and Dagnan-Bouveret. On his return to London exhib. at RA, SS, GG and NG; also at Institute of Painters in Oils, and NEAC. Lived at Bosham, Surrey. La Thangue was a friend of Stanhope Forbes, and was in sympathy with the aims and ideals of the Newlyn School in Cornwall.

Probable price range £200-500, but more for important works.

Bibl: AJ 1893, P.169-75;
Studio 9, (1897) 167 ff (mono. with plates by George Thomson).

LATILLA, Eugenio H. RBA 1800-1859

Painter of portraits, genre, landscape and historical subjects. Son of an Italian living in England. He worked from 1828-42 in London, 1842 in Rome, 1847-8 in Florence, 1849 in London, and then in America where he died. Exhibited from 1828-59 in London, at the RA from 1829-37, BI, and SS. RBA in 1838. Among his portraits are those of R. Godson, D. Harvey, D. O'Connell and Queen Victoria.

Probable price range £30-70

Bibl: Redgrave, Dict.; Cat. of Engr. Brit. Portr., BM, 1908-25.

LAUDER, James Eckford RSA 1811-1869

Edinburgh painter of genre and historical subjects, and landscape. Younger brother of Robert Scott Lauder (q.v.). Pupil at the Trustees' Academy under Sir William Allan, RA, and Thomas Duncan, ARA., 1830-3; 1834-8 in Rome with his brother; on his return settled in Edinburgh. In 1847 his paintings 'Wisdom' and 'The Parable of Forgiveness' gained the £200 premium in the Westminster Hall competition. Elected ARSA in 1839; RSA, 1846; exhibited in London from 1841-58, RA (1841-6), BI, SS and elsewhere. Among his more important paintings are 'Baillie Duncan McWheeble at Breakfast', 1854 (bequeathed to the Nat. Gall. of Scotland) 'The Parable of the Ten Virgins', 1855, and 'Hagar', 1857, which Caw notes has the faults and good qualities of his average performance. From about 1857 he turned to painting landscape, hoping he would be more successful than he had been with figure subjects. However, he was not more successful; and "the result was indifference, which led to carelessness, and, finally, to absolute neglect by the public: this hastened his end" (AJ). Caw, however, notes that he was a finer draughtsman than his brother and praises 'Baillie McWheeble' as a most admirable piece of painting', in the Dutch tradition. He did not fulfil his early promise. 'The Parable of Forgiveness' is in the Walker AG, Liverpool.

Probable price range £100-300

Bibl: AJ, 1869, 157 (obit); Portfolio 1887, 153;
Redgrave, Dict.;
Caw 118; DNB.

LAUDER, Robert Scott RSA 1803-1869

Scottish painter of historical and biblical genre. Pupil of Sir William Allan. Studied in Italy for five years, where he existed by painting portraits. Returned to London 1838; exhib. at RA & BI. In 1852 appointed Master of the Trustees Academy in Edinburgh. Lauder was a popular and successful teacher, and under his guidance the Academy produced many of its best pupils. The subjects of his own pictures

are mostly drawn from Scott and the Bible. His historical scenes, such as 'The Trial of Effie Deans' are generally more effective than his religious works, which tend to be large and theatrical. His wife was a daughter of the amateur artist, the Rev. John Thompson of Duddingston.

'Poor Louise, the Gleemaiden' sold at Christie's 2.4.69 for £294.

Bibl. AJ1850 p.12 f; 1869, 176 (obit); 1898, p.339-43, 367-71; Redgrave, Dict.;
Caw 115-17 and index (plate opp. p.116).

LAURENCE, Samuel 1812-1884
London portrait painter. Exhib. at RA 1836-82, SS and elsewhere, mostly chalk drawings. Several pictures and drawings by Laurence are in the NPG, London. His works are sometimes mistakenly attributed to Sir Thomas Lawrence PRA.

'W.M. Thackeray Reading' sold at Christie's 25.11.69 for £115.

Bibl: DNB XXXII; BM. Cat. of Engr. Brit. Portraits VI (1925).

*LAVERY, Sir John RSA RA RHA 1856-1941
Scottish portrait, genre and landscape painter. Studied in Glasgow, London and Paris (under Bouguereau). Returned to Glasgow, where he was a friend of many of the Glasgow School artists including James Guthrie (q.v.). In 1888 he painted the official picture of the Queen's State Visit to Glasgow. This led to more commissions, and in the 1890's he moved to London, where he became a highly fashionable portrait painter. Painted several official pictures, such as 'The Arrival of the German Delegates on the HMS Queen Elizabeth 1918'. One of his best known pictures was 'The Prime Minister at Lossiemouth 1933' (Ramsay MacDonald). Also painted genre scenes and landscapes in a characteristically broad and fluid style, similar to the early work of Munnings. Exhib. at RA, SS, GG, NEAC, in Scotland, and at many European academies. Elected ARSA 1892, RSA 1896, ARA 1911, RA 1921. Knighted 1918, Vice President of the International Society of Sculptors, Painters and Gravers. Lavery had a studio in Tangier where he usually spent the winter every year.

'String out Exercising at Newmarket' sold at Christie's 30.10.70 for a record £3,780. Other prices in the 1968-9 season ranged from £110 to £1,000.

Bibl: AJ 1904, p.6-11 (A.C.R. Carter); 1908, 3-6; Studio 27 (1903), 3-13, 110-20 (J.S. Little); 45 (1909) 171-81 (S. Brinton); Apollo 2 (1925); D. Martin, *The Glasgow School of Painting 1902;* Caw 376-9 (pl. opp. p.378); W.S. Sparrow, *J.L. and his Work* 1911; J. Lavery, *The Life of a Painter,* 1940; Belfast Museum and AG *Sir John Lavery Exhibition* 1952; Scottish Arts Council, *The Glasgow Boys,* Exhib. Cat. 1968.

LAW, David RPA RPE 1831-1901
Landscape painter and etcher. Born in Edinburgh; apprenticed early to George Aikman, steel engraver; 1845, admitted to the Trustees' Academy where he studied under Alexander Christie and Elmslie Dallas until 1850. He became a 'hill' engraver in the ordnance survey office, Southampton, and it was not until 20 years later that he resigned and became a painter. He was one of the founders of the R.S. of Painter-Etchers in 1881. Exhibited from 1869, at the RA (1873-99), SS, NWS and elsewhere. His plates after Turner and Corot and some modern landscape painters had many admirers, and during 1875-90 were in great demand, (when reproductive etching was in high fashion). His best and most vital etched work was done from watercolours by himself.

'At the Mouth of the River Hamble' sold at Sotheby's 12.7.67 for £100.

Bibl: AJ 1902, 85 (obit); Portfolio 1879. 193 ff (with plates); 1880, 93; 1883; 1884; 1902, 85 ff (obit., with plates); Bryan; DNB, 2nd Supp.

LAWLESS, Matthew James 1837-1864
Pre-Raphaelite painter and illustrator. Born Dublin. Studied under several teachers, including Henry N. O'Neil (q.v.). Exhib. at RA and SS. His early works are mostly domestic scenes in the manner of O'Neil, but 'The Sick Call' (RA 1863) is a work of remarkable power. Had Lawless not died of consumption at the age of 27, he might have produced some first-rate Pre-Raphaelite paintings. He is best known for the illustrations he produced for *Once a Week* and other magazines. As an illustrator Lawless was compared with Millais during his own lifetime.

Probable price range £100-300

Bibl: Studio, British Book Illustration, Winter No. 1923/4, p.77; 90, (1925), 56; Bate 83-4 (plate opp. p.84); Strickland II; DNB; Gleeson White 162-3, and index (several plates).

*LAWSON, Cecil Gordon 1851-1882
Landscape painter and watercolourist. Born in Shropshire of Scottish parents. Came to London in 1861 with his father William Lawson, who was a portrait painter. At first painted small, detailed studies of fruit and flowers in the manner of William Hunt. Exhib. 1869-1882 at RA, SS & GG. Scored his first notable success with 'The Minister's Garden' in 1878 at the opening of the GG. Lawson's death four years later at the age of 31 cut short his promising career. What few pictures he did paint show him to be an artist "singularly sensitive to the grandeur and bold rhythm of nature" (Hardie). Many critics would still agree with Caw that "he remains one of the greatest landscape painters of his century". His wife Constance was a flower painter, who exhib. 1880-92 at RA, SS, NWS, GG, NG and elsewhere.

A group of pictures sold at Sotheby's 22.10.69 for prices ranging from £100 to £450.

Bibl: AJ 1882, p.232f (obit); 1895, 282; 1908, 122; 1909, 102; Mag. of Art No. 158 Dec. 1893; Studio 66 (1916), 240; (1923) 261; *Early Eng. Watercolours by the Great Masters,* Special No. 1919, p.48; E.W. Gosse, *Lawson, A Memoir,* 1883; Redgrave, Cent.; DNB XXXII (1892); Caw 314-16 (plate opp. p.314); Binyon; Cundall; Reynolds VP 155 (pl.110); Hardie III 188-9, (pl.221); Maas 228.

LAWSON, Mrs. Cecil (Constance B. Philip) See under
LAWSON, Cecil Gordon.

LAWSON, Francis Wilfred fl.1867-1913
Painter of genre and allegories, portraits and landscape; illustrator. Elder brother of Cecil Gordon Lawson (q.v.). Born in Shropshire; began as a designer for periodicals, especially *The Graphic;* exhibited from 1867-87, at the RA (1867-84), SS, GG, Dudley Gallery and elsewhere. Caw notes that he attained considerable distinction as a painter of allegories and of incidents in the life of poor city children, treated with a touch of symbolism which makes them homilies, eg. 'Imprisoned Spring; Children of the Great City', 1877. He is represented at the Walker Art Gallery, Liverpool.

Probable price range £50-150.

Bibl: Caw 313; John Denison Champlin and Charles C. Perkins, *Cyclopedia of Painters and Paintings,* 1913, III (noted as 'Living').

LEA, Miss Anna See under MERRITT, Mrs. Henry

*LEADER, Benjamin Williams RA 1831-1923
Worcester landscape painter. Born Benjamin Williams, but added the surname Leader to distinguish himself from the Williams family of artists, to whom he was not related. Exhib. at RA 1857-1922, BI, SS and at Birmingham Society of Artists. Subjects usually set in Scotland or the Midlands, but he was especially fond of the landscape around Bettws-y-Coed, Wales. Leader's early pictures show some Pre-Raphae-

lite influence, but he later developed a broader, more naturalistic style, which was enormously successful. His best known picture is 'February Fill-Dyke' (Birmingham AG) which has been described as the equivalent in landscape painting of 'The Light of the World' in religious painting, or of 'Bubbles' in popular art. Although repetitive, Leader's works have always been admired for their literalness and "truth to Nature".

'Green Pastures and Still Waters' sold at Sotheby's 15.10.69 for £4,200 – the current record price. Leader was a prolific and a variable artist, and the range of his prices is therefore wide. Last season they ranged from about £100 to £2,000.

Bibl: AJ 1871, p.45-7; 1893, 96-99; 1901-1905, see index; L. Lusk, *B.W.L.* Christmas Annual 1901 (part of AJ); Connoisseur 66 (1923), 53 (obit); Studio (1916) 88; 85, (1923), 219 f (obit); M. Rees, *Welsh Painters,* 1912; Reynolds VP 155 (pl.112); Maas 228 (pl. on p.228).

LEAHY, Edward Daniel 1797-1875
Painter of portraits, and historical and marine subjects e.g. the Battles of the Nile and Trafalgar. He studied at the Dublin Society's School, and was working and exhibiting in Dublin from 1815-27. He then moved to London and exhibited from 1820-53 at the RA, BI and SS. He mostly exhibited portraits at the RA, but also historical subjects, e.g., 'Mary Queen of Scot's Escape from Lochleven Castle', 1837 and 'Lady Jane Grey, Summoned to her Execution', 1844. Both the Duke of Sussex and the Marquis of Bristol sat to him, and his sitters also included many prominent Irishmen. He painted marines both in England and Ireland. Between 1837 and 1843 he lived in Italy, and in Rome painted a portrait of John Gibson RA. After his return he exhibited a few Italian subjects. His portrait of Father Matthew, the "Apostle of Temperance" is in the NPG.

Probable price range £50-150

Bibl: Redgrave, Dict; DNB; Strickland; Wilson, Marine Painters.

*LEAR, Edward 1812-1888
Topographical watercolourist, one of the best watercolour painters of the nineteenth century; landscape painter also in oils, illustrator, author and traveller. Lear was the youngest of twenty-one children, his father a stock-broker who lived in Holloway. In 1831 he found employment at the Zoological Gardens as a draughtsman, and in 1832 published the *Family of the Psittacidae,* one of the earliest collections of coloured ornithological drawings made in England. From 1832-6 he worked at Knowsley for the 13th Earl of Derby, and for him illustrated the above work; the bird portion of Lord Derby's *The Knowsley Menagerie,* 1846; and for his children, *The Book of Nonsense,* first edition 1846. There, too, he met many of his aristocratic friends, and in 1846 came to give drawing lessons to Queen Victoria. From 1837 onwards he never again lived permanently in England: from 1837-41 he wintered in Rome. He worked throughout Italy, and later travelled to Corsica, Malta, Greece, 1849, Turkey, the Ionian Isles, Egypt, Jerusalem, Corfu, Syria etc. From 1864-70 Lear spent his winters in Nice, Malta, Egypt and Cannes, till finally he settled at San Remo where he died. In 1873-5 he went to India and Ceylon for Lord Northbrook. Amongst other books he published *Journals of a Landscape Painter in Greece and Albania* 1851, and *In Southern Calabria* 1852. He exhibited from 1836 at SS, and from 1850-73 at the RA, and also at the BI, GG and elsewhere. His output of work was enormous: his "topographies" were always done in pencil on the actual site, and were often scribbled over with colour notes and dated. They were then inked in in sepia and brush washed with colour in the winter evenings. His oil paintings were mainly done between the years 1840-53. Hardie notes that Lear carried on through the Victorian period the tradition of watercolour drawing as exemplified in the work of Francis Towne. He comments, "Turner alone had the same zest for life, the same infinite capacity for work, but Turner,

though he did try his hand at poetry, could not write nonsense verse. 'Topographies' these drawings are, but they possess something more. Lear set down observantly, rightly, rhythmically, the facts of life and nature, without any high flight of poetry or imagination".

The average range for drawings is £200–500, although fine examples have sold for up to £2,000. An important oil painting might be worth even more, but these are very rare.

Bibl: DNB; VAM; A. Davidson *Edward Lear* 1938; Reynolds VP 12 154 (pl. 162); Hardie III 43, 63-67, 187 (pls. 78-81); Maas 38, 79, 84-5, 99-100, 184, 193 (pls. 99, 100, 108); Vivien Noakes *Edward Lear: the Life of a Wanderer* 1968 (for full bibliography and for a list of his own published works).

*LEE, Frederick Richard RA 1798-1879
Landscape, seascape and still-life painter. Lived mostly in Barnstaple, Devon, his birthplace. As a young man served in the Army, but resigned his commission due to ill-health. Entered RA Schools 1818. Elected ARA 1834, RA 1838. Exhib. at RA 1824-70, BI and SS. Subjects mostly views in Devon, also Scotland. Like Shayer, Creswick and Witherington, Lee was a popular painter of idealised landscape and sentimental rustic genre. He often collaborated with the animal painter T.S. Cooper (q.v.), and sometimes with Landseer. Retired from the RA 1872; died in S. Africa.

'Landscape in Sussex' sold at Christie's 11.7.69 for £441. Works in which Lee collaborated with T.S. Cooper make much more; 'The Watering Place' sold at Phillip's 20.1.69 for £2,000, and a pair have been sold for £1,208.

Bibl: AJ 1879, p.184 (obit); 1908, 376; W. Sandby, *History of the RA,* 1862; Ottley; G. Pycroft, *Art in Devonshire,* 1883; DNB XXXII (1892); E.J. Poynter; *N.G. Cat. III* (1900); Maas 53, 226 (2 plates on p.51).

*LEE, John fl.1850-1860
Little-known Liverpool Pre-Raphaelite painter. Exhib. at SS in 1860 and 1861. Graves lists a J.J. Lee under the same address who exhib. at RA 1863-67 – this is probably also John Lee. His works are rare, but are "striking testimony to the triumph of Pre-Raphaelitism in the provinces" (Maas).

Probable price range £200-500

Bibl: Maas 237 (plate on p.238).

LEE, William RI 1809-1865
Painter of rustic genre, often English or French figures in coastal scenes, and mainly in watercolour. Member and Secretary of the Langham Sketching Club, All Souls' Place, for many years. Exhibited from 1844-55, at the RA (1844-54), SS, NWS (91 works); A of RI 1845; RI 1848. 'French Fisherwomen' is in the V & A.

Probable price range £30-70

Bibl: AJ 1865, 139 (obit); Redgrave, Dict; DNB; VAM.

LEECH, John 1817-1864
Illustrator and caricaturist. At first studied medicine, but abandoned it for art. Contributed his first cartoon for *Punch* in 1847, and was a regular contributor to this and many other magazines. His best known illustrations were those he did for the novels of Surtees. Most of Leech's work was done in pen and ink; he occasionally used watercolour and gouache, but rarely oils. His drawings and cartoons present a charming panorama of Victorian life, observed with gentle wit, although his jokes at the expense of the lower classes are regarded as bad taste by our more democratic age. His studio sale was held at Christie's on April 25, 1865.

'Well Over!' sold at Sotheby's 22.1.69 for £150.

Bibl: AJ 1864, p.373 (obit); Quarterly Review Appr. 1865; North Brit. Review Mar. 1865; J. Brown, *J.L. and other Essays* 1882; F.B. Kitton, *J.L. Artist and·*

Humorist, 1883; W.P. Frith, *Leech, life and work* 1891; DNB XXXII (1892); Everitt, *English Caricature*, 1893; Bryan; Reynolds, VS 31; Maas 70 (plate on p.190); Leonée Ormond *George du Maurier*, 1969 see index.

*LEES, Charles RSA 1800-1880

Scottish portrait, landscape and genre painter. Born Cupar, Fifeshire. Pupil of Raeburn. After a six-month visit to Rome, he returned to Edinburgh, where he passed the rest of his career. Elected RSA 1830. As well as portraits, Lees painted many charming scenes of Scottish life, landscapes, and sporting scenes. He is best known for his skating scenes, such as the one illustrated. Treasurer of the RSA.

'The Golfers, a Grand Match played over St. Andrew's Links' sold at Sotheby's 30.8.68 for £4,200.

Bibl: AJ 1880, p.172; DNB XXXII; Caw 120

LEGROS, Professor Alphonse RPE 1837-1911

Painter of portraits, landscape, genre and historical subjects; etcher; lithographer; sculptor; medal designer; teacher. Born in Dijon; apprenticed to a builder and decorator. In 1851 he moved to Paris, where he worked as a scene-painter; studied at the Ecole des Beaux-Arts, and under Lecoq de Boisbaudran. Exhibited at the Salon from 1857, where a profile portrait attracted Champfleury's attention and led him to be drawn into the group of so-called 'Realists', and he appears in Fantin-Latour's portrait group 'Hommage a Delacroix'. In 1859 he exhibited 'Angelus' which led Baudelaire to call him a "religious painter gifted with the sincerity of the Old Masters". Encouraged by Whistler that he might find work in London, Legros came to England in 1863. A few years later he was appointed Teacher of Etching at the South Kensington School of Art, and in 1876 Professor of Fine Art at the Slade School, University College London, a post which he held until 1892, having considerable influence on many of the students he taught. Exhibited from 1864-1889, at the RA (from 1864-82), GG, NG and elsewhere — paintings, etchings and medals. One of the founders of the Royal Society of Painter Etchers and Engravers. Much of his work outside his classroom continued to bear trace of the rebellious romanticism of his youth — eg. his etchings from Edgar Allan Poe, the 'Bonhomme Misère', and 'La Mort du Vagabond'. In his later years, after 1892, he etched 'Le Triomphe de la Mort', and idylls of fishermen by willow-lined streams, labourers in the fields and rustic scenes in France and Spain.

'Study of Hands' – a drawing – sold at Sotheby's 7.11.62 for £100.

Bibl: For full bibliography see Thieme-Becker; selected bibliography only: AJ 1897; 105-8, 213-16; Studio 27 (1913), 245-67 (plates); 29 (1903) 3-22; L. Benedicte *Alphonse Legros* 1900 Paris; *L'Oeuvre Grave et Lithogr. de Alphonse Legros*, 1904 Paris; Burlington Magazine 20, (1911-12); 273 f; DNB 2nd Supp; M. Salaman, *Alphonse Legros*, 1926; VAM.

LEHMANN, Rudolf 1819-1905

German painter of portraits, historical and genre subjects. Born at Ottensen, Hamburg, son of Leo Lehmann, portrait painter. In 1837 he went to Paris where he studied under his brother Heinrich Lehmann, later professor at the Ecole des Beaux Arts. From Paris he went to Munich, studying under Kaulbach and Cornelius, and in 1838 joined his brother in Rome. First visited London in 1850; lived in Italy from 1856-66, mostly in Rome. In 1861 he married in London, and in 1866 settled there. Exhibited from 1851 at the RA, GG, NG and elsewhere. He painted four portraits of Browning, who became a close friend. In his later years he mainly did portraiture (e.g. Lord Revelstoke, Earl Beauchamp, and Miss Emily Davies, (Girton College; one of his best), but also other paintings, eg. 'Undine', 1890 and 'Cromwell at Ripley Castle' 1892.

'The Confessional' sold at Christie's 3.4.69 for £179.

Bibl: For full bibliography see Thieme-Becker; AJ 1873, 169-72; 1893, 260;

1905; 385; Rudolf Lehmann, *An Artist's Reminiscences*, 1894; R.C. Lehmann, *Memories of Half a Century*, 1908; DNB 2nd Supp.

LEIGH, Miss Clara Maria See POPE, Mrs. Alexander

LEIGH, James Matthews 1808-1860

Painter of historical subjects and portraits; teacher. Son of Samuel Leigh, well-known publisher and bookseller in the Strand. Studied under William Etty (his only pupil), in 1828. Exhibited from 1825-49, at the RA (1828-49), BI and SS, often scriptural subjects, e.g. 'The Trial of Rebecca', 1840. He was also an author and in 1838 published an historical play 'Cromwell', and 'The Rhenish Album'. He was better known as a teacher, starting the well-known painting school in Newman Street, which was very well attended and a rival to the school run by Henry Sass. Although he did not exhibit in his later years, he often sketched the subjects set for his students, the subjects often being scenes from Scott and Shakespeare. Many hundreds of these sketches, with his paintings and watercolours, were sold after his death at his studio sale at Christie's on June 25, 1860.

'The Crowning of Queen Victoria' sold at Bonham's 16.1.69 for £130.

Bibl: AJ, 1860, 200 (obit); Redgrave, Dict; DNB

LEIGHTON, Charles Blair See under LEIGHTON, Edmund Blair

LEIGHTON, Edmund Blair 1853-1922

Historical genre painter. Son of Charles Blair Leighton, a portrait and historical painter (1823-55), who exhib. in London 1843-54. E.B. Leighton exhib. at RA 1878-1920, SS and elsewhere. Typical titles 'The Dying Copernicus' 'Un Gage d'Amour' 'Romola' etc. 'Lady Godiva' is in the Leeds A.G. His pictures of elegant ladies in landscapes or interiors have a similar kind of charm to those of Tissot.

'Sunshine and Shadow' sold at Sotheby's 4.6.69 for £340.

Bibl: AJ 1895, p.176; 1896, 175; 1897, 173, 205; 1900, 133-8; 1901, 181; 1902, 206, 380; 1903, 168; Connoisseur 64 (1922), 125 (obit); The Year's Art 1923, p.339;

*LEIGHTON, Lord
(Baron Leighton of Stretton) PRA, RWS, HRCA, HRSW 1830-1896

Painter of historical and mythological subjects, and leader of the Victorian neo-classical painters. Born Scarborough, Yorkshire, the son of a doctor. Studied under various teachers in Florence and Rome, including the German Nazarene Steinle. In 1855 his first RA picture 'Cimabue's Celebrated Madoma is Carried in Procession through the Streets of Florence' was bought by Queen Victoria for £600, thus launching him on a long and successful career. In the 1860's Leighton turned away from medieval and biblical subjects towards classical themes. It is for these Hellenic subjects that he is now best known. Among his best works are 'Flaming June' 'The Garden of the Hesperides' and 'The Daphnephoria'. Leighton made nude studies and draped studies of each figure in his pictures, and also figure sketches of the whole composition. These drawings and sketches are often more admired than his finished pictures, which can be sterile and mechanical. Exhib. at RA 1855-96, SS, OWS, GG and elsewhere. Elected ARA 1864, RA 1868, PRA 1878. Although conscious of his own limitations as a painter, Leighton was by the end of his life a pillar of the Victorian art establishment. He was knighted in 1878, made a baronet 1886, and raised to the peerage in 1896, just before his death. He is the only English artist to have been accorded this honour. His house in Holland Park Road is now a museum with a permanent exhibition of his pictures and drawings. After his death sales of his pictures were held at Christie's on July 11 and 13, 1896.

'Tragic Poetess' sold at Sotheby's 17.6.70 for £3,600. Other auction prices in recent years have ranged from about £100 to £1,000. Because of their size, Leighton's works tend to fight shy of the saleroom; many important works have been sold privately for larger sums.

Bibl: Main biographies – Mrs. A. Lang *Sir F.L. Life and Works,* 1884.
E. Rhys *Sir F.L.* 1895; 1900,
G.C. Williamson, *Fred Lord L.* 1902.
Alice Corkran *Leighton,* 1904.
Mrs. R. Barrington, *The Life and Works of F.L.* 1906;
E. Staley, *Lord L.* 1906;
A.L. Baldry, *L.* 1908;
R. and L. Ormond, Book on L. in preparation.
Other references – Ruskin *Academy Notes,* 1855. 1875; Sir. W. Bayliss, *Five Great Painters of the Victorian Era,* 1902; RA Exhibition 1897; DNB Supp. III (1901), 88 ff; Encyclopedia Brit. XVI (1911); Roget; Bryan; Binyon; Cundall; VAM; W. Gaunt, *Victorian Olympus,* 1952; Reynolds VP 117-19 et passim, (pls. 78-80, 87); Hutchinson 136-7; Maas 178-81 (pls. on p.176-181, 185); Michael Levey *Sunday Times Colour Supplement,* Nov. 2. 1969.

LEITCH, William Leighton RI 1804-1883

Landscape painter and watercolourist. Born in Glasgow. Became scene-painter at Glasgow Theatre Royal. Came to London and worked as scene-painter with Clarkson Stanfield, David Roberts and others. Studied in Italy. Exhib. at RA 1833-61, BI, SS and NWS. Elected RI 1862; Vice-President for many years. Teacher of watercolour-painting to Queen Victoria and many other members of the Royal Family. Although at times superficial and cluttered, his work is "characterised by thorough observation, nicety of touch, and supreme competence". (Hardie). After his death two sales of his works were held at Christie's on March 13 and April 17, 1884.

'Ornamental Fountain at Piggia' a watercolour, sold at Christie's 14.10.69 for £147. Usual range £50-100.

Bibl: AJ 1884, p.127; Portfolio 1883, p.145; A. MacGeorge, *Memoir of W.L.* 1884; Bryan; Binyon; Caw 155-6; Cundall; DNB XXXIII; Hughes; VAM; Hardie III 186, (plates 216-17).

LE JEUNE, Henry L. ARA 1820-1904

London genre painter. Studied at RA Schools. Exhib. at RA 1840-94, BI and SS. Subjects historical genre, country scenes, and pictures of children. In 1845 became Drawing Master at RA, and in 1848 Curator. Elected ARA 1863. Works by Le Jeune are in Manchester and Salford AG. Titles at RA 'Field Flowers' 'Tickled with a Straw' 'Little Bo-Beep'. In the 1840's and 50's Le Jeune painted some historical and biblical subjects, but he later abandoned these in favour of more commercial genre themes.

'A Girl Asleep in a Cornfield' sold at Christie's 11.7.68 for £78.

Bibl: AJ 1858, p.265 ff; 1904, 381;

LEMON, Arthur 1850-1912

Painter of genre, particularly Italian pastoral scenes. Born on the Isle of Man, he spent his youth in Rome; was for ten years a cowboy in California, where he made studies of Indians. Returning to Europe, studied under Carolus Duran in Paris. Lived in England and Italy. Exhib. at the RA, GG, NG, and elsewhere from 1878-1902, titles at the RA including 'Cattle in the Roman Campagna', 'A Sussex Ox Team', 'Milking Time' etc. A memorial exhibition was held at the Goupil Gallery, 1913. 'An Encampment' is in the Tate Gallery (Chantrey Purchase).

'A Ploughing Team in Tuscany' sold at Bonham's 10.4.69 for £105.

Bibl: Cat. Cape Town Art Gallery, 1903, 25 (with plates);
Der Cicerone, V, 1913, 216;
The Standard, V, 19, 2, 1913;
Tate Cat.

LEONARD, John Henry 1834-1904

Landscape and architectural painter. Born in Patrington, Holderness. 1849-60, lived in York where he was engaged in architectural and lithographic drawing. He was a pupil there of William Moore (father of John, Henry and Albert Moore). Close friend of Henry Moore throughout his life, and influenced by his interest in atmospheric effects. Moved to Newcastle; in 1862 settled in London. At first did architectural drawing for Messrs. R.H. and Digby Wyatt, but afterwards devoted himself to painting only, landscapes and architectural subjects, mostly in watercolour, but also in oils. The architectural precision and topographical subject matter, however, always remained in his work. Exhibited from 1865-81, at the RA (1868-81), SS, Dudley Gallery and elsewhere. From 1886-1904 he was Professor of Landscape Painting at Queen's College, Harley St. He travelled in France, Holland and Belgium.

Probable price range £50-150

Bibl: AJ 1909, 84-6 (monograph with plates).

LESLIE, Charles fl.1835-1863

Landscape painter, lived in Wimbledon, London. Exhib. at RA 1856-62 BI, SS and elsewhere. Subjects usually Scottish or Welsh moorland scenes. Titles at RA 'A Shower Passing the Welsh Hills' 'The Crags of Cader Idris' 'Upper Leke' etc.

'Highland Landscape' sold at Bonham's 8.5.69 for £200.

*LESLIE, Charles Robert RA 1794-1859

Painter of historical genre. Father of Robert and George Dunlop Leslie (q.v.). In 1800 his parents went to live in Philadelphia. Studied with George Sully. Came to London and studied at RA schools. 1817 visited Brussels and Paris. Exhib. at RA 1813-59 and BI. Elected ARA 1825, RA 1826. Leslie painted historical and humorous genre in the manner of Wilkie and Mulready. His sources were taken from a wide range of authors – Cervantes, Shakespeare, Swift, Addison, Moliere etc. One of his most popular works was 'Roger de Coverley Going to Church'. Leslie was a friend of Walter Scott, and illustrated many of the Waverley Novels. From 1847 to 1852 was Professor of the RA. For Queen Victoria he painted 'Queen Victoria Receiving the Sacrament' and 'The Christening of the Princess Royal'. Leslie was a great friend of John Constable, and their letters are one of the great sources of information about Constable's life and character.

'Reading the Will' sold at Christie's 20.12.68 for £294.

Bibl: AJ 1856, p.73-5, 105-7, 1859, 187 (obit); 1902, 144-8; *Autobiographical Recollections,* by C.R.L. 1860; Redgrave, Dict., and Cent.; J. Dafforne, *Pictures by Leslie,* 1875; Bryan; Binyon; Cundall; DNB; J. Constable, *The Letters of John Constable and C.R.L.* 1931; Studio, Spring No. 1916. *Shakespeare in Pictorial Art;* Dunlap, *History of Arts and Design in the US* 1918; Reynolds VP 13, 94, 117 (pl.6); Maas 109 (pl. on p.120).

*LESLIE, George Dunlop RA 1835-1921

Landscape and genre painter; son of C.R. Leslie (q.v.). Studied under his father, and at RA Schools. Exhib. at RA from 1857, BI, SS, GG, NG and elsewhere. After a brief period of Pre-Raphaelitism, Leslie turned to landscapes with children and girls, especially views on the Thames. Titles at RA 'Whispering Leaves' 'The Lily Pond' and also some historical works e.g. 'The War Summons 1485' 'Lucy and Puck' etc. For a time Leslie lived in St. John's Wood and was a member of the St. John's Wood Clique (see bibl.), until he moved to Wallingford.

'Pot-Pourri' sold at Christie's 10.7.70 for £2,625. Another in the same sale, 'School Revisited' made £1,995. These were both exceptionally good examples; the average range is still £200-500.

Bibl: Portfolio 1894, p.42; RA Pictures 1893-96; Studio 81 (1921) 155 (obit); Connoisseur 59 (1921) 244; Clement and Hutton; Bate 90 (plate opp.); Bevis Hillier, *The St. John's Wood Clique* Apollo June 1964; Reynolds VP 13, 26, 179, 195.

LESLIE, Robert C. fl.1843-1887

Painter of marine views, portraits and genre. Eldest son of Charles R. Leslie (q.v.)., and younger brother of George D. Leslie (q.v.). Made a speciality of marine subjects, and for many years had a studio in Southampton; exhibited from 1843-87 at the RA, BI, SS, Dudley Gallery and elsewhere. Among titles at the RA are: 'The Great Horseshoe fall, Niagara, Canada'; 'Robinson Crusoe Visits the Spanish wreck'; and 'A Last Shot at the Spanish Armada in the North Sea'. Tom Taylor, in *English Painters of the Present Day,* 1870, "All that Robert Leslie has executed of this kind, (sailor life, shipping and the sea), has shown a genuine love and pure feeling for Nature, a thorough mastery of the technical elements of his subjects, and a consistency in all parts of his pictures such as in this particular walk of art only exact knowledge can secure. These qualities give a distinctive value and interest to Robert Leslie's pictures, which as yet (1870) have hardly the recognition their merits entitle them to". He was also the author of several works on nautical subjects.

Probable price range £100-200.

Bibl: AJ 1902, 148; Clement and Hutton.

LESSORE, Jules **RBA RI RWS** 1849-1892

Painter of landscape, portraits, genre and architectural subjects. Son of Emile Aubert Lessore, 1805-1876, Parisian painter, lithographer and engraver. Born in Paris; pupil of his father and of F.J. Barrias. Worked principally in England; exhibited from 1879-92, at the RA (1885-90), SS, NWS, GG and elsewhere; at the Paris Salon from 1864-77. Became a member of the RI in 1888.

Probable price range £30-100

Bibl: Cundall; VAM; Pavière, Landscape.

***LEVIN, Phoebus** fl.1836-1878

Portrait and genre painter. Born in Berlin, where he studied 1836-44, and exhibited until 1868. In Rome 1845-47, and London 1855-78, where he exhib. mainly at SS, also RA & BI. His best known picture is 'The Dancing Platform at Cremorne Gardens' in the London Museum.

Probable price range £100-300; more for scenes of Victorian life.

Bibl: Maas 117 (plate p.118).

LEWIS, Arthur James fl.1848-1893

London painter of landscape and portraits, who exhibited from 1848-93, at the RA (1848-85), BI, GG, NG and elsewhere, titles at the RA including 'Far Away on the Hills — Scene in Arran', 1881.

Probable price range £30-70

LEWIS, Charles James **RI** b.1830-6-1892

Painter of landscape, small domestic subjects, rustic genre, and angling scenes. He was an industrious and rapid artist and his work was very popular. Exhibited from 1852-93, at the RA, (1853-90), BI, SS, NWS (72 works), GG, NG, and elsewhere (187 works). Elected RI in 1882. The AJ, 1869, reproduces 'The Mill-Door', and comments 'We are pleased to meet with something which breaks the monotony of what is ordinarily set before us. . . . both in the subject and its treatment we have an attractive work: the introduction of the mother and her children gives animation to the scene, while they do not appear forced in for the sake of effect; they express only a domestic incident natural enough in their daily life'.

'Old Letters' sold at Sotheby's 20.3.63 for £140.

Bibl: AJ 1869, 244 (plate); DNB; Pavière, Sporting Painters.

LEWIS, Frederick Christian 1779-1856

Engraver and landscape painter, in oil and water-colour. Brother of George R.Lewis (q.v.) and father of John F.Lewis (q.v.) and F.C.Lewis jun. (q.v.) He held the appointment of Engraver of drawings to Princess Charlotte, Prince Leopold, George IV, William IV and Queen Victoria. He did the aquatint work for some of Girtin's *Views of Paris* and for Turner's first experimental plate in the *Liber Studiorum.* He engraved many of T. Lawrence's crayon portraits. He engraved his own drawings in *Picturesque Scenery of the River Dart,* 1821, *Scenery of the Tamar and Tavy* 1823 and *Scenery of the Exe,* 1827. He was also a painter of some merit and exhibited from 1802-53 at the RA, BI and SS, and watercolours at the OWS from 1814-20.

'Portrait of a Parsee Girl' sold at Sotheby's 12.3.69 for £280.

Bibl: AJ 1857, 61; 1875, 279; 1880, 300; 1910, 93-5; Dibdin, *Bibliographical Decameron,* 1817 ii 520; Gent. Mag. 1857; i 251; Redgrave Dict.; Roget; Bryan; Binyon; DNB; Cat. of Engr. Brit. Portr. BM 1908-25 VI 514, 644 ff; S.T. Prideaux, *Aquatint Engraving* 1909, 366, 398 ff; T.M. Rees, *Welsh Painters,* 1912; Hughes; Connoisseur 37 (1913) 2; 46 (1916), 102, 115; *Print Collector's Quarterly,* XII (1925) 383; XIII (1926); 53, 56, 60, 62; VAM; *Walker's Monthly* May 1929; Hardie III 48.

LEWIS, George Robert 1782-1871

Painter of landscape, portraits, and figure subjects including many scenes of pilgrimages (eg. 'Pilgrimage to the Monastery of Goetweig, near Vienna', 1820). Younger brother of F.C. Lewis (q.v.). Studied under Fuseli at the RA Schools. Worked with his brother, in aquatint on Chamberlaine's *Original Designs of the Most Celebrated Masters* and Ottley's *Italian School of Design.* Exhibited from 1805-17 at the RA (1820-59), BI, SS, NWS and elsewhere. In 1818 accompanied Dr. Dibdin as draughtsman on his continental journey, and drew and engraved the illustrations for Dibdin's *Bibliographical and Picturesque Tour through France and Germany,* 1821. He also published many engraved books on different subjects, (See DNB).

'Harvest Home' sold at Sotheby's 15.5.68 for £480.

Bibl: See under F.C. Lewis.

***LEWIS, John Frederick** **RA RWS HRSA** 1805-1876

Painter and watercolourist of animals, landscape, and genre, especially Spanish and oriental subjects. Lewis was born into an artistic family: both his father Frederick Christian Lewis and his uncle George Robert Lewis were artists. As a boy he studied animals with Edwin Landseer (q.v.). In 1820 he began to exhibit at the BI, and in 1821 at the RA. His early works mostly animal subjects. About 1825 he turned to watercolours, elected ARWS 1827, RWS 1829. 1827 visited Switzerland and Italy; 1832-4 in Spain. In 1835 published *Sketches and Drawings of the Alhambra* with lithographs by J.D. Harding (q.v.), and other books of Spanish views. 1837 visited Paris, 1838-40 settled in Rome. From Rome Lewis set out for Greece and the Middle East, arriving in Cairo in 1841, where he remained for ten years. From 1841 to 1850 he did not exhibit in London, but in 1850 his watercolour 'The Hareem', created a sensation. Ruskin praised it as "faultlessly marvellous" and hailed Lewis as a leading Pre-Raphaelite. Although Lewis used similar technical methods to the PRB painters, he was never associated with them. Elected PRWS 1855, but resigned in 1858 to take up oil-painting again. ARA 1859, RA 1865. In both his oils and his watercolours, Lewis was a meticulous craftsman, combining to a remarkable degree detailed observation, jewelled colour, and effects of light. An exhibition of his work was held at the RA in 1934. After his death, a sale of his studio was held at Christie's on May 4, 1877.

The usual range for watercolours and minor paintings is about £300-500. Exceptionally fine paintings and watercolours, however, have sold for up to £5,000.

Bibl: AJ 1858, p.41-3; 1876, 329; 1891, 323, 325, 327; 1908, 293; Portfolio 1892, 89-97, 125; Connoisseur 56 (1920), 202, 220; 65 (1923), 46, 48; 71 (1925) 169, 174; Redgrave, Cent. and Dict.; Ruskin Academy Notes, 1855-58; Roget; DNB XXXIII (1893); Ruskin, *Modern Painters,* 1898, V.177; Bate 91-92,

(pl. opp. p.92); Binyon; Cundall; Hughes; VAM; R. Davies, *J.F.L.* OWS III 1926; H. Stokes, *J.F.L.* Walker's Quarterly XXVIII 1929; Reynolds VP 12, 143-4, 156 (pl. 95 and 97); Hardie III 48-55, (pls. 65-69); Maas 91-93, (pls. on p.90, 92, 93).

LEWIS, Leonard RBA fl.1848-98
Landscape and architectural painter, who exhibited from 1848-98 at the RA, BI, SS, NWS, GG, NG and elsewhere. Painted views and buildings in England, France and Portugal.

Probable price range £30-100.

LEYDE, Otto Theodore RSA RSW 1835-1897
Painter of portraits; engraver. Prussian by birth, he was born in Wehlau; as a youth he came to Edinburgh where he was employed as a lithographic artist; then he devoted himself to painting. Began to exhibit at the RSA in 1859, in London from 1877-88 at the RA and elsewhere. ARSA 1870; RSA 1880. He was a member of the Council of the RSA and Librarian for some years.

Probable price range £50-150

Bibl: AJ 1897, iv (obit); Cat. of Engr. Brit. Portr., BM, 1908-25, VI, 515, 645.

LIDDERDALE, Charles Sillem RBA 1831-1895
London genre painter. Exhib. 1851-93 at RA, BI and SS. Subjects mostly single figures in landscapes, especially pretty farm girls; pictures often of small size. Titles at RA 'A Chelsea Pensioner' 'Threading Granny's Needle' 'Foul Play' etc.

'Peasant Girl Gathering Faggots' sold at Knight, Frank and Rutley, 30.10.69 for £160.

Bibl: AJ 1859, 165; 1868, 278;

LINDNER, Peter Moffat RBA RWS 1852-1949
Landscape and marine painter, working in London and St. Ives. Studied at the Slade and Heatherley's School. Exhibited from 1880 at the RA (from 1881), SS, NWS, GG, NG, NEAC and elsewhere. His paintings are in museums in Barcelona, Bradford, Brighton, Cheltenham, Dublin, Hull, Liverpool (Walker Art Gallery), Oldham and Wellington, NZ. His watercolours – notably these reproduced in the studio – are liquid and atmospheric in their effects, especially those of Venice.

Probable price range £50-150.

Bibl: Studio, 32 (1904, 160, 185-190, (plates); 44, 51, 76; 47, 56, (plate); 59, (plate); 60, 139, 140 (plate) 141; 68, 54-5; 89, 285-6 (plate); Special Summer Number 1900; Special Summer Number 1919; The Athenaeum 1920 II, 185; Who Was Who 1941-50.

LINDSAY, Sir Coutts, Bt. RI 1824-1913
Painter and watercolourist. Exhib. at RA 1862-75, NWS, GG and elsewhere. Titles mostly portraits, or portrait studies e.g. 'The String of Pearls' etc. His most important work was the ceiling of a room in Dorchester House. As an artist, he was not particularly distinguished, but he is best remembered today for his role in the founding of the Grosvenor Gallery in 1878. Throughout the 1880's it was the focus of the aesthetic movement, patronised by Burne-Jones and many avant-garde artists, satirised by du Maurier and Gilbert and Sullivan – "greenery-yallery-Grosvenor-Gallery" etc. His wife Blanche Fitzroy was also a painter and writer, and it was their separation which led to the closing of the Grosvenor in 1890, and the founding of the rival New Gallery Lady Lindsay exhib. from 1876-92 at the NWS, GG, NG and elsewhere.

Probable price range £30-100

Bibl: Who's Who 1912-14; Champlin-Perkins, *Cyclop. of Painters etc.* 1888, III; C.E. Halle, *Notes from a Painter's Life* 1909.

LINDSAY, Lady RI
(Blanche Fitzroy) See under LINDSAY, Sir Coutts.

LINDSAY, Thomas RI 1793-1861
Landscape painter in watercolour, whose speciality was Welsh scenery. Born in London, he worked first at Bow Road, Mile End, then at Greenwich, and finally settled at Cusop, Hay, nr. Brecon. He was one of the earliest members of the NWS, and from 1833-61 exhibited 347 works there; also exhibited at SS. In his obituary, the AJ commented: "His pictures, the majority of which were representations of Welsh scenery, were pleasing, but not of a high character; his colouring was feeble and unimpressive, and his manipulation wanted firmness; he belonged, in fact, to a school of art which had passed away".

Probable price range £30-70

Bibl: AJ 1859, 175; 1861, 76 (obit.); Redgrave, Dict.; VAM.

LINES, Henry Harris 1801-1889
Birmingham landscape and architectural painter, eldest son of Samuel Lines, also a painter. Exhib. at RA 1818-46, BI, SS and at Birmingham Society of Artists, of which he was a member (RBSA). Awarded Silver Medal at SS. Subjects mostly Warwickshire landscapes, and views on the Welsh borders. About 1830 settled near Worcester, as a teacher. Several works by him are in the Birmingham AG.

'A Hilly Wooded Landscape' sold at Christie's 14.3.69 for £189.

Bibl: Cat. of NG of British Art, VAM II; Birmingham Cat.

LINNELL, James Thomas fl.1850-1888 d.1905
Landscape painter, second son of John Linnell (q.v.). Lived in London, later at Redhill, Surrey. Exhib. at RA 1850-88. Subjects mainly landscapes with farm-workers, or children. His style is similar to his father's, but usually more brightly-coloured and broader. Works by him are in Rochdale, Manchester and Sheffield AG. In the 1850's he painted some religious subjects, but after this devoted himself entirely to landscape.

'Sunny Hours' sold at Sotheby's 16.10.68 for £400.

Bibl: AJ 1872, p.250 f; H. Blackburn, *Academy Notes,* 1877; Clement and Hutton.

*LINNELL, John 1792-1882
Landscape painter. Son of James Linnell, a carver and gilder. Pupil of John Varley, together with William Hunt and Mulready (q.v.). Under the patronage of Benjamin West, entered RA schools 1805. At first painted portraits and watercolours. Member of OWS from 1810 till 1820, when he resigned in order to concentrate on landscape painting. Exhib. at RA 1807-82, BI and OWS. Lived in Hampstead; then Porchester Terrace; in 1852 retired to Redhill, Surrey, where he lived surrounded by his large family for the rest of his life. Linnell was a friend and patron of Blake, and also father-in-law of Samuel Palmer (q.v.). He was strongly religious, and his landscapes are imbued with a feeling of the grandeur of nature. His subjects were mostly of country life in Surrey, painted in a distinctive brown tone, with masses of fleecy white clouds. Among his best known works are 'The Last Gleam before the Storm' 'The Timber Waggon' and 'Barley Harvest'. Linnell was proposed as an ARA, but withdrew his name, and would never consent to submitting it again. Three of his sons, John (Junior), James Thomas, and William (q.v.), were painters.

Most of Linnell's pictures and drawings sell in the range between £200 and £800. Exceptionally fine pictures or drawings, however, have made up to £2,000.

Bibl: AJ 1850, 230; 1851, 272; 1859, 105 ff; 1862, 216; 1865, 208; 1882, 261-4, 293-6, (F.G. Stephens); 1883. 37-40; 1892, 301-5; 1893, 43; Portfolio 1872, 45-8; 1882, 61; 1883, 41; Smith, *Recollections of the British Institution,*

1860; Redgrave, Cent.; A.T. Story, *The Life of J.L.* 1892; Roget; Bryan, Binyon; Cundall; VAM; Hughes; DNB XXXIII: Studio, *Early Eng. Watercolours by the Great Masters,* 1919, 43-4; OWS Annual 1924-5; Reynolds VP 16 (pls. 13-15); Hardie II 156-7 (pls. 156-8); Maas 42-4 (Pls. 42-3).

LINNELL, Thomas G. fl.1864-1884

Landscape painter, presumably related to the Linnell family, as he also lived at Redhill. Exhib. at RA 1865-84. Titles 'The Old Oak' 'Summer Foliage' 'The Bridle Path' etc.

'The Old Road' sold at Christie's 14.11.69 for £273.

LINNELL, William b.1826 fl.1851-1891 d.c.1910.

Landscape and rustic genre painter, eldest son of John Linnell (q.v.). Exhib. at RA 1851-91. Subjects rustic landscapes in similar vein to his father's — eg. 'Summer Crops' 'Through the Barley' 'Return from Labour' etc. Visited Italy, and painted some Italian genre scenes. William Linnell did not marry, and lived near his father's house at Redhill, Surrey. Works by him are in Sheffield, Manchester, and Salford AG. After his death his collection of pictures was sold at Christie's on May 27, 1910.

'View Across a Valley' sold at Sotheby's 2.4.69, for £180.

Bibl: H. Blackburn, Academy Notes, 1875, p.31; 1877; Clement and Hutton.

LINTON, Sir James Dromgole PRI HRSW 1840-1916

Painter of figure subjects in watercolour; portraits and historical pictures in oil; lithographer. Pupil at J.M. Leigh's Art School, and exhibited from 1863 onwards, at the RA (from 1865), SS, NWS (104 works), GG, NG, Dudley Gallery and elsewhere. In his early years he made many drawings for *The Graphic;* became an Associate of the NWS in 1867; RI 1870; PRI 1884-98, 1909-16; knighted in 1885. Hardie writes: "In his work he was a little laboured and heavy handed, following Cattermole in a dull and encyclopaedic fashion, but without any of Cattermole's 'curiosa felicitas'. He painted figure subjects and liked colour in costume and rich stuffs, but the costume was fancy dress". His studio sale was held at Christie's on Jan. 19, 1917.

'Music that Gentler on the Spirit Lies, than Tire'd Eyelids upon Tir'd Eyes' — a watercolour — sold at Christie's 5.2.65 for £60.

Bibl: AJ 1891, 57-62; 1904, 192; 1905, 191; The Studio 38, (1906) 16; 60 (1914) 141; Vol. 69, 67; Special Number, *Art in 1898;* Special Summer Number, 1900; The Portfolio 1885, 43; 1893, 224-31; Chesneau, *Artistes Anglais Contemp.,* Paris, 1887; Roget; Connoisseur, 36 (1913), 108; 39, (1914), 81 (plate), 84; 42 (1915), 59, 251; (1916) 59; (1917), 54 f: VAM; Hardie. III, 82, 96.

LINTON, William RBA 1791-1876

Landscape painter. Born in Liverpool, where at the age of sixteen he was placed in a merchant's office. He painted landscapes in the Lake District and copied pictures by Richard Wilson, and eventually made art his profession and settled in London. He took an active part in founding the SBA in 1824. Exhibited from 1817-71, at the RA (1817-59), BI, SS (101 works), OWS, and NWS. Early in his career his subjects were taken from scenery in England, especially that in the vicinity of the lakes; but later he turned to classical landscapes — and it was here that he made his reputation. Many are treated ideally, eg. 'Embarkation of the Greeks for the Trojan War', 'Venus and Aeneas', many literally, eg. 'The Temple of Jupiter, Athens', 'Temple of Paestum'; some also are of scenery in Italy, Sicily and Calabria. In 1853 he published *Ancient and Modern Colours, from the Earliest Periods to the Present Time, with their Chemical and Artistical Properties;* and in 1857 *Scenery of Greece and its Islands,* illustrated by fifty engravings. After his retirement in 1865, a sale of his works was held at Christie's on April 28, 1865.

'Views of Sicily' — a pair — sold at Sotheby's 20.11.68 for £220.

Bibl: AJ, 1850, 252; 1858, 9-11; 1876, 329-30 (obit); Redgrave, Dict.; Binyon; Cundall; DNB; Connoisseur 68 (1924); VAM;

LITTLE, Robert W. RWS RSW 1854/5-1944

Scottish painter of landscape and genre, interiors and flowers, closely related to the Glasgow School in the decorative quality of his work. Also a lithographer. Born in Greenock, son of a shipowner; educated at Glasgow University. Studied at the RSA Schools from 1876-1881, worked at the British Academy in Rome, and under Dagnan-Bouveret in Paris (1886). He was elected RSW in 1886; A of the RWS in 1892; RWS 1899, Vice-President in 1913, hon. retired member in 1933. He exhibited from 1885 at the RA, OWS, GG and elsewhere from 1885, and settled in London in 1890. He painted both in oil and watercolour, and his work presents considerable variety; at first studies of interiors and groups of flowers, then Italian subjects — hill towns in Italy, domestic genre with titles like 'Renunciation' and 'Yours Faithfully', and latterly, landscapes. Caw notes that his work is "marked by a certain romanticism of sentiment and by a pleasing mingling of decorative quality and of classic balance and restraint in design".

Probable price range £50-200.

Bibl: Studio 23 (1901) 48; 41 (1907) 172-180; 55 (1912), 189, 190 (pls); Summer No. 1900; Winter No. 1917-18, pl. X 28; M.B. Huish, *British Watercolour Art* 1904; Caw 387-8; Hardie III 194.

LLEWELLYN, Sir William H. Samuel PRA RBA 1858-1941

Painter of portraits and landscape. Born in Cirencester, Gloucestershire. Studied under Poynter at the RCA, and in Paris under J. Lefebvre and G. Ferrier. Exhibited from 1884 at the RA, and also at SS, NWS, GG, NG and elsewhere. Member of NEAC, 1887-9; RBA RP. Painted the State portrait of Queen Mary, 1910. ARA 1912, RA 1920, PRA 1928-38; KCVO 1918; GCVO 1931.

Probable price range £100-300

Bibl: AJ 1906, 181; Studio Vol. 39, 150; Vol. 41, 52; Vol. 42, 131; RA Pictures 1891, 59; 1893, 30; 1894, 115; 1895, 8; 1896, 147; R.L. Poole, *Cat. of Portraits in Oxford University,* III, 1925; Who's Who 1927; Tate Cat.: Hutchison.

LLOYD, R.Malcolm fl.1879-1899

Painter of landscape and coastal scenes, living at Catford Bridge and in London, who exhibited from 1879-99, at the RA, (1881-99), SS, NWS and elsewhere. Titles at the RA include 'Coast of Cornwall' and 'A Squally Evening'.

Probable price range £20-50.

LLOYD, Thomas James RWS 1849-1910

Painter, principally of landscape, but also of genre and marine subjects. Living in London, Walmer Beach and Yapton, Sussex. Exhib. from 1870 at the RA, (1871-1910), SS, OWS (83 works), and elsewhere. AJ, 1877. August — "In 'Pastoral' (RA 1877) the lighting up of the hill beyond is remarkably like nature, and 'Nearly Home' is very faithful to rural circumstances, as well as natural fact. . . . This artist is making rapid strides, and bids fair to become one of our great landscape-painters".

Probable price range £30-70.

Bibl: AJ, 1877, August; Clement and Hutton; Wilson, Marine Painters.

LLOYD, W. Stuart RBA fl.1875-1902

Landscape and marine painter, who exhibited from 1875-1902 at the RA, SS (117 works), NWS, GG and elsewhere, titles at the RA including 'Autumn Morning', and 'Salmon Fishing: Christchurch Bay'.

'View in Oxfordshire' sold at Bonham's 9.10.69 for £150.

Bibl: RA Pictures, 1893, 1894.

*LOBLEY, James 1829-1888

Little-known Brighton painter of domestic genre. Exhib. at RA 1865-

87, SS and elsewhere. Although he painted a few pictures in detailed Pre-Raphaelite style, the majority of Lobley's works are humorous genre in the manner of Thomas Webster and F.D. Hardy. As Lobley lived in Brighton, it is possible that he knew and was influenced by Webster and other artists of the Cranbrook Colony in Kent. Most of his subjects are scenes in church e.g. 'Little Nell Leaving the Church'. 'I Believe' 'A Village Choir' etc.

'A Village Choir' sold at Bonham's 13.2.69 for £310.

Bibl: Reynolds VS 86 (pl.68); Birmingham Cat.

LOCKHART, William Ewart RSA ARWS RSW 1846-1900

Painter of genre, landscapes, Spanish subjects, Scottish historical subjects and portraits. Born at Eglesfield, Annan, Dumfriesshire, his father a small farmer, who sent him at the age of fifteen to study art in Edinburgh, under J.B. Macdonald, RSA. In 1863 he was sent to Australia for his health. On his return he settled in Edinburgh, and in 1867, much stimulated by the influence of John Phillip's latest pictures, made the first of his journeys to Spain. Here he found material for some of his best works, subjects such as the 'Muleteer's Departure' 1871, 'Orange Harvest, Majorca' 1876, the 'Swine Herd' 1885, and the 'Church Lottery in Spain' 1886, which are marked by much bravura of execution and brilliance of colour. He also found subjects in the literature and romantic history of Spain, illustrating several incidents in *Don Quixote* and *Gil Blas* and the story of the Cid. Episodes in Scottish history were another source of inspiration. In 1871 he was elected ARSA, and in 1878 RSA; 1878 ARWS, and for some years RSW. He exhibited from 1873-99 at the RA, OWS and GG. In 1887 he was commissioned by Queen Victoria to record on a large canvas 'The Jubilee Ceremony at Westminster Abbey' (Windsor Castle), and after this he remained in London and devoted himself principally to portraiture. Hardie notes that although he was successful in oil painting, his work in watercolour was more subtle and distinguished: ". . . . it shows genuine feeling for open-air effects, a good pictorial sense, expressive drawing, both in landscape and figures, and an informal, breezy directness which connects him with Sam Bough".

Probable price range £100-300

Bibl: Portfolio 1878, 84, 132, 148, 164, 190; 1883, 226; 1887, 228; RA Pictures 1891-6; Bryan; Caw 264-6; Cundall; Hardie III 174, 190.

LODER, James fl.1820-1857

Sporting painter, known as 'Loder of Bath'. Did not exhibit in London, but was well known in his day as a local painter of horses and sporting groups. Some of his pictures were aquatinted by G. Hunt.

'A Saddled Bay Horse with a Groom' sold at Christie's 25.4.69 for £998.

Bibl: Pavière Sporting Painters, 59 (pl.27).

*LOGSDAIL, William b.1859 fl.1877-1903

Landscape and genre painter. Born in Lincoln, where he studied at the Art School under E.R. Taylor. Also studied in Antwerp, together with his friend, Frank Bramley (q.v.)., who was also from Lincoln. Exhib. at RA from 1877, SS, GG, NG and elsewhere. Although not a member of the Newlyn School, his *plein-air* style and rustic subjects show that he was influenced by their ideas. Logsdail achieved his greatest success with his large, realistic London scenes, such as 'The Ninth of November – Lord Mayor's Day' and 'St. Martins in the Fields 1888' (bought by the Chantrey Bequest for £600). He also painted similar panoramas in Venice, and landscapes in France and Italy.

'In the Villa Borghese' sold at Christie's 21.1.66 for £252.

Bibl: AJ 1892, p.321 ff; 1903, 95;

LOMAX, John Arthur RBA 1857-1923

Genre painter. Born in Manchester. Studied in Munich Academy. Exhib. mainly at SS, also at RA from 1880. Subjects mostly historical genre of the 17th and 18th century, especially of the Civil War period, often with a dramatic or sentimental theme. Titles at the RA 'Thoughts of Christmas' 'An Old Master' 'A Flaw in the Title' etc.

'Old Friends Well Worn' sold at Sotheby's 4.6.69 for £340.

Bibl: AJ 1903, p.27 ff; RA Pictures 1892-96; Reynolds VP 179;

*LONG, Edwin RA 1829-1891

Painter of portraits, historical and biblical genre. Born in Bath. Pupil of John Phillip (q.v.). At first Long painted Spanish subjects in the manner of his teacher Phillip, but achieved fame and fortune with large biblical and historical pictures, especially of Egyptian subjects. His style, which derives from Alma-Tadema, is similar to that of Edward Armitage (q.v.). In 1875 his large work 'The Babylonian Marriage Market' created a sensation at the RA and was sold for 7000 guineas. In 1882 it was sold at Christie's for 6300 guineas, the Victorian sale-room record for the work of any living English artist. This and Long's flair for choosing popular subjects enabled him to charge very high prices for his pictures. Exhib. at RA 1855-91, BI and SS. Elected ARA 1875 RA 1881. After his death, Long's reputation did not last, and his works find little favour today. A large group of his works are in the Russell-Cotes Museum, Bournemouth.

'The Favourite' sold at Parke-Bernet 25.11.69 for £510.

Bibl: AJ 1891, p.222 (obit); 1908, 175 f; 1911, p.88; DNB XXXIV (1893); L. Cust. *NPG* II (1902); Bryan; Richard Quick, *The Life and Works of E.L.* 1931 repr. 1970; P.H. Ditchfield, *The City Companies of London* 1904, p.292; G. Reitlinger, *The Economics of Taste,* 1961, p.159-60, (pl. opp. p.149); Maas 184 (pl. p.184).

LONG, John O. RSW fl.1868-1882

Landscape painter, working in London, who exhibited from 1868-82, at the RA (from 1872-82), SS and elsewhere, titles at the RA including 'Crofters' Homes in the Hebrides', and 'Tarbert, Loch Fyne'.

Probable price range £30-70

LONG, William fl.1821-1855

London painter of historical subjects, genre and portraits, who exhib. from 1821-55 at the RA, BI and SS, titles at the RA including 'The Vision of Joseph', 'Orpheus and Eurydice', and 'A Domestic Scene in the Park at Sunset'.

Probable price range £20-50

Bibl: Binyon.

LONSDALE, R.T. fl.1826-1849

Painter of landscape, portraits, genre and historical subjects. Son of James Lonsdale, 1777-1839, portrait painter. Exhibited from 1826-49, at the RA (1826-46), BI, SS, titles at the RA including 'The Curiosity Shop' and 'A Visit from the Nurse'.

Probable price range £30-70

LORIMER, John Henry RSA RSW 1856-1936

Painter of portraits and contemporary genre, particularly the 'more refined and cultured side of modern society' (Caw). Born in Edinburgh, son of Professor James Lorimer, LLD, and brother of the architect Sir Robert Lorimer; studied at the RSA under McTaggart and Chalmers, and in Paris under Carolus Duran (1884). Travelled in Spain 1877, Italy, 1882, and Algiers 1891. Exhib. at the RSA from 1873 and at the RA from 1878. ARSA, 1882; RSA 1900; RPE; ARWS. In his early years he concentrated on portraiture, and flower painting and on the study of tone; later he won distinction as a painter of con-

temporary genre — mainly scenes of Scottish middle-class home life, eg. 'Winding Wool', 1890, 'Grandmother's Birthday — Saying Grace', 1893, and 'The Flight of the Swallows' 1907. 'The Ordination of the Elders in a Scottish Kirk', 1891, was a scene in a country kirk and Caw calls it "one of the most national pictures ever painted". He was always much concerned with the effects of light, and his interiors especially, both in oils and watercolours are luminous and transparent. His work was popular in France and in exhibitions abroad came to be associated with the members of the Glasgow School — Sir James Guthrie, Sir John Lavery, Joseph Crawhall etc.

Probable price range £100-300.

Bibl: AJ 1893, 308; 1895, 321-4; 1908, 127; Studio, vol. 34, 270; vol. 68, 125; Portfolio, 1893, 104, 118, 153; The Artist 1899, 113 ff; Caw 346, 362, 420-3, 450, 481; (plate opp. p.422); A. Dayot, *La Peinture Anglaise*, 1908, 275, 281 ff with plates); Who's Who, 1924; Tate Cat; Hardie III 209 (pl. 243).

LOUDAN, William Mouat **1868-1925**
Portrait and genre painter. Born in London, of Scottish parentage. Educated at Dulwich College. Studied at the RA Schools, where he won the gold medal, and finally the travelling studentship. Studied also in Paris, under Bouguereau. Exhibited from 1880 at the RA, SS, GG, NG and elsewhere. Member of the Art Workers' Guild, and the N. Portrait Society. 'The Red Cloak' is in Birmingham Art Gallery; in his later years he devoted himself almost entirely to portraiture.

'Mischievous Pupils' sold at Sotheby's 1.10.69 for £110.

Bibl: Who Was Who 1916-1928.

LOUND, Thomas **1802-1861**
Norwich landscape painter, both in oil and watercolour; engraver. Born to a brewer's business; studied under J.S. Cotman, and became known as a successful landscape painter. He was never a member of the Norwich Society, but exhibited at Norwich from his eighteenth year until 1833, and in London from 1846-57, at the RA (1846-55) and BI. Clifford notes that he was an eclectic, there being considerable variety in his work, it often appearing like Cotman, Bright or Cox (by whom he was much influenced). After Cotman and Bright he was the most prolific watercolourist of the Norwich School.

'The Three Trees' sold at Sotheby's 12.3.69 for £260.

Bibl: Redgrave, Dict; Cundall; DNB; Dickes, *The Norwich School of Painting*, 575-83 (plates); Studio, Special Number, *'Norwich School'*, 1920, p.LXXVIII, f; Clifford, 48-9, 52, 61, 72, 75, 77, (plates 60a-62a); Hardie II 62, 70, -(pl.61); H.A.E. Day *East Anglian Painters* 1969 III 71-90.

LOW, Charles **fl.1870-1902**
Landscape painter, living in Hungerford and Witley, Surrey, who exhibited from 1870-1902, at the RA (1885-1902), SS and NWS, titles at the RA including 'Cinerarias' and 'A Farmyard Corner'.

Probable price range £30-70.

***LOWCOCK, Charles Frederick** **fl.1878-1904**
Genre painter. Exhib. at RA 1878-1904, SS and elsewhere. Titles at RA 'In the Temple' 'The Lost Chord' 'A Love Letter' etc.

Probable price range £50-150, although Victorian interiors such as the one illustrated would be worth more.

LUCAS, Albert Durer **b.1828 fl.1859-1910**
Flower painter; son of the sculptor Richard Cockle Lucas. Exhib. in London 1859-78 at BI, SS and elsewhere. Painted small, detailed studies of flowers and foliage, sometimes with butterflies and other insects. In 1910 he caused a sensation by revealing that his father, Richard Cockle Lucas, the sculptor, was the real author of a bust of Flora which had recently been bought by the Berlin Museum as a Leonardo.

'Wild Flowers' sold at Parke Bernet 14.5.69 for £115.

Bibl: Burlington Mag. XVII (1910) 178, 181.

LUCAS, E.G. Handel **fl.1875-1899**
Croydon painter of landscape and genre, who exhibited from 1875-99, at the RA (from 1879-99), SS, GG and elsewhere. Titles at the RA include 'Roses from the Vicarage', 'Poverty's Home', and 'Veterans, Having Done their Duty'.

Probable price range £30-70.

LUCAS, George **fl.1863-1899**
Landscape painter who exhibited from 1863-99, at the RA (1871-99), SS, NW, GG, and elsewhere. In Bristol Art Gallery is 'A Surrey Corn-field'.

'Fair Waves the Golden Corn' sold at Sotheby's 22.1.69 for £120.

LUCAS, John **1807-1874**
London portrait painter and engraver. At first studied mezzotint engraving under S.W. Reynolds. Exhib. at RA 1828-74, BI and SS. Lucas built up an enormously successful practice as a fashionable portrait painter. Among his sitters were the Prince Consort and the Duke of Wellington. Most of Lucas's works are large, similar in style to Richard Buckner (q.v.), and are still mostly in possession of the families for whom they were painted. A full list of Lucas's sitters is in his biography by his son Arthur Lucas (see bibl.). His studio sale was held at Christie's on Feb. 25, 1875.

Probable price range £100-500.

Bibl: AJ 1874 p.212 (obit); Redgrave, Dict; DNB XXXIV; Arthur Lucas, *J.L. Portrait Painter*, 1910; Cat. of Engraved Brit. Portr. BM VI (1925) p.516, 647.

***LUCAS, John Seymour** **RA RI** **1849-1923**
London genre painter, nephew of John Lucas (q.v.). Exhib. 1867-93 at RA, SS, NWS and elsewhere. Subjects mostly genre scenes set in seventeenth or eighteenth century costume, or episodes in English history. His wife Marie (d.1921) was also a painter of portraits and genre, exhib. at RA, SS and elsewhere. In addition to his genre work, Lucas also painted portraits.

'Drawing the Longbow' sold at Christie's 13.10.67 for £273.

Bibl: AJ 1887, p.65-69; 1905, 170; 1908, 107 f, 338; Christmas Number 1908, 1-32 (with 60 illustrations); Connoisseur 62 (1922)49 (obit. Marie); 66 (1923) 114 f (obit. J.S.L.); Who's Who 1913, 1924; Cat. of Engraved Brit. Portraits, BM VI (1925) 516; Maas 240 (pl. on p.243).

LUCAS, John Templeton **1836-1880**
Landscape and genre painter. Son of John Lucas, portrait painter, 1807-74, (q.v.). Exhibited from 1859-76, at the RA (1861-75), BI, SS and elsewhere, titles at the RA including 'The Spinning Wheel, N. Wales', and 'The Fairy at Home'. York Art Gallery has 'Not Sold Yet'. He also published a farce, *Browne the Martyr*, which was performed at the Royal Court Theatre, and a little volume of fairy tales, *Prince Ubbely Bubble's New Story Book, 1871*.

'An Itinerant Actor and his Family' sold at Sotheby's 12.3.69 for £240.

Bibl: DNB

LUCAS, Ralph W. **fl.1821-1852**
Painter of landscape, portraits, and occasionally genre, working in Greenwich and Blackheath, who exhibited from 1821-52 at the RA, BI, SS and NWS RA titles 'View of Canterbury' 'Landscape — Evening' 'Sunset' etc. and views in Wales and Scotland.

Probable price range £30-70.

LUCAS, William 1840-1895
Watercolour painter of portraits and figure subjects, who exhibited from 1856-80, at the RA (1856-74), BI, SS, NWS (100 works), and elsewhere. Early in his career, he showed great promise, was elected an associate of the "New" Society in 1864, but resigned in 1882 when it moved to the Piccadilly Institute. However his career was marred by an early physical breakdown; and for many years he practised lithography. The AJ notes that his father was the well-known portrait painter, his cousin the ARA, and his brother the Art publisher.

Probable price range £30-70.

Bibl: AJ 1895, 191 (obit); The Year's Art 1904, 114; Cundall.

LUCY, Charles 1814-1873
Painter of historical subjects, and portraits. Born in Hereford; studied at the Ecole des Beaux Arts under Paul Delaroche; returned to London and studied at the RA Schools. He settled at Barbizon, near Fontaine-bleau, where he stayed for about 16 years, painting large historical pictures from English, and especially Puritan, history. Exhibited from 1834-73, at the RA, (from 1838-73), BI, SS, NWS and elsewhere. He won prizes at the Westminster Hall competitions in 1844, 1845, and 1847. Many of his works were purchased for public institutions in America. He was commissioned by Sir Joshua Walmesley to paint a series of portraits of eminent men, including Oliver Cromwell, Nelson, Bright, Cobden, Gladstone etc., and these were bequeathed to the V & A.

Probable price range £100-300.

Bibl: AJ, 1873, 208 (obit); Redgrave, Dict; Clement and Hutton; Bryan; Binyon; DNB.

LUDBY, Max RI RBA 1858-1943
Cookham painter of landscape and genre; engraver. Studied from 1882-84 in Antwerp; exhibited from 1879 at the RA, SS, NWS, GG and elsewhere; exhibited From 'Oxford to Greenwich', a series of 82 watercolours at Dowdeswells, 1893, and 'Some Sketches of Venice', a series of 60 watercolours at Dickinson and Fosters, 1897. Some of his noted paintings were 'A Berkshire Common', RA 1888, 'One of the Flock', RI, 1891, and 'An Old Shepherd', RI, 1893, RI in 1891.

Probable price range £30-70.

Bibl: Who Was Who, 1941-50.

LUDOVICI, Albert RBA 1820-1894
Genre painter. Exhib. mainly at SS (224 works) also at RA 1854-89, BI, NWS, GG and elsewhere. Father of Albert Ludovici, Junior (q.v.) and like him, lived mainly in Paris. Titles at RA 'An American Jewess' 'Lorelei' 'A Bit from Normandy' etc.

'The Reception' sold at Christie's 10.6.66 for £273.

LUDOVICI, Albert, Junior RBA fl.1870-1923
Genre painter; son of Albert Ludovici (q.v.). Exhib. mainly at SS (147 works) also at RA 1880-97, NWS, GG and elsewhere. Ludovici fell under the spell of Whistler while the latter was President of the RBA. His pictures show Whistler's influence, particularly his London scenes, which are painted in a delicately Impressionistic style. Like his father, Ludovici lived mostly in Paris, and his pictures of London life do reflect something of the Parisian boulevard gaiety of the period. Titles at the RA 'Dreamland' 'A Victim of Fashion' 'The Park' 'The Grey Lady' etc. Ludovici was also a member of the International Society of Painters, Sculptors and Engravers.

'Hyde Park Corner' sold at Christie's 21.11.69 for £126.

Bibl: Studio Vol. 35, 238; Vol. 36, 350 ff; Vol. 63, 140; Vol. 68, 54; NPG Illustrated List 1928.

LUKER, William fl.1851-1889
Painter of portraits, genre, animals and landscape, working in London and Faringdon, who exhibited from 1851-89, at the RA (1852-89), BI, SS (127 works), and elsewhere. Titles at the RA include 'Deer-stalkers, Portraits of a Gentleman, his Son and Attendants, with Favourite Pony and Deer Hound.' 1851.

'A Bay Hunter' sold at Sotheby's 19.11.69 for £200.

LUKER, William, Junior b.1867, fl.1886-1892
Painter of genre, portraits, and landscape; illustrator. Son of William Luker (q.v.). Exhibited from 1886-92 at the RA, SS, NW and elsewhere, titles at the RA including 'Pleading Guilty' and 'A Rest in the Wood'.

Probable price range £30-70.

LUMLEY, Augustus Savile fl.1856-80
London genre and portrait painter. Exhib. at RA 1856-80, BI and SS. Exhibited works mostly portraits; occasional genre scenes e.g. 'Le Rendezvous' etc.

Probable price range £30-70.

LUPTON, Nevil Oliver fl.1851-1877
Painter of landscape and genre. Youngest son of Thomas Goff Lupton, engraver and miniature painter, (1791-1873). Exhibited from 1851-77 at the RA, BI, SS, Portland Gallery and elsewhere, the majority silvan landscapes and rustic genre, e.g. at the RA, 'A Favourite Walk of the Poet Coleridge at Highgate'. The AJ says of "Brewhurst Mill, Sussex', BI 1860, "Foliage is the principal feature here, and it is painted with a view to the identity of the different trees that are brought into the essay."

Probable price range £30-100.

Bibl: AJ, 1859, 121-2, 163; 1860, 79; Binyon; Cat. York Art Gallery, 1907

LUTYENS, Charles Augustus Henry fl.1862-1903
London painter of portraits, animals and hunting scenes. Exhib. at RA 1861-1903, BI, SS, and GG. Titles 'Hog Hunting' 'Doncaster-Derby Winner 1873' 'Major Browne and Northumberland Hounds' etc.

Probable price range £100-300.

LUSCOMBE, Henry A. b.1820 fl.1845-1865
Plymouth marine painter and watercolourist. Exhib. at RA 1845-65. Subjects mainly shipping scenes around Plymouth, or modern naval incidents. Luscombe was one of the first artists to paint steam warships, and to record the events of Victorian naval history.

Probable price range £100-200.

Bibl: G. Pycroft, *Art in Devonshire*, 1883, p.89; Wilson, Marine Painters, 52 (plate 22).

LYNDON, Herbert fl.1879-1898
London landscape painter, who exhibited from 1879-98 at the RA, BI, NWS, GG, and elsewhere, titles at the RA including 'On the Wye', 'In the Birch Wood' and 'Harbingers of Weather'.

Probable price range £30-70.

MACALLUM, Hamilton RI RSW 1841-1896

Scottish painter of coastal and fishing scenes. Studied RA Schools. Exhib. at RA 1869-96, SS, NWS, GG, NG and elsewhere. Like Colin Hunter (q.v.). he found most of his subjects on the west coast of Scotland. He also travelled in Italy. His pictures are usually sunny and cheerful, and the figures slightly sentimental. As a painter of the sea, Macallum achieved technical mastery, but his works have an emotional superficiality which prevented him from achieving the first rank.

'Better Small Fish than None' sold Christie's 18.10.68 for £136.

Bibl: AJ 1880, p.149 ff; Portfolio 1870 p.150; 1887, 211; 1890, 184; Bryan; Caw 327-9 (pl. opp. p.326).

MacARTHUR, Miss Blanche F fl.1870-1888

London genre painter. Exhib. at RA 1870-83, but more regularly at SS and elsewhere. Titles at RA 'The Spinner's Daydream' 'Footsteps' 'Shy', etc.

Probable price range £20-50

MACARTNEY, Carlile Henry Hayes 1842-1924

London landscape painter. Exhib. at RA 1874-97, and occasionally elsewhere. Titles at RA 'Kew Bridge' 'A Track over the Moor' 'In the Yorkshire Dales' etc. Painted in Devon and Cornwall; also travelled in France and Italy. Occasionally painted portraits.

Probable price range £20-50

MACAULAY, Miss Kate RSW fl.1872-1884

Scottish painter of coastal scenes. Exhib. at SS, RA 1881-3, and elsewhere. Lived in Wales. Titles at RA 'Scotch Herring Trawlers' 'A Sea Cliff' 'A Corner of the Quay' etc.

Probable price range £20-50

MACBETH, James 1847-1891

London landscape painter. Exhib. at RA 1872-84, SS, NWS, GG and elsewhere. Painted mostly around London, and in the Scottish Highlands.

Probable price range £20-50

Bibl: Clement and Hutton

MACBETH, Norman RSA 1821-1888

Scottish portrait painter. Studied engraving in Glasgow; later studied at RA Schools and in Paris. Worked in his native Greenock, then Glasgow, and after 1861 in Edinburgh. Exhib. at RA 1837-86, but enjoyed a more lucrative practice in Scotland. Although prolific and competent, his work is mostly "conventional and completely undistinguished". (Caw).

Probable price range £30-70

Bibl: Portfolio 1886, p.25; 1887, 233; Clement and Hutton; Caw 176, 178; DNB.

MACBETH, Robert Walker ARA RI RPE 1848-1910

Painter of pastoral landscape and rustic genre. Son of Norman Macbeth (q.v.). Studied in London, and worked for *The Graphic*. Influenced by

G.H. Mason (q.v.)., and Frederick Walker (q.v.). Exhib. at RA from 1871, OWS, GG, NG and elsewhere. Elected ARA 1883. Macbeth's realistic scenes of country life, which he painted mostly in Lincolnshire or Somerset, are compared by Caw to the novels of Thomas Hardy. He was also an accomplished watercolourist and etcher.

'Dog Days' sold at Sotheby's 4.6.69 for £190.

Bibl: AJ 1883, p.296; 1893, 28; 1897, 324; 1900, 289-92, 1908, 12; Portfolio 1881, p.21; 1883, 64; 1884, 224; 1887, 233; Wedmore, *Etching in England*, 1895, p.152; ff; Studio, Special No. 1917, *Graphic Arts of Great Britain*; p.123, 132; Caw 277-9; VAM Supp; Hardie III 190.

***MacCULLOCH, Horatio RSA 1805-1867**

Scottish landscape painter. Born in Glasgow. Studied under John Knox with Macnee and W.L. Leitch (q.v.). Elected ARSA 1834, RSA 1838, after which he settled in Edinburgh. Exhibited mostly at RSA; showed only two pictures at RA in 1843. His preference for grand Highland subjects reflects the influence of John Thomson of Duddingston, but his detailed technique is more akin to the Dutch seventeenth century style. MacCulloch's work was very popular, and influenced a whole generation of Scottish landscape painters, such as John Fleming, Arthur Perigal, and J. Milne Donald (q.v.). Although an important figure in Scottish painting, his technique and colours were often unable to match the grandeur of his subjects. One of his pupils was Edmund Hargitt (q.v.).

'A Mill near Glenfinlas' sold at Christie's 2.4.69 for £336.

Bibl: AU 1847, p.380; AJ 1867, p.187 f (obit); Portfolio 1887, p.135 f; 207; Redgrave, Dict.; A. Fraser, *Scottish Landscape, The Works of H.M.* 1872; Caw 143-5 and index (pl. opp. 144); DNB; Cundall; Hardie III 187-8 (pl.213).

MacCULLOCH, James RBA RSW fl.1872-1893

Landscape painter. Exhib. in London 1872-93 mostly at SS, also RA and NWS. Mostly Highland subjects eg. 'River Ewe, Ross-shire' 'Loch Alsh from the Isle of Skye'.

Probable price range £30-100

MacDONALD, John Blake RSA 1829-1901

Scottish historical genre and landscape painter. exhib. at RA 1866-76, but more often at RSA. His historical subjects were mostly from the Jacobite period. In later life gave up figure painting for landscape. Elected ARSA 1862, RSA 1877. MacDonald's work was of a conventional type, and he used the dark colours and chiaroscuro effects of Lauder and his pupils.

Probable price range £50-100

Bibl: Bryan; Caw 262, 264.

MacDUFF, William fl.1844-1876

London genre painter. Exhib. at RA 1844-66, BI and SS. Titles at RA 'The Doubtful Purchaser' 'A Country Auction' 'Rest by the Wayside' etc. His best-known picture is 'Shaftesbury, or Lost and Found' (RA 1863) which was in the Arts Council Exhibition of Victorian Paintings. 1962 No.42.

Probable price range £100-300

Bibl: Reynolds VS 84 (pl.63); Victorian Paintings, Arts Council Exhibition, 1962.

MacFARREN, I.J. fl.1839-1846

Landscape painter. Exhib. mainly at SS, also at RA 1840-46 and BI. Titles at RA English landscapes, also Italian views and genre, eg. 'Casa Nassini, near Lodi' and 'Il Doppomezzogiorno'.

Probable price range £20-50

MacGREGOR, Miss Jessie fl.1872-1904 d.1919
Liverpool genre and historical painter. Moved to London c.1879. Exhib. at RA 1872-1904, and occasionally elsewhere. Titles at RA 'The Gardener's Daughter' 'The Wail of the Valkyrs' 'King Edward the Sixth' 'The Nun' etc. and some portraits.

Probable price range £30-70

Bibl: Academy Notes 1879-82
Cat. of Perm. Col. Walker AG Liverpool 1927 p.123.

MacGREGOR, William York RSA RSW 1855-1923
Scottish landscape painter. Son of a Glasgow shipbuilder. Studied under James Docharty, and later under Legros at the Slade School. At first his landscapes were of a conventional type, but under the influence of his friend James Paterson (q.v.), who had studied in Paris, he began to develop a broader, more robust style. His ideas were quickly taken up by other young Glasgow artists, and for this reason MacGregor is traditionally regarded as the father of the Glasgow School. From 1888-90 he went to South Africa because of ill-health. After his return, his style again changed, tending towards sombre colours, and an almost abstract concern for solid form. He exhib. mainly in Scotland, or at International Shows. Elected member of RSW 1885, NEAC 1892, ARSA 1898, RSA 1921.

Probable price range £50-150

Bibl: AJ 1898, p.47; 1904, 172; Studio 89 (1925) 89 ff; 92 (1926), 53, 55; Connoisseur 68 (1924) 55; Who's Who; D. Martin *The Glasgow School of Painting*, 1902, p.42-4; A. Dayot *La Peinture Anglaise*, 1908; Caw 380-82 (pl. opp.380); Cat. of *The Glasgow Boys Exhibition*, Scottish Arts Council 1968.

MacIAN, Ronald Robert ARSA 1803-1856
Scottish painter of historical genre. Although quite a good actor, he gave up the stage about 1840 to devote himself to painting. Exhib. at RA 1836-47, BI and SS. Painted episodes from Scottish history, and incidents illustrative of Highland courage and character. His wife Fanny (q.v.) was also a painter. Redgrave gives his names as Robert Roland.

'Mephistopheles Entreating Tortius, Rex Britannicus' sold at Sotheby's 4.6.69 for £100.

Bibl: AJ 1857, p.62 f (obit); Redgrave, Dict.; Caw 120.

MacIAN, Mrs. Ronald Robert (Fanny) fl.1835-1852
Genre painter, wife of R.R. MacIan (q.v.). For many years a teacher in the Government School of Design. Exhib. at RA 1836-47, BI and SS. The sources of her pictures were mostly historical or literary e.g. 'The Little Sick Scholar' 'Nell and the Widow' 'The Slave's Dream' etc.

Probable price range £30-70

Bibl: see under R.R. MacIan.

MACINTOSH, John M RBA 1847-1913
London landscape painter. Exhib. mainly at SS, also at RA 1880-1901, NWS and GG. Titles at RA include views in the south of England, and also some ideal landscapes e.g. 'Spring' 'Eventide' 'December Evening' etc.

Probable price range £30-70

Bibl: Who's Who 1913.

MACIRONE, Miss Emily fl.1846-1878
London genre and portrait painter. Exhib. at SS most often; also at RA 1846-73 and elsewhere. Titles at RA 'Nell in the Churchyard' 'The New Playmate' 'Love and Labour', etc., and some French and Italian genre subjects.

Probable price range £20-50

MACKENZIE, Kenneth fl.1884-1899
Landscape painter. Exhib. at RA 1885-99, and elsewhere. Lived in Wales, and after about 1892, in Scotland. Subjects mostly Highland scenes eg. 'The Home of the Heather' 'Snipe Land' 'Wild Grouse' etc.

Probable price range £20-50

MacLAREN, Walter fl.1869-1893
Genre painter. Lived for a time in Capri, where he painted many scenes of Capri life and landscape. Exhib. at RA 1869-1904, GG, NG and elsewhere. Titles at RA 'A Capri Mother' 'Capri Life - the Embroiderers' 'Scene in an Orange Garden' etc.

Probable price range £30-70

MacLEOD, Miss Jessie fl.1845-1875
London genre painter. Exhib. at RA 1848-74, BI and SS. Titles at RA 'A Village Genius' 'Sunny Hours' 'At the Church Door', and also some German scenes.

Probable price range £20-50

MacMANUS, Henry RHA 1810-1878
Irish historical and genre painter. Began to exhibit at RHA in 1835. Elected ARHA 1838, RHA 1858. Worked in London 1837-44, Glasgow 1845-49, then returned to Dublin. Appointed Headmaster of Dublin School of Design. Also exhib. at RA 1839-41, BI and OWS. Painted historical scenes, and also scenes of Irish life e.g. 'May Day at Finglas, Dublin' and 'Rory O'More'. Also worked as book illustrator. Professor of painting at RHA 1873-8.

Probable price range £50-200

Bibl: AJ 1878, p.156 (obit); Strickland.

MacMASTER, James RBA RSW fl.1885-1897
Scottish landscape painter and watercolourist. Exhib. mainly at SS, and at RA 1885-97, NWS, RSA and RSW. Subjects Highland views and coastal scenes. Titles at RA 'At Anstruther, Fife, NB' 'Off to the Fishing Ground' 'Out on the Deep' etc.

Probable price range £50-150

MACNAB, Peter RBA fl.1864-1892 d.1900
London landscape and rustic genre painter. Exhib. mainly at SS, also RA 1868-92, NWS and elsewhere. Titles at RA 'Coming through the Rye' 'Amid the Ripening Corn' 'The Smuggler's Wife' etc. Painted in Brittany and Spain.

'Waiting for the Fishing Boats' sold at Christie's sale in Tokyo, Japan for £526.

MACNEE, Sir Daniel PRSA 1806-1882
Scottish portrait painter. Born Fintry, Stirlingshire. Studied in Glasgow under John Knox, together with MacCulloch and W.L. Leitch (q.v.). Worked for an engraver in Edinburgh, while studying at the Trustees Academy. In 1832 returned to Glasgow, where he quickly established himself as a portrait painter. Elected RSA 1829. Exhib. at RA 1832-81, and at RSA. After the death of Watson Gordon in 1864, and Graham Gilbert in 1866, Macnee became the leading Scottish portrait painter of the day. Elected PRSA 1876. As a portrait painter he has been described as "an understudy of Raeburn". His best work was done between 1845 and 1860.

'A Sketch for a Portrait of a Lady' sold at Christie's 2.4.69 for £116.

Bibl: Portfolio 1887, p.139; Caw 177-8 and index; DNB.

MacQUOID, Percy T. RI fl.1866-89 d.1925

Genre painter, and watercolourist; son of T.R. MacQuoid (q.v.). Exhib. at RA 1875-87, SS, NWS, GG and elsewhere. Titles at RA 'Not for you'. 'The Eve of the Battle of Salamis' 'Horses Bathing'.

Probable price range £30-70

MacQUOID, Thomas Robert RI fl.1820-1912

Architectural painter, watercolourist, and illustrator. Exhib. at RA 1838-94, SS, NWS and elsewhere. Painted buildings in England, France and Spain, and occasional Spanish genre scenes. Also worked as an illustrator for *The Graphic* and *The Illustrated London News*.

Probable price range £30-70

Bibl: Who's Who 1911.

***MacWHIRTER, John RA HRSA RI 1839-1911**

Scottish landscape painter. Born in Edinburgh. Elected ARSA 1867, but left Edinburgh soon after to settle in London. Exhib. at RA 1865-1904, NWS, GG and elsewhere. Elected ARA 1879, RA 1894. MacWhirter's preference was for peaceful and poetic landscapes. At first he attempted Pre-Raphaelite detail, but later abandoned this for a broader style. Travelled widely in Europe and America, and in Alps, France and Italy. Exhibitions of his work were held at the FAS in 1901, and the Leicester Gallery in 1910 and 1911.

'View of Melrose' sold at Sotheby's 30.7.70 for £250.

Bibl: AJ 1879-1911 passim; M.H. Spielman, *The Art of J. Mac W.* 1904; W.M. Sinclair, *The Life and Work of J. Mac W.* A.J. Christmas Annual 1903; Caw 256-8 and index (pl. opp. p.256); DNB; Who's Who 1911; J. MacWhirter; *Sketches from Nature,* intro. by Mrs. Mac W. 1923; Hardie III 199 (pl. 232).

McCALLUM, Andrew 1821-1902

Landscape painter. Born in Nottingham, where he studied at the Government School under J.A. Hammersley (q.v.). Studied in London at Government School of Design. 1851 took teaching post in Manchester, then at Stourbridge School. Travelled in Italy 1853-8, after which he began to devote himself seriously to landscape. Exhib. at RA 1850-86, BI, SS and elsewhere. Continued to travel in Italy, Switzerland and Egypt. Was particularly known for his painting of trees.

'First Tints of Autumn' sold at Christie's 13.11.69 for £147.

Bibl: AJ 1877, p.321-4, 1908, 17; Clement and Hutton; DNB Supp. II (1912).

McCULLOCH, George fl.1859-1901

Painter of historical genre and sculptor. Exhib. at RA 1859-1901, SS and elsewhere. Titles at RA 'Love Shaping his Bow' 'The Story of Cain', 'The Saving of Andromeda' etc. Also exhibited allegorical statues and reliefs 'Higher and still Higher' etc. (RA 1867).

Probable price range £30-70

McDOUGAL, John fl.1877-1903

Liverpool painter of landscape and coastal scenes. Exhib. at RA 1877-1903, SS NWS and elsewhere. Painted views in Wales, Cornwall, Devon and elsewhere, and also ideal landscapes e.g. 'A Midsummer Day' 'When the Tide Flows in' 'The Tranquil Light of Rosy Morn', etc. Works by him are in Blackburn and Liverpool AG.

Probable price range £30-70

Bibl: AJ 1907, p.373.

McGREGOR, Robert RSA 1848-1922

Scottish painter of pastoral landscape and rustic genre. Worked as an illustrator for Nelson's in Edinburgh before taking up painting. Exhib. mainly at RSA, also RA 1878-1904 and elsewhere. Elected ARSA 1882, RSA 1889. MacGregor's *plein-air* style and his preference for rustic subjects show an affinity with such Dutch artists as Mauve and Israels, although he did not study outside Scotland.

Probable price range £50-150

Bibl: AJ 1903, p.124; Studio 68 (1916), 123; 85 (1923) 106 f; Connoisseur 65 (1923), 108; Caw 283-4, (pl. opp. 282).

McINNES, Robert 1801-1886

Scottish genre painter. Exhib. at RA 1841-66, BI and elsewhere. Painted both Highland and Italian scenes, usually of a conventionally picturesque type e.g. 'Fiore dal Carnivale' 'The Highland Girl' 'The Sunday School' etc. Also occasionally painted portraits and historical scenes. A work by him is in Glasgow AG.

'The Shepherdess' sold at Christie's 2.4.69 for £368.

Bibl: AJ 1859 p.170; Caw 120.

McINTYRE, Joseph Wrightson fl.1866-1888

Painter of coastal scenes and seascapes. Exhib. at RA 1871-88, BI and mostly at SS. Titles indicate mostly stormy subjects eg. 'A Gleam of Hope' 'A Wild Night on Goodwin Sands' 'Bridlington Quay' etc.

'Shipping off the Channel Coast' – a pair – sold at Parke-Bernet 31.10.68 for £321.

McKAY, David B. See ROFFE, William John

McKEWAN, David Hall RI 1816-1873

Landscape painter and watercolourist. Exhib. at RA 1837-53, BI, SS, and NWS (498 works). Elected RI 1848. Painted in Wales, Scotland, Ireland and Kent. Published *Lessons on Trees in Watercolours.*

Probable price range £20-50

Bibl: Redgrave, Dict.; DNB.

McLACHLAN, Thomas Hope 1845-1897

Landscape painter. Born in Darlington of Scottish parents. Studied for the bar, and in 1878 gave up the law for painting, encouraged by Pettie and others. Exhib. at RA 1877-97, GG, NG and elsewhere. His landscapes are romantic and moody, showing the influence of G.H. Mason and C.G. Lawson, but his technique remained rather amateurish. His figures are usually solemn peasant workers of the Millet type; his theme the unity of Man and Nature.

Probable price range £50-150

Bibl: AJ 1897, p.191; Mag. of Art 1903, p.117 ff; Studio Vol. 39 (1907), 134 f; DNB; Caw 316-8.

***McTAGGART, William RSA RSW 1835-1910**

Scottish painter of landscape and coastal scenes. Born in Aros, on the Atlantic coast of Scotland, whose "seas and sands made him a painter" (Hardie). Studied under Lauder at Trustees Academy 1852-9, where his fellow pupils included Orchardson, MacWhirter, Tom Graham and Pettie (q.v.). Exhib. at RSA from 1853, and RA from 1866. Elected ARSA 1859, RSA 1870. McTaggart's swirling and brilliant style, and his rendering of effects of light and atmosphere, was similar to that of the French Impressionists, although it was not until the 1890's that he saw his first Monet. He was also a brilliant watercolourist, but after 1889 he painted mainly in oils. "Even Turner has not excelled him in his knowledge of the swift movement, the

scudding foam and spray, the changing light and colour of the sea". (Hardie). His work remained comparatively unknown outside Scotland until the exhibition at the Tate in 1935, which was followed by exhibitions at the Nat. Gall. in Edinburgh in 1935 and Manchester in 1937.

'Machrihanish Shore Scene' sold at Morrison McChlery (Glasgow) 22.5.69 for £1,300. Usual range £500-1,000.

Bibl: AJ 1894, p.243-6; Studio 47 (1909), 83-93; Burlington Mag. 32 (1918), 227 f; Connoisseur 50 (1918), 106 f; Caw 248-54 and index (2 pls.); J.L. Caw, *W. McT.* 1917; D. Fincham, *W. McT.* 1935; FAS McT. Exhibition, 1967; Hardie III 195-8, (pl. 230).

***MACLISE, Daniel RA 1806-1870**
Irish portrait and historical painter. Born in Cork, where he studied at the local Academy. Came to London 1827; entered RA Schools 1828. At first he made a living by portraits, but soon turned to historical genre. Exhib. at RA 1829-70, BI and SS. Elected ARA 1835, RA 1840. His historical scenes were usually based on popular literary sources, such as *The Vicar of Wakefield, Gil Blas,* Shakespeare etc. He also painted some ambitious historical scenes such as 'The Marriage of Strongbow and Eva' 'Here Nelson Fell' etc. In the House of Lords he painted two frescoes, 'Spirit of Justice' and 'Spirit of Chivalry', and later his two best known historical scenes. 'The Death of Nelson' and 'The Meeting of Wellington and Blucher'. Worn out by these immense commissions, which he completed in 1864, he produced very little in the last years of his life. He also illustrated several books. His studio sale was held at Christie's on June 24, 1870.

'Robin Hood and his Foresters Entertaining King Richard Coeur de Lion' sold at Christie's 25.6.65 for £682 (Northwick Sale). Other prices in recent years have ranged from £200-450.

Bibl: AJ 1870 p.181 f (obit); Connoisseur 64 (1922) 120, 123; Vol.74, 30, 33; Vol. 75, 186; J. Ruskin, *Academy Notes,* 1855, 1857; Redgrave, Dict. and Cent.; J. Dafforne, *Pictures by D.M.;* W.J. O'Driscoll, *A Memoir of D.M.* 1872; Caw; DNB; Strickland; Reynolds VS 57, 67, (pl.17); T.S.R. Boase *Eng. Art 1800-70* 1959, index; Reynolds VP passim; Maas 24-5 (pl.p.26).

MAGGS, John Charles 1819-1896
Bath coaching painter. Ran a school of painting in Bath, at his studio in 34 Gay Street. Although he never exhibited in London, he was widely patronised by lovers of coaching, including Queen Victoria. Like Cooper Henderson (q.v.) he carried the tradition of coaching painting well into the railway age. He was particularly fond of painting coaches in snow.

'Mail Coach Outside the George Inn, Bath' sold at Sotheby's 12.3.69 for £1,150. Usual range £200-500.

Bibl: Pavière, Sporting Painters p.61 (pl.28).

MAGUIRE, Thomas Herbert 1821-1895
Portrait, genre, and historical painter, and lithographer. Exhib. at RA 1846-87, BI and SS. As well as genre scenes, he exhib. many portrait lithographs at the RA. He was lithographer to Queen Victoria. Later he turned to portraits in vitrified enamel. His daughter, Adelaide, was a promising genre and landscape painter who exhib. at the RA 1872-76, and SS, but she died young in 1876. Bertha, Helena, and Sidney Calton Maguire, who also lived at 6 Blomfield Crescent, were all probably children of T.H. Maguire, and all also painted.

Probable price range £30-70

Bibl: AJ 1876 p.48 (obit); Strickland; Clayton I, 420 ff (Adelaide Maguire).

MANDER, William Henry fl. c.1880-1910
Birmingham landscape painter. Did not exhibit at all in London.

Painted views in the Midlands and North Wales in a style similar to the late manner of B.W. Leader (q.v.).

Price range during the 1968-9 season was £110-280.

MANLY, Miss Alice Elfrida fl.1872-1893
London landscape painter. Exhib. 1872-93 at RA, SS, NWS and elsewhere. In addition to landscapes, also painted flowers and portraits. Her sister Eleanor was also a painter, who exhib. at the RA 1888-98, SS and NWS. Her works were genre scenes, especially of children.

'Reading in the Park' sold at Christie's 5.2.65 for £105.

Bibl: Clayton II 189-191

MANN, Alexander 1853-1908
Scottish landscape and genre painter. Born Glasgow. Pupil of Carolus Duran. Exhib. 1883-93 at RA, SS and elsewhere. His picture of 'A Bead Stringer, Venice' was one of the first Glasgow pictures to be noticed at the Paris Salon in 1884. He painted genre scenes in Italy, France, and Morocco, and settled in London in the mid-nineties. His landscapes show a refined feeling for atmosphere, and a taste for subdued colours. Works by him are in Glasgow, Liverpool and Nottingham AG.

Probable price range £50-150

Bibl: Studio 46 (1909) p.300-305; Who's Who 1908; Caw 384-5.

MANN, Joshua Hargrave Sams RBA fl.1849-1884
London genre painter. Exhib. mainly at SS (128 works) where he was a member; also at RA, BI and elsewhere. Titles at RA include subjects from Byron, Coleridge, Tennyson, and Milton, some portraits, and other genre e.g. 'Wayfarers' 'Hark, Hark the Lark' 'In Time of War' etc. Painted in France and Spain. After his death two studio sales were held at Christie's on May 7 and 25, 1886.

'Rustic Life in Brittany' sold at Christie's 3.4.70 for £48.

Bibl: AJ 1859 p.82, 168 f; 1866, 232; 1873, 168; 1879, 104.

MANTON, Grenville fl.1878-1899
London portrait painter. Exhib. at RA 1880-99, SS and elsewhere. Also some allegorical portraits e.g. 'Cinderella' 'Dawn' etc.

Probable price range £20-50

MARKS, Barnett Samuel RCA b.1827 fl.1859-1891
Welsh portrait painter. Born in Cardiff 1827; moved to London about 1867. Exhib. at RA 1859-91, and occasionally elsewhere. Also painted some genre e.g. 'Listening to a Fairy Tale' 'A Rabbi Reading' 'A Jewish Bibliophile' etc.

Probable price range £20-50

Bibl: Rees *Welsh Painters* 1912.

MARKS, George fl.1876-1904
Landscape painter. Lived at Penge. Exhib. at RA 1878-1904, SS, NWS and elsewhere. Painted mainly in Kent, Surrey and the southern coast. Many of his pictures have idealised titles e.g. 'Solitude' 'Autumn Glow' 'A Gleam of Sunshine' etc.

Probable price range £30-70

***MARKS, Henry Stacy RA RWS HRCA HRPE 1829-1898**
London genre painter and watercolourist, and illustrator. Pupil of J.M. Leigh, and Picot in Paris 1851-3. Exhib. at RA 1853-97, BI, SS, OWS, GG and elsewhere. Elected ARA 1870, RA 1878. Most of his genre was either literary, especially Shakespearian, or historical, and often humorous e.g. 'Toothache in the Middle Ages'. Later Marks

turned mainly to painting animals, which he did with sympathy, accuracy, and lack of sentiment. He was one of the founders of the St. John's Wood Clique, and a notorious practical joker. Ruskin reproved him for "that faculty" which, he said, impeded his progress as an artist. His studio sale was held at Christie's on March 25-26, 1898.

'Cockatoos in a Tree' sold at Sotheby's 4.6.69 for £400.

Bibl: AJ 1870, p.361-3; 1898, 94; Bryan; DNB Supp. III (1901), 140; Cundall; 234; Bevis Hillier, *The St. John's Wood Clique*, Apollo June 1964; Reynolds VP 179-80 (pl.123); Maas 82 (pl.p.86).

MARSH, Arthur H ARWS RBA fl.1865-1893 d.1909

London genre painter and watercolourist. Exhib. at OWS (108 works) RA, SS and elsewhere. Titles at RA 'The Harpischord' 'The Salmon Fishers' 'Shrimpers' etc. Painted many scenes of fishing life on the Northumberland coast, at Whitby, Cullercoats and Tynemouth.

Probable price range £30-70

Bibl: AJ 1884, p.85, 87; 1893, 29; 1904, 305; Year's Art 1910 p.388 (obit).

MARSHALL, Charles 1806-1890

London landscape painter; father of R.A.K. Marshall (q.v.). Worked in the theatre, painting scenery, decorations, and panoramas. Later turned to landscape painting. Exhib. at SS (149 works) RA, BI, NWS and elsewhere, 1828-1884. Painted mostly in Wales. His son, Charles, (Junior) was also a landscape painter, who exhib. 1864-86 at RA, BI, SS and elsewhere.

'Storm Passing' sold at Christie's 13.11.69 for £116.

Bibl: Connoisseur 72 (1925), 245, 249; Clement and Hutton; Hardie III 29.

MARSHALL, Charles Edward RBA fl.1872-1903

London portrait and genre painter. Exhib. 1872-1903 at SS, RA and elsewhere. Titles at RA 'The Old Pump' 'A Cavalier' 'Love in her Eyes Sits Playing' etc.

Probable price range £30-70

MARSHALL, Herbert Menzies RWS RPE 1841-1913

London topographical painter and watercolourist, and architect. Pupil of the French architect Questel. Professor of landscape painting at Queen's College, London. Exhib. 1871-93 at OWS (277 works) RA, SS and elsewhere. Produced several series of topographical watercolours, e.g. 'The Scenery of London' 'Cathedral Cities of France'. Exhibitions of his work were held at the FAS in 1886, and the Abbey Gall. in 1935.

Probable price range £30-100

Bibl: Studio 58 (1913), 222 f; Special No. 1909, *Sketching Grounds*, 231-8; Daily Telegraph 7.6.1910; Who's Who 1913-14; VAM; Hardie III 163 (pl.193).

MARSHALL, John fl.1881-1896

Painter of genre, still life, and animals. Lived in Croydon, Surrey. Exhib. at RA 1881-96. Titles 'Dead Snipe' 'The Passing Shower' 'Victoria Plums' etc. His son (?) J. Fitz Marshall (q.v.) was also a painter.

Probable price range £30-70

MARSHALL, J. Fitz b.1859 fl.1876-1903

Croydon painter of landscape, animals and flowers. Probably the son of John Marshall (q.v.). Exhib. at RA 1883-1903, SS, GG, NG and elsewhere. Titles at RA 'Chestnut Boughs' 'During the Sermon — the Choirmaster's Terrier' 'A Challenge' etc.

'Companions of the Arts; Companions of the Pot' — a pair — sold at Sotheby's 2.4.69 for £110.

Bibl: Who's Who 1913.

MARSHALL, Peter Paul 1830-1900

Liverpool genre painter. Born in Edinburgh. By profession an engineer; painted only in his spare time. While working in Liverpool became friendly with many artists there, and fell under the influence of the Pre-Raphaelites. Exhib. at Liverpool Academy. Settled in London, where through Madox Brown, he became a partner in William Morris's firm 'Morris, Marshall, Faulkener & Co' in 1861. He never played a very active role and resigned in 1875. Exhib. only once at RA in 1877, and occasionally elsewhere in London.

Probable price range £30-100

Bibl: Marillier 170-3; Singer, *Der Prae-Raphaelitismus in England*, 1912, p.124.

MARSHALL, Roberto Angelo Kittermaster b.1849 fl.1864-1902

London landscape painter; son and pupil of Charles Marshall (q.v.). Exhib. at RA 1867-1902, SS, NWS and elsewhere. Painted in Sussex, Gloucestershire, and especially Hampshire.

Probable price range £30-70

Bibl: Clement and Hutton.

MARSHALL, Mrs. Rose fl.1879-1890

Leeds flower painter. Exhib. 1879-80 at RA, SS, GG and elsewhere. Titles at RA include some genre subjects e.g. 'The Year's at the Spring' etc.

Probable price range £20-50.

MARSHALL, Thomas Falcon 1818-1878

Liverpool genre painter. Began exhibiting at Liverpool Academy in 1836. Elected associate 1843, member 1846. Exhib. at RA 1839-78, BI and SS. He was a versatile and prolific painter, and an admirer of W.P. Frith (q.v.). His subjects included rustic scenes, cottage interiors, farmyard scenes and also historical genre drawn from Goldsmith, Thomson, Byron and others.

'Summer', and 'Winter', two portraits of girls, sold at Christie's 20.11.70 for £1,365.

Bibl: AJ 1878, p.169 (obit); Redgrave, Dict; Marillier 174-6; Cundall 234; Reynolds VP 113 (pl.75).

MARTENS, Henry fl.1828-1854

London military painter and watercolourist. Exhib. 1828-54 at BI and SS. Subjects mostly episodes from Victorian military history. Also did many drawings of military uniforms for Ackermann's *Costumes of the Indian Army* (1846) and *Costumes of the British Army in 1855* (1858).

'A Troop of the 2nd Dragoon Guards' — watercolour — sold Christie's 18.7.67 for £63.

Bibl: Connoisseur 40 (1914), 143; Print Collectors Quarterly XIII 62.

MARTIN, Anson A fl.1840-1861

Painter of coaching and hunting scenes, and other sporting subjects. May possibly have collaborated with Cooper Henderson. Did not exhibit in London; presumably worked entirely for private patrons.

'Return from Shooting' sold at Sotheby's 18.6.69 for £1,850.

Bibl: Pavière, Sporting Painters p.62 (pl.30).

MARTIN, Charles 1820-1906

London portrait painter; son of John Martin (q.v.). Exhib. at RA 1836-96, BI, SS and NWS. A portrait of Turner is in the NPG, and

several drawings in the BM. A portrait of his father on his death-bed is in the Laing AG, Newcastle.

Probable price range £30-100

Bibl: Binyon; The Year's Art 1907 (obit); Other references see under John Martin.

MARTIN, Henry fl.1870-1894

Painter of coastal landscapes and scenes of fishing life. Exhib. at RA 1874-94, SS and elsewhere. Titles at RA 'The Sail Mender' 'Newlyn Quay' 'Mending the Old Buoy' etc. Lived at Newlyn, Cornwall, and at other villages on the Cornish coast, and was almost certainly associated with the Newlyn School. Also visited Venice.

Probable price range £50-150.

MARTIN, Henry Harrison fl.1847-1882

Genre painter. Exhib. mainly at SS (56 works) also at RA 1852-79, and BI. Titles at RA include some historical genre, from Scott and Sheridan. Also visited Spain, and painted some Spanish scenes e.g. 'At the Bull Fight' 'La Gitana' etc.

'The Bridal Gown' sold at Christie's 9.6.67 for £126.

*MARTIN, John 1789-1854

Painter of historical and biblical scenes, and landscape. Born at Eastland Ends, a cottage near Haydon Bridge, Northumberland. Apprenticed to a coach painter in Newcastle, but ran away to study painting with an Italian, Boniface Musso. 1806 came to London, and at first worked as a china painter. Began exhibiting at the RA in 1811. His grandiose biblical scenes soon began to catch the popular imagination, and 'Belshazzar's Feast', which made him famous, became through engravings one of the most popular pictures of the age. Exhib. at RA 1811-52, BI, SS, NWS and elsewhere. He continued to paint similar subjects, such as 'The Plains of Heaven' 'The Great Day of his Wrath' 'The Last Judgement' which were scorned by Ruskin and the critics, but enjoyed enormous popular appeal. Although his technique and colouring were sometimes deficient, he had an undoubted ability to convey a sense of awe-inspiring grandeur, which has often been compared to the methods of modern epic films. He was also a watercolourist, and book illustrator. Even today, he is often referred to as "Mad Martin", a sobriquet which he does not deserve. Possibly it arises from confusion with his brother Jonathan, who was insane, and earned considerable notoriety by trying to burn down York Minster. Exhibitions of Martin's work were held at the Hatton Gallery, Newcastle in 1951, at the Whitechapel in 1953, and at the Laing AG, Newcastle in 1970.

On 18.3.64 a series of oil sketches of 'Paradise Lost' illustrations were sold at Sotheby's for prices ranging from about £100 to £850. Since 1964 no works of major importance have appeared, and the range of prices has remained about the same.

Bibl: AJ 1909 p.20; The Artist 30 (1901), 189-197, (E.W. Cooke); J. Ruskin; *Modern Painters*; Redgrave, Cent. and Dict.; Binyon; Cundall; VAM; Smith *Recollections of the British Institution*, 1908; Mary L. Pendred, *J.M. Painter, his life and times*, New York 1924; T. Balston, *J.M.* 1947; Reynolds VP 15 (pl.10); Hardie II 46 (pls. 31-3); Maas 34-5 (pls. on p.35, 37); Cat. of J.M. Exhibition, Laing AG Newcastle 1970.

MARTINEAU, Miss Edith ARWS fl.1862-1893

Landscape, genre and portrait painter and watercolourist. Exhib. at RA 1870-90, SS, OWS, NWS, GG and elsewhere. Titles at RA 'A Doubtful Passage' 'Oranges' 'Touching the Strings' etc. and several portraits.

Probable price range £100-300

MARTINEAU, Miss Gertrude fl.1862-1894

Genre and animal painter. Exhib. at RA 1862-94, SS, NWS and else-where. Titles at RA mostly animals e.g. 'Do Doggies Gang to Heaven?' 'Master and Pupil' 'Naughty' etc.

Probable price range £100-200

*MARTINEAU, Robert Braithwaite 1826-1869

Pre-Raphaelite painter. Educated at University College School. Studied law 1842-6. No doubt encouraged by his mother, Elizabeth Batty, who was a talented amateur watercolourist, he gave up law and entered the RA Schools. Became a friend and pupil of Holman Hunt (q.v.), and worked in his studio c.1851-2. After Hunt's first trip to the Middle East, Martineau, Hunt and Michael Halliday shared a studio at 14 Claverton St. Pimlico. Martineau began to exhibit at the RA in 1852 with 'Kit's Writing Lesson' (Tate Gallery). This was followed by 'Katherine and Petruccio' (1855) 'The Last Chapter' (1863) and other genre and historical scenes. By far his best, and his most successful work was 'The Last Day in the Old Home' (Tate Gallery) shown at the International Exhibition of 1862. Hunt and Martineau continued to share a studio until 1865, when M. married Maria Wheeler. His death in 1869 at the age of only 43 prevented him from fulfilling the promise of 'The Last Day in the Old Home'. At his death he was still working on the large 'Christians and Christians' in the Walker AG, Liverpool.

Because of his early death, M's output was very small, and his work is consequently rare. No important works have been sold in recent years; sketches and drawings might make £100-500.

Bibl: AJ 1869, p.117 (obit); Athenaeum Feb. 20. 1869 p.281 (obit); Connoisseur 62 (1922) 117; 110 (1942), 97-101; Burlington Mag. 43 (1923), 312; Studio 87 (1924) 207 ff; (by Helen M. the artist's daughter); 143 (1947), 78-9; Redgrave, Dict.; DNB, Bate 75, 81 ff; Ironside and Gere 27 (pl.22); Fredeman, see index; Reynolds VS 3, 17, 21, 75-6 (pls. 45-6); Reynolds VP 65, 68-9; Maas 121; Diana Holman Hunt *My Grandfather, his Wives and Loves*, 1969 see index.

MARTINO, Mrs. see BLUNDEN, Miss Anna

MASON, George Hemming ARA 1818-1872

Painter of landscapes and pastoral scenes. Born Witley, Staffordshire. Studied to be a doctor. In 1844 visited France, Germany, Switzerland and Italy, settling in Rome for several years, where he decided to take up painting as a profession. Exhib. at RA 1857-72. Elected ARA 1869. In 1858 he returned to England. He painted both Italian views, mainly in the Campagna, and English landscapes. His English scenes are romantic and poetic in feeling; he delighted especially in effects of mist, sunset and moonlight. His influence on other romantic landscape painters was considerable. He died of heart disease, aged 54. His studio sale was held at Christie's on Feb. 15, 1873.

'An Italian Coast Scene' – a sketch – sold at Christie's 10.7.70 for £50.

Bibl: AJ 1872, p.300 (obit); 1883, 43 ff; 108 ff, 185 ff (Alice Meynell); Portfolio 1871, 113-17; 1873, 40-43; 1880, 132; 1887, 65, 164; Redgrave, Cent. and Dict; Clement and Hutton; Cundall; DNB.

MASON, W.H. fl.1860-1885

Marine painter. Lived at Chichester and Worthing. Exhib. at RA 1863-88, BI, SS and elsewhere. Titles at RA 'Spithead' 'After a Gale – Seaford Bay' 'Ironclads at Spithead' etc.

Probable price range £20-50

MATHER, John Robert b.1848 fl.1862-1873

Newcastle marine painter. Exhib. 13 works at SS 1862-73.

Probable price range £20-50

MAULE, James fl.1835-1863

Lewisham marine painter. Exhib. 1835-63 at RA, BI and SS. Titles at

RA 'Portsmouth Harbour' 'View of Holland' 'Off Dover' etc.

Probable price range £20-50

MAWLEY, George 1838-1873
London landscape painter and watercolourist. Exhib. 1858-72 at RA, SS and elsewhere. Painted on the Thames, in Yorkshire, and elsewhere. Exhib. most of his watercolours at the Dudley Gallery.

Probable price range £20-50

Bibl: Redgrave, Dict.

MAWSON, Miss Elizabeth Cameron fl.1877-1892
Flower painter; lived at Gateshead, near Newcastle. Exhib. 1877-92 at RA, SS, NWS and elsewhere. Also painted genre scenes e.g. 'An Illustrious Ancestor' 'A Reverie' etc.

Probable price range £20-50

MAY, Arthur Dampier fl.1872-1900
Genre and portrait painter. Exhib. at RA 1876-1900, SS, NWS, GG and elsewhere. Most of his exhibited portraits were of children. He also painted genre scenes e.g. 'The Children's Hour' 'A Little Brides-maid' 'The Lord's Prayer' etc.

Probable price range £30-70

Bibl: Mrs. R.L. Poole, *Cat. of Portraits of Oxford*, III (1925) 145.

MAY, Arthur Powell fl.1875-1893
Landscape painter. Possibly the brother of Arthur Dampier May (q.v.), as both have Lee addresses. Exhibited from 1875-93, at the RA (in 1876), SS, NWS, and elsewhere. At the RA he exhibited a landscape: 'At Zennor, Cornwall, Gurnard's Head in the Distance'.

Probable price range £30-70

MAY, Walter William RI 1831-1896
Marine painter and watercolourist. Exhib. 1859-93 at NWS (281 works) RA, BI, SS and elsewhere. Painted coastal and shipping scenes in England, France and Holland. A work by him is in the Norwich Museum.

Probable price range £30-70

Bibl: Cundall, 235; Nat. Gall. of Ireland, *Cat. of Pictures etc.* 1920, p.177.

MEADOWS, Arthur Joseph fl.1860-1905
Painter of coastal scenes. Exhib. mostly at SS, also at RA 1863-72, and BI. Painted harbours and coastal scenes in England, France and Holland.

Price range during the 1968-9 season ranged from £100 to £400. Several pairs were sold for high prices, ranging from £320 to £1,260.

Bibl: Wilson, Marine Painters, p.54 (pl.23).

MEADOWS, Edwin L. fl.1854-1872
London landscape painter. Exhib. at RA 1858-67, BI and mostly SS. Titles at RA 'Near Dorking, Surrey' 'A Shady Pool' 'In Epping Forest – Evening' etc.

'Cattle by a Stream' sold at Sotheby's 8.1.69 for £170.

MEADOWS, James 1828-1888
Painter of marine subjects and coastal scenes. Exhib. at RA 1855-63, BI, SS and elsewhere. Titles at RA 'Fresh Breeze' 'Clearing Off' 'Shrimping' etc.

'Fishing Boats off the Dutch Coast' sold at Bonham's 16.1.69 for £150.

Bibl: AJ 1859, p.121; Roget; Rees, *Welsh Painters*, 1912; Wilson, Marine Painters, p.54 (pl.24)

MEADOWS, James Edwin fl.1853-1875
London landscape painter. Exhib. at RA 1854-72, BI, SS and elsewhere. Titles at RA include views in Essex, Kent, Sussex, Surrey, the Isle of Wight etc. and some coastal scenes.

Price range during the 1968-9 season was £170 to £290.

MEARS, G. fl. c.1874-5
Very little-known marine painter. Lived in Brighton, and painted shipping scenes off the South Coast. Works by him are in Folkestone AG and the Greenwich Maritime Museum.

'H.M.S. Devastation' sold at Parke-Bernet 30.4.69 for £219.

Bibl: Wilson, Marine Painters, p.54 (pl.24).

MEASHAM, Henry b.1844 fl.1867-1883
Manchester landscape and portrait painter. Exhib. 1867-83 at RA and elsewhere. Titles at RA mostly portraits, and some genre e.g. 'An Italian Shepherd' 'Fruit for Winter' 'An Old Basket Maker' etc. Works by him are in Manchester and Salford AG.

'Frolic in Somerset' sold at Christie's 14.3.69 for £137.

MEDLYCOTT, Sir Hubert J. Bt. b.1841 fl.1878-1893
Landscape and architectural painter. Lived in Somerset. Exhib. 1878-93 at SS, NWS, GG and elsewhere.

Probable price range £20-50

Bibl: Court Journal 22.2.1908.

MELLOR, William
Little-known landscape painter working in the second half of the nineteenth century. He did not exhibit in London, but his works appear frequently on the market. His subjects usually landscapes in N.Wales or the West Country.

Price range in the 1968-9 season was £100-180.

MELVILLE, Alexander fl.1846-1868
Painter of portraits and genre who exhibited from 1846-68 at the RA, BI and SS, titles at the RA including 'Portrait of a Lady' 1846, and 'Meditation' 1847.

Probable price range £20-50

METEYARD, Sidney RBSA 1868-1947
Painter in oil, watercolour and tempera; designer of stained glass. Studied at Birmingham School of Art under Edward R. Taylor. Elected Associate of RBSA 1902, member 1908. Exhib. at RA, Birmingham, Liverpool and the Paris Salon. Illustrated Longfellow's *Golden Legend*, and designed a stained glass window for St. Saviour's, Scarborough. All his work shows a strong influence of Burne-Jones; examples can be seen in Birmingham AG, and also in the Town Hall, Birmingham.

Probable price range £200-500 — more for major works.

Bibl: Studio 1 (1893) 237-40; Cat. of Symbolists Exhib. Piccadilly Gallery, June 1970.

MELVILLE, Mrs. Alexander fl.1854-1868
(Eliza Anne Smallbone)
Painter of genre and portraits, who exhibited 'Morning Post' at the RA in 1854 under the name "Smallbone", and under the name "Melville" from 1862-68 at the RA, BI and SS – all portraits.

Probable price range £20-50

MELVILLE, Arthur ARWS HRSA RSW 1855-1904
Scottish painter and watercolourist of Eastern subjects. Entered RSA schools 1875. Studied in Paris 1878. Travelled in the Middle East 1881-3. By 1884 he was back in Scotland, and his arrival lent impetus to the newly-formed "Glasgow School" movement. Exhib. at RA 1878-96, OWS, NWS, GG, etc. Elected ARWS 1889, after which he settled in London. It was still the East to which he turned for inspiration – Egypt, Algeria, Morocco, and Spain – "wherever he found scenes of vivid life, and of colour in motion". (Hardie). He developed a brilliant and quite individual impressionistic style, which has had many imitators, but few rivals. Among those influenced by Melville are Brangwyn, Brabazon and several Scottish watercolourists.

Probable price range £100-300

Bibl: AJ 1904, p.336, 381 (obit); Studio 37 (1906) 284-93; 42 (1908) 143-5; 82; (1921) 227, 251, 257; 83 (1922) 132-5; Caw; Cundall; VAM; R. Fedden, *A.M. OWS*, 1923; A.E. Mackay, *A.M.* 1951; Hardie III 199-203 (pls. 231, 233).

MELVILLE, Harden S. fl.1837-1879
London genre and landscape painter. Exhib. at RA 1837-65, BI and SS. Titles at RA 'A Horse' 'Dinner Time' and 'Toast for Papa' etc. and some animal studies.

Probable price range £20-50

Bibl: Binyon III

MENPES, Mortimer RBA RPE 1860-1938
Painter, watercolourist, and etcher. Born in Australia. Pupil and follower of Whistler. Exhib. at RA 1880-1900, SS, NWS, GG and elsewhere, including NEAC. Painted street and market scenes in Brittany, Tangier, India and Japan, and also genre scenes. e.g. 'The Village Smithy' 'Washing Day' 'Sunday Morning' etc. His broad, delicate colours and choice of subjects both reflect the influence of Whistler and the Japanese style. Also exhib. etchings at the RA, some after Old Masters; and illustrated travel books.

Prices in the 1968-9 season ranged from £100 to £140.

Bibl: AJ 1881, p.352; Connoisseur 30 (1914) 289; Who's Who; Wedmore, *Etching in England*, 1895, 144-7; Hind, *A Short, Hist. of Engraving.* 1911.

MERRITT, Mrs. Henry (Anna Lea) b.1844 fl.1878-1893
Portrait and genre painter. Born in Philadelphia. Her husband, Henry Merritt, was also a painter, restorer and bookseller. Exhib. at RA 1878-93, GG and NG. Subjects mostly portraits, also genre. Her best-known work is the much ridiculed 'Love Locked Out' in the Tate Gallery. After her husband's death in 1877 she was known as Mrs. Anna Lea Merritt.

Probable price range £100-300.

Bibl: Henry Merritt, *Art Criticism and Romance*, 1879; Who's Who; M. Fielding, *Dict. of American Painters* 1926; W. Shaw-Sparrow, *Women Painters of the World* 1905.

MEYER, Miss Beatrice fl.1873-1893
London historical painter. Exhib. 1873-93, mainly at SS, also RA, NWS and elsewhere. Only exhib. once at the RA, in 1888, with a picture entitled 'The Betrothal'.

Probable price range £30-70

MEYER, F.W. fl.1869-1892
Painter of shipping and coastal scenes. Lived in Putney. Exhib. at RA 1869-92, SS and elsewhere. Painted the English coasts, and also Brittany. Also painted landscapes, mostly in Wales.

'On the Devonshire Coast' sold at Christie's 11.10.69 for £40.

MEYERHEIM, Robert Gustav RI fl.1866-1913
German landscape painter; one of a family of Danzig artists. Studied under H. Gude and Oswald Achenbach. Settled in England in 1876, and exhib. 1875-93 at RA, SS, and NWS. Lived in London, later moved to near Horsham, Surrey. Painted English landscapes and farming scenes; also visited Holland. An Exhibition of his works, entitled 'The Soul of the Countryside' was held at the Carroll Gallery in 1913.

Probable price range £30-100

Bibl: Connoisseur 36 (1913) 132-3.

MICHIE, James Coutts ARSA 1861-1919
Scottish landscape and portrait painter. Born in Aberdeen. Studied in Edinburgh, Rome, and Paris (under Carolus Duran). Settled in London about 1890. Exhib. 1889-93 at RA, SS, GG etc. Elected ARSA 1893. Member of Aberdeen Art Soc. and the Soc. of Scottish Artists. Subjects usually peaceful rural scenes. Works by him are in the Aberdeen AG and the Walker AG Liverpool. He was a good friend of the collector, George McCulloch, and after McCulloch's death in 1909, he married Mrs. McCulloch. His sister Miss M. Coutts-Michie was a flower painter.

'A Mill Pond' sold at Christie's 10.7.70 for £168. Two copies by J.C.M. after Whistler sold in the same sale for £68 and £147.

Bibl: AJ 1902, p.290-3; 1905, 122; 1907, 164; Studio 38 (1906) 15, 16, 21; *Art in 1898,* Special No.; Connoisseur 56 (1920) 126; Caw 311-12.

MIDDLETON, James Godsell fl.1826-1872
Portrait and genre painter. Exhib. at RA 1827-72, BI and SS. Also painted historical genre, 'Scene from Old Mortality' 'Jennie Deans' 'Nell Gwynn and Charles II' etc. His self-portrait is in the Pitti Palace, Florence.

Probable price range £30-70

Bibl: *Cat. of Paintings etc. in the India Office,* London 1914, p.83; BM, *Cat. of Engr. Brit. Portraits* VI 520.

MIDDLETON, John 1828-1856
Norwich School landscape painter. Studied under Crome, J.B. Ladbrooke and Stannard. Worked together with Henry Bright and Thomas Lound. Educated in Norwich; visited London 1847-8. Exhib. at RA 1847-55, and BI 1847-55. He painted rustic scenes of the Norwich type, and occasionally collaborated with the animal painter H.B. Willis. Hardie describes his watercolours as "unusually fresh and vigorous". Works by him are in Norwich Castle Mus.

'Willows by a Stream' sold at Sotheby's 12.3.69 for £800.

Bibl: AJ 1857, 62; Redgrave, Dict.; Cundall; W.F. Dickes *The Norwich School of Painters* 1905; VAM; DNB; Clifford; Hardie II 71 (pls. 66-7); H.A.E. Day *East Anglian Painters* 1969 III 105-21.

MIDWOOD, W.H. fl.1867-1871
Little-known genre painter, working in London in the 1860's and 70's. Although Midwood's work appears quite often on the art market, he only appears to have exhibited two works at SS between 1867 and 1871. His subjects are domestic scenes, sometimes humorous.

'The Tired Seamstress' sold at Sotheby's 8.1.69 for £620.

MILES, Arthur fl.1851-1880
Painter of portraits and genre, who exhibited from 1851-80, at the RA (from 1851-72), BI, and SS (77 works). Titles at the RA mostly include portraits (some in chalk), and also 'The Lost Kitten', and Trying his First Composition'. One of his portraits is in the NPG.

Bibl: NPG Illustrated List 1928.

MILES, G. Frank (George Francis) 1852-1891

Portrait, genre and marine painter. Exhib. 1874-87 at RA and GG. Specialised in female portraits. RA titles 'An Evening on Lough Muck, Connemara' 'Sea-Dreams' 'Sweet Doing Nothing' etc.

Probable price range £30-70

Bibl: DNB; Bryan; F. Harris, *My Life,* 1926 p.428 f.

MILES, Leonidas Clint fl.1860-1883

Landscape and architectural painter. Exhib. 1858-83 at SS, BI and RA. Titles at RA views of London e.g. 'Charing Cross from Trafalgar Square' and landscapes e.g. 'Moonrise' etc.

Probable price range £50-200.

MILES, Thomas Rose fl.1869-1888

Painter of landscapes and coastal scenes. Exhib. at RA 1877-88, and SS. Titles at RA 'Peel Harbour, Isle of Man' 'Daybreak during a Gale' 'Launch of the Lifeboat' etc.

'Rain Squall off North Foreland' sold at Bonham's 4.12.69 for £110.

***MILLAIS, Sir John Everett, Bt. PRA HRI HRCA** 1829-1896

Painter, watercolourist and illustrator. Came to London from Jersey with his parents in 1837. Entered Sass's School 1838; RA schools 1840. Exhib. his first work at the RA in 1846, at the age of 16. Won several prizes, including the Gold Medal for historical painting in 1847. While at the RA schools, formed a lasting friendship with Holman Hunt (q.v.). Together with Hunt and D.G. Rossetti (q.v.) he founded the Pre-Raphaelite Brotherhood in 1848-9. By the far the most accomplished painter of the Brotherhood, he produced most of its memorable masterpieces, such as 'Lorenzo and Isabella', 'Christ in the House of his Parents', 'Ophelia', 'Mariana', 'The Blind Girl' etc. His work was reviled by the critics, until Ruskin came to the rescue in 1851. In 1853 he was elected ARA, effectively dissolving the PRB. In the same year he went on the ill-fated trip to Scotland with John Ruskin and Effie, who he was to marry in 1855. About this time, he began to turn away from Pre-Raphaelite ideas, towards a more popular style. 'The Black Brunswicker' of 1860 marks a new departure in this direction. From then on he produced a succession of popular works which earned him greater success than any other English painter. Typical works of this period are 'Bubbles', 'Cherry Ripe', 'The North-West Passage', 'The Boyhood of Raleigh', 'Yeoman of the Guard', etc. He also became a fashionable society portrait painter, numbering Gladstone, Tennyson and Carlyle among his many famous sitters. By the 1880's his income was estimated at £30,000 a year. He also produced many fine illustrations for magazines such as *Good Words, Once a Week etc.* and many books. Exhib. at RA 1846-96, BI, NWS, GG and NG and elsewhere. Elected RA 1863. In 1885 he became the first English artist to be made a Baronet. Elected PRA 1896, but died a few months later. Although his late work is regarded by most critics as inferior to his great Pre-Raphaelite pictures, perhaps Ruskin's judgement was more just "whether he is good one year, or bad, he is always the most powerful of them all". Exhibitions of his work were held at the RA in 1898 and 1967. After his death three sales were held at Christie's, of his own work, engravings after them, and his private collection, on May 1, 1897, March 21, 1898 and July 2, 1898.

The last two major works to come on the market were 'Portrait of John Ruskin' sold at Christie's 16.7.65 for £25,200, and 'Peace Concluded' sold at Sotheby's 3.4.68 for £11,500. Other works have sold from about £1,000 to £9,000; smaller sketches and drawings can sell for under £1,000, particularly the works of his late period.

Bibl: Main Biographies – *J.G. Millais, Life and Letters of J.E.M.* 1899. A.L. Baldry *Sir J.E.M.* 1899. J.E. Reid *Sir J.E.M.* 1909

Other References –
Bryan; Binyon; Cundall; DNB; VAM; Bate; Ironside and Gere; Fredeman (for full bibliog.); Reynolds VP 62-4 and passim (pls. 40, 42); Mary Lutyens *Millais and the Ruskins* 1967; Cat. of the Millais Exhibition, RA 1967; Hardie III 124-5 (pls. 144-6); Maas 127-8 and passim (pls. p.125, 126, 128, 139, 149, 212, 214).

MILLAIS, William Henry 1828-1899

Landscape painter and watercolourist; brother of John Everett Millais (q.v.). Exhib. 1853-92 at RA, NWS and elsewhere. Titles at RA 'Beddington Park, Surrey' 'Sea View, Isle of Wight' 'Bamburgh Castle' etc. He and John are known to have collaborated on a few pictures, mostly in the 1850's period. William Henry lacked both the talent and energy of his brother, and his reputation has been completely eclipsed by the other's fame.

'Hayes Common' a joint work by W.H. and J.E. Millais, sold at Sotheby's 18.3.64 for £800.

Bibl: Bryan; for further references see under J.E. Millais.

MILLARD, Fred fl.1882-1893

Genre painter. Lived at Newlyn, Cornwall; presumably associated with the Newlyn school. Exhib. mainly at SS, also RA 1885-8 and elsewhere. Titles at RA 'The Convalescent' 'Bad News' 'Walls Have Ears'.

Probable price range £50-200

MILLER, Philip Homan ARHA fl.1877-1903

Irish painter of genre, portraits and literary subjects, who exhibited from 1877-1903, at the RA (from 1879-1903), SS and elsewhere. Titles at the RA include 'A Punjab Water-bottle', 'The Old Armchair', and 'Mariana in the Moated Grange', 1903. He became ARHA in 1890.

Probable price range £30-100.

Bibl: Strickland.

MILLER, William E. fl.1873-1903

London portrait painter. Exhib. 1873-1903 at RA, SS and elsewhere. Painted occasional figure subjects, e.g. 'A Little Royalist' 'A Girl's Head' etc.

Probable price range £20-50

Bibl: Poole, *Cat. of Portraits etc. at Oxford,* 1925, III

MILLETT, Francis David 1846-1912

American painter of genre, portraits and frescoes; also illustrator, medallist and travel writer. Pupil of J. van Lerius and N. de Keyser in Antwerp. Although American, he worked and exhibited frequently in London. Exhib. at RA from 1879, NG and elsewhere. Subjects mostly interiors with figures in vaguely historical costume. 'Between Two Fires' (RA 1892) was bought by the Chantrey Bequest. Died in the sinking of the *Titanic*.

Probable price range £100-300

Bibl: AJ 1893 p.27; Clement and Hutton; M. Fielding, *Dictionary of American Painting* 1926; Who's Who in America VI (1910-11); American Art Annual X (1913) 79 (obit); C.H. Caffin, *Story of American Painting,* 1905; S. Isham, *American Painting,* 1905.

MILLINGTON, James Heath 1799-1872

Irish portrait painter and miniaturist. Born in Cork. Lived mostly in Cork and Dublin. Exhib. at RA 1831-70, BI and SS. Painted some figure subjects, e.g. 'The Choice of Hercules' 'A Study of Moonlight'

'A Magdalene' etc. Was for a short time Curator of the School of Painting at the RA.

Probable price range £30-70

Bibl: Strickland; Redgrave, Dict.; DNB.

MILLNER, William Edward 1849-1895

Genre and animal painter. Lived and worked all his life in Gainsborough, Lincs. His father William Millner (1818-1870) was also a local artist and teacher. Exhib. at RA 1869-96, BI and SS. Titles at RA mostly rustic genre e.g. 'Labourers' 'Unyoking' 'Ploughing — Lincolnshire'. He also painted animals, especially horses. A number of his pictures can be seen in the Gainsborough Old Hall Museum. 'A Wayside Gossip' signed and dated 1873, is in the Tate Gallery.

'A Wayside Gossip' sold at Christie's 11.7.69 for £89.

MILLS, S.F. fl.1858-1882

Painter of genre, landscape, interiors and architectural subjects. Exhibited from 1858-82, at the RA (from 1858-80), SS and elsewhere, titles at the RA including 'A Centenarian', 'Lighting Up', 'Granny's Lesson', and 'Mending Nets'. For some time he was a master at the Metropolitan School of Art, Spitalfields. Three of his water-colours are in the VAM.

Probable price range £30-100

Bibl: VAM.

MINSHULL, R.T. fl.1866-1885

Liverpool genre painter. Exhib. at RA 1874-85, SS and elsewhere. Titles at RA mostly of children 'Baby's New Frock' 'Nursing Dolly' etc. and occasional landscapes 'The Hay Harvest' etc.

Probable price range £30-70

MITCHELL, Charles William fl.1876-1893

Newcastle genre painter. Exhib. at RA 1876-89, GG and NG. Titles at RA portraits, and some genre e.g. 'A Duet' 'Egyptian Dancing-Girl' 'Avide' etc.

Probable price range £30-100.

MOGFORD, John RI 1821-1885

Painter and watercolourist of coastal scenes. Born in London, of a Devonshire family. Studied at Government School of Design at Somerset House. Married a daughter of Francis Danby (q.v.). Exhib. at RA 1846-81, BI, SS, NWS (292 works), GG and elsewhere. Elected associate of RI 1866, member 1867. Specialised in painting rocks and cliffs; his work is sometimes similar in feeling to that of John Brett (q.v.). His studio sale was held at Christie's on Feb. 25, 1886.

'Sunset over a Lake' sold at Sotheby's 26.2.69 for £125.

Bibl: AJ 1885 p.382 Bryan; Cundall; DNB; VAM; Hardie III 81 (pl.102).

MOGFORD, Thomas 1800-1868

Exeter portrait, genre and landscape painter. Exhib. at RA 1838-54, BI and SS. Genre titles mostly country scenes e.g. 'Rustic Boy' 'The Love Letter' etc. Was well-known in Devonshire as a portrait painter. Also painted some highly detailed Pre-Raphaelite landscapes, mostly views in his native county. The obituary of the *Art Journal* states that although his early promise was not fulfilled, he left a small number of works which "for exquisite feeling in execution and truthfulness of effect, have rarely been equalled".

Probable price range £100-300

Bibl: AJ 1868 p.158; G. Pycroft *Art in Devonshire* Exeter 1883.

MOLE, John Henry VPRI 1814-1886

Landscape painter and watercolourist. Born in Alnwick, Northumberland. Worked as a clerk in solicitor's office in Newcastle, but gave it up for miniature painting. He exhibited miniatures at the RA in 1845, 1846 and 1879. Later he turned to landscape, particularly in watercolour, and exhib. at NWS (679 works), BI, SS, GG and elsewhere. Elected associate of the RI, member in 1848, and Vice-President in 1884. His studio sale was held at Christie's on Feb. 1, 1887.

'A Tale of the Sea' sold at Sotheby's 13.3.69 for £110. Usual range £30-70.

Bibl: AJ 1859 p.175; 1887, 63; Bryan; Cundall; Laing AG Newcastle, *Catalogue of Permanent Collection of Watercolour Drawings* 1939.

MOLTINO, Francis fl.1847-1867

Painter of coastal scenes, who exhibited from 1847-67, at the RA (from 1848-55), BI and SS; titles at the RA including 'Early Morning, Waiting for the Tide', 1850, 'View of the Thames, Battersea Old Mill', 1851 and 'Morning on Burgh Flats', 1853.

'The Ducal Palace, Venice' sold at Bonham's 9.10.69 for £100.

MONTAGUE, Alfred fl.1832-1883

Painter of landscapes, town views and coastal scenes. Exhib. at RA 1836-70, BI, SS (156 works) and elsewhere. Painted landscapes and coastal scenes in England, Holland and France. His town views in northern France and Belgium are similar to those of Henri Schafer (q.v.).

Prices in the 1968-9 season ranged from £100 to £260.

MONTAIGNE, William John fl.1839-1889 d.1902

Painter of historical subjects, portraits, landscapes, and some coastal scenes at Southwold and Porthleven. Pupil of the RA Schools at the same time as Millais. Exhibited from 1839-89, at the RA (1841-89), BI, SS and elsewhere, titles at the RA including 'Portrait of a Lady', 'How Queen Elizabeth Passed her Last Days', 'Farm Buildings at Ewelme, Oxon' and 'Jacobite Prisoners'.

Probable price range £30-70.

Bibl: Bryan; Wilson, Marine Painters.

MONTALBA, Miss Clara RWS 1842-1929

Landscape, topographical and marine painter, principally of Venetian subjects. Sister of Ellen and Hilda, painters, (q.v.) and of Henrietta, sculptor. Born in Cheltenham; studied for four years in Paris under Eugene Isabey. Travelled in France and especially Normandy. However, she felt most at home in Venice and lived there for many years, her principal works being paintings, in oil and water-colour, of interiors and exteriors of churches, shipping and views in Venice. Exhibited from 1866 at the RA, BI, SS, OWS (86 works), GG, NG and elsewhere, her more important works at the RA being 'San Marco' 1882, 'King Carnival' 1886, and 'The Port of Amsterdam'. A of OWS 1884; RWS 1892; she also belonged to various Continental art institutions including the Accademia di Belle Arti, Venice. The AJ said of her work: " 'Il Guardino Publico' stands foremost among the few redeeming features of the exhibition (OWS). In delicate perception of natural beauty the picture suggests the example of Corot. Like the great Frenchman, Miss Montalba strives to interpret the sadder moods of Nature — when the wind moves the water a little mournfully, and the outlines of the objects become uncertain in the filmy air."

Probable price range £100-400.

Bibl: AJ 1874 Jan; Clayton II Clara 226-7; Ellen 258; Clement and Hutton; Portfolio 1882 156; Connoisseur 84 (1929) 263 (obit); Who Was Who 1929-1940.

MONTALBA, Miss Ellen fl.1868-1902

Painter of portraits, landscape and genre, working in London and Venice. Younger sister of Clara (q.v.). Born in Bath; studied at the S. Kensington Schools. Exhibited from 1868-1902, at the RA (1872-1902), SS and elsewhere, titles at the RA including 'Spring' 1872, 'H.R.H. the Princess Louise' 1882, and 'A Posy from the Rialto', 1891. She travelled in France a good deal, but, like her sisters, preferred Venice and the scope its subjects gave her splendid colouring. Her life-size portraits were also painted with considerable power. She also occasionally drew illustrations for magazines.

Probable price range £50-200.

Bibl: See under Clara Montalba.

MONTALBA, Miss Hilda fl.1873-1903

Painter of landscape and genre, particularly scenes in Venice. Sister of Clara (q.v.). Exhibited from 1873-1903, at the RA (from 1876-1903), SS, GG, NG and elsewhere, titles at the RA including 'Early Spring' 1876 and 'Venetian Boy Unloading a Market Boat' 1880. Worked in London and Venice.

Probable price range £50-200.

MOODY, Miss Fannie (Mrs. Gilbert King) b.1861 fl.1885-1897

London animal painter. Daughter of F.W. Moody (q.v.). Pupil of J.T. Nettleship (q.v.). Exhib. at RA 1888-97, SS and elsewhere. Titles at RA all rather whimsical scenes of animal behaviour e.g. 'Professional Jealousy' 'A Question of Privilege' etc. She lived at 34, Lupus St, Pimlico, where she knew Rossetti, Hunt, Stephens, Annie Miller and others.

Probable price range £30-70.

Bibl: RA Pictures 1893, 1895;
The Artist Nov. 1899, p 121-30;
Diana Holman Hunt, *My Grandfather, His Wives and Loves,* 1969, p.247.

***MOODY, Francis Wollaston** 1824-1886

London genre and portrait painter. Exhib. at RA 1850-77, BI and SS. Instructor in decorative art at the South Kensington Museum (now V & A), where he painted several ceilings and lunettes. He also designed mosaics there and at the Bethnal Green Museum. He lived for a time in Pimlico where he knew Holman Hunt's model, Annie Miller. His best-known picture is 'A Scene in Chelsea Gardens' (RA 1858) in which the Chelsea pensioner portrayed is Annie Miller's father.

Probable price range £100-300; possibly more for scenes of London life.

Bibl: Reynolds VS 17, 82 (pl.56); Diana Holman Hunt, *My Grandfather, His Wives and Loves,* 1969, p.176, 188, 247.

MOON, C.T. fl.1837-1849

Painter of landscapes and coastal scenes in England and Italy, near Sorrento. Exhibited from 1837-49 at the RA, BI and SS.

Probable price range £30-70.

MOORE, A. Harvey fl.1874-1903, d.1905.

Landscape and marine painter, living in Putney and Leigh, Essex, who exhibited from 1874-1903, at the RA (from 1876-1903), SS, NG and elsewhere. One of his works is in the City Art Gallery Manchester — 'The Thames off Yantlett Creek, Kent'.

Probable price range £30-70.

Bibl: The Year's Art, 1906, 362.

***MOORE, Albert Joseph ARWS** 1841-1893

Neo-classical painter. Son of William Moore (q.v.)., and brother of

Henry Moore RA (q.v.). Exhib. at RA 1857-93, SS, OWS, GG, NG and elsewhere. After a brief period of Pre-Raphaelitism, he began to exhibit classical subjects in 1860's. His later work consists entirely of single Grecian figures, or groups of figures, carefully posed in an elaborate design. His prime interest was not subject-matter, but colour. Whistler admired, and was probably influenced by Moore's "genuine feeling for the juxtaposition and interrelation of colour". (Reynolds). In his exploration of colour relationships he would often repeat compositions, using different colour schemes. The titles of his pictures reveal his lack of interest in subject or anecdote e.g. 'Beads' 'Apples' 'The Dreamers' 'A Sofa' etc. As a monogram he used the Greek anthemion, which could be incorporated into the design of his pictures. This may well have given Whistler the idea of using his butterfly monogram. Like Leighton, Moore made careful studies and drawings for every figure in his pictures, first nude, then draped. He also made several colour sketches for each picture, and would sometimes complete these later, which accounts for the existence of many versions of the same composition.

The last work of any importance to appear was 'Sea-Shells' sold at Christie's 17.1.69 for £1,155.

Bibl: AJ 1881, p.160 ff; 1895, 48f; 1903, 33f (A.L. Baldry); 1904, 143f; 1909, 236; Portfolio 1870 p.4-6; Studio 3 (1894), 3 ff 46 ff; 31 (1904), 345 f; 62 (1914), 130 ff; Winter Number 1923/4, British Book Illustration; F. Wedmore, *Studies in English Art* 1880; A.L. Baldry, *AM, His Life and Works* 1894; DNB; Bryan; Reynolds VP 121-2 (pls. 82-4); Maas 187, (pls. p.186, 187, 203).

MOORE, Edwin 1813-1893

Watercolour painter, mainly of topographical and architectural subjects. Eldest son of William Moore (q.v.), by his first wife. Born in Birmingham. Studied watercolours under David Cox the Elder, and also under Samuel Prout. Exhibited from 1855-85, at the RA (1855-73), NWS, and elsewhere. Employed for many years as a watercolour teacher at York, especially by the Society of Friends in their schools there, from whom he received a pension after fifty-seven years work for them. Two of his works are in the Walker Art Gallery, Liverpool, (Cat. 1927, 131).

Probable price range £30-100.

Bibl: Bryan; DNB.

MOORE, George Belton 1805-1875

Painter of topographical and architectural subjects. Pupil of A.C. Pugin. Exhibited from 1830-70, at the RA (from 1830-59), BI, SS and elsewhere; at the RA chiefly pictures of foreign scenery, and his last work to be hung there was 'Monument of Lord Norris, Westminster Abbey', 1859. For some time he was Drawing Master at the Royal Military Academy, Woolwich, and at University College, London. He published two treatises *Perspective, its Principles and Practice,* 1850 and *The Principles of Colour applied to Decorative Art,* 1851.

Probable price range £50-200.

Bibl: AJ 1876, 47; Redgrave Dict.; DNB; Hardie III 13.

***MOORE, Henry RA RWS** 1831-1895

Marine painter and watercolourist. Son of William Moore (q.v.) and elder brother of Albert Joseph Moore (q.v.). Studied under his father; at the York School of Design; and at RA schools. At first painted landscapes and rural scenes, which show Pre-Raphaelite influence, but about 1857 turned to marine painting, for which he is best known. Exhib. at RA 1853-95, BI SS (174 works) OWS, GG, NG and elsewhere. Elected ARWS 1876 RWS 1880, ARA 1885, RA 1893. Moore has often been described as an imitator of J.C. Hook(q.v.), but although his colours are similar, his paintings of the sea for its own sake are quite different in approach from Hook's coastal scenes with

figures. Moore was one of the first painters to try and observe accurately the movement and moods of the sea. In his search for accuracy his technique became more fluid, and his colours more impressionistic. The artist closest to him in technique and ideas is the Scottish painter, William MacTaggart (q.v.). In the 1880's and 90's Moore was regarded as one of England's most important artists, and his work was exhibited throughout Europe.

'Summer Squall off Mare Head, Cornwall' sold at Parke-Bernet 12.3.69 for £251.

Bibl: AJ 1881 p.160ff; 1895, 280, 282; 1904, 143f; 1905, 159, 160; 1908, 352; 1909, 92; Portfolio 1887, 126; 1890, 88, 110; Studio Special Number, *British Marine Painting,* 1919, 15f; F. Maclean, *H.M.* 1905; Bryan; DNB; VAM; Cundall; Reynolds VP 153-4 (pl.104); Hardie III 81 (pl. 104); Maas 67-8 (pl. p.67).

MOORE, Miss Jennie fl.1877-1900
Painter of domestic genre and scriptural subjects, who exhibited from 1877-1900 at the RA, SS, NWS, NG and elsewhere. Titles at the RA include: 'Delilah' and 'Dreams' 1877, 'Sad Thoughts', 1879, 'Homeless Ragged and Tanned' 1880, and 'Mary, the Mother of Jesus', 1900.

Probable price range £30-70

MOORE, John Collingham 1829-1880
Painter of portraits, landscape and genre. Born at Gainsborough, the eldest son of William Moore (q.v.) by his second wife, and brother of Albert, Edwin and Henry (q.v.). Entered RA Schools in 1850, and up to 1857 he was occupied in portrait painting. In 1858 he went to Rome, and painted many views of the Roman Campagna, mostly in watercolour. Many of these were exhibited at the Dudley Gallery, e.g. 'Olive-trees near Tivoli', and 'The Shady Sadness of a Vale', which were simple and poetic in their treatment. In Rome in 1858 he met and became influenced by George Mason (q.v.). After 1872 Moore turned his attention chiefly to portraits of children, and often with extreme subtlety of colour and childish expression. He exhibited from 1852-81, at the RA (from 1852-80), BI, Dudley Gallery, GG, and elsewhere.

Probable price range £50-200.

Bibl: AJ 1880, 348 (obit); L'Art 22 (1880), 144; Bryan; DNB; VAM.

MOORE, Sidney fl.1879-1900
Landscape painter, who exhibited from 1879-1900, at the RA (from 1883-1900), SS (41 works) and elsewhere; titles at the RA including 'Among the Birches' 1883, 'Comin' thro' the Rye' 1889, and 'Near Pulborough' 1900.

Probable price range £30-70

MOORE, William 1790-1851
York portrait painter. Father of Albert Joseph (q.v.) Edwin (q.v.) Henry (q.v.) John Collingham (q.v.) and William Moore, Junior (q.v.). Painted portraits in oils, watercolours and pastel, for local patrons.

Probable price range £20-50

Bibl: Bryan; DNB

MOORE, William, Junior 1817-1909
Landscape painter, son of William Moore (q.v.) of York. Exhib. at RA 1855-61, NWS, and elsewhere. Painted in Yorkshire, the Lake District, Scotland, and Switzerland.

Probable price range £20-50

MORDECAI, Joseph b.1860, fl.1873-1899
London painter of portraits, genre and literary subjects. Studied at

the RA Schools. Exhibited from 1873-99, at the RA, SS and elsewhere, titles including 'A Nubian' 1873, and 'Day Dreams' 1888. One of his works is in the Leeds City Art Gallery ('The Minstrel's Curse' — depicting how a King murdered a Minstrel's son), and one in the Corporation of London Art Gallery.

Probable price range £30-70

Bibl: Cat. of Leeds City Art Gallery 1909; Cat. of Corporation of London Art Gallery 1910.

MORGAN, Alfred fl.1862-1904
Painter of still life, dead game, fruit and flowers, genre, portraits, landscape, historical and scriptural subjects. Exhibited from 1862-1904, at the RA (from 1864-1904), BI, SS, GG and elsewhere, titles at the RA including 'The Young Pretender' 1864, 'A Dead Pheasant' 1867, 'Baby's Nosegay' 1873, and 'Return of the Prodigal Son' 1902. Two of his paintings, 'Cat and Dead Pigeons' and 'Part of the Ruins of Whitby Abbey' are in the VAM. Also in the VAM is a reduced copy made by the artist of W. Etty's 'Youth at the Prow and Pleasure at the Helm'.

Probable price range £50-150.

Bibl: VAM *Catalogue of Oil Paintings* 1907.

MORGAN, Frederick ROI 1856-1927
Painter of child life, domestic genre, animals and portraits, who exhibited from 1865 at the RA, BI, SS, NWS, GG and elsewhere. Titles at the RA include 'Just Caught' 1868, 'The Doll's Tea Party', 1874, 'An Apple Gathering' 1880, and 'H.M. Queen Alexandra, Her Grandchildren and Dogs' 1902 (dogs by T.Blinks). Morgan's paintings of children were very popular and often reproduced. His works are in Leeds and Sheffield Art Galleries, and in the Walker Art Gallery, Liverpool.

'Grandfather's Birthday' sold at Anderson and Garland (Newcastle) 29.7.69 for £150.

Bibl: Connoisseur, 78 (1927) 104; The Year's Art 1928, 360; Reynolds VP 12; Pavière, Sporting Painters.

MORGAN, Mrs. Frederick See HAVERS, Miss Alice Mary

MORGAN, John RBA 1823-1886
Genre painter. Exhib. at SS (114 works) RA 1852-86 and BI. Many of his pictures are of children e.g. 'The Young Politician' 'Ginger Beer' 'Marbles', in the manner of Thomas Webster (q.v.). He also painted historical and biblical genre. Works by him are in the VAM, the Walker AG Liverpool, and the Guildhall. His studio sale was held at Christie's on March 1, 1887.

'A Loose Tooth' sold at Christie's 11.7.69 for £273.

MORGAN, Walter Jenks RBA RBSA 1847-1924
Painter of genre; illustrator. Born at Bilston; educated at Sir Robert Peel's School, Tamworth. Came to Birmingham, and apprenticed to Thomas Underwood, lithographer; studied also at the Birmingham School of Art and at the Birmingham Society of Artists; won a scholarship at the former which enabled him to study for three years at South Kensington. Painted in oils and watercolours and produced numerous drawings for book and magazine illustration; worked for *The Graphic, Illustrated London News, and* Messrs. Cassell and Co. Exhibited from 1876, at the RA (from 1879), SS, NWS, and elsewhere, titles at the RA including 'A Bit of Scandal, Algiers', 1879, 'A Fishermaid' 1882, and 'Going to the Hayfield' 1883. RBA, 1884; RBSA 1890. President of the Birmingham Art Circle and of the Midland Arts Club.

Probable price range £50-150.

Bibl: Birmingham Cat.

MORISON, Douglas 1810-1846 (DNB- 1814-1847).
Topographical watercolour painter and lithographer. Studied drawing
under Frederick Tayler, and practised chiefly in watercolours. Princi-
pally an architectural painter, but he also painted several views in
Scotland. A of RI in 1836, but resigned in 1838. In 1844 elected A of
OWS. He also practised in lithography, and published *The Eglinton
Tournament;* views of *Haddon Hall* 1842; *Views of the Ducal Palaces
of Saxe-Coburg and Gotha* 1846 (with notes and suggestions from the
Prince Consort). He made some sketches for the Queen at Windsor
and received several medals in recognition of his art. Exhibited from
1836-46, at the RA (from 1836-41), OWS and NWS, titles at the
RA including 'Melrose' 1836, 'Haddon Hall' and 'Chatsworth', 1841.

Probable price range £50-200.

Bibl: Roget; Bryan; Cundall; DNB.

MORLEY, George fl.1832-1863
Animal painter, who exhibited from 1832-63 at the RA and BI. He
was employed by Queen Victoria and Prince Albert to paint portraits
of their horses and dogs, and was also employed by other members of
the Royal Family, and by officers to paint pictures of their chargers.
Three of his works were in the Hutchinson Sporting Gallery.

Probable price range £100-300

Bibl: Pavière, Sporting Painters; Maas 78

MORLEY, Robert RBA 1857-1941
Painter of animal subjects, landscape, genre and historical subjects.
Lived in Frensham, Surrey and Stroud, Glos. Son of Professor Henry
Morley LLD. Educated at the Slade School under Poynter and
Legros, and afterwards at Munich and Rome. Was Slade Scholar and
Painting Medallist. Exhibited from 1879, at the RA (from 1884), SS
and elsewhere. At first he largely exhibited figure subjects but after
1888 turned to animal painting and landscape. RBA 1889; Hon. Secy.
RBA and subsequently Hon. Treasurer 1890-96. In 1921 he exhibited
at the Society of Animal Painters "half a dozen 'anecdotes' rendered
with his wonted taste for the whimsicalities of animal life!"; and in
1922 at the SBA 'The Manor Farm 1693' – "a sincere record of a
charming stone-built house".

*'Terrier and Tabby Cat on a Tennis Court' sold at Bonham's 4.12.69
for £120.*

Bibl: Connoisseur 58 (1920) 238; 60 (1921) 118; 63 (1922) 117 243;
Who Was Who 1941-1950;
Pavière, Sporting Painters.

MORNEWICK, Charles Augustus fl.1826-1875
Dover marine painter. Exhib. at RA in 1826 and 1831, also BI and SS.
Subjects mostly shipping off the south coast.

Probable price range £30-100

MORNEWICK, Charles Augustus Junior fl.1836-1874
Dover marine painter, son of Charles Augustus M. Exhib. at RA
1836-74, BI and SS. Subjects often storms or shipwrecks. Painted in
England and abroad.

Probable price range £20-50

MORNEWICK, Henry Claude fl.1827-1846
Dover marine painter, related to Charles Augustus Mornewick (q.v.).
Exhib. once at RA in 1846 'Fresh Gale off Dover', and once at BI
and SS.

Probable price range £20-50

MORRIS, Alfred fl.1853-1873
Deptford painter of genre, landscape and sporting subjects, who

exhibited from 1853-73, at the RA (1866 and 1870), BI, SS and
elsewhere. His RA exhibits were landscapes.

Probable price range £30-100.

MORRIS, Charles Greville RBA b.1861 fl.1886-1894
Manchester landscape painter. Born in Lancashire, studied in Paris under
M M. Bollinger, Collin and Courtois. Exhibited from 1886-94 at the
RA and elsewhere – all landscapes – titles including, 'Winter in
Finistère' 1887, 'Thistledown' 1889, and 'Evening, Cornwall' 1890.
He lived in St. Ives after 1892. One of his paintings – 'Marshland' –
is in the City Art Gallery, Manchester.

Probable price range £30-70

Bibl: RA Pictures 1893, 142.
City Art Gallery Manchester Cat. 1910.

MORRIS, Ebenezer Butler fl.1833-1863
Painter of historical and mythological subjects, portraits and genre, who
exhibited from 1833-63 at the RA, BI and SS. Titles at the RA in-
clude 'Horatius Returning in Triumph after his Victory over the
Curiatii' 1838, 'Apollo and the Muses' 1848, 'Maternal Affection'
1841, and 'John Knox and Mary, Queen of Scotland' 1852.

Probable price range £30-70

Bibl: Thomas Smith *Recollections of the B.I.* 1860 p.112 121-2.

MORRIS, J.C. fl.1851-1863
Painter of landscape, genre and animals, working in Greenwich and
Deptford, who exhibited from 1851-63, at the RA (from 1851-62),
BI, SS and elsewhere. Titles at the RA include 'A Sketch on the
Mountains, Argyllshire', 1856 and 'A Runaway at the Wrong Door',
1862. He was a pupil of T. Sidney Cooper, (q.v.). One of his
paintings, 'Sheep', 1859, is in Birmingham Art Gallery.

'Pastoral Landscape' sold at Christie's 13.6.69 for £158.

***MORRIS, Philip Richard RA 1836-1902**
Painter of genre and portraits. Born at Davenport. Entered RA schools
1855. He won two silver medals, and in 1858 the gold medal for a
historical picture 'The Good Samaritan'. Awarded a Travelling
Studentship; visited France and Italy. Exhib. at RA 1858-1901, BI,
SS, GG and elsewhere. Painted both historical and biblical genre,
and also domestic scenes. Later he turned almost entirely to portrait
painting. Retired as an RA in 1900.

'The Return of the Hostage' sold at Christie's 2.4.69 for £893.

Bibl: AJ 1868, p.200; 1872, 161-3; 1902, 231; Mag. of Art 1902, p.423 ff; RA
Pictures 1891-5; Bryan. DNB; E. Chesneau, *Art Anglaise Contemp.* 1887;
Champlin and Perkins, *Cyclop. of Painters,* 1888; A. Dayot, *La Peinture
Anglaise,* 1908.

MORRIS, William Bright b.1844 fl.1869-1900
Genre and portrait painter. Pupil of William Muckley (q.v.) in Man-
chester. Exhib. at RA 1869-1900, GG, NG and elsewhere. Travelled
in Italy and Spain, and painted mostly Spanish or Italian genre scenes.
He lived for a time in Capri and Granada – The AJ 1894 describes
him as "par excellence the painter of the patio".

'Two Highlanders with Dogs' sold at Sotheby's 3.6.64 for £100.

Bibl: AJ 1875, p.180; 1894, 283;
Academy Notes 1876, 1878-81;
Cat. of Art Gallery, Manchester, 1894 p.82.

MORRIS, W. Walker fl.1850-1867
Painter of genre and sporting subjects, who worked in Greenwich and
Deptford at the same address as J.C. Morris (q.v.). Exhibited from

1850-67 at the RA, BI and SS, titles at the RA including 'The Task' 1850, 'The Match Seller' 1851, and 'The Pets' 1854.

Two Boys with Pony and Dogs' sold at Bonham's 24.7.69 for £140.

MORRISH, Sydney S. fl.1852-1894
London painter of genre, landscape and portraits, who exhibited from 1852-94 at the RA, BI and SS. Titles at the RA include 'Fruit' 1852, 'A Welsh Interior' 1862, 'Reading to Grandmother' 1867, 'Homeless' 1872 and 'Harvesting in S.Devon' 1892.

Probable price range £30-70

Bibl: G. Pycroft, *Art in Devonshire* 1883, 97

MORRISON, Robert Edward RCA 1852-1925
Liverpool painter of portraits and genre. Born in Peel, Isle of Man. Member of the RCA and Liverpool Academy. Exhibited from 1883, at the RA (from 1884), SS, NWS and at many local exhibitions. The portraits listed and illustrated in *The Studio* are The Mayor of Birkenhead, 1915, and other portraits of professional men. His works are in the Walker Art Gallery, Liverpool, and Queen's College, Oxford.

Probable price range £30-70

Bibl: Studio 24 (1902) 136 (plate); 28 (1903) 209 (plate) 210; 63 (1915) 218; 66 (1916) 214;
Poole *Cat. of Portraits at Oxford University II* 1925 137;
Cat. Walker Art Gallery, Liverpool. 1927.

MORTON, Andrew 1802-1845
Portrait painter. Born in Newcastle-on-Tyne, son of Joseph Morton, master mariner, and elder brother of Thomas Morton (1813-49) the surgeon. Studied at the RA Schools, gaining a silver medal in 1821. Exhibited from 1821-45 at the RA, BI and SS. His art was entirely confined to portraiture, in which his style resembled that of Sir T. Lawrence. He had a large practice and many distinguished sitters. In the NPG are amongst others portraits of Sir James Cockburn, Marianna, Lady Cockburn and Marianna Augusta, Lady Hamilton; in Greenwich Hospital, a portrait of William IV.

Probable price range £50-200.

Bibl: Redgrave Dict; Capetown Art Gallery Cat. 1903-17; DNB.

MORTON, George fl.1879-1904
London painter of genre and portraits, who exhibited from 1879-1904, at the RA (1884-1904), SS, NWS, GG and elsewhere. Titles at the RA include 'The New Curate's First Audience' 1885, 'A Vegetarian' 1892, and 'Rivals' 1897.

Probable price range £30-70.

MOSCHELES, Felix Stone 1833-1917
Jewish portrait and genre painter; son of the composer Ignaz M. Studied under Jacob van Lerius, at the Antwerp Academy, where he met his friend George du Maurier (q.v.). Moscheles wrote a book about these early years — *In Bohemia with George du Maurier.* He often featured in du Maurier's cartoons. It was through him that du Maurier became interested in hypnotism. Worked as a portrait painter in Paris; came to London in 1861. Built up a successful portrait practice in London. and also painted sentimental genre scenes. Worked in Leipzig; also travelled in Spain and Algiers.

Probable price range £30-70.

Bibl: Chronicle des Arts 1917-19, p.84; Connoisseur 70 (1924) 117; 76 (1926) 63; Champlin-Perkins, *Cyclop. of Painters,* etc. 1888; Leonée Ormond, *George du Maurier* 1969 see index.

MOSELEY, R.S. fl.1862-1893
Painter of genre and animals, who exhibited from 1862-83 at the RA, (1863-80), BI, SS and elsewhere. Titles at the RA include 'Mutual Benefit' 1863, ' "If the Dog is Awake – why, the Shepherd may Sleep" ' 1870, and 'The Dog of the Alps' 1879.

Probable price range £30-70.

***MOTE, George William** 1832-1909
Landscape painter. A self-taught artist, he worked as gardener and caretaker to Sir Thomas Phillipps, the great manuscript collector, at Middle Hill, near Broadway, Worcestershire. His early pictures, mostly of the house and gardens at Middle Hill, are painted in a remarkably direct and evocative primitive style. He was fond of the device of painting a landscape through an open window. Later he became a full time artist, and exhib. at the RA 1857-73, BI, SS and elsewhere. He painted views in Surrey, Sussex and Wales, and occasional houses and gardens. His style became more accomplished but "he had lost some of the original intensity of his vision" (Maas). After 1877 he stopped exhibiting, and the quality of his work began to decline.

'View towards Middle Hill House' sold at Sotheby's 18.6.69 for £700.

Bibl: AJ 1909 p.94 (obit); Maas 229 (pl. p.229).

MOTTRAM, Charles Sim RBA fl.1876-1903
Painter of coastal scenes, who exhibited from 1876-1903, at the RA (1881-1903), SS, NWS, and elsewhere. Titles at the RA include 'A Cornish Sea', 1888, 'Gathering Clouds' 1887, and 'A Stiff Breeze off Godrevy, St. Ives' 1903.

Probable price range £30-70.

MUCKLEY, William Jabez RBA 1837-1905
Flower and still-life painter. Born in Audnam, Worcestershire. Studied in Birmingham, London and Paris. Exhib. at RA 1858-1904, BI, SS, NWS, GG and elsewhere. Worked as a teacher at the Government Schools in Wolverhampton and Manchester. His pictures are mostly large, showy vases of flowers, set in sumptuous interiors.

'Peonies in a Vase' sold at Christie's 18.10.68. for £198.

Bibl: RA Pictures 1892-3, 1895-6;
Handbook to the Permanent Coll. Manchester City AG 1910.

***MULLER, William James** 1812-1845
Painter and watercolourist. Born in Bristol, the son of a Prussian refugee. As a young man Muller was apprenticed to J.B. Pyne (q.v.), but the indentures were cancelled after two years. He painted in and around Bristol; visited Wales 1833. 1834-5 travelled up the Rhine to Switzerland, Venice, Florence and Rome. He made many drawings and sketches on his travels, which he later worked up into finished paintings. He was especially enthralled by Venice, of which he painted many of his best pictures. 1838-9 visited Greece, Egypt, Malta and Naples. 1839 moved to London; became member of Clipstone St. Society. 1840 visited N. France. 1843-4 Turkey with an archaeological expedition. Developed a heart condition and died aged only 33 in 1845. A sale of his works was held at Christie's on April 1-3, 1846. Muller exhib. at RA 1833-45, BI and SS. His style in both oil and watercolour was rapid, accurate and confident. "He does not often rise to the heights of creative intuition, but for sheer vitality and lucid expression he has rarely been surpassed" (Hardie). He is now best known for his Venetian and Middle Eastern scenes. Exhibitions of his work were held in Birmingham 1896, RA 1934 and Bristol 1962.

'The Grand Canal, Venice' sold at Sotheby's 16.10.68 for £9,200. A smaller version of the same composition sold at Christie's 11.10.69 for £4,725. Venetian subjects make the highest prices; small landscapes and sketches can still sell for £50-200 or thereabouts.

Bibl: AJ 1850 p.344; 1864, 293 ff; 1895, 154 ff; 1909, 274; Connoisseur 36 (1913) 101 ff; N.N. Solly, *Memoir of W.J.M.* 1875; Redgrave Dict. and Cent.; Roget; Bryan; Binyon; Cundall; DNB; Hughes; VAM; *A Letter from WJM,* OWS XXV 1947; Hardie III 55-63, (pls. 71-4); Maas 94-5 (pls. on p.48, 94 and 174).

*MULREADY, Augustus E. fl.1863-1880 d.1886

Genre painter, and member of the Cranbrook Colony, with Webster, F.D. Hardy, Horsley and G.B. O'Neill (q.v.). Exhib. at RA 1863-80. Painted London street scenes, especially of street urchins, flower-sellers and children. Titles at RA 'Uncared For' 'Stop my Hat' 'A Little Creditor' etc. One of the few artists to record without too much sentiment the everyday street scenes of Victorian life.

'Her first Earnings' sold at Christie's 6.3.70 for £315.

Bibl: Reynolds VP 37, 95 195 (pl.34); Maas 234 (pl. p.255).

*MULREADY, William RA 1786-1863

Genre painter. Born at Ennis, County Clare, Ireland, the son of a leather breeches maker. Moved to Dublin, then London. Showing a precocious talent for drawing, he entered the RA schools in 1800 at the age of 14. At first he attempted historical genre and landscape, without success. In 1807 he turned to Wilkie-style genre scenes, drawing inspiration from the Dutch masters of the seventeenth century. Meanwhile he supported his family by teaching, and painting theatrical scenery. He married a sister of John Varley, but they later separated. His first major success was 'The Fight Interrupted' at the RA 1816. This picture, now in the VAM, of a vicar stopping a fight between two boys, clearly shows the influence of Wilkie and Webster in style and subject. Its success set the course of Mulready's career. Elected ARA 1815, RA 1816. Exhib. at RA 1804-62, BI and SS. Later he developed a more personal technique, using a white ground and pure, luminous colours, anticipating the methods of the Pre-Raphaelites. Typical of his late style are 'Burchell and Sophia in the Hayfield' (Lord Northbrook Collection) and 'Choosing the Wedding-Dress' (VAM) of which Ruskin wrote they "remain in my mind as standards of English effort in rivalship with the best masters of Holland". One of his sons, William Mulready (Junior) (q.v.), was also a painter. His wife, Miss Elizabeth Varley, exhibited landscapes at the RA, BI and OWS 1811-19. His studio sale was held at Christie's on April 28, 1864.

'Rural Festival with Figures' sold at Warner, Sheppard and Wade (Leicester) 16.6.69 for £525.

Bibl: AJ 1863, p.166, 181, 210; 1864, 65 ff, 130 f; 1876, 136; Portfolio 1887, 23, 85-90, 119-25 (F.G. Stephens); Redgrave Dict. and Cent.; J. Ruskin, *Modern Painters;* also Academy Notes 1846-7, 1857, 1859; F.G. Stephens, *Memorials of W.M.* 1867; J. Dafforne, *Pictures and Biographical Sketch of W.M.* 1872; Roget; Binyon; Cundall; DNB; Strickland; VAM; Reynolds VS see index; W.M. Exhibition Catalogue, Bristol AG 1964; Reynolds VP 12, 14, 37, 60 (pls. 2-3); Hardie II 91, 98, 69, 156; Maas 107, 168 (pls. on p.106 and 167).

MULREADY, William, Junior b.1805 fl.1831-1842

Painter of dead game, son of William Mulready (q.v.). Exhib. at RA 1835-42, BI and SS.

Probable price range £30-70

MUNN, George Frederick RBA 1852-1907

American landscape and flower painter; sculptor. Born in Utica, New York. First studied under Charles Calverly, the sculptor, and later at the National Academy, New York. He came to England and entered the S. Kensington Schools, where he received a gold medal, the first awarded to an American, for a model in clay of the Farnese Hercules. At the RA Schools he received a silver medal for a life drawing; subsequently he was in the studio of George F. Watts (q.v.). in 1876. He painted and sketched in Brittany, and exhibited from 1875-86, at the RA (1877-86), SS, GG and elsewhere. Titles at the RA include

'Wallflowers' 1877, 'A Grey Day, Brittany' 1878, 'The Story of the Church' 1884 and 'On the Kennet' 1886. His flower paintings, especially, were much admired for their minute detail.

Probable price range £50-200

Bibl: Clement and Hutton; American Art Annual 6, 1907-8, 112; M. Fielding, *Dict. of American Painting,* 1926.

MURRAY, Charles Fairfax 1849-1919

Pre-Raphaelite painter. Worked for Morris & Co. Sent to Italy by Ruskin to copy Old Masters. His style and subject-matter are strongly imbued with the spirit of the Italian Renaissance, but with the additional overtones of Burne-Jones and Rossetti. Exhib. mainly at GG, also NG, RA in 1867 and 1871, and elsewhere. His output was not large, as he devoted most of his time to collecting. His drawings collection was famous; part of it was bought by Pierpoint Morgan; Birmingham, the Fitzwilliam and other museums were left the remainder. His own paintings can be seen in Birmingham and the Walker AG Liverpool.

Probable price range £100-300

Bibl: Bate.

MURRAY, Sir David RA HRSA RSW 1849-1933

Scottish landscape painter. Born in Glasgow. Spent eleven years in business before taking up painting. Elected ARSA 1881; moved to London 1882. Elected ARA 1891, RA 1905. Exhib. at RA from 1875, OWS, NWS, GG, RSA and elsewhere. His landscapes are realistic, and painted in a broad and vigorous style. Up to 1886 he painted in Scotland, but after that he found his subjects mostly in the south of England and the Continent. 'In the Country of Constable' (RA 1903) was bought by the Chantrey Bequest. At his death he left a bequest to the RA to encourage landscape painters.

'The Heat of the Day' sold at Christie's 2.4.69 for £189.

Bibl: AJ 1892, p.144-8; 1895-98 (illustrations); Caw 304-6 (pl. p.304).

MURRAY, Frank fl.1876-1899

London landscape and decorative painter, who exhibited from 1876-99, at the RA (1879-99), SS, NWS and elsewhere. Titles at the RA include 'Shipman's Land, E.London' 1879, 'A Dry Dock on the Thames' 1885, and 'Section, Decorative Frieze for Board Room, P & O Company' 1899.

Probable price range £40-150.

MURRAY, Mrs. Henry John RI 1815-1882
(Miss Elizabeth Heaphy)

Painter of portraits, genre and oriental subjects. Daughter of Thomas Heaphy (q.v.). Studied under her father, and taken by him to Rome where she drew from the antique, and attracted the attention and encouragement of Horace Vernet. In about 1835, when her father died, she left England for Malta to execute some commissions for Queen Adelaide. Her own book *Sixteen Years of an Artist's Life* gives an account of her career until some time after her marriage to Henry John Murray in 1846. He was then British Consul at Gibraltar and Mrs. Murray accompanied him as he moved to Tangiers and Constantinople. In Turkey she made sketches in the slave markets, and painted portraits of the various members of the foreign embassies, and in Greece she also painted portraits of the King and Queen. They then moved to America where she became very well known; she had many pupils and Clayton notes that "she may be said to have practically introduced watercolour painting of the modern school into the United States". She exhib. in London as Miss Heaphy from 1834-43 at the RA (portraits); and as Mrs. Murray from 1846-82, at the RA (1846 and 1847), SS, NWS (52 works), GG and elsewhere. RI in 1861.

Among her best pictures are 'The Eleventh Hour', 'A Spanish Letter Writer', 'The Best in the Market, Rome', 'Spanish Bolero Dancer', 'Ave Maria' and 'The White Rose'. Among her best portraits are ones of the Duke of Cambridge, Prince Demidoff, and Garibaldi, who was a personal friend. 'Just Awake' was her diploma picture at the RI.

Probable price range £100-300

Bibl: AJ 1859, 84; Gazette des Beaux Arts 2, 1859, 179; 6, 106; Elizabeth Murray, *Sixteen Years of an Artist's Life;* Clayton II, 111-116; Clement and Hutton; Bryan; Williamson, History of Portrait Miniatures, 1, 1904, 199; VAM.

MUSCHAMP, F. Sydney fl.1870-1903

London painter of genre, and historical and mythological subjects, who exhibited from 1870-1903, at the RA (from 1884-1903), SS and elsewhere. Titles at the RA include 'Scene from the "Merchant of Venice" ' 1884, 'The Winning of the Golden Fleece' 1894, and 'Circe' 1897.

'Harvest Time' sold at Bonham's 5.12.68 for £170.

MUSGRAVE, Thomas M. fl.1844-1862

London still-life painter, who exhibited from 1844-62, at the RA (in 1848 and 1853), BI and SS.

Probable price range £30-70

MUTRIE, Miss Annie Feray 1826-1893

Flower and fruit painter. Born in Manchester and studied at the Manchester School of Design under George Wallis. Exhibited from 1852-82 at the RA, BI and elsewhere. The truthfulness of her painting (and her sister's) was much admired by Ruskin, who continually praised her work, e.g. (Academy Notes, 1855),. "all these flower paintings are remarkable for very lovely, pure, and yet unobtrusive colour – perfectly tender and yet luscious, and a richness of petal texture that seems absolutely scented. The arrangement is always graceful – the backgrounds sometimes too faint. I wish this very accomplished artist would paint some banks of flowers in wild country, just as they grow, as she appears slightly in danger of falling into too artificial methods of grouping".

Probable price range £30-100.

Bibl: J. Ruskin, *Academy Notes,* 1855, 1856, 1857, 1858; Portfolio 1886, 43; 1893, Art Chron. p.XXIII; Clayton II 289; Clement and Hutton.

MUTRIE, Miss Martha Darley 1824-1885

Flower painter. Elder sister of Miss Annie Feray Mutrie (q.v.). Also studied under George Wallis at the Manchester School of Design, and had a similarly successful career as her sister. Exhibited from 1853-84, at the RA (from 1853-78), BI, NWS and elsewhere.

'Hollyhocks and Fuchsias in a Garden' sold at Christie's 14.4.67 for £105.

Bibl: See above.

NAFTEL, Miss Maude ARWS 1856-1890

London painter of flowers and landscape. Daughter of Paul Jacob Naftel (q.v.) by his second wife, and sister of Isabel Naftel (q.v.). Studied at the Slade School and under Carolus Duran in Paris. Exhib. from 1875-89, at the RA, OWS, NWS, GG, NG, and elsewhere. Titles

at the RA are mostly flower subjects, for which she was well known, and 'An Autumn Garden' and 'Sand Dunes near Boulogne'. Elected ARWS in 1887. She published a book on *Flowers and How to Paint Them.*

Probable price range £30-100

NAFTEL, Paul Jacob RWS 1817-1891

Guernsey painter of landscape. Born in Guernsey and lived the early part of his life there, and although he was self-taught, he was appointed Professor of Drawing at Elizabeth College. Settled in England in 1870 where he practised as a Drawing master, and among his pupils was Kate Prentice. He exhib. from 1850-91, prolifically at the OWS (689 works), and also at GG. A member of the OWS in 1856; RWS 1859. His subjects were, in his earlier days, the scenery of the Channel Islands, and later views in Britain and Italy. He also made designs to illustrate Ansted and Latham's book *The Channel Islands* 1862. His second wife was Isabel Oakley (q.v.). His works are in the VAM, Reading and Cardiff Museums. His studio sale was held at Christie's on April 6, 1892.

'Guernsey Coastal Scene' sold at Messenger, May & Baverstock 11.3.70 for £130.

Bibl: AJ 1891, 352; J. Ruskin *Academy Notes* 1856-1859; Clement and Hutton; The Year's Art 1892, 288; Cundall; DNB; VAM.

NAFTEL, Mrs. P.J. (Miss Isabel Oakley) fl.1857-1891

Guernsey painter of genre, landscape, flowers and portraits. Second wife of P.J. Naftel (q.v.), and youngest daughter of Octavius Oakley (q.v.). Exhib. from 1857-91, at the RA (1862-89), SS, NWS, GG, NG and elsewhere, titles at the RA including 'A Little Red Riding Hood' 1862, 'Musing' 1869, and 'A Sark Cottage' 1885.

Probable price range £30-70

NAISH, John George 1824-1905

Painter of genre, classical figures and nymphs etc., landscape and marine subjects, working in Midhurst, Ilfracombe and London. Studied at the RA Schools and exhib. from 1843-93 at the RA, BI, SS and elsewhere. From 1850-1 he studied in Paris, Bruges and Antwerp. In about 1860 he altered the style of his paintings, leaving the ideal and classical figures, (eg. 'The Water Nymph's Hymn to the Rising Sun' RA 1849), for marine subjects, mostly set on the Devonshire and Cornish coasts, (e.g. A Summer Sea – Scilly Islands' RA 1860). The AJ 1875 noted "Certainly there was no truer or finer combination of land and ocean among the pictures of that year than the view of the town ('Ilfracombe' RA 1870) in which the painter had been resident for some time" – it afterwards gained a gold medal at the Crystal Palace. The Walker Art Gallery Liverpool have some of his works.

Probable price range £50-150

Bibl: Clement and Hutton.

NALDER, James H. fl.1853-1881

Painter of genre and portraits, living in London and Wantage, who exhib. from 1853-81, at the RA (1856, '58 and '68), BI, SS and elsewhere. Titles at the RA include 'Portrait of a Lady' and 'A Pleasure Party on the Celebrated Shell Beach at Herm, a Little Island in the Channel' 1858.

Probable price range £30-70

NAPIER, John J. fl.1856-1876

London painter of portraits, who exhibited from 1856-76 at the RA and BI. The AJ comments on 'The Hon. Sir Samuel Cunard Bt. RA' 1859, "A life sized figure, seated, with a head and features full of vigorous intelligence".

Probable price range £20-50

Bibl: AJ 1859, 168.

NASH, Frederick RWS 1782-1856

Water-colour painter of architectural subjects and landscapes; architectural draughtsman; engraver and lithographer. Born in Lambeth, the son of a builder. Studied architectural drawing under Thomas Malton II; at the RA Schools from 1801; and was occasionally employed by Sir R. Smirke RA, the architect. For the first ten years he was almost fully occupied in supplying architectural drawings to be engraved in his own publications or in books issued by Britton and Ackerman. Exhib. from 1799-1856, at the RA (1799-1847), BI, SS, OWS, (472 works) and elsewhere. Member of OWS 1810; resigned in 1812, re-elected in 1824. Member of the Associated Artists in Water-colours, 1809. In 1807 he was appointed architectural draughtsman to the Society of Antiquaries. Turner called Nash the finest architectural painter of his day. He did not, however, only paint buildings. He accompanied De Wint on sketching excursions, eg. to Lincoln in 1810, and travelled much in France, Switzerland and Germany. His usual practice when sketching was to make three drawings of his subject, at morning, midday and evening. He also continued to paint elaborate church interiors at Westminster, Durham, Windsor and elsewhere. Amongst others, he illustrated Ackerman's *History of Westminster Abbey* 1810 and T. Pennant's *History of London* 1805, and his own published works include *A Series of Views, Interior and Exterior of the Collegiate Chapel of St. George at Windsor* 1805, *Twelve Views of the Antiquities of London* 1805-10, and *Picturesque Views of the City of Paris and its Environs* 1823.

'The Fleet bearing the Body of Lord Nelson seen off Greenwich' — chalk and wash — sold at Sotheby's 5.3.70 for £170.

Bibl: AJ 1857, 31, 61 (obituary); Redgrave, Dict; Roget; Binyon: Cundall; DNB (for full list of published works); Hughes; S.T. Prideaux *Aquatint Engraving* 1909; VAM; Hardie III 12, 16-17 (pl.20).

NASH, Joseph RWS 1808-1878

Topographical and architectural painter, architectural draughtsman and lithographer. Born at Great Marlow; son of a clergyman who kept a school at Croydon. Pupil of Augustus C. Pugin, under whom he became a skilful draughtsman especially in Gothic architecture, and with whom he went to Paris in 1829 to make drawings for *Paris and its Environs* 1830. He early practised lithography and lithographed the plates in Pugin's *Views Illustrative of Examples of Gothic Architecture* 1830. He also illustrated novels and books of poetry, and between 1834 and 1848 did plates for *The Keepsake* and other Annuals. Exhib. from 1831-79, at the RA (in 1863 and 1871), BI, OWS (276 works) and NWS, also 6 Drawings at the Paris Exhibition of 1855, when he was awarded an honourable mention. Elected A. of OWS in 1834; RWS 1842. His exhibits at the OWS were architectural subjects, mixed with designs from Shakespeare, Scott and Cervantes. His most typical works were nearly always the grand interiors of Tudor or Elizabethan mansions peopled with figures in bright costume. Knole, Hampton Court and Speke Hall were buildings he often depicted. His published works include *Architecture of the Middle Ages* 1838 (25 lithographs), *The Mansions of England in the Olden Time* 1839-49 (4 sets of 26 lithographs), *Scotland Delineated* 1847-54, and *Views of Windsor Castle* 1848.

'St. George's Chapel and Round Tower, Windsor' sold at Christie's 17.6.69 for £1050. Another view of Brasenose College, Oxford sold in the same sale for £682.

Bibl: AJ 1879, 73 (obit); Roget; Binyon; Cundall; DNB; Hughes; Studio Special Spring No 1915, *Old English Mansions*; VAM; Hardie III 93-4 (pl.118).

NASH, Joseph, Junior RI fl.1859-1893

London marine painter. Only son of Joseph Nash (q.v.). RI in 1886.

Exhibited from 1859-93, at the RA (1877-85), SS, NWS and elsewhere, titles at the RA including 'On the Sands "Hold On" ' 1878, and 'The Fisherman's Hospital, Gt. Yarmouth' 1885.

Probable price range £30-70

Bibl: DNB.

*NASMYTH, Patrick RBA 1786-1831

Landscape painter. Son of the Scottish landscape painter Alexander Nasmyth (1758-1840). Studied under his father, and came to London in 1807. Although his subject-matter was usually found in the country-side around London, his style was modelled on the Dutch seventeenth century artists, especially Hobbema. His landscapes are pleasing and conventional, and achieved considerable success in their day. He exhib. at the RA, BI, and SS, and was one of the founder members of the RBA. Nasmyth's works were forged in his own lifetime, and many of his brothers and sisters were also painters, which has led to much confusion about the family and their work. Alexander had 11 children, of whom Patrick was the eldest. Of the other 10 Jane (b.1788) Anne (b.1798) and Charlotte (b.1804) were all landscape painters. His other three daughters Barbara, Margaret and Elizabeth were also artists, but their work is so little known that it probably now goes unrecognised.

'A View of Inverary' sold at Christie's 2.4.69 for £6,300. This was a record price. The more usual range is £500-1,500.

Bibl: AJ 1908, p.36; Connoisseur 35 (1913) 75 ff; 53 (1919) 40; 73 (1925) 30, 51; Whitehall Review Apr. 1910 p.22 f; Portfolio 1887, p.143; Bryan; DNB; Caw 157-9 (pl. opp. p.158).

NEALE, John Preston 1780-1847

Painter of topographical and architectural subjects, insects, flowers and fruit; architectural draughtsman. His earliest works were drawings of insects, flowers and fruit (exhibited some of these at the RA, 1797-1803). He met John Varley in 1796, who became a lifelong friend, and together they published *The Picturesque Cabinet of Nature*, No. I 1796 (Neale etched and coloured the plates, Varley drew the landscapes; No.2 never appeared). For a time he was a clerk in the Post Office, but eventually resigned. His works were now topographical landscapes and to give them greater truth he studied architecture; some were in oil, but mostly they were in pen tinted with water-colour. He travelled through Great Britain making drawings of country seats and churches, which were later published. His most famous published works include: *History and Antiquities of the Abbey Church of St. Peter, Westminster* 1823 (text by E.W. Brayley); *Views of the Seats of Noblemen and Gentlemen in England, Wales, Scotland and Ireland* (1st series 6 vols. 1824; 2nd series 5 vols. 1824-9). He exhibited from 1797-1844 at the RA, BI, SS and OWS.

'A Panoramic View of Ipswich' sold at Christie's 17.6.69 for £273.

Bibl: Gent. Mag. 1847 ii 667; Redgrave Dict; Roget; J.H. Slater *Engravings and their Value* 1900; Bryan; Binyon; DNB (for list of Neale's topographical publications); S.T. Prideaux *Aquatint Engraving* 1909, 367, 460.

NESBITT, John 1831-1904

Edinburgh landscape and marine painter, who exhibited from 1870-1888 at the RA. Titles include 'After a Gale' 1870, and 'Looking East from the Roundell, Gullane' 1888. Caw writes: "The marines and shore-pieces of Messrs. J.D. Taylor, Andrew Black, John Nesbitt, J.D. Bell, Alexander Ballingall, and one or two more of somewhat similar age and standing, if unaffected in feeling, possess no qualities of technique or emotion calling for comment......" One of his works is in Glasgow Art Gallery.

Probable price range £30-70

Bibl: Caw 331.

NESFIELD, William Andrews RWS 1793-1881
Painter of landscape — chiefly waterfalls — and marines, in watercolour; landscape gardener. Son of the rector of Brancepeth, Durham; educated at Winchester, Trinity College, Cambridge and Woolwich. Entered the army in 1809, served in the Peninsular War and in Canada, and retired in 1816. He took up painting in watercolour — landscapes — and became well known for his paintings of waterfalls. Ruskin speaks of him as "Nesfield of the radiant cataract". He exhibited from 1823-51 at the OWS (91 works), the subjects being chiefly waterfalls in N. and S. Wales, Yorkshire and Scotland. In 1852 he retired from the OWS and took up the profession of landscape gardening. He helped to lay out several London parks, notably St. James's and Kew Gardens, and also planned gardens for leading house owners, such as at Trentham, Alnwick and Arundel Castle. He was the father of the architect William E. Nesfield.

Probable price range £50-200

Bibl: J. Ruskin, *Modern Painters*, I 1843; II 1846; Roget; Binyon; Cundall; DNB; Hughes; VAM; A. Bury, *William Andrews Nesfield*, OWS XXVII; Hardie III 28 (pl.37).

NETTLESHIP, John Trivett 1841-1902
Painter of animals and genre; illustrator; author. Born in Kettering; went to the Cathedral School, Durham; entered his father's solicitor's office; then he entered Heatherley's and the Slade School. His early work is in black and white, and often biblical scenes. He illustrated his friend Arthur W.E. O'Shaughnessy's *An Epic of Women* 1870 and Mrs. A. Cholmondeley's *Emblems* 1875. He did many sporting activities; boxed, and accompanied Sir Henry Cotton on a mountaineering expedition to the Alps. He then became an animal painter and studied at the Zoological Gardens. Exhibited from 1871-1901, at the RA (1874-1901), SS, NWS, GG, NG and elsewhere. In 1880 he was invited to India by the Gaekwar of Baroda, for whom he painted a cheetah hunt — 'The Last Leap but One' (RA 1881) as well as an equestrian portrait. In his later years he also used pastel. He was also an author and published *Essays on Robert Browning's Poetry* 1868 (3 editions, 3rd in 1895), and *George Morland and the Evolution from him of some Later Painters* 1898. Nettleship often painted animals in other people's pictures; for example, he did the pigeons in Henry Holiday's 'Dante and Beatrice'. His eldest daughter married Augustus John.

'The Last Leap but One' sold at Christie's 6.3.70 for £683.

Bibl: 1907, 251; Magazine of Art 1903, 75-9; DNB 2nd supp; Sir Henry Cotton *Indian and Home Memories* 1911.

NEWCOMBE, Frederick Clive 1847-1894
Liverpool landscape painter, chiefly in water-colour. His real name was Frederick Harrison Suker, and he adopted his pseudonym to distinguish him from his father John Suker and brother Arthur Suker, also painters. Studied at the Mount Street School of Art under John Finnie. Exhibited at the Liverpool Academy from 1867, and at the RA from 1875-87. His 'The Head of a Highland Glen' RA 1875, attracted the notice of Ruskin who described it as "the best study of torrent, including distant and near water, that I find in the rooms ...". Newcombe's earliest sketching-ground was at Bettws-y-Coed, and he afterwards worked in Scotland, Warwickshire, Devonshire and the Lake District. The last was his favourite, and in 1880 he made Keswick his head quarters. He died at Coniston.

Probable price range £30-100.

Bibl: AJ 1894, 125; J. Ruskin, *Academy Notes* 1875; Bryan.

NEWENHAM, Frederick 1807-1859
Painter of portraits and historical subjects. Born in Co. Cork; early in life he went to London where he painted portraits and historical subjects. In 1842 he was selected to paint a portrait of Queen Victoria for the Junior United Service Club, and also a companion portrait of the Prince Consort. Subsequently he became a fashionable painter of ladies' portraits. He exhibited at the RA from 1838-55 — mostly portraits, and at the BI from 1842-52 — subject pictures, and many very large in size. Titles include 'Arming for Battle' 1841; 'Jenny's Lament' 1849, 'Cromwell Dictating to Milton' 1850, and 'Princess Elizabeth Examined by the Council' 1852. One of his historical paintings is in Salford Museum.

Probable price range £30-70

Bibl: Gent. Mag. 1859 I 548; Redgrave, Dict; DNB; Strickland.

NEWTON, Alfred Pizzey/Pizzi RWS 1830-1883
Landscape painter, especially of mountain scenery, and mainly in watercolour. Born at Rayleigh, Essex; self-taught. His earliest works were painted in the Highlands of Scotland, and obtained the patronage of Queen Victoria when he was painting scenery near Inverlochy Castle. She selected him to paint a picture as a wedding present for the Princess Royal in 1858, and he also contributed some sketches for the royal album of drawings. Exhibited from 1855-83, at the RA (1855-81), SS, and especially at the OWS (249 works). He travelled in Italy (1862) and Greece (1882). Ruskin wrote on 'View in Argyllshire' (OWS 1858): "Let Mr. Newton but draw all the four sides of Ben Nevis as he has done this one, and nobody need ever go to the mountain again for the mere sake of seeing what it is like".

'A Village Church' — watercolour — sold Christie's 29.10.68 for £136.

Bibl: J. Ruskin, *Academy Notes* 1858, 1859; Portfolio 1870, 147; 1883; 225; The Year's Art 1884, 217; Roget; Bryan; Cundall; DNB; VAM.

NEWTON, Ann Mary (Mrs. Charles J.) 1832-1866
Painter of portraits, topographical landscapes and antiquities. Born in Rome, daughter of Joseph Severn (q.v.), then English Consul. Pupil of her father and George Richmond (q.v.), who lent her some of his portraits to copy and employed her for the same purpose. When she was 23 she went to Paris and studied under Ary Scheffer. While there she painted a watercolour portrait of the Countess of Elgin, which was much admired and gained her numerous commissions on her return to England, including some from the Queen. Exhibited at the RA from 1852-6 as Miss Mary Severn, and from 1864-5 as Ann Mary Newton. She married (Sir) Charles Newton, keeper of Classical Antiquities at the BM, and afterwards made drawings of the antiquities in the BM for her husband's books and lectures, and made many sketches accompanying him in Greece and Asia Minor.

Probable price range £30-100

Bibl: AJ 1866, 100; Redgrave, Dict; Clayton I 410; Bryan; DNB; S. Birkenhead, *Illustrious Friends*, 1965 see index.

NEWTON, John Edward RI fl.1835-1891
Liverpool painter of fruit and landscape, who exhibited at the RA (1862-1881), BI, SS, NWS and elsewhere. Titles at the RA include 'Inspection of the Morning's Sport' 1862, 'The Dragon-fly's Haunt' 1863 and 'Early Spring, Sowing Mangold' 1870. From 1856 to 1867 he lived in Liverpool, where he was a member of the Academy. In this period he painted in a highly detailed Pre-Raphaelite style, but after moving to London, he changed to a broader style. An interesting example of his Pre-Raphaelite style 'Mill on the Alleyne River, near Gresford, Denbighshire' is in the Walker AG Liverpool.

Probable price range £50-200. His early Pre-Raphaelite works would make more than this.

Bibl: Cundall 240; *The Taste of Yesterday* Cat. of Exhibition at Walker AG Liverpool, 1970, no.66 (with pl.).

NIBBS, Richard Henry c.1816-1893

London and Brighton painter of marines, landscapes, genre and battles. He lived in Brighton, painting numerous views in Sussex as well as scenes in France and Holland. In 1843 he painted a picture of Queen Victoria landing at Brighton. Exhibited from 1841-89, at the RA (1841-88), BI, SS and elsewhere, titles at the RA including 'Battles of Trafalgar and Nile' 1849, 'Newhaven Harbour, Sussex', and 'Brigantine Dropping out of Port'. The AJ wrote on 'Early Morning on the Coast, Bosham, Sussex' (BI 1860):- "The subject looks infinitely Dutch; it is difficult to believe that on the Sussex coast there is anything so primitive".

Prices during the 1968-9 season ranged from £105-310.

Bibl: AJ 1860, 79; Binyon; VAM; Wilson, Marine Painters.

NICHOL, Edwin fl.1876-1900

London landscape painter, who exhibited from 1876-1900, at the RA (from 1879-1900), SS and elsewhere. Titles at the RA include 'When the Summer Sun is Hot' 1886, and 'The Mill Stream' 1900.

Probable price range £30-70

NICHOLL, Andrew RHA 1804-1866

Irish landscape painter and illustrator. Born in Belfast, son of a boot-maker; apprenticed to a printer. Studied in London and subsequently worked in Dublin, where he exhibited in 1832 and was elected A of RHA in 1837; RHA 1860. In 1840 he settled in London. Exhibited from 1832-67, at the RA (1832-54), BI, SS, NWS and elsewhere, titles at the RA including 'Giant's Causeway' 1845 and 'The Fort of Colombo, Ceylon' 1849. In 1849 he went to Colombo as teacher of painting and drawing at the Colombo Academy. After living again in London, Belfast and Dublin, he finally returned to London. Some of his drawings were engraved and lithographed, and he also wrote some articles and poetry. William, his brother, (1794-1840), was also a landscape painter, and a Member of the Association of Artists at Belfast.

'Wild Flowers near a Coast' sold at Sotheby's 23.1.69 for £130.

Bibl: Binyon; Cundall; Strickland; VAM.

NICHOLL, Mrs. Samuel Joseph 1842-fl.1892
(Miss Agnès Rose Bouvier).

London painter of genre and flowers. Born in London, the youngest of a family of six, all artists. Her father was French, and the family travelled a good deal abroad. She first exhibited in 1860 in Birmingham, 'Sticks for Granny', the painting gaining several commissions for her. In 1868 she visited Germany and Venice. In 1874 she married the architect Samuel Joseph Nicholl. She exhibited as Agnès Rose Bouvier from 1866-74, at the RA (1871-4), SS, and elsewhere, and as Mrs. S.J. Nicholl from 1874-92, at the RA (1876-84), SS, NWS and elsewhere. Titles at the RA include 'Carry Me' 1871, 'Buttercups and Daisies' 1872, 'My Lady Carries Love within her Eyes', etc. 1884. She always painted in watercolour, her favourite subjects being young rustic girls and children, painted from the living model.

Probable price range £30-70

Bibl: Clayton II 34.

NICHOLL, William See NICHOLL, Andrew

NICHOLLS, Charles Wynne RHA 1831-1903

London painter of genre, historical subjects and landscape. Born in Dublin; studied at the Royal Dublin Society's Schools and at the RHA, and began to exhibit in 1859. A. of RHA in 1861; RHA 1869. Left Ireland in 1864 and lived in London, but continued to exhibit regularly in Dublin. Exhibited in London from 1855-86, at the RA (1866-81), BI, SS and elsewhere. Titles at the RA include 'The Tomb of Grace Darling' 1866, 'Lilies' 1878, and 'Relics of Trafalgar' 1881. He always found a ready sale for his pictures. His 'Tomb of Grace Darling' was engraved for the AJ in 1872.

Probable price range £50-150.

Bibl: Strickland.

***NICOL, Erskine RSA ARA 1825-1904**

Scottish painter of genre, often of a humorous character. Born at Leith. House-painter's apprentice; attended the Trustees' Academy 1838; went to Ireland 1846; received appointment in Dublin, and, during four years' residence there, found the material for a long series of paintings of the humorous side of Irish life. After he had settled in London in 1862 he still made a yearly journey to Ireland to study his subjects at first hand. Later when he could not travel so far he painted Scottish genre instead, at Pitlochry. ARSA, 1855; RSA 1859; ARA 1868. Exhib. in London from 1851 at the RA and BI. After 1885 he lived in retirement, living in Scotland and at Feltham, Middlesex, where he died.

'His Legal Adviser' sold at Christie's 2.4.69 for £368. Other prices ranged from £136 to £209.

Bibl: AJ 1870 65-7; 1893, 301; 1904, 170; Ruskin, Academy Notes 1875; Portfolio 1879, 61 f; 1887, 227; Caw; DNB; Bulletin Worcester Art Museum 17 (1926) 28; VAM; Reynolds VS 64 (pl. 30); Maas 116-7.

***NICOL, John Watson fl.1876-1924**

London painter of genre, historical subjects and portraits. Son of Erskine Nicol (q.v.). Follower of Pettie. Exhibited from 1876-1924 at the RA and elsewhere, titles at the RA including 'A Young Cavalier' 1877, 'Before Culloden' 1882, and 'Westward Ho!' 1901. The AJ 1884 illustrates 'Lochaber No More', the tragedy of a Highlander who has to leave his shepherd's life; and 1906 illustrates a brushwork drawing of an Arts and Crafts design, based on the tulip, for a book cover. Sheffield Museum has 'For Better, for Worse', (Rob Roy and the Bailie).

'If this be Vanity, who would be Wise?' sold at Christie's 5.6.70 for £179.

Bibl: AJ 1884, 348 (pl. 288); 1906, pl.150; *Gazette des Beaux Arts,* 1879 II 371; Caw 272.

***NICOL, William W. fl.1848-1864**

Genre painter. Lived in Worcester, Cheltenham, and later London. Exhib. at RA 1855-64, BI and elsewhere. Titles at RA 'The Recruit' 'Jack in the Box' 'He Doubts' etc. A picture by him is in York AG.

Probable price range £50-200

Bibl: AJ 1859, p.168.

NIEMANN, Edmund John 1813-1876

Painter of landscape, angling subjects and marines. Born at Islington, his father being German. Employed as a young man at Lloyds, but after 1839 he devoted himself to art, and settled at High Wycombe where he worked incessantly out of doors. Exhibited from 1844-72, at the RA, BI (1845-67), SS and elsewhere. He returned to London in 1848 for the foundation of the 'Free Exhibition' held in the Chinese Gallery at Hyde Park Corner. Later in 1850 this became the Portland Gallery, Regent St., of which he became Secretary. His paintings, often very large, illustrate every phase of nature. He often painted the

scenery of the Thames and of the Swale near Richmond in Yorkshire. They are characterised by great versatility, but have been described as at once dexterous and depressing. His son Edward H. Niemann (q.v.) closely imitated his style, and their work is often confused.

Prices during the 1968-9 season ranged from about £100 up to £480.

Bibl: AJ 1876, 203; 1877, 201-4 (monograph with pls.); G.H. Shepherd *Critical Catalogue of Some of the Principal Pictures Painted by Edmund John Niemann,* 1890; DNB; VAM; Wilson, Marine Painters; Pavière, Sporting Painters; Pavière, Landscape (pl.53).

NIEMANN, Edward H. fl.1863-1867
London landscape painter. Son of Edmund John Niemann (q.v.). Exhibited two landscapes at the BI in 1863 and '67. A landscape 'Near Maidstone, Kent' is in Birmingham Art Gallery. His style is very similar to that of his father, but coarser and broader in colour.

'View of Salisbury Cathedral' sold at Christie's 21.2.69 for £294.

NIGHTINGALE, Frederick C. fl.1865-1885
An amateur landscape painter, working in Wimbledon, who exhibited from 1865-85 at various galleries (not known). The VAM has a watercolour 'San Biagio, Venice' 1868.

Probable price range £20-50

Bibl: VAM.

NIGHTINGALE, Robert 1815-1895
Painter of sporting subjects, landscape, still life and portraits, working in Malden. Exhibited from 1847-74, at the RA and SS, titles at the RA including 'Portrait of a Lady' 1847, 'A Walk Round the Shrubberies' 1860 and 'Fruit' 1874. Nightingale painted many series of horse portraits for private patrons.

A group of horse portraits was sold at Christie's 21.7.67 for prices ranging from about £80 to £273.

NISBET, Mrs. M.H. fl.1908
Battersea painter of genre and imaginative subjects, not listed in Graves, Dict. or R. Acad. Two of her paintings, dated 1908, were exhib. at the Maas Gallery in 1969.

Probable price range £30-70

NISBET, Pollok Sinclair ARSA RWS 1848-1922
Edinburgh painter of landscape, architectural subjects and coastal scenes. Brother of R.B. Nisbet (q.v.). Exhibited in London at the RA in 1871 and 1884. ARSA in 1892. He travelled abroad — working in Italy, Spain, Morocco, Tunis and Algeria. His loch and glen pieces are rather formally handled and conventionally composed, and his best and most characteristic works are his paintings of market places, mosques and palaces in Morocco and Spain.

Four landscape studies sold at Christie's 15.10.69 for £189.

Bibl: RSA ed Charles Holme 1907; Caw 298.

NISBET, Robert Buchan RSA RBA RWS RI 1857-1942
Scottish landscape watercolour painter. Born in Edinburgh, son of a house painter. At first apprenticed in a shipping office, but took up painting in 1880; joined his brother Pollok Nisbet, (q.v.)., in Venice, and then studied in Edinburgh at the Board of Manufacturers' School and the RSA Life Class 1882-5, and in Paris under Bouguereau. Exhib. at the RSA from 1880; ARSA 1893, RSA 1902; and from 1888 at the RA, SS, OWS, NWS, GG and elsewhere. RWS 1887, RI 1892-1907. Founder member 1892 and second P of the Society of Scottish Artists. Hon-member of the R. Belgian Watercolour Society. His work

was always popular and much appreciated abroad. Hardie notes that his work was "similar to De Wint in broad contrasts of light and shade and in depth of low-toned masses, but his method was much less direct and spontaneous. Some of his small sketches are fresh and fluent but in larger work he was tempted into rubbing and scrubbing his colour".

Probable price range £50-200

Bibl: Studio 27 (1903) 135; Vol.37, 349; Vol.58, 66; Vol. 64, 60; Vol. 65, 102; Vol. 66, 106; Vol. 67, 58, 258; Vol. 68, 125 ff; Vol. 69, 98; Vol. 70, 44; VAM MSS Eleven letters to F.C. Torrey 1899-1909; RSA ed Charles Holme 1907 pl.XXX; Caw 312-13; Studio Winter No. 1917-18 'The Development of British Landscape Painting in Watercolour; VAM; Tate Cat; Hardie III 191 (pl.225).

NIXON, James Henry 1808-c.1850
London painter of genre and historical and scriptural subjects. Pupil of John Martin, history painter. Exhibited from 1830-47 at the RA, BI and SS, titles including 'Ingress Hall, Greenhithe, Kent' 1838, 'A French Peasant' 1844, 'The Convent' 1847. 'Queen Victoria's Progress to Guildhall on 9th November 1837', (exhib. RA 1838) is in the Guildhall Art Gallery.

Probable price range £50-200

Bibl: Guildhall Art Gallery Catalogue 1968, 17 (pl.23).

NOBLE, Miss Charlotte M. fl.1871-1892
London painter of domestic genre, who exhibited from 1871-92 at SS (41 works).

Probable price range £20-50

NOBLE, James RBA 1797-1879
London painter of genre and landscape who exhibited from 1829-78, at the RA (1829-55), BI and SS (156 works). Titles at the RA include 'The Truant' 1837, 'Dressed for the Masquerade' 1839, and 'Thoughtful Moments' 1855. For many years he was a member and Treasurer of the RBA. The AJ noted he was "chiefly a painter of figure subjects of a genre character, but he occasionally produced landscapes, principally views of Italian scenery in and about the Roman States..... one of his best works is 'Rembrandt Painting his Father's Portrait' (SS 1875)".

Probable price range £30-100

Bibl: AJ 1879, 156 (obit, called 'John').

NOBLE, James Campbell RSA 1846-1913
Scottish painter of landscape, portraits and rustic genre. Studied at the RSA Schools under Chalmers and McTaggart, and much influenced by the former. He began with rustic genre — dark cottage interiors, or idylls of country life painted out of doors. But once elected ARSA (1879; RSA 1892) he abandoned genre for landscape, scenes of shipping, rivers and ports, and pictures on the Medway, Tyne, Seine and Clyde. In the early 1880's he went to live at Coldingham and painted the rocky coast of Berwickshire. In 1900 he revisited Holland, and after that his most characteristic works were of Dutch waterways. He exhibited at the RA from 1880-96.

Probable price range £50-200

Bibl: Studio 44 (1908) 232; 58 (1913) 66; RSA ed. Charles Holme 1907; Caw 309-10, pl.310; The Year's Art, 1914, 445.

NOBLE, John Sargent RBA 1848-1896
London animal and sporting painter. Studied at the RA Schools and was a pupil of Landseer. Exhibited from 1866-95, at the RA (1871-95), SS and elsewhere, titles at the RA including 'Otter Hounds' 1876, 'Royal Captives' 1888 and 'Trusty Friends' 1890. The AJ illustrates 'Unwelcome Visitors' — "a family of donkeys receive a group of

geese, of whom one is evidently inclined to become impertinent."

Prices during the 1968-9 season ranged from about £100 to £200.

Bibl: AJ 1895, 220 (pl.); Pavière, Sporting Painters.

NOBLE, Robert RSA 1857-1917

Scottish landscape and genre painter. Born in Edinburgh; studied under his cousin James Campbell Noble (q.v.). at the Trustees' School and the RSA Life Class 1879-84, sharing the Keith Prize in 1882. He first attracted notice by a number of large cottage interiors with figures, deep-toned in their contrasting effects of light and shade, but about 1880, after studying in Paris under Carolus Duran, he turned to landscape, a development confirmed when he moved to East Linton, East Lothian. He exhibited at the RSA from 1877; ARSA 1892, RSA 1903; and at the RA, GG, NG and elsewhere, from 1889. He was a foundation member and first President of the Society of Scottish Artists 1892. Caw writes that "the scenery of his choice is a combination of sylvan and pastoral, and preferably the tree-fringed meadows, variously wooded watersides, rocky linns and foliage — embowered water-mills of the Haddingtonshire Tyne near East Linton, and in the later eighties, under the influence of Monticelli, whose art was so admirably represented in the Edinburgh Exhibition of 1886, he produced a series of pictures with brilliantly costumed figures amongst the blaze of the Tynninghame rhododendrons in full bloom". He is represented at the Tate Gallery by 'Dirleton Church, E. Lothian' 1912. His work is also in the National Gallery, Edinburgh. After his death a sale of his collection and his own works was held at Christie's on Dec. 7, 1917.

Probable price range £50-200

Bibl: AJ 1890, 159; Studio 58 (1913) 66; 64 (1915), 60; 65 (1915) 100 ff; 68 (1916) 125; 70. (1917) 44; 73 (1918) 73; 92 (1926) 53; Charles Holme *RSA* 1907; Caw 310-1; Charles Holme *Sketching Grounds* 1909, 71-6, 81; Connoisseur 55 (1919), 99; Tate Cat.

NOBLE, Robert Heysham RBA fl.1821-1861

London painter of landscape and coastal scenes, who exhibited from 1821-61 at the RA (1821-3), BI and SS. He specialized in coastal scenes, many executed at Hastings and in Lancashire.

Probable price range £30-70

Bibl: Wilson, Marine Painters.

NOBLE, R.P. fl.1836-1861

London landscape painter, who exhibited from 1836-61, at the RA (1836-60), BI, SS and elsewhere. Titles at the RA — all landscapes — include 'An Old House near Guildford' 1844, and 'A Mill by the Conway River' 1853. Two of his watercolours are in Birmingham Art Gallery and the National Gallery.

Probable price range £30-70

NORBURY, Richard RCA 1815-1886

Liverpool painter of portraits and historical subjects; illustrator; engraver; sculptor. Born in Macclesfield; held successively the posts of assistant master to the Schools of Design at Somerset House and Liverpool. Elected P of the Liverpool Watercolour Society. Member of the Liverpool and Cambrian Academies. Painted a large number of portraits, and was also much involved in decorative design and book illustration. Exhibited from 1852-78 at the RA, SS and elsewhere, titles at the RA including 'St. John and the Virgin Mary Returning from the Crucifixion' 1853, and 'Caractacus Leaving Britain a Prisoner' 1860. One of his paintings is in the Walker Art Gallery, Liverpool.

Probable price range £30-70.

Bibl: Bryan.

NORIE, Orlando fl.1876-1889

London painter of battles, who exhibited from 1876-89, at the RA (in 1882 and 1884), NWS and elsewhere. Titles at the RA are 'Battle of Ulundi' 1882, and 'Tel-el-Kebeer' 1884. He also did many watercolour studies of military uniforms.

Usual price range £50-150, although fine or rare items can make up to £400-500.

NORMAN, Philip FSA fl.1876-1904

London landscape painter, who exhibited from 1876-1904, at the RA (1877-1904), SS, NWS, GG, NG and elsewhere, titles at the RA including 'The Thames at Rotherhithe' 1881, and 'The Red Cow Inn and Dr. Burney's House, Hammersmith Road' 1904. The VAM has a collection of his drawings of Old London.

Probable price range £30-70

Bibl: VAM.

NORMAND, Ernest 1857-1923

Painter of historical subjects, genre and portraits, living in Upper Norwood and London. Studied at the RA Schools 1880-3, under Pettie, and in Paris under Constant and Lefebvre in 1890. Exhib. from 1881 onwards at the RA, NG and elsewhere, titles at the RA including 'A Study of Eastern Colour' 1882, 'Pygmalion and Galatea' 1886, and 'Mordecai Refusing to do Reverence to Hamon' 1892. His paintings are in Bristol, Oldham, Southport and Sunderland Art Galleries. In 1884 he married the painter Henrietta Rae (q.v.).

Probable price range £30-100

Bibl: See NORMAND, Mrs. Ernest.

NORMAND, Mrs. Ernest (Miss Henrietta Rae) 1859-1928

Painter of classical and literary subjects, portraits and genre. Married Ernest Normand (q.v.) in 1884. Began to study art at the age of thirteen, and was a pupil at Heatherley's and at the RA Schools. Medallist at Paris and Chicago Universal Exhibitions. Exhib. from 1881 at the RA, GG, NG and elsewhere. Her principal paintings are: 'Ariadne' 1885; 'Ophelia' 1890, (Liverpool, Walker Art Gallery); 'Flowers Plucked and Cast Aside', 1892; 'Sir Richard Whittington and his Charities' 1900 (fresco for the Royal Exchange); 'Portrait of Lady Tenterden, and Echo' 1906, 'Hylas and the Water Nymphs', 1910 etc.

Probable price range £30-100

Bibl: AJ 1901, 137-41, 302-7; Magazine of Arts 1901, 134 ff; A Fish *Henrietta Rae* 1906; Who Was Who 1916-1928.

*NORTH, John William ARA RWS 1842-1924

Painter of landscape and genre; illustrator and wood-engraver. Born at Walham Green. Studied at the Marlborough House School of Art; apprenticed to J.W. Whymper as a wood-engraver in 1860, working with F.Walker, Pinwell and Charles Green. An intimate friend of F. Walker, whose art he influenced and who sometimes drew figures in North's paintings. R.W. Macbeth, A.B. Houghton and Cecil Lawson belonged to the same group of artists. 1862-6 employed by the Dalziel Bros, and his landscapes may be seen in *Wayside Posies*, 1867, and other publications of this period. Drew illustrations for *Once a Week, Good Words, The Sunday Magazine* etc. Exhibited from 1865 at the RA, (from 1869) OWS, GG, NG and elsewhere. 1871 A of OWS; 1883 RWS; 1893 ARA. Member of the Royal West of England Academy. From 1868 he lived at Halsway Farm, Washford, Somerset. He travelled to Algiers with Walker. Hardie notes that his landscapes reveal "an almost scientific search for detail in the tangled luxuriance of orchard and copse. He was interested in effects of light, and his method to express shimmering atmosphere can be compared to 'pointillisme' ". He preferred landscape to figures, and was inclined to avoid them, sometimes inducing Walker to put one in

for him. He spent years of his life in the unremunerative commercial venture of producing a pure linen 'OW' paper.

'Gossips in a Farmyard' – watercolour – sold at Christie's 21.10.69 for £115.

Bibl: J. Pennell, *Modern Illustrators* 1895; R.D. Sketchley *English Book Illustration of Today* 1903; The Studio Winter No. *British Book Illustrations* 1923-4 27 f 82; Apollo I (1925) 126; Connoisseur 71, (1925) 112; VAM; Gleeson White; H. Alexander *John William North* OWS V 1927; Hardie I 27 n; III 137-8 (pl.158) and passim; Maas 235 (pl.235).

NORTON, Benjamin Cam fl.1862

Sheffield landscape painter who exhibited two paintings at the BI in 1862, 'Shades of Evening, Waiting for the Drover', and 'The Random Shot'. He also painted horse portraits, and other sporting subjects, working for private patrons in the Midlands.

'Correy Boy' with jockey up, and 'Thilbais' on a racecourse – a pair, sold at Christie's 3.4.69 for £200.

NOWLAN, Frank c.1835-1919

Painter of genre and portraits. Born in County Dublin; came to London in 1857 and studied at Leigh's School, where he became a friend of F. Walker. Nowlan's portrait by Walker (1858) is at the BM. He afterwards studied from the life at the Langham School of Art. He painted in oil and watercolour and occasionally in enamel; he also painted some miniatures and had a considerable reputation as a restorer of miniatures. He was employed by Queen Victoria, King Edward VII, and other members of the Royal Family. He exhibited from 1866-1918, at the RA (1873-78), SS, RS of Miniature Painters, and elsewhere, titles at the RA including 'Our Beauty' 1873, 'An Interesting Story' 1876, and 'Art Critics' 1878. He devoted much time to the invention and patenting of unforgeable cheques. Two watercolours, 'Lady Wearing a Lace Veil and Holding a Fan', and 'Head of a Girl Wearing a Yellow Headdress' are in the VAM.

Probable price range £30-70

Bibl: VAM.

NOWELL, Arthur T. RI RP 1861-1940

Painter of portraits, landscape, genre and literary subjects. Educated at Dudley and Bury Grammar Schools; Manchester School of Arts, and the RA Schools where he won Gold Medals in Landscape and Historical Painting. Travelled throughout the Continent. Lived in Runcorn and London. Exhibited from 1881 at the RA, NWS, NG, R.S. of Portrait Painters, and elsewhere, titles at the RA including 'Quiet Pleasures' 1881, 'Flora and Zephyr' 1903, and 'Isabella and the Pot of Basil' 1904. He exhibited 'Pandora' at the NWS in 1917, which was noted by *The Connoisseur*: "Mr. A.T. Nowell's 'Pandora' introduced us to a classically draped figure set in an environment of statuary and marble such as Alma Tadema often painted. Mr. Nowell's art is, however, more personal than that of the great Anglo-Dutch painter, and in the resonant blue of the draperies, accentuated by the contrast of the white sunlit stonework, he has struck an individual note, which makes the work interesting as a colour-scheme as well as for its finished technique and archaeological detail."

Probable price range £30-100

Bibl: Connoisseur 39 (1914) 274; 48 (1917) 55; 49 (1917) 172; 66 (1923) 46; Burlington Mag. 39 (1921) 312; American Art News 20 (1921-2) No. 9, 9; No. 15, 5; 21 (1922-3) No. 33, 1; Art News 22 (1923-4) No. 9, 6; 24 (1925-6) No. 10 1; Who Was Who 1929-40.

NOYES, Miss Dora fl.1883-1903

Painter of genre, landscapes and portraits, working in London, Salisbury and Torquay, who exhibited from 1883-1903 at the RA, SS, NWS, GG and NG. Titles at the RA include 'An Old Fatalist' 1883, 'Sea Poppies' 1889, and 'Two at a Stile' 1894.

Probable price range £30-70

NURSEY, Claude Lorraine 1820-1873

Landscape and marine painter. Born in Woodbridge, Suffolk. After practising for a short time as a landscape painter at Ipswich, he went through a course of training in the Central School of Design, Somerset House, and in 1846 was appointed Master of the Leeds School of Design. While there he superintended the establishment of a similar school at Bradford. In 1849 he moved to the Belfast School, until about 1855 when he transferred to the School at Norwich. While in Belfast he was successful in interesting the local manufacturers in the subject of industrial art. For some time he was Secretary of the Norwich Fine Arts Association. Exhibited from 1844-71 at the BI and SS, and at the RHA in 1853 and 1854. He painted a picture of the local Volunteers on the rifle-range on Mousehold Heath, Norwich, containing portraits of the officers.

Probable price range £30-70

Bibl: Strickland; Pavière, Landscape.

*OAKES, John Wright ARA 1820-1887

Liverpool landscape painter. Began to exhibit at Liverpool Academy in 1839; at BI 1847; and at RA 1848. Elected Associate of Liverpool Academy 1847; Secretary 1853-5. 1859 moved to London. Exhib. at RA 1848-88, BI, SS, NWS and elsewhere. He mostly painted in N. Wales; also made a tour of Switzerland. His landscapes are naturalistic, in the tradition of Leader and Vicat Cole, but he often attempted Turneresque effects of light and sky. Elected ARA 1876.

'River Scene near Porchester Castle' sold at Christie's 6.6.69 for £147.

Bibl: AJ 1879, 193-6; 1887, 287 (obit); Portfolio 1887 186 (obit); Bryan; DNB; Marillier 182-8 (pl. p.186)

OAKLEY, Miss Isabel See NAFTEL, Mrs. P.J.

OAKLEY, Octavius RWS 1800-1867

Derbyshire portrait and rustic genre painter, mainly in watercolour. Worked for a cloth manufacturer near Leeds, and gradually built up a reputation as a portrait artist. Worked in Leamington, then settled in Derby. Among his many aristocratic patrons were the Duke of Devonshire and Sir George Sitwell of Renishaw. Exhib. at RA 1826-60, OWS and elsewhere. Came to London about 1841; elected ARWS 1842, RWS 1844. In addition to portraits, he painted many landscapes with rustic figures and gipsies, which earned him the nickname of "Gipsy Oakley".

'Gipsy Encampment' – watercolour – sold at Christie's 22.1.65 for £52.

Bibl: Redgrave, Dict; Roget; Bryan; Cundall; VAM; Hardie III 97-8 (pl.123)

*O'CONNOR, John RI RHA 1830-1889

Irish topographical painter and watercolourist. Worked in Belfast and Dublin as a painter of theatrical scenery. Came to London 1848, and was principal scene-painter at Drury Lane and the Haymarket from 1863-1878. About 1855 he began to paint topographical views, which he exhib. at RA 1857-88, BI, SS, NWS, GG and elsewhere. He travelled in Germany, Italy, Spain and India, painting towns and buildings.

Probable price range £100-500.

Bibl: DNB; Cundall; Strickland

OGILVIE, Frederick D. fl.1875-1886
North Shields marine painter. Very little known. Exhib. 2 works at SS, and occasionally elsewhere.

Probable price range £20-50.

O'KELLY, Aloysius C. b.1853 fl.1876-1892
Genre and landscape painter. Born in Dublin. Studied under Bonnat and Gérôme in Paris. Lived in London and New York. Exhib. at RA 1876-91, SS, NWS and elsewhere. Painted genre scenes in Ireland and Brittany, but after 1886 all his pictures at the RA were Egyptian views and Arab genre.

'Religious Procession' sold at Parke-Bernet 20.2.69 for £102.

Bibl: M. Fielding, *Dictionary of American Painters* 1926; American Art Annual

OLDMEADOW, F.A. fl.1840-1851
Bushey sporting painter. Exhib. at RA 1840-51. Titles at RA mostly horse portraits. Worked for the Duke of Westminster at Moor Park.

Probable price range £30-100.

OLIVER, Robert Dudley 1883-1899
London portrait and genre painter. Exhib. at RA 1883-99. Genre titles at RA 'The Chatelaine' 'House and Studio, Holland Park'. etc.

Probable price range £30-70.

OLIVER, William RI 1804-1853
Landscape painter and watercolourist. Exhib. at RA 1835-53, BI, SS, NWS and elsewhere. Painted views in England, France, Italy and Switzerland; especially fond of the Pyrenees. Works by him are in the VAM, Sheffield and Sunderland AG. His wife Emma (q.v.) was also a painter.

Prices during the 1968-9 season ranged from about £100-280.

Bibl: Redgrave, Dict.; DNB

OLIVER, Mrs. William RI (Miss Emma Eburne) 1819-1885
Landscape painter and watercolourist. Pupil of her husband William (q.v.) who she married in 1840. Like him, she painted views in England and on the Continent. Exhib. at RA 1842-68, BI, SS, NWS and elsewhere. After the death of her husband in 1853, she married John Sedgwick.

'River Landscape' sold at Sotheby's 17.6.70 for £350.

Bibl: See under William Oliver

OLSSON, Julius RBA 1864-1942
Painter of coastal scenes and landscapes. Born in London; his father was Swedish, his mother English. Exhib. at RA from 1890, SS, GG, NEAC and elsewhere. Most of his works are coastal scenes and sea studies in the late impressionistic style of Henry Moore (q.v.).

'View of Stockholm in Winter' sold at Christie's 1.8.63 for £115.

Bibl: AJ 1905 p.356; 1907, 194; 1909, 268; Studio See Index 1909-15; Connoisseur See Index 1915-24; Who's Who.

***O'NEIL, Henry Nelson ARA** 1817-1880
Historical genre painter. Born in St. Petersburg. Friend and fellow-student of Alfred Elmore (q.v.) with whom he travelled in Italy. As a young man he was a member of the Clique (q.v.) and his ambition was to paint incidents to strike the feelings. Most of his work was historical and literary genre, but he scored his greatest success with a contemporary scene, 'Eastward Ho' (RA 1857) followed by 'Home Again' (RA 1859). Exhib. at RA 1838-79, BI and SS. Elected ARA 1879. None of his later works achieved the same success as 'Eastward Ho'. Although a clever and sociable man, his contemporaries felt that his talents

were so varied as to prevent him becoming a first-rate artist. His studio sale was held at Christie's on June 18, 1880.

'Going to the Masked Ball' sold at Bonham's 2.10.69 for £240.

Bibl: AJ 1864 p.40; 1880, 171 (obit); Redgrave; Cent; F. van Boetticher, *Malerwerke des 19. Jahrh*, 1898; Bryan; DNB; Reynolds VS passim (pls. 69-70); Reynolds VP 29, 31, 37 (pl.17); Maas 13, 104, 97, 115-16 (pl. p.115); Derek Hudson, *Billiards at the Garrick in 1869,* Connoisseur Dec. 1969.

***O'NEILL, George Bernard** 1828-1917
Genre painter. Born in Dublin. Exhib. at the RA from 1847. Although little is known of his life, he was a prolific and charming painter of small genre scenes, often of children. His style has an affinity with those of Webster and F.D. Hardy (q.v.); he was associated with both artists in the Cranbrook Colony (q.v.). One of his best-known works is 'Public Opinion' (RA 1863) now in the Leeds City AG.
'Children's Party', sold at Sotheby's 17.2.71 for £4,500. This is the current auction record. Usual range is still £300-£700.
Bibl: AJ 1864 p.260 (plate); Reynolds VS 54, 67 (pl.34); Reynolds VP 36-7 (pl.33); Maas 234.

OPIE, Edward 1810-1894
Genre painter. Great-nephew of the portrait painter John Opie. Pupil of H.P. Briggs (q.v.). Worked mainly in London and Plymouth. Exhib. at RA 1839-86, and once at SS. Subjects mostly rustic genre, some historical genre (Civil War period) and portraits.

Probable price range £30-70.

Bibl: Connoisseur 84 (1929) 164-71 (Recollections by E.Opie)

***ORCHARDSON, Sir William Quiller RA** 1832-1910
Scottish genre painter. Born in Edinburgh. Pupil of R.S. Lauder. Among his fellow-pupils were John Pettie (q.v.) and Tom Graham (q.v.) with whom he later shared lodgings in London. Came to London in 1862. Exhib. at RA from 1863, and at BI, GG, NG and elsewhere. Elected ARA 1868, RA 1877. At first he painted historical genre, choosing subjects mainly from Shakespeare and Scott. Later he turned to psychological dramas of upper-class life, such as 'Le Mariage de Convenance' and 'The First Cloud', for which he is now best known. His grouping of figures, and feeling for the value of empty spaces, gives his pictures a theatrical air. His technique was equally refined and distinctive. He used deliberately muted colours — mostly yellow and brown — "as harmonious as the wrong side of an old tapestry" (Chesneau). He was also a distinguished portrait painter, and illustrator. He worked mainly for the magazine *Good Words.* His studio sale was held at Christie's on May 27, 1910.

'Mrs. Siddons in Sir Joshua Reynolds' Studio' sold at Sotheby's 12.3.69 for £420.

Bibl: AJ 1867, 212; 1870, 233 ff; 1894, 33 ff; W. Armstrong *The Art of W.Q.O.* (Portfolio Mono.) 1895 repr. 1904; Stanley Little *Life and Works of W.Q.O.* Art Annual 1897; Hilda Orchardson Gray *The Life of Sir W.Q.O.* 1930; DNB 2nd Supp; Caw 236-40 (2 pls.); Reynolds VS passim (pls. 87-90); Reynolds VP passim (pls. 127, 130); Maas passim (pls. p.19, 245-6)

ORROCK, James RI 1829-1913
Landscape painter and watercolourist. Born in Edinburgh. Qualified as a dentist, and practised in Nottingham. Worked at Nottingham School of Design, and later studied under James Ferguson, John Burgess, Stewart Smith and W.L. Leitch (q.v.). Came to London 1866; elected associate of RI 1871, member 1875. Exhib. at RA 1858-82, SS, NWS, GG, NG and elsewhere. He was a great admirer of David Cox, and his style and subject matter both reflect this. He was also a keen collector, writer and lecturer. An exhibition of his work was held at the FAS in 1893.

Probable price range £30-70.

Bibl: Mag. of Art 1904 p.161-7; Studio 30 (1904) 360 f; *'Light and Water-*

colours' A Series of Letters by J.O. to the Times 1887; J. Webber *J.O. Painter Connoisseur Collector* 1904; Caw; Who's Who 1913-14; VAM; Hardie III 159-160 (pl. 181)

***OSBORN, Emily Mary b.1834 fl.1851-1893**
Genre painter. Daughter of a London clergyman. Studied at Dickinson's Academy in Maddox St, first under John Mogford (q.v.), later under J.M. Leigh. Exhib. at RA 1851-93, BI, SS, GG, NG and elsewhere. Her pictures mostly genre, sometimes historical, often of children. The theme of many of her pictures is the "damsel in distress". A typical example is the recently rediscovered 'Nameless and Friendless' (see Maas p.121), for which there is a preparatory drawing, falsely signed Millais, in the Ashmolean, Oxford.

'Family Portrait of Mrs. Sturgiss and her Children' sold at Bonham's 7.8.69 for £290.

Bibl: AJ 1864, 261 f; 1868, 148; H.A. Müller, *Biog. Kunsterlexicon d. Gegenw.* 1884; Maas 121 (pl. p.121)

OSBORNE, Walter Frederick RHA 1859-1903
Irish landscape and portrait painter, son of William Osborne (q.v.). Studied at the RHA, and at the Antwerp Academy under Verlat. Up to 1884 he signed himself Frederick Osborne, but after 1885 changed it to Walter F. Osborne. Began exhibiting at RHA in 1877. Spent his summers sketching in England, or on the Continent. Exhib. at RA 1886-1903. 'Life in the Streets, Hard Times' — a pastel of 1892, was bought by the Chantrey Bequest. In the 1890's he turned mainly to portraiture.

Probable price range £30-70.

Bibl: DNB; Strickland II 201 (with a list of main works); Thomas Bodkin *Four Irish Landscape Painters,* Dublin 1920 Cat. of Pictures etc. NG of Ireland 1920.

OSBORNE, William RHA 1823-1901
Animal and portrait painter. Father of Walter Frederick Osborne (q.v.). Entered RHA as a student in 1845. Exhib. mainly at RHA. Elected ARHA 1854, RHA 1868. Painted animals, especially dogs, and hunting groups.

Probable price range £50-150.

Bibl: Strickland II 207-8

OSCROFT, Samuel William 1834-1924
Nottingham landscape painter and watercolourist. Exhib. at RA 1885-9, SS, NWS and elsewhere. Titles at RA 'Rye from the Marsh' 'Crab Boats on the Coast, S. Devon' 'At Eventide it shall be Light'. Several views by him are in the Nottingham AG.

Probable price range £30-70.

Bibl: Connoisseur 71 (1925) 187.

OSSANI, Alessandro fl.1857-1888
Portrait and genre painter. Exhib. at RA 1860-88, SS, GG and elsewhere. Most of his RA pictures were portraits, with occasional genre scenes, e.g. 'Italian Flower Girl' 'The Gleaner' etc.

Two pictures of Italian children sold at Sotheby's 12.2.69 for £420 and £500.

OULESS, Walter William RA 1848-1933
Portrait painter. Born St. Helier, Jersey. Studied at RA Schools 1865-9. Exhib. at RA from 1869. Elected ARA 1877, RA 1881. A prolific and competent artist, but not an inspired one, he nonetheless built up an enormously successful practice as a portrait painter in late Victorian and Edwardian society.

Probable price range £50-200.

Bibl: Clement and Hutton; L. Cust NPG Cat. 1901; Cat. of Engr. Brit. Portraits BM VI (1925) 525; R.L. Poole, *Cat. of Portraits in Oxford* 1912-25.

OVEREND, William Heysham 1851-98
London marine painter. Worked for *Illustrated London News.* Exhib. at RA 1872-98, SS and elsewhere.

Probable price range £30-70.

Bibl: American Art Annual 1898 p.36; The Year's Art 1899 p.336; Portfolio 1890 p.7; Cundall 242

PADGETT, William 1851-1904
Landscape painter; lived in London, Hampton and Twickenham. Exhib. at RA 1881-98, SS, GG, NG and elsewhere. Titles at RA 'Winter on the Marsh' 'The Old Mill' 'In Flanders' etc.

Probable price range £30-70

PAGE, Henry Maurice fl.1878-1890
Landscape and animal painter. Lived in London and Croydon. Exhib. at RA 1879-90, but mostly at SS (54 works). Titles at RA suggest that he painted birds and still life — e.g. 'Sport from Loch and Moor' 'Winged' 'On the Flight' etc.

Probable price range £30-70

PAGE, Robert fl.1880-1890
Painter of rustic genre. Lived at Great Claxton, Essex. Exhib. at RA 1881-9, SS and elsewhere. Titles at RA 'The Old Hedger' 'Noonday Rest' 'Essex Calves' etc, and some historical scenes.

Probable price range £20-50

PAGET, H.M RBA fl.1874-1894
Painter and illustrator. Exhib. at RA 1879-94, SS, GG and elsewhere. Most of his RA exhibits were portraits, or historical subjects, e.g. 'Enid and Geraint' 'Circe' etc. He illustrated the works of Dickens. Some of his portraits are at Oxford University. His brothers Sidney (q.v.) and Walter were also illustrators. His wife, Mrs. H.M. Paget, exhib. at the GG in 1883 and 1884.

Probable price range £30-70

Bibl: Sketchley, *English Book Illustration of Today,* 1903; Poole, *Cat. of Portraits etc. of Oxford,* 1912.

PAGET, Sidney 1861-1908
Painter and illustrator. Exhib. at RA 1879-1903, SS and elsewhere. Titles at RA mostly portraits, and some genre e.g. 'Under the Hill' 'Shadows on the Path' 'Outcast' etc. Among the books he illustrated were the works of Scott and C. Doyle. A picture of 'Lancelot and Elaine' (RA 1891) is in the Bristol AG. His brothers H.M. Paget (q.v.) and Walter Paget were also illustrators.

'Extensive View of Goodrich Castle' sold at Bonham's 7.5.70 for £140.

Bibl: Sketchley *English Book Illustration of Today* 1903.

PAICE, George fl.1878-1900
Sporting and animal painter; lived in Croydon. Exhib. at RA 1881-97,

SS and elsewhere. Painted many small portraits of horses and dogs in landscapes, most of which are still in English private collections.

Usual price range £20-60

PAIN, Robert Tucker fl.1863-1877
Landscape painter. Exhib. at RA 1866-76, BI and SS and elsewhere Titles at RA include views in Wales, Scotland and Switzerland. A watercolour by him is in the VAM.

Probable price range £20-50

PALIN, William Mainwaring b.1862 fl.1887-1904
Painter and decorator. Born at Hanley, Staffordshire, son of the engraver William Palin. Worked for 5 years with Josiah Wedgwood & Sons, then studied at the RCA. Also studied in Italy and Paris. Exhib. at RA 1889-1904, SS and NWS. Painted portraits, landscapes and also genre e.g. 'Orphans' 'Reflections' 'A Summer Afternoon' etc. Among his decoration commissions were the MacEwan Hall of Edinburgh University, and St. Clements Church, Bradford.

Probable price range £30-70

Bibl: AJ 1896, p.234-36; Studio 66 (1916) 206; Who's Who.

PALMER, Harry Sutton RBA 1854-1933
Landscape painter and watercolourist. Born in Plymouth. Exhib. at RA from 1870, SS, NWS and elsewhere. Many of his landscapes were painted in Surrey. The mood of his scenes is always peaceful and idyllic, perhaps a little artificial. "It is a pleasing but a conscious and sophisticated art, depending upon recipe and very skilful technique". (Hardie).

Usual price range £30-70

Bibl: Connoisseur 56 (1920) 262 f; 63 (1922) 186; 65 (1923) 238; Studio 83 (1922) 348; Holme, Sketching Grounds, Studio Special No. 1909, p.15, 17; Who's Who; VAM; Morning Post 16.3.1909; Hardie III 234 (pl.228).

***PALMER, Samuel RWS 1805-1881**
Painter of pastoral landscapes, illustrator and etcher, and most important follower of William Blake (1757-1827). Son of a bookseller, he was very precocious and at an early age read the Bible and Milton and studied Latin. In 1819, at the age of fourteen, he exhib. two landscapes at the BI and three at the RA. By 1822 he had met Stothard, John Linnell, John Varley and Mulready, and through Linnell met Blake in 1824. Palmer was much influenced by Blake's mystic visionary teaching, and especially by his illustrations to Dr. R.J. Thornton's *Virgil's Eclogues,* 1820-1: "They are visions of little dells, and nooks, and corners of Paradise; models of the exquisitest pitch of intense poetry". He first visited Shoreham in Kent in 1825-6 and settled there in 1827. Frequent visitors to his "valley of vision" were George Richmond, Edward Calvert, Henry Walter and Francis Oliver Finch, who called themselves "The Ancients" (because of their interest in the ancient poets and painters e.g. Virgil and Milton). In his 'Shoreham Period' (1826-35) Palmer painted landscapes charged with Christian symbolism — depicting sheep and shepherds, sunsets, moons, clouds and hills, abundant harvests and the rounded blossoming trees of Shoreham, often illustrating some text of pastoral life taken from Virgil, Milton or Shakespeare. In their directness, blazing colour and lack of literal representation, the works of these years were far in advance of their time, and only came to be fully appreciated in 1925 with the publication of Laurence Binyon's *The Followers of William Blake,* and with the Palmer exhibition held at the VAM in 1926. This "primitive and infantine feeling" (his own words) for landscape began to fade c.1822; in 1835 he settled in London; in 1837 he married Hannah, daughter of John Linnell and afterwards spent two years in Italy. There he painted a series of careful drawings, ranging

from studies of trees (which were especially admired by Ruskin), to panoramic views of Rome and Florence. He returned to London in 1839 where he lived until 1861, when he moved to Reigate and in 1862 to Redhill. Exhib. 57 works at the RA, 1819-73; 20 at the BI, 1819-53; 10 at SS; and 178 at the OWS. Elected A of the OWS in 1843, and Member, 1854. He exhib. Italian subjects, and after 1854, drawings of pastoral scenery in Great Britain. He now made his living by teaching and by highly-wrought exhibition landscapes, gorgeously coloured and sentimental in their appeal. His last period began in the 1850's when he abandoned transparent colour and worked with an impasto of opaque colour on a board prepared with a wash of Chinese white, giving an effect of rich oil painting, very bright and rich in tone. More similar, however, to his Shoreham Period are his monochrome drawings illustrating Virgil and Milton, and at the time of his death he was working on an English metrical version of Virgil's *Eclogues,* illustrated with his own designs.

In Feb. 68 a small early watercolour was sold in Glasgow for £14,000. This is still the auction record. Other prices for early works have ranged from about £3,000 — £9,000; later works usually sell in the £1,000 — £3,000 range.

Bibl: AJ 1881, 223; 1893, 44; Portfolio 1876, 60-4, 90; 1884, 31 f, 145 f; 1887, 28 f; 1891, 255-60; Connoisseur 44 (1916) 177 f; 78 (1927), 125 f; Apollo 2 (1925) 305; 5 (1927) 82 f; Ruskin, Modern Painters 1846; Redgrave, Cent.; Roget; A.H. Palmer, *S.P. A Memoir* 1882 and *Life and Letters of S.P.* 1892; Cundall; DNB; Hughes; VAM; Williams; L. Binyon, *The Followers of William Blake,* 1925; Cat. of Exhibition etc. by S.P. and other Disciples of Blake, VAM 1926; M. Hardie *S.P.* OWS IV 1927; G. Grigson, *S.P. The Visionary Years* 1947; R. Melville, *S.P.* 1956; S.P. and his Circle — The Shoreham Period, Arts Council Exh. 1957; *Paintings and Drawings by S.P.* Ashmolean Museum, Oxford 1960; Reynolds VP 141-2 et passim (pl.24); Hardie II 158-68 (pls.) III passim; C. Peacock *S.P. Shoreham and After* 1968; Maas 40-1 (pls. p.39-40).

PALMER, William James fl.1858-1888
Landscape and genre painter. Exhib. at RA 1868-85, SS, NWS and elsewhere. Titles at RA 'Northumberland Moors' 'Monte Leone and the Simplon Pass' and genre subjects from Tennyson and Wordsworth.

Probable price range £30-70

PANTON, Alexander fl.1861-1888
Landscape painter. Exhib. at SS (69 works) also RA 1866-88 and BI. RA pictures mostly views in Kent and Surrey.

Probable price range £20-50

PARK, Stuart 1862-1933
Glasgow flower painter. At first painted in his spare time, but in 1888 took up art professionally. Specialised in painting carefully arranged bouquets of roses, lilies, orchids and azaleas. He developed a very individual technique, using thick and rapid strokes against a dark background, suggesting rather than defining the texture and colour of flowers. He worked only in Scotland, and did not exhibit in London.

Prices during 1969 and 1970 ranged from about £40 up to £147.

Bibl: Studio 29 (1903) 296; 31 (1904) 67, 163; 37 (1906) 200; Connoisseur 37 (1913) 121; D. Martin *The Glasgow School of Painting* 1902; Caw 499-50; Cat. of The Glasgow Boys Exhibition, Scottish Arts Council, 1968.

PARKER, Miss Ellen Grace fl.1875-1893
London flower and genre painter; lived in St. John's Wood. Exhib. at SS, RA 1878-93, and elsewhere. Titles at RA flowers, and genre scenes e.g. 'Schoolboys Bathing' 'An Art Student's Holiday' 'Up the River' etc.

Probable price range £30-70

PARKER, Frederick fl.1833-1847
Landscape and topographical painter. Exhib. at SS, RA 1845-7, and BI. Titles at RA all of castles — 'Stirling Castle' 'Edinburgh Castle' 'Castle of Marksburg' etc.

Probable price range £30-100

PARKER, Frederick H.A. **RBA** **1881-1904**
Landscape and genre painter. Exhib. at SS, and RA 1886-1904. Genre scenes mostly of children e.g. 'The Millers Little Maid' 'A Truant' 'A Girl in White' etc.

Probable price range £20-50

PARKER, Henry H.
Little-known Midlands landscape painter working in the last quarter of the 19th century. He did not exhibit in London, but his works now appear frequently at auction. He painted mostly views on the Thames, in Surrey, Kent and Wales, in a style similar to the late work of B.W. Leader (q.v.).

Prices during the 1968-9 season ranged from about £70 to £420.

PARKER, Henry Perlee **HRSA** **1795-1873**
Genre and portrait painter. Known as 'Smuggler' Parker, because he specialised in pictures of smugglers. Born in Devonport, Cornwall; son of Robert Parker, a painter, carver and gilder. In 1814 he married and set up as a portrait painter in Plymouth. 1815 moved to Newcastle, where he soon established himself as a painter of portraits and local subjects. Exhib. at RA 1817-59, BI, SS, NWS, and at many exhibitions in Newcastle. He was a member of the Northumberland Institution for the Promotion of the Fine Arts; and co-founder with T.M. Richardson Sen. (q.v.)., of the Northern Academy of Arts. About 1826 he first began to paint smuggling subjects. His best known work was 'The Rescue of the Forfarshire Steam Packet' by Grace Darling and her father. Other local subjects include 'The Opening of the Grainger Market' 'Eccentric Characters of Newcastle on Tyne' etc. Moved to Sheffield 1841-5, where he was a drawing master at Wesley College. In 1845 he moved to London where he later died in poverty. His beach scenes have a remarkable similarity to those of William Shayer Sen. (q.v.).

'Idle Moments' sold at Christie's 14.3.69 for £273. 'The Doge's Palace' sold at Sotheby's 7.5.69 for £380.

Bibl: Bryan; Richard Welford Men of Mark Twixt Tyne and Tweed 1895 vol.3; N.A. Johnson H.P.P. Newcastle Life, Sept. 1969; Cat. of H.P.P. Exhibition, Laing AG Newcastle 1969-70.

PARKER, John **RWS** **1830-1916**
Landscape and genre painter, mostly in watercolour. Born and studied in Birmingham. Exhib. at OWS (185 works) RA from 1871, SS, GG, NG and elsewhere. Lived in St. John's Wood. Titles at RA 'The River, Hurley, Bucks' 'Sheep Marking' 'Little Nell's Garden' etc.

Probable price range £20-50

Bibl: Studio 67 (1916) 254; Who's Who.

PARIS, Walter fl.1849-1891
Topographical painter and watercolourist. Exhib. at RA in 1849 and 1872, SS, NWS, and elsewhere. Painted views in England, Jersey, France, Venice, and India. 8 watercolours by him are in the VAM. He should not be confused with Walter Paris (1842-1906), an architect and watercolourist who studied in London and later emigrated to the USA.

Probable price range £30-100, depending on the interest of his topographical views.

Bibl: VAM Cat. of Watercolours 1908.

PARRIS, Edmund Thomas 1793-1873
Portrait, genre and landscape painter and architect. Exhib. at RA 1816-74, BI, SS and NWS. Painted a panorama of London for the Colosseum 1824-29. In 1843 his picture of 'Joseph of Arimathea Converting the Jews' won a prize in the Westminster Hall competition. He also painted large pictures of the Coronation of Queen Victoria, and the Funeral of the Duke of Wellington, both of which were engraved. Between 1853 and 1856 he worked on the restoration of Thornhill's frescoes in the dome of St. Paul's Cathedral. In 1832 he was appointed Historical Painter to Queen Adelaide.

A pair of Welsh landscapes sold at Sotheby's 26.2.69 for £290.

Bibl: AJ 1874, 45; Connoisseur 4 (1902) 205; DNB; Bryan; Roget; Shakespeare in Pictorial Art, Studio Special Spring No. 1916; Cat. of Engraved British Portraits, BM 1908-25.

PARROTT, William 1813-1869
Topographical painter and watercolourist, and lithographer. Exhib. at RA 1835-63, BI, SS and elsewhere. Visited Paris 1842-3, Rome 1845. Published a set of lithographs, *Paris et ses Environs.* He is now best known for his Italian views, especially ot Rome.

'The Port of Brest, France' sold at Sotheby's 16.10.68 for £1,050. Large Italian views could make even more than this.

Bibl: Londoners then and now, Studio Special No.1920, p.133; Hardie III 20-21 (pl.30).

PARSONS, Alfred **RA RI** **1847-1920**
Landscape painter and watercolourist, and illustrator. Worked as a post office clerk, while studying at S. Kensington Art School, after which he took up painting professionally. Exhib. at RA from 1871, and at SS, NWS, GG, NG and elsewhere. Elected ARA 1897, RA 1911. 'When Nature Painted all Things Gay' (RA 1887) was bought by the Chantrey Bequest. In addition to his realistic pastoral scenes and landscapes, he also specialised in painting gardens, and plants.

Probable price range £50-200 for oils, £20-50 for watercolours.

Bibl: AJ 1890, 162; 188, 1911, 170, 174; Studio 16 (1909) 149-156; Connoisseur 38 (1914) 66f; 56 (1920) 251f; DNB; Who was Who 1916-28; H. Fincham Artists and Engravers of Book Plates 1897; R.E.D. Sketchley, Eng. Book Illustrators of Today 1903; Hardie III 96, 163.

PARSONS, Miss Beatrice E. fl.1889-1893
Flower and genre painter. Exhib. at RA 1889-99. Titles 'Chrysanthemums' 'Autumn' 'Spring' etc.

Probable price range £20-50

PARSONS, Miss Letitia Margaret (Mrs. Keith) fl.1877-1887
Flower painter. Lived at Frome, Sussex. Exhib. at RA 1879-87, GG and NG. Titles at RA 'A Winter Bouquet' 'Daffodils' 'Flowers and Berries' etc.

Probable price range £20-50

PARTINGTON, J.H.E. b.1843 fl.1873-1888
Painter of genre, portraits and marine subjects, working in Stockport and Ramsey, Isle of Man. Born in Manchester and died in Oakfield, California. Exhibited from 1873-88, at the RA (1873-86), NWS and GG, titles at the RA including 'Shetland Turf Gatherers' 1873, 'Hard Weather' 1875 (called by Ruskin "highly moral"), 'The Smuggler's Yarn' 1880, and 'A Ramsey Wrecker' 1884. A portrait of W.A. Turner is in the City Art Gallery, Manchester.

Probable price range £30-70

Bibl: J. Ruskin Academy Notes 1875.

PARTON, Ernest ROI 1845-1933
American landscape painter. Born in Hudson, New York; younger brother of Arthur Parton, in whose studio he spent two winters, receiving no other regular art instruction. In 1873 he came to England, where he settled, exhibiting from 1874, at the RA (from 1875), SS, NWS, GG, NG and elsewhere. He also lived in France and travelled in Switzerland and Italy. In 1879 his large landscape 'The Waning of the Year' (RA 1879) was purchased for the Tate Gallery by the Chantrey Bequest, and in the same year 'Woodland Home' was purchased for the Walker Art Gallery, Liverpool.

'View of the Thames at Wargrave' sold at Parke-Bernet 24.9.69 for £208.

Bibl: AJ 1892, 353-7 (monograph); Clement and Hutton; *Who Was Who* 1929-1940; Pavière, Landscape.

PARTRIDGE, John 1790-1872
Portrait painter. Pupil of Thomas Phillips. Exhib. at RA 1815-46, and at BI. Partridge was a successful society portrait painter. In 1842 he exhibited portraits of Prince Albert and Queen Victoria, and the following year was appointed Portrait Painter Extraordinary to Her Majesty and HRH Prince Albert.

Probable price range £30-100

Bibl: AJ 1902, p.145; *Cat. of 3rd Exhib. of National Portraits*, S. Kensington Museum, 1868; Redgrave, Dict.; DNB; L. Cust., *The NPG*, 1902; Cat. of Drawings by Brit. Artists, BM 1902; Cat. of Engraved Brit. Portraits, BM 1908-25 Vol. VI 526; R.L. Poole, *Cat. of Oxford Portraits*, etc. 1912-15.

PASCOE, William fl.1842-1844
Landscape painter, working in London and Plymouth, who exhibited from 1842-4, at the RA (1842 and 43) BI and SS, titles at the RA including 'View on the Caddiver River, Dartmoor, Devon', 1842.

Probable price range £20-50

PASMORE, Daniel, Junior fl.1829-1891
Genre and portrait painter, son of David Pasmore (q.v.). Exhib. mostly at SS (86 works) also at RA 1829-34, BI and NWS. Titles at RA 'The Juvenile Architects' 'Boys Blowing Bubbles' 'Contemplation' etc.

'Gold for Notes' sold at Christie's 10.7.70 for £137.

PASMORE, Daniel, Senior fl.1829-1865
Genre and portrait painter, presumably the father of Daniel P. (Junior) (q.v.). Exhib. at RA 1829-65, and elsewhere. Titles at RA mostly historical genre and portraits, e.g. 'The Happy Days of Anne Boleyn' etc. Four pictures by Daniel P. (Senior or Junior), are in York AG.

'The Mountebank' sold at Christie's 26.3.70 for £179.

PASMORE, John fl.1830-1845
Animal and still-life painter. Exhib. at RA 1831-45, BI and SS. Titles at RA 'Still Life' 'Sheep' 'Portrait of a Highland Sheepdog' etc.

'Spring' sold at Sotheby's 16.10.68 for £260.

PASMORE, John F. fl.1841-1866
Painter of rustic genre, animals and still life. Exhib. at RA 1842-62, BI, SS and elsewhere. Titles at RA 'The Cattle Shed' 'The Farmer's Boy' 'A Farm Yard' etc. His wife Mrs. J.F. Pasmore was also a painter, who exhib. 1861-1878 at RA, BI and SS. Graves lists her speciality as "domestic".

'Mother and Child feeding Goats' – a pair – sold at Bonham's 10.7.69 for £120.

PASMORE, Mrs. John F. See under PASMORE, John F.

PATERSON, James PRSW RSA RWS 1854-1932
Scottish landscape painter and watercolourist. Son of a cloth manufacturer. Worked as clerk for four years before taking up painting. Studied in Paris under Jacquesson de la Chevreuse and J.P. Laurens. On his return, he became a leading member of the Glasgow School, together with his lifelong friend and sketching companion, W.Y. Macgregor (q.v.). In 1884 he married and settled near Monaxie, Dumfriesshire, where he found the best type of landscape for his quiet, pastoral paintings, which show the romantic influence of Corot and the Barbizon School. He exhib. at the RA from 1879, also RSA, SS, GG, NEAC etc. Titles at the RA 'Windy Trees' 'The Old Mill' etc.

'November at Corte, Corsica' sold at Christie's 15.10.69 for £336.

Bibl: AJ 1894, 77, 79; 1905, 184, 352f; 1906, 186; 1907, 187; 1908, 28; Studio 63 (1915) 112f, also indexed 1903-1918; Art News 30 (1932) Nr. 20 p.12; D. Martin, *The Glasgow School of Painting* 1902; Caw 382-3 (pl. p.382); Catalogue of The Glasgow Boys Exhibition, Scottish Arts Council 1968.

PATMORE, Miss Bertha G. fl.1876-1903
Figure and landscape painter, working in Hastings and Lymington, Hampshire, who exhibited at the RA from 1876-1903, titles including: 'Portion of a Survey of Westmorland, Natural Scale', 1876, and 'Love in a Mist' 1880.

Probable price range £20-50

PATON, Frank 1856-1909
Painter of genre and animals; illustrator; working in London and Gravesend; exhibited from 1872-90, at the RA (1878-90), SS and elsewhere, titles at the RA including 'Puss in Boots' 1880, and 'A Happy Family' 1890.

'Rabbits Playing on a Bank' sold at Sotheby's 15.10.69 for £550.

Bibl: The Year's Art 1910.

***PATON, Sir Joseph Noel RSA 1821-1901**
Painter of historical, religious, mythical and allegorical subjects. Born at Dunfermline. Studied at RA schools 1843; met Millais (q.v.), who remained a lifelong friend. Won prizes in Westminster Hall competitions 1845 and 1847. Although he sympathised with the aims of the PRB, he never became a member because of his return to Scotland. Exhib. at RA 1856-83; mostly at RSA. Elected ARSA 1847, RSA 1850. Appointed H.M. Limner for Scotland and knighted 1866. A man of wide learning and culture, the subjects of his pictures were drawn from an equally wide range of sources. Perhaps his most original works were his paintings of fairies, such as 'Oberon and Titania' and 'The Fairy Raid'. He also painted a few pictures of contemporary life. His technique was laborious and Pre-Raphaelite in detail, but he was primarily a painter of the intellect, and cared more for ideas than techniques. After 1870 he began to devote himself to religious works, moving towards a cold and academic style, often compared to the Nazarenes. The sketches for these late works — usually in brown monochrome — are often livelier and more interesting than the finished picture. He also published books of poetry. His brother, Waller Hugh Paton (q.v.) was also a painter.

'Mors Janua Vitae' sold at Christie's 10.7.70 for £210.

Bibl: AJ 1861, 119; 1863, 64; 1866, 140; 1869, 1-3; 1881, 78-80; 1895, 97-128; 1902, 70-72; Mag. of Art III (1880) 1-6; L'Art 59 (1894) 386ff; 61 (1902) 30; Ruskin, *Academy Notes* 1856, 1858; Bate 71 ff; Bryan; Caw 167-70 (pl. p.68); Fredeman section 53 et passim; Maas 152 (pls. p.152-3, 231).

PATON, Waller Hugh RSA RSW 1828-1895
Scottish landscape painter. Born in Wooers-Alley, Dunfermline. At first he assisted his father who was a damask designer. In 1848 he became interested in landscape painting, and had lessons in watercolour from John Houston RSA. A of RSA 1857; RSA 1865; exhibited there annually from 1851-95, and at the RA from 1860-80. In 1858 he

joined his brother Sir Noel Paton (q.v.) in illustrating Ayton's *Lays of the Scottish Cavaliers* 1863. From 1859 he lived in Edinburgh; 1860 he stayed in London; 1861 and 1868 he toured the Continent. In 1862 he was commissioned by Queen Victoria to make a drawing of Holyrood Palace. FSA of Scotland 1869; RSW 1878. He was the first Scottish painter to paint a picture throughout in the open air, and most of his subjects were the hill scenery of Perthshire, Aberdeenshire, and especially Arran, generally at sunset. His prevailing colour effect was the purple of the Northern sunset, and in his earlier work, his close study of detail is almost Pre-Raphaelite, i.e. as in 'The Raven's Hollow'. Paton's work was always very popular with the general public, but Caw notes that his later pictures are mannered and lack the fresh observation and detail of the earlier ones. His Diploma work 'Lamlash Bay' is in the N.G. Edinburgh.

'View of a Railway Bridge over the River Cart at Paisley' sold at Christie's 14.6.68 for £997. This was an exceptional price, the usual range being £100-200.

Bibl: AJ 1895 169 (obit); Bryan; Caw 194-5; DNB

PATRY, Edward RBA 1856-1940

London painter of portraits and genre. Educated at Rugby, and at the S. Kensington Schools where he studied under Sir Edward Poynter from 1879-1882; also worked in the studio of Herr Frisch, court painter, in Darmstadt. Exhibited from 1880, at the RA (from 1883), SS and elsewhere; exhibited at the Paris Salon (1909 Gold Medal), Brussels International Exhibition (1910 diploma, first class medal, portrait purchased by Belgian Government for the Musée Moderne, Brussels). Principal works include 'Pleading', 'Mandolinata', 'A Daughter of Eve', Portrait Panel of Sir Richard Glyn (Royal Exchange 1922), and Antony Gibbs (Royal Exchange 1926).

'For Those at Sea' sold at Christie's 10.7.10 for £52.

Bibl: Connoisseur 76 (1926) 266, pl.265; Who Was Who 1929-40.

PATTEN, Alfred Fowler RBA 1829-1888

Genre painter; son of the portrait painter George Patten (q.v.). Exhib. at RA 1850-78, BI and SS (118 works). Painted historical genre, oriental subjects, and country scenes. Titles at RA 'Hamlet and Ophelia' 'The Fair Persian Tempting the Sheikh with Wine' 'May Day' etc.

'The Two Pets' sold at Christie's 11.7.69 for £210.

Bibl: Clement and Hutton.

PATTEN, George ARA 1801-1865

Painter of portraits, and of historical, mythological and scriptural subjects. Son of William Patten, a miniature painter; taught painting by his father. Entered RA Schools, 1816, and chiefly practised miniature painting until 1828, when he again entered the RA Schools to become proficient in oil painting, the practice of which he adopted in 1830. In 1837 he went to Italy, and was elected ARA. In 1840 he went to Germany to paint a portrait of Prince Albert (exhib. RA 1840), who subsequently appointed him Painter-in-Ordinary. From this he gained a considerable patronage in presentation portraits, e.g. Richard Cobden, Lord Francis Egerton and Paganini (exhib. 1833). He also painted mythological and scriptural subjects, e.g. 'A Nymph and Child' 1831, 'Bacchus and Io' 1836 and 'The Destruction of Idolatry in England' 1849. Many of these were also exhibited at the BI. Of this type of painting – "the ideal" – the AJ commented: "Several of these are painted on a scale too large for the artist's powers to carry out successfully: Mr. Patten evidently aimed at Etty's manner, and though his flesh painting of the nude, or semi-nude figure, was fairly good, it cannot for an instant be brought into comparison with that of Etty". He exhibited 131 works at the RA, 1819-64, and 16 at the BI, 1832-44.

Probable price range £50-200

Bibl: AJ 1865, 139; W. Sandby *The History of the R. Academy of Arts* 1862; Redgrave, Dict.; DNB; Cat. of Engr. Brit. Portr. BM (1908-25) VI 527; Emporium 73 (1931) 299.

PAUL, Robert

Robert Paul, and sometimes J.Paul are artists to whom imitations of Crome and Canaletto are often attributed by dealers and auctioneers. It has been fairly conclusively proved that both artists are fictitious, and never really existed. See an article by Miklos Rajnai, *Robert Paul, the Non-Existent Painter* (Apollo, April 1968).

PAUL, Robert Boyd fl.1857-76

Painter of portraits and genre. Exhibited from 1857-76, at the RA (1859 and 1863), BI, SS and elsewhere, titles at the RA including 'A Portrait' and 'Dinner Preparations'.

Probable price range £30-70

PAULSON, Mrs. Anna fl.1838-1857

Mansfield painter of fruit, vegetables etc., who exhibited from 1838-57 at BI (1850), SS, and elsewhere (31 works).

Probable price range £20-50

PAYTON, Joseph fl.1861-1870

Warwick painter of domestic genre, who exhibited from 1861-70, at the RA (1861-5), BI and elsewhere, titles at the RA including 'Skating at Chantilly' 1861, 'The Anonymous Letter' 1865, and 'The Morning of the Duel' 1865.

Probable price range £30-70

PEACOCK, Ralph 1868-1946

Painter of portraits, especially of children, and landscape; illustrator. Born in Wood Green, London. In 1882 he entered S. Lambeth Art School, for some years working there twice a week in the evening, meanwhile studying for the Civil Service. John Pettie, however, suggested that he should take up painting as a profession, so he went to St. John's Wood Art School, and finally to the RA Schools in 1887, where he won a gold medal and the Creswick Prize. Exhib. from 1888 at the RA, SS, GG and elsewhere. From 1890 he illustrated books and taught at St. John's Wood Art School. He won a gold medal at Vienna in 1898, and a bronze medal at the Paris Universal Exhibition in 1900. 'Ethel' (Chantrey Purchase 1898) and 'The Sisters' 1900, are in the Tate Gallery.

Probable price range £30-100

Bibl: AJ 1898, 178; 1900, 182, 165 (pls.); Studio 21 (1902) 3-15 (monograph by W. Shaw-Sparrow); 23 (1901) 119, 29, (1903), 48; 38 (1906) 4; 58 (1913) 205: 68 (1916) 40, 53; *Who Was Who 1941-1950*, Tate Cat.

PEARCE, Stephen 1819-1904

Portrait and equestrian painter. Born in London. Trained at Sass's Academy and the RA Schools, 1840 and in 1841 became a pupil of Sir Martin Archer Shee. From 1842-6 he acted as amanuensis to Charles Lever, and afterwards visited Italy. Exhibited from 1837-85, at the RA (from 1839-85 – 92 works), BI, SS and GG. He was attached to the Queen's Mews, and paintings by him of favourite horses in the Royal Mews were exhibited at the RA in 1839 and 1841. In 1851 he completed 'The Arctic Council Discussing a Plan of Search for Sir John Franklin', containing portraits of Back, Beechey, Bird, Parry, Richardson, Ross, Sabine and others, (exhib. RA in 1853). He was widely known as a painter of equestrian presentation portraits and groups, most important of which is 'Coursing at Ashdown Park' 1869 (containing 60 equestrian portraits). He retired from active work in 1888. His studio sale was held at Christie's on Feb. 5, 1886.

'Portrait of A.S. Brook on a Horse' sold at Christie's 25.4.69 for, *£126.*

Bibl: L. Cust., PNG 2 1901; Stephen Pearce *Memories of the Past* 1903 (19 pls. and a list of subjects painted; DNB 2nd Supp; Cat. Engr. Brit. Portr. BM (1908-25) VI 527; Pavière, Sporting Painters (pl.34).

PEARSALL, Henry W. fl.1824-1861
Painter of landscape and genre, working in London, Bath and Cheltenham, who exhibited from 1824-61, at the RA (1832-59), BI, SS, NWS and elsewhere. Titles at the RA include 'An Interior from Nature' 1832, 'An Alehouse Kitchen' 1847, and 'Gleaners' 1851.

Probable price range £30-70

PEARSON, Cornelius c.1809-1891
Landscape and topographical painter; engraver. Born at Boston, Lincs. Came to London at an early age, and apprenticed to an engraver. Then began to paint, mainly in watercolour. Exhibited 145 works at SS, 1843-79; 4 at the RA, 1845-72; also at the NWS and elsewhere. One of the oldest members of the Langham Sketching Club. Two watercolour views in Wales are in the VAM. Often signed in monogram "C.P".

Probable price range £20-50

Bibl: The Portfolio 1891, Art Chron. p.XXVI; Bryan; VAM.

PEDDER, John b.1850 fl.1875-1912
Landscape painter and watercolourist. Exhib. at RA 1875-1912, SS, NWS, GG and elsewhere. Lived in Liverpool, and also near Maidenhead. Titles at RA 'Conway' 'Water-Lilies near Cookham' and 'A Hillside Frolic' etc.

'Lake Vyrnwy, N. Wales' sold at Christie's Mar. 6 1970 for £99.

PEEL, Miss Amy fl.1876-1884
Landscape painter; lived in Walthamstow, Essex. Exhib. 22 works at SS between 1876 and 1884.

A small landscape 'Near Roundheath' sold at Christie's 6.6.69 for £44.

PEEL, James RBA 1811-1906
Landscape painter. Exhib. mostly at SS (248 works), also RA 1843-88, BI and elsewhere. A prolific painter of English views, in the North-Eastern Counties, the Lake District, North Wales and also in other parts of England. His naturalistic style and colouring similar to B.W. Leader (q.v.).

Prices during the 1968-9 season ranged from about £50 up to £260.

Bibl: AJ 1906, 96, 134; DNB 2nd Supp. 3 (1912).

PEELE, John Thomas RBA 1822-1897
Painter of genre, landscape and portraits. Born at Peterborough. At the age of 12 emigrated to America with his parents. Settled in Buffalo, where he began painting. Studied in New York; then worked in Albany for two years as a portrait painter. Returned to New York, and elected member of the National Academy of Design. About 1851 came to London, where he remained, except for stays in Liverpool and the Isle of Man. Exhib. at SS (161 works) also at RA 1852-91 and BI. His genre subjects often of children. One of his works 'The Children in the Wood' was bought by Prince Albert. He also had many patrons in America, including Frederick Church, the landscape painter.

'The Homestead, Isle of Man' sold at Christie's 11.7.69 for £200.

Bibl: AJ 1856, 136; 1876, 109-12 (mono. with plates); Clement and Hutton.

PELHAM, James II 1800-1874
Miniaturist and painter of portraits and small genre subjects. Son of James Pelham (d. c.1850), also a miniaturist but not equal to his son in ability. He travelled much, painting portraits of notable persons, especially in Bath and Cheltenham. He was appointed painter to the Princess Charlotte and had many distinguished sitters. He exhibited in London from 1832-68, at the RA (1832, 1836 and 1837), SS and elsewhere. In or before 1846 he settled in Liverpool, and exhibited from that year at the Liverpool Academy, becoming a member in 1851, and in 1854/5 Secretary. After 1854 he stopped exhibiting portraits and turned to domestic genre, usually on a small scale, in 1855, 1859 and 1867. From 1858 there is confusion with his son who began to exhibit in Liverpool in that year.

Probable price range £30-70

Bibl: Bryan; Cat. Walker Art Gallery, Liverpool, 1927.

PELHAM, James III 1840-1906
Painter of landscape, genre and angling subjects, in watercolour. Son of James Pelham II (q.v.). Born in Saffron Walden, lived in Liverpool. Began to exhibit at the Liverpool Academy in 1858, and in London from 1865-81, at the RA (in 1880), GG and elsewhere. Succeeded his father as Secretary of the Liverpool Academy in 1867.

Probable price range £30-70

Bibl: See James Pelham II

PELHAM, Thomas Kent fl.1860-1891
London genre painter, who exhibited from 1860-91, at the RA (1863-91), BI, SS and elsewhere, titles at the RA including 'Domestic Beauties' 1864, 'A Cornish Mussel-gatherer' 1874, and 'A Serious Question' 1886. Cardiff Museum and Art Gallery has 'Basque Fisherman'.

'Roman Fruit Girls' sold at Sotheby's 4.6.69 for £100.

PELLETIER, A. fl.1816-1847
London painter of flowers, fruit and birds, who exhibited from 1816-47, at the RA and OWS, titles at the RA including 'A Study of Peaches' 1816, 'Foreign Birds' 1822, and 'Gold Pheasant' 1830.

Probable price range £20-50

PEMEL/PEMELL, J. fl.1838-1851
Painter of portraits, genre, landscape and historical subjects, working in Canterbury and London. Exhibited from 1838-51, at the RA (1841-51), BI and SS, titles at the RA including 'Child Praying' 1841, and 'Mr. Hills of Guy's Hospital' 1843. Four landscape watercolours are in the VAM.

Probable price range £30-70

Bibl: VAM.

PENLEY, Aaron Edwin RI 1807-1870
Landscape and portrait watercolourist. Exhib. mostly at NWS (309 works) also at RA 1835-69, BI and SS. Elected RI 1838; resigned 1856. In 1851 he was appointed drawing master of Addiscombe East India College. He was also drawing master at Woolwich Military Academy, and watercolour painter to King William IV and Queen Adelaide. He was later teacher to Prince Arthur. His subjects were mostly landscape and rustic genre. He was the author of several books on watercolour painting. His studio sale was held at Christie's on April 23, 1870.

Usual price range for watercolours £20-50

Bibl: AJ 1870, p.71; Connoisseur 59 (1912) 210; Redgrave, Dict.; Binyon; Cundall; DNB; Hughes; VAM; Hardie III 217.

PENLEY, Edwin A. fl.1853-1872

Landscape watercolourist. Very little known – presumed to be son of Aaron Edwin Penley (q.v.). Exhib. 11 works at SS, and 7 at other exhibitions.

Usual price range for watercolours £20-50

PENSON, R. Kyrke RI 1815-1886

Architect and painter of architectural subjects and coastal scenes, working in Ferryside. Exhibited from 1836-72, at the RA (from 1836-59), SS, NWS (134 works) and elsewhere. Titles at the RA include 'Coast Scene' 1836, 'Château Gaillard' 1839, and in 1858 'Penywarr, Aberystwyth', 'View of the Church at Wrexham', and views of lime-kilns in Carmarthenshire.

Probable price range £30-70

Bibl: Cundall; T.M. Rees *Welsh Painters, Engravers, Sculptors* 1912.

PENSTONE, Edward fl.1871-1896

London painter of landscape and genre, who exhibited from 1871-96, at the RA (1877, 1894 and 1896), SS and elsewhere, titles at the RA including 'The Approach of Spring' 1877, and 'Canterbury Cathedral by Moonlight' 1896.

Probable price range £30-70

PENTREATH, R.T. fl.1844-1861

Painter of portraits, landscape and marine subjects, working in Penzance and London. Exhibited from 1844-61 at the RA and SS, titles at the RA including 'View of the Mount's Bay, Cornwall' 1845, and 'Fisher People Waiting the Return of the Fishing Boats' 1856.

Probable price range £30-70

PEPPERCORN, Arthur Douglas 1847-1926

Landscape painter in oils and watercolours, often called "our English Corot". Born in London. Studied at the Ecole des Beaux Arts in Paris (in 1870) under Gérôme, by whom he was little influenced. Met, however, Corot and the painters of the Barbizon School, to whose work his own bears a great resemblance, both in subject matter and technique. Exhibited from 1869 at the RA, SS and elsewhere; also held 'one-man' shows at the Goupil Galleries. Member of the International Society of Sculptors, Painters and Gravers. Friend of Matthew Maris, 1839-1917, the Dutch landscape and genre painter, who greatly admired Peppercorn's work. Early in his career Peppercorn chiefly painted woodland scenes; later he also painted marine subjects. In 1926 a memorial exhibition of his work was held at the Leicester Galleries.

Usual price range for oils £20-70

Bibl: AJ 1896, 201-5; 1904, 194; 1905, 91, 94, 143; Studio 21 (1901) 77-85; 57 (1913) 150-58 (1913) 214; 65 (1915), 110; 92 (1926) 347; special number *Art in 1898*; Burlington Magazine 32 (1918) 206; VAM.

***PERCY, Sidney Richard** 1821-1886

Landscape painter. Although a member of the Williams family (see under Boddington, Gilbert and Williams) he used the name Percy to distinguish himself from them. Exhib. at RA 1842-86, BI, SS and elsewhere. He painted in Devon, Yorkshire, the Lake District and Skye, but mostly in North Wales. His pictures are always competent and pleasing, though he tended to repeat certain formulas. His colours are bright and meticulous, and noticeably similar to those of his relative, Edwin Boddington (q.v.). His studio sale was held at Christie's on Nov. 27, 1886.

Percy was a prolific and variable painter, and his prices vary accordingly. The highest so far recorded is £1,985; during the 1968-9 season they ranged from £250 to £1,800.

Bibl: AJ 1859, 121, 122, 163; Gazette des Beaux Arts IV (1863) 40, 42; Bryan; T.M. Rees, *Welsh Painters* 1912; Pavière, Landscape.

PERCY, William 1820-1903

Manchester portrait painter, who exhibited from 1854-79 at the RA and elsewhere. He was a pupil of William Bradley, a leading Manchester portrait painter. He was a close friend of the Lancashire poet Edwin Waugh, and his portrait of Waugh, together with his own self-portrait, are in the Manchester City Art Gallery. Percy practised throughout his life in Manchester as a portrait painter.

Probable price range £20-50

Bibl: Catalogue of the Permanent Collection, City of Manchester Art Gallery 1910.

PERIGAL, Arthur RSW RSA 1816-1884

Scottish landscape painter; son of Arthur Perigal (Senior), a historical and portrait painter. Exhib. at RA 1861-84, BI, SS and at RSA. Titles at RA all Scottish landscapes. Elected RSA 1868; appointed Treasurer 1880. Caw, perhaps unfairly, describes his "harsh and unsympathetic Highland panoramas" as "so much inferior McCulloch".

'Loch Fad, Bute' sold at Christie's 3.4.69 for £168.

Bibl: AJ 1884, 224; Redgrave Dict. (Perigal Senior); Bryan; Caw 146.

PERRY, Alfred fl.1847-1881

Painter of landscape, animals and genre, who exhibited from 1847-81, at the RA (1847-78), BI, SS, and elsewhere. After 1858 he often painted subjects in the Roman campagna and around Naples. Titles at the RA include 'Arundel Castle' 1847, 'The Village Common' 1852, 'Roman Pack Horses' 1858, and 'Neapolitan Fishing Boat Running in for Naples' 1870. In the VAM is 'A Bull of the Roman Campagna' 1868.

Probable price range £30-70

Bibl: VAM.

PERUGINI, Charles Edward 1839-1918

Genre and portrait painter. Born in Naples. Came to London 1863. Exhib. at RA from 1863, BI, SS, NG and elsewhere. Titles at RA 'A Cup of Tea' 'A Siesta' 'Silken Tresses' etc. His pictures are mostly of elegant ladies in interiors, sometimes with a romantic or humorous theme. His wife Mrs. Charles Edward Perugini (q.v.), was also a painter.

'Powdering her Ladyships Coiffure' sold at Christie's 11.7.69 for £252.

Bibl: AJ 1876, 360; 1882, 43 (pl. p.l.); Connoisseur 84 (1929) 60 (obit of Mrs. C.E.P.); Times 5.10.5 1929; Clement and Hutton; Who Was Who 1916-1928.

PERUGINI, Mrs. Charles Edward (Kate Dickens) 1839-1929

Genre and portrait painter. Daughter of Charles Dickens. Married to Charles Allston Collins (q.v.). 1860-73, then married Charles Edward Perugini (q.v.). Exhib. at RA from 1877, SS, NWS, GG, NG and elsewhere. Titles at RA 'Little Nell' 'Mollie's Ball Dress' 'Flossie' etc. and some portraits. She was the model for the girl in 'The Black Brunswicker' by Millais.

Probable price range £50-200

Bibl: See under Charles Edward Perugini.

***PETHER, Henry** 1828-1865

Painter of landscapes, especially by moonlight. Son of Abraham

Pether (1756-1812) and brother of Sebastian Pether (q.v.). Exhib. at RA 1828-62, BI and SS. Painted moonlight scenes along the Thames, other English views, and also Venice.

Two moonlight views on the Thames sold during the 1969-70 season, one at Sotheby's for £1,700, the other at Christie's for £1,785. These are the highest recorded prices; less important works can sell for £200-800.

Bibl: Redgrave, Dict.; Bryan; DNB; Maas 49, 51 (pl. p.55).

PETHER, Sebastian 1790-1844
Painter of landscapes and moonlight scenes. Son of Abraham Pether (1756-1812) and brother of Henry Pether (q.v.). Exhib. at RA 1812-26, BI and SS. In addition to moonlight scenes, he also painted fires and other destructive effects of nature e.g. 'Destruction of a City by a Volcano' (RA 1826) and 'A Caravan Passing the Desert Overtaken by a Sandstorm' (RA 1826). His pictures are sometimes confused with those of his brother Henry, if not signed. Sebastian's colours are in general harder and more metallic, in the Dutch manner, whereas Henry's are warmer and brown in tone.

Prices during the 1968-9 season ranged from £100-500

Bibl: AU 6 (1844) 144 (obit); Redgrave, Dict.; Bryan; DNB; Maas 49-51.

PETTAFOR, Charles R. fl.1862-1900
Landscape painter, living in Eltham and Greenwich, who exhibited from 1862-1900, at the RA (1870-1900), BI, SS, NWS and elsewhere, titles at the RA including 'On the Arun' 1870, and 'Autumn Sunrise, Connemara' 1900.

Probable price range £30-70

***PETTIE, John RA 1839-1893**
Scottish historical painter. Aged 16 studied at Trustees' Academy, Edinburgh. There he met W. MacTaggart (q.v.) a lifelong friend; also Tom Graham and W.Q. Orchardson, with whom he later shared a studio in London. Began to exhib. at RA in 1860. Moved to London 1862. Worked as illustrator for *Good Words*. Exhib. at RA, BI, SS, GG and elsewhere. Elected ARA 1866, RA 1873. His historical scenes were of many periods — medieval, the Civil War, and the 18th c. His interpretations were always dramatic and imaginative, sometimes a little theatrical. Caw compares his work to the novels of Dumas. He especially liked military episodes e.g. 'The Drumhead Court Martial' etc. His style was equally vigorous; in power and richness of texture it shows the influence of Van Dyck and Rubens. After 1870 he experimented with chiaroscuro effects, and turned more to portrait painting, often depicting his sitters in historical costume. His studio sale was held at Christie's on May 26, 1893 and his own collection was sold on May 27.

'The Chieftain's Candlesticks' sold at Christie's Hopetoun Sale 15.10.69 for £273.

Bibl: AJ 1869, 265-7; 1893, 206-10; 1907; 97-116; Bryan; Caw 240-3 and passim (pl. p.242); M. Hardie *J.P.* 1908; Reynolds VS 36, 95; Reynolds VP 12,; 193, 194; Hardie 198-9; Maas 244.

PETTITT, Alfred fl.1850-1871
Birmingham landscape painter. Exhib. at BI, SS and elsewhere. Titles at BI 'A Cumberland Cottage' 'A Mountain Stream'.

Probable price range £50-150

PETTITT, Charles fl.1855-1859
Landscape painter. Exhib. at BI, SS and elsewhere. Titles at BI 'Cottage near Keswick' and 'A Peep at Nature, North Wales'.

'A Mountain Landscape' sold at Christie's sale in Japan 27.5.69 for

£292.

Bibl: Cat. of York AG 1907.

PETTITT, Edwin Alfred 1840-1912
Landscape painter. Exhib. at RA 1858-1880, BI, SS and elsewhere. Titles at RA include views in Cumberland, N. Wales and Switzerland.

Probable price range £50-150

Bibl: The Year's Art 1913 p.437 (obit).

PETTITT, George fl.1857-1862
Landscape painter. Exhib. at RA in 1858, BI and elsewhere. Titles at BI 'Langdale Pikes' 'Buttermere' 'A Cumberland Lake' and views in North Italy. He was particularly fond of painting lakes.

'Loch Awe with Castle, Figures and a Boat' sold at Sotheby's 29.8.69 for £160.

Bibl: AJ 1858 p.78 no.49, p.80 no.426; 1859 p.81 no.43, p.121, no.144; 1861 p.71.

PETTITT, Joseph Paul fl.1845-1880 d.1882
Birmingham landscape painter. Exhib. at RA 1849-53, BI, and mostly at SS (104 works). Titles at RA include views in England, on the Thames, in the Alps, and Savoy.

'A View in the Lake District' sold at Sotheby's 2.10.68 for £130.

Bibl: The Year's Art 1883 p.229; Bryan.

PHILIP, Miss Constance B See under Mrs. Cecil Lawson.

PHILLIP, Colin Bent RWS 1855-1932
Scottish landscape painter, principally a watercolourist. Son of John Phillip RA (q.v.); studied drawing for a short period at Lambeth School of Art, and at Edinburgh; also studied under David Farquharson (q.v.). Exhibited in London at the RA, OWS and GG from 1882. RWS, 1886. His watercolours are almost entirely of Highland scenery. Caw notes that "he is perhaps more draughtsman than painter, and his landscapes often large in size are marked by careful and learned drawing of mountain form and structure, rather than by justness of tone, fullness of colour, or fineness of atmospheric relationship and effect."

Probable price range £50-150

Bibl: Caw 308; Who Was Who 1929-40; Pavière Landscape.

***PHILLIP, John RA 1817-1867**
Scottish genre painter. Sometimes known as "Spanish" Phillip because of his success in painting Spanish subjects. Born in Aberdeen. Apprenticed to a local house painter, and later to a portrait painter. In 1834 he ran away to London as a stowaway on a boat. He spent an entire day at the RA exhibition, which fired him with enthusiasm to become a painter. In 1836 a gift of £50 from Lord Panmure enabled him to study, first under T.M. Joy (q.v.), later at RA schools, where he became a member of the Clique (q.v.). In 1839 he returned to Aberdeen, but continued to exhib. at RA, RSA and BI. 1846 returned to London. Visited Spain three times, in 1851, 1856 and 1860. On his second trip he travelled with Richard Ansdell (q.v.). After this he turned away from the Scottish genre subjects of his earlier, Wilkie-inspired period, and concentrated on colourful Spanish scenes. In 1866 he visited Florence and Rome. Exhib. at RA 1838-67, BI, SS and RSA. Elected ARA 1857, RA 1859. He was one of the most naturally facile of all Victorian painters. His style is firm, broad and confident; his colours strong and luminous. The subject matter of his pictures is usually simple and straightforward, although his Spanish

scenes now have too much of a picture postcard flavour. His oil sketches are painted with surprising freedom of brushwork, and look as if they could have been painted 50 years later. His son Colin Bent (q.v.) was also a painter. His studio sale was held at Christie's on May 31, 1867.

Prices during the 1968-9 season ranged from £115-350. A combined work of Phillip and Ansdell 'A Spanish Market' sold at Phillips 20.1.69 for £1,500.

Bibl: AJ 1859, p.132; 1867, 127 f (obit); Portfolio 1887 p.157 f; 175 f (W. Armstrong); Connoisseur 38 (1914) 123; Ruskin *Academy Notes* 1856, 1859; Bryan; DNB; Caw 179-184 (pl.182); Reynolds VS 10, 11, 56, 62 (pl.24); Reynolds VP 12, 29, 31, 40 (pls. 19-20); Catalogue of J.P. Exhibition, Aberdeen AG 1967 (with full bibliog.); Maas 95-6 and passim (pls. p.96-7).

PHILLIPS, Giles Firman 1780-1867
London landscape painter in watercolour. Became a member of the RI in 1831, but resigned a few years later. Exhibited from 1830-66, at the RA (1831-58), BI, SS, NWS and elsewhere. He published *Principles of Effect and Colour, as applicable to Landscape Painting* 1833 (3 eds), *Theory and Practice of Painting in Watercolours* 1838, and *A Practical Treatise on Drawing and on Painting in Watercolours,* 1839.

'View on the Thames from East Greenwich' sold at Christie's 14.6.68 for £210.

Bibl: Redgrave, Dict., Cundall; DNB; VAM; Cat. of Engr. Brit. Portr. BM 4 (1914) 101 552.

PHILLIPS, Henry Wyndham 1820-1868
Portrait painter. Younger son and pupil of Thomas Phillips RA, portrait painter. Exhibited from 1838-68 at the RA, BI and elsewhere. Between 1845 and 1849 he painted a few scriptural subjects which he exhibited at the BI, but his works were chiefly portraits, e.g. Charles Kean as Louis XI (for the Garrick Club), Dr. William Prout and Robert Stephenson. He was a Captain in the Artists' Volunteer Corps, and for thirteen years the energetic secretary of the Artists' General Benevolent Institution.

Probable price range £30-100

Bibl: AJ 1869, 29; DNB; Rev. T.M. Rees *Welsh Painters* 1912; Cat. of Engr. Brit. Portr. 6 (1925) 528.

PHILLIPS, Philip fl.1826-1864 d.1864
London painter of panoramas, architectural subjects and landscapes, who exhibited from 1826-65, at the RA (1841-59), BI and SS. He was the only pupil of Clarkson Stanfield (q.v.); his wife was the painter Elizabeth Phillips (Miss Elizabeth Rous) (q.v.). He painted an enormous panorama of the Ganges, from Calcutta to the Himalayas, and one which commemorated the Queen's visit to Ireland, and in these was often helped by his wife. Titles at the RA also include 'The Vale of Keswick, Cumberland, looking towards Causay and Grisdale Pikes' 1844, 'Panoramic view of Zurich, Switzerland, from the Katzen Bastei' 1854, and 'The Bayan Tower' 1857.

'A Rhenish Landscape' sold at Christie's 17.2.67 for £105.

Bibl: see under PHILLIPS, Mrs. Philip.

PHILLIPS, Mrs. Philip (Miss Elizabeth Rous) fl.1832-1878
London painter of landscape, architectural subjects, the exteriors and interiors of churches and ruins, still life, flowers and fruit. Her father was Lt. James Rous, an amateur artist who had worked at the Battle of Waterloo. Her husband was Philip Phillips (q.v.), and it was his enthusiasm that made her take up painting. She often helped him in his panoramas, and they always went on sketching tours together. She exhibited from 1832-78, at the RA (1844-55), BI, SS, and elsewhere, and was best known for her still-life pictures, her views of churches

and landscapes of Rhenish scenery. One of her most important watercolours was 'The Dutch Collection' (still-life of Dutch ware), which was hung on the line at the RA, 1852.

Probable price range £30-70

Bibl: Clayton II 230-4.

PHILLOTT, Miss Constance ARWS fl.1864-1904
Painter of genre, historical subjects, portraits, landscape and classical subjects, who exhibited from 1864-1904, at the RA (1868-81), SS, RWS, GG, NG and elsewhere. Titles at the RA include 'In Wotton Woods' 1868, 'Waterbearers' 1878, and 'Owen Glendower's Parliament House, Dolgelly' 1873. Shaw Sparrow illustrates 'The Herdsman of Admetus' — a classical-pastoral subject — exhibited at the RWS in 1904.

Probable price range £30-70

Bibl: W. Shaw Sparrow *Women Painters of the World* 1905 pl.138.

PHILP, James George RI 1816-1885
Painter of landscape and coastal scenes. Born in Falmouth. Exhibited from 1848-85, at the RA (1848-53), SS, NWS (347 works) and elsewhere. He painted almost entirely in Devon and Cornwall, chiefly coastal scenes. He first exhibited two landscapes in oil at the RA, but afterwards his work was almost entirely in watercolour. RI 1856.

Probable price range £30-70

Bibl: Bryan; Cundall; Wilson, Marine Painters.

'PHIZ' See BROWNE, Hablot Knight ('Phiz')

PHYSICK, Robert RBA fl.1859-1866
Animal painter, who exhibited from 1859-66, at the RA (1859-64), BI and SS, titles at the RA including 'Forbidden Fruit' 1859 and 'Rabbits' 1864.

Probable price range £30-50

PICKERING, Miss Evelyn see under DE MORGAN, Mrs. Evelyn

PICKERING, Ferdinand fl.1831-1882
Painter of genre and historical subjects, who exhibited from 1831-82, at the RA (1841-78), BI and SS. Titles at the RA include 'A Visit to Vandyck' 1841, 'The Escape of Prince Rasselas' 1845, 'Scene from the Maya Ballad of Cuncoh and Pixan' 1846, 'A Syrian girl' 1870, 'Thinking it Over' 1877.

Probable price range £30-70

PICKERSGILL, Frederick Richard RA 1820-1900
Historical genre painter; son of Richard Pickersgill (q.v.) nephew of Henry William P. (q.v.) father of Henry Hall P. (q.v.). Pupil of his uncle W.F. Witherington (q.v.). Exhib. at RA 1839-75, and BI. Subjects at RA mythological, biblical and literary — especially Shakespeare and Spenser. Elected ARA 1847, RA 1857. He was influenced by William Etty (q.v.) and shared his taste for grand historical subjects in emulation of Titian and the great painters of 16th century Venice.

'Mother and Child in a Wooded Landscape' sold at Christie's 22.11.68 for £262.

Bibl: AJ 1850, 108; 1855, 233-6; 1852; 1863; 1864; 1869 (plates); 1901, 63; Portfolio 1887, 106; The Year's Art 1901 p.311 (obit); DNB; Bryan.

PICKERSGILL, Henry Hall 1812-1861
Historical genre and portrait painter; son of Henry William P. (q.v.). Studied in Holland; travelled in Italy and Russia. Exhib. at RA 1834-61, and BI. Titles at RA include Italian and Russian scenes,

historical genre, especially Shakespeare, and later mostly portraits. His wife Jane P. was also a painter, and exhibited still life and genre at the RA and BI 1848-63. Pictures by Henry Hall P. are in the VAM and Salford Museum.

Probable price range £50-150.

Bibl: AJ 1861, 76; DNB.

PICKERSGILL, Henry William RA 1782-1875

Portrait painter; father of Henry Hall P. (q.v.), brother of Richard P. (q.v.). Pupil of George Arnald (q.v.). Throughout his long life, he was a very prolific painter, exhibiting 384 works at the RA from 1806 to 1872, and 26 at the BI. His sitters came from a wide variety of professions — theatrical, legal, religious, military and political; he was also patronised by the aristocracy, usually for presentation portraits. He occasionally painted historical genre. Elected ARA 1822, RA 1826. His studio sale was held at Christie's on July 16, 1875.

'Harriet, Lady Ashburton' sold at Christie's 28.6,63 for £136.

Bibl: AJ 1850, 75; 1875, 231; 1903, 374; Connoisseur 41 (1915) 52; 70 (1924) 177; W. Sandby *History of the RA* 1862; E.J. Poynter *The Nat. Gall.* 1900; L. Cust *The NPG* 1902; Bryan; DNB; Cat. of Engraved Brit. Portraits BM 6 (1925) 529; Poole, *Cat. of Portraits etc. of Oxford* 1925.

PICKERSGILL, Richard fl.1818-1853

Marine and landscape painter; brother of Henry William P. (q.v.), father of Frederick Richard P. (q.v.). Exhib. at RA 1818-45, BI, SS and NWS. Subjects landscapes, coastal scenes, and contemporary naval incidents.

Probable price range £50-150.

Bibl: AJ 1855, 233.

PICKNELL, William Lamb RBA 1853/4-1897

Landscape and marine painter. Born in Boston, Massachusetts. Pupil of George Inness in Rome (1874-6), and of Gérôme in Paris; painted in Brittany for several years under Robert Wylie. Awarded honourable mention, Paris Salon, 1880. Exhibited in London from 1877-90, at the RA, SS and elsewhere, and has a London address during that time. Titles at the RA include 'Breton Peasant Girl Feeding Ducks, Pont Aven, Brittany' 1877, 'Unloading Fish' 1884, 'Brockenhurst Road' 1885, and 'A Toiler of the Sea' 1887. Member of the Society of American Artists; elected A. Member of National Academy of Design; RBA. Represented by "The Road to Concarneau" 1880, in the Corcoran Art Gallery, Washington.

Probable price range £30-70

Bibl: Gazette des Beaux Arts 1880 II 66; L'Art 57 (1894) 170 f; American Art Annual I 1898 333 (pl.); III 1900 203 (pl.); Mantle Fielding *Dictionary of American Painters, Sculptors and Engravers* 1965.

PIDDING, Henry James RBA 1797-1864

Painter of humorous subjects from domestic life, and still life. Born in Cornwall. Pupil of A. Aglio. Exhibited from 1818-64, at the RA (from 1818-55), BI and SS (177 works). Attained some note by his paintings of humorous subjects: elected RBA in 1843. The AJ notes 'Massa Out, Sambo Very Dry' (a negro helping himself to a wine decanter), 'The Fair Penitent' (a negro seated in the stocks) and 'The Battle of the Nile' (two ancient Greenwich pensioners discussing the battle) as being the best of his works. C.1860 he tried to make a sensation with a larger painting — 'The Gaming Rooms at Homburg'. In 1836 he etched a series of six humorous illustrations to *The Rival Demons,* an anonymous poem. He was also well known as a painter of fish. 'The Enthusiast' is in Leicester Art Gallery.

Probable price range £50-100.

Bibl: AJ 1864, 243; Ottley; Redgrave, Dict; DNB.

PIDGEON, Henry Clark RI 1807-1880

Painter of landscape and architectural subjects, and portraits; engraver and lithographer; antiquary. He intended originally to enter the church, but he then adopted art as a profession, practising as an artist and teacher in London. 1847 became Professor of Drawing at the Liverpool Institute, and drew many local scenes and antiquities. Member of Liverpool Academy in 1847, Secretary 1850, and exhibited regularly there. Joined Joseph Mayer and Abraham Hume in 1848 in founding the Historic Society of Lancashire and Cheshire, and contributed many etchings and lithographs to the Society's publications. RI 1861.

Probable price range £30-70

Bibl: AJ 1859, 176; American Art Review I 1880 555; Marillier; DNB.

PIERCY, Frederick fl.1848-1882

London painter of portraits, landscape and genre, who exhibited from 1848-82, at the RA (1848-80) and SS, titles at the RA including 'A Portrait' 1848, 'A Garden Gate near that of Osborne' 1857, and 'Coaxing a Puppy to Swim' 1859. Possibly the same person or related to Frederick Hawkins Piercy, sculptor, who also lived at 534 Caledonian Road, in 1880, and exhibited at the RA in 1880.

'Homage to Turner' — a watercolour sold at Christie's 3.4.69 for £210.

PIKE, Sidney fl.1880-1901

Painter of landscape and genre, living in Taplow, Christchurch and London, who exhibited from 1880-1901, at the RA (1885-1901), SS and elsewhere, titles at the RA including 'The Shepherd's Wife' 1885, 'Tipped with Golden Light' 1889, 'April Showers' 1892, and 'Fading into Night 1901.

Probable price range £30-70

PIKE, W.H. RBA b.1846 fl.1874-1893

Plymouth landscape painter, who exhibited from 1874-93, at the RA (in 1874 and 1888), SS (60 works), NWS and elsewhere. Titles at the RA are 'King Arthur's Castle, Tintagel' 1874 and 'Old Impressions' 1888.

'The Fair' sold at Sotheby's 29.1.69 for £140.

Bibl: G. Pycroft *Art in Devonshire* 1883 105.

PILKINGTON, H. fl.1839-1856

London painter of genre, portraits, animals, landscape and interiors, who exhibited from 1839-56, at the RA (1839-55) and BI, titles at the RA including 'Sportman's Pets' 1839, 'Donkey and Sheep — outskirts of a Common' 1846, 'Reading the news' 1853.

Probable price range £30-70

PILLEAU, Henry RI ROI 1813/1815-1899

London landscape painter, in oil and watercolour. Educated at Westminster School; entered the Army Medical Corps, where he spent many years and became Deputy Inspector-General of Hospitals. On his retirement he devoted himself exclusively to art, his favourite painting grounds being Venice and the East. Exhibited from 1850-80 at the RA, and also at the BI, SS, NWS (76 works), and elsewhere (172 works). RI 1882. He died in Brighton.

Probable price range £30-70

Bibl: Cundall 244; VAM.

PILSBURY, Wilmot RWS 1840-1908

Painter of landscape and domestic genre. Born in Dorking, Surrey; studied at Birmingham School of Art and the S. Kensington Schools; pupil of J.W. Walker. Became Headmaster of the Leicester School of

Art. Exhibited from 1866, at the RA (from 1872), SS, OWS (230 works), GG and elsewhere, titles at the RA including 'Near the Farm' 1872, 'Catching Minnows' 1873, 'Stokesay Castle' 1878, and 'Ploughing Time' 1896. A memorial exhibition of his work was held at the FAS in 1908, of which *The Studio* writes: ". a regard for detail in itself, expressed with a feminine but not very sensitive touch, and little regard for the effect in general. Mr. Pilsbury's was a conventional art with a precedent in the work of Mrs. Allingham, and a great deal of its charm — a charm arising out of pleasant subjects; and a love of the English countryside so strong that it impels towards sympathetic expression."

Probable price range £20-50 for watercolours; £30-100 for oils.

Bibl: Studio 28 (1903) 135; 44 (1908) 142; Cundall 244; Cat. Norwich Castle Museum 1909; Pavière, Landscape

*PINWELL, George John RWS 1842-1875

Illustrator and engraver; painter in watercolour of genre and historical subjects. Born at High Wycombe; studied at St. Martin's Lane School and at Heatherley's. In 1863 began his professional career by designing and drawing on wood, chiefly for the Dalziel Brothers, whom he assisted in the production of *Arabian Nights' Entertainments* and Goldsmith's *Vicar of Wakefield* 1864. Together with Frederick Walker, John W. North and others he illustrated *A Round of Days* 1866, R. Buchanan's *Ballad Stories of the Affections* 1866, *Wayside Posies* 1867 and Jean Ingelow's *Poems* 1867. Exhib. from 1865-75 at the Dudley Gallery and OWS, of which he was elected A in 1869, member in 1870. He died of consumption. Hardie notes that "one may set him beside Charles Keene as one of the greatest of British draughtsmen". An exhibition of his works was held at the Deschamps' Gallery in February 1876. His studio sale was held at Christie's on March 16, 1876.

Since 1964 auction prices have ranged from about £75 up to £220.

Bibl: AJ 1864 326; 1875 365; 1876, 151; 1901, 321; 1903, 228; 1905, 145; Redgrave, Cent. and Dict.; Roget II 396-9; Gleeson White; G.C. Williamson, *G.J.P. and His Works* 1900; Bryan; Binyon; Cundall; DNB; Studio Special No. *Graphic Arts of Great Britain* 1917 (6) 18; Studio Spring No. *Drawings in Pen* 1922 115; Studio 83 (1922) 240; Connoisseur 62 (1922) 236; 65 (1923) 72; 69 (1924), 165, 183; 72 (1925) 55; Studio Winter No. *British Book Illustration* 1923-4 22 60; *Print Collector's Quarterly* 10 (1923) 108 130; 11 (1924) 162-189; Hardie III 138-9, (pls. 159-60;) Maas 235 (pl.234); Magazine of Art 1901, 550

PIPER, Herbert William fl.1871-1889

London painter of portraits, landscape and genre, who exhibited from 1871-89, at the RA (1873-8), SS and elsewhere, titles at the RA including 'Mrs. William Playfair' 1873, 'Springtime' 1874 and 'Primroses' 1878.

Probable price range £30-70

PITMAN, Miss Janetta R.A. fl.1880-1901

Painter of genre, still life and flowers, living in Basford, near Nottingham, who exhibited from 1880-1901, at the RA, SS, NWS, GG and elsewhere, titles at the RA including 'Dead Wood-pigeon' 1880, 'Christmas Bills' 1882, and 'White Paeonies' 1900.

Probable price range £20-70

PITT, Thomas Henry fl.1827-1852

London landscape painter, who exhibited from 1827-52, at the RA (1839-48), BI and SS, titles at the RA including 'Dunmow Church, Essex' 1839 and 'Abbeville' 1842.

Probable price range £30-70

PITT, William fl.1853-1890

Birmingham landscape painter. Exhib. at RA 1863-80, BI, and elsewhere, but mostly at SS. He painted English views, especially in Devon and Cornwall.

'Helford River, Cornwall' sold at Bonham's 6.3.69 for £360.

Bibl: AJ 1859, 142;
Cat. of the Nat. Gall. of British Art, VAM, 1908.

PITTAR, I.J. fl.1845-1856

Painter of portraits, genre and historical subjects, living in London and Brighton, who exhibited from 1845-56, at the RA (1845-51), BI and elsewhere, titles at the RA being mostly portraits and 'Don Juan and Haidee' 1851.

Probable price range £20-50

PITTARD, Charles William fl.1878-1904

Painter of genre and still life, living in Brixton, Streatham and Twickenham, who exhibited from 1878-1904, at the RA (1881-1904), and SS. Titles at the RA include 'Faint Heart and Fair Lady' 1881, 'The Quarrel' 1884, 'Roses' 1891, and 'Sleep' 1904.

Probable price range £20-50

PLATT, Henry fl.1825-1865

London painter of rustic genre, landscape and coastal scenes, who exhibited from 1825-65, at the RA (1825-63), BI, SS, and NWS, titles at the RA including 'Cattle and Landscape' 1825, and 'Coast Scene' 1863. Wilson notes that he was a "painter of rural scenes, but specialised in beach scenes with children, shrimpers etc. Few of his views are localised but inland scenes were unusual".

Probable price range £30-70

Bibl: Wilson, Marine Painters.

PLAYER, F. de Ponte fl.1873-1881

Marine painter, living in Ventnor and London, who exhibited from 1873-81 at the RA, SS and elsewhere, titles at the RA including 'Unloading: near Paignton, S. Devon' 1877.

Probable price range £20-50

PLAYER, William H. fl.1858-1884

Landscape painter, living in Ventnor and London, who exhibited from 1858-84, at the RA (1863 and 1884), BI, SS, NWS and elsewhere, titles at the RA being 'The Nearest Way to the Village — Scene in the Isle of Wight' 1863, and 'A Watery Moon' 1884.

Probable price range £30-70

Bibl· *The Victorian Painter Abroad* Trafalgar Galleries London 1965, pl.17. Pavière, Landscape.

PLIMPTON, Miss Constance E. fl.1882-1900
(Mrs. Constance Smith)

London painter of domestic genre, flowers and portraits, who exhibited as Miss Plimpton from 1882-93 at the RA, SS, NW and elsewhere, and as Mrs. Smith from 1897-1900 at the RA. Titles include 'Two Pets' 1888, 'Sweet Violets' 1893, and 'A Silver King' 1900.

Probable price range £20-50

POCOCK, Lexden Lewis 1850-1919

Genre and landscape painter. Born in London, son of Lewis Pocock F.S.A. Studied under Poynter at the Slade School, where he won a prize and a silver medal; and later at the RA Schools, where he was awarded a silver medal for drawing from the life. Subsequently he studied and taught for two years at Rome. He was a Member of the Council of the Dudley Art Society, and exhibited from 1872, at the RA (from 1875), SS, NWS and elsewhere. Titles at the RA include 'After Rain' 1875, 'Claude Lorraine's Villa on the Tiber' 1879, and

'The Microscope, "Consider the Lilies" ' 1904.

Probable price range £30-70

Bibl: VAM.

POINGDESTRE, Charles H. fl.1849-1901 d.1905.
Painter of Italian landscape and genre. He was for many years the President of the British Academy in Rome. Exhib. at RA 1850-1901, BI, SS, NWS, GG, NG and elsewhere. His subjects all of Rome, the Campagna, and Italian rustic life e.g. 'In the Pontine Marshes' 'Poultry Market, Rome' 'A Steep Road at the Marble Quarries, Carrara' etc. He spent periods of his life in England and Jersey, and painted English landscapes.

'A Gaucho with Wild Horses' sold at Bonham's 3.10.68 for £200.

Bibl: The Year's Art 1906 (obit); L'Art 64 (1905) 547.

***POLLARD, James 1792-1867**
Painter of coaching and sporting subjects; engraver. Son and pupil of Robert Pollard (1755-1838) an engraver and publisher. Also received much help and advice from Thomas Bewick. In 1820 began to paint coaching scenes, and 1821 exhib. a large work at the RA 'North Country Mails at the Peacock, Islington'. By 1825 he was successful enough to leave his father, marry, and set up on his own. Exhib. a few works at RA, BI and SS, but worked mainly for dealers and private patrons. In 1840 both his wife and his youngest daughter died. This was a blow from which he never fully recovered, and his later work shows evidence of decline. Although now best known for coaching subjects, he also painted racing, hunting, steeplechasing, shooting and fishing scenes. He was never a technically accomplished artist, but his work is valued for its historical accuracy, in evoking the spirit of the coaching age. He produced many prints, which were engraved by himself, his father, R. Havell, J. Harris and others.

In 1960 'North Country Mails at the Peacock, Islington' sold at Sotheby's for £19,000, which is still the record. Small works usually make around £2,000-8,000; larger ones anything from £10,000 upwards.

Bibl: Connoisseur 51 (1918) 15-22; 90 (1932) 371, 409, 410; Print Collector's Quarterly 12 (1925) 173-5, 180; 17 (1930) 169-195; Oude Kunst 4 (1918-19) 124-6; Studio Special No. 1920 *Londoners Then and Now;* Apollo 7 (1928) 158-161, 164; W. Gilbey *Animal Painters in England* 1900; W. Gilbey *Early Carriages and Roads* 1903; W. Shaw Sparrow *British Sporting Artists* 1922 repr. 1965; N.C. Selway *J.P.* 1965, (with catalogue of complete works); Pavière, Sporting Painters 70 (pl.34); Maas 71, 74 (pl. p.74).

POLLARD, S.G. fl.1864-1877
Genre painter, living in London and Taunton, who exhibited from 1864-77, at the RA (1864-74), BI, SS and elsewhere, titles at the RA including 'Tired' 1864, 'The Invalid's Friend' 1866, and ' "She Sails Well" ' 1874.

Probable price range £30-70

POLLENTINE, Alfred fl.1861-1880
Painter of Venetian scenes. Exhib. 1861-1880 at BI and SS. Also recorded are R.J. Pollentine (fl.1852-1862) a landscape painter, and W.H. Pollentine (fl.1847-1850) who painted shipping and coastal scenes. They were probably all related, but nothing is known of them.

Prices during the 1968-9 season ranged from about £50 up to £893.

POLLENTINE, R.J. See under POLLENTINE, Alfred.

POLLENTINE, W.H. See under POLLENTINE, Alfred.

PONCY, Alfred Vevier de fl.1871-1890
Painter of landscape and genre, living in Balham and London, who exhibited from 1871-90, at the RA (1877-90), SS and elsewhere, titles at the RA including 'A Severe Winter' 1877, 'The Flock' 1879, and 'Landscape and Cattle in Repose' 1890.

Probable price range £30-70

POOLE, Christopher fl.1882-1891
Landscape painter, living in Poole and Teignmouth, who exhibited from 1882-91, at the RA (1889 and 1891), SS, NWS, and elsewhere, titles at the RA being 'St. Servan' 1889 and 'Ye Olde Cannon Inne' 1891.

Probable price range £30-70

POOLE, James 1804-1886
Little-known landscape-painter. Did not exhibit in London, but his works now appear at auction quite often. Usually painted mountain and moorland scenery, often in Wales and Scotland.

'Salmon Trapping in North Wales' sold at Christie's 20.12.68 for £136.

Bibl: The Year's Art 1887, p.230.

***POOLE, Paul Falconer RA RI 1807-1879**
Painter of historical subjects, genre and portraits. Born in Bristol, the son of a grocer, and as an artist was almost entirely self-taught. When only twenty he became involved in a scandal in which Francis Danby was also concerned: Poole probably lived with Danby's wife in about 1830, and Danby eloped to Geneva with Poole's wife. Poole ultimately married Danby's widow after her husband's death in 1861. Exhib. at the RA from 1830-79, and also at BI, SS and NWS. ARA in 1846; RA 1861; RI 1878. In 1843 he attracted much attention by his highly dramatic 'Solomon Eagle Exhorting the People to Repentance during the Plague of London', and in 1847 won a prize of £300 in the Houses of Parliament Competition for 'Edward III's Generosity to the People of Calais'. Reynolds VP notes that many of his paintings are routine, like those of smiling country girls with their children posed against the rocky streams of the West Country, and that "he needed to accumulate reserves of concentration and feeling to produce his most impressive canvases", e.g. 'The Last Scene in Lear' 1858, and 'The Vision of Ezekiel' 1875. Ruskin especially admired the latter; ". . . . there is, as there has always been in Mr. Poole's work, some acknowledgment of a supernatural influence in physical phenomena, which gives a nobler character to this storm-painting than can belong to any merely literal study of the elements". An exhibition of his works was held at the RA in 1884. His studio sale was held at Christie's on May 8, 1880.

'The Lighting of the Beacon' sold at Christie's 17.1.69 for £200. The usual range for his country-girl type works is £50-150; important dramatic works would obviously make more.

Bibl: Ruskin Academy Notes 1858, 1875; AJ 1859, 41-3; 1864, 320; 1865, 364; 1866, 212; 1879, 263; 1908, 289; Redgrave Cent.; Clement and Hutton; The Portfolio 1879, 189; 1882, 165; 1883, 225; 1884, 43; Binyon III; DNB; Reynolds VP 142, (pl.147); Maas 37-8.

POPE, Mrs. Alexander fl.1796-1838, d.1838.
(Miss Clara Maria Leigh and Mrs. Francis Wheatley).
Painter of rustic genre, portraits and fruit and flowers. Daughter of Jared Leigh; married Francis Wheatley. From 1796-1807 she exhibited as Mrs. Francis Wheatley at the RA and BI, first miniatures, and then rustic subjects with figures of children, e.g. 'Little Red Riding Hood'. In 1801 Wheatley died, and in 1807 she married the actor Alexander Pope. From 1808-38 she exhibited as Mrs. A. Pope at the RA, BI and SS, at first rustic genre, but from 1817 entirely studies of fruit and flowers. She had a great reputation for her groups of flowers, and for

a long time she was employed as an illustrator by Mr. Curtis, the botanical publisher. She also had many pupils – among them Princess Sophia of Gloucester.

Probable price range £50-150

Bibl: AU 1839, 23; Clayton I 401; Redgrave, Dict.; DNB.

POPE, Gustav fl.1852-c.1910
London genre, historical and portrait painter who exhibited from 1852-95, at the RA (1854-95), BI, SS, and elsewhere, titles at the RA including portraits and 'The Noble Substitute' 1854, 'The Orphan's Refuge' 1861, and 'Andromache Feeding Hector's Horses' 1883. The AJ engraves 'Accident or Design' – a bashful youth approaching a young girl sketching, in historical costume. In 1910 Pope's 'A Rainy Day' was given to Bristol Art Gallery.

'The Knife-Thrower and his Family in a Garret' sold at Christie's 9.10.64 for £136.

Bibl: AJ 1872, 112 (pl.); Building News 1910 II 490.

PORTEUS, Edgar fl.1868-1878
London painter of domestic genre, who exhibited from 1868-78, at SS and elsewhere, and at the RA in 1873, 'Bad Times', 'Good Times'.

Probable price range £20-50

POTCHETT, Miss Caroline H. fl.1862-1881
Landscape painter, living in Great Ponton, who exhibited from 1862-81 at SS.

Probable price range £20-50

POTCHETT, Miss Emily fl.1869-1880
London landscape painter, who exhibited from 1869-80 at SS.

Probable price range £20-50

POTT, Laslett John RBA 1837-1898
Painter of historical genre. Born in Newark, Notts. Studied under Alexander Johnston. Exhib. at RA 1860-97, and SS. His historical scenes were based on real and imaginary events, usually of the 17th or 18th centuries. Typical titles 'Charles I Leaving Westminster Hall after his Trial' 'Dismissal of Cardinal Wolsey' 'His Highness in Disgrace' 'The Ruling Passion' 'The Jester's Story' etc. He also painted scenes of the Napoleonic Wars.

'The new Publicans' sold at Sotheby's 4.6.69 for £500. 'The Ruling Passion' sold at Sotheby's 4.6.69 for £950.

Bibl: AJ 1869, 68, 1873, 264; 1875, 151; 1877, 257-60; Clement and Hutton; American Art Annual 1898 p.40.

POTTER, Charles RCA fl.1867-1892
Landscape painter, living in Oldham and Tallybont, Conway, who exhibited from 1867-92, at the RA (1871-92), NWS, GG and elsewhere. Titles at the RA include 'The Grave of Taliesin, the Welsh Bard' 1871, 'Street of the Tombs, Pompeii 1874 and 'Early Spring Welsh Pastoral' 1892.

Probable price range £30-70

***POTTER, Frank Huddlestone RBA** 1845-1887
Genre painter. His father was a solicitor, his uncle Cipriano Potter, a well-known composer, sometime President of the Royal Academy of Music. Some years after leaving school, Potter entered Heatherley's, and then the RA Schools. He then went to Antwerp but returned to London in a few months. Exhibited at the RA in 1870, 1871 and

1882; from 1871-85 at SS, and became a RBA in 1877. Potter's work did not meet with the recognition it deserved in his lifetime. A 'Quiet Corner' was exhibited at the GG in 1887, and attracted much notice, but unfortunately he died on the opening day of the exhibition. A memorial exhibition of his work was held at SS in 1887, and many of his paintings were bought by Samuel Butler, who had been a fellow-student at Heatherley's. 'Little Dormouse' and 'Girl Resting at a Piano' are in the Tate Gallery.

Probable price range £100-300

Bibl: Studio Vol. 64, 234 (pl.); Vol. 72, 148 (pl.); Bryan; Studio Year Book 1920 57 (pl.); Reynolds VS 41 100 (pl.95).

POTTS, George B. fl.1833-1860
London landscape painter who exhibited from 1833-60, at the RA (1835-60), BI and SS, titles at the RA including 'Banstead Downs' 1835, 'Evening near the Thames' 1842, and 'The River from Greenwich Park' 1860.

Probable price range £30-70

POULTON, James fl.1844-1859
Painter of still life and game, living in Homerton and Dalston, who exhibited from 1844-59 at the RA, BI and SS, titles at the RA including 'Pigeons' 1844, 'The Harem Lily' 1847, and 'Game' 1859. He was the brother of George Poulton, landscape painter, fl.1846-56.

'Still Life with Fruit' sold at Bonham's 8.5.69 for £150.

POWELL, Alfred fl.1870-1901
London landscape painter, who exhibited from 1870-1901 at the RA, SS, NWS and elsewhere, titles at the RA including 'A Cattle Path on the Greta, Yorks' 1870, 'A Summer Morning. Ullswater' 1872, and 'St. Michael's Mount' 1901. One of his watercolours is in the VAM.

Probable price range £30-70

POWELL, Sir Francis RWS PRSW 1833-1914
Watercolour painter of landscape and coastal scenes. Born at Pendleton Manchester, the son of a merchant. Studied at the Manchester School of Art. Exhibited at the OWS from 1856, became A. in 1867, RWS 1876. In 1878 he was one of the founders at Glasgow of the R. Scottish Society of Watercolour Painters, and he was its first President. Knighted in 1893. His watercolours were mostly marine and lake views. Died at Dunoon. Hardie: "His own example as an admirable painter of sea subjects, coupled with his enthusiasm, tact and personal charm, did much to advance the development of watercolour in Scotland."

Probable price range £30-100

Bibl: Studio 63 (1915) 220; Vol.67, 256; Caw 211 334; Who Was Who 1897-1915; VAM; Hardie III 82 174-5 (pl.103).

POWELL, Joseph Rubens fl.1835-1871
London painter of portraits, genre and classical subjects, who exhibited from 1835-71, at the RA (1835-58), BI, SS and elsewhere, titles at the RA including 'The Golden Age' 1850, 'Innocence' and 'Cupid Disarmed' 1855. He also painted copies of works by Claude Lorraine (for Lord Normanton), Greuze and Reynolds, which were mistaken for the originals by Dr. Waagen in *Galleries and Cabinets of Art in Great Britain. (See Fine Arts Quarterly Review)*.

Probable price range £30-70

Bibl: Fine Arts Quarterly Review 2 (1864) 201-2.

POWELL, P. fl.1826-1854
Painter of landscape and marine subjects, genre and portraits, living

in Clapham, Brighton and London, who exhibited from 1826-54, at the RA (1839-54), BI, SS and NWS, titles at the RA including 'Lake Scene at Aix in Savoy – Morning' 1839, 'East Cliff, Hastings' 1850 and 'Lucy' 1853. He worked much abroad but also on the coasts of Kent and Sussex.

Probable price range £30-70

Bibl: Wilson, Marine Painters.

*POYNTER, Sir Edward John PRA RWS 1836-1919
Neo-classical painter. Son of Ambrose Poynter, an architect. Born in Paris. Visited Italy in 1853, where he met the young Frederick Leighton (q.v.), and was much influenced by his neo-classical ideas. Returned to London and studied with Leigh and W.C.T. Dobson (q.v.), and also at RA schools. In 1856 he entered Gleyre's Studio in Paris. From 1856-9 lived mainly in Paris, where he met Du Maurier, Lamont, Armstrong and Whistler, all of whom were to feature later in Du Maurier's novel *Trilby*. Returned to London 1860. Appointed Slade Professor and later Director of Art at the South Kensington Museum. Exhib. at RA from 1861, and at BI, OWS, GG, NG and elsewhere. Scored his first major success with 'Israel in Egypt' (RA 1867). Later he turned more to Greek and Roman subjects e.g. 'A Visit to Aesculapius' 'Psyche in the Temple of Love' etc. He also painted many smaller scenes of Roman or Greek life, mostly figures in marble interiors similar to those of Alma-Tadema. Elected ARA 1869, RA 1876, PRA 1896-1918. Director of the National Gallery 1894-1906. Poynter was a strictly academic artist, who believed in study of the life model, and made studies for every figure in his pictures. He was also an illustrator, medallist, designer of tiles, and painter of wall decorations. His studio sale was held at Christie's on Jan. 19. 1920.

'When the World was Young' sold at Garrod Turner (Woodbridge) in February 1971 for £5,600, the current record price. The previous record was £3,518 for 'Cave of the Storm Nymphs' at Christie's 21.3.69. Smaller works and single figure subjects can still sell for under £1,000.

Bibl: AJ 1877, 17-19; 1903, 87-192; Studio 7 (1896) 3-15; 30 (1904) 252 ff; 72 (1918) 89 ff; Connoisseur 36 (1913) 56; 55 (1919) 51-2; 64 (1922) 55-6; Athenaeum 1919 II 691 (obit); Ruskin *Academy Notes* 1875; Roget; DNB; VAM; A. Margaux *The Art of E.J.P.* 1905; M. Bell *The Drawings of E.J.P.* 1906; L. Forrer *Biog. Dict. of Medallists* 4 (1909); Who Was Who 1916-28; W. Gaunt *Victorian Olympus* 1952; Reynolds VP 119-21 and passim (pls. 85.86.88); Hutchison, see index; Maas 183-4 and passim (pls. p.183, 184, 186); L. Ormond *George du Maurier* 1969 see index.

PRATT, Claude fl.1887-1892
Birmingham genre painter and watercolourist; son of Jonathan Pratt (q.v.). Exhib. only 2 works at NWS; worked mainly in Birmingham and the Midlands. Subjects mainly rustic genre.

'Springtime in the Cotswolds' sold at Christie's 10.10.69 for £68.

PRATT, John fl.1882-1897
Leeds flower and still-life painter. Exhib. at RA 1882-97. Titles 'Paeonies' 'A Corner of the Larder' 'A Reverie' etc.

Probable price range £20-50

PRATT, Jonathan fl.1871-1903
Birmingham genre painter. Exhib. at RA 1871-1903, SS and elsewhere. Titles at RA 'Where's Grandpa?' 'A Devonshire Cottage' 'A Breton Cottage' etc. His son Claude Pratt (q.v.) was also a painter. A work by J.P. is in Bristol AG.

'James Watts' Workshop' sold at Christie's 17.1.69 for £210.

Bibl: AJ 1905, 356.

PRATT, Ralph fl.1881-1893
Leeds still-life painter. Exhib. at RA 1881-93. Titles 'Study of

Lemons' 'Dessert' 'Lemons and Jar' etc. Probably the father of John Pratt (q.v.) as they both had the same address, 49 Portland Crescent, Leeds. A work by R.P. is in Leeds AG.

Probable price range £30-70

PREINDLSBERGER, Miss Marianne See STOKES, Mrs. Adrian

PRENTIS, Edward RBA 1797-1854
Painter of contemporary domestic genre, humorous, pathetic and sentimental, which gained considerable temporary popularity. Born in Monmouth. Exhibited at the first exhibition of the SBA (founded in 1825), and sent all his subsequent pictures there, until 1850. Exhibited at the RA in 1823. Maas likens the theme of 'The Sick Bed' (Glasgow) to Luke Fildes's 'The Doctor' painted later in the century. The AJ quotes what appeared in a daily paper after his death, "His collected works would furnish a striking pictorial epitome of all that is most to be admired and most to be deplored in the hearths and homes of England." He also contributed illustrations to Layard's *Monuments of Nineveh* (1849 fol.).

'The Price of the Game' sold at Bonham's 23.1.69 for £150.

Bibl: AJ 1855, 108; Redgrave Dict; DNB; Reynolds VS 55 (pl.14); Maas 119.

PRE-RAPHAELITE BROTHERHOOD
Association of young artists formed 1848-9 by D.G. Rossetti, J.E. Millais and Holman Hunt. Other members were W.M. Rossetti, James Collinson, F.G. Stephens and Thomas Woolner. Although there were many friends and associates on the fringe of the group (e.g. F.M. Brown, W. Deverell, Arthur Hughes, C.A. Collins etc.) there were only these original seven members. Collinson resigned in 1850, and the Brotherhood was virtually dissolved by 1853. The literature of the movement and its members is enormous; the best bibliography is W.B. Fredeman, *Pre-Raphaelitism, a Bibliocritical Study*, 1965.

PRICE, Frank Corbyn fl.1888-1897
Landscape painter, living in London and Billingshurst, who exhibited from 1888-97 at the RA, SS and NWS, titles at the RA including 'Coming Winter' 1888, 'Pulborough, Sussex' 1890, and 'A Passing Shower' 1897. His wife, Miss Lydia Jemima Jeal, was a painter of domestic genre.

Probable price range £30-70

PRICE, James fl.1842-1876
Landscape painter, living in Old Charlton, Kent and Blackheath, who exhibited from 1842-76, at the RA (1842-75), BI, SS and elsewhere, titles at the RA including 'Scene in a Wood' 1842, and 'Scene in Sussex' 1875.

Probable price range £30-70

PRICE, William Lake 1810-c.1891
Painter chiefly of architectural subjects, but also of portraits, historical subjects and landscapes; architect; illustrator, etcher and lithographer. Grandson of Dr. Price, chaplain to George IV and of Sir James Lake, Bt. Articled to Augustus C.Pugin; after studying under De Wint, he abandoned architecture for painting. Travelled extensively on the Continent. Exhibited from 1828-52, principally at the OWS, and also at NWS, RA (1828-32) and elsewhere. A. of OWS in 1837; resigned in 1852. He illustrated *Interiors and Exteriors of Venice* 1843, S.C. Hall's *Baronial Halls of England* I 1843. *The Keepsake* 1845/1846, and he published a manual on photography in 1858. Living at Blackheath in 1891.

Probable price range £30-70

Bibl: Roget II; Cundall; *Old English Mansions* Studio Spring No. 1915; Cat. of National Gallery of Ireland Dublin 1920 185; VAM.

PRIEST, Alfred 1810-1850
Painter mainly of marines and coastal scenes in Norfolk, and also of landscapes in Norfolk, Derbyshire, on the Wye and at Oxford — one of the last of the Norwich School. Also an etcher and lithographer. A pupil of Henry Ninham, from whom he acquired his skill in etching, and later of James Stark. Exhibited in London from 1833-47, at the RA (1833-45), BI and SS. He had moved to London in the early thirties but returned to Norwich in 1848. Most of his known work is in oils, and Clifford notes that he has seen only two watercolours certainly by him, both in Norwich Castle. "They are best described as clumsy romanticized 'Miles Edmunds' lit by a slightly unexpected cinema-organ sky." He is said to have taken to brandy in his later years, and probably did very little work.

Probable price range £30-70

Bibl: W.F. Dickes *The Norwich School of Painting* 1905; H.M. Cundall *The Norwich School* 1920 pl.80 (Studio Special Number); Clifford 61 73 (pl.67 b); Wilson, Marine Painters.

PRIESTMAN, Arnold RBA b.1854 fl.1883-1908
Landscape painter, working in Bradford, who exhibited from 1883-c.1908, at the RA (1887-1902), SS, GG and NG. Titles at the RA include 'A Grey Day near Conway' 1887, 'On the River Blythe' 1893, and 'On the Maas' 1902. The AJ reproduced 'the spacious Walberswick' exhibited at the NG in 1908. His paintings are in Leeds and Rochdale Art Galleries.

Probable price range £30-70

Bibl: AJ 1908 179 pl.178

PRIESTMAN, Bertram RA ROI 1868-1951
Painter of cattle and lush pastoral life, landscape and coastal scenes. Born in Bradford, Yorkshire; came to London in 1888; exhib. from 1889 at the RA, SS, GG, NG and elsewhere, titles at the RA including 'In Dock for Repairs' 1890, 'Ebb-tide' 1898, and 'The River Meadow' 1900. He was much travelled in Holland and France, and many of his paintings were made there. Member of NEAC 1897; ARA 1916; RA 1923; Associate of the International Society of Sculptors, Painters and Gravers, 1900. His paintings are in galleries in Bradford, Leeds, Birmingham and throughout England.

'In Dorset Meadows' sold at Bonham's 4.12.69 for £110.

Bibl: AJ 1907 179-84, 185; 1898 31; 1899 199 203; 1900 184; 1901 184; 1904 206; 1905 19; Studio 14 (1898) 77-98 (monograph with pls.); 29 (1903) 297; 31 (1904) 346; 34 (1905) 162; 36 (1906) 261; *Who Was Who 1951-60.*

PRINGLE, John William Graham fl.1867-1879
London landscape painter who exhibited from 1867-79 at the BI, SS and elsewhere. Title at the BI 'Near Ryde'.

Probable price range £20-50

PRINSEP, Valentine Cameron RA 1838-1904
Painter of portraits, historical subjects and genre, influenced by Pre-Raphaelitism and Lord Leighton. Born in Calcutta, son of an Indian civil servant. Educated at Haileybury. A close friendship with G.F. Watts encouraged him to turn to painting instead of the Civil Service, and at first he studied under Watts. He met Rossetti, and became influenced by Pre-Raphaelitism, but soon came under the influence of Leighton, to whose work his own has a close similarity. Assisted in the decoration of the Oxford Union, 1857. Worked in Paris in the studio of Gleyre, 1859. There Whistler, Poynter and Du Maurier were his fellow students, and he was the model for Taffy in *Trilby*. He then went to Italy with Burne-Jones and met Browning in Rome, 1859-60. He exhibited annually at the RA from 1862-1904, and also at SS, GG, NG and elsewhere. In 1876 he was commissioned by the Indian Government to paint the historical durbar held by Lord Lytton to proclaim Queen Victoria Empress of India. This resulted in 'At the Golden Gate' 1882 — a large canvas, and also a number of smaller works on Eastern subjects. ARA 1878; RA 1894; Professor of Painting from 1901. Prinsep was extremely versatile, socially gifted, and, after his marriage to Florence Leyland, very rich. He published an account of his visit to India, *Imperial India; an Artist's Journal* 1879; he also wrote two plays, and two novels *Virginie* 1890, and *Abibal the Tsourian* 1893.

'The Gleaners' sold at Christie's 13.6.69 for £441.

Bibl: AJ 1894, 221; 1905, 33; Framley Steelcraft *Mr. Val C. Prinsep RA* Strand Magazine XII Dec. 1896 603-15; Bate 90 pl.90; Mrs. Orr *Life of Robert Browning* 1908 224 ff; DNB 2nd supp; The Connoisseur 36 (1913) 151-2; 'The Art of Val. C. Prinsep' *Windsor Magazine* XXXIX April 1914, 613-628; Fredeman Index.

PRITCHARD, Edward F.D. 1809-1905
Marine, landscape and architectural painter, living in Bristol and London, who exhibited from 1852-73, at the RA (1852-63), BI, SS and elsewhere. Titles at the RA include 'Winter in Belgium' 1852, and 'Portland Island from the beach at Sandsfoot Castle, Portland Bay' 1863. In 1859 he exhibited at the BI 'Antwerp, Sunset' of which the AJ said "This view is taken from the upper quays, whence is obtained a perspective view of the river front of the city, with its most important buildings. The sunset glow is satisfactorily sustained throughout the picture".

'Antwerp Habour' sold at Christie's 7.2.69 for £168.

Bibl: AJ 1859, 81.

***PRITCHETT, Edward fl.1828-1864**
Painter of Venetian scenes. Exhib. at RA 1828-49, BI and SS. Nearly all his pictures were of Venice, but he did exhibit occasional English views. Although practically nothing is known of his life, his Venetian pictures are now attracting attention. Although repetitive, they are painted in a lively broad manner similar to James Holland (q.v.).

A large and typical Venetian view sold at Christie's 12.7.68 for £3,150, the highest auction price so far. Other prices have ranged from about £200 to £2,000.

Bibl: Hughes; Hardie III 31 (pl.45).

PROCTOR, Adam Edwin RI ROI RBA 1864-1913
Painter of genre and landscape, living in Brixton and Guildford. Studied at Lambeth School of Art, afterwards at Langham Life Class, and under Professor Fred Brown at Westminster School of Art. Exhibited from 1882 at SS, and from 1888 at the RA, where titles include 'The Shrimper' 1888, 'The Morning Catch' 1895, and 'Market Morning' 1904. He also painted in Algeria, Holland, etc.; Hon. Sec. RBA 1895-99; RBA 1889; RI 1908; ROI 1906.

Probable price range £30-100

Bibl: Who Was Who 1897-1916.

PROUT, J. Skinner RI 1806-1876
Watercolour landscape painter. Nephew of Samuel Prout, (q.v.). Born at Plymouth; mainly self-taught, but followed his uncle in choice of subject. As a young man he went to Australia, staying in Sydney and Hobart. Friend of W.J. Muller (q.v.), and with him made sketches for *Antiquities of Bristol*. Member of a Sketching Club formed by Muller with Samuel Jackson, William West and T.L. Rowbotham. Exhibited from 1839-76 at the NWS and elsewhere. RI in 1838; re-elected (because of his stay abroad) A. in 1849, RI in 1862. Hardie notes that "he followed his uncle in manner of composition and in picturesque, crumbling handling of architecture in foreign towns, but had neither his power of drawing nor his eye for colour. In texture and tint he is far more woolly than Samuel Prout". His studio sale was held at Christie's on Feb. 26, 1877.

'The Church of St. Maclou, Rouen' sold at Bonham's 4.6.70 for £110.

Bibl: AJ 1876, 330 (obit); Redgrave, Dict.; Roget; Bryan; Binyon; Cundall; DNB;
Hughes; VAM; Connoisseur 84 (1929) 191, 194; Hardie III 11-12, 80 (pl.8).

PROUT, Samuel 1783-1852

Topographical watercolourist and painter of architectural subjects.
Born at Plymouth; educated at Plymouth Grammar School, where a
fellow pupil was B.R. Haydon, through whom Prout, at the age of
eighteen, met John Britton the antiquary. Employed by Britton to
make drawings of local architecture but his work proved unsatisfactory.
In 1802 he went to London to live with Britton for two years and
studied the work of Turner, Girtin and Cozens. In 1803-4 commissioned
by Britton to make drawings for his *Beauties of England and Wales*
in Cambridge, Essex and Wiltshire. In 1805 ill health made him return
home, but in 1808 he returned to London where he sold his work to
London dealers, and in 1810 became a member of the Associated
Artists in Watercolours. After 1811 he lived in Stockwell, where he
taught, one of his first pupils being J.D. Harding (q.v.). In 1813 he
published *Rudiments of Landscape in Progressive Studies,* the first of
his drawing books for the use of beginners: between 1813 and 1844 he
issued eighteen publications. Until 1818 he exhibited drawings of West
Country scenes and architecture, coastal scenes and shipping; in all he
exhib. 28 works at the RA, 1803-27; 8 at the BI, 1809-18; 60 else-
where; and 560 at the OWS, of which he was elected a member in 1819.
In 1819 he first visited the Continent, and found his metier in
painting the picturesque architecture of old continental towns. For the
rest of his life he constantly produced views of the streets, market
places and crowds of old French towns, which became immensely
popular. In 1822 and 1823 he added views in Belgium and Germany,
and in 1824 first visited Italy. His sketches of Venice also provided
him with a constant source of material. His drawings are undated, but
from 1820 onwards there is a change from an earlier simplicity and
sombre tones to his more mannered later style, which is distinguished
by his use of a crinkled and intricate line to outline objects and
buildings. Prout did all his watercolour work and outlining indoors over
an outdoor pencil drawing. These pencil studies always remained in
his possession, and the sale of his work at Sotheby's in 1852 consisted
almost entirely of them. Prout's mannerism and lack of true observation
has now been recognized, and his work today has none of the popu-
larity it had in the late 19th century. Ruskin, however, had nothing
but praise for him: "We owe to Prout, I believe, the first perception,
and certainly the only existing expression, of precisely the characters
which were wanting to old art; of that feeling which results from the
influence, among the noble lines of architecture, of the rent and the
rust, the fissure, the lichen and the weed. . . . There is *no* stone
drawing, no vitality of architecture like Prout's" *(Modern Painters I,*
vii, 31).

*Over the last 10 years, prices have ranged from about £30 up to
£240, usually averaging around £50-70.*

Bibl: AJ 1849, 76; 1852, 75 (obit); 1857, 337; Ruskin, Modern Painters
passim. Academy Notes passim and *Notes on S.P. and Hunt* 1879; Redgrave
Dict. and Cent.; Roget; Binyon; Cundall 86, 246; DNB; Hughes; Connoisseur
39 (1914) 75, 78, 142; 43 (1915) 59, 62; 65 (1923) 83, 86; 66 (1923) 74; 68
(1924) 72; C.E. Hughes *S.P.* OWS VI: J.G. Roe *Some letters of S.P.* OWS XXIV;
Studio Special Winter No. 1914-15, 1-26 (E.G. Halton *The Life and Art of S.P.*);
J. Quigley *Prout and Roberts* 1926; VAM; A. Neumeyer *An Unknown Collect-
ion of English Watercolours at Mills College* 1941; Williams; Hardie III 4-11 and
passim (pls. 5-7).

*PROVIS, Alfred fl.1843-1886

Domestic genre painter. Exhib. at RA 1846-76, BI, SS and elsewhere.
He specialised in small, detailed interiors of cottages and farmhouses,
with women and children doing household chores. His pictures are
usually small, and predominantly brown in colour, his style and subject
matter shows affinity to Webster and the Cranbrook Colony. Works by
him are in the VAM and Aberdeen AG.

'A Cottage Interior' sold at Sotheby's 16.10.68 for £130.

Bibl: AJ 1859, 81; 1860, 78
City of Nottingham AG Cat. 1913.

PULLER, John Anthony fl.1821-1867

Landscape and genre painter. Exhib. at RA 1821-62, BI and SS. At
first painted mostly landscape, and views on the Thames. Later
turned increasingly to rustic genre e.g. 'The Sailor's Return' 'Cottage
Children' 'The Gipsy's Tent' etc. Many of his compositions were used
by George Baxter (q.v.) in his books of Baxter Prints.

*'Practical Joker' and 'A Gipsy Encampment' – a pair – sold at
Christie's 20.2.70 for £1,365. This was an exceptional price – the
usual range is around £200-400.*

PYNE, Charles fl.1861-1880

Landscape painter. Exhib. mainly at SS, once at RA in 1864, and
occasionally elsewhere. Title of RA picture 'Windsor Castle from
Romney Island'. A watercolour by him is in the VAM.

Probable price range £20-70

Bibl: Cat. of Nat. Gall. of British Art VAM 1908.

PYNE, Charles Claude 1802-1878

Landscape, genre and architectural painter. Exhib. 2 pictures at RA in
1839, and one at BI in 1836. RA titles 'Hall at Bridgefoot, Surrey'
and 'Back of Abbots Hospital, Guildford.'

Probable price range £20-70

Bibl: Bryan; Cundall 247;
Cat. of Nat. Gall. of British Art VAM 1908.

PYNE, George ARWS 1800-1884

Landscape, architectural and genre painter, mostly in watercolour. Son
of William Henry Pyne; son-in-law of John Varley. Exhib. at OWS,
and SS. ARWS from 1827-43. He wrote several books on drawing and
perspective. Works by him are in the Nat. Gall. Dublin, and the VAM.

'Eton College from the River' sold at Christie's 19.3.68 for £252.

Bibl: Connoisseur 54 (1919) 52; Roget;
Cat. of the Nat. Gall. of British Art, VAM 1908.

*PYNE, James Baker RBA 1800-1870

Landscape painter and watercolourist. Born in Bristol, where he
worked as a self-taught local artist up to the age of 35. While in Bristol
he gave painting lessons to W.J. Muller (q.v.). Moved to London 1835.
Exhib. at RA 1836-55, BI, SS (206 works) and NWS. Member of
RBA 1841, later Vice-President. In his early period he painted views
and scenery around Bristol, but after 1835 he travelled in Italy and
the Continent, gathering material to work up into finished pictures. He
was an admirer and imitator of Turner; his dramatic effects and use of
pale yellow tones distinctly reflect Turner's influence. He was a
methodical artist, and numbered as well as dated all his oil paintings.
The MSS of his unpublished autobiography is in the VAM. His studio
sale was held at Christie's on Feb. 25, 1871.

*'Extensive Landscape' sold at Christie's 6.3.70 for £1,260, the highest
recorded price so far. Other prices have ranged from about £100 to
£683.*

Bibl: AJ 1849, 212; 1856, 205-8; 1870, 276; Connoisseur 56 (1920) 225; 83
(1929) 331, 371; Studio 83 (1922) 239-40; Studio Spec. No. 1919 British
Marine Painting; Studio Spec. No. 1919 Early Eng. Watercolours by the Gt.
Masters; Studio Spec. No. Winter 1922-3, Masters of Watercolour Painting;
Redgrave Dict. and Cent.; Roget; Binyon; Cundall; DNB; Hughes; VAM;
Reynolds VP 16, 28 (pl.12); Hardie III 55-6 (pls. 75-6); Maas 34, 44.

PYNE, Thomas RI RBA b.1843 fl.1863-1893
Landscape painter and watercolourist; son and pupil of J.B. Pyne
(q.v.). Exhib. at RA 1874-93, SS (110 works) NWS and elsewhere.
Titles at RA all English landscapes, and a few continental e.g. 'Interior
at Andernach' 'A Venetian Courtyard' etc.

'A Venetian Courtyard' sold at Sotheby's 7.5.69 for £120.

Bibl: Who's Who 1914, 1924; The Year's Art 1928, p.515.

QUINTON, Alfred Robert fl.1874-1902
Landscape painter. Exhib. mainly at SS, also at RA 1879-1902, NWS
and elsewhere. In 1902 he illustrated two articles in the *Art Journal*
on the Wye Valley and Wharfedale (see Bibl.).

Probable price range £20-50

Bibl: AJ 1902, 37 ff; 233 ff; The Standard V. 11.4.1910.

RACKHAM, Arthur RWS 1867-1939
Illustrator of fantastic tales and children's books, in black and white
and watercolour. Entered the Lambeth School of Art in 1884, where
fellow students were Charles Ricketts, Leonard Raven-Hill and Thomas
Sturge Moore; particularly influenced by the former. At the same time
from 1885-92 worked as a clerk in an insurance office. From 1884
contributed illustrations to the cheaper illustrated papers, e.g. *Scraps,*
the *Pall Mall Budget,* and in 1892 joined the staff of *The Westminster
Budget,* his drawings forming a remarkable record of life and the well-
known personalities of the 90's. From 1893 he became increasingly
occupied with book illustrations: two of his early books were *The
Ingoldsby Legends,* 1898 (revised ed.1907) and Charles and Mary
Lamb's *Tales from Shakespeare,* 1899 (revised ed.1909); however, he
became famous with *Grimm's Fairy Tales* 1900 (revised ed. 1909).
Rip Van Winkle 1905 and an exhibition held at the Leicester Galleries
in 1905. Hardie notes that in these books he showed "the full measure
of his exquisite fancy and fertility of imagination coupled with un-
usual technique and a rare quality of line and tone". He also illustrated,
among many others, J.M. Barrie's *Peter Pan in Kensington Gardens*
1906; Shakespeare's *A Midsummer-Night's Dream* 1908; Swift's
Gulliver's Travels 1909; Hans Andersen's *Fairy Tales* 1932; and
Kenneth Grahame's *The Wind in the Willows* 1940. He also exhibited
many watercolour landscapes not conceived as book illustrations at the
OWS, NWS and RA (from 1888), and became ARWS in 1902, RWS
in 1908. His collected works were shown in 1912 at the Société
Nationale des Beaux-Arts, Paris, of which he was elected an Associate.
Master of the Art Workers' Guild 1919. Designed the scenery and
costumes for *Hansel and Gretel,* Cambridge Theatre, 1934. A memorial
exhibition was held at the Leicester Galleries in 1939.

Prices in recent years have ranged from about £70 up to £380.

Bibl: Derek Hudson *Arthur Rackham: His life and Work* 1960 (contains full
bibliography and list of books and periodicals Rackham illustrated). Hardie III
147-8 (pl.171).

RADCLIFFE, Radcliffe W. fl.1875-1895
Landscape painter. Lived at Dorking and Petersfield. Exhib. at RA
1879-95, SS, NWS, GG and elsewhere. Titles at RA 'December' 'After
the Storm' 'A Lonely Shore' etc and some rustic genre e.g. 'Feeding
Poultry' etc.

Probable price range £30-70

RADCLYFFE, Charles Walter 1817-1903
Birmingham landscape painter; son of William Radclyffe, an engraver.
His brothers Edward and William (Junior) were also artists. Exhib. at
RA 1849-81, BI, SS, NWS and elsewhere. Titles at RA 'The Path
through the Wood' 'Sketch from Nature' etc. A watercolour by him
is in the VAM.

Probable price range £30-70

Bibl: Bryan; DNB.

RADFORD, Edward ARWS b.1831 fl.1865-1893
Genre painter and watercolourist. Exhib. at RA 1867-90, SS, OWS
and elsewhere. Titles at RA mostly military subjects e.g. 'From the
Camp' 'Pour l'Honneur' etc.

Probable price range £20-50

RADFORD, James fl.1841-1859
Landscape painter. Exhib. at RA 1841-59, BI and SS. Titles at RA
include views in Yorkshire, N.Wales and the Thames; also some Italian
views.

'The Thames near Henley' sold at Sotheby's 13.7.66 for £280.

RAE, Miss Henrietta R. see under NORMAND, Mrs. Ernest

RAGON, Adolphe fl.1872-1924 d.1924
London marine painter. Pupil of Lionel B. Constable. Exhib. at RA
from 1877, SS, NWS and elsewhere. Titles at the RA 'In the Channel'
'Rochester by Moonlight' and other harbour and coastal scenes. Lived
in the area of Willesden and Cricklewood, and later retired to Felstead,
Essex.

Probable price range £20-50

Bibl: Connoisseur 70 (1924) 57 f, 116 (obit).

RAILTON, F.J. fl.1846-1866
London landscape painter; lived in Chelsea. Exhib. at RA 1847-63,
BI and SS. Titles at RA 'An English Village' 'A Woodland Cottage'
'The Port of London' etc. and views in Surrey and Kent.

Probable price range £20-50

RAINEY, William RI b.1852 fl.1876-1904
Genre and landscape painter, and watercolourist. Studied RA Schools.
Exhib. at RA from 1878, SS, NWS and elsewhere. Titles at RA 'The
Mill House' 'The Widower' 'A Dutch Auction' etc. Works by him are
in Leeds AG and the Nat. Gall. Melbourne.

Probable price range £30-70

Bibl: Who's Who 1924.

RAMSAY, James 1786-1854
Portrait, historical and genre painter. Exhib. at RA 1803-54, BI and
SS. Many of his patrons were from Newcastle and the North-East, and
after 1846 he settled in Newcastle, where he died. Among his many
sitters were Thomas Bewick and Earl Grey; most of his portraits were
of members of northern landowning families.

Probable price range £30-100

Bibl: Connoisseur 49 (1917) 85 ff; Print Collectors Quarterly 12 (1925) 184; DNB; Cat. of Engraved Brit. Portraits BM 6 (1925) 532 f.

***RANKLEY, Alfred 1819-1872**

Genre and historical painter. Pupil of RA Schools. Exhib. at RA 1841-71, BI and SS. Painted historical genre, often from Scott and Johnson, and domestic scenes e.g. 'The Lonely Hearth', 'The Evening Sun' etc. His best known work is 'Old Schoolfellows' (RA 1854) illustrated Reynolds VP pl.62, which shows "that clarity of anecdote and simplicity of moral appeal which was strength as well as the limitation of mid-Victorian subject painting" (Reynolds).

'A Summer Posy' sold at Sotheby's 20.5.70 for £400.

Bibl: AJ 1873 p.44; Redgrave, Dict. DNB; Reynolds VP 110-11 (pl.62).

RATTRAY, Wellwood RSW 1849-1902

Scottish landscape painter and watercolourist. Lived mostly in Glasgow. Exhib. at RA 1883-98, GG, RSA, RSW and elsewhere. Subjects almost entirely Scottish scenes; typical RA titles 'In the Heart of the Highlands' 'Summer Evening, Isle of Arran' etc. Caw writes of his works "forceful rather than robust, and to have attracted attention more from their size and a certain peculiarity in colour than from any deeper qualities".

Probable price range £50-150

Bibl: Who Was Who 1897-1915, 1929 The Year's Art 1903 p.317; Caw 303.

RAVEN, John Samuel 1829-1877

Landscape painter; son of Thomas Raven, an amateur watercolourist. Exhib. at RA 1849-77, BI, SS and elsewhere. RA titles mostly views in Sussex, Wales and Scotland. Also visited Switzerland. A self-taught artist, he was influenced by Constable's visions of English countryside, and also by Pre-Raphaelite techniques.

Probable price range £50-200

Bibl: AJ 1874, p.212; 1877, 309 (obit); Redgrave, Dict.

RAWLE, John S. fl.1870-1887

Landscape painter and watercolourist. Teacher at the Government School of Design, Nottingham. Exhib. at RA 1870-87, SS, NWS and elsewhere. Titles at RA 'Evening' 'A Home in Surrey' 'The Village of Ross, Berwickshire' etc. and coastal scenes.

Probable price range £20-60

RAYNER, Miss Louise J. fl.1852-1893

Architectural and topographical painter and watercolourist. Daughter of Samuel Rayner (q.v.). Exhib. at RA 1852-86, BI, SS, NWS and elsewhere. She painted churches, church interiors, old buildings, town views etc. in England, Wales and N. France.

'Market Scene, Chippenham' sold at Sotheby's 18.3.69 for £280.

Bibl: Clayton I 383 f; also see under Samuel Rayner.

RAYNER, Samuel A. fl.1821-1872

Architectural painter and watercolourist. Exhib. at RA 1821-64, BI, SS, OWS and elsewhere. Titles at RA mostly English Cathedrals and Abbeys. His five daughters, Louise (q.v.). Frances, Margaret, Nancy and Rose were all painters.

Probable price range £20-60

Bibl: Roget; Bryan; Cundall; DNB

READ, Samuel RWS 1815/16-1883

Architectural painter and watercolourist. Pupil of W. Collingwood

Smith (q.v.). Exhib. at RA 1843-72, SS, OWS (212 works) and elsewhere. Painted churches, cathedrals, castles and buildings in England, France, and Holland. His studio sale was held at Christie's on Feb. 29, 1884.

Probable price range £50-200

Bibl: Portfolio 1883 p.145; Roget; Bryan; Binyon; Cundall; DNB; VAM; Hardie II 233.

REDGATE, A.W. fl.1886-1901

Nottingham landscape painter. Exhib. at RA from 1886, and SS. He painted the countryside of his native Midlands. Most of his pictures are rustic figures, or farm-workers; he only occasionally painted pure landscape. Titles at RA 'Haymakers' 'The Squire's Daughter' 'A Tea Garden' etc.

Usual price range £30-70; one has sold for as much as £150.

REDGRAVE, Miss Evelyn Leslie fl.1872-1888

Landscape painter and watercolourist; daughter of Richard R. (q.v.). Exhib. at RA 1876-87, SS, NWS and elsewhere. Titles at RA indicate that she specialised in painting old buildings e.g. 'The Seat of the Evelyns at Wotton' 'A Bit of Old Kensington' etc. Titles also include farmyard scenes and rustic landscapes.

Probable price range £30-100

REDGRAVE, Miss Frances M. fl.1864-1882

Rustic genre painter; daughter of Richard R. (q.v.). Exhib. at RA 1864-82, BI and SS. Titles at RA 'The Whortleberry Gatherer' 'The Keepers' 'The Breadwinner's Return' etc.

Probable price range £30-100

REDGRAVE, Gilbert Richard fl. c.1870-1880

Although an architect, he produced some watercolours remarkable for their Pre-Raphaelite detail and colouring.

Probable price range £20-60

***REDGRAVE, Richard RA 1804-1888**

Genre and landscape painter. Entered RA Schools 1826. At first painted historical genre in 18th century costume, but in the 1840's he was among the first to turn to social subjects in contemporary dress e.g. 'The Sempstress' 'Bad News from the Sea' 'The Poor Teacher' etc. Exhib. at RA 1825-83, BI, SS and elsewhere. Elected ARA 1840, RA 1851. His numerous official duties curtailed his output of paintings. He was first keeper of paintings at the S. Kensington Museums; took over from Dyce on the national art education project; was Inspector of the Queen's pictures; and co-author with his brother Samuel of *A Century of Painting,* still a valuable book on English art. The only time he could paint was in the summer at his country house, so his later work is mostly landscape.

Prices during the 1968-9 season ranged from £150 to £294.

Bibl: AJ 1850, 48-9 (autobiog); 1859, 205-7; 1889, 61; Connoisseur 88 (1931) 60; Ruskin, Academy Notes 1855, 1856, 1859; Bryan; Binyon; DNB; The Nat. Gall. of British Art, VAM Cat. of Oil Paintings 1907; Reynolds VS, 10, 11, 53 (pl.10); Reynolds VP 91-2, 151-2 (pl.100, 102); Maas 113-14 (pl.p.114, 119).

***REDMORE, Henry 1820-1887**

Hull marine painter. Exhib. only two pictures at RA in 1868, 'Fishing Ground in the North Sea' and 'A Calm on the Humber'. Although he worked entirely locally, he attained a high level of competence. His subjects were mostly on the Humber and the Yorkshire coast. He also worked in other parts of England, and probably visited the Continent. The influence of Dutch 17thc. painting is apparent in his work, and also that of William Anderson (q.v.) and John Ward (q.v.), both of

whom worked in Hull. One of his sons, E.K. Redmore, was also a marine painter.

'Shipping in an Estuary' sold at Bearne's 13.7.71 for £2,950, the current auction record. Other prices have ranged from about £200-1,900.

Bibl: Wilson, Marine Painters (pl.31); O. & P. Johnson Ltd. *Cat. of Redmore Exhibition* March – April 1971.

REED, Joseph Charles RI 1822-1877
Landscape painter, mainly in watercolour. Exhib. once at the RA in 1874, SS and NWS (186 works). Painted views all over England, Wales and Scotland. His works were often large and elaborate; the AJ describes them as "clever, but showy".

Probable price range £20-60

Bibl: AJ 1878, p.16 (obit)
Cundall 248; DNB.

REES, John fl.1852-1879
Landscape painter. Exhib. mainly at SS; also at BI, and at RA in 1856 and 1868, and elsewhere. Titles at RA 'Spring Flowers' and 'St. George's Hill, Surrey'.

Probable price range £20-50

REID, Archibald David ARSA RSW 1844-1908
Aberdeen landscape painter; brother of Sir George Reid (q.v.), and of Samuel Reid, also a landscape painter. Studied at RSA and in Paris. Exhib. at RA from 1872, RSA and RSW. Titles 'On the Sands' 'A Lone Shore' 'A Yorkshire Moor' etc. In spite of his training, the predominant influence on his work was the Dutch School, as is shown by his subdued tones and grey atmospheric colouring. His subjects were mostly Scottish coastal scenes; he also travelled in Holland, France and Spain.

Probable price range £50-200

Bibl: DNB; Who was Who 1897-1915; Caw 301 f.

REID, Miss Flora M. fl.1879-1903
Scottish genre painter; sister and pupil of John Robertson Reid (q.v.). Exhib. at RA from 1881, SS, GG, NG and elsewhere. Titles at RA 'Our Cinderella' 'The Miller's Frau' 'A Dutch Fishwife' 'Gossips' etc. Works by her are in Leeds, Liverpool, Manchester and Rochdale AG. Her style very similar to her brother's. "Her subjects are often drawn from Continental market-places, the bargaining or gossiping groups supplying incidental interest, and the black, blue and white costumes, the sunlit houses and shadow-chequered pavements, the green trees and the canvas booths scope for her favourite colour-scheme, in which a blueness of tone predominates". (Caw).

Probable price range £30-100

Bibl: Caw 283.

REID, Sir George PRSA HRSW 1841-1913
Scottish portrait painter and illustrator. Brother of Archibald David R. (q.v.) and Samuel Reid. Studied in Edinburgh, Utrecht and Paris. Exhib. at RA from 1877, and at RSA. His vivid and assured style quickly attracted notice, and he soon established himself as Scotland's leading portrait painter. Elected ARSA 1870, RSA 1877. Moved from Aberdeen to Edinburgh in 1884; PRSA and knighted 1891. Retired 1902. "His work tells in virtue of vividness of characterisation, power of expression, and simplicity of design" (Caw). His colours are usually silvery and atmospheric. Among his sitters were most of the distinguished Scotsmen of his day. He also painted landscapes, and drew for illustrations.

'Cawdor Castle, Nairn' sold at Christie's 3.4.70 for £147.

Bibl: AJ 1882 p.361-5; Studio 55 (1912) 169-78; Sketchley *Eng. Book Illustration of Today* 1903; The Royal Scottish Academy 1826-1907, The Studio 1907 Special No.; Caw 286-9 and passim (pl.p.288); Poole *Cat. of Portraits etc. of Oxford* 1912-25.

REID, George Ogilvy RSA 1851-1928
Scottish historical genre painter. Born in Leith. Worked as an engraver for 10 years before turning completely to painting. Exhib. at RSA from 1872, RA from 1887. Elected ARSA 1888, RSA 1898. Subjects mostly scenes of 18th century social life e.g. 'The New Laird' 'A Literary Clique', or historical incidents e.g. 'After Killiecrankie' 'The Prince's Flight' etc. He also painted occasional Wilkie type scenes of homely life.

'The Author and his Friends' sold at Sotheby's 8.2.67 for £180.

Bibl: AJ 1893, p.151; 1903, 123;
Studio 43 (1908) 134, 137;
Caw 271-2 (pl. p.272).

***REID, John Robertson 1851-1926**
Scottish painter of genre, landscape and coastal scenes. Brother of Flora M. Reid (q.v.). Pupil of G.P. Chalmers and W. MacTaggart. Exhib. at RA from 1877. Painted scenes of rural life e.g. 'Toil and Pleasure' (Chantrey Bequest 1879) 'Country Cricket Match' etc. and fisherfolk e.g. 'The Waterman's Wife' 'The Boatman's Lass' 'Pilchard Fishers, Cornwall' etc. Although the content of these pictures is often sentimental, his style is remarkably robust and vigorous, as one might expect from a pupil of MacTaggart. In the 1880's his style began to change. His handling became coarser and more mannered, and his subjects over-dramatic e.g. 'Shipwreck' 'The Smugglers' etc. but even in this period he was still capable of an occasional brilliant work. Although he lived in England, he knew the Glasgow Boys, and made a notable contribution to the development of the Glasgow School. An exhibition of his work was held at the FAS 1899. Several works are in the VAM.

'Happy Days of Childhood' sold at Christie's 2.4.69 for £158.

Bibl: AJ 1884 p.265-8; Connoisseur 74 (1926) 250; R. Mutner, *Gesch. d. Malerei im 19 Jahr.* 1893; Caw 281-3 and passim; Hardie III 192 (pl.227).

REID, Miss Lizzie fl.1882-1893
Painter of domestic genre. Graves lists her at the same address as Miss Flora M. Reid (q.v.) presumably her sister. Exhib. mostly at SS, also RA in 1884 and 1886, GG, NG and elsewhere. Titles at RA 'Over the Sea', 'The Music Lesson'.

Probable price range £20-70

REYNOLDS, Frederick George 1828-1921
Landscape painter. Exhib. at RA from 1864, SS and elsewhere. Titles at RA 'Stacking Hay' 'A Quiet Nook' 'Solitude' etc.

Probable price range £30-80

Bibl: The Year's Art 1922 p.313 (obit).

REYNOLDS, Walter fl.1859-1885
Landscape painter. Exhib. at RA 1879-84, SS, NWS and elsewhere. Titles at RA 'Hills near Reigate' 'Brook at Edmonton' etc. and views near Enfield, where he lived.

Probable price range £30-70

RHYS, Oliver fl.1876-1893
Landscape and genre painter. Exhib. at RA 1880-93, SS, GG and elsewhere. Titles at RA 'Hampstead' 'A Venetian' 'The Dawn of Vanity' etc.

'The Fish Seller' sold at Christie's 21.2.69 for £158.

Bibl: AJ 1908 p.316; Academy Notes 1880;

RICHARDS, Charles fl.1854-1857

Painter of animals and rustic genre. Exhib. at RA 1854-7, BI, SS and elsewhere. Titles at RA 'Study of Sheep and Lambs' 'The Bristol Market Woman' 'The Little Cleaner' etc. Lived at Keynsham, near Bath.

Probable price range £30-70

RICHARDSON, Charles fl.1855-1901

Landscape painter and watercolourist. Son of T.M. Richardson (Senior) (q.v.). Exhib. at RA from 1855, BI, NWS and elsewhere. Subjects mostly scenes around Newcastle, or landscapes in Yorkshire and Cumberland. About 1873 he moved to London, and later to Hampshire. Several works by him are in the Laing AG, Newcastle.

Probable price range £20-60

Bibl: Roget II 283.

RICHARDSON, Edward 1810-1874

Landscape painter and watercolourist. Son of T.M. Richardson (Senior) (q.v.). Exhib. at RA in 1856 and 1858, but mostly at NWS (187 works) of which be became an associate in 1859. Painted landscapes in England, Scotland and Europe, in a picturesque style similar to that of his brother T.M. Richardson (Junior) (q.v.). Works by him are in the VAM and the Laing AG, Newcastle. A sale of his watercolours was held at Christie's on Feb. 19, 1864; his studio sale was also held there on May 25, 1875.

Usual range for watercolours £20-50

Bibl: Cundall;C.B. Stephenson *Cat. of the Perm. Coll. of Watercolour Drawings*, Laing A.G. 1939.

RICHARDSON, Frederick Stuart RSW fl.1884-1902

Landscape and genre painter. Lived at Sandy, Bedfordshire. Exhib. at RA from 1885, SS, NWS, and presumably at RSW, of which he was a member. Titles at RA mostly coastal scenes and fisherfolk, as well as landscapes. Painted in England, Scotland, Ireland, Holland and also Venice. Titles 'The Herring Fleet, Carradale', 'The Morning Catch', 'The First Snow of Winter' etc.

Probable price range £30-100

RICHARDSON, George 1808-1840

Newcastle landscape painter and watercolourist. Eldest son of T.M. Richardson (Senior) (q.v.). Exhib. at BI 1828-33 and NWS. Subjects mostly landscapes around Newcastle, in Durham and Yorkshire. Together with his brother, T.M. Richardson (Junior) (q.v.), he opened a drawing Academy at 53, Blackett St. Newcastle. Died of consumption at an early age. Works by him are in the Laing AG Newcastle.

Probable price range £30-100

Bibl: C.B. Stephenson, *Cat. of the Perm. Coll. of Watercolour Drawings* Laing AG Newcastle 1939.

RICHARDSON, Henry Burdon fl.1828-1872

Landscape painter and watercolourist. Son of T.M. Richardson (Senior) (q.v.)., by his second marriage. Lived with his brother Charles R. (q.v.) at 20, Ridley Place, Newcastle, where he gave painting lessons. Exhib. at RA 1828-61, SS and elsewhere. Painted views in England, Scotland, and Europe. In 1848 he painted a series of watercolour views of the Roman Wall for Dr. John Collingwood Bruce; these are now in the Laing AG Newcastle.

Usual price range for watercolours £20-50

Bibl: C.B. Stephenson *Cat. of the Perm. Coll. of Watercolour Drawings* Laing AG Newcastle 1939.

RICHARDSON, John J. RI 1836-1913

Landscape and genre painter, and watercolourist. Son of T.M. Richardson (Senior) (q.v.). According to Graves, began to exhibit at RA in 1846, at the age of 10. Also exhib. at BI, SS, NWS and elsewhere. Titles at RA 'A Girl of Sorrento' 'Scotch Herd Girls' 'A Northumberland Straw-Yard' etc.

Probable price range £30-80

Bibl: Who Was Who 1897-1915, 1929.

***RICHARDSON, Thomas Miles Senior 1784-1848**

Newcastle landscape painter and watercolourist. Worked as a cabinet-maker until 1806, when he became Master of St. Andrews School. Exhib. at RA 1814-45, BI, SS, OWS and NWS. His subjects mostly views in the North-East. He also painted continental scenes, but these were worked up from drawings made by others. His watercolours show admiration for David Cox, but the figures in his pictures are often similar to those of William Shayer (q.v.). With Thomas Bewick and others, he organised in 1822 the first Fine Art Exhibition in the north of England; he also helped to found the Northern Academy of Arts. His works have always enjoyed a wide reputation in the North-East. An exhibition of his work was held at the Laing AG, Newcastle in 1906. Many of his sons were painters, including Thomas Miles (Junior), Charles, Edward, George, Henry Burdon and John J. (all q.v.).

'Newcastle-upon-Tyne from the River' a large oil, sold at Sotheby's 18.2.70 for £3,200. This is the current record price. Usual range for oils is £200-500; watercolours £50-200.

Bibl: AU 1847, p.389; 1848, 195 (obit); Studio 67 (1916) 251, 253; *Memorials of Old Newcastle-upon-Tyne with a Sketch of the artist's Life* 1880; R.Welford *Art and Archaeology: the Three Richardsons* 1906; C.B. Stephenson *Cat. of Watercolours, Laing AG Newcastle* 1939; Roget; Cundall; DNB; VAM; Hardie II 230 (pl.218).

RICHARDSON, Thomas Miles, Junior RSA RWS 1813-1890

Landscape painter, mostly in watercolour. Son of T.M. Richardson (Senior) (q.v.). At first worked with his father in Newcastle. Exhib. at RA 1837-48, BI, SS, and OWS (702 works). Elected ARWS 1843, RWS 1851. After his marriage in 1845 he settled in London. His subjects were mostly views in Scotland, later in Italy and Switzerland. He liked panoramic effects, and often used long narrow sheets of paper for this reason. He also tended to overdo the use of bodycolour, giving his watercolours an unnatural and mannered look. His best works are his Highland sketches, rather than his elaborate exhibition pieces. A sale of his 'Sketches from Nature' was held at Christie's on May 9, 1862. His studio sale was also at Christie's on June 16, 1890.

'Estuary, Cumberland' sold at Sotheby's 20.11.68 for £220. The usual range for watercolours is £50-250.

Bibl: Ruskin, Notes on the OWS 1857; Roget; Cundall; VAM; C.B. Stephenson *Cat. of Perm. Coll. of Watercolour Drawings* Laing AG Newcastle 1939; Hardie II 230-1 (pl.219).

RICHARDSON, William fl.1842-1877

Landscape and architectural painter. Exhib. at RA 1842-69, BI, SS and elsewhere. Titles at RA 'The Interior of Bolton Abbey' 'The Weald of Kent' 'Roslyn Chapel' etc.

'Cattle Watering by a Windmill' sold at Sotheby's 18.2.70 for £260.

RICHMOND, George RA 1809-1896

Portrait painter and watercolourist. Son of Thomas Richmond (Senior), brother of Thomas R. (Junior) (q.v.). Father of Sir William Blake R. (q.v.). Studied at RA Schools, where he formed a lifelong friendship with Samuel Palmer (q.v.). Together with Palmer and Calvert (q.v.)., he was part of the group of Blake's followers called "The Ancients", His early work shows strong Blake influence, but after his death in 1827, the demands of making a living forced him to turn to portrait painting in miniatures, chalks and oils. He eventually became a leading portrait painter of his day. Exhib. at RA 1825-84, BI, SS. ARA 1857,

RA 1866. His ideal of portraiture was "the truth lovingly told"

'Saint Cecilia' sold at Sotheby's 18.3.70 for £240.

Bibl: AJ 1896 p.153 (obit); Connoisseur 33 (1912) 158; 52 (1918) 116; 70 (1924) 117; 71 (1925) 55; 76 (1926) 116; 77 (1927) 49 f; Print Collector's Quarterly 17 (1930) 353 ff; 18 (1931) 199 f; Redgrave Cent.; Bryan; Roget; Cundall; DNB; VAM; R.L. Binyon *The Followers of William Blake* 1925; A.M.W. Stirling *The Richmond Papers* 1926; Hardie III 98-9 (pl.120); Maas 88, 216: Also see references in Samuel Palmer bibliography.

RICHMOND, Thomas, Junior 1802-1874

Portrait painter and miniaturist. Son of Thomas R. (Senior); brother of George R. (q.v.). Pupil of his father, and of RA Schools. 1841 visited Rome, where he met Ruskin. Exhib. at RA 1822-53, and SS. A portrait of Charles Darwin by him is in the Cambridge Medical Schools.

'Portrait of Effie Ruskin' a watercolour – sold at Sotheby's 3.4.68 for £1,100. This was an exceptional price, the result of special interest in Ruskin and his wife, who later married Millais. Usual price range more like £100-200.

Bibl: Bryan.

RICHMOND, Sir William Blake RA 1842-1921

Painter, sculptor and medallist; son of George Richmond (q.v.). Entered RA Schools in 1857, after some early coaching from Ruskin. Began to exhib. at RA in 1861, and from the first established himself as a successful portrait painter. After the death of his first wife in 1864, he went to Italy, where he met Leighton and Giovanni Costa, both of whom had a great influence on his art. 'Procession in Honour of Bacchus' (RA 1869), a large neo-classical piece, clearly shows a debt to Leighton's great 'Cimabue' picture. After his return from Italy, he married again, and settled in a house in Hammersmith. Although his ambition was to paint big neo-classical scenes, he still kept up a large portrait practice. Among his sitters were Browning, Darwin, Pater, Gladstone and Bismarck. Exhib. at RA from 1861, BI, GG (119 works) NG and elsewhere. Elected ARA 1888, RA 1895.

'Boxhill Forest' sold at Sotheby's 19.11.69 for £140.

Bibl: AJ 1890, p.193-8, 236-9; 1901, 125 f; 1904, 373 f; A.J. Summer Number and Christmas Art Annual 1902; Mag. of Art 1901 p.145 ff, 197 ff; Der Cicerone 6 (1914) 297 f; Connoisseur 59 (1921) 240 f (obit); 71 (1925) 50; 77 (1927) 49 f; A.M.W. Stirling *The Richmond Papers* 1926; W. Gaunt, *Victorian Olympus* 1952; Fredeman; Hutchison; Maas 184-7 (pl. p.219).

RICKATSON, Octavius RBA fl.1877-1893

Landscape painter. Exhib. at RA 1880-93, SS, NWS, GG, NG and elsewhere. Titles at RA 'A Quiet Spot' 'Little Bo-Peep' 'Coming Twilight' etc.

Probable price range £20-60

RIDLEY, Matthew White 1837-1888

Landscape, genre and portrait painter. Born in Newcastle-on-Tyne. Pupil of Smirke, Dobson, and the RA Schools. Exhib. at RA 1862-88, BI, SS and elsewhere. Painted landscapes, portraits, and occasional scenes of Victorian life in the manner of Frith.

'Derby Day' sold at Sotheby's 18.6.69 for £680.

Bibl: AJ 1859 p.142; Portfolio 1873, 81f
Connoisseur 74 (1926) 251; Bryan.

RIGBY, Cuthbert ARWS b.1850 fl.1874-1893

Landscape painter and watercolourist. Born in Liverpool. Pupil of W.J. Bishop. Exhib. at RA from 1875, but mostly at OWS. Titles at RA nearly all views in Cumberland. Works by him are in the VAM and Norwich Museum.

Probable price range £20-50

Bibl: AJ 1908, p.342; Who's Who 1924.

RILEY, Thomas fl.1878-1892

Painter and etcher. Lived in Chelsea, London. Exhib. both pictures and etchings at RA from 1880, SS, NWS, GG, NG and elsewhere. Titles at RA mostly genre scenes e.g. 'Expectant Curiosity' 'Jealousy' 'At the Garden Wall' etc.

Probable price range £30-70

Bibl: AJ 1883 p.88
Portfolio 1882, p.25, 212; 1883, 25.

RIMER, Mrs. Louisa Serena fl.1855-1875

London flower painter, who exhibited from 1855-75, at the RA (1856-74), BI, SS and elsewhere.

Probable price range £20-50

RIPPINGILLE, Edward Villiers 1798-1859

Genre painter, born in King's Lynn, Norfolk. He was self-taught and first practised in Bristol, exhibiting at the RA, SS and BI from 1813-57. His subjects were taken from English rural life until he visited Italy in 1837, when for some years his inspiration was Italian, e.g. 'Father and Son; Studies from Calabrian Shepherds (1838 RA); and 'An English Servant Attacked by Robbers near Rome', (1840 RA). In 1841 he paid a second visit to Italy. In 1843 he won one of the prizes in the Westminster Cartoon Competition. He lectured on art and claimed to be the first to advocate the formation of Schools of Design; he edited *The Artist and Amateur's Magazine*. He died suddenly at Swan Village railway station, Staffs. Painted a series of six pictures entitled 'The Progress of Intemperance' of which one, 'The Invitation to Drink' is in the Walker AG, Liverpool.

'Cottage Interior with Figures' sold at Bonham's 7.11.68 for £130.

Bibl: Redgrave Dict.; Bryan; VAM.

*RITCHIE, John fl.1858-1875

Genre painter. Exhib. at RA 1858-75, BI and SS. Most of his RA pictures were imaginary genre scenes set in 16th or 17th century costume e.g. 'The Strolling Players' 'The Young King James VI at Church' 'Rogues in Bond' etc. His best known work is 'A Summer Day in Hyde Park' in the London Museum.

Prices in recent years have ranged from £100 to about £350.

RIVERS, Leopold RBA 1850/2-1905

Landscape painter, who exhibited at the NWS and SS from 1873 RBA in 1890, and at the RA from 1873-1904. He was the son and pupil of William Joseph Rivers (exhibited 1843-55 at the RA and BI). 'Stormy Weather' 1892, Tate Gallery, was a Chantrey Purchase.

Probable price range £30-100

Bibl: L'Art 64 1905, 452.
The Year's Art 1906, 362; Tate Cat.

*RIVIERE, Briton RA 1840-1920

Genre and animal painter. Son of William Riviere (q.v.). Pupil of his father, and of J. Pettie (q.v.) and W. Orchardson (q.v.). Exhib. at RA from 1858, BI, SS, GG and elsewhere. Elected ARA 1878, RA 1880. His knowledge and love of animals was based on sound anatomical study, and frequent visits to London Zoo. He usually incorporated animals in all his genre and historical scenes; especially lions, birds, dogs and other domestic pets. His pictures of dogs are often humorous, but nearly always very sentimental; they appealed to the dog-loving public, and were widely reproduced through engravings. His works are in most British museums. 'Beyond Man's Footsteps' (RA 1894) was bought by the Chantrey Bequest.

Nothing by R. seems to have appeared on the market recently. Probable price range would be £100-300 for small subjects, more for

large ones.

Bibl: Portfolio 1892 p.61-6, 77-83; Connoisseur 57 (1920) 119 f; Studio 79 (1920) 149; W. Armstrong *B.R. His life and work,* Art Annual 1891; DNB; Maas 82 (pl. p.83).

RIVIERE, Henry Parsons ARWS 1811-1888

Genre, landscape and portrait painter, mostly in watercolour. Brother of William Riviere (q.v.). His father Daniel Valentine Riviere was also a painter. Exhib. at RA 1835-71, BI, SS, OWS (299 works) and NWS. He lived in Rome from 1865-1884, and most of his works are of Italian genre and landscape. Several watercolours by him are in the VAM.

Probable price range £30-80

Bibl: Connoisseur 71 (1925) 50; Roget; DNB; Cundall; VAM Cat. 1908.

RIVIERE, William 1806-1876

Genre and portrait painter. Brother of Henry Parsons R. (q.v.). and father of Briton R. (q.v.). Exhib. at RA 1826-60, BI and SS. From 1849 to 1859 he was teacher of drawing at Cheltenham College; then settled in Oxford.

Probable price range £30-80

Bibl: AJ 1877 p.38; Connoisseur 71 (1925), 50; Redgrave, Dict.; Poole *Cat. of Portraits etc. of Oxford* 1925; Cat. of Engraved Brit. Portraits BM 1925.

ROBB, G.M. fl.1860-1881

Painter of landscape and genre, living in Chingford and Manningtree, who exhibited from 1860-81, at the RA (1861-81), BI, SS and elsewhere, titles at the RA including 'Rocks near Ryde' 1861, 'Gleaners' 1968, and 'A May Evening' 1873.

Probable price range £20-60

ROBBINSON, Mrs. Margaret fl.1854-1870

London painter of genre and historical subjects, who exhibited from 1854-70 at the RA and SS, titles at the RA including ' "Wae's me for Prince Charlie" ' 1854, 'What we Still See in Chelsea Gardens' 1860, and 'A Venetian Girl' 1870.

Probable price range £30-100

ROBERTS, Benjamin fl.1847-1872

Painter of fruit and genre, living in Chislehurst and London, who exhibited from 1847-72, at the RA (1851-72), BI and SS, titles at the RA including Gipsy Boy' 1851, and 'Prince of Wales's Plums' 1866.

Probable price range £20-60

*ROBERTS, David RA 1796-1864

Painter of architectural subjects, prolific both in oil and watercolour, often called 'the Scottish Canaletto'. Born at Stockbridge, near Edinburgh, the son of a shoemaker. Apprenticed for seven years to a house painter, much of his spare time being occupied in sketching local architectural monuments. At the age of twenty-one, he joined a travelling circus as a scene-painter, visiting Carlisle, Newcastle, Hull and York. Owing to this experience he was engaged to paint scenery for the Edinburgh Pantheon, the Theatre Royal, Glasgow and then for the Theatre Royal, Edinburgh. In 1822 he was engaged as a scene-painter at Drury Lane Theatre, and settled in London. Also working at Drury Lane was Robert's friend Clarkson Stanfield (q.v.), and their joint work won reputation for both. On the formation of the SBA in 1823, Roberts became its Vice-President, and President in 1830, gradually abandoning scene-painting for architectural subjects. In 1827, he was entirely responsible for designing the sets for the first London production of Mozart's *Il Seraglio.* He exhib. at the RA 1826-64, at the BI 1825-59, and at SS. Elected ARA 1838; RA 1841. In 1829 elected an honorary member of the RSA. Owing to his high position in the world of art he was made one of the Commissioners for the Great Exhibition of 1851. He travelled widely on the Continent; 1831, in France; 1832-3 he spent a considerable time in Spain and at Tangier; 1838-9 he visited Egypt and the Holy Land, making sketches sufficient to keep him working for ten years; in 1851 and 1853 he toured Italy. Hardie notes that "he became one of the best known of the later topographers, and the results of his many journeys exist not only in oil-paintings and watercolours, but in the form of coloured reproductions which were highly popular and brought him a considerable fortune". Some of Roberts's most pleasing and lively works are done before 1840; his drawings done in the East are monotonous in their uniform scheme of grey, red, brown and yellow. Ruskin praises his endurance, his exquisite drawings and his statement of facts, but says that among his sketches he saw "no single instance of a downright study; of a study in which the real hues and shades of sky and earth had been honestly realised or attempted — nor were there, on the other hand, any of these invaluable blotted five minutes works which record the unity of some simple and magnificent impressions". Among his publications are *Picturesque Sketches in Spain during the Years 1832 and 1833;* and *Views in the Holy Land, Syria, Idumea, Arabia, Egypt and Nubia,* published in six volumes, 1842-9, the plates all in chromo-lithography. His studio sale was held at Christie's on May 13, 1865. Another sale of his estate took place on April 7, 1881.

The usual range for oils and watercolours is about £200-800, although exceptional works have sold for up to £2,500.

Bibl: AJ 1858 201; 1865 43; 1867 21; J. Ruskin *Modern Painters* II i Chap. vii, J. Ruskin *Academy Notes* 1855-9; VAM MSS Letter to W.H. Dixon 1864; James Ballantine *The Life of D.R. RA* 1866; Redgrave Cent. and Dict.; *The Portfolio* 1887 45 136-7; Bryan; Binyon; Caw 153-5; Cundall; DNB; Hughes; Connoisseur 51 (1918) 51 59; 68 (1924) 48; 69 (1924) 195; 86 (1930) 402, 406; J. Quigley 'D.R.' *Walker's Quarterly* X 1922; J. Quigley *Prout and Roberts* 1926; VAM; A.G. Reynolds 'British artists abroad, V: Roberts in Spain, etc'. *Geographical Magazine* XXI 1949; M. Hardie 'D.R.' OWS 1947; Hardie III 179-183 and passim (pls. 208-212); Maas 95 (pls. p.95, 107, 207).

ROBERTS, Edwin fl.1862-1886

London painter of genre, who exhibited from 1862-86 at SS (46 works) and the RA (1882 and 1884), titles at the RA being 'The Professor' 1882, 'The Dishonoured Bill' 1884 and ' "Polly, What's the Time" ' 1884.

'The Proposal' sold at Christie's 20.12.68 for £100.

*ROBERTS, Henry Benjamin RI RBA 1832-1915

Genre painter, a close follower of the work of William Henry Hunt (q.v.). Born in Liverpool, son of the landscape painter and house-decorator (Benjamin Roberts). Became a member of the Liverpool Academy in 1859; exhibited in London from 1859-80, at the RA (1859-75) BI, SS NWS (64 works), and elsewhere; was a member of the RI from 1867-84. He worked in oil and watercolour, and typical of his work is 'The Dull Blade' (Marillier, pl.202), a study of an old barber sharpening his scissors, while a small boy is sitting with a sheet round his neck waiting to have his hair cut, everything in the shop being observed with great minuteness. He also did many single figure studies in watercolour, modelled closely on Hunt's work, e.g 'The Sermon' (VAM, Hardie, pl.135). Marillier remarks that if one of these figure studies were hung as a pair to one of Hunt's, it would be difficult to tell which was which, especially in the minuteness of stippling.

'The First Lesson in Melody' sold at Sotheby's 12.2.69 for £140.

Bibl: Marillier 200-2 (pl.202); VAM Hardie III 113-4 (pl.135).

*ROBERTS, H. Larpent fl.1863-1873

London landscape and flower painter, exhib. at RA 1863-66, BI and SS. Titles at RA 'The Word of God; a Parable' 'The Bread of Man' 'The Sweet Story of Old'. He exhibited very few works, but his flower pieces are of good Pre-Raphaelite detail and quality.

'Bluebells and other Flowers' sold at Christie's 11.7.69 for £315.

***ROBERTS, Thomas E. RBA 1820-1901**
London painter of genre, portraits and historical subjects; engraver. Exhibited from 1850-1904, at the RA (1851-1904), SS (127 works) and elsewhere, titles at the RA including ' "He Loves Me – he Loves me Not" ', 1851, 'Basking – a Corner in the Alhambra' 1884, and 'The Opening of the First Parliament of the Australian Commonwealth by H.R.H. the Prince of Wales, 9 May 1901', 1904. In 1859 Roberts exhibited 'The Opinion of the Press' (No.173) at SS – a painting showing a young artist much discouraged by a bad review. Ruskin noted it, saying "The two works are interesting. for their fidelity of light and shade. The sentiment of No.173 is well and graphically expressed to warn young painters against attaching too much importance to press criticism as an influence on their fortune". And it led him to a sermon on "Do your work well and kindly, and no enemy can harm you".

Probable price range £100-400

Bibl: AJ 1859, 141, 142
J. Ruskin *Academy Notes* (RBA 1859); Ottley.

ROBERTSON, Charles ARWS RPE fl.1863-85 d.1891
Painter of landscape and genre; engraver; living in Aix-en-Provence, Walton-on-Thames, and Godalming, Surrey, who exhibited from 1863-92, at the RA (1863-85), SS, OWS (103 works), NWS and elsewhere. Titles at the RA include 'Bonffasik, Algeria' 1863, 'The Wall of Wailing, Jerusalem' 1877 and 'The Ebbing Tide, Porlock' 1883.

Probable price range £30-100

Bibl: The Year's Art 1892, 288.

ROBERTSON, Henry Robert RPE 1839-1921
London painter of landscape, rustic genre and portraits; etcher and engraver. Exhibited from 1861, at the RA (from 1869), BI, SS, NWS, GG and elsewhere, titles at the RA including 'The Tatler' 1869, 'A Ferry on the Upper Thames' 1875 and 'Her Own Gleanings' 1904. His published works include *The Art of Etching Explained and Illustrated* 1883, *The Art of Painting on China* 1884, *The Art of Pen and Ink Drawing* 1886, *Life on the Upper Thames* 1875 (a series of river scenes and rustic genre first published in the AJ 1873-4), *Plants We Play With* 1915, and *More Plants We Play With,* 1920. His painting 'Winter' is in Sheffield Art Gallery.

'Chequered Shade' sold at Sotheby's 26.2.69 for £160.

Bibl: AJ 1873 13-15, 73-75, 141-43, 205-7; 1874 17-20, 69-72, 141-44, 193-95, 233-36, 261-4, 301-4; A.M. Hind *History of Engraving and Etching* (1923) 387, 397; Who Was Who 1916-1928; British Museum *General Catalogue of Printed Books* 1963.

ROBINS, Thomas Sewell RI 1814-1880
Painter and watercolourist of marine subjects and landscapes. Exhib. at RA 1829-74, BI, SS and NWS. Member of NWS 1839; resigned 1866. 'At his best, Robins was a highly accomplished painter of marine subjects, and conveyed a vivid sense of atmospheric effect' (Hardie). Examples of his work are in the VAM and Bethnal Green Museum. A sale of his works was held at Christie's Feb. 19, 1859. On his retirement from the RI, another sale took place at Christie's on April 17, 1866; after his death two studio sales were held on Feb. 25, 1881 and Feb. 23, 1882.

'British Men o'War off a Harbour' sold at Sotheby's 26.6.69 for £280. Usual range for watercolours £50-150.

Bibl: Portfolio 1890 p.54; Bryan; Cundall; VAM; Wilson, Marine Painters; Hardie III 78-9 (pl.96).

ROBINSON, Miss Annie Louisa See SWYNNERTON, Mrs. Joseph William.

ROBINSON, Charles F. ARPE fl.1874-1915
Landscape painter and engraver, living in London and Rainham, who exhibited from 1874-90, at the RA (1876-82), SS, NWS and elsewhere, titles at the RA including 'On the Thames at Moulsford' 1876, 'The Village at Leigh' 1881 and 'Nature's Mirror' 1882. He was an ARPE from 1890-96. One of his watercolours is in the VAM.

Probable price range £30-70

Bibl: VAM.

ROBINSON, Edward W. fl.1859-1876
London landscape painter who exhibited from 1859-76, at the RA (in 1859, 1872-5), SS and elsewhere, titles at the RA including 'Evening' 1859, 'Valley of the Ticino, St. Gothard, Switzerland' 1873, and 'The Village of Shottery, near Stratford-on-Avon' 1875. A watercolour of Salisbury Cathedral is in the VAM.

Probable price range £30-70

Bibl: VAM.

ROBINSON, Frederick Cayley ARA RWS RBA 1862-1927
Painter of idyllic scenes and domestic interiors, decorator and illustrator, influenced by Puvis de Chavannes, Burne-Jones and the Italian Quattrocento. Born at Brentford, Middlesex. Studied at the St. John's Wood School of Art, and then at the RA Schools; lived on a yacht painting realistic sea pictures 1888-90. Studied at the Académie Julian in Paris 1890-2. The influence of Puvis de Chavannes, and that of Fra Angelico after a visit to Florence in 1898, caused him to adopt a more decorative manner. Professor of Figure Composition and Decoration at Glasgow School of Art 1914-24. Exhibited from 1877 at SS, becoming RBA 1888, and at the RA from 1895, ARA 1921, RWS 1919. Member of NEAC 1912. First one-man exhibition at the Carfax Gallery 1908. Designed décor and costumes for Maeterlinck's *Blue Bird*, Haymarket Theatre 1909; painted a series of mural panels for Middlesex Hospital 1910-14. Designed posters for the London, Midland and Scottish Railway. Illustrated *The Book of Genesis* 1914. He was experimental in technique, particularly in different forms of tempera, and his membership of the Tempera Society connected him with the Birmingham Group of Painters and Craftsmen. Charlotte Gere notes that the quietism and brooding quality of his pictures has much in common with the Cotswold artists, Joseph Southall, Frederick Griggs, Arthur Gaskin and Henry Payne.

Probable price range £100-300

Bibl: AJ, 1902, 387; 1903, 96; 1904, 205; 1906, 379; 1907, 379, 381; 1909, 174; Studio, 19 (1900) 46 f; 31 (1904) 235-41; 38 (1906) 62; 49 (1910) 204-13; 57 (1913) 145; 62 (1914), 176; 65 (1915) 181; 83, (1922) 293-99; 85 (1923) 132, 269; Bate; Who Was Who 1916-28; Connoisseur, 42 (1915) 253; 49 (1917) 238; 63 (1922) 109, 112; 65 (1923) 170; 67 (1923) 242; 72 (1925) 126; 77 (1927), 125; Apollo, 7 (1928) 145; 9 (1929) 118; 11 (1930) 65; Charles Johnson *English Painting* 1932; Tate Cat; Maas 231-2; Charlotte Gere *The Earthly Paradise, F. Cayley Robinson, F.L. Griggs and the Painter-Craftsmen of The Birmingham Group*, FAS Exhibition 1969.

***ROBINSON, Matthias fl.1856-1884**
Genre painter; lived in Chelsea. Exhib. mostly at SS, also at RA 1856-63, BI and elsewhere. Most of his pictures are of children. Although not known to have been associated with the Cranbrook Colony, his work shows the influence of Thomas Webster (q.v.) and F.D. Hardy (q.v.).

'Too Clever by Half' sold at Christie's 10.7.70 for £210. 'The Young Artist' sold at Bonham's 5.3.70 for £360.

ROBINSON, William 1835-1895
Manchester landscape painter, who exhibited from 1884-89 at the RA (1), and NWS.

Probable price range £20-50

ROE, Clarence fl. c.1870-1880

Little-known painter of highland landscapes. Did not exhibit in London. Probably related to Robert Henry Roe (q.v.)., who painted similar subjects.

'Highland Haunt, Glen Finlas' sold at Christie's 3.4.69 for £147.

ROE, Frederick fl.1885-1902

Genre and historical painter and watercolourist; son of Robert Henry Roe (q.v.). Usually known as Fred Roe. Exhib. at RA from 1887, and elsewhere. His pictures are usually historical scenes set in period costume. He also painted portraits, and illustrated books on old oak furniture.

'Health to the Old Love' sold at Christie's 20.12.68 for £147.

Bibl: AJ 1893, p.160; Connoisseur see Index 1913-1932; Studio 68 (1916) 40; 83 (1922) 302; Who's Who; RA Pictures 1891 ff.

ROE, Robert Henry 1793-1880

Painter of Highland landscapes and animals, miniaturist and engraver. Father of Fred Roe (q.v.). Exhib. at RA 1852-68, BI and SS. Titles at RA all Highland scenes and Landseer-style deer.

Probable price range £20-80

Bibl: Connoisseur 63 (1922) 232, Smith *Recollections of the BI* 1860, p.125 f.

ROE, Walter Herbert fl.1882-1893

Genre painter. Exhib. mostly at SS, also at RA 1885-93, NWS and elsewhere. Titles at RA 'Waiting' 'La Petite Bonne' 'The Pet of the Laundry' etc.

Probable price range £20-60

ROFFE, William John fl.1845-1889 (David B. McKAY)

Painter of landscapes and coastal scenes. One of a family of engravers and printers. Exhib. at RA 1845-89, BI, SS, GG and elsewhere. Titles at RA 'A Moorland Scene - Twilight' 'Robinson Crusoe Bringing Stories from the Wreck' 'Caught in the Squall' etc. Between 1871 and 1877 he used the pseudonym David B. McKay, and exhib. under this name at the RA and SS.

ROGERS, James Edward ARHA 1838-1896

Painter of landscapes, architectural and marine subjects; architect; illustrator. Born in Dublin. By profession an architect, but devoted much of his time to watercolours, mainly of architectural and marine subjects. First exhibited at the RHA in 1870 and for many years afterwards; ARHA 1871. Moved to London in 1876, exhibited from 1876-93, at the RA (1881-4), NWS, and elsewhere. Several books were illustrated from his drawings. As an architect he designed the Carmichael School of Medicine in N. Brunswick St., Dublin. In the NG of Ireland is 'A Street in Limburg'.

Probable price range £30-100

Bibl: Strickland.

ROGERS, Mrs. Jane Masters fl.1847-1870

London portrait painter, who exhibited from 1847-70 at the RA, BI and SS.

Probable price range £20-50

ROGERS, Philip Hutchings 1786/94-1853

Marine and landscape painter. Born at Plymouth and educated at Plymouth Grammar School under John Bidlake, where a fellow pupil was Benjamin Robert Haydon. Encouraged to study art by Bidlake who sent him to study in London, maintaining him for several years at his own expense. Rogers returned to Plymouth and painted views of Mount Edgcumbe and Plymouth Sound, painting chiefly wide expanses of

water under sunlight or golden haze in imitation of Claude. Many of these are at Saltram House. Exhibited from 1808-51 at the RA, BI, SS, NWS and elsewhere. Etched twelve plates for Noel Thomas Carrington's *Dartmoor* 1826. After living abroad for some years, he died at Lichtenthal near Baden-Baden.

'View in an Estuary' sold at Christie's 18.12.64 for £231.

Bibl: Gentleman's Magazine 1853 II 424; Athenaeum 1853, 30th July; Smith *Recollections of the BI* 1860, 76; G. Pycroft *Art in Devonshire* 1883; Bryan; DNB.

ROLFE, Alexander F. fl.1839-1871

Painter of landscape, still life and sporting subjects, especially fishing. Exhib. mostly at SS, and at BI. Titles at BI 'First Woodcock of the Season' 'Salmon Fishing on the Usk, South Wales' 'Dead Game' etc. Presumably related to Henry Leonidas Rolfe (q.v.). Sometimes collaborated with J.F. Herring Sen. (q.v.).

Probable price range £50-200

ROLFE, Henry Leonidas fl.1847-1881

Painter of fishing subjects. Exhib. at RA 1847-74, BI, SS and elsewhere. Titles mostly still lives of fish and fishing-tackle, set in landscapes or by rivers. Also recorded are Alexander F. Rolfe (q.v.), and an F. Rolfe, who lived for a time at the same address as Henry Leonidas R.

'Playing a Salmon' sold at Sotheby's 1.10.69 for £130.

Bibl: Clement and Hutton.

ROLT, Charles fl.1845-1867

Painter of portraits, landscape, mythological and biblical subjects, living in Merton and London, who exhibited from 1845-67, at the RA (1846-66) BI and SS. Titles at the RA include 'Scene from Comus' 1847, 'Sappho Watching the Departure of Phaon' 1852, and 'Christ and the Syrophoenician Woman' 1859.

Probable price range £30-100

ROMER, Mrs. Frank (Miss Louise Goode)
See under JOPLING, Mrs. J.M.

ROODS, Thomas fl.1833-1867

London painter of portraits (often group portraits), and genre, who exhibited from 1833-67, at the RA (1834-67), BI, SS and elsewhere. Titles at the RA include 'A Girl Selecting a Nosegay' 1834, 'A Kentish Hop-garden' 1844, 'The Return from Coursing; Portraits of Thomas Sherwin Esq., and Family' 1844, and 'Mr. Alderman Finnis, Sheriff of London for 1849' 1850.

Probable price range £20-80

ROOKE, Thomas Matthew RWS 1842-1942

Painter of architectural subjects, biblical subjects, portraits and landscape, closely associated in his younger days with Ruskin, Burne-Jones and William Morris, and much influenced by them. Began in an Army Agent's Office; then attended classes at the R.C.A., and RA Schools. Aged 29 he applied for a vacancy as designer in William Morris's firm, and was appointed assistant to Burne-Jones, with whom he worked for many years. In 1878 Ruskin was searching for artists to make drawings of cathedrals and other ancient buildings on the Continent, and Burne-Jones recommended Rooke, as saying"also there is a very high place in Heaven waiting for him, and *He Doesn't Know It*". As a result up till 1893 Rooke spent half of his time working for Ruskin abroad. The drawings were given by Ruskin to the Ruskin Museum at Sheffield. For the next 15 years he continued to make similar drawings for the Society for the Preservation of Pictorial Records of Ancient Works of Art, and these are in the Birmingham Art Gallery. In 1891 he was elected ARWS, and RWS in 1903; he had exhibited

since 1871, at the RA (from 1876) OWS, NWS, GG, NG and elsewhere. Hardie notes that "he both knew and loved the buildings which he portrayed, and he never varied from the painstaking exactness which had very properly won Ruskin's approval". In his early days he had also painted biblical subjects in the Pre-Raphaelite tradition, and adopted the manner of painting several compositions of successive scenes of the same story, which were designed to be placed in one frame.

'French Street Scenes' — a pair — sold at Bonham's 10.4.69 for £130.

Bibl: AJ 1880, 172; Gazette des Beaux Arts 1877 II 294; 1879 II, 370; Ruskin *Academy Notes* 1877-1882; Bate 114 (pl. facing p.114); William White *Principles of Art as Illustrated by Examples in the Ruskin Museum at Sheffield*; Extracts from letters to Sir S. Cockerell OWS XXI; Birmingham Cat.; Who Was Who 1941-50; Hardie III 129-130 (pl.152).

ROOM, Henry 1802-1850

Portrait painter. Born at Birmingham, of a leading evangelical family; studied at the drawing school conducted by Joseph and J.V. Barber. In 1826 he was one of the members of the short-lived "Birmingham Society of Artists" which was formed for establishing an exhibition of original works of art and included the artist-members of the Society of Arts. Went to London in 1830. Exhibited in London from 1826-48, at the RA, BI and SS. He painted a portrait of Thomas Clarkson for the central Negro Emancipation committee, and also two groups of 'Interview of Queen Adelaide with the Madagascar Princes at Windsor', and 'The Caffre Chiefs' Examination before the House of Commons Committee'. Many of his portraits were engraved in the *Evangelical Magazine*.

Probable price range £50-200

Bibl: AJ 1850, 339; Gentleman's Magazine 1850 II 449; Redgrave Dict.; DNB; Cat. of Engr. Brit. Portraits B.M. 1925, 543; Birmingham Cat.

ROSCOE, S.G.W. fl.1874-1888

London landscape painter, who exhibited from 1874-88, at the RA (1880-83), SS, NWS and elsewhere, titles at the RA including 'On the Exe, Devon' 1880, and 'Richmond Bridge, Surrey' 1883.

Probable price range £20-50

ROSE, Miss H. Ethel fl.1877-1890

Peckham painter of portraits and genre, who exhibited from 1877-90, at the RA (1885-88), SS, NWS and elsewhere, titles at the RA including 'The Sensitive Plant' 1885 and 'A Knotty Question' 1888.

Probable price range £20-50

ROSE, H. Randolph fl.1880-1901

London painter of landscape, portraits and genre, who exhibited from 1880-1901 at the RA (1885-1901), SS, NWS, GG, NG and elsewhere, titles at the RA including 'Roscoff, Brittany' 1885, 'A Dancing Girl. Algiers' 1897, and 'Franciscans at Prayer, Redentore, Venice' 1900.

Probable price range £20-50

ROSE, William S. 1810-1873

Landscape and genre painter, working exclusively in oil, who painted chiefly the rural scenery of the Home Counties. Lived in St. Mary Cray, Kent; Wargrave; Foot's Cray, Kent, and Edenbridge. Exhibited from 1845-75, at the RA (1853-75), BI, SS and elsewhere, titles at the RA including 'Kentish Heath Scene' 1853, 'A Rustic Village' 1863, and 'Water Mill, Ashdown Forest' 1875. The AJ noted in his obituary: "His pictures — small landscapes painted with taste and feeling, from the pleasant scenery of Kent and Sussex — were seen almost annually in the Academy and BI".

Probable price range £20-60

Bibl: AJ 1859, 82, 122, 171; 1873, 208, Redgrave, Dict.

ROSS, Christine Paterson See under ROSS, Robert Thorburn.

ROSS, Joseph Thorburn See under ROSS, Robert Thorburn.

*ROSS, Robert Thorburn RSA 1816-1876

Scottish genre and portrait painter. Pupil of G. Simson, and Sir W. Allen. Worked firstly in Glasgow; moved to Berwick 1842; Edinburgh 1852. Exhib. mostly at RSA; also RA 1871-79 and SS. Elected ARSA and RSA 1869. Painted homely scenes of Scottish life, in the manner of the Faeds and Erskine Nicol (q.v.), but without their technical accomplishment or humour. Caw praises especially his watercolours and sketches. His son Joseph Thorburn R. (1849-1903), was also a painter; also his daughter Christine Paterson R. (1843-1906)

'The Fisherman's Home' sold at Christie's 2.4.69 for £504.

Bibl: AJ 1871, 281-3; 1876, 295 (obit); 1900, 287; Studio 39 (1907) 258; Caw 166; Cundall.

ROSS, Sir William Charles RA 1794-1860

Miniature portrait painter, and also painter of historical, classical and biblical subjects in oils. Son of William Ross, a miniature painter and teacher of drawing, (exhibited at the RA 1809-25); his mother, Maria Ross, was a portrait painter, (exhibited at the RA in 1833). In 1808 he entered the RA Schools, and won numerous prizes; he also received 7 premiums at the Society of Arts between 1807 and 21. He exhibited at the RA from 1809-59 (304 works), at first oils of an historical, classical and biblical character. In 1814 he became assistant to Andrew Robertson, an eminent miniature painter, and he abandoned historical painting for miniatures. He soon had a large practice in the highest circles: in 1837 the Queen and Duchess of Kent sat to him, and later, Queen Adelaide, Prince Albert, the Royal children and various members of the royal families of France, Belgium, Portugal and Saxe-Coburg. He was elected ARA in 1838; RA in 1843; knighted in 1842. In 1843 he won a premium of £100 at the Westminster Hall Competition for the cartoon 'The Angel Raphael Discussing with Adam'. He continued to hold the first place among miniature painters until 1857, when he was struck with paralysis. An exhibition of miniatures by him was held at the Society of Arts in 1860, and in June 1860 his remaining works were sold at Christie's. Reynolds notes that "it was his especial gift to catch his sitters at their most genial and agreeable, and his miniatures of Prince Albert, Melbourne and Louis Phillippe rank among the most attractive and effective portraits of their epoch".

Probable price range £50-100, but more for an important sitter.

Bibl: AJ 1849, 76; 1860, 72; Art Union 1839, 85; Gentleman's Magazine 1860, I 513; Sandby *History of the Royal Academy* 1862 II 171-4; Redgrave Dict.; Clement and Hutton; J.J. Foster *British Miniature Painters* 1898; G.C. Williamson *History of Portrait Miniatures* 1904; Binyon; Caw 90; DNB; Connoisseur 31, (1911) 210, 261; 55 (1919) 93-4; 61 (1921) 177; 63 (1922) 99; 64 (1922) 56; 65 (1923) 46, 48; Burlington Magazine 39 (1921) 314; 40 (1922) 154; 41 (1922) 99; 46 (1925) 33; VAM; Reynolds VP 174, 177 (pl.170).

*ROSSETTI, Dante Gabriel Charles 1828-1882

Pre-Raphaelite painter and poet. His father, Gabriel Rossetti, was an Italian refugee, and Professor of Italian at King's College, where Rossetti first studied 1837-42. Entered RA Schools 1845. Pupil of Ford Madox Brown for a few months in 1848, after which he shared a studio with Holman Hunt. Together with Hunt and Millais, Rossetti played a leading role in the formation of the Pre-Raphaelite Brotherhood (q.v.) 1848-9. Toured France with Hunt 1849. In 1850 he met Elizabeth Siddal (q.v.), who became his favourite model, his mistress, and later, in 1860, his wife. Although Rossetti was the driving force behind the PRB, he only contributed two oil paintings to this first phase of the movement — 'The Girlhood of Mary The Virgin' and 'Ecce Ancilla Domini'. Because of the furore aroused by the paintings of the PRB, he never exhibited his pictures in public again, preferring to sell through agents, such as the disreputable C.A. Howell, or direct to

collectors. From this period until about 1864 he preferred to work in watercolour, although as Hardie writes "neither oil nor watercolour were pliant and malleable materials in his hands. He was wrestling with refractory substances, and perhaps for that very reason his work has the intensity and inner glow so often lacking in the painter who attains a surface of superficial ease". He always considered himself primarily a poet (as was also his sister Christina). The subjects of his works in the 1850's were mostly taken from Dante or *Morte d'Arthur.* and Elizabeth Siddal appears in practically all of them. In 1857-8 he worked on the Oxford Union frescoes with Burne-Jones and William Morris, both of whom became his disciples, thus generating the second phase of the Pre-Raphaelite movement. In 1862, after the tragic death of his wife from an overdose of laudanum, he moved to Tudor House, 16, Cheyne Walk, which he shared with his brother, William Michael Rossetti, Swinburne, Meredith, and numerous pets. He turned back to oil painting, concentrating on allegorical female portraits, or groups of females, with titles like 'La Donna della Fiamma' 'Prosɜrpine' 'Venus Verticordia' 'Pandora' etc. Although he used several models, the same facial type, languid and sensual, features in all of them. His most famous model, and the one most associated with the Rossetti image, was Jane Morris, wife of William Morris. From 1871-4 he and Morris shared Kelmscott Manor in Oxfordshire. Rossetti began to suffer mental disturbance, and became increasingly dependent on chloral. The quality of his work declined, but he was still successful enough to employ studio assistants, first W.J. Knewstubb (q.v.), and later Henry Treffry Dunn (q.v.). Burne-Jones and Morris both thought that Rossetti's best work was done before 1860, and many modern critics agree with this. But the influence of his ideas and his personality, transmitted through Burne-Jones and his many followers, remained a potent feature of English painting even into the early 20th century. His studio sale was held at Christie's on May 12, 1883.

During the 1969-70 season, two watercolours sold at Christie's for £5,775 each – the highest so far recorded at auction. With interest in the Pre-Raphaelites increasing, this record is bound to be broken soon, especially if some work of major importance appears. Less important works have sold in recent years in the £1,000-3,000 range.

Bibl: For full bibliography see Fredeman Sections 22-34 et passim.
Main biographies – W.M. Rossetti *D.G.R. his family letters* 1895.
F.M. Hueffer *R. a Critical Essay* 1902.
H.C. Marillier *R.* 1904 (still the standard work).
P.J. Toynbee *Chronological List of Paintings from Dante by D.G.R.* 1912.
Sir M. Beerbohm *R. and his Circle* 1922.
Evelyn Waugh *R. his Life and Work* 1928.
H.M.R. Angeli *D.G.R.* 1949.
R. Glynn Grylls (Lady Mander) *Portrait of R.* 1964.
G.H. Fleming *R. and the PRB* 1967.
V. Surtees *The Paintings and Drawings of D.G.R. A Catalogue Raisonné* 1970. Other references – Binyon; VAM; Cundall; DNB; Bate; Ironside and Gere; Reynolds VP 60-1, 64-5 et passim (pls. 36-8); Maas 124-6 et passim (pls. p.138, 141-3, 200); Hardie III 118-21 et passim (pls. 136-9).

ROSSETTI, Mrs. William Michael
See under BROWN, Miss Lucy Madox.

ROSSI, Alexander M. fl.1870-1903
Painter of genre and portraits, living in Preston and London, who exhibited from 1870-1903, at the RA (1871-1903), SS (47 works), NWS and elsewhere. Titles at the RA include 'A Family Group' 1871, 'Caught in the Tide' 1889, and 'Their Morning Bath' 1900.

'Throwing Pebbles' sold at Sotheby's 25.2.70 for £240. Another picture in the same sale sold for £160.

***ROSSITER, Charles b.1827 fl.1852-1890**
Genre painter. Exhib. at RA 1859-90, BI, SS and elsewhere. Titles at RA 'Sad Memories' 'Rival Anglers' 'Quiet Enjoyment' etc. His wife

Mrs. Charles Rossiter (q.v.) was also a painter. His best-known work is 'Brighton and Back, 3/6' in the Birmingham AG.

Probable price range £100-300

Bibl: Clement and Hutton; Birmingham Cat.

ROSSITER, Mrs. Charles (Miss Frances Sears) fl.1858-1892
Genre painter and watercolourist. Studied under Leigh of Newman St, and Charles Rossiter (q.v.) who she married in 1860. Exhib. first at Liverpool Academy in 1862, later at RA, BI, SS, NWS and elsewhere. Her subjects were mostly sentimental domestic scenes, but in 1866 she began to exhibit paintings and watercolours of birds, which later became her speciality.

Probable price range £30-100

Bibl: Clayton II 316-18

ROSSITER, Miss Mary P. See HARRISON, Mrs.

ROTHWELL, Richard RHA 1800-1868
Painter of portraits and genre. Born in Athlone, Ireland; trained in Dublin where he worked for a few years. Became RHA in 1826; soon afterwards moved to London where he became Sir Thomas Lawrence's chief assistant. When Lawrence died, Rothwell was entrusted with the completion of his commissions and could have succeeded to his practice, but he was unable to sustain the reputation of his early works, painted in Lawrence's manner. He exhibited from 1830-63, at the RA (1830-62), BI, SS and elsewhere. Amongst others, he painted portraits of the Duchess of Kent, the Prince of Leiningen, Viscount Beresford and William Huskisson. In c.1846 he returned to Dublin, where, having resigned in 1837, he was re-elected RHA in 1847. From 1849-54 he was again in London, and then went to Leamington. The last years of his life were spent in Paris, and then in Rome, where he died. Three of his genre paintings 'The Little Roamer', 'Novitiate Mendicant', and 'The Very Picture of Idleness' (RA 1842), are in the VAM. His portraits of Huskisson and Viscount Beresford are in the NPG.

Probable price range £50-150

Bibl: AJ 1868 245 (obituary); 1872, 271; Redgrave Dict.; Bryan; DNB; Cat. of Engr. Brit. Portr. BM; Strickland.

ROUS, Miss Elizabeth See PHILLIPS, Mrs. Philip

ROUSE, Robert William Arthur RBA fl.1882-1898
Landscape painter, living in London and Brixton, who exhibited from 1882-98, at the RA (1883-98), SS, NWS and elsewhere, titles at the RA including 'Far from the Busy Hum of Men' 1883. 'In the Month of May' 1889, and 'Afternoon, August' 1898.

Probable price range £30-70

ROWBOTHAM, Charles fl.1877-1888
Landscape painter, who exhibited from 1877-88 at SS, NWS and elsewhere. He was the eldest son of T.C.L. Rowbotham (jun.) (q.v.). and during the later years of his father's career often painted the figures in his landscapes. His 'Clifton Bridge' (watercolour) is in Cardiff Art Gallery. Like his father, he used a great deal of body colour in his watercolours, giving them an unnaturally bright and colourful appearance.

Usual price range for watercolours £20-60

ROWBOTHAM, Thomas Charles Leeson RI 1823-1875
Landscape painter in watercolour; engraver and lithographer. Son of Thomas Leeson Rowbotham, 1783-1853, also a painter of landscape, marines and coastal scenery. Pupil of his father. His first serious work was done in 1847 on a sketching tour of Wales. Exhibited from 1840-

75, at the RA (1840 and 1848), SS, NWS (464 works) and elsewhere. In 1848 he became A of the RI, and RI in 1851. He succeeded his father as Professor of Drawing at the Royal Naval School, New Cross, collaborated with him in *The Art of Painting in Watercolours,* and illustrated his father's *The Art of Sketching from Nature.* In his later years his love of sunny effects led him to restrict himself to Italian subjects, especially those of sea or lake, although he had never been in Italy. His remaining works were sold at Christie's on 21 April, 1876. Ruskin praised his work, and in 1858 said he had the making of a good landscape painter, in spite of his "artificialness". In 1875 he published small volumes of *English Lake Scenery and Picturesque Scottish Scenery,* and a series of chromolithographic *Views of Wicklow and Killarney,* with descriptive text by the Rev. W.J. Loftie. He published many other chromolithographs; a series entitled *T.L. Rowbotham's Sketch Book* was issued after his death. A sale of his "Sketches in Watercolours" was held at Christie's on July 8. 1863; his studio sale was also held there on April 21, 1876.

Usual price range for watercolours £30-80

Bibl: For Father and son – AJ 1875, 280; J. Ruskin *Academy Notes* 1857, 1858, 1859 (NWS reviews); Redgrave, Dict.; Roget; Bryan; Binyon; Cundall; DNB; Hughes; Strickland; VAM; Hardie III 12, 57.

ROWE, E. Arthur fl. 1885-1921, d. 1922

Landscape painter, living in Lambeth and Tunbridge Wells, who exhibited from 1885 at the RA, SS, NWS, NG and elsewhere, titles at the RA including 'Memories of the Past' 1885, 'A Winter's Tale' 1891, and 'Kale Pots and Cherry Blossom' 1893. He had a one-man show of his watercolours at the Greatorex Galleries, Grafton St., in 1921, of which *The Connoisseur* commented: "Mr. E.A. Rowe arranged an attractive exhibition of watercolours in his accustomed metier. His drawings of old-world gardens are always pleasing, and evince marked sincerity of purpose. Dealing in detail rather than in broad effects, he sometimes permits himself to be carried away by a comprehensive observation of minutiae, with the result that a few of his more laboured studies lack reticence and become spotty in construction and coloration. An artist should be judged by his best works, however, and in such a sensitively rendered and varied sketch as 'A Quiet Corner – Villa Borghese, Rome', the dross was eliminated, leaving pure quality behind". A watercolour 'The Villa d'Este, Tivoli' is in the City of Birmingham Museum and Art Gallery.

Probable price range £20-60

Bibl: Connoisseur 59 (1921) 248
American Art News 10 (1922) No.20 6

ROWE, George James fl.1830-1862 d.1883

Landscape painter, living in Woodbridge and London, who exhibited from 1830-62, at the RA (1830-54), BI and SS, titles at the RA including 'On the Woodbridge River' 1844, and 'Suburban Study-Bayswater' 1854.

Probable price range £20-50

Bibl: The Year's Art 1884, 217.

ROWE, Sidney Grant ROI 1861-1928

Landscape painter, living in London and Warlingham. Son of Charles J. Rowe, lyric author. Studied at the St. Martin's School of Art; exhibited at SS, NWS and elsewhere from 1877 and at the RA from 1882. Titles at the RA include 'Cloudy Day' 1882 and 'Solitude' 1896.

Probable price range £20-70

Bibl: Who Was Who 1916-1928; Pavière, Landscape.

ROWE, Tom Trythall b.1856, fl.1882-1899

Landscape painter living in London, Cookham Dene and Rotherham,

who exhibited from 1882-99 at the RA, SS, NWS and elsewhere, titles at the RA including 'Old Battersea Bridge' 1882 and 'Field Flowers' 1899. In Nottingham Museum and Art Gallery is 'Evening Glow'.

Probable price range £20-60

ROWLEY, Miss Elizabeth fl.1852-1859

Edmonton genre painter, who exhibited from 1852-59, at the RA (1852, 1853 and 1856), BI, SS, and elsewhere, titles at the RA including 'Laura' 1852, and 'Sortie le Bal' 1856.

Probable price range £20-50

ROWLEY, E.S. fl.1859-1875

London landscape painter, who exhibited from 1859-75, at the RA (1862-72), SS and BI, titles at the RA including 'A Shady Place – Fin Glen, Campsie, Scotland' 1962, and 'A Peep Down a Trout Stream, near Brecon, S. Wales' 1872.

Probable price range £20-50

RUDGE, Bradford fl.1840-1883

Bedford landscape painter and lithographer, who exhibited from 1840-83 at the RA (1840-72), SS, and elsewhere, titles at the RA including 'In the Grounds of Ampthill Park, Beds.' 1864, and 'A Peep at the Mwthoc; the Arrans in the Distance' 1872. In 1859 he exhibited at the Portland Gallery 'Yew Tree in Lorton Vale, Cumberland', of which the AJ said ". . . . the tree is certainly most skilfully painted, but it stands alone a melancholy spot in the picture, entirely unsupported by any shred of sympathizing shade"

Probable price range £20-60

Bibl: AJ 1859, 122; Cat. of Engr. Brit. Portr. BM I 1908, 476.

RUMLEY, Miss Elizabeth see DAWSON, Mrs. B.

*RUSKIN, John HRWS 1819-1900

Writer, critic and artist. The most influential critic of the Victorian age. Born in London, the only child of a wealthy sherry merchant. Educated at Christ Church, Oxford; won the Newdigate prize 1839. In 1840 he met Turner (q.v.), whose work he greatly admired. In 1843 he published the first volume of *Modern Painters,* begun as a defence and justification of Turner, but expanded into a general survey of art. Among his other books were *The Seven Lamps of Architecture* (1849) and *The Stones of Venice* (1851-3) both illustrated by himself. The great success of these works established his position as England's leading writer on art, and enabled him to wield more authority than any other critic before or since. Rede Lecturer at Cambridge 1867; Slade Professor of Art at Oxford 1869-1884. From 1848-54 he was married to Effie Gray, who left him to marry Millais (q.v.). Ruskin was himself a talented watercolourist and draughtsman, and studied under Copley Fielding and J.D. Harding. Exhib. at OWS 1873-84; elected HRWS 1873. His drawings reflect his analytical and scientific approach to art. They are mostly of architectural details, or studies of rocks, mountains, and plants. In painting he always insisted on minutely detailed observation of nature, and it was this aspect of the Pre-Raphaelite movement which led him to intervene in their defence in 1851. It also attracted him to artists like John Brett (q.v.), who shared his scientific and geological interests. Later in life he became increasingly interested in social reform. He also began to suffer from mental illness, which made him increasingly eccentric and unreliable as a critic, and led to the notorious Whistler trial of 1878. Retired to Brantwood, Coniston, in the Lake District, where he died. For his opinions on Victorian painters, a good source is his *Academy Notes.* The best complete edition of his works is Cook and Wedderburn 1902-12, but several good anthologies have been published more recently.

Prices in recent years have ranged from about £50 to £520, the

average being around £100-300

Bibl: For full bibl. see Fredeman Section 45;
Main Biographies – W.G. Collingwood *The Life and Works of J.R.* 1893
C.E. Godspeed & Co. *Cat. of Paintings, Drawings etc. of J.R.* 1931
R.A. Wilenski *J.R.* 1933
J.H. Whitehouse *R. The Painter and his Works at Bembridge* 1938
P. Quennell *J.R.* 1949
J. Evans *J.R.* 1954
M. Lutyens, *Millais and the Ruskins* 1967
A. Severn *The Professor – Arthur Severn's Memoir of J.R.* 1967.
Other references – Roget; Binyon; Cundall; Hughes; VAM;
DNB; Ruskin and his Circle, Arts Council Exhibition 1964
Hardie II 43-5 (pls. 29-30); Maas passim (pls. p.15, 226, 228).

RUSSELL, Edwin Wensley fl.1855-1878
London painter of portraits, genre and historical subjects, who exhibited from 1855-78, at the RA, BI, SS and elsewhere, titles at the RA including 'Consolation' 1855, 'The Rose Seller of Andalusia' 1869, and 'Forbidden Fruit' 1876. The AJ noted of his 'Ave Maria' (RA 1859); "A study of a girl at Vespers, painted with firmness and very appropriately circumstanced". A 'Portrait of Miss Nancy Hargreaves' and a watercolour are in Blackburn Museum.

Probable price range £30-70

Bibl: AJ 1859, 167.

RUST, Miss Beatrice Agnes fl.1883-1893
London painter of portraits and genre, who exhibited from 1883-93, at the RA (1883-92), SS, NWS and elsewhere, titles at the RA including 'An Artist's Model' 1886, 'Sad News' 1887 and 'Sweet Flowers' 1892.

Probable price range £20-50

RYLAND, Henry RI 1856-1924
Painter, watercolourist, decorator and designer. Exhib. at RA from 1890, also NWS, GG, NG and elsewhere. His style is a rather sugary combination of Alma-Tadema and Albert Moore (q.v.), and at times very similar to J.W. Godward (q.v.). His usual subject is young women in classical draperies on marble terraces; typical RA titles 'The Spirit of May' 'Tryst' 'Summer Music' etc.

Probable price range £100-250

Bibl: AJ 1895, p.153; Studio *A Record of Art in 1898* p. 70; 35 (1905) 294; Bate 119; R.E.D. Sketchley *Eng. Book Illustration of Today* 1903; H.W. Singer *Pre-Raphaelitisism in England* 1912; Who was Who 1916-28; R. Mudie-Smith *The Art of H.R.* Cassells Mag. No. 194, p.49-57

RYLE, Arthur Johnston RBA 1857-1915
London landscape painter. Third son of the Bishop of Liverpool. Educated at Eton and New College, Oxford. Exhibited from 1889-1903, at the RA (1891-1903), SS and NG, titles at the RA including 'Torish, Helmsdale' 1891, and 'Harbour and Hillside' 1903.

Probable price range £20-50

Bibl: Who Was Who 1897-1915

SADLER, Miss Kate fl.1878-1893
Flower painter and watercolourist; lived at Horsham, Sussex. Exhib at RA 1880-89, SS, NWS and elsewhere. Titles at RA mostly of azaleas and chrysanthemums.

Probable price range £20-50

***SADLER, Walter Dendy RBA 1854-1923**
Genre painter. Studied at Heatherley's Art School in London, and with W. Simmler in Dusseldorf. Exhib. at RA from 1873, also at SS, GG and elsewhere. His subjects were mostly costume pieces of the eighteenth or early nineteenth century period, often with humorous or sentimental themes e.g. 'Scandal and Tea' 'A Meeting of Creditors' 'An Offer of Marriage' etc. About 1896 he moved to Hemingford Crag, near St. Ives, Huntingdon, where he died. His pictures were very popular and much reproduced through engravings. Works by him are in the Tate, Liverpool, Manchester and Rochdale galleries.

'The Bagman's Toast to Sweethearts and Wives' sold at Christie's 11.10.68 for £336.

Bibl: AJ 1885 p.72; 1895, 193-99, (F.G. Stephens); Art News 22 (1923/4) no.6 p.6 (obit); Connoisseur 68 (1923) 52 f; 70 (1925) 50; RA Pictures 1891-6 etc.

SAINSBURY, Everton 1849-1885
London genre painter. Exhib. at RA 1878-85, SS, GG, and elsewhere. Titles at RA 'The Latest News' 'Superstition' 'A Glimpse of the Unknown' (child in the East End of London seeing butterflies for the first time) etc.

Probable price range £50-150

Bibl: Year's 1886 p.224; Academy Notes 1880, 1883.

ST. JOHNS WOOD CLIQUE
Group of artists who lived in St. John's Wood during the 1860's and 70's, consisting of P.H. Calderon, W.F. Yeames, G.D Leslie, H. Stacy Marks, J.E. Hodgson, G.A. Storey, and D.W. Wynfield. They held weekly meetings at each other's houses, to make drawings and discuss them. Chief sources of information on this clique are 'Sketches from Memory' by G.A. Storey (1899) and an article by Bevis Hillier in *Apollo* June 1964.

SALMON, John Cuthbert RCA 1844-1917
Liverpool landscape painter. Exhib. at RA from 1878, NWS and elsewhere. Like many Liverpool artists, he spent most of his time painting in North Wales. Titles at the RA all Welsh views, except for an occasional Scottish scene.

Probable price range £50-100

Bibl: Who Was Who 1916-28; VAM Cat. of Watercolours 1908

SALTER, William RBA 1804-1875
Historical and portrait painter. Studied under James Northcote 1822-27; travelled in Italy, spending some years in Florence; returned to London 1833. Exhib. at RA 1825-45, and BI, but mainly at SS (101 works) of which he was Vice-President. Painted portraits, historical genre, and Graves also mentions "mythological". His best known picture is 'The Waterloo Banquet', which was engraved.

Probable price range £30-100

Bibl: Clement and Hutton; Redgrave, Dict; DNB; Poole Cat. of Portraits etc. Oxford, 1925; Cat. of Engraved Brit. Portraits BM, 1925.

SALTMER, Miss Florence A. fl.1882-1900
Genre and landscape painter. Exhib. at RA 1886-1900, SS, NWS, GG, and elsewhere. Titles at RA mostly rustic genre e.g. 'The Reapers Lunch' 'The Old Farm' 'Village Gossip' etc.

Probable price range £30-80

SAMBOURNE, Edward Linley 1844-1910
Designer and illustrator; worked for many years for *Punch* producing illustrations and cartoons. Exhib. from 1885 at the RA, mainly cartoons for *Punch,* and from 1875 elsewhere. Elizabeth Aslin notes that, unlike du Maurier, Sambourne worked "almost entirely from

imagination, producing what were described as quaint and fanciful drawings with captions so brief that the editors of *Punch* sometimes provided explanations for their less quick-witted readers", and that from 1877 his political cartoons and fanciful drawings often had an aesthetic note. He designed and painted furniture as can be seen at his own house at 18 Stafford Terrace, (1874), which is one of the most perfect examples of an artistic interior. He also illustrated books, e.g. Charles Kingsley's *Water Babies,* Macmillan, 1886 and Lord Brabourne's *Friends and Foes from Fairyland* 1886.

Probable price range £20-60

Bibl: AJ 1886 31 f.; The Year's Art 1911, 416; J. Pennell *Die Modern Illustrator* 1895; Elizabeth Aslin *The Aesthetic Movement* 1969 114, pls. 49, 58, 68, fig.6.

SAMPSON, James Henry fl.1869-1879

London painter of coastal and shipping scenes. Exhib. mostly at SS, also at RA 1870-79 and elsewhere. Titles at RA 'Trawling' 'The Restless Sea' 'Spratting' etc.

Probable price range £20-60

SAMPSON, Thomas fl.1838-1856

Portrait and genre painter. Exhib. at RA 1838-53, BI, SS and elsewhere. At first exhib. portrait miniatures at the RA, but later turned to landscape and historical genre.

Probable price range £20-50

SANDERS, Walter G. fl.1882-1901

London flower painter. Exhib. at RA from 1884, SS and elsewhere. Titles at RA mostly of roses; also some of still life.

Probable price range £20-50

*SANDYS, Frederick 1829-1904

Pre-Raphaelite painter, portraitist, and illustrator. Born in Norwich. His father was a minor Norwich School painter. Studied at RA Schools under George Richmond (q.v.), and Samuel Lawrence, who taught him to draw in chalks. Began to exhib. at RA in 1851. His first work to attract notice was 'The Nightmare', a print satirising Millais' picture 'Sir Isumbras at the Ford'. As a result of this he met Rossetti, Swinburne, and others, and became a member of Pre-Raphaelite circles. His work falls into three distinct categories. Firstly, his oil paintings. These are mostly female heads or half-lengths of the Rossetti type, with titles like 'Fair Rosamund' 'La Belle Ysonde' etc. He was capable of more dramatic, individual works, such as 'Medea' and 'Morgan le Fay'. He also painted some portraits in oils, which for their extraordinary fidelity and high finish have often been compared with Holbein. Secondly, his portrait drawings. These were mostly done in pale colours on light blue paper. In female portraits, he often added a background of lilies, iris or other flowers, which give them an Art Nouveau appearance. Thirdly, his woodcuts and illustrations. It was in this field that he made his most important contribution to the PRB movement. He worked for *The Cornhill, Once a Week, Good Words, The Argosy* and many other magazines, and illustrated poems by Swinburne and Christina Rossetti. His illustrations are a unique blend of Pre-Raphaelite subjects and an almost Dürer-like precision. After about 1880, he began to devote himself more and more to chalk portraits. Exhib. at RA 1851-86, BI and GG.

'King Pelles' Daughter' sold at Sotheby's 20.11.69 for £520. Good portrait drawings can make similar sums – 'Wondertime – a Portrait of Gertrude Sandys' sold at Christie's 11.3.69 for £735.

Bibl: AJ 1884 p.75-8; 1904, 270 (obit.); 1905, 81f; 1909, 149-151; Studio 33 (1905) 3-16; Winter No. 1923-4 (p.20f.) 52f; The Artist, Special Winter No. 1896 (Esther Wood); Pall Mall Mag. XVI (Nov. 1898) 328-338; Print Collectors Quarterly 7 (1917) 201-16; Apollo 2 (1925) 258f; Bryan; Bate; DNB; Gleeson

White; Fredeman (with full bibl.); T. Crombie *Some Portraits by F.S. Apollo* Nov. 65; Reynolds VP 65, 70, 71 (pl.47); Maas 144, 217 (pls. p.146, 218, 219).

SANT, George RBA fl.1856-1877

London landscape painter. Presumed to be the brother of James Sant (q.v.). Exhib. at RA 1858-77, BI, SS and elsewhere. Subjects mostly Welsh views, with the figures often painted by James S.

Probable price range £30-100

Bibl: see under James Sant

*SANT, James RA 1820-1916

Portrait painter. Pupil of John Varley and A.W. Callcott (q.v.). Exhib. at RA 1840-1904. Elected ARA 1861, RA 1869. Appointed portrait to the Queen 1872. Retired from RA in 1914. He was an immensely prolific portrait painter; he also painted allegorical female figures, and genre subjects. As a portrait painter he enjoyed the patronage on many noble and landed families. Portraits by him can still be seen in many English country houses. George S. (q.v.), was probably his brother.

'Courage, Anxiety and Despair' sold at Christie's 11.7.69 for £441.

Bibl: Studio 68 (1916) 176 f (obit.); Clement and Hutton; Who Was Who 1916-28; Cat. of engraved Brit. Portraits, BM, 6 (1925); Reynolds VP 193 (pl.134); Maas 215-16, 244-5 (pls. p.215, 247).

*SARGENT, John Singer RA 1856-1925

Painter and watercolourist. Born in Florence; son of a retired Philadelphia doctor. As a boy he travelled widely in Europe with his parents. Studied in Rome, Florence, and finally with Carolus-Duran in Paris 1874. First exhib. at Paris Salon 1878. Visited Spain, where he was much impressed by the work of Velasquez. In 1882 his picture of flamenco dancers 'El Jaleo' was picture of the year at the Salon. He followed this in 1884 with the sensational portrait of Madame Gautreau. In 1886 he settled in London at 33, Tite Street, Whistler's old house. The following year 'Carnation, Lily, Lily, Rose' was a great success at the RA. But it was as a portrait painter that he was to make his greatest contribution to English painting. By about 1890 he was beginning to establish himself as a fashionable portraitist; by the turn of the century he was acclaimed as England's greatest portrait painter since Lawrence. Between about 1890 and 1907, he produced many masterly portraits, which present a penetrating record of late Victorian and Edwardian society. About 1907 he began to refuse portrait commissions, and thereafter did only charcoal portraits. He also visited the United States regularly to fulfil commissions for portraits. He also was occupied after 1890 on a series of mural decorations for Boston Public Library and Museum. In addition to his portraits, he was also a prolific painter of landscape, figures, town scenes, and topographical sketches done on his frequent travels in Europe, North Africa and the Middle East. Later he turned increasingly to watercolour. Exhib. at RA from 1882, GG and NG. Elected ARA 1894, RA 1897. A sale of his studio was held at Christie's on July 24 and 27, 1925.

'Portrait of Mrs. Edward L. Davis and her Son' sold at Parke-Bernet 19.3.69 for £30,370. This appears to be the highest auction price in recent years. The usual range for small pictures and watercolours is £500-£1,500. More important subjects seem to sell for about £5,000-£8,000.

Bibl: Main Biographies – Mrs. Meynell *The Work of J.S.S.* 1903
W.H. Downes *J.S.S.* 1925
A. Stokes *J.S.S.* OWS III 1925
E. Charteris *J.S.S.* 1925
M. Hardie *J.S.S.* 1930
C.M. Mount *J.S.S.* 1957
Richard Ormond *Sargent* 1970 (with bibl.)
Other References – AJ 1888, 65-9; 1911, 1-10; Studio 19 (1900) 3-21, 107-19; 90 (1925) 79-87, 162; Hughes; VAM; Caw; Cundall; Reynolds VP 31, 173, 194 (pl.116); Hardie III 168-70 (pls. 198-9); Maas passim (pls. p.222-3).

SAUBER, Robert RBA b.1868 fl.1888-1904
Genre and portrait painter and illustrator. Born in London of a German father; grandson of Charles Hancock (q.v.). Studied at the Academie Julian, Paris. Exhib. at RA from 1889, SS and elsewhere. Titles at RA portraits and genre e.g. 'Unwelcome Guests' 'An Evening Stroll' 'Mammon' etc.

Probable price range £30-70

Bibl: AJ 1899 p.1-6; Who's Who;
Sketchley, *English Book Illustration of Today* 1903

SAY, Frederick Richard fl.1825-1854
Portrait painter. Son of William Say, an engraver. Exhib. at RA 1826-54, BI and SS. Among his sitters were Earl Grey, the Duke of Saxe-Coburg and Gotha, and Prince Albert.

Probable price range £30-100

Bibl: DNB; Bryan; Cat. of engraved British Portraits, BM 6 (1925); Poole, Cat. of Paintings etc. of Oxford (1925) 3; Cat. of Paintings etc. in the India Office, London 1914.

SAYERS, Reuben T.W. 1815-1888
London painter of portraits, genre and biblical subjects. Exhib. from 1841-67, at the RA (1845-63), BI and SS, titles at the RA including portraits and 'The Two Pets' 1845, 'Asleep and Awake' 1846 and 'Childhood' 1863. Bryan notes that some churches possess large paintings of religious subjects which he presented to them. Salford Art Gallery has one of his portraits.

Probable price range £30-70

Bibl: Smith *Recollections of the BI* 1860, 118, 127; Courier de l'Art 1883, 352; The Year's Art 1889, 256; Bryan; Cat. of Engraved British Portraits BM I (1908) 173-4.

SCANDRETT, Thomas 1797-1870
Architectural draughtsman. Exhib. mostly at SS, also RA 1825-60, and BI. Except for a few architectural designs, his drawings were mostly of churches, both in England and the Continent.

Probable price range £20-50

Bibl: Redgrave, Dict.

SCANLAN, Robert Richard fl.1832-1876 d.1876
Irish portrait, genre and animal painter. Exhib. at RA 1837-59, BI, SS and elsewhere. Titles at RA mostly horse and dog portraits; also some historical genre scenes.

Probable price range £20-60

Bibl: Strickland II; Cat. of Engraved Brit. Portraits, BM, 6 (1925).

SCANNELL, Miss Edith M.S. fl.1870-1903
Genre painter. Exhib. at RA 1870-1903, SS and elsewhere. Titles at RA 'In the Schoolroom' 'The Torn Frock' 'Hard Lines' etc. and a few portraits of children.

Probable price range £30-70

SCAPPA, G.A. fl.1867-1886
Painter of landscape and coastal scenes. Exhib. at RA 1869-74, SS and elsewhere. Titles at RA mostly views on the Thames at Wapping and Limehouse.

Probable price range £30-80

SCHAFER, Henry (Henri?)
Little-known painter, probably of French birth, working around the end of the nineteenth century. He painted only town scenes and buildings in the area of northern France and Belgium, in a style resembling that of Alfred Montague (q.v.).

Prices in the last two years have ranged from about £50 to £260.

SCHAFER, Henry Thomas RBA fl.1873-1915
Genre painter and sculptor. Exhib. both pictures and sculpture at RA from 1875, SS, NWS, GG and elsewhere. Titles at RA 'Sisters' 'The Bride' 'A Faithful Friend' etc. Not to be confused with the painter of town scenes, Henry Schafer (q.v.).

Probable price range £50-200

***SCHETKY, John Christian 1778-1874**
Marine painter, watercolourist and teacher. Born in Edinburgh. Studied under Alexander Nasmyth. In 1801 visited Paris and Rome. 1808 appointed teacher of drawing at the Royal Military College, Sandhurst; 1811 teacher at Royal Naval College, Portsmouth; 1836 teacher at E. India College, Addiscombe. Exhib. at RA 1805-72, BI, SS, OWS and elsewhere. Painted ships, naval incidents both old and contemporary. In 1844 he was appointed Marine Painter in Ordinary to Queen Victoria. His brother John Alexander (1785-1824), an army surgeon, was also an amateur painter of landscapes and military subjects. Graves lists a J.T. Schetky, but this is a misprint for J.C.S. His studio sale was held at Christie's Feb. 26, 1875.

'A Sloop entering Valetta Harbour, Malta' sold at Christie's 9.5.69 for £441.

Bibl: AJ 1874, p.80; 1877, 160; Redgrave, Dict.; S.F.L. Schetky *Ninety Years of Work and Play* 1877; Roget; Binyon; Caw; Cundall; Wilson, Marine Painters pl.33; Hardie III 220-1; Maas 63.

SCHMALZ, Herbert Gustave b.1856 fl.1879-1918
London painter of genre, portraits and of oriental and biblical subjects. Exhib. from 1879 at the RA, GG, NG, and elsewhere, titles at the RA including 'Light and Shade' 1879, 'Sir Galahad' 1881, 'Widowed' 1887, and 'The Daughters of Judah in Babylon' 1892. In 1890 he visited Jerusalem and the Holy Land, where he painted many landscapes and collected material for such biblical works as 'The Return from Calvary'. This journey 'A Painter's Pilgrimage' is published in the AJ, with many plates, 'Inspiration' is in Bristol Art Gallery.

Probable price range £30-100

Bibl: AJ 1893, 97-102, 337-42; T. Blakemoore *The Art of Herbert Schmalz* 1911; The Graphic 13, 1, 1912, 48 (2 pls.).

SCHOLDERER, Otto 1834-1902
German painter of genre, still-life and portraits. Born in Frankfurt where he studied at the State Institute under J.D. Passavant and Jak. Becker, 1849-52. He spent twenty-eight years in England from 1871-99, living in Putney and London, and exhibited from 1871-96, at the RA (1875-96), SS, GG and elsewhere. He also had spent some time in Paris where he was friendly with and much influenced by Fantin-Latour. Manet and Leibl. He returned to Frankfurt in 1899, where he died. Titles at the RA include 'Heron and Ducks' 1875, 'Man with Peacocks' 1888, 'At the Fishmonger's' 1892, and 'The little flower-seller' 1896. 'Man with Hares' is in Sheffield Art Gallery.

'A Girl Knitting' sold at Bonham's 7.11.68 for £260.

Bibl: Fr. Herbst *Otto Scholderer* 1934 (for full bibl.); Pavière, Sporting Painters; Also see TB for fuller bibl.

***SCOTT, David RSA 1806-1849**
Scottish historical painter. Born in Edinburgh, the son of Robert S. an engraver; brother of William Bell Scott (q.v.). Studied under his father and at Trustees' Academy. Visited Italy 1832-4. Settled in Edinburgh 1834. Like B.R. Haydon and Maclise in England, Scott tried in Scotland to revive the tradition of grand historical painting. His subjects were usually biblical or mythological e.g. 'Cain' 'Sappho' 'Philoctetes left in the Isle of Lemnos' etc. or sometimes historical e.g. 'The

Traitors' Gate'. His works are romantic and mystical, "they breathe a particular intellectual and spiritual atmosphere, and hence, whatever their defects, they possess a life and interest of their own". (Caw). He exhib. mostly at RSA, at RA only twice in 1840 and 1845. Elected ARSA 1830, RSA 1835. Unfortunately his work met with little response from the public, and he died disappointed at the age of 43. In addition to his painting, he was a powerful illustrator, best known for his work on *The Ancient Mariner* and *Pilgrim's Progress*.

His works rarely seem to appear at auction, perhaps because they are usually very large. Probable price range £100-500.

Bibl: AJ 1849 p.144; Portfolio 1887, 153 f; W.B. Scott *Memoir of D.S.* 1850; J.M. Gray *D.S. and his works* 1884; Artwork 4 (1928) 250 ff; Redgrave, Dict; DNB; Fredeman; Reynolds VP 13, 17 (pl.7); Maas 24 (pl.).

SCOTT Miss Emily fl.1826-1855
Painter of miniature portraits, living in Brighton and London, at 14 Maddox Street. Exhib. from 1826-55, at the RA (from 1836-55) and SS, all miniature portraits.

Probable price range £20-40

SCOTT, Miss Emily Anne (Mrs. Seymour) fl.1825-1855
Painter of miniature portraits, living in London at Park Village East, and from 1855 in Manchester. Exhib. from 1825-55, at the RA (from 1844-55) and SS, all miniature portraits.

Probable price range £20-40

SCOTT, J fl.1850-1873
Little-known ship painter. Painted mostly ship portraits, some of which can be seen at Greenwich Maritime Museum.

'S.S. Claude Hamilton off Dover' sold at Parke-Bernet 17.11.68 for £380.

Bibl. Wilson, Marine Painters pl.33

SCOTT, John RI RBA fl.1862-1904
London painter of genre and of historical and literary subjects. Exhib. from 1862-1904, at the RA (1872-1904), BI, SS, NWS, GG, NG and elsewhere, titles at the RA including 'Coming from Mass' 1872, 'An Incident from "The Marsh King's Daughter"' 1884, and 'Cinderella and her Fairy God-mother' 1900.

Probable price range £30-100

SCOTT, Miss Katharine fl.1872-1892
Streatham painter of flowers and game, who exhib. from 1872-92, at the RA (1879-90), SS, NWS and elsewhere. Titles at the RA include 'Scarlet Primula' 1879, and 'Dead Birds' 1887.

Probable price range £20-50

SCOTT, Laurence fl.1883-1898
Cheltenham painter of landscape, genre and flowers, who exhib. from 1883-98 at the RA, SS and elsewhere, titles at the RA including 'The Kitchen Garden' 1888, ' "De Profundis" ' 1893, and 'Hydrangeas' 1898.

Probable price range £20-60

SCOTT, Walter fl.1831-1853
London painter of portraits and genre, living in Park Village East and therefore possibly the brother of Miss Emily Anne Scott (q.v.). Exhib. from 1831-53, at the RA (1841-53) and SS, titles at the RA including portraits and ' "In Maiden Meditation Fancy Free" ' 1848, 'The Scrap-book' 1851, and 'Isabel' 1853.

Probable price range £30-70

SCOTT, William fl.1810-1855
Brighton landscape painter, mainly in watercolour, who exhib. from 1810-55, at the RA (1810-33), BI, SS, and prolifically at the OWS (229 works). He was first elected A of the OWS in 1810, and then re-elected in 1820. His home was Brighton, "whence", says Redgrave, "he seldom strayed abroad". His subjects were the scenery and cottages of Sussex and Surrey, views in the N. of France, on the rivers Meuse and Moselle, and in the Pyrenees, and several views in Edinburgh.

Probable price range £20-60

Bibl: Redgrave, Dict; Roget.

*SCOTT, William Bell 1811-1890
Pre-Raphaelite painter, watercolourist, illustrator and poet. Son of Robert Scott, an Edinburgh engraver; brother of David Scott (q.v.). Studied under his father, and at Trustees' Academy. 1837 came to London. Entered for Westminster Hall Competition. This led in 1843 to his appointment as master of the Government School of Design in Newcastle. In 1847 the young Rossetti wrote to Scott, praising one of his poems. They became friends, and Scott contributed poems to *The Germ*. While in Newcastle, he executed his best-known pictures. These are the series depicting the History of Northumbria painted for the Inner Hall of Wallington Hall, the Northumberland seat of the Trevelyan family. He painted another series called The King's Quhair for Miss Alice Boyd of Penkill Castle, Ayr. The Pre-Raphaelite style did not come easily to Scott, and his oil paintings are often laboured in detail, and harsh in colour. His subjects, although well chosen and historically accurate, are often sentimentally superficial. In the medium of watercolour he was usually more effective. While in Newcastle he helped James Leathart of Low Fell to form his remarkable Pre-Raphaelite collection. He returned to London in 1858. Exhib. at RA 1842-69, BI, SS and elsewhere.
'The Gloaming — The Manse Garden in Berwickshire' sold at Anderson and Garland (Newcastle) for £1,000.
Bibl: W.B. Scott *Autobiographical Notes etc.* 1892; Blackwoods Mag. CLIII (Feb. 1893) 229-235; DNB; Bryan; Bate; Caw 171-2; Windsor Mag XL (Sep. 1914), 413-28; R. Ironside in Architectural Review XCII (Dec. 1942) 147-9; Ironside and Gere; Maas; Fredeman Section 56 et passim (with full bibl.).

SCOTT, William Wallace 1819-1905
Painter of miniature portraits, who lived for a time at the same address in London, Park Village East, as the painters Miss Emily Anne Scott (q.v.), and Walter Scott (q.v.). He exhib. in London from 1841-59 at the RA, BI and SS — all portraits including one of Thomas Webster RA (RA 1853). After 1859 he is said to have moved to New York, where he worked for many years and where he died.

Probable price range £20-40

Bibl: *American Art Annual* 6 1907-8 115 (obit); Mantle Fielding *Dictionary of American Painters, Sculptors and Engravers*, 1965.

SEAFORTH, Charles Henry b.1801 d-.after 1853.
Marine painter. Recorded as being admitted to the RA Schools in 1823 at the age of 22. He was a prolific marine artist painting every kind of craft, and also executed many coastal scenes. Lived from 1852 in Naples. Exhib. from 1825-53, at the RA (1827-53), BI and SS, titles at the RA including 'Shipping Vessels of different rates performing various evolutions' 1829, 'H.M's ships Vanguard and Royal Frederick off Cobreta Point, working into Gibraltar Bay — Sunshine' 1837, and 'The Great Western' 1838.

'George IV Inspecting Ships' sold at Sotheby's 3.5.61 for £100.

Bibl: Wilson Marine Painters 71.

SEALY, Allen Culpeper fl.1873-1886
London painter of landscape and genre, who exhib. from 1873-86, at the RA (1875-86), SS, and elsewhere, titles at the RA including 'Rushy Point, Tresca, Sicily' 1875, 'Tramps, Hazley Heath, Hants'.

1879, and 'Life on the Ocean Wave' 1886.

Probable price range £30-70

***SEDDON, Thomas B. 1821-1856**
Pre-Raphaelite painter. Son of a cabinet maker; brother of architect John Pollard Seddon. 1841 visited Paris; 1850 Barbizon; 1852/3 Dinan. In 1853-4 he accompanied Holman Hunt on his first trip to the Holy Land. In 1856 he returned to Cairo, where he died. His works are remarkable for their minute fidelity to the external facts of landscape, but owing to his early death, his output was small. He exhib. only 6 works at the RA, between 1852 and 1856. After his death an exhibition of his work was held at the Society of Arts, (1857), at which Ruskin delivered a speech (see bibl.).

Because of the rarity of his work, a good landscape would probably make £1,000 or more.

Bibl: AJ 1857 p.62 (obit.); L'Art I (1875) 256-62, 272-6; J. Ruskin, *Speech on T.S. Journal of the Society of Arts V;* (May 1857) 360-62; *Memoirs and Letters of T.S. Artist,* by his brother J.P.S. 1858; DNB; Poynter, Nat. Gall. 3 (1900); Reynolds VP 12 (pl.108); Fredeman Section 57 et passim (with full bibl); Maas 90, 133 (pl. p.91).

SEDGWICK, Mrs. John See under OLIVER, Mrs. William

SELLS, V.P. fl.1851-1865
London painter of landscape and architectural subjects (mainly church interiors), who exhib. from 1852-65 at the RA and SS. Titles at the RA include 'S.Transept, Rouen Cathedral' 1851, 'Druidical Remains at Goray, Jersey' 1855, and 'Evening on the Coast' 1859.

Probable price range £20-80

SELOUS, Henry Courtney (formerly SLOUS) 1811-1890
London painter of genre, portraits, landscape, and historical and literary subjects — especially scenes from Shakespeare; lithographer, illustrator and author. Son of George Slous, fl.1791-1839, painter of genre, portraits, landscape and miniatures. Pupil of John Martin. Entered RA Schools c.1818. Exhib. under the name 'Slous' from 1818-31, at the RA (1818-28), BI and SS, titles at the RA including 'Portrait of a Favourite Cat' 1818, and 'A Boar Hunt' 1820. In 1837 he altered the spelling of his name to 'Selous'. Exhib. as 'Selous' from 1838-85, at the RA and BI, titles at the RA including 'Sea Coast and Figures – View near Holland' 1839, 'A Scene at Holyrood, 1566' 1854, and 'Katharine and Petruchio's Wedding Supper' 1870. 1843, won a £200 premium in the Westminster Hall Cartoon Competition. He produced illustrations for the Art Union of London, and illustrated many books, including *Outlines to Shakespeare's Tempest* 1836 (12 pls.); J. Bunyan *The Pilgrim's Progress* 1844; C. Kingsley *Hereward the Wake* 1869; and Cassell's *Illustrated Shakespeare* 1864. He wrote and illustrated several children's books, e.g. *Granny's Story-Box* 1858 and *Eleanor's Governess* 1867, and also produced children's books under the pseudonyms 'Aunt Cae' and 'Kay Spen'. His painting 'The Great Exhibition in Hyde Park, London; the Opening by H.M. Queen Victoria on 1st May, 1851' 1851-2, is in the VAM.

'Swiss Lake Scenes' – a pair – sold at Bonham's 20.2.69 for £160.

Bibl: Bryan; VAM Cat. of Oil Paintings 1907; Cat. of Engr. Brit. Portr., BM 6 1925; BM General Catalogue of Printed Books 1964; Reynolds VP 36; Maas 28.

SENTIES, T. fl.1852-1858
Portrait painter living in London, who exhib. from 1852-58 at the RA and SS. TB mentions a Pierre Asthasie Théodore Senties, a Dieppe painter of portraits and religious subjects, born in 1801; this may be the above, although no mention is made of his having been in England.

Probable price range £20-50

SETCHEL, Miss Sarah RI 1813/4-1894
Painter of portraits, genre and landscape. Awarded a premium by the Society of Arts in 1829; exhib. from 1831-67, at the RA (1831-40), SS and NWS; became a member of the RI in 1841, but resigned in 1886. 'The Momentous Question' exhibited at the NWS in 1842, (now in VAM), established her reputation and became very popular. The question asked by the girl in the 'M.Q' is "Will you remain faithful to me and die, or shall I marry your brother and thus preserve your life?" (Crabbe's *Tales of the Hall* Book XXI). Titles at the RA are mainly portraits, and also 'Fanny' 1831, 'Sketch of a Cottager' 1832, and 'Study of a Gentleman Reading' 1840.

Probable price range £20-60

Bibl: VAM; Roget

SETON, Charles C. fl.1881-1894
London painter of landscape, genre and historical and literary subjects. Exhib. from 1881-94 at the RA, SS, GG and elsewhere, titles at the RA including 'The Third Age, "And then the lover etc" ' 1883, 'The Unconverted Cavalier' 1884, and 'A Mill on the Teme' 1894.

Probable price range £30-100

SEVERN, Arthur RI 1842-1931
Landscape and marine painter, mainly in watercolour. Son of Joseph S. (q.v.). In 1871 he married Ruskin's niece, Joan Ruskin Agnew. He was influenced by Ruskin's ideas, and in 1872 visited Italy with him, and Albert Goodwin (q.v.). Exhib. at RA 1863-96, NWS, GG, but mostly at Dudley Gallery, of which his brother Walter (q.v.) was President and founder. A work by him is in the Walker AG Liverpool Exhibitions of his work were held at the FAS in 1892, 1899 and 1901, and at the Leicester Gallery in 1906 and 1911.

Probable price range £30-100

Bibl: Connoisseur 87 (1931) 261; Lady Birkenhead *Illustrious Friends* etc. 1965: Maas 23, 230-1.

SEVERN, Joseph 1793-1879

Historical and portrait painter. Studied at RA schools 1813-19. Won Gold Medal for historical painting in 1819. Accompanied John Keats to Rome in 1820; and was present when Keats died in 1821. In Rome Severn's popularity as a personality and as an artist earned him a very successful practice as a portrait painter. He stayed there until 1841, when he returned to London. In 1860 he was appointed British Consul in Rome, and he lived there till his death in 1879. Exhib. at RA 1819-57, BI, OWS and elsewhere. Works by him are in the NPG and the VAM. Three of his children were also painters, Walter (q.v.), Arthur (q.v.) and Mary Newton (q.v.).

'Portrait of Anne Matthew' sold at Christie's 6.3.70 for £787.

Bibl: W. Sharp *The Life and Letters of J.S.* 1892; DNB; Bryan; Cundall; Roget; VAM; Connoisseur 87 (1931) 261; Lady Birkenhead *Against Oblivion, the Life of J.S.* 1943; H.E. Rollins *The Keats Circle* 1948; Lady Birkenhead, *Illustrious Friends, the Story of J.S.' and his son Arthur,* 1965; Maas 23, 28.

SEVERN, Miss Mary See NEWTON, Ann Mary (Mrs. Charles J.)

SEVERN, Walter RCA 1830-1904
Landscape painter, mainly in watercolour. Eldest son of Joseph S. (q.v.). Exhib. at RA only twice in 1853 and 1855, both times with pictures of deer; also at SS and GG. In 1865 he was one of the founders of the Dudley Gallery, and from then on exhib. most of his work there. Later he became its President.

'Horace Visiting the Isle of Area' sold at Sotheby's 22.10.69 for £160.

Bibl: DNB 2nd. Supp. III 293 Who Was Who 1897-1915 Lady Birkenhead *Illustrious Friends* etc. 1965.

SEYFFARTH, Louisa See SHARPE, Family

SEYMOUR, Mrs. See SCOTT, Miss Emily Anne

SHACKLETON, William 1872-1933

Painter, watercolourist and designer. Studied in London, Paris and Italy. His paintings show a very personal style; a blend of art nouveau design and surrealist fantasy, but they are little seen or appreciated today. A work by him is in the Tate Gall.

Probable price range £50-150

Bibl: Studio 63 (1915) 215 (1915) 186; 67 (1916) 58; 70 (1917) 43; 83 (1922) 17-22; Art News 31 (1932-3) No.20 p.8; H.W. Fincham *Art and Engr. of Book Plates* 1897; Who's Who.

SHALDERS, George RI 1826-1873

Landscape painter and watercolourist. Lived in Portsmouth and London. Exhib. at RA 1848-62, BI, SS and NWS. Subjects mostly summery views in Wales, Ireland and Surrey, and occasionally the Continent. His work is conventional but attractive, and shows affinities with two other artists from the South-West, William Shayer (q.v.) and F.R. Lee (q.v.). Works by him are in the Walker AG and the VAM. A benefit sale for his children was held at Christie's on March 9, 1874; this was a mixed sale and contained only four works by Shalders.

'River Landscape with Hay Cart' sold at Bonham's 2.10.69 for £220. Another landscape sold at Bonham's 6.11.69 for £460.

Bibl: AJ 1873 p.80; Redgrave, Dict.; DNB; Cundall 255

SHANNON, Charles Haslewood RA ARPE 1863-1937

Painter of figure subjects and portraits; illustrator and lithographer; connoisseur. Born at Quarrington, Lincolnshire. Studied wood engraving at the Lambeth School of Art, 1882, where he met Charles Ricketts. Ricketts and Shannon, nicknamed 'Orchid' and 'Marigold' by Oscar Wilde, became life-long companions and collaborators and lived together until Ricketts's death in 1931. First they worked at illustration: Shannon drew for Quilter's *Universal Review* and for Oscar Wilde's *A House of Pomegranates* 1891 (4 pls; mainly illustrated by Ricketts). They wanted to control all the circumstances of book production, and their joint enterprise produced *Daphnis and Chloe* 1893, *Hero and Leander* 1894, and five numbers of *The Dial* 1889-97 (with the help of the poets John Gray and Thomas Sturge Moore), to which Shannon contributed a number of lithographs. He then turned to painting — producing large canvases in oils, (many worked out from his lithograph designs), portraits and self-portraits. Such works include 'A Wounded Amazon' 1896, the self-portrait 'The Man in the Black Shirt' 1897, 'Tibullus in the House of Delia' 1898 (containing portraits of himself, Ricketts, Lucien Pissaro and Sturge Moore), 'Mrs. Dowdall' 1899 ('The Lady with the Cyclamen'), 'The Bath of Venus' 1898-1904, and 'The Romantic Landscape' 1904. From 1904-1919 he returned to lithography, producing forty-six catalogued prints. Exhib. at the GG (1885-99), the International Society (of which he later became V. President) — 1898-1919, NEAC 1897-1900, SS, NG and the RA (from 1885); ARA 1911; RA 1920; member of the National Society of Portrait Painters, and A of the Société Nationale des Beaux Arts, Paris. First one-man exhibition at the Leicester Galleries, 1907. Incapacitated after a fall from a ladder in 1929 and remained alive until 1937, not really recognizing his friends. The greater part of the art collection he and Ricketts had formed was left to the Fitzwilliam Museum, Cambridge.

His work seems to appear rarely at auction. 'Studies of a Female Figure' a Drawing, sold at Sotheby's 29.10.64 for £50.

Bibl: AJ 1902 43-6; C. Ricketts *A Catalogue of Mr. Shannon's Lithographs* 1902; Campbell Dodgson, 'C.S's Art' *Die Graph Künste* 26 (1903) 73-85; T.M. Wood 'The Lithographs of C.H.S.' Studio 33 (1905) 26-34; C. Ricketts *L'Art et Les Artistes* 10 (1909-10) 206-19; George Derry *The Lithographs of C.S. with a Catalogue of Lithographs issued between 1904 and 1918* 1920; "Tis" C.S. ARA (Masters of Modern Art, list of works up to 1919) 1920; *The Print Collector's*

Quarterly 8 (1921) 275-6; 11 (1924) 217-8; 12 (1925) 60; 14 (1927) 203 ff; E.B. George *C.S.* (Contemporary British Artists) 294; DNB 1931-40; Tate Cat; Hardie III 147, 170-1.

SHANNON, Sir James Jebusa RA RBA 1862-1923

Painter of figure subjects and society portraits, considered by some to rival Sargent. Born at Auburn, New York, USA, of Irish parents. Came to London, aged sixteen, in 1878 and studied at the RCA under Poynter, 1878-91, receiving the Gold Medal for figure painting. Exhib. at the RA 1881-1922, and also at GG, SS, NG and elsewhere; foundation member of NEAC 1886; first one-man exhibition at the FAS 1896; ARA 1897; RA 1909; President of the RP 1910-23; knighted 1922; memorial exhibition at the Leicester Galleries 1923, and included in the RA Late Members' exhibition 1928. Several of his portraits won him awards, and his subject picture 'The Flower Girl', RA 1901, was bought by the Chantrey Bequest for the Tate Gallery.

'Sir John Martin Harvey as Sydney Carton in "The Only Way"' sold at Sotheby's 15.2.67 for £160.

Bibl: AJ 1901 41-5; S. Isham *The History of American Painting* 1905; *The Art News*, N.Y., 21 (1922-3) No.22 8; *American Art Annual* 20 (1923) 265; Connoisseur 65 (1923) 243 f; Studio 85 (1923) 220; Who Was Who 1916-28; Apollo 17 (1933) 96 f (pls.); Tate Cat.; Maas 223.

SHARPE, Family (Charlotte, Eliza, Louisa, Mary Anne)

The four daughters of William Sharpe, a Birmingham engraver, were all painters of miniature portraits and "subjects", and all prominent members of the OWS. The eldest, Charlotte, married a Captain Morris in 1821 and died in 1849. The second Eliza, (1795/6-1874) was unmarried and exhib. from 1817-69 at the RA and OWS (87 works). The third, Louisa, (1798-1843), was the most prolific and gifted of the sisters. She exhib. miniature portraits at the RA from 1817-1829, when she was elected a member of the OWS. After 1829 she exhib. at the OWS until 1842 where her exquisitely finished "costume pieces" were a great attraction. Popular works were 'Brunetta, from Addison' 1832; 'The Good Offer' 1835, 'Constancy and Inconstancy' 1840, 'Alarm in the Night' 1841 and 'The Fortune Teller' 1842, and many of her domestic and sentimental scenes were engraved in *The Keepsake* and other Annuals. On her marriage in 1834 to Dr. Woldemar Seyffarth, she went to live in Dresden, where her husband was settled as a professor. The youngest, Mary Anne, was unmarried and died in 1867. She exhib. at the RA and BI from 1819.

Probable price range £30-100

Bibl: Clayton I 379-382
Roget I 547-8; II 206-7.

***SHAW, Byam** 1872-1919

Pre-Raphaelite painter, decorator and illustrator. Studied at the RA schools, where he won several awards. Began to exhib. at RA in 1893. His works are mostly large and elaborate compositions, painted in the late Pre-Raphaelite style of J.W. Waterhouse, Cadogan Cowper etc, although Shaw's work also shows a lyrical art-nouveau influence. His subjects were sometimes taken from Rossetti poems e.g. 'Rose Marie' 'The Blessed Damozel' 'Circle-Wise Sit They' 'Love's Baubles' etc. He painted in pure pigments, which even now gives his pictures a startlingly bright appearance. Faithful to his academic training, he made careful studies for all the figures in his pictures; his drawings are similar in style to those of Leighton and Poynter. In 1910 he painted 'The Entry of Queen Mary with Princess Elizabeth into London' in the House of Lords. He also illustrated Browning, Boccaccio, *Old King Cole's Book of Nursery Rhymes, The Cloister and the Hearth*, and many other books.

Probable price range £100-500

Bibl: Studio 2 (1894) 136 f, 10 (1897) 109-21; 16 (1902) 136; The Artist, March 1907 p.159 f; Mag. of Art 1903 p.1-4; Connoisseur 41 (1915) 42; 47 (1917) 56; 53 (1919) 110; 68 (1924) 236, 91 (1933) 189 f, Burlington Mag. 30

(1917) 84; Apollo 5 (1927) 105; 16 (1932) 196; R.E.D. Sketchley *English Book Illustration of Today* 1903; DNB; Who Was Who 1916-28; Bate; R.V. Cole *The Art and Life of B.S.* 1932.

SHAW, Hugh George fl.1873-1889
Genre painter, living in Stratford-on-Avon, who exhib. from 1873-89, at the RA (1874 and 1875), BI and elsewhere; titles at the RA including 'The Poacher' 1874 and 'Possession Nine-Tenths of the Law' 1875.

Probable price range £30-60

SHAW, Walter J. b.1851 fl.1878-1904
Painter of coastal scenes and landscape, living in Salcombe, Devon, who exhib. from 1878-1904 at the RA and elsewhere, titles at the RA including 'The Storm', 'The Ebb-tide on the Bar' 1880 and 'Salcombe Bar' 1904. Bristol Art Gallery has 'Bantham Sands' and 'Salcombe Bar in Bad Weather'.

Probable price range £20-60

SHAYER, Charles fl.1870-80
Very little-known Southampton painter. Exhib. only once in London, at SS in 1879. Painted landscapes and sporting scenes. Presumably related to William Shayer (q.v.).

'A Gipsy Encampment' sold at Christie's 1.4.69 for £147

*SHAYER, William RBA 1788-1879
Landscape and animal painter. A self-taught artist, he lived in Southampton, and painted mostly in Hampshire and the New Forest. His work falls into two distinct categories; firstly, woodland scenes with gipsies, rustic figures and animals, and secondly, beach or coastal scenes with boats and fisherfolk. He was a prolific artist, and tended to repeat his formulas endlessly. Exhib. mostly at SS (338 works), also at RA 1820-43 and BI. His work is in many English provincial museums. He sometimes collaborated with Edward Charles Williams (q.v.). His son William J. Shayer (q.v.) was also a painter.

'Village Festival' sold at Sotheby's 20.11.68 for £7500. This is still the auction record. Other prices have ranged from £1000 to about £3000. Smaller and less good examples can sell for under £1000.

Bibl: AJ 1880 p.84 (obit.); Mag. of Art 1901, 330; Connoisseur 67, (1923) 126, 176, 74 (1926) 130, 184; Apollo 8 (1920) 316, 266, 9 (1929) 211, 215; 15 (1932) 139 f; 18 (1933) 19, 44; Pavière, Landscape pl.66; Ottley; Maas 53 (pl.52).

SHAYER, William J. b.1811 fl.1829-1885
Animal and landscape painter; son and imitator of William Shayer (q.v.). Exhib. at RA in 1858 and 1885, BI and SS. His pictures are often confused with his father's, as they undoubtedly worked together, and both signed 'W. Shayer'. A work by Shayer (Junior) is in Glasgow AG.

'Pointers in a Field' sold at Christie's 25.4.69 for £273

SHELLY, Arthur 1841-1902
Landscape painter, living in London, Plymouth and Torquay, who exhib. from 1875-88, at the RA (1881-88), SS, NWS and elsewhere, titles at the RA including 'Study at Trachsellauinen, Lauterbrunnen' 1881 and 'Winter Sunset on the Thames' 1888. Born in Yarmouth; died in Torquay. One of his paintings is in the Norwich Castle Museum.

Probable price range £30-100

SHEPHARD, Henry Dunkin fl.1885-1891
London painter of genre and architectural subjects, who exhib. from 1885-91 at the RA, SS, NWS and GG, titles at the RA including 'In a German Church' 1885, 'The Last of his Race' 1886, and 'A Chorister' 1891.

Probable price range £30-70

SHEPHEARD, George 1770?-1842
Watercolour painter of landscape and rustic genre, engraver. Studied at the RA Schools, exhib. from 1800-42, at the RA (1811-41), BI, SS, OWS and elsewhere, titles at the RA including 'Fishermen in Folkestone Harbour dividing the fish by auction, which is decided by dropping a pebble; sketched from nature' 1837, 'Hop-picking, sketched at Hawkhurst, Kent, in the autumn of 1839' 1840, and 'Dad's a-Coming' 1842. He chiefly painted rural scenery, views in Surrey and Sussex, in which he introduced pleasing groups of rustic figures. He also engraved prints after other artists' works, and in 1814-15 published a set of *Vignette Designs,* drawn by himself and etched by G.M. Brighty.

Probable price range £30-100

Bibl. Redgrave Dict. Binyon; Cundall; DNB
Cat. of Engr. British Portraits, BM 2 (1910) 186

SHEPHEARD, George Walwyn 1804-1852
Watercolour landscape painter. Eldest son of George Shepheard (q.v.). Travelled much on the Continent, and in 1838 married an Italian lady at Florence. Exhib. from 1836-51 at the RA, sending in chiefly views in France and Italy and studies of trees, titles including 'The Cedar Pine: view near Spoletto; a drawing in pencil' 1839, 'Ash-trees in the forest of Fontainebleau' 1834 and 'On the Lake of Geneva, near Vaud' 1846.

Probable price range £30-70

Bibl: see under SHEPHEARD, George

SHEPHERD, George Sidney RI fl. from 1830 d.1858
Son of George Shepherd (fl. 1800-30), water-colour topographical artist. Practised water-colour painting in the style of his father, chiefly topographical subjects, but occasionally rustic scenes and still life, but his works were more artistic in treatment. Exhib. at the RA, 1830-37, SS, and at the NWS (RI in 1831) — 223 works from 1833-58. He exhib. many views of metropolitan buildings, and drew for C. Clark's *Architectura Ecclesiastica Londini,* and W.H. Ireland's *England's Topographer.* Died in 1858, or according to some accounts, in 1860 or 1861.

'Trout Fishing in a Mountain Stream' – a watercolour – sold at Sotheby's 19.8.69 for £105

Bibl: Redgrave Dict; Binyon; Cundall; DNB; VAM; Hardie III 15 (pl.14).

SHEPHERD, Thomas Hosmer fl.1825-1840
Water-colour painter of topographical views of streets and old buildings in London. Apparently the son of George Shepherd and brother of George Sidney Shepherd (q.v.). Exhibited four landscapes at SS, 1831-2. He made many drawings of London and in 1827-31 collaborated in the production of several topographical works. Frederick Crace, 1779-1859, employed him to make water-colours of old buildings in London before they were demolished; many of these are in the BM.

'A View of the Old Bank of England' sold at Christie's 14.6.68 for £840.

Bibl: Redgrave Dict; Cundall; DNB; Hardie III 15 (pls. 15-16)

SHERRIN, Daniel
Little-known landscape painter working around the turn of the century, Although he does not seem to have exhibited in London at all, his pictures are frequently seen on the market. They are usually imitations of the late style of B.W. Leader (q.v.). He also painted pictures of sailing ships, very similar to those of T. Somerscales (q.v.) and early Montague Dawson.

Usual price range £50-200

SHERRIN, John RI 1819-1896
Still-life and animal painter, mainly in watercolour. Pupil of W.H. Hunt (q.v.). Exhib. at RA 1859-94, SS, NWS and elsewhere. Works by him are in the VAM.

Probable price range £20-80

Bibl: Roget; Cundall

SHIELDS, Frederick James ARWS 1833-1911
Manchester Pre-Raphaelite painter, watercolourist and decorator. First impressed by the works of the PRB, which he saw at the Manchester Art Treasures Exhibition in 1857. Later became a close friend of Rossetti and Ford Madox Brown. Painted mostly in watercolour, which he exhib. at the OWS. Elected ARWS 1865. His work is realistic and mostly religious, more akin to Holman Hunt than any of the other Pre-Raphaelites. He was also a fine illustrator, and mural decorator. His two major commissions were the Chapel of Eaton Hall, home of the Grosvenor family and the Chapel of the Ascension in the Bayswater Road, London, now destroyed. An exhibition of his work was held at Manchester City AG. 1907.

His work has rarely appeared at auction. Probable range for oils £200-500, watercolours £50-250

Bibl: Portfolio 1883, 184; 1884, 134-7; 1887, 116; AJ 1902, 337-43; Building News 1911, 312 (obit); Gleeson White; H.E. Scudder *An English Interpreter* Atlantic Monthly 50 (Oct. 1882), 464-75; H.C. Ewart *F.S. An Autobiography* (Toilers in Art) 1891; C. Rowley *F.S.* 1911; E. Mills *Life and Letters of F.J.S.* 1912; Bate; DNB; Fredeman Section 58 et passim (with full bibl.); Hardie III 128-9.

SHIELS, William RSA 1785-1857
Scottish painter of animals and domestic genre of the Wilkie type, and also of mythological subjects. Born in Berwickshire, little is known of his life; he became a member of the Scottish Academy at its formation in 1826, and exhib. in London from 1808-52 at the RA, BI and SS. Titles at the RA include 'Ulysses and Laertes' 1808, 'Interior of a Scottish Fisherman's cottage' 1851, and 'Preparing for a Visitor' 1852.

Probable price range £50-150

Bibl: Redgrave, Dict; Caw 198
Cat. of Engr. Brit. Portr. BM 3 (1912) 105.

***SHIPHAM, Benjamin 1806-1872**
Landscape painter, born in Nottingham, who exhib. from 1852-72 at the RA, BI, SS and elsewhere, titles at the RA including 'Midland Scenery near Nottingham' 1852. Pavière reproduces 'Harvesting, Nottingham Castle'. His paintings are in Glasgow and Nottingham Art Galleries.

'A View of Bulwell, Nottingham' sold at Christie's 4.6.70 for £179.

Bibl: Paviere, Landscape (pl.67)

SHIRLEY, Henry fl.1843-1870
London painter of genre and landscape, who exhib. from 1843-70, at the RA (1844-59), BI and SS, titles at the RA including 'The Babes in the Wood' 1844, 'Sunset – Gipsies Preparing for a Revel' 1847, and 'Sunshine on the Lake' 1855. One of his paintings is in Glasgow Art Gallery.

'View of Llanberis Lake, Wales' sold at Christie's 22.11.68 for £787.

SHORT, Frederick Golden fl.1885-1892
Landscape painter, living in Lyndhurst, Hampshire, who exhib. from 1885-92, at the RA (1887-92), SS, NWS and elsewhere; titles at the RA including 'By the Thames, Limehouse' 1887 and 'Shadows of Departing Day' 1892.

Probable price range £20-80

SHORT, Richard RCA 1841-1916
Cardiff painter of coastal scenes and landscape, working in S. Wales. Exhib. from 1882 at the RA, SS, GG and elsewhere, titles at the RA including 'Penarth Head' 1882 and 'East Wind, Cardiff' 1900. His work is represented at the National Museum of Wales, Cardiff.

Probable price range £30-100

Bibl: Wilson, Marine Painters.

SHUBROOK, Miss Minnie J. fl.1885-1899
London painter of portraits, genre and flowers, who exhib. from 1885-99, at the RA, SS, NWS and elsewhere, titles at the RA including 'Grace' 1885, 'Christmas Roses' 1889 and 'A City Luncheon' 1892. Her sister Miss Laura A. Shubrook was also a painter.

Probable price range £30-70

***SHUCKARD, Frederick P. fl.1868-1901**
Genre and flower painter. Exhib. at RA 1870-1901, SS and elsewhere. Titles at RA 'Returning with the Spoils' 'A Little Friend' etc. and some flower pictures.

Probable price range £100-300

SIBLEY, Charles fl.1826-1847
London painter of genre, still-life, and portraits, who exhib. from 1826-47 at the RA, BI and SS, titles at the RA including 'Dead Game' 1826, 'Female Reading' 1835 and 'The Suppliant' 1839.

Probable price range £30-100

Bibl: Cat. Engr. Brit. Portr. BM II 461
Pavière Sporting Painters.

***SICKERT, Walter Richard RA 1860-1942**
Impressionist painter. Born in Munich, the son of Oswald Adalbert S. a Danish painter and illustrator. Came to England with his parents 1868. Studied to be an actor, then switched to Slade School 1881. Became a pupil of Whistler, and helped to print his etchings. 1883 took Whistler's picture 'Portrait of my Mother' to Paris, where he met Degas, who was to have an important influence on his work. From 1887 to about 1899 he painted a series of theatre and music-hall interiors, especially of the Old Bedford. At first exhib. at SS 1884-8; then NEAC 1888-1912. Lived in Dieppe 1899-1905. His later work falls outside the Victorian period. After his return to England in 1905, he was leader of the Camden Town Group 1907-14. He painted street scenes, interiors, genre and portraits, and also did illustrations, but recognition of his work did not come until fairly late. Elected ARA 1924, RA 1934.

During the past few years, his oils have been selling for about £500-2,500, watercolours and drawings £50-200.

Bibl: Main Biographies – Virginia Woolf *W.S. A Conversation* 1934
 W.H. Stephenson *S. Random Reminiscences* 1940.
 R. Emmons *The Life and Opinions of W.R.S.* 1941
 O. Sitwell *A Character Sketch of W.R.S. Orion II* 1945.
 A Bertram *S.* 1955
 Lilian Browse *S.* 1960 (with bibl.)
Other References – AJ 1909, 297- 301;
Studio 97 (1929) 336-40; 100 (1930) 292, 319-24; 103 (1932) 266-72;
Burlington Mag. 33 (1918) 203, 206f; 34 (1919) 80f; 37 (1920) 52f
Connoisseur 65 (1923) 235f; 84 (1929) 125f
Apollo II (1930) 227; 295-300; 13 (1931) 344-7
Artwork 4 (1928); 6 (1936); Reynolds VP; Maas.

SIDDAL, Elizabeth Eleanor (Mrs. D.G. Rossetti) 1834-1862
Discovered by W.H. Deverell (q.v.) working in a milliner's shop. Quickly established herself as Rossetti's favourite model and mistress, although they did not marry until 1860. She was the inspiration for

many of Rossetti's works of the 1850's, and featured in several other Pre-Raphaelite paintings, notably Millais's 'Ophelia' and Hunt's 'Two Gentlemen of Verona'. While living with Rossetti, she produced a small number of drawings and poems of her own, interesting but mostly very derivative echoes of Rossetti. Ruskin was an admirer of her work, and agreed to buy her complete output. Works by her can be seen in the Fitzwilliam Museum, Cambridge, the Tate and the Ashmolean. On February 10, 1862 she was found dead from an over-dose of laudanum. A verdict of accidental death was returned, but the possibility of suicide has never been completely disproved. In her coffin Rossetti laid the manuscripts of all his poems, but he was per-suaded a few years later to have them exhumed.

'Illustration to the Ballad of Clerk Saunders 1854' a drawing, sold at Christie's 12.5.70 for £336.

Bibl: for full bibliography etc. see Fredeman Section 59 et passim.

SIDLEY, Samuel RBA ARCA 1829-1896

Painter of portraits, and occasionally of genre and literary subjects. Born in York, and first studied painting at the Manchester School of Art; subsequently entered the RA Schools. Exhib. from 1855-95, at the RA, BI, SS, GG and elsewhere, titles at the RA including 'The Ancient Mariner' 1855, 'Companions in Mischief' 1864, and 'Civil War' 1865. He became chiefly known as a successful portrait painter, and gained frequent commissions for official and presentation portraits. Among these were portraits of Professor Fawcett, Bishop Colenso (NPG), Lady Brassey and the Duke and Duchess of Buckingham. He also painted some subject pictures, e.g. 'Alice in Wonderland' and 'The Challenge', which were engraved and became popular.

'The Naughty Dog' sold at Sotheby's 22.1.69 for £260.

Bibl: *Chronicle des Arts* 1896 251f; L. Cust. NPG Cat. 2 1902 (pls.); DNB; Cat. of Engr. British Portraits BM 6 (1925) 99.

SIGMUND, Benjamin D. fl.1880-1903

Maidenhead painter of genre and landscape, who exhib. from 1880-1903, at the RA (1881-1903), SS, NWS and elsewhere, titles at the RA including 'Tranquillity' 1881, 'On Exmoor, near Lynton' 1886, 'By Willowy Streams' 1888, and 'The Orchard Gate' 1897.

Probable price range £30-70

SIM, James fl.1870-1893

London painter of landscape and genre, who exhib. from 1870-93 at the RA, SS and NWS, titles at the RA including 'The Suspicious Letter' 1870, 'The Return from the Baptism, Mentone' 1873 and 'The Nightingale's Grove, Lake Lecco' 1886.

Probable price range £30-100

SIMMONS, J. Deane fl.1882-1889

Painter of landscape and rustic genre, living in Holmbury St. Mary, Dorking, Henley-on-Thames and London. Exhib. from 1882-89, at the RA (1883-89), SS, NWS and elsewhere, titles at the RA including 'Before the Leaf' 1883, 'The Merry May-time' 1886, and 'A Rustic Flirtation' 1889.

Probable price range £30-100

SIMMONS, W. St. Clair fl.1878-1899

London painter of portraits, landscape and genre, who exhib. from 1878-99, at the RA (1880-99), SS, NWS, NG and elsewhere, titles at the RA including 'Backwater, Ostend' 1880, 'The Time of Primroses' 1882, 'Iris; Portrait of a Lady' 1896, and 'Blackberry Gatherers' 1896.

Probable price range £30-80

SIMMS, A.G. fl.1859-1873

London painter of genre and sporting subjects, who exhib. from 1859-73, at the RA (1859-65), BI, SS and elsewhere, titles at the RA including 'Repose' 1859, 'The Culprit' 1860 and 'Rather More Free than Welcome' 1865.

Probable price range £30-100

SIMPSON, Miss Agnes fl.1827-1848

London painter of miniature portraits, who exhib. from 1827-48 at the RA and SS.

Probable price range £10-30

SIMPSON, Charles fl.1833-1847

London painter of landscape, genre and coastal scenes, who exhib. from 1833-47, at the RA (1835-45), BI, SS, and NWS. Titles at the RA include 'A Sea-piece' 1835, 'Portuguese Boys' 1838, and 'The Break-up of a Fishing Boat off Margate' 1845. Not to be confused with Charles Walter Simpson (b.1885), the prolific painter of marines, animals and wild birds, sporting scenes and portraits, who first exhib. at the RA in 1897, but whose work falls outside the Victorian period.

Probable price range £20-60

SIMPSON, Henry fl.1875 d.1921

London painter of genre, who exhib. from 1875, at the RA (from 1878), SS, NWS, GG and elsewhere, titles at the RA including 'A Pilgrim' 1878, 'Waiting for the Boats, Scheveningen' 1884, and 'From his Soldier Boy' 1886 Born in Nacton. In April 1910 there was an exhibition of his work at the Leicester Galleries, watercolours of land-scapes, architectural and oriental subjects.

Probable price range £30-100

Bibl: Daily Telegraph 21.4.1910; The Year's Art 1922, 314.

SIMPSON, W.H. fl.1866-1886

Landscape painter, living in Farnham and Malmesbury, who exhib. from 1866-1886, at the RA (1874-8), SS and elsewhere, titles at the RA including 'A Sunny Day in March' 1874 and 'Burnham Beeches — Winter' 1878.

Probable price range £30-70

SIMPSON, William RI FRGS 1823-1899

Painter of topographical and architectural subjects, chiefly in water-colour; war artist; illustrator and engraver of contemporary events. Born in Glasgow, intended to become an engineer, but in 1839 apprenticed to a Glasgow firm of lithographers; 1851 came to London and employed by Messrs. Day and Son. Sent to the Crimean War by Messrs. Colnaghi to make sketches, and was thus one of the first war artists. After the war he was attached to the Duke of Newcastle's party which explored Circassia. From 1859-62 he travelled in India, Kashmir and Tibet making architectural and archaeological sketches. In 1866 he joined the *Illustrated London News,* for which he attended the marriage of the Czarevitch (Alexander III) at St. Petersburg, and followed the operations of Lord Napier's Magdala expedition and the Franco-German War. He also visited China for the Emperor's marriage, recorded the Prince of Wales's Indian Tour 1875-6, and accompanied the Afghan expedition in 1878-9. His last long journey was in 1884 when he was with the Afghan Boundary Commission at Penjdeh, and the latter years of his life were spent completing the series of water-colour drawings 'Glasgow in the Forties' (from sketches made in his youth), acquired by Glasgow Art Gallery in 1898. Exhib. from 1874 at SS and NWS. A of RI in 1874; RI 1879. His published works include: *The Seat of War in the East* (81 lithographs from his drawings) 1855; Brackenbury's *Campaign in the Crimea* 1855 and *India Ancient and Modern*. Hardie notes that "Simpson's work, like

that of Roberts, was spirited and dexterous. Much of what he produced in colour (his output in pencil and wash was prodigious) was in the nature of a tinted sketch, but his more thoughtful work, as in some of the watercolours made in India and Egypt, has considerable merit".

A pair of Indian watercolour views sold at Christie's 3.3.70 for £252.

Bibl: AJ 1866 258; Clement and Hutton; W. Simpson *Autobiography* 1903; Cundall; *Who Was Who 1897-1915;* VAM; Hardie III 96, 186-7 (pls. 218-19): Maas 97.

SIMS, Charles RA 1873-1928
Painter and illustrator. Studied at National Art Training School (South Kensington) 1891 in Paris at Academie Julian, 1893 RA Schools. In 1903 he returned to Paris, where he worked under Baschet. Exhib. at RA from 1893, BI, SS and elsewhere. Titles include portraits, mostly of mothers and children, landscapes, and allegories e.g. 'In Elysium' 'Water Babies' 'A Fairy Wooing' etc. Elected ARA 1908, RA 1915. In 1921 he learnt aquatinting, and subsequently produced many prints and illustrations. He was Keeper of the RA from 1920 to 1926, but resigned as a result of mental illness. In 1928 he committed suicide. Works by him are in the Tate, St. Stephen's Hall, Leeds and Liverpool AG.

'The Beautiful is Fled' sold at Christie's 18.7.69 for £1,155.

Bibl: *C.S. Picture Making: Technique and Inspiration.* With a critical Survey of his work and life by Alan Sims, New Art Library, 2nd series (reviewed in Studio 108 (1934) p.309 f); AJ 1905, 1908, 1911 (see plates); Artwork 4 (1928) 218; 219f; The Art News 1923-27; Connoisseur 1914-26; Studio 41 (1907) 89-98; 1909 – 1922 see index; Who Was Who 1916-28, 1929.

SIMSON, William RSA 1800-1847
Scottish painter of landscape, portraits and historical genre. Born in Dundee. At first painted landscapes and coastal scenes near Edinburgh. 1827 visited Low Countries. 1834-5 visit to Italy. 1838 settled in London. After this he turned mainly to historical genre from English and Italian history e.g. 'Cimabue and Giotto' 'The Murder of the Princes in the Tower' etc. He also painted portraits, and occasional sporting subjects. Exhib. at RA 1830-47, BI, SS and RSA. Elected RSA 1830. Works by him are in the Nat. Gall. of Scotland. His two brothers were also painters, George S. (1791-1862) a portraitist, and David S. (d.1874).

Probable price range £50-250

Bibl: AU 1847, 353 (obit); Studio Spec. No. The RSA 1907, p.vii, xiv; Redgrave, Dict; Ottley; Bryan; DNB; VAM; Caw 156-7, 483; M.H. Grant *Old English Landscape Painters*, 385f (pls.).

SINCLAIR, John fl.1872-1890
Liverpool landscape painter, who exhib. from 1872-90, at the RA (in 1874, 1879 and 1888), SS, NWS and elsewhere, titles at the RA including 'Mountain Solitude' 1874, and 'A Cheshire Hayfield' 1888.

Probable price range £30-100

SINTZENICH, Gustavus Ellinthorpe fl.1844-1866
London painter of genre, portraits, biblical and literary subjects, who exhib. from 1844-66, at the RA (1844-56), BI, SS and elsewhere. Titles at the RA include 'The Grandfather's Visit' 1844, 'Lefevre, the First French Reformer, Preaches the Reformation to Margaret of Valois' 1851, 'Rosalind Reading Orlando's sonnet' 1854, and 'Mary and Martha Mourning at the Tomb of Lazarus' 1856.

Probable price range £20-60

SKILL, Frederick John RI 1824-1881
London painter of landscape and rustic genre; illustrator and engraver. Trained as a steel engraver. Exhib. from 1858-81, at the RA (1858-76), SS, GG, elsewhere, and especially at the NWS (176 works. A in 1871, RI in 1876); also exhib. frequently in Paris. Drew portraits for

the *London Journal,* and illustrations for *Cassell's Family Paper,* 1860-1. He spent several years at Venice, where some of his best sketches were produced. The AJ noted in his obit. : "Endued with a fine feeling for colour, he was to treat his subjects in a delightfully delicate manner. He was, however, insufficiently appreciated by the mass of buyers, and less gifted men giving him the go-by, he died, we understand more from a broken heart than aught else". Two of his best works are in the VAM.

Probable price range £30-100

Bibl: AJ 1881 160 (obit); Bryan; Cust. NPG 2 1902 110f; VAM.

SKIPWORTH; Frank Markham fl.1882-1916
Chelsea painter of genre, portraits and historical subjects, who exhib. from 1882-1916, at the RA (from 1883), SS, NWS, GG, NG and elsewhere. Titles at the RA include 'A Dangerous Conspirator' 1883, ' "Keep Still while I Make you Pretty, Dear" ', 'She Loves a Sailor' 1892, and 'Satisfaction' 1903. His portrait of Field Marshal Roberts is in the Walker Art Gallery, Liverpool.

Probable price range £30-100

SLATER, John F. fl.1889-1904
Landscape and rustic genre painter. Lived at Forest Hall, Northumberland, and in Newcastle. Exhib. at RA from 1889, but has always been better known in the North-East. Titles at RA 'Going to Market' 'A Fresh Breeze' 'Fleeting Sunshine in the Vale' etc. and some coastal scenes.

Usual price range £20-50

SLATER, Walter James RCA fl.1877-1890
Manchester landscape painter, who exhib. from 1877-90, at the RA and NWS, titles at the RA including 'Autumn' 1877, 'Edge of the Marsh' 1880, 'A Sussex Pastoral' 1886 and 'The Arun at Burpham' 1890.

Probable price range £30-70

SLOCOMBE, Frederick Albert RPE b.1847 fl.1866-1916
Landscape and genre painter, and etcher. Lived in Cricklewood, and Hendon, London. Exhib. at RA 1866-1916, SS, NWS and elsewhere. Titles of paintings at RA include landscapes and coastal scenes in England and Wales, and rustic genre 'A Dark-eyed Maiden' 'Thoughts of Love' 'Meditation' etc. Apart from his own etchings, he made etchings after paintings by J. Farquharson, A. Parsons, B.W. Leader and others. His brother Charles Philip S. (1832-1895) was also an etcher and watercolourist. Edward C.S. (fl.1873-1904) and Alfred S. (fl.1865-86) presumably all of the same family, were also both etchers and members of the RPE.

Probable price range £20-80

Bibl: AJ 1879, 1882-89, 1895 (see pls);
Portfolio 1885, 1889, 1891;
A.M. Hind *A Short History of Engraving and Etching* 1911

SLOUS, Henry Courtney See SELOUS, Henry Courtney

SMALL, Miss Florence (Mrs. Deric Hardy) fl.1881-1901
Painter of genre, flowers and fairy-tale subjects, living in Nottingham and from 1894 at Gloucester Road, Regent's Park. In 1893 she married. Exhib. from 1881-1901 at the RA, SS and elsewhere, titles at the RA including 'Rosaria' 1881, 'Between the Lights' 1893, 'Fortunée and the Enchanted Prince' 1895 and 'A Nymph' 1901.

Probable price range £20-60

SMALL, William RI b.1843 fl.1869-1900
Painter, watercolourist and illustrator. Pupil of RSA. Moved to

London 1865. Exhib. at RA 1869-1900, NWS, GG and elsewhere. Titles at RA 'The Woodlands' 'Waiting for Tide' 'Water Polo' etc. 'The Last March' (RA 1887) was bought by the Chantrey Bequest. As an illustrator he worked for *Once a Week, Good Words, The Graphic, Harpers* etc. and illustrated several books. Works by him are in Leicester, Liverpool and Manchester AG.

Probable price range £50-150

Bibl: Clement and Hutton; J. Pennell *Modern Illustration* 1895; Gleeson White; Caw 292-4; A. Hayden *Chats on Old Prints* 1909; Hardie III 96.

SMALLBONE, Eliza Anne **See MELVILLE, Mrs. Alexander**

***SMALLFIELD, Frederick** **ARWS** **b.1829 fl.1849-1893**
Genre painter and watercolourist. Pupil of RA schools. Exhib. at RA 1849-86, BI, SS, OWS (425 works) NWS, GG and elsewhere. Titles at RA 'Entering the Garden' 'A Christmas Invitation' 'The Old Apple Room' etc; also some flower prices, and historical scenes from Shakespeare. In the Manchester AG, is a charming Pre-Raphaelite work 'Young Love'.

'Vase of Mixed Flowers' sold at Christie's 30.10.64 for £136.

Bibl: AJ 1883 p.336 (pl); Maas 119 (pl. p.238).

SMART, John **RSA RSW RBA** **1838-1899**
Scottish landscape painter. Born in Leith. Pupil of H. McCulloch (q.v.). Exhib. at RA 1870-99, SS, NWS, GG, RSA, RSW and elsewhere. He devoted himself to painting the life and scenery of the Highlands. "If coarse in handling and wanting in subtlety of feeling, they are simple and effective in design, vivid in effect and powerful in execution, and breathe an ardent passion for the landscape of his native land" (Caw). His best work was done between 1870-1890. Elected ARSA 1871, RSA 1877. Founder member of RSW.

'View from the Ruins of Dynevor Castle' sold at Christie's 13.11.69 for £210.

Bibl: Clement and Hutton; Bryan; Caw 297-8; Who Was Who 1897-1915.

SMART, T. **fl.1835-1855**
London painter of historical subjects, genre and portraits, who exhib. from 1835-55, at the RA, BI and SS, titles at the RA including 'Sir John Ramony's Spurs being Struck off Previous to his Execution' 1836, 'Au Revoir' 1842, and 'One of the Effects of Punch' 1852.

Probable price range £30-100

***SMETHAM, James** **1821-1889**
Painter of portraits, imaginative landscapes, literary, poetical and biblical subjects; etcher; essayist. Son of a Wesleyan minister, Smetham remained all his life a devout member of that sect. He began by painting portraits in Shropshire; came to London in 1843 and studied at the RA Schools. When commercial photography destroyed this means of livelihood, he became drawing-master at the Wesleyan Normal College, Westminster in 1851. Exhib. from 1851-76, at the RA (1851-69), BI, SS and elsewhere. The last twelve years of his life were darkened by madness, to which religious melancholia and a sense of failure and disappointment undoubtedly contributed. His mind was continually distracted between art and literature which prevented his success, and after 1869 his paintings were all rejected by the RA. Ruskin and Rossetti were both his friends, and thought highly of his work, but he attained no reputation outside his own small circle. Smetham passed through a phase of Pre-Raphaelitism in the 1850's, e.g. 'Naboth's Vineyard' 1856 (Tate Gallery), and his close friendship with Rossetti in the 1860's from 1863-c.1868, is also reflected in his work. He is more remembered today for his critical articles and letters, and for his essay on Blake, first published in the *Quarterly Review* in 1868 (reprinted as an appendix to the second edition of Gilchrist's *Life of Blake* 1880), which was one of the first

to establish Blake's true importance.

'A Young Lady in Exotic Costume' sold at Sotheby's 10.6.70 for £900.

Bibl: AJ 1904 281-84, 'J.S. and C. Allston Collins'; Sara Smetham and William Davies ed. *The Literary Works of J.S.* 1893; Ford Madox Hueffer *Ford Madox Brown* 1896, 289; H.C. Marillier *D.G. Rossetti* 1899, 82, 189; Bryan; William Beardmore *J.S. Painter, Poet and Essayist* 1906; DNB; VAM Annual Review 1932, 29; M.H. Grant *Old English Landscape Painters* 1935, 233, 286; Geoffrey Grigson *'J.S. Cornhill Magazine* No. 976 (Autumn 1948), 332-346; Ironside and Gere 25-6; Fredeman section 60 and Index; Reynolds VP 62, 142 (pl.145); Maas 42, 44, 67, 133 (pls. 66-7).

SMITH, Carlton Alfred **RI RBA** **fl.1871-1916**
Genre painter and watercolourist. Exhib. mostly at SS (158 works) NWS, also at RA from 1879 and elsewhere. Titles at RA mostly domestic scenes e.g. 'First Steps' 'Home' 'Firelight Glow' etc. Works by him are in the VAM, Sunderland AG, and the Nat. Gall. Melbourne. His wife, Mrs. Carlton A. Smith (fl.1883-93), was a painter of coastal scenes. She exhib. at SS and elsewhere.

'The Love Letter' sold at Bonham's 8.5.69 for £120.

SMITH, Mrs. Caroline **fl.1832-1869**
London painter of genre and portraits, who exhib. from 1832-69, at the RA (1851-69), BI and SS, titles at the RA including 'Roman Peasant-boy' 1851 and 'Henry Warren Esq., President of the Institute of Painters in Watercolours' 1869.

Probable price range £20-60

SMITH, Charles **fl.1857-1908**
Landscape painter, living in London, Greenwich, Putney and Richmond, who exhib. from 1857-1908, at the RA, BI, SS (145 works), NWS and elsewhere. Titles at the RA include 'The Castle of Chillon, Geneva' 1857 and 'The Swale near Richmond, Yorks' 1872.

Probable price range £30-70

SMITH, Colvin **RSA** **1795-1875**
Scottish portrait painter. Studied at RA Schools, and visited Italy. In 1827 he set up as a portrait painter in Raeburn's old studio in Edinburgh. Although an average portrait painter, he achieved a large practice and reputation by following the traditions of Raeburn and Watson Gordon. Exhib. at RSA, RA 1843-71, BI and SS. Elected RSA 1829.

Probable price range £30-60

Bibl: AJ 1875 p.304 (obit); Redgrave, Dict.; Bryan; DNB; Caw 88; Poole *Cat. of Engraved Brit. Portraits* BM 6 (1925) 550.

SMITH, Mrs. Constance **See PLIMPTON, Miss Constance E.**

SMITH, C. Dowton **fl.1842-1854**
Painter of marine subjects, who specialized in shipping incidents on the Thames and Medway. Exhib. from 1842-54 at the RA (1843-54), BI and SS, titles at the RA including 'Fishing Smack Coming up the Medway' and 'Fishing Lugger off Hastings'. His brother C.W. Smith was resident with him.

Probable price range £20-60

Bibl: Wilson, Marine Painters.

SMITH, Edward Blount **fl.1877-98 d.1899**
London landscape painter, who exhib. from 1877-98, at the RA (1886-98), SS, NWS, GG, NG and elsewhere, titles at the RA including 'River Meadows' 1886, 'Battersea' 1897, and 'The Red Forest' 1898.

Probable price range £30-70

***SMITH, George 1829-1901**

Genre painter. Pupil of RA Schools, and C.W. Cope (q.v.). Exhib. at RA 1848-87, BI, SS, NWS and elsewhere. He painted domestic scenes, often of children, in the manner of Webster and F.D. Hardy. Titles at RA 'A Game at Marbles' 'A Cottage Fireside' 'The New Boy' etc. Works by him are in the VAM, Nottingham and Rochdale AG.

Prices in the last two years have ranged from about £100 to £500.

Bibl: AJ 1863 p.126 pl. 1867, p.112 (pl); The Year's Art 1902 p.319; Clement and Hutton; Bryan; Reynolds VS 56 (pl.15).

SMITH, H.G. fl.1839-1856

Camden Town painter of portraits and genre, who exhib. from 1839-56 at the RA, titles being mainly portraits, and also 'Preparing for the Fête' 1845 and The Mountain Violet' 1856.

Probable price range £20-50

SMITH, Henry Smith fl.1825-1844

London painter of genre, portraits and historical subjects, who exhib. from 1825-44, at the RA (1828-44), BI and SS, titles at the RA including 'The Shipwrecked Mariner' 1838, 'Spenser in his Study' 1839, and 'The Schoolmistress' 1844.

Probable price range £30-100

SMITH, Herbert Luther 1811-1870

Painter of portraits, historical and biblical subjects. Younger son of Anker Smith, ARA. Exhib. from 1830-54, at the RA (1831-54), BI and SS, titles at the RA being mainly portraits and 'The Bodleian Picture-gallery' 1838, 'Ruth and Naomi' 1842 and 'Jonah's Impatience Reproved' 1845. His portrait of Sir Walter Raleigh is in Oriel College, Oxford.

Probable price range £20-50

Bibl: Redgrave, Dict.
Poole, *Cat. of Portraits etc. in Oxford* 2 1925, 80;
Cat. of Engr. Brit. Portraits BM 6, 1925.

SMITH, J. Bell See SMITH, James Bennett H.

SMITH, James Bennett H. fl.1830-1847

London painter of genre, portraits and flowers, who exhib. from 1830-47, at the RA, BI, SS and elsewhere, titles at the RA being mostly portraits, and also 'Flowers from Nature' 1830, 'The First Essay' 1844 and 'A Girl of Normandy' 1847. Graves, in R. Acad. notes "This painter appears in my Dictionary as J. Bell Smith, in error. It is clear that J.B. and J.B.H. Smith are one man, and neither name appears in the catalogues after 1847."

Probable price range £20-60

SMITH, James Burrell fl.1850-1881

Landscape painter and watercolourist. Exhib. only at SS 1850-81. Lived mainly at Alnwick, Northumberland. He painted landscape views in many parts of England, but was most fond of painting streams and waterfalls, sometimes with anglers in the foreground.

Prices in the last two years have ranged from about £50 to about £250. A pair sold at Christie's 3.4.69 for £441.

Bibl: Pavière, Landscape pl.68.

SMITH, James Whittet fl.1859-1886

London painter of landscape, who exhib. from 1859-86, at the RA (1862-86), SS, NWS and elsewhere, titles at the RA including 'Edinburgh from Inch Colme' 1862, 'The Mer de Glace, Chamonix' 1875, 'Mont Blanc at Sunset' 1877, and 'The Turn of the Tide at Sloughden, Suffolk' 1880.

Probable price range £30-70

SMITH, James William Garrett fl.1878-1887

London landscape painter, who exhib. from 1878-87, at the RA (1882-87), SS, NWS and GG, titles at the RA including 'The Old Quay at Haughden, Suffolk' 1882 and 'The Roseg Glacier at Sunrise' 1887.

Probable price range £30-100

SMITH, John Brandon fl.1859-1884

London landscape painter, who exhib. from 1859-84, at the RA (1860-74), BI and SS, titles at the RA including 'View in Surrey' 1860, 'On the Lledr' 1867 and 'Caldron Linn, Perthshire' 1874.

'Langdale Beck in Teesdale' sold 14.10.69 for £356. Another work in the same sale made £121.

SMITH, John Henry fl.1852-1893

Painter of genre, landscape and animals, living in London, Brixton and S. Lambeth, who exhib. from 1852-93 at the RA, BI, SS and elsewhere. Titles at the RA include 'Where the Shoe Pinches' 1882, and 'A book is the best solitary companion in the World' 1885. Two of his paintings were painted with Miss C.E. Plimpton (q.v.). 'The Audience' 1892, and 'Idle Summer Time' 1893.

Probable price range £30-70

SMITH, Samuel Mountjoy fl.1823-1859

London painter of marine subjects, landscape, portraits, genre and animals, who exhib. from 1823-59, at the RA (in 1831 and 1836), BI, SS and elsewhere. Titles at the RA include 'A Lion and Lioness Reposing' 1831, and 'Robinson Crusoe' 1836, and at the BI, 'Fishing Boats on the Beach at Hastings'.

Probable price range £30-100

Bibl: Cat. Engr. Brit. Portraits BM 2 (1910) 658; Wilson, Marine Painters.

SMITH, Stephen Catterson the Elder PRHA 1806-1872

Portrait painter. Born in Yorkshire. Studied at RA Schools, and in Paris. Worked in Londonderry 1839-45; 1845 moved to Dublin. President of RHA 1859-66. Director of Nat. Gall. of Ireland 1868. Exhib. mostly at RHA, occasionally in London at RA (1830-58) and BI. He painted many well-known Irishmen, and members of the Irish aristocracy. His son, Stephen Catterson S. (Junior) (q.v.) was also a painter, and his wife Anne Wyke, a miniaturist.

Portrait of a Lady' sold at Christie's 25.6.65 for £157.

Bibl: AJ 1872 p.204; DNB; Bryan; Strickland; Poole *Cat. of Portraits etc. of Oxford* 1912; Cat. of Engr. British Portraits BM 6 (1925) 551.

SMITH, Stephen Catterson the Younger RHA 1849-1912

Son and pupil of Stephen Catterson Smith the elder (q.v.). Also painted portraits. Did not exhib. in London; only in Ireland, Secretary of RHA for twenty years.

Probable price range £30-100

Bibl: See under S.C. Smith the Elder

SMITH, W. Armfield fl.1832-1861

Portrait painter, who exhib. from 1832-61, at the RA (1832-49), SS, and elsewhere. Brother of George Armfield Smith, who changed his name to George Armfield in 1840.

Probable price range £20-50

SMITH, W. Harding C. RBA 1848-1922

Painter of genre and historical subjects, and of landscape; collector. Son and pupil of William Collingwood Smith (q.v.) 1815-1887; derived his second name from J.D. Harding who had been his father's friend

and instructor. Exhib. from 1868 at SS, NWS and elsewhere, and at the RA from 1870, titles at the RA including 'Making Advances' 1873, 'King Charles at Cothele on the Tamar' 1873, and 'A Dilettante' 1876. RBA in 1894. *The Connoisseur* notes that he "inherited his father's gift for watercolour, and many of his drawings were executed in the neighbourhood of Chichester. In his earlier days he executed some subject pictures but had abandoned this field many years before his death." He was also a discriminating collector of Japanese, Egyptian, Babylonian and Persian antiquities.

Probable price range £30-100

Bibl: Connoisseur 62 (1922) 112 ff (obit.)

SMITH, William fl.1813-1859

Painter of animals, portraits and landscape, living in London and Newport, Shropshire. Exhib. from 1813-59 at the RA, BI, SS and OWS, titles at the RA including 'Portrait of Mr. William Drury, a Shropshire Yeoman and his Pony Ben' 1840, 'A Loiterer and Rabbit Catchers' 1848, and 'Severn Fish' 1849. Graves in his Dict. incorrectly divides up his work between W. Smith (1841-59) and William Smith (1813-47).

'A Bay Horse held by a Farmer' sold at Christie's 3.5.68 for £420

Bibl: Poole *Cat. of Oxford Portraits* 1 1912 11 1915

SMITH, William Collingwood RWS 1815-1887

Landscape painter and watercolourist. Born in Greenwich. Received some lessons from J.D. Harding (q.v.). At first painted in oils, but later became purely a watercolourist. Exhib. at RA 1836-55, BI, SS and OWS. Graves lists over 1,000 exhibits at the OWS, but Roget says that it was nearer 2,000. Elected ARWS 1843, RWS 1849; Treasurer 1854-79. Painted extensively in the British Isles and Europe, especially in Italy. Was also a popular drawing-master. "His own work is marked by breadth of effect, firmness of drawing and precision of touch" (Hardie). His studio sale was held at Christie's on March 3, 1888.

'The Bacino, Venice' sold at Christie's 19.4.69 for £157.

Bibl: AJ 1887 p.160; Roget; Bryan; Binyon; Cundall: VAM; Hardie II 233 (pl.224).

SMITH, William H. fl.1863-1880

London painter of studies of fruit, who exhib. from 1863-80, at the RA (1863-72), BI, SS and elsewhere.

'Grapes, Plums and a Bird's Nest' sold at Christie's 11.7.69 for £105.

SMYTHE, Edward Robert 1810-1899

Ipswich landscape painter. Son of a bank manager. Lived and worked in East Anglia; painted landscapes and coastal scenes, with figures and animals. Exhib. 1850-61 at RA, BI and SS. Graves and other dictionaries list him incorrectly as Emily R. Smythe. Brother of Thomas S. (q.v.).

Prices in the last two years have ranged from about £100-900.

Bibl: Wilson, Marine Painters pl.35; Pavière, Landscape pl.69; The Smythes of Ipswich, Exhib. at Lowndes Lodge Gallery, London 1964; H.A.E. Day *East Anglian Painters* 1968 1 113-151.

SMYTHE, Lionel Percy RA RWS RI 1839-1918

Painter of landscape and rustic genre. Educated at King's College School, studied at Heatherley's Art School. Exhib. from 1860, at the RA (from 1863), BI, SS, OWS, NWS and elsewhere. RI from 1880-90, ROI 1883-6; ARWS 1892; RWS 1894; ARA 1898; RA 1911. In 1889 'Germinal' was purchased by the Chantrey Bequest for the Tate Gallery. Smythe lived principally at Wimereux where he died, and the French peasant girls and countryside round Wimereux and Ambleteuse figure in much of his work. Hardie notes that "his

landscapes and episodes of rural life, painted with great purity of delicate colour, are poetic and refined. The outdoor figures are surrounded by shimmering light and air, e.g. 'Under the Greenwood Tree' " (VAM).

'Farmyard Scene' – a drawing – sold at Sotheby's 2.3.66 for £68.

Bibl: AJ 1904 223-8; Studio 49 (1910) 171-85; Connoisseur 38 (1914) 67; 55 (1919) 163, 56 (1920) 220; 68 (1924) 57 f; Studio Special Winter No. 1917-8 pl. XII; R.M. Whitelaw 'Leonard Percy Smythe' OWS 1 1923; F.W. Stokes 'List of Works exhibited by L.P.S. in the OWS's Club 1 1923-4 69-78; Rosa M. Whitelaw and W.L. Wyllie *L.P.S. His life and Work* 1924; VAM; Hardie lll 140-1 pl. 164.

SMYTHE, Thomas 1825-1907

Ipswich landscape painter. Brother of Edward Robert S. (q.v.). Like him, painted landscapes and coastal scenes with animals and figures, but did not exhibit in London. Worked in East Anglia and exhib. there; also painted good winter landscapes.

Prices in the last two years have ranged from about £100-800.

Bibl: Pavière, Landscape 121; The Smythes of Ipswich. Exhib. at Lowndes Lodge Gall. London 1964; H.A.E. Day *East Anglian Painters* 1968 1 193-207.

SNAPE, Martin fl.1874-1901

Gosport painter of birds, animals and landscape, who exhib. from 1874-1901 at the RA, SS, GG and elsewhere, titles at the RA including 'The Gamekeeper's Museum' 1883, 'The Ferret Hutch' 1894. and 'Gosport Fair' 1897.

Probable price range £30-100

Bibl: Pavière Sporting Painters.

SNELL, James Herbert RBA ROI 1861-1935

London landscape painter, who exhib. from 1879, at the RA (from 1880), SS, NWS, GG, NG and elsewhere, titles at the RA including 'Signs of Winter' 1880, 'Woodland and Solitudes' 1882, and 'An Old Time Garden' 1902. Studied at Heatherley's, and in Paris and Amsterdam.

Probable price range £30-100

Bibl: Pavière Landscape.

SODEN, John E. fl.1861-1887

London genre painter. Exhib. at RA 1861-68, BI, and SS (64 works). Titles at RA 'Quizzing the Neighbours' 'The Odd Change' and 'Well I Never' etc.

Probable price range £20-80

Bibl: Cat. of Paintings, Drexel Institute, Philadelphia, 1935.

*SOLOMON, Abraham 1824-1862

Painter of historical and contemporary genre. Elder brother of Rebecca and Simeon S. (q.v.). Studied at Sass's Academy and RA schools. Exhib. at RA 1841-62, BI and SS. At first painted eighteenth century historical genre, taking his subjects from Scott, Sterne, Molière, Goldsmith etc. In 1854 he turned to contemporary genre, and exhib. at the RA two railway subjects – '1st Class – The Meeting' and '3rd Class – The Parting'. These were an enormous success, and widely reproduced through engravings. He went on to paint other subjects of this type, such as 'Waiting for the Verdict' (1857) and 'The Acquittal' (1859), which were also very popular. In 1861 he married, but owing to heart trouble, he was advised to go abroad. In 1862 he died in Biarritz. on the same day as the Academy elected him an A.R.A. His studio sale was held at Christie's March 14, 1863.

'The Letter' sold at Christie's 14.3.69 for £682.

Bibl: AJ 1862, 73-5; 1863, 29; Apollo 23 (1936) 241ff; Bryan; Bate; DNB; Jewish Lexicon IV 2 (1930); Reynolds VS and VP (pl.66); Maas 238; Lionel Lambourne in the Jewish Historical Society of England Vol. XXI (1968) 174-86.

SOLOMON, J.W. fl.1827-1849

Genre and portrait painter. Exhib. at RA 1828-49, BI and SS. Titles at RA 'The Young Rover' 'The Present' 'La Promenade' etc., also some portraits, and historical genre from Milton and Shakespeare.

Probable price range £50-150

SOLOMON, Miss Rebecca 1832-1886

Historical genre painter. Sister of Abraham (q.v.) and Simeon (q.v.). Studied at Spitalfields School of Design, and with her brother Abraham. Exhib. at RA 1852-69, BI, SS and elsewhere. Her early works are genre scenes similar to her brother's e.g. 'Peg Woffington' 'Fugitive Royalists' 'The Arrest of a Deserter' etc. She also helped several artists to produce studio replicas, including Millais, Frith, Phillip and T. Faed. A copy of Phillips's 'Marriage of the Princess Royal' by her is in the Royal Collection. During the 1860's she visited France and Italy. Before her brother Simeon's downfall, they moved in artistic circles together, but after 1871 she seems to have shared in his disgrace. She exhibited nothing after 1869, and her later years are blanketed in complete obscurity. The DNB says that "she developed like Simeon an errant nature and came to disaster". Her death in 1886 was also due to alcoholism.

'Christ in the House of his Parents' a copy after Millais with additions by Millais himself, sold at Christie's 11.7.69 for £1,260. The Millais interest must have accounted for this price; normally Rebecca Solomon's work would not make more than £100-200.

Bibl: DNB; Clayton II 129; Daphne du Maurier *The Young George du Maurier* 1951 see index; Lord Baldwin *The MacDonald Sisters* 1962 see index; C. Wood in Christie's Review of the Year 1968-9 p.55-7; See also references under Simeon Solomon.

*SOLOMON, Simeon 1840-1905

Pre-Raphaelite painter and illustrator. Younger brother of Abraham (q.v.) and Rebecca (q.v.). Entered RA schools 1855. First major exhibit at RA was 'The Mother of Moses' in 1860. Exhib. at RA 1858-72, SS, GG, NG and elsewhere. A precocious and brilliant artist, he produced most of his best work in the 1860's. It includes illustrations for Dalziel's Bible, and many drawings of Jewish life and ritual. During this time he met Rossetti, Burne-Jones, Pater, Swinburne, and others of the Pre-Raphaelite circle, all of whom greatly admired his work. He illustrated books for Swinburne, but the corrupting influence of the poet is generally thought to have hastened his moral and artistic decline. In 1871 he was arrested for homosexual offences, and became a complete social outlaw. Both his family and his fellow-artists deserted him, and he was forced to live a pathetically bohemian life, mostly in St. Giles Workhouse, Holborn. To relieve his poverty he produced large numbers of drawings and pastels, mostly of mythological and biblical figures. Most of these are weak and repetitive, "virtually a parody of the yearning intensity of the movement". (Reynolds) but they were nonetheless popular in the 1880's and 90's, especially in the decoration of undergraduate rooms in Oxford. His death in 1905 was due to chronic alcoholism. Exhibitions of his work were held at the Baillie Gall. 1905, and the Durlacher Gall. New York, 1966.

'Ruth, Naomi and the Child Obed' sold at Christie's 10.7.70 for £525. Good drawings can be worth about the same amount; later works usually somewhat less.

Bibl: AJ 1906, 311f; Connoisseur 56 (1920) 220, 224; Bate; Binyon; Cundall; DNB; VAM; S. Solomon *A Vision of Love Revealed in Sleep* 1871; A. Swinburne *S.S.* in the Bibelot XIV (1908); T.E. Welby *The Victorian Romantics* 1929; B. Falk *Five Years Dead etc.* 1937; J.E. Ford *S.S.* 1964; Fredeman Section 61 et passim (with full bibliog.). Reynolds VP 71 (pl.58); Hardie III 126-7 (pl.151); Maas 146 (pl.143); L. Lambourne in the Jewish Historical Society Vol. XXI (1968) p.274-268.

*SOLOMON, Solomon Joseph RA PRBA 1860-1927

Portrait and genre painter. Studied at RA schools, Munich Academy, and under Cabanel at the Beaux Arts, Paris. Exhib. at RA from 1881, SS, NG, and elsewhere. Painted mostly portraits, but also mythological and biblical scenes e.g. 'Ruth' 'Niobe' 'The Birth of Love' etc. These are often large and dramatic, but his attempts to portray emotion tend to be forced and theatrical. Elected ARA, RA 1906, PRBA 1919. Works by him are in the Walker AG, Liverpool, Preston and Leeds AG.

'Samson and Delilah' sold at Christie's 6.3.70 for £199.

Bibl: AJ 1905 p.165, 174; 1907, 29; 1908, 167; Studio 8 (1896) 3-11; Connoisseur 79 (1927) 58; O.S. Phillips, *S.J.S.* 1933 (see Apollo 18 (1933) 196f).

SOMERSCALES, Thomas 1842-1927

Marine painter. Born in Hull. Teacher in the Navy. In 1865 he was put ashore in Chile because of ill-health. He remained in Chile until 1892, and while there took up painting. Returned to England and exhib. at RA from 1893. 'Off Valparaiso' was bought by the Chantrey Bequest. His pictures are mostly of sailing ships at sea, and are often similar to those of the better-known Montague Dawson. Works by him are in Hull, Greenwich and the Tate.

'Sailing Boats Offshore' sold at Christie's 9.5.69 for £168.

Bibl: Mag. of Art 1902 p.241-6; Studio Spec. No. 1919 Brit. Marine Painting p.31, 82f; Connoisseur 79 (1927) 127; RA Pictures 1893-1901, 1903-06, 1908, 1911; Wilson, Marine Painters, p.73 (pl.36).

SOMERSET, Richard Gay VPRCA ROI 1848-living 1927

Landscape painter, living in Manchester, Hulme and Bettws-y-Coed. Exhib. from 1871, at the RA (from 1876), SS, GG, NG and elsewhere, and exhibiting in 1927 at the RCA, ROI and the Walker Art Gallery Liverpool. Titles at the RA include 'The First Day of January' 1876, 'An Olive Grove in Winter, Isola di Capri 1884, and 'Falls on the Conway' 1902. Vice-President of the RCA. Paintings are in Manchester City Art Gallery and Rochdale Art Gallery.

Probable price range £30-100

Bibl: The Year's Art 1928 532.

SOPER, Thomas James fl.1836-1890

Landscape painter. Exhib. at RA 1836-82, BI, SS, NWS and elsewhere. Painted around London and on the Thames, in Devon, Wales, and other parts of the British Isles.

Probable price range £30-100

Bibl: AJ 1859 p.121; Pavière, Landscape pl.70.

SOUTHERN, J.M. fl.1879-1892

Liverpool landscape painter, who exhib. from 1879-92, at the RA (1879-82), and GG, titles at the RA including 'A Welsh Moorland in Autumn' 1879 and 'The Shallows of a Welsh River' 1882.

Probable price range £30-100

SOWERBY, John G. fl.1876-1914

Landscape painter, living in Gateshead, Colchester and Abingdon, Berks, who exhib. from 1876-1914, at the RA (from 1879) and elsewhere. Titles at the RA include 'Twilight' 1879, 'The Erring Burn' 1897, and 'The Avon' 1904.

Probable price range £20-80

SPALDING, C.B. fl.1840-1849

Sporting and animal painter, lived in Reading, Brighton and London. Exhib. five pictures at RA 1840-49. Three of these were of horses, the others 'The Battle of Aliwal' and 'A Forester'.

'The Hambledon Hounds at Preshaw' sold at Christie's 27.11.69 for £1,785. This was a record price; the average range is £200-400.

SPARKES, Mrs. J. b.1842, fl.1866-1891
(Miss Catherine Adelaide Edwards)
Genre painter and illustrator. Pupil of Lambeth and RA schools, and also of John O'Connor. In 1868 she married John Sparkes. Exhib. at RA in 1866 and 1868 under her maiden name, 1870-90 as Mrs. Sparkes, also at NWS, GG and Dudley Gall. She illustrated several books, and also worked as a tile painter and designer for Lambeth Pottery, of which her husband was the director.

Probable price range £30-100

Bibl: Clayton II, 130-2.

SPARTALI, Miss Marie See under STILLMAN, Mrs. W.J.

SPENCER, R.B. fl.1840-1870
Marine painter. Did not exhibit in London, but worked for private patrons. Painted ship-portraits, and also naval battles.

'The Earl of Balcarres and other Vessels off Dover' sold at Christie's 30.1.70 for £294.

Bibl: Wilson, Marine Painters pl.36.

SPENLOVE, Frank Spenlove RBA 1864-1933
Landscape and rustic genre painter. Studied in London, Paris and Antwerp. Exhib. at RA from 1887, SS, NWS and elsewhere. His landscapes were often painted in Kent, Suffolk or Holland. In 1896 he founded the Spenlove School of Modern Art, known as The Yellow Door School, at Beckenham in Kent. Works by him are in the Guildhall, Bristol, Doncaster, Glasgow, Hull, Liverpool, Manchester, Newcastle, Newmarket and Rochdale AG., and also in the Luxembourg Museum and the Hotel de Ville, Paris.

Probable price range £50-150

Bibl: AJ 1895, 159; 1901, 191; 1904, 196; 1905, 300, 385; 1906, 269; 1907, 186; Studio see Indexes Vols. 27, 29, 41, 43, 63, 66; Connoisseur 42 (1915) 59f; 91 (1933) 409; Art News 31 (1932/3) No.36 p.8; Who's Who 1924.

SPIERS, Benjamin Walter fl.1875-1893
London genre painter, who exhib. from 1875-93, at the RA (1876-91), SS, NWS and elsewhere, titles at the RA including ' "Crack'd Bargains from Brokers, Cheap Keepsakes from Friends" ' 1876, 'The Old Bookstall' 1880, and 'A Visit to Wardour St.' 1890.

Probable price range £30-100

SPIERS, Miss Charlotte H. fl.1873-1901
London landscape painter, who exhib. from 1873-1901, at the RA (in 1881, 1897 and 1901), SS, NWS, GG and elsewhere, titles at the RA including 'On the Wye' 1881 and 'In the Marshes, Kessingland' 1901.

Probable price range £20-60

SPINKS, Thomas fl.1872-1880
Landscape painter. Exhib. 1872-80 at the RA and SS. Painted Welsh scenery.

'Figures Picnicking under a Tree' sold at Bonham's 3.7.69 for £170.

Bibl: Pavière, Landscape pl.71.

SPREAD, William RPE fl.1880-89, d.1909
London painter of landscape and architectural subjects; engraver. Pupil of Charles Verlat in Antwerp. Exhib. from 1880-89, at the RA, SS, GG and elsewhere, titles at the RA including 'A Shop, Dinan, Brittany' 1880 and 'A Street in Bruges' 1889.

Probable price range £20-80

Bibl: *Le Blanc Manuel de L'Amat, d'Est. 3,* 1888
The Year's Art 1910, 389.

SPRY, William fl.1832-1847
London painter of fruit and flowers, who exhib. from 1832-47, at the RA (1834-47), BI, SS and NWS.

Probable price range £20-60

SQUIRE, Miss Alice RI fl.1864-1894
London painter of genre and landscape, who exhib. from 1864-94, at the RA (1873-94), SS, NWS, GG and elsewhere, titles at the RA including 'Windfalls' 1873, 'A Country Lass' 1885, and 'The Cuckoo's Voice' 1893. Member of the Society of Lady Artists. Sister of Miss Emma Squire (q.v.).

Probable price range £30-80

SQUIRE, Miss Emma fl.1862-1901
London painter of genre and still-life, who exhib. from 1862-1901, at the RA (1872-1901), SS and elsewhere, titles at the RA including 'Hoping for the "Yes" Word' 1872, 'Meeting an Old Friend' 1877, and 'Singing the Psalms of David' 1901. Sister of Miss Alice Squire (q.v.).

Probable price range £30-80

SQUIRE, John fl.1867-1896
Landscape painter, living in Ross, Herefordshire; Swansea, and London. Exhib. from 1867-96, at the RA (1873-96), SS (50 works), NWS and elsewhere, titles at the RA including 'Watergate Bay, Cornwall' 1873 and 'Coombe Park Water, Exmoor' 1896.

Probable price range £30-100

SQUIRES, H. fl.1864-1875
Stratford flower painter, who exhib. from 1864-75, at the RA (1865 and 1868), BI, SS and elsewhere.

Probable price range £30-70

STACEY, Walter S. RBA ROI 1846-1929
Painter of landscape, genre and historical subjects; decorative designer and illustrator; living in Clapham and Hampstead. Exhib. from 1871, at the RA (from 1872), SS, NWS and elsewhere, titles at the RA including 'The Old Family Pew' 1873, 'Memorial Window, Christ Church Hampstead' 1898, and 'The Verger's Corner' 1904. He was Vice-President of the Dudley Society. 'Summer Holidays', a coastal scene, exhib. at the Dudley Society 1906 is reproduced in the AJ.

Probable price range £30-100

Bibl: AJ 1906, 379 (pl.),
Connoisseur 67 (1923) 119 ff; 84 (1929) 313.

***STANFIELD, William Clarkson RA** 1793-1867
Marine painter in oil and watercolour. Born in Sunderland. Entered merchant navy 1808; later pressed into the navy; discharged after an injury 1818. At first worked as a scenery-painter in theatres in London and Edinburgh, where he met his great friend David Roberts (q.v.). Began to exhibit easel pictures, and gave up scene painting in 1834. A close friend of Dickens, he produced much of the scenery for his private theatricals at Tavistock House. Exhib. at RA 1827-67, BI and SS. ARA 1832, RA 1835. Painted shipping, coastal and river scenes, both in England and the Continent, in a straightforward, realistic style. He was commissioned by William IV to paint 'The Opening of New London Bridge' and 'Portsmouth Harbour'. Probably his finest work was 'The Battle of Trafalgar' (1863) painted for the United Services Club in Pall Mall, and still in their possession. His studio sale was held at Christie's on May 8, 1868. His son George Clarkson S. (q.v.), was also a painter.

Prices in recent years have ranged from about £100-500. Two very large pictures sold at Christie's in 1971 for £1,050 and £1,890.

Bibl: AJ 1857, 137-9; 1859, 112; 1867, 171; 1878, 136; Gentleman's Mag. 4 July 1867; Studio Spec. No. British Marine Painting 1919; Studio Spec. No: Early Eng. W/Cols. by the Gt. Masters 1919; Apollo 7 (1928) 25: Connoisseur pls. in Vols. 47-8, 63-4, 68, 71, 87; Ruskin *Modern Painters I*; J. Dafforne *C.S.* 1873; C. Dickens *The Story of a Great Friendship* 1918 (letters); Redgrave, Dict. and Cent.; Bryan; Binyon; Cundall; DNB; Hughes; VAM; Wilson, Marine Painters pl.37; Pavière, Landscape pl.72; Hardie III 69-70 et passim (pls. 85-6); Maas 61-2 et passim (pls. p.60-1).

STANFIELD, George Clarkson 1828-1878

Painter of continental scenes; son of Clarkson Stanfield (q.v.). Exhib. at RA 1844-76, BI and elsewhere. Painted views in N. France, Holland, Germany, Switzerland and Italy; especially the Rhine and the Italian lakes. Occasionally painted English coastal views. Although he painted in a distinct and repetitive style, his works are sometimes confused with those of his father. He usually signed 'George Stanfield' or 'G.C. Stanfield' whereas his father usually signed 'C. Stanfield RA'.

Usual price range £150-300, although two sold at Sotheby's 29.8.69 for £500 and £600.

Bibl: see under Clarkson Stanfield.

*STANHOPE, John Roddam Spencer 1829-1908

Pre-Raphaelite painter. Pupil of G.F. Watts (q.v.). Exhib. at RA from 1859, NWS, GG, NG and elsewhere. Subjects usually mythological or allegorical. Although deriving inspiration from Burne-Jones, Stanhope evolved a very personal Pre-Raphaelite style, more similar to that of J.M. Strudwick (q.v.). He painted frescoes in the Anglican Church, Florence, Marlborough School Chapel, and the Union at Oxford. In 1880 he moved permanently to Florence. After his death an exhibition of his work was held at the Carfax Gallery in 1909, with a catalogue by William de Morgan (q.v.). Stanhope was uncle and also teacher of Evelyn de Morgan (q.v.). Works by him are in the Liverpool, Manchester and the Tate galleries.

'Morning; and Night' – a pair – sold at Christie's 20.11.70 for £1,995.

Bibl: AJ 1909, p.158 (pl. 155, 159); Studio 35 (1905), 293; 48 (1910) 20; Clement and Hutton; Bate; Morning Post 11.3.1909; A.M.W. Stirling *A Painter of Dreams; The Life of R.S.S. Pre-Raphaelite* 1916; Fredeman; Reynolds VP 69; Maas 146 (pl. p.144).

STANIER, Henry fl.1860-1864

Genre and flower painter. Lived in Birmingham, but was for a time Vice-Consul in Granada, Spain. Exhib. at SS 1860-64. Painted historical genre, flowers, and Spanish views.

'A Bird's Nest, with Bluebells and May Blossom' sold at Christie's 6.3.70 for £105.

STANILAND, Charles Joseph RI ROI b.1838 fl.1861-1911

Painter of genre and historical subjects; illustrator. Born at Kingston-upon-Hull; studied at Birmingham School of Art, Heatherley's, S. Kensington Schools, and the RA Schools in 1861. He drew illustrations for *The Illustrated London News* and for *The Graphic*. Exhib. from 1861, at the RA (from 1863), BI, SS, NWS (62 works) and elsewhere, titles at the RA including 'Fugitives for Conscience Sake' 1877, and 'The Relief of Leyden 1574' 1881. He became A of the RI in 1875, RI 1879, resigned in 1890, ROI 1883-96. The AJ illustrates a historical costume piece 'Henry III of France and the Dutch Envoys', 1884. The VAM has two watercolours : 'Stormy' 1880, two monks standing in a road, the one rebuking the other, and 'Scene near the Coast, with a Group round a Knife-grinder' 1877.

Probable price range £30-100

Bibl: AJ 1884, 136 (pl.); Who's Who 1911; VAM.

STANLEY, Archer fl.1847-1877

Landscape and architectural painter. Son of Caleb Robert Stanley (q.v.) 1795-1868, landscape and architectural painter, and brother of Charles H. Stanley, painter of genre and church interiors who exhib. from 1824-60. Exhib. from 1847-77, at the RA (1847-71), SS and elsewhere, titles at the RA including 'Study of Beech Trees in Knowle Park', 1847, and 'Approaching Storm in the Highlands' 1853

Probable price range £30-100

STANLEY, Caleb Robert 1795-1868

Landscape painter and watercolourist. Father of Archer Stanley (q.v.) and Charles H. Stanley. Honorary Exhibitor at RA 1816-63, mainly exhib. at BI (87 works) SS, OWS, NWS etc. Many of his works are topographical views of towns in England, Scotland, France, Holland and Germany. Works by him are in the VAM and the Nat. Gall. Dublin. His son Charles H. Stanley (fl.1824-60), exhib. landscapes and genre at RA 1824-58, BI and SS. His studio sale was held at Christie's on March 19, 1869.

'On the River Thames' sold at Christie's 13.6.69 for £200.

Bibl: AJ 1868, p.73; Redgrave, Dict.; Bryan; Cundall; VAM Catalogues 1907-8; Col. M.H. Grant *English Landscape Painters* 1925, p.311; Pavière, Landscape pl.73.

STANLEY, Charles H. See under STANLEY, Caleb Robert

STANLEY, Mrs. H.M. See under TENNANT, Miss Dorothy

STANNARD, Alfred 1806-1889

Norwich landscape and marine painter. Brother and pupil of Joseph S. (1797-1830); father of Alfred George (q.v.) and Eloise Harriet (q.v.). Exhib. at BI 1826-60 and SS. Titles at BI mostly views around Norwich, and some on the coast near Yarmouth. Works by him are in Norwich Museum.

'Fisherfolk on a Beach' sold at Sotheby's 11.3.70 for £400.

Bibl: Studio Special No.1920, Norwich School, pl.69; Connoisseur 66 (1923) 178, 129; 67 (1923) 164, 176; DNB; The Year's Art 1890 p.229; W.F. Dickes *The Norwich School of Painting* 1905, p.534-9; Paviere, Landscape pl.74; H.A.E. Day *East Anglian Painters* III 1969, 177-189.

STANNARD, Alfred George 1828-1885

Norwich landscape painter. Son of Alfred S. (q.v.), and brother of Eloise Harriet (q.v.). Exhib. at RA 1856-9, BI and SS. Titles at RA 'The Village Brook' 'Woodlands' 'A Sunny Afternoon' etc. Works by him are in Norwich Museum.

'Sheep and a Horse and Cart on a Road' sold at Christie's 23.6.61 for £73.

Bibl: W.F. Dickes *The Norwich School of Painting* 1905, p.539 f; Col. M.H. Grant *English Landscape Painters* 1925, p.196, 237; H.A.E. Day *East Anglian Painters* III 1969, 191-205;

STANNARD, Miss Eloise Harriet fl.1852-1893

Norwich still-life painter. Eldest daughter of Alfred S. (q.v.) and sister of Alfred George (q.v.). Exhib. pictures of fruit and flowers at RA 1856-93, BI, SS and elsewhere. Three works by her are in Norwich Museum. Member of the Society of Lady Artists. Her pictures of fruit are often compared to those of George Lance (q.v.), who was an admirer of her work. Sometimes confused with Emily S. (q.v.).

'Still Life of Fruit' sold at Bonham's 4.12.69 for £380.

Bibl: AJ 1859, p.170
W.F. Dickes *The Norwich School of Painting* III 1969, 207-221.

STANNARD, Emily (Mrs. Joseph STANNARD) 1803-1885

Still-life painter. Born Emily Coppin, she married Joseph Stannard in 1826. After his death in 1830, she continued to be known as Mrs. Joseph Stannard. Exhib. 4 works at BI 1832-3, otherwise exhib. mainly in her native Norwich. She painted meticulous fruit and

flower pieces, in a traditional Dutch style.

Prices in the last year have ranged from about £200 to £850.

Bibl: H.A.E. Day *East Anglian Painters* III 1969, 223-233.

STANNUS, Anthony Carey fl.1862-1903

London painter of genre, marines and landscapes, who exhib. from 1862-1903, at the RA (1863-1903), BI, SS, GG, and elsewhere, titles at the RA including 'A Young Skipper' 1863, 'View of the City of Mexico' 1868, and 'Evening on the Dogger Bank' 1902. He painted several watercolours (in VAM) of offices and houses at the S. Kensington Museum, dated 1863, e.g. 'Lord Talbot's house, used for Male Schools and Barracks', and 'Refreshment Room, erected by the Commissioners of the Exhibition in 1851'.

Probable price range £50-150

Bibl: The Year's Art 1911, 537; VAM.

HUGHES-STANTON. See under HUGHES

STAPLES, Mrs. John C. b.1839 fl.1862-1908
(Miss Mary Ellen Edwards, also Mrs. Freer)

Painter and illustrator. Exhib. at RA 1862-1908 under her maiden name, and later under both married names; also exhib. at BI, SS, and elsewhere. Titles at RA mostly romantic genre e.g. 'The Last Kiss' 'The First Romance' 'Our Village Beauty' etc. She also illustrated many books and periodicals, including *Good Words, Cornhill Mag., The Graphic, Illustrated London News* etc. In 1866 she married John Freer, who died in 1869. In 1872 she married John Staples. Her main works are listed in Clayton (see bibl.).

Probable price range £30-100

Bibl: Clayton II 75-80; W. Shaw-Sparrow *Women Painters etc.* 1905; Gleeson White, see index.

STAPLES, Sir Robert Ponsonby, 12th Bt. 1853-1943

Irish painter of portraits, genre and landscape, living in Cookstown, Co. Tyrone. Studied at the Louvain Academy of Fine Arts, 1885-70; under Portaels in Brussels, 1872-4; at Dresden, 1867; visited Paris, 1869, Australia, 1879-80. Exhib. from 1875 at the RA, SS, GG and elsewhere. Served as Art Master at the People's Palace, Mile End Road, 1897; Member Union International des Beaux-Arts; The Belfast Art Society. Works include 'Guilty or Not Guilty?' 1883; 'The Emperor's Farewell : The Dying Emperor Wilhelm I' 1888; 'The Last Shot for the Queen's Prize—Wimbledon' 1887 (Worthing Municipal Gallery); 'Mr. Gladstone Introducing the Home Rule Bill, 13th Feb. 1893'; portraits of Mr. Labouchère, J. McNeill Whistler and C.A. Swinburne (NPG); The Queen and King Edward VII; and two Triptychs, illustrating Shipbuilding, for New City Hall, Belfast.

'A Winter Morning in Kensington Gardens' sold at Christie's 11.10.68 for £147.

Bibl: Cat. of Engr. Brit. Portr., BM, 6 (1925) 552; Who Was Who 1941-50.

STARK, Arthur James 1831-1902

Landscape and animal painter. Son of James S. (q.v.). Pupil of his father, also of Edmund Bristow (q.v.) and RA schools. In 1874 studied with F.W. Keyl, animal painter to Queen Victoria. Exhib. at RA 1848-83, BI, SS, NWS and elsewhere. His pictures are usually rustic scenes with farm workers and animals. He lived in Windsor and London, but in 1886 moved to Nutfield, Surrey, where he died. Works by him are in Norwich, Glasgow, VAM & B.M.

Prices in the last two years have ranged from about £100-400.

Bibl: AJ 1859, p.82, 168; Cundall; DNB; W.F. Dickes *The Norwich School of Painting* 1905, p.492 f; VAM Catalogues 1907-8; H.A.E. Day *East Anglian Painters* 1968, II 78-90.

*STARK, James 1794-1859

Norwich landscape painter and watercolourist. Born in Norwich. Studied with John Crome 1811-14. Exhib. at Norwich Society, of which he became a member. Entered RA schools 1817. Exhib. mostly at BI (136 works), also RA 1831-59, SS, OWS, NWS and elsewhere. His style owes much to his master, Crome. Like him, he painted English landscapes, with animals and rustic figures. Due to illness, he returned to Norwich for twelve years, returning finally to London in 1830. His son Arthur James S. (q.v.), was also a painter.

'Woodland Landscape' sold at Sotheby's 19.11.69 for £5,400. This is the current auction record; average prices are usually in the £500-2,000 range.

Bibl: AJ 1850, 182; 1859, 135; Portfolio 1897, 23-4, 37, 42, 46, 93; Studio Special No. 1920, The Norwich School 53-7; W.F. Dickes *The Norwich School of Painting* 1905; Redgrave, Dict. and Cent.; Roget; Bryan; Binyon; Cundall DNB; VAM; Pavière, Landscape pl.75; Clifford; Hardie II 68 et passim (pls. 55-6); Maas 57 (pl.p.55); H.A.E. Day *East Anglian Painters* 1968 II 56-77.

STARLING, Albert fl.1878-1922

Genre, marine and portrait painter, living in Sutton, Surrey. Exhib. from 1878, at the RA (from 1884), SS, NWS and elsewhere, and still exhibiting in 1922. Titles at the RA include 'Student Days' 1885, 'Saved from the Sea' 1888, and 'Called to the Lifeboat' 1891. Represented in the Walker Art Gallery, Liverpool.

Probable price range £30-100

Bibl: RA Pictures 1892, 92 (pl.); The Year's Art 1923, 528.

STARR, Miss Louisa See under CANZIANI, Mrs.

STARR, Sidney RBA 1857-1925

Painter of genre, portraits, landscape and decorative subjects. Born in Kingston-upon-Hull, Yorkshire, died in New York. Exhib. from 1872-89 at the RA (1882-86), SS, NWS, GG and elsewhere, titles at the RA including 'George Wilkinson MA' 1882, 'Sketch, the Fan' 1885, and 'Finchley Road, N.W.' 1886. Awarded bronze medal, Universal Exposition, Paris, 1889. Later he moved to New York. His decorative works include mural decorations for Grace Chapel, New York and twenty-four figures in the Congressional Library, Washington, D.C.

Probable price range £30-100

Bibl: AJ 1890, 154 (pl.); Cat. of Engraved British Portraits BM 4 (1914), 476; American Art Annual 22 (1925) 304; Studio 92 (1926) 42; M. Fielding *Dictionary of American Painters, Sculptors and Engravers*, 1965.

STEAD, Frederick b.1863 fl.1892-1903

Landscape and genre painter. Exhib. at RA 1892-1903. Titles, 'Shades of Evening' 'The Magic Crystal' 'The Princess and the Frog' etc. He lived at Bradford, and works by him are in the Museum there, and at Preston AG.

Probable price range £30-100

Bibl: AJ 1893, p.157; Who's Who in Art.

STEEDMAN, Charles fl.1826-1858

Painter of genre, and of landscape and coastal scenes chiefly in Scotland and the Isle of Wight. Exhib. from 1826-58, at the RA (1826-55), BI and SS, titles at the RA including 'Coast Scene, Forfarshire' 1846, 'A Fish Girl' 1847 and 'The Hay Binder' 1853.

Probable price range £30-100

Bibl: Wilson, Marine Painters.

STEELL, Gourlay RSA 1819-1894

Scottish animal painter. Son of John S. an Edinburgh engraver, and brother of Sir John S., a sculptor. Studied at Trustees Academy, and

with R.S. Lauder (q.v.). Exhib. at RA 1865-80, RSA. Elected ARSA 1846, RSA 1859. Appointed painter to the Highland and Agricultural Society, and also "Animal Painter for Scotland" by Queen Victoria, after the death of Landseer in 1873. This prestige ensured him a virtual monopoly of annual and sporting commissions in Scotland. He also painted genre and historical scenes.

Probable price range £100-300

Bibl: AJ 1893 p.125; DNB; Caw 198-9.

STEEPLE, John RI RBSA fl.1852-86, d.1887

Painter of landscapes and coastal scenes, living in Birmingham and London, who exhib. from 1852-86, at the RA (1852-79), SS, NWS and elsewhere. Titles at the RA include 'The Ford – a Scene on the Dee' 1852, 'Mountain and Moorland, N. Wales' 1874 and 'Curfew' 1879. In the VAM is a watercolour 'Squally Weather on the Welsh Coast'. Elected RBSA in 1862.

'Villagers Crossing a Stream' sold at Sotheby's 6.11.68 for £110.

Bibl: VAM; Birmingham Cat; Wilson, Marine Painters.

STEER, Henry Reynolds RI 1858-1928

Landscape and genre painter and watercolourist. Pupil of Heatherley's 1879-88. At first a lithographer; turned later to oils and then watercolours. He painted literary and historical genre, especially scenes from Dickens, Sheridan and Pepys; also landscape. Exhib. mainly at NWS, also RA 1888-95, SS and elsewhere. Works by him are in Liverpool and Leicester AG.

Probable price range £30-100

Bibl: Connoisseur 87 (1931) 141;
Cundall; Who was Who 1916-28, 1929.

*STEER, Philip Wilson 1860-1942

Painter of landscape, genre and portraits. Born in Birkenhead, Cheshire. Studied at Gloucester School of Art under John Kemp. Entered Academie Julian, Paris, 1882. Returned to London 1884. During this period he painted coastal and beach scenes with figures, mainly at Walberswick and on the French coast. These are generally considered to be his best works, and are among the most interesting impressionist paintings produced by an English artist. In 1886 Steer joined the newly-formed NEAC, where he continued to exhibit for many years. Also exhib. at RA from 1883, SS and GG. Contributed to "London Impressionists" exhibition at Goupil Gallery in 1889. One-man show at Goupil Gall. 1894. After 1900 he turned increasingly to landscape painting. He rarely travelled abroad, preferring to make annual sketching tours of various parts of England, especially Yorkshire. Although Impressionist in technique, his work of this period can be seen as a continuation of the English landscape tradition of Constable and Turner. Steer was teacher of painting at the Slade School for nearly 40 years. His studio sale was held at Christie's July 16-17, 1942.

Usual range for oils £500-2,500, drawings £50-200. A good picture of the 1880's or '90's could well make much more – perhaps up to £10,000.

Bibl: AJ 1906, 231-6; Burlington Mag. 15 (1909) 225-7; Studio 24 (1902) 263-6; 38 (1906) 225-7; 46 (1909) 259-66; also see indexes to vols. 53, 54, 61, 65 and 100; Apollo 4 (1926) 28-31; 21 (1935) 290-2; Artwork 5 (1929) 3-22; VAM; Who's Who; Who's Who in Art 1934; R. Ironside *P.W.S.* 1943; D.S. MacColl *P.W.S.* 1945; (with catalogue of works); Arts Council Exhibition 1960; Reynolds VP 194-5 (pl.135); Maas 250-2 (pls. p.169, 171, 251).

STEERS, Miss Fanny fl.1846-1860, d.1861

London landscape painter, who exhib. from 1846-60 at the NWS (59 works), of which she was a member.

Probable price range £20-60

Bibl: Cundall.

STEPHANOFF, Francis Philip 1790-1860

Painter of genre, historical, biblical and literary subjects, both in oil and watercolour; illustrator; architectural draughtsman. Son of Fileter N. Stephanoff, a Russian painter of portraits and stage scenery, who had settled in London. Entered the RA Schools in 1801; exhib. from 1807-45 at the RA, BI, SS, OWS and elsewhere, titles at the RA including 'Answering an Advertisement – "Wanted a respectable female, as housekeeper to a middle aged gentleman of serious and domestic habits" ' RA 1841 (now in Glasgow Art Gallery). His best works were 'The Trial of Algernon Sidney', 'Cranmer Revoking his Recantation', and 'The Reconciliation'. He furnished most of the costume portraits for George Naylor's sumptuous work on the *Coronation of George IV*, (now in VAM), and obtained a premium of £100 at the Westminster Hall Competition in 1843 for a scene from Milton's *Comus*. Both he and his brother James (q.v.) were men of learning as well as artists, and were considered "two of the best dilettante violins of the day". They worked as architectural draughtsmen in close association with A.C. Pugin and C. Wild, and were among the illustrators of Pyne's *Royal Residences* 1819. They also contributed humorous and sentimental subjects to the popular Annuals of the period – the *Literary Souvenir, Forget-Me-Not, The Keepsake* and others.

'Domestic Happiness' – a picture of Victoria and Albert with their family, sold at Sotheby's 26.6.68 for £320.

Bibl: AJ 1860; 1902, 193-4; Ottley; Redgrave, Dict.; Roget; Burlington Magazine 7 (1905), 265; Binyon; Cundall; DNB; VAM; Cat. of Engraved British Portraits BM 6, 552; The BM Quarterly 8 (1933-4) 140 (with pls.); 9 (1934-5), 104; Reynolds VS 52 fig. 9 (Francis); Hardie III 16 pl.18 (James), pl.19 (Francis).

STEPHANOFF, James 1788-1874

Painter of historical, biblical and literary subjects, exclusively in watercolour; illustrator; architectural draughtsman. Elder brother of Francis Philip Stephanoff (q.v.). Trained for a short time from 1801 at the RA Schools; Exhib. from 1810-59, at the RA (1812-49), BI, SS, OWS (245 works) and elsewhere. Became a member of the OWS in 1819, and retired in 1861 owing to ill-health. He was one of the founders of the Sketching Society. In 1830 he was appointed Historical Painter in Watercolours to William IV. He also contributed to Naylor's *Coronation of George IV*. His subjects, like those of his brother, were largely taken from the Bible, from legends and from the poets, and he excelled in the representation of public ceremonies and historical incidents which required the skilful grouping of large numbers of figures. See also under STEPHANOFF, F.P. (q.v.).

Probable price range £50-250

Bibl: See under STEPHANOFF, F.P.

*STEPHENS, Frederick George 1828-1907

Critic, writer, and painter; member of the Pre-Raphaelite Brotherhood. Stephens and W.M. Rossetti were the two non-artistic members of the PRB, but Stephens did make a few attempts at painting between 1848 and 1850. He exhib. at the RA in 1852 and 1854, both portraits. Most of his works are in the Tate. He wrote for *The Germ*, and devoted the rest of his life to art criticism. He was art editor of *The Athenaeum* for over 40 years, and wrote many catalogues and monographs on artists, including W. Mulready, Alma-Tadema, Landseer and Samuel Palmer.

Owing to the rarity of his work, very difficult to estimate prices. Probably £500-1,000.

Bibl: AJ 1907, p.158;
Athenaeum 1907 No.4142;
J.B. Manson *FGS and the Pre-Raphaelite Brothers* 1920;
Basil Taylor *FGS and PRB* Architectural Review CIV (Oct. 1948) 171-8;
R. Glynn Grylls *The Correspondence of FGS* Times Lit. Supp. No.2875-6.
Fredeman Section 39 and index (for full bibliography);
Reynolds VP; Maas.

STEVENS, Albert fl.1872-1902

London landscape painter. Exhib. mainly at SS, also RA 1877-1902, NWS, GG and elsewhere. Titles at RA include English views, also Switzerland and Italy.

Probable price range £30-100

STEVENS, Alfred 1817-1875

Painter, sculptor, decorator and architectural designer — one of the greatest of all English craftsmen and designers. Born in Blandford, the son of a house painter. In 1833 some friends subscribed to send him to Italy, where he lived for nine years, studying and copying. In Rome he studied under Thorwaldsen. After his return to England, he worked from 1845-7 at the Government School of Design, Somerset House. In 1850 he moved to Sheffield to work as designer for Hoole and Robson, a firm of metal-workers. Stevens was primarily a designer and decorator — among the houses where he worked were Dorchester House, Harewood House and Deysbrook Hall. He produced very few oil paintings, mostly portraits, but many of his drawings, watercolour plans and designs, and bronze models survive. He was a superb draughtsman, and his nude studies in red chalk are among the finest of their kind in English art. Exhib. sculpture at the RA in 1874 and 1876 only. His most famous commission was the Wellington Monument in St. Paul's Cathedral, on which he began work in 1858, and left unfinished at his death. The long years of struggle with unsympathetic officials and the financial hardship, which this commission involved eventually undermined his health, causing his tragic early death. The monument was completed to his designs by pupils — among them Hugh Stannus and James Gamble. An exhibition of his work was held at the Tate Gallery in 1950. (Alfred Stevens should not be confused with the Belgian painter of coastal scenes and interiors, Alfred Stevens, whose dates are 1823-1906).

Oil paintings are very rare, but drawings do occasionally appear on the market. Probable price range £100-500

Bibl: L'Art 1880 (article by W. Armstrong, published as book 1881); Portfolio 1890, 127-132; AJ 1875, 232 (obit); 1902, 385f; 1903, 340f; Burlington Mag. 14 (1908-9), 266-77; Architectural Review 1903, 1911; Redgrave, Dict.; Bryan; Binyon; DNB; VAM; Reynolds VS 87 (pl.71); Hardie III 128 (pl.155); Maas 168 et passim (pls. p.12, 13, 171, 211, 213).

STEVENS, George fl.1810-1865

Still-life and animal painter. Exhib. at SS (246 works) also RA 1810-61, and BI. Titles at RA include still-life pictures of game and fruit; also animal pictures, especially horses and cats.

'Snipe in a Marshy Landscape' sold at Sotheby's 14.5.69 for £300.

STEVENS, John RSA 1793-1868

Scottish genre and portrait painter. Born at Ayr; studied at the RA Schools, where he obtained two silver medals in 1818. After practising portraiture for a time at Ayr, he went to Italy, where he spent the chief part of his artistic career. Foundation member of the RSA. He exhib. in London from 1815-64, at the RA (1815-57), BI and SS, titles at the RA including 'Italian Costume' 1823, 'Capuchin Friar' 1834 and 'Portrait of a Lady of Quality' 1851. 'The Standard-Bearer' is in the National Gallery, Edinburgh. He died in Edinburgh after a railway accident in France. The AJ says of his 'Scene at Bethlehem — the Infant Jesus Sleeping Watched over by an Angel' (SS 1859): "The treatment and tone of the picture seem to be suggestive of the Bolognese School".

Probable price range £30-100

Bibl: AJ 1859, 141; Redgrave, Dict.; Bryan; Cat. of Engr. Brit. Portr., BM 2 (1910), 409, 658.

STEVENS, Walter Rupert fl.1874-1891

London landscape painter, who exhib. from 1874-91, at the RA (1885-91), SS, NWS, NG and elsewhere, titles at the RA including

'A Surrey Common' 1885, 'A Sussex Hayfield' 1889 and 'March' 1891.

Probable price range £30-70

STEVENSON, William Grant RSA 1849-1919

Sculptor; painter of animal subjects. Brother of David Watson Stevenson, 1842-1904, sculptor. Studied at the Royal Institution, Edinburgh and at the RSA Life School; ARSA 1885; RSA 1896. His important works in sculpture were the statues of Robert Burns at Kilmarnock, Denver and Chicago and the statue of Sir W. Wallace in Duthie Park, Aberdeen, 1883. The AJ, however, considered "his best work has been modelled in silver and on a small scale" e.g. 'The Return of the Spies with the Grapes of Eshcol' for the Marquis of Bute. Caw said of his paintings : "he has painted incidents amongst puppies and poultry with obvious humour but in a hard and uninteresting style, and cold and unsympathetic colour". He exhib. from 1874-95 at the RA, BI and elsewhere.

Probable price range £30-100

Bibl: AJ 1885, 335 (pl.); 1898, 72, 128 (pl.), Caw 340; Who Was Who 1916-28.

STEWART, George fl.1851-1885

London painter of landscape and architectural subjects, who exhib. from 1851-85, at the RA (1851-84), SS and elsewhere, titles at the RA including 'Rochester Cathedral' 1851, 'A River Scene' 1860, and 'Harvest Time, Rustington, Sussex' 1884.

Probable price range £30-100

STEWART, James RSA RBA 1791-1863

Engraver; painter of portraits, landscape and genre. Born in Edinburgh, articled to Robert Scott, the engraver; also studied drawing in the Trustees' Academy, and became a very able line engraver. He engraved many of Sir William Allan's paintings, e.g. 'Circassian Captives' 1820 and 'The Murder of Archbishop Sharpe' 1824, and later Sir David Wilkie's, e.g. 'The Penny Wedding'. He became a foundation member of the RSA in 1826. In 1830 he moved to London. In 1833, due to lack of money, he emigrated to Cape Colony where he settled as a farmer, but within a year lost everything through the outbreak of the Kaffir War. He then went to live in Somerset, Cape Colony where he taught and painted portraits. He died in the Colony. He exhib. in London from 1825-61, at the RA (1825-59), BI and SS (148 works). Throughout this period London addresses are given in Graves, R. Acad. Titles at the RA include 'Hop Picking near Gravesend' 1850, 'Sunset' 1854, and 'Sheridan Knowles Esq.' 1858.

'Hop Picking in Kent' sold at Christie's 11.10.68 for £315.

Bibl: AJ 1863, 165; Redgrave, Dict.; DNB; *Fine Arts' Quarterly Review* 2, 1864, 209; *Le Blanc Manual de l'Amat. d'est.*, 3, 1888; *The Print Collector's Quarterly* 16, 1929, 273.

***STILLMAN, Mrs. William J. (Maria Spartali) 1844-1927**

Pre-Raphaelite painter. Pupil of Ford Madox Brown. Used as model by Rossetti. Exhib. at RA 1870-77, SS, NWS but more frequently at GG and NG. Her style shows a combination of Pre-Raphaelite influences, but mostly that of Rossetti. She married the American journalist William J. Stillman, also a member of the Rossetti circle.

'Portrait of a Girl' sold at Christie's 3.4.69 for £168.

Bibl: Portfolio 1870 p.118 f; Studio 30 (1904) 254 f; Clement and Hutton; W.M. Rossetti *English Painters of the Present Day* 1871; Clayton II 135-7; Bate 112 (2 pls.); Fredeman; Reynolds VP 16, 152; Maas 146 (pl. p.145).

STIRLING, John 1820-1871

Aberdeen painter of portraits and genre, fairy tale and literary subjects, and subjects in Morocco. After 1855 his addresses vary between London and Aberdeen. 1868-9 he visited Morocco. He exhib. in London from 1852-71, at the RA and BI, titles at the RA including 'The Princess and the Seven Dwarfs' 1859, and 'Ablution; Scene in

Morocco' 1870. Ruskin noted 'Scottish Presbyterians, in a Country Parish Church — the Sermon' (RA 1855): "A very noticeable picture, showing careful study and good discrimination of expression. But the painter cannot yet do all he wants to do; he should try to work more delicately, and not attempt so much at once."

Probable price range £100-300

Bibl: J. Ruskin *Academy Notes* 1855
G.M. Fraser *Aberdeen Journal* 7.7.1934

STOCK, Francis R. fl.1875-1884
London painter of fruit and genre, who exhib. from 1875-84 at the RA, SS, and elsewhere, titles at the RA including 'Apples' 1875, 'A Foundling' 1877 and 'St. Valentine's Day' 1882.

Probable price range £30-70

STOCK, Henry John RI ROI 1853-1930
London painter of genre, portraits and imaginative subjects, who exhib. from 1874 at the RA, NWS, GG and elsewhere. Titles at the RA include 'Good and Evil Spirits Fighting for Man's Soul' 1882, 'Death Turning away from the Innocence of a Child' 1894 and 'The Red Apple' and 'Listening to Brahms' 1901. Studied at the RA Schools; RI in 1880; Hon. Member of the Society of Miniaturists. The *Connoisseur* said in his obituary: "Mr. Stock's Watts-like compositions were well-known features at the RI exhibitions".

Probable price range £30-100

Bibl: Cat. of Engr. Brit. Portr., BM, 6 (1925) 552;
Connoisseur 87 (1931) 61; Who was Who 1929-40.

STOCKS, Arthur RI 1846-1889
Genre and portrait painter. Son of Lumb S. the famous Victorian engraver. Studied with his father, and at RA schools. Exhib. at RA 1867-89, BI, SS, NWS and elsewhere. Elected RI 1882. Titles at RA often sentimental or humorous e.g. 'Her Sweetest Flower' 'On the Sick List' 'Saved from the Snow' etc. A portrait of his father is in the Macdonald Collection, Aberdeen AG. and two works are in the Walker AG. Liverpool. Both his brothers Bernard O.S. and Walter Fryer S. (q.v.) were painters.

'Her Sweetest Flower' sold at Bonham's 5.2.70 for £300.

Bibl: AJ 1889 p.364; DNB; Bryan; Cundall.

STOCKS, Walter Fryer fl.1862-1903
Landscape, topographical and still life painter. Son of Lumb Stocks, the engraver, and brother of Arthur S. (q.v.). Exhib. at RA 1862-1903, BI, SS, NWS and elsewhere. Titles at RA include landscape views in many parts of England, views of castles, towns and old buildings, and still life. Two watercolours by him are in the VAM.

Probable price range £50-150

Bibl: DNB 54 (1898) 393; VAM 1908 Cat. of Watercolours; Pavière, Landscape pl.77.

STOKES, Adrian Scott RA VPRWS 1854-1935
Painter of landscape, portraits, genre, historical and literary subjects. Born at Southport; brother of Leonard Aloysius Scott Stokes, 1858-1925, the architect; studied at the RA Schools 1872-5, and in Paris under Dagnan-Bouveret, 1885-6. Exhib. at the RA from 1876, and also at SS, OWS, NWS, GG and elsewhere; member of NEAC 1887; ARA 1910, RA 1919; Vice-President of the RWS 1933. Painted in Britain, Spain, France, Italy, Austria and Holland. Married the Austrian painter Marianne Preindlsberger in 1884, and first exhibited with her at the FAS in 1900. Author of *Hungary*, 1909, and *Landscape Painting* 1925. The Tate Gallery has 'Uplands and Sky' 1888, and 'Autumn in the Mountains' 1903, both Chantrey Purchases.

Prices in the last two years have ranged from about £150-350.

Bibl: W. Meynell 'Mr. and Mrs. Adrian Stokes' AJ 1900, 193-8 (pls.); Tate Cat.

STOKES, Mrs. Adrian (Marianne Preindlsberger) 1855-1927
Painter of genre, biblical subjects and portraits in a semi-decorative style very similar to that of Arthur Gaskin, J. Southall and the Birmingham Group of Artists. Born in Southern Austria, she studied in Munich under Lindenschmidt, worked in France, and later came to England where she married Adrian Stokes (q.v.) in 1884. Exhib. from 1883 at the RA, SS, GG, NG and elsewhere. Two of her best known works are 'St. Elizabeth Spinning for the Poor' and 'Little Brother and Little Sister' (reprd. Studio 1901). She often painted in gesso and tempera, using a bought preparation known as "Schoenfield's tempera" upon an unpolished ground, producing almost the appearance of fresco on a rough plaster wall.

Probable price range £50-250

Bibl: AJ 1900, 193-8; Studio 23 (1901) 157 (pl.); 43 (1908) 82 (pl.); 47 (1909) 54 (pl.); Magazine of Art 1901, 241-6; Shaw Sparrow *Women Painters of the World* 1905 (2 pls.); Connoisseur 61 (1921) 177; 63 (1922) 112; 66 (1923) 50; 79 (1927) 127 (obit).

*STONE, Frank ARA 1800-1859
Painter of historical genre and portraits, and illustrator. Born in Manchester. Began to study art at the age of 24. Came to London 1831. At first concentrated on watercolours, but later turned to oil painting. Elected ARWS 1837, RWS 1843, resigned 1847. Exhib. at RA 1837-60, BI, SS, and OWS. Subjects mostly sentimental genre, in historical costume, e.g. 'The Last Appeal' 'The Tryst' 'The Course of True Love' etc. Stone was a specialist in the type of 'Keepsake' beauty so disliked by the Pre-Raphaelites. Both he and his son Marcus S. (q.v.) were friends of Dickens. Elected ARA 1851.

'The Gamekeeper's Son' sold at Sotheby's 31.7.69 for £140.

Bibl: AJ 1856 p.333-6; 1860, 9 (obit.); Connoisseur 62 (1922) 175; Redgrave, Dict.; Roget; DNB; W. Sandby *Hist. of the RA* 1862; Reynolds VS, and VP passim (pl.74); Maas 107, 239, (pl. p.109).

*STONE, Marcus RA 1840-1921
Historical genre painter and illustrator. Son and pupil of Frank S. (q.v.). Exhib. at RA from 1858, and elsewhere. Elected ARA 1876, RA 1886. Mainly painted genre scenes set in eighteenth century or Empire costume. The themes are usually dramatic, sentimental, or sometimes humorous. RA titles 'Rejected' 'The First Love Letter' 'A Stolen Kiss' etc. 'Il y a Toujours un Autre' (RA 1882) was bought by the Chantrey Bequest for £800. In his own day, Stone's pictures were much admired, and fetched high prices. He illustrated *Our Mutual Friend* for Dickens, and worked for *Cornhill Magazine*. Works by him are in many English museums.

Prices during the last two years have ranged from about £100-675.

Bibl: AJ 1869 p.33-5; 1885, 68-72; 1895, 217f; Connoisseur 60 (1921) 59f; Clement and Hutton; R. Muther *Gesh. d.Malerie in 19th c.* 1893-4; F.V. Boetticher *Malerwerke d. 19th c.* 1901 p.845f; Reynolds VP 112, 180; Maas 239 (pl. p.242).

STONEHOUSE, Charles fl.1833-1865
London painter of genre, portraits, historical, literary and biblical subjects; engraver. Exhib. from 1833-65 at the RA, BI and SS. Titles at the RA including 'Mary Queen of Scots Forced into Signing the Resignation of the Crown' 1843, 'Our Saviour Reproving Martha' 1846, and 'Jersey Peasant Girl at a Fountain' 1849.

Probable price range £30-100

Bibl: Cat. of Engr. Brit. Portr., BM 2 (1910) 170, 190.

STONEY, Charles B. fl.1879-1893
Painter of landscape, flowers, portraits and architectural subjects, living in London, Malmesbury, Newton Abbot and Parkstone, Dorset. Exhib. from 1879-93, at the RA (1881-93), SS, NG and elsewhere, titles at the RA including 'Anemones' 1881, 'Malmesbury Steeple'

1884, and 'Brixham Trawlers' 1890.

Probable price range £30-80

STOREY, George Adolphus ARA 1834-1919

Genre and portrait painter. Pupil of J.L. Dulong. Exhib. at RA from 1852, BI, SS, NWS and elsewhere. His early works are Pre-Raphaelite in feeling, but he later turned to portraits and more conventional genre e.g. 'Rosy Cheeks' 'Lesson of Love' 'The Love Letter' etc. and historical genre. Storey lived in St. John's Wood, and was a member of the St. John's Wood Clique, until he moved to Hampstead. Elected ARA 1875. In 1899 he published his autobiography (see bibl) a valuable source of information about the Clique.

'Follow My Leader' sold at Christie's 22.4.66 for £115.

Bibl: AJ 1875 p.173-6; Tatler No. 369 v. 22.7, 1908 p.92f; Clement and Hutton; Bate 90 (with pl.); G.A. Storey *Sketches from Memory* 1899; Bevis Hillier *The St. John's Wood Clique* Apollo June 1964.

*STOTT, Edward ARA 1858 (1859?)-1918

Painter of landscape and rustic genre. Born in Rochdale. Studied in Paris under Carolus-Duran and Cabanel. Came under the influence of Bastien-Lepage, and also Millet. On his return to England, he lived at Evesham, Worcs, and later Amberley, Sussex. Following the example of Millet, he painted scenes of everyday life in the country, in a *plein-air* style similar to that of Clausen and La Thangue (q.v.). He made careful studies for all the figures and animals in his pictures, usually in chalk. Exhib. at RA from 1883, GG, NG, NEAC and elsewhere. Elected ARA 1906.

'The Inn, Evening' sold at Christie's 10.7.70 for £651.

Bibl: AJ 1889 p.294-8 (A.C.R. Carter); Studio 6 (1896) 70-83 (J.S. Little); 55 (1921) 1-10; Mag. of Art 1901 p.28 f; Who was Who 1916-28; Maas 253 (pl. p.254).

*STOTT, William (of Oldham) RBA 1857-1900

Landscape and figure painter. Born Oldham, near Manchester; called Stott of Oldham to avoid confusion with Edward S. (q.v.). Went to study in Paris 1879. Worked in the studio of J.L. Gérôme, and exhib. with success at the Paris Salons of 1881 and 1882. Returned to London and exhib. at RA 1882-99, SS, GG, NG and elsewhere. Painted landscapes, mountain scenery, portraits, and also ideal figure compositions in the style of Gérôme e.g. 'Diana, Twilight and Dawn' 'The Awakening of the Spirit of the Rose' etc. Works by him are in Glasgow and the Walker AG. Liverpool. 'The Bathing Place' (RA 1891) one of his best works is in the New Pinakoteck, Munich. His portraits and interiors contain echoes of Whistler and Manet.

'View across the Plough, Autumn' – a gouache – sold at Christie's 18.7.69 for £105. Oils would be likely to make more – perhaps £200-500.

Bibl: AJ 1900 p.124; Studio 4 (1894) 1-15 (R.A.M. Stevenson); Mag. of Art 1902 p.81 f; Maas 253 (pl. p.257).

STRANGE, Albert fl.1878-1897

Painter of genre, landscape and coastal scenes, living in Maidstone and Scarborough. Exhib. from 1878-97, at the RA (1881-97), SS, NWS and elsewhere, titles at the RA including 'Deserted' 1882, 'Moonrise and Sea Mist, St. Valery' 1886, and 'A Fisherman's Haven' 1897.

Probable price range £30-80

STREET, Miss Kate fl.1880-1902

London painter of birds and flowers, who exhib. from 1880-1902 at the RA, SS, NWS and elsewhere, titles at the RA including 'Wren and Nest' 1880, 'Dividing the Spoil' 1885, 'Found Dead' 1891, and 'Clematis' 1901.

Probable price range £20-60

STRETTON, Philip Eustace fl.1884-1904

London painter of animals, sporting subjects and genre, who exhib. from 1884-1904 at the RA, SS and elsewhere, titles at the RA including 'Disturbed' 1884, 'The Apple of Discord' 1889 and 'The Pet of the Kennel' 1901.

Probable price range £50-150

Bibl: Pavière, Sporting Painters.

*STRUDWICK, John Melhuish 1849-1935

Pre-Raphaelite painter. Studied at S. Kensington and RA Schools, where he met with very little success. He then worked as a studio assistant for Spencer Stanhope and Burne-Jones. This gave his work the direction which it needed, and he evolved a very personal Pre-Raphaelite style. His subjects were derived mainly from Burne-Jones — mythological and allegorical figures — with poetic titles e.g. 'The Ramparts of God's House', 'The Gentle Music of a Bygone Day' 'Golden Strings' 'Elaine' etc. but his technique was quite different. He painted in a flat linear style, with great attention to detail, especially in the draperies and accessories, using rich and glowing colours. The effect is sometimes rather lifeless and static, but always highly decorative. Exhib. mostly at GG and NG, also at RA, SS and elsewhere. George Bernard Shaw wrote an article on Studwick for the *Art Journal* of 1891 (see bibl) in which he wrote "transcendent expressiveness is the moving quality in all Strudwick's works and persons who are sensitive to it will take almost as a matter of course the charm of the architecture, the bits of landscape, the elaborately beautiful foliage, the ornamental accessories of all sorts, which would distinguish them even in a gallery of early Italian paintings."

'Evensong' sold at Sotheby's 19.11.69 for £2,400.

Bibl: AJ 1891 p.97f (G.B. Shaw); Who's Who 1929; Who's Who in Art 1934; Bate 112-14 (3 pls.); Maas 146.

STRUTT, Alfred William RBA ARPE 1856-1924

Animal, genre and portrait painter. Son and pupil of William S. (q.v.). Born Tanaraki, New Zealand. Studied at S. Kensington School. Exhib. at RA from 1879, SS, NWS and elsewhere. Titles at RA 'Her First Litter' 'The King's Pillow' 'Oliver Asks for More' etc. Accompanied King Edward VII on a hunting trip to Scandinavia.

Probable price range £30-100

Bibl: Connoisseur 68 (1924) 243 (obit.)
Who Was Who 1916-29
Cat. of 'The Strutt Family' Exhibition, Carlisle City AG. 1970.

STRUTT, Jacob George fl.1819-1858

Landscape and portrait painter. Travelled in Austria, Switzerland and Italy, returned to England 1851. Exhib. at RA 1819-58, BI and SS. Painted portraits, Italian views, and landscapes, especially woods and forests. He also illustrated books on trees, such as *Sylvia Britannica* 1822. Does not seem to have been related to William S. (q.v.) or any others of the Strutt family.

Probable price range £30-100.

Bibl: DNB; Bryan.

STRUTT, William RBA 1826-1915

Genre, animal and portrait painter. Son of William Thomas S. (1777-1850) a miniaturist, and father of Alfred William S. (q.v.). Studied at the Beaux-Arts in Paris, where he developed an early interest in animal painting. Went to Australia in 1850, where he produced his *Australian Journal* and the *Illustrated Australian Magazine*. He also made studies of Australian life, which are among the earliest records of the colonial days. Visited New Zealand 1856, and returned to England 1862. Exhib. at RA from 1865, BI, SS and elsewhere. He painted genre and also religious subjects, but his best works were his sympathetic studies

and drawings of animals. His daughter Rosa S. was also an animal and flower painter.

'Returning from the Harvest Field' sold at Bonham's 5.6.69 for £160 Usual range for drawings £10-70.

Bibl: Connoisseur 41 (1915) 170 (obit.)
Cat. Nat. Gall. Melbourne, Australia
Cat. of 'The Strutt Family' Exhibition, Carlisle City A.G. 1970

STUART, Charles 1880-1904

London painter of landscape and marine subjects, who exhib. from 1880-1904 at the RA, titles including 'The Summit of Cader Idris, N. Wales' 1880, and ' "Break, break, break at the foot of thy crags, O sea!" (Tennyson)' 1884. Paintings by him are in Derby and Sunderland Art Galleries.

Probable price range £30-100.

Bibl: Art Dazu. Academy Notes 1882; RA Pictures 1893-6

STUART, Charles fl.1854-1868

Painter of fruit, still-life and landscape, living in Stepney and Gravesend, who exhib. from 1854-67 at the BI, and from 1859-68 at the RA. Titles at the RA include 'Fruit' 1859, 'The Baron's Dessert' 1861, and 'Parian Vase and Fruit' 1862. His wife was Miss J.M. Bowkett (q.v.), the genre painter. In Graves Dict. he and Charles Stuart (q.v.) are amalgamated under one name with the dates 1854-93. This leads to confusion in other dictionaries.

'Still Life of Fruit' sold at Phillips 18.7.69 for £170. Other prices ranged from about £150-170.

STUART, Mrs. Charles F.S.A. See Bowkett, Miss J.M.

STUART, W.E.D. fl.1846-1858

Still-life painter. Lived in Stepney, London. Exhib. mainly at BI and SS, also RA 1846-58. Titles mostly fruit and flowers, and occasional genre e.g. 'The Gondola-night' 'Their Majesties the Emperor and Empress of Lilliput' and 'The Thames off Limehouse' etc.

'Still Life of Fruit' sold at Phillips 8.9.69 for £130.

STURGESS, John fl.1875-1884

Little known sporting and animal painter. Exhib. at SS and elsewhere.

'Steeple-chasing' sold at Christie's 17.12.69 for £200.

SUKER, Frederick Harrison. See NEWCOMBE, Frederick Clive

SURGEY, J.B. fl.1851-1883

Painter of landscape, genre and architectural subjects, living in London, Chigwell, Essex; Cranford Bridge, Middlesex and Bridge Bourton, Dorset. Exhib. from 1851-83, at the RA (from 1852-83), BI, SS, and elsewhere, titles at the RA including 'Leaving the Temple church' 1852, 'The House that Jack Built, on the Coast of Suffolk' 1864, and 'A Rustic Relic, New Forest' 1883.

Probable price range £30-100.

SURTEES, John 1819-1915

Landscape and rustic genre painter. Lived in London and Newcastle, and later Cannes. Exhib. at RA 1849-89, BI, SS, and elsewhere. Painted landscapes in N. Wales, Scotland, and elsewhere, and also rustic genre. Works by him are in Cardiff, Sunderland, and the Laing AG. Newcastle.

'Iffley Mill' sold at Sotheby's 12.3.69 for £260.

Bibl: AJ 1904 p.106. 108, 310
Cat. of Perm. Coll. of Watercolours, Laing AG. Newcastle 1939.

SUTCLIFFE, Miss Hariette fl.1881-1907

Hampstead painter of genre and portraits, who exhib. from 1881-1907 at the RA (1881-1899) and elsewhere. Titles at the RA include 'After the Bath' 1891, 'As Rosy as a Pippin' 1895 and 'Beauty and the Beast' 1899.

Probable price range £20-60

SUTCLIFFE, Thomas 1828-1871

Watercolour painter of landscape, marines and still-life. Born in Yorkshire, studied at the RA Schools. Exhib. in London from 1856-71, at the RA (only one work in 1856) and NWS (109 works), titles at the NWS including 'Early Spring' 1857 and 'A Study in Winter, Adel Moor' 1858. Elected A. of the NWS in 1857. Watercolours by him are in the VAM, Leeds Art Gallery and the Ferens Art Gallery, Hull. In his obituary the AJ said: "His pictures are not of the highest order; but they gained as they merited, attention from their truthfulness and poetic feeling. Mr. Sutcliffe was a native of Yorkshire, and lived many years in the neighbourhood of Leeds and latterly at Whitby".

Probable price range £20-60

Bibl: Ruskin Academy Notes (NWS 1857, 1858); AJ 1872, 48 (obit.); Redgrave Dict.; Cundall 260; Cat. of City Art Gallery Leeds 1909; VAM; Wilson, Marine Painters.

SUTHERLAND, Miss Fanny fl.1876-1886

London painter of portraits, interiors and topographical subjects, who exhib. from 1876-86, at the RA (1877-83), NWS and elsewhere. Titles at the RA include 'A Corner of the Study, Hardwick Hall' 1879 and 'A Stately Home of England' 1881.

Probable price range £30-100

***SWAN, John Macallan RA 1847-1910**

Animal painter and sculptor. Studied at Lambeth School of Art, and RA schools. Studied in Paris with Gérôme and the sculptor Frémiet. Also much influenced by Barye. Exhib. at RA from 1878. In 1889 'The Prodigal Son' was bought by the Chantrey Bequest. Also exhib. at GG, NG and elsewhere. Elected ARA 1894, RA 1905. He is best known for his superb studies of lions, leopards and tigers, executed in rapid pen and wash drawings, pastels, oils, or in bronze. He did also paint landscapes and allegorical figure subjects, but his true vocation was to paint wild animals.

Probable price range £50-200. A bronze of a leopard sold at Christie's 10.7.70 for £199.

Bibl: AJ 1894 p.17-22 (R.A.M. Stevenson); Studio II (1897) 236-42; 22 (1901) 75-86, 151-61 (A.L. Baldry); M.H. Spielman *Brit. Sculpture and Sculptors of Today* 1901); DNB; Maas 82 (with pl.).

SWARBRECK, Samuel Dukinfield fl.1852-1863

London painter of architectural subjects and interiors, who exhib. from 1852-63, at the RA (1852-62), BI, SS and elsewhere. Titles at the RA include 'Bedroom of Mary Queen of Scots, Holyrood Palace' 1856. 'Watergate Row, Chester' 1854, and 'Interior of St. John's Church, Chester' 1856. The AJ said of 'Rosslyn Chapel' (Portland Gallery 1859) "one of the best pictures of this famous relic that we remember to have seen".

Probable price range £30-100

Bibl: AJ 1859, 122.

SWINGLER, John Frank fl.1886-1900

London painter of still-life, flowers, fruit and fish, who exhib. from 1886-1900 at the RA, SS, and elsewhere, titles at the RA including 'Roses' 1887, 'Herrings and Smelts' 1891, and 'Lemons and Nuts' 1899.

Probable price range £30-80

SWINSTEAD, George Hillyard RBA RI 1860-1926

Painter of portraits, genre and coastal scenes. Fourth son of Charles Swinstead, landscape painter, and brother of Alfred Hillyard Swinstead who exhib. from 1874-97 at the RA. Exhib. from 1877 at SS and elsewhere, and from 1882 at the RA. RI in 1908. Entered RA Schools in 1881, and in 1882 exhib. for the first time at the RA with 'By Appointment'. Although for many years his principal work consisted of portraits and genre, he also devoted much time to coastal scenes, and latterly exhibited little else, (for these see Nettlefold Collection). 'When Trumpets Call, then Homes are Broken', RA 1883, is in Sheffield Art Gallery. He also belonged to the Painter Stainer's Company, and was author of *My Old-World Garden* and *How I Made it in a London Suburb*.

Probable price range £30-100

Bibl: Connoisseur 74 (1926) 189 (obit); Who Was Who, 1916-1928; Wilson Marine Painters.

SWINTON James Rannie 1816-1888

Scottish portrait painter, one of the most fashionable of his day. In 1838 he was allowed to train as an artist, and in Edinburgh was much encouraged by Sir William Allan and Sir John Watson-Gordon, and worked in the latter's studio. Studied at the Trustees' Academy; in April 1839 went to London; in 1840 entered the RA Schools and also went to Italy where he remained for about three years, visiting Spain. At Rome he found many sitters and laid the foundation of his subsequent popularity as a painter of the fashionable beauties of his day. On his return to London, he settled in Berners St., and soon had a thriving practice. His portraits are chiefly life-sized boldly executed crayon drawings, although many of them were completed subsequently in oils. One of his best-known paintings was the large portrait group of the three beautiful Sheridan sisters, the Countess of Dufferin, the Hon. Mrs. Norton and the Duchess of Somerset. He also drew and painted the portraits of eminent men with great success, among them being Louis Napoleon (Napoleon III), Lord Stratford de Redcliffe, the Duke of Argyll and others. He exhib. from 1844-74 at the RA, BI and SS — all portraits.

Probable price range £30-60

Bibl: Bryan; DNB
Cat. of Engr. Brit. Portr. BM 6 (1925) 554 692

SWYNNERTON, Mrs. Joseph William ARA 1844-1933
(Annie Louisa Robinson)

Painter of allegorical and symbolical pictures of Italy, portraits, and pictures of children. Born at Kersal, near Manchester, daughter of a Manchester solicitor, studied at the Manchester School of Art, Paris and Rome, exhib. at the RA from 1879, and also at GG, NG and elsewhere. Married Joseph Swynnerton, a Manx sculptor, in Rome, 1883. Lived for the most part in Rome until the death of her husband in 1910. Influenced by G.F. Watts, and her work also shows affinities with the French Impressionists. Elected ARA, 1922, being the first woman to receive academic honours since 1768, when Angelica Kauffman and Mary Moser became foundation members of the RA. Died at Hayling Island. Sargent bought and gave 'The Oreads' to the Tate Gallery, and three of her paintings were bought by the Chantrey Bequest for the Tate: 'New Risen Hope' 1924, 'The Convalescent' 1929 and 'Dame Millicent Fawcett' 1930.

'Three Fishergirls' sold at Christie's 6.3.70 for £241.

Bibl: AJ 1908 174 (pl.); W. Shaw-Sparrow *Women Painters of the World* 1905 71; Connoisseur 50 (1918) 51; 54 (1919) 173; 66 (1923) 112; 72 (1925) 126; 93 (1934) 59; *American Art News* 20 (1922) No. 27. 5; 21 (1922-3) No. 10. 3; No. 11 5, *The Art News* 22 (1923-4) No. 2 3; No. 21 8; 32 (1933-4) No. 4 10; Studio 85 (1923) 44; Birmingham Cat.

SYER, James fl. 1867-1878

Painter of coastal scenes. Son of John S. (q.v.) Exhib. mainly at SS, also at RA 1872-3. Titles 'An Autumn Day on the Cornish Coast' etc.

Probable price range £20-100

SYER, John RI 1815-1885

Landscape painter. Father of James Syer (q.v.). Studied with J. Fisher, a miniaturist in Bristol. Exhib. at RA 1846-75, BI, SS, NWS, GG and elsewhere. Painted landscapes and coastal scenes with figures, often in Devon and Wales. Works by him are in Bristol, Leeds, Leicester and Sheffiled AG. His studio sale was held at Christie's on March 22, 1886,

Prices in the last few years have ranged from about £100-500.

Bibl: Bryan; Cundall; Wilson, Marine Painters pl.38
Pavière, Landscape pl. 78

SYKES, Henry RBA fl.1877-1895

Painter of landscape and genre, who exhib. from 1877-95, at the RA, SS, NWS, NG, and elsewhere, titles at the RA including 'In Fixby Park, Yorks' 1877, 'Summer Roses' 1887, and 'Idlers' 1889. One of his paintings is in Cardiff Museum.

Probable price range £30-100.

SYMONDS, William Robert 1851-1934

Portrait painter. Born in Yoxford, Suffolk; in the 1920's living in Brook Green. Studied in London and Antwerp. Exhib. from 1876 at the RA, GG, NG, and elsewhere. His portraits are in the Wallace Collection (Sir Richard Wallace); Army Medical School (4); Queen's College, Belfast; Town Hall, Ipswich; Royal Victoria Hospital, Netley; and Oriel College, Magdalen College and Pembroke College, Oxford.

Probable price range £50-150

Bibl: Austin Chester 'The Art of Mr. W.R.S.' *Windsor Magazine* 1910 No. 184 577-92; Supplement to *The Graphic* 1.1.1913; R.L. Poole *Cat. of Portraits........ Oxford* 3 (1925) 342; The Year's Art 1928

SYMONS, William Christian 1845-1911

Decorative designer, and painter, in oil and watercolour, of portraits, genre, landscape, still life, flowers, and historical subjects. Sent at an early age to Lambeth School of Art, and in 1866 entered the RA Schools. Exhib. from 1865, at the RA (from 1869), SS, NWS, GG, NRAC, ROI and elsewhere, titles at the RA including 'Lily' 1869, 'Studies for Decoration', 'Diana Hunting' and 'The Triumph of Bacchus' 1878, 'Margaret of Anjou and the Robber of Hexham' 1882, and 'Electricians' 1898. In 1870 became an RC and began his long connection with the firm of Lavers, Barraud and Westlake for whom he designed stained glass. RBA in 1881 but resigned with Whistler in 1888. Acted as Secretary to the celebrated dinner organized in honour of Whistler on 1 May 1899. From 1899 executed mosaic decorations at Westminster Cathedral (Holy Souls' Chapel; outer wall l. transept, rood; altar mosaic, crypt) which were unfairly criticized at the time for their over-emphasis of pictorial illusion. Worked at Newlyn in Cornwall for some time, and though not a member of that school, he contributed an account of it to the AJ in April 1890. In later life he lived almost entirely in Sussex. He was better known as a decorative designer than as a painter; he executed the spandrels at St. Botolph's Bishopsgate, and one of his best oils is 'The Convalescent Connoisseur' in Dublin Municipal Art Gallery. His flower pieces were also particularly good. Symons was obviously influenced by Sargent and Brabazon, but preserved his own individuality and did not allow his art to be influenced by Whistler. A posthumous exhibition of his paintings and watercolours was held at the Goupil Gallery in 1912. In the Mappin Art Gallery, Sheffield are 'In Hora Mortis' and 'Home from the War'.

Probable price range £50-200

Bibl: AJ 1909 28 (pl.); The Times 5.2.1912; The Morning Post 6.2.1912; The Standard 6.2.1912; DNB 2nd Supp. 1913.

***TAIT, Robert S.** fl.1845-1875

London portrait and genre painter. Exhib. at RA 1845-75 and once at BI. Titles at RA mostly portraits, and occasional Italian genre subjects e.g. 'Florentine Boy' 1865 'The Future Still Hides in it Gladness and Sorrow' 1866 etc. His best-known work is 'Thomas and Jane Carlyle in the Drawing Room of their House in Cheyne Row' which hangs in Carlyle House, Cheyne Row.

Probable price range £50-200, although a picture such as the Carlyles' portrait is obviously worth a great deal more.

Bibl: AJ 1859, 165, 169; Cat. of Engraved Brit. Portraits, BM, 6 (1925) 554; Reynolds VP 79 (pl. IV).

TALFOURD, Field 1815-1874

Painter of portraits and landscape, and occasionally of genre. Born at Reading, the younger brother of Mr. Justice Talfourd. Exhib. from 1845-74, at the RA, (1845-73), BI and elsewhere. His works were chiefly portraits, but from 1865-73 he also exhibited landscapes. Other titles at the RA include 'A Roman Peasant' 1859, and 'The Fisher Boys' 1870. His portrait of Elizabeth Barrett Browning and Robert Browning, 1859, is in the NPG. The AJ noted that "as a painter of portraits and landscapes he obtained considerable reputation."

Probable price range £50-150

Bibl: AJ 1874, 154 (obit.); Bryan; Cat. NPG 2 1902, 289; Cat. Engr. Brit. Portr. BM 6 1925.

TAYLER, Albert Chevallier 1862-1925

Genre and portrait painter. Studied at Heatherley's and the RA; also in Paris. Exhib. at the Paris Salon 1891. Lived for 12 years in Newlyn, Cornwall, before settling in London. Exhib. at RA from 1884, SS and elsewhere. His output was varied, and included historical genre, interiors with or without figures, genre, and portraits. Later he turned more to portrait painting. Works by him are in Birmingham, Bristol, Liverpool & Preston AG. Portraits by him are in the Imperial War Museum, the Guildhall, the Devonshire Club and elsewhere.

Probable price range £50-150

Bibl: Studio 22 (1901) 49; Connoisseur 74 (1926) 127; RA Pictures 1893-1915; Who's Who 1924; Who Was Who 1916-28.16-28.

TAYLER, Edward 1828-1906

Painter of miniature portraits and figure studies, "the father of present-day miniature painters" (AJ 1906). Exhib. from 1849 at the RA, SS, NWS, GG, NG and elsewhere. Hon.Treasurer and one of the founders of the Royal Society of Miniature Painters, and an exhibitor at the RA for more than three decades, Tayler was the connecting link between the days of Sir William Ross and the new school.

Probable price range £10-40

Bibl: AJ 1906, 120, (obit.); Studio 37 (1906) 158; The Year's Art 1907, 380; Connoisseur 64 (1922) 93, 121.

TAYLER, J. Frederick PRWS 1802-1889

Painter of sporting subjects, landscapes with figures and animals (chiefly Scottish), and illustrations of past times, some of them scenes in the Waverley Novels; lithographer and etcher. Born at Boreham Wood, Hertfordshire. Educated both at Eton and Harrow; studied art at Sass's Academy, the RA Schools, in Paris under Horace Vernet, and in Rome; shared a studio with Bonington for a time in Paris, c.1826. Exhib. from 1830-89, at the RA (1830-65, 5 works), BI, and OWS (528 works), of which he became A in 1831, Member in 1834, and President, 1858-71. Awarded gold medals at the Paris Exhibition of 1855, in Bavaria, 1859, and Vienna, 1872. Member of the Etching Club. After Paris he soon became known as a watercolour painter of sporting and pastoral scenes, and appears to have added figures and animal life to the paintings of several of his contemporaries, notably those of George Barret with whom he collaborated between 1834-6 on a dozen pictures. Tayler was a frequent guest at country houses in Scotland and often had aristocratic pupils. Queen Victoria purchased several of his pictures, which are now in the Royal Collection. Tayler handled watercolour with free fluid strokes which he seems to have derived from Cox, and Ruskin compares them. Ruskin was an early admirer of Tayler, and in the first volume of *Modern Painters,* says: "There are few drawings of the present day that involve greater sensations of power than those of Frederick Tayler. Every dash tells and the quantity of effect obtained is enormous in proportion to the apparent means. But the effect obtained is not complete. Brilliant, beautiful and right as a sketch, the work is still far from perfection as a drawing". However, he was becoming more critical by the 1850's. *Academy Notes* 1858, on 'Highland Gillie, with Dogs and Black Game': "It is not Presidential work, Mr. Tayler, you know as well as I that it is not right, and you know better than I, how much you could do with that facile hand of yours if you chose. . . ." Many examples of his work are in the VAM, BM, and in the Dixon Bequest, Bethnal Green Museum.

Probable price range £50-200

Bibl: Ruskin Modern Painters I (1843) 24; Academy Notes (OWS 1856, 1858); AJ 1858, 120, 329-31; 1863, 174; 1889, 275; Gazette des Beaux Arts 21 (1866) 74; 23 (1867) 356; Redgrave Cent.; Clement and Hutton; Roget; Bryan; Binyon; Cundall; DNB; Hughes; VAM; Williams; Paviere, Sporting Painters; Maas 48, 84; Hardie III 85 91-2; 95 (fig. 112).

TAYLER, Norman E. ARWS fl.1863-1915

Painter of genre, landscape and flowers. Second son of J. Frederick Tayler (q.v.). Studied at the RA Schools, and gained the first medal for drawing from the life. Worked in Rome. Exhib. from 1863, chiefly at the OWS (90 works), and also at the RA, BI, SS and elsewhere, titles at the RA including 'Girl with Oranges' 1863, 'Contadini Returning from Rome' 1870, and 'An Anxious Moment' 1882. ARWS, 1878-1915. The VAM has one watercolour, 'Country Girl with a Basket of Eggs, Crossing a Ditch, and a Youth Offering Help' 1878.

Probable price range £30-60

Bibl: Clement and Hutton; Roget II 215, VAM.

TAYLOR, Alfred Henry fl.1832-1867, d.1868

London painter of portraits and genre, who exhib. from 1832-67, at the RA (1832-63), BI, SS, NWS (107 works) and elsewhere. Titles at the RA are mostly portraits, but also include 'Design for Westminster Hospital' 1832, 'Reading the News' 1843, and 'Gathering Blackberries' 1851. Member of the NWS.

Probable price range £30-100

Bibl: Cundall; Cat. of Engr. Brit. Portraits BM, 3 (1912) 307.

TAYLOR, Charles fl.1836-1871

London painter of marines and historical subjects, who specialised in stormy coastal scenes at Brighton, Deal and Yarmouth. Exhib. from

1836-71 at the RA and SS, titles at the RA including 'Brighton at Flood-tide' 1843, 'Annabel Bloundel on the Eve of Departing from her 'Father's House with the Earl of Rochester' 1843, and 'Towing the Lifeboat out of Gorleston harbour' 1871.

Probable price range £50-150. A pair of marine watercolours were bought in at Christie's 9.5.69 for £252.

TAYLOR, Charles, Jun. fl.1841-1883
London marine painter, son of Charles Taylor (q.v.). Exhib. from 1841-83, at the RA (1846-9), BI, SS, NWS and elsewhere, titles at the RA including 'Vessels off Chapman's Head Beacon — Waiting for Ebb Tide' 1847, and 'In Chelsea Reach — Showery Day' 1849. Cape Town Art Gallery has one of his marines.

Probable price range £50-150

Bibl: Cat. South African Art Gallery, Cape Town 1903, 33.

TAYLOR, Edward R. RBSA 1838-1912
Painter of portraits, genre, landscape, coastal scenes, biblical and architectural subjects; potter. Born at Hanley; son of a manufacturer of earthenware, with whom he worked as a youth, but afterwards entered the Burslem School of Art for training as an art teacher. Studied also at the RCA. Appointed first headmaster of the Lincoln School of Art in 1863. Headmaster of the Birmingham Municipal School of Art, 1876-1903. Amongst his pupils were W. Logsdail, Frank Bramley, Fred Hall, Walter Langley, W.J. Wainwright, Jelley, Edwin Harris, Skipworth and Breakspeare; for thirteen years in succession the Birmingham School obtained the largest number of awards, and was the first to teach arts and crafts. Was the technical expert for art and technological teaching in the Technical Education scheme of the L.C.C. Exhib. from 1861, at the RA (from 1865), BI, SS, NWS, GG, NG and elsewhere, titles at the RA including 'Knitting' 1867, 'The Village Well' 1879, 'On the Look-out for her Boat' 1893, and 'The Four Evangelists and Twelve Apostles at Cleeve Prior' 1896. Elected RBSA in 1879. Gold medallist in 1879 for the best figure picture exhibited at the Crystal Palace Gallery. From 1898 made pottery of rich and delicate colouring. Published *Elementary Art Teaching and Drawing* and *Design for Beginners.*

Probable price range £50-150

Bibl: Who Was Who 1897-1916; Birmingham Cat.

TAYLOR, Henry King fl.1857-1869
London painter of shipping and coastal scenes. Exhib. at RA 1859-64, BI, SS, and elsewhere. Titles at RA 'The Passing Storm' 'The Ramsgate Lifeboat' 'Dutch Shipping' etc.

Prices during the last two seasons have ranged from £158 to £550. A pair sold at Christie's 9.5.69 for £998.

Bibl: Wilson Marine Painters 76 (pl.38).

TAYLOR, Stephen fl.1817-1849
Painter of dead game, animals and portraits, living in Winchester, Oxford and London. Exhib. from 1817-49, at the RA, BI and SS, titles at the RA including 'The Tiger Cat Pouncing upon an Indian pheasant' 1828, 'Mandarin, a Chinese Drake; painted at the Zoological Gardens' 1832, and ' "Love me, Love my Dog!" ' 1849.

'Rustic Sports' a watercolour, sold at Sotheby's 23.3.66 for £110.

Bibl: Pavière, Sporting Painters.

TAYLOR, William Benjamin Sarsfield 1781-1850
Painter of landscape, battle-pieces, genre, literary, historical and architectural subjects; etcher and engraver; art writer and critic. Born in Dublin, son of John McKinley Taylor, fl.1765-1819, engraver.

Pupil at the Dublin Society's Schools in 1800, and exhib. there from 1801. Joined the Commissariat Dept. and served in the Peninsula, being present at the Siege of San Sebastian in 1813. Exhib. at the RHA from 1826. At some time before that date he moved to London where he lived for the rest of his life. Exhib. from 1829-47 at the RA, BI, SS and NWS, titles at the RA including 'Opening of the Cloisters of St. Stephen's Chapel, Westminster, by Henry VIII and Queen Catherine of Aragon' 1837, 'Admiral Nelson's Flag-ship "Vanguard" as seen at Break of Day in June 1798 nearly Dismasted in a Gale' 1839, and 'An Afghan Chief Alarmed by the Cries of a Night Raven' 1847. He was a Member for a short time of the RI from 1831-33. In the latter part of his life he was Curator of the St. Martin's Lane Academy. He never attained any distinction as an artist and he is better known as an art writer and critic. He contributed to the *Morning Chronicle,* and besides his *History of the University of Dublin* (1845, 9 pls. published in 1819), published a translation of Merimée's *Art of Painting in Oil and Fresco* 1839, *A Manual of Fresco and Encaustic Painting* 1843, and *The Origin, Progress and Present Condition of the Fine Arts in Great Britain and Ireland,* 2 vols. 1841.

Probable price range £30-70

Bibl: AJ 1851 44; Redgrave Dict.; Universal Cat. of Books on Art, South Kensington, 1870; Cundall; DNB; Strickland.

TEMPLE, Robert Scott fl.1874-1900
Scottish landscape painter, living in Edinburgh, London, and Lammas, Norfolk. Exhib. from 1874-1900, at the RA (1879-1900), and SS, titles at the RA including 'Among the Pentland Hills' 1879. 'Day's Requiem' 1877, and 'A Kentish Sandpit' 1896.

Probable price range £30-70

TEMPLETON, John Samuelson/Samuel fl.1819-1857
Lithographic artist, and painter of portraits and landscape. Born in Dublin and attended the Dublin Society's Drawing School in 1819. Early in life he went to London, and exhib. landscapes at the RA from 1830-33, titles including 'Christ Church Cathedral' 1830 and 'The Quarries, Hill of Howth' 1832. From 1841-57 he exhib. portraits. He also exhib. at the BI and SS. He was, however, chiefly employed as a lithographer and reproduced a number of portraits after pictures and drawings by other artists. His name does not occur after 1857. Among his lithographs are 'Lord Palmerston, after W.C. Ross ARA', 'Sir P.B.V. Broke, after W.C. Ross ARA', and 'The American Ship "Edward", wrecked on the North Bull in Nov. 1825', drawn and lithographed by Templeton.

Probable price range £30-70

Bibl: Strickland; Print Collector's Quarterly 18 (1931) 237; Cat. of Engr. British Portraits BM 6 (1925).

TENISWOOD, George F. fl.1856-1876
London painter of landscape and marine subjects, who exhib. from 1856-76, at the RA (1863-74), BI, SS, and elsewhere. Titles at the RA include 'The Curfew Hour' 1863, 'Stonehenge — Early Morning' 1866, and 'The Stranded Wreck — Cloudy Moonlight' 1868. Nearly all the titles are of twilight or moonlight subjects.

Probable price range £20-60

Bibl: Cat. of Engr. Brit. Portr. BM 2 (1910) 378.

TENNANT, Mrs. Dorothy (Lady Stanley) fl.1879-1909 d.1926
Genre painter and illustrator. Studied at Slade School, and with Henner in Paris. Married the African explorer Sir Henry Stanley in 1890. Exhib. at RA from 1886, GG, NG and elsewhere. Titles at RA 'An Arab Dance' 'A Load of Care' 'The Forsaken Nymph' etc. She illustrated *London Street Arabs* 1890, and Stanley's autobiography.

A work by her is in Sheffield AG.

'Nymph Weeping over Dead Cupid' sold at Christie's 5,2,70 for £126.

Bibl; The Nat. Gall. ed. E.J. Poynter 1899-1900 III 266 f; Who's Who 1924; Who Was Who 1916-29; Cat. of Engraved Brit. Portraits BM 4 (1914) 177.

TENNANT, John F. RBA 1796-1872
Painter of genre, landscape and coastal scenes. Mostly self-taught, although he did receive lessons from William Anderson. At first he painted historical genre subjects, mostly taken from Walter Scott, but soon turned to landscape, for which he is better known. Exhib. mostly at SS, where he became a member in 1842; also at RA 1820-67, BI and NWS. He lived for a long time in Devon and Wales. Now best known for his river and coastal scenes, painted in a clear and colourful style.

'A Scene on the Thames' sold at Sotheby's 16.10.68 for £1,850, the highest recorded price. Other prices have ranged from about £500-£1,000.

Bibl. AJ 1873, 177 (obit); Redgrave Dict; Clement and Hutton; Pavière, Landscape pl.79.

TENNIEL, Sir John RI 1820-1914
Painter, illustrator and cartoonist. Practically self-taught in art; exhib. from 1835-1880 at the RA, SS, NWS and elsewhere, titles at the RA including cartoons and illustrations of literary works, e.g. 'The Expulsion from Eden' from Milton. Won a premium in the Westminster Hall Competition of 1845. RI in 1874. Knighted in 1893. From 1851-1901 he was on the staff of *Punch,* for which he drew nearly all the principal cartoons. He also illustrated many books including Lewis Carrol's *Alice in Wonderland* and *Alice Through the Looking-Glass.*

Probable price range £20-80

Bibl: AJ 1882 13-16; Clement and Hutton; G. Everitt *English Caricaturists* 1893, M.H. Spielmann *The History of Punch* 1895 and *The First Fifty Years of Punch* 1900; R.E.D. Sketchley *English Book Illustration of Today* 1903; Connoisseur 38 (1914) 259 f; 40 (1914) 173; Who Was Who 1897-1915; Burlington Magazine 30 (1917) 31 123; *Graphic Arts of Great Britain* Studio Special No. 1917 6, 24 (pl.); DNB 1912-21; *Drawings in Pen* Studio Spring No.1922 128; *British Book Illustration* Studio Winter No.1923-4 30 f; 95 (pl.); The Art News 24 (1925-6) No. 7 p.7 (pl.); VAM.

TERRELL, Mrs. Georgina fl.1876-1903
(Miss G.F. Koberwein)
London painter of still-life, portraits, genre and fruit, who exhib. from 1876-78 as Miss G. Koberwein, at the RA, SS and elsewhere, and from 1879-1903 as Mrs. Terrell, at the RA, SS, NWS and elsewhere. Titles at the RA include 'Stella' 1879, and 'Sweet Memories' 1887, but mostly portraits in the later years. She was the daughter of Georg Koberwein, 1820-1876, a Viennese portrait painter, who settled in London and exhib. portraits from 1859-76 at the RA, BI, SS and elsewhere. Her sister was Miss Rosa Koberwein, fl.1876-85, who exhib. for those years at the RA (1876-82), SS, NWS, GG and elsewhere, mostly portraits and genre, e.g. 'In Maiden Meditation, Fancy Free', RA 1878.

Probable price range £30-100

TERRY, Henry fl.1879-1894
Painter of genre and literary subjects, living in Brixton and Tetsworth, who exhib. from 1879-94, at the RA (1880-94), SS, NWS, NG and elsewhere. Titles at the RA include 'Land of my birth, I think of thee still' 1880, 'An Old Dame' 1886, and 'An Old Garden Gay and Trim' 1894. The VAM has a watercolour 'A Half-caste, wearing a Striped Turban and Dress' 1879, which is attributed to another artist, Henry J. Terry, not listed in Graves, Dict. or Graves, R. Acad., 1818-1880 who was born in England and studied in Switzerland under Calame, many of whose works he lithographed. He took part in many exhib-

itions in Switzerland and died in Lausanne. (VAM)

Probable price range £30-70

THOM, James Crawford 1835-1898
Painter of landscape, rustic genre, and portraits. Born in New York, son of James Thom, sculptor. Studied at the National Academy of Design in New York, and first exhibited there in 1857. Also studied under Edward Frere in Paris, to whose works his own bear a close resemblance in style. Exhib. from 1864-73 at the RA, BI, SS, and the French Gallery, Pall Mall, and elsewhere, sending his first picture to the RA, 'Returning from the Wood — Winter', from Ecouen. Other titles at the RA include ' "Hush-a-Bye, Baby" ' 1866 and 'The Monk's Walk' 1873. In 1866-c.1874 he was living in Brentford. He also exhib. at the Boston Athenaeum and the Pennsylvania Academy. Died at Atlantic Highlands. The AJ reproduces 'The Grandfather's Grave', showing an old Frenchwoman and a child kneeling by a grave.

Probable price range £30-100

Bibl: AJ 1874, 248 (pl); Clement and Hutton; American Art Annual 1898, 31 (obit.); Fielding, Dictionary of American Painters.

THOMAS, Florence Elizabeth See under WILLIAMS, Alfred Walter.

THOMAS, George Housman 1824-1868
Painter of ceremonial subjects and group portraits (largely commissioned by the Royal Family), genre and contemporary history; illustrator and wood engraver. Began his career in Paris as a wood engraver, after studying under G.W. Bonner, the engraver; went to New York for two years to draw illustrations for a newspaper; designed American banknotes; returned to Europe, was in Rome during its siege by the French and sent drawings of the operations to the *Illustrated London News;* subsequently joined its staff on settling in London. Exhib. from 1851-68, at the RA (1854-68), BI and elsewhere, works at the RA including 'Garibaldi at the Siege of Rome 1849' 1854, 'Ball at the Camp, Boulogne' 1856, and 'The Queen and the Prince Consort at Aldershot 1859', 1866. He also continued to work as an illustrator, and among the books he drew for are *Uncle Tom's Cabin* and *The Child's History of England.* He later painted many pictures of ceremonies, group portraits and marriages for Queen Victoria, e.g. 'The Presentation of Medals for Service in the Crimea by the Queen 1855' 1858, 'The Review on the Champ de Mars' 1859, and 'The Coronation of the King of Prussia' 1863. An exhibition of his work was held at the German Gallery, Bond St., in 1869.

Probable price range £100-300

Bibl: AJ 1868, 181 (obit.); 1869, 183; *In Memoriam George Housman Thomas 'Artist. A Collection of Engravings from his Drawings on Wood* 1869; Redgrave, Dict.; Bryan; VAM; *The Print Collector's Quarterly* 23 (1936) 181.

THOMAS, Miss Margaret fl. from 1868, d.1929
Portrait painter and sculptress; writer. Born in Croydon; her parents emigrated to Australia, where she began to study sculpture under Charles Summers. Returned to England in 1868; entered the S. Kensington Schools for ten months; spent two and a half years in Rome; on her return studied at the RA Schools for two years where she gained a silver medal. Exhib. from 1868-80, at the RA (1868-77), SS and elsewhere. Marble busts by her of Fielding, Jacob, Fox and Summers are in Shire Hall, Taunton, and a bust of Richard Jefferies is in Salisbury Cathedral. She lived in Letchworth, and travelled in Italy, Spain, Sicily, Egypt, Syria, Denmark etc. She published *A Hero of the Workshop* 1880; *Poems in Australian Poets* and *Century of Australian Song* 1888; *A Scamper through Spain and Tangier* 1892; *Two Years in Palestine and Syria* 1899; *Denmark, Past and Present* 1901; *How to Judge pictures* 1906; *A Painter's Pastime* 1908; *How to Understand Sculpture* 1911; and *Friendship, Poems in Memoriam* 1927.

Probable price range £30-80

Bibl: Clayton II 259; Who was Who 1929-40.

THOMAS, Percy RPE 1846-1922

Etcher, and painter of portraits, landscape, genre and architectural subjects. Son of Sergeant Thomas, an early patron of Whistler, and brother of Edmund Thomas, art dealer, and Ralph Thomas, painter, solicitor and author. Educated at the RA Schools. One of the earliest friends and first pupil of J.A.M. Whistler (q.v.), from whom he learnt etching. Learnt printing from Augusta Délâtre, whom his father had brought over from Paris to print Whistler's etchings. Exhib. at the RA from 1867 – mainly etchings, but also 'On Strike' 1879, 'Sir Paul Pindar's House, Bishopsgate St.' 1882, 'Relics', 1886 (reprd. RA Cat. 1886), and 'A Parting Request' 1892. Also exhib. at SS and elsewhere. Contributed to *English Etchings;* etched the portrait of Whistler for Ralph Thomas's *Catalogue of Whistler's Etchings* 1874; etched, for the Art Union, 'Windmill' by John Crome, and a series of *The Temple, London* (text by Canon Ainger).

Probable price range £20-80

Bibl: Portfolio 1876, 156 (pls.); Wedmore *Etching in England* 1895 160 (pl.); E.R. and J. Pennell *The Life of James McNeill Whistler,* 1908 I 86 152-3, 182, 184, 199; Hind *A Short History of Engraving* 1911; Who Was Who 1916-1928; Cat. of Engraved British Portraits BM 6 (1925) 555 694; Connoisseur 77 (1927) 125.

THOMAS, Robert Strickland RN 1787-1853

Portsmouth marine painter. Painted ships, naval actions and historical events. Exhib. 3 pictures at RA 1839-42. Titles at RA 'Trafalgar, after the close of the action' 'The Battle of Navarino' etc. A number of his works are in the Greenwich Maritime Museum.

'Men of War in Portsmouth Harbour' sold at Sotheby's 20.11.68 for £480. Another in the same sale made £110.

Bibl: Wilson, Marine Painters 77 (pl.39).

THOMAS, William Cave b.1820 fl.1838-1884

Painter of genre, historical, literary and biblical subjects; etcher and author. Moved on the outer fringes of the PRB in its early years. Studied at the RA Schools in 1838; in 1840 went to Munich to see the work of Cornelius and the Nazarenes. Entered the Munich Academy of Art, and worked under Hess on the frescoes in the Basilica. Returned to England in 1842. In 1843 won a premium of £100 at the Westminster Hall Competition for 'St. Augustine Preaching to the Saxons', and later, in the third exhibition at Westminster Hall, £400 for a cartoon of 'Justice'. Exhib. from 1843-84, at the RA (1843-62) BI, NWS, and elsewhere, titles at the RA including 'A Guardian Angel; Infancy' 1843, 'Canute Listening to the Monks of Ely' 1857, and 'Petrarch's First Sight of Laura' 1861. From c.1849-50 he was associated with Thomas Seddon and Ford Madox Brown in a scheme for teaching drawing and design to artisans. He proposed a list of titles for *The Germ,* and is generally credited with the one used. He published *Pre-Raphaelitism Tested by the Principles of Christianity: An Introduction to Christian Idealism* 1860, (reviewed AJ 1861 April 100) which Fredeman notes "seeks to examine the movement as purely a religious phenomenon and to identify Pre-Raphaelitism with moral and ethical values rather than with artistic ones". His altarpiece 'The Diffusion of Gifts' 1867 "in Early Renaissance style"(Pevsner, London II) is in Christ Church, Cosway St., St. Marylebone.

Probable price range £50-200

Bibl: AJ 1869, 217-219 (pls.); Ottley; Portfolio 1871, 149-53; Clement and Hutton; VAM; Fredeman 10; 4.1; 66.7; Raymond Watkinson *Pre-Raphaelite Art and Design* 1970, 137, 140.

THOMAS, William Luson RI 1830-1900

Wood engraver and watercolourist. Founded *The Graphic* as an illustrated weekly newspaper in 1869, and invited Holl. and Fildes, together with Herkomer, Pinwell and Walker, to contribute to its illustrations. Also engraved for the *Daily Graphic,* worked in Paris, Rome and New York. As a painter, exhib. from 1860-89, at SS, NWS (173 works) and elsewhere, but not at the RA.

Probable price range £20-60

Bibl: The Year's Art 1894, 1901; Cundall; Cat. of Engraved British Portraits BM 6 (1925) 694; Reynolds VS 27.

THOMPSON, Elizabeth See under Lady Butler

THOMPSON, Sir Henry 1820-1904

Leading surgeon; pioneer of cremation; an authority on diet; student of astronomy; man of letters; collector of China; amateur painter of landscapes and still-life. For his career in medicine and his other versatile interests see DNB. Born in Framlingham, Suffolk; his mother was Susannah Medley, daughter of Samuel Medley, the artist. Studied under Alfred Elmore RA (q.v.) and Sir L. Alma-Tadema RA (q.v.); exhib. from 1865-1901 at the RA, GG and elsewhere, and also at the Paris Salon. Titles at the RA include 'The Chrysalis' 1865, 'A Japanese Group' 1872, and 'Bellagio – Summer Morning Haze from Caddennabbia, Lake Como' 1901. He was an eminent collector of Nanking china, and published *A Catalogue of White and Blue Nanking Porcelain* 1878 (illustrated by himself and J.M. Whistler (q.v.)). He was also a famous host – remembered for his 'octaves' – dinners of eight courses for eight people at eight o'clock.

Probable price range £20-60

Bibl: DNB; 2 Supp. 3 1912.

*THOMPSON, Jacob 1806-1879

Landscape, portrait and genre painter. Born in Penrith, Cumberland, and usually known as Thompson of Penrith. Pupil of RA Schools. Exhib. at RA 1831-66, BI and SS. About 1845 or 1846 he returned to Hackthorpe in Cumberland, where he lived for the rest of his life. He painted landscapes, sometimes with rustic figures, mostly depicting the scenery of Cumberland and Westmorland; also portraits, and animals. He also painted two altarpieces for the Church of St. Andrew's in Penrith.

'The Path of True Love Never did Run Smooth' sold at Christie's 11.7.69 for £683.

Bibl: Portfolio 1882 p.164; DNB 56 (1898); Llewellin Jewitt *Life and Works of J.T.* 1882; Catalogue of Engraved Brit. Portraits BM 6 (1925) 555; Pavière, Landscape Painters pl.80.

THOMPSON, Thomas Clement RHA 1778-1857

Painter of portraits, and also occasionally of genre, biblical subjects, scenes from Shakespeare, and landscape. Born probably in Belfast; attended the Dublin Society's Schools in 1796, and after his course started as a miniature painter in Belfast and Dublin. After 1803 he confined himself to portrait painting in oil. In 1810 he settled in Dublin where he had a good practice; in 1817 he went to London. On the foundation of the RHA in 1823, he was elected one of the original members and he exhib. there until 1854. Exhib. in London from 1816-57, at the RA, BI and SS. In about 1848 he went to Cheltenham where he remained for the rest of his life. Thompson appears to have had a good practice and had many distinguished people as sitters. Strickland notes that "his portraits are carefully done, the drapery well painted, but the drawing, especially in the arms of his female figures, is defective and his flesh painting raw and unpleasant". His self-portrait in the NG Dublin shows him, palette in hand, before an easel on which is his portrait of George IV. His portraits include Thomas Campbell the poet, 1833; George IV, 1826; Duke of York 1825 (R.H. School, Phoenix Park), and the 'Embar-

kation of George IV from Kingstown', RA 1845 (a large picture begun in 1821, finished 1826, containing numerous portraits, Royal Dublin Society).

Probable price range £30-100

Bibl: Redgrave Dict.; Strickland; Cat. of Engr. British Portraits BM 6 (1925) 555

THOMPSON, Wilfred H.　　fl.1884-1894
Hampstead painter of historical subjects, genre and landscape, who exhib. from 1884-94, at the RA (1887-94), SS, NWS and elsewhere. Titles at the RA include 'In Deal Marshes' 1887, 'Dante and Virgil in the Limbo of the Unbaptised' 1891 and 'Prayer; the Church of Sta. Maria in Ara Coeli, Rome' 1893.

Probable price range £30-80

THOMSON, John Knighton (Kinghorn)　　1820-1888
London painter of genre and historical subjects, who exhib. from 1849-83, at the RA (1849-82), BI, SS and elsewhere, titles at the RA including 'The Lover's Grave' 1849, 'The Last Illness of Little Richard Evelyn' 1874, and 'Via Crucis' 1877. His 'First Easter Dawn' was engraved.

Probable price range £30-100

Bibl: The Year's Art 1889 (obit.); Bryan

THOMSON, J. Leslie　RBA RI　　1851-1929
Scottish painter of landscape and coastal scenes, much influenced by Daubigny and painters of the Barbizon School. Born in Aberdeen, exhib. from 1872, at the RA (from 1873), SS, NWS, GG, NG and elsewhere, titles at the RA including 'On the River' 1873, 'After Sunset – Brittany' 1878, and 'A New Forest Stream' 1898 Member of NEAC, 1886. The subject-matter of his paintings came from the scenery of the Southern and Eastern counties of England : Dorset, Poole Harbour, Sussex, the flats of Winchelsea and Rye, the rivers and Broads of Essex, and the general character of a wide open expanse of landscape. He also painted in Normandy and Brittany, and the AJ, 1906, reproduces 'Washing Place : Normandy' – "by J. Leslie Thomson, whose sense of atmosphere, of colour-correspondences, is here admirably exemplified"

Probable price range £50-150

Bibl: AJ 1898 53-75 (8 pls.); 1904 195; 1906 87; 1907 162; Studio Summer No. 1900; Cat. de l'Exp. décenn. d. b-arts 1889-1900 Paris 1900 302; Caw 307-8; Connoisseur 84 (1929) 60; Who's Who 1929, 1930 (obit.).

*THORBURN, Archibald　　1860-1935
Animal painter and illustrator, especially of birds. Son of Robert Thorburn ARA, a miniaturist.. Specialised in the study of game birds "their forms and plumage, their habits and their flight" (Caw). His pictures are minutely detailed, and show a real knowledge of birds, but they do not contain much imagination or pictorial sense. Exhib. at the RA from 1880, SS and elsewhere.

'Wildfowl in Fens' sold at Sotheby's 19.6.69 for £1,800, the current auction record. Two others sold at Christie's 3.3.70 for £1,050 and £1,365, but the usual range is still £200-600 for average examples.

Bibl: Studio 91 (1926) 79; Who's Who 1936; Caw 443; Pavière, Sporting Painters, 83 (pl.42).

THORN, Miss Sarah Elizabeth　　fl.1838-1846
London painter of genre, animals, portraits and historical subjects, who exhib. from 1838-46, at the RA (1842-46), BI and SS, titles at the RA including 'Elizabeth, Queen of Edward IV, Parting with her Youngest Son in the Sanctuary of Westminster' 1842, 'The Lecture' 1843, and 'Portrait of a Spaniel' 1844.

Probable price range £30-100

Bibl: Pavière Sporting Painters.

THORNELEY, Charles　RBA　　fl.1858-1898
London painter of river and coastal scenes. Exhib. at RA 1859-98, BI, SS, NWS, GG, NG and elsewhere. His titles at the RA include coastal scenes on the South Coast, Wales, the Channel Islands, and Holland.

'Sailing Vessels off the Coast' – a pair – sold at Knight, Frank and Rutley 30.10.69 for £120.

THORNLEY, Hubert and William
Painters of coastal scenes whose work is very similar, so may have been members of the same family. Although neither exhibited in London, their fishing scenes are spirited and similar in style to those of "Jock" Wilson.They frequently appear on the London art market. Both artists frequently painted their pictures in pairs.

The usual price for both artists is £50-200, and a pair by Hubert have sold for £400.

THORNYCROFT, Miss Helen　　fl.1864-1912
London painter of biblical subjects, genre, flowers and landscape. Daughter of sculptors Mary (1814-95) and Thomas (1815-85) Thornycroft, and sister of sculptors Alyn Thornycroft and Sir William Hamo Thornycroft (1850-1925), the painter Theresa G. Thornycroft (q.v.)., and the Naval architect and engineer Sir John Isaac Thornycroft (1843-1923). She exhib. from 1864-1912, at the RA, SS, NWS, NG and elsewhere, titles at the RA including 'The Pet Thrush' 1867, 'The Martyrdom of St. Luke' 1878, and 'Harebells' 1904. Member of the Society of Lady Artists.

Probable price range £30-100

THORNYCROFT, Miss Theresa G.　　fl.1874-1883
London painter of biblical and literary subjects. Daughter of the sculptors Mary and Thomas Thornycroft. Exhib. from 1874-83, at the RA (1875-83), NWS and GG, titles at the RA including 'Design from the Parable of the Ten Virgins' 1875 and 'The Feeding of the Multitude' 1880.

'The Parable of the Ten Virgins' sold at Sotheby's 12.3.69 for £120.

THORPE, John　　fl.1834-1873
London painter of marines and landscape, and animal subjects, who exhib. from 1834-73, at the RA (1835-72), BI, SS, NWS and elsewhere (92 works). He specialised in coastal scenery in Devon, Kent, Wales, Sussex, Yorkshire and Scotland, and titles of other subjects at the RA include 'Sheep and Lambs' 1860, 'To the Rescue' 1865, and 'Out at Grass' 1871.

Probable price range £30-80

Bibl: Wilson, Marine Painters.

THORS, Joseph　　fl.1863-1884
Landscape painter. Lived in London, but also worked in the Midlands, where he is regarded as a member of the Birmingham School. Exhib. mostly at SS, also RA 1863-78 and BI. His landscapes are usually rustic scenes with cottages, figures and animals, painted in a style which derives ultimately from the Norwich School.

Prices during the last two years have ranged from about £50 to £504.

Bibl: Pavière, Landscape pl.81.

TIDDEMAN, Miss Florence　　fl.1871-1897
Brixton painter of genre, historical subjects and flowers, who exhib.

from 1871-97 at the RA (1873-97), SS, and elsewhere, titles at the RA including 'Florentine Artist of the 15th century' 1874, 'Wild Roses' 1875 and 'A Dark Beauty' 1897.

Probable price range £30-70

TIFFIN, Henry fl.1845-1874
London painter of landscape and genre, who exhib. from 1845-1874, at the RA (1846-71), BI, SS and elsewhere, titles at the RA including 'Prayer' 1846, 'The Upper End of the Lake of Como from Colico' 1854, and 'Pussy in Mischief' 1869. Brother of artists Miss Alice Elizabeth Tiffin (exhib. SS 1873); James Benjamin Tiffin (exhib. 1847-9 at RA and BI); Miss Lydia Emily Tiffin (exhib. 1863 at SS); and the miniature painter Walter Francis Tiffin (exhib. 1844-67 at RA, BI and SS).

Probable price range £30-100

TINDALL, William Edwin RBA 1863-1938
Landscape painter. Born in Scarborough; educated at St. Martin's Grammar School, Scarborough and studied under L. Timmermans in Paris. Worked in Leeds and in Boston Spa. Yorks. Exhib. from 1888 at the RA and SS, titles at the RA including ' "Nature Alone"; Adel, Yorkshire' 1888 and 'When Daylight Softens into Even' 1904. Paintings by him are in Leeds and Doncaster Art Galleries. He published *Selection of Subject*.

Probable price range £30-80

Bibl: Who's Who in Art 1934; Who Was Who 1929-40.

***TISSOT, James (Jacques Joseph) 1836-1902**
Genre painter. Born in Nantes. Studied at the Beaux-Arts in Paris. Began to exhib. at Paris Salon 1859. His early works are historical, costume pieces, very much in the manner of Henri Leys, whom he visited several times in Antwerp. About 1864 he began to paint subjects of modern life. During the 1860s his work also shows the influence of the Impressionists, notably Manet and Monet. In 1871 he came to London after the fall of the Commune, and began to paint the English conversation pieces for which he is now best known, such as 'Too Early' 'The Ball on Shipboard' 'The Concert' etc. Exhib. at RA 1864-81, SS, GG and the Dudley Gallery. About 1876, Mrs. Kathleen Newton, a divorcee, became his mistress, and she appears in many of his pictures of this period. In 1882 Mrs. Newton died, and Tissot returned to Paris. After painting another series of modern life scenes entitled 'La Femme à Paris', he devoted the rest of his life to religious paintings. Like Holman Hunt before him, he went to the Holy Land several times in search of realistic illustrations for his *Life of Christ* published in 1896-7. He became a recluse, and when he died he was still working on a series of Old Testament drawings. Although Tissot is thought of as "Victorian", his art occupies an ambiguous position. In England he is part of the Pre-Raphaelite genre tradition, although his pictures do have a definite French flavour. In France he is considered to be an interesting minor figure on the fringe of the Impressionist movement.

'The Terrace of the Trafalgar Tavern, Greenwich' sold at Sotheby's 20.5.70 for £4,100. Other recent prices have ranged from about £500 to £3,000.

Bibl: Academy Notes 1875-6, 1881; Correspondent 25 (1896) II; Les Arts 1902, no.9, p.1-8; Hochland 1904 II 24-34; Apollo 17 (1933) 255-8; Bate 90; Bryan; Clement and Hutton; J. Laver *Vulgar Society – The Romantic Career of J.T.* 1936; Reynolds VS 33-6, 98-9 (pls. 93-4, 98-102); Reynolds VP 173, 180, 183 (pls. 126, 129); Maas 241-4 (pls. p.244,255);Cat. of Tissot Exhibition, Art Gall. of Ontario, Toronto 1968 (with full bibliography and list of exhibitions).

TITCOMBE, William Holt Yates RBA 1858-living 1924
Painter of realistic genre. Studied at the South Kensington Schools in

Antwerp under Verlat, in Paris under Boulanger and Lefèbvre and at the Bushey School of Art under Herkomer, whose style of realism Titcombe's work closely follows. Exhib. from 1881-1903, at the RA (1886-1903), SS and elsewhere, titles at the RA including 'Fresh this Morning' 1886, 'Baby's First Market-day' 1893, and 'Good News from the War' 1900. He also exhib. at the Chicago Exhibition in 1893, and at the Paris Salon 1890. From 1887 he was living at St. Ives, Cornwall. In 1892 he married the genre painter, Jessie Ada Titcombe (née Morison). The AJ reproduces 'Primitive Methodists' (showing simple Cornish fishermen in prayer), and notes: ". . . for 'Primitive Methodists' there should be nothing but praise. . . . the expressions he has given to faces and figures, to hands and actions, in this remarkable interior are all thorough."

Probable price range £50-150

Bibl: AJ 1892, 290 (pl.), 292 f; RA Pictures 1891, 1893-5; Kurtz,Illustrations from the Art Gallery at the World's Columbian Exhibition 1893 76 (pls.); Studio 'Art in 1898'; Who's Who 1924.

TODD, Ralph fl.1880-1893
Genre and landscape painter, living in Tooting and Newlyn, Cornwall, who exhib. from 1880-93, at the RA (1885-93), SS, NWS and elsewhere. Titles at the RA are 'Early Morning – the Latest News' 1885, 'A Darkened Home' 1887, and 'The Prodigal's Return' 1893. Father of Arthur Todd.

Probable price range £30-70

Bibl: RA Pictures 1893, 118 (pl.).

TOFT, Peter Petersen 1825-1901
Danish landscape and topographical painter, who is said to have settled in London in 1875. He exhib. however, from 1872, at the RA (from 1874-81), SS, NWS, GG, NG and elsewhere, and possibly the 'Peter Toft' given in Graves, Dict. and R. Acad. is the same artist. Titles at the RA include 'Gateway of the Bloody Tower, Tower of London' 1874, and 'Stathies, Coast of Yorkshire' 1881. He died in London.

Probable price range £30-70

Bibl: See TB for further bibl.

TOMKINS, Charles F. RBA 1798-1844
Scene painter, draughtsman and caricaturist; landscape painter in watercolour. Worked for the theatres with Stanfield (q.v.), and David Roberts (q.v.); painted temporary buildings for Queen Victoria's Coronation; employed by Macready for his Shakespeare revivals at Drury Lane, and drew for the early numbers of *Punch*. Exhib. landscapes from 1825-44 at the BI and SS. RBA in 1837. The VAM have two watercolours: 'Dinant on the Meuse' and 'Scene on the Seashore'. Hardie notes that Tomkins was "much more akin to the Bonington, Holland, Callow group in his use of precise drawing and simple washes, with a richer colour accent here and there".

Probable price range £20-80

Bibl: Binyon; VAM; Birmingham Cat; Hardie III 29

TOMLINSON, George Dodgson 1809-1884
Huddersfield miniature portrait painter, who exhib. in 1848, 1851 and 1872, at the RA. Born in Nottingham.

Probable price range £10-30

Bibl: The Year's Art 1885, 229.

TOMLINSON, J. fl.1824-1853
London miniature portrait painter, who exhib. from 1824-53 at the

RA and SS.

Probable price range £10-30

TOMSON, Arthur 1858-1905
Painter of landscape, genre and animals. Born at Chelmsford, Essex; on leaving school at Uppingham, he studied art at Dusseldorf. Returning to England in 1882, he settled down to landscape painting. Working chiefly in Sussex and Dorset. His landscapes were poetic, and rather similar in sentiment to the art of George Mason and Edward Stott. Exhib. from 1883 at the RA, and also at SS, GG, NG and NEAC, of which he was one of the early members. Favourite subjects were also cats and other animals. A characteristic example of his work was the 'Chalk Pit', (VAM). He was also an interesting writer on art. He published *J.F. Millet and the Barbizon School,* 1903, and for some years chiefly art critic for the *Morning Leader* under the pseudonym 'N.E. Vermind'. He contributed to the AJ descriptions of places in the southern counties, illustrated by his own drawings; and illustrated *Concerning Cats* 1892, (poems selected by his first wife 'Graham R. Tomson'). He also wrote a novel *Many Waters.* A memorial exhibition of his work was held at the Baillie Gallery, 1906, including two of his best works 'The Happy Valley' and 'Coming Storm'. Died at Robertsbridge, Sussex.

Probable price range £50-200

Bibl: AJ 1901 231 f. (pl.); 1902, 243 f. (pl.); 1903, 230 f. (pl.); 1905, 259, (obit.); 1906, 275 (pl.); Cat. of Baillie Gallery exhibition 1906 (introduction by Mrs. Pennell);DNB 2nd. Supp. III; VAM.

TOOK, William fl.1857-1892
London painter of landscape and portraits, who exhib. from 1857-92, at the RA (1857-73), BI, OWS (21 works) and elsewhere, titles at the RA including 'Portrait of a Boy' 1857, and 'On the East Lynn' 1873.

Probable price range £30-80

TOOVEY, Edwin fl.1865-1867
Leamington landscape painter, who exhib. from 1865-7 at SS and elsewhere. The VAM has a watercolour 'Rustic Cottage'.

Probable price range £20-50

Bibl: VAM.

TOOVEY, Richard G.H. (Dick) RPE fl.1879-1888
Painter of genre, landscape and coastal scenes; etcher. Working in Chelsea and Leamington. Exhib. from 1879-88, at the RA (1884-88), SS, NWS, GG and elsewhere, titles at the RA including 'The Mill Sluice' 1884, 'Concarneau Harbour' 1885 and 'The Broker's Shop' 1887. Possibly related to Edwin Toovey (q.v.).

Probable price range £20-80

***TOPHAM, Francis William RWS 1808-1877**
Genre painter and watercolourist. Born in Leeds. Came to London about 1830 to work as an engraver of heraldic designs. Took up line engraving, then watercolours and oils. In 1842 elected associate, and in 1843 member, of the NWS; in 1847 he retired to become ARWS, and in 1848, RWS. He usually painted rustic figures, especially peasant girls and children. Travelled in Ireland and Spain in such of suitably picturesque subjects. Exhib. mainly at OWS, also RA 1832-70, BI, SS and NWS. Died at Cordoba, on his second visit to Spain. His remaining works were sold at Christie's on March 30, 1878.

Probable price range £50-200 for oils, £20-60 for watercolours.

Bibl: AJ 1877, 176 (obit.); 1880, 21-3; F.G. Kitton *Dickens and his Illustrators* 1899; Redgrave, Dict.; Clement and Hutton; Roget; Binyon; Cundall; DNB; VAM; Hardie III 100 (pl. 121); Maas 240 (pl. p.243).

TOPHAM, Francis William Warwick RI 1838-1924
Genre painter and watercolourist. Pupil of his father F.W. Topham (q.v.) RA schools, and Gleyre in Paris. Exhib. at RA from 1860, BI, SS, NWS, GG, NG and elsewhere. Titles at RA include many scenes of Italian life and history, and occasional biblical subjects. Works by him are in the Walker AG. Liverpool and Rochdale AG.

'Italian Market Scene' sold at Bonham's 5.6.69 for £340. This was an exceptional price; normal range for oils is £50-150, watercolours £20-50.

Bibl: AJ 1882 p.108; Clement and Hutton.

TOPLIS, William A. fl.1875-1902
Landscape painter, living in Sheffield and on Jersey and Sark, the Channel Islands. Exhib. from 1875-1902, at the RA (1881-1902) SS, and elsewhere, titles at the RA including 'Nature's Architecture, Sark', 1894, and 'A Monarch of the Shore, Sark' 1902.

Probable price range £20-60

TOURRIER, Alfred Holst 1836-1892
French painter, long resident in London, of historical subjects and genre; illustrator. Exhib. from 1854-89, at the RA (1857-88), BI, SS and elsewhere, titles at the RA including 'The Cavalier' 1857, 'Henry II of France and Diana of Poitiers Witnessing the Execution of a Protestant' 1870, and 'Galileo before the Inquisition' 1881. His pictures were often engraved, and his work as a book illustrator, e.g. an edition of Scott, published by Nimmo, attracted attention. The AJ reproduced 'Gold', an historical subject, exhib. at the RA in 1871.

'The Losing Card' sold at Sotheby's 6.11.63 for £180.

Bibl: AJ 1875 pl. p.232; Bryan.

TOURRIER, J. fl.1834-1848
London painter who specialized in coastal scenes and river views in Kent, Ireland and France. Exhib. from 1834-48 at the RA, BI and SS, titles at the RA including 'Sea Coast' 1834, 'View in the Pyrenees' 1835, and 'Scene in Ireland' 1843.

Probable price range £20-60

Bibl: Wilson, Marine Painters.

TOVEY, Samuel Griffiths fl.1847-1865
Bristol painter of architectural subjects, who exhib. from 1847-65, at the RA (1847-58), BI and SS, titles at the RA including 'The Lady Chapel, Wells Cathedral' 1847, 'On the Grand Canal, Venice' 1848, and 'Interior of the Campanile of St. Marks, Venice' 1858. He specialized in scenes in Venice.

Probable price range £50-150

TOWERS, James ARCA 1853-living in 1934
Landscape painter, living in Liverpool, Birkenhead, Heaverham (near Sevenoaks, Kent) and Purley, Surrey. Educated at the Liverpool College School of Art and the Liverpool Academy of Art. Exhib. from 1878 at the RA, SS, NWS, GG and in Liverpool. Titles at the RA include 'A Welsh Mountain Path' 1878, 'King Arthur's Castle, Tintagel, Cornwall' 1882, and 'Evening in August' 1901.

Probable price range £30-100

Bibl: Studio 24 (1902) 136; Who's Who in Art 1934; Who's Who 1937.

TOWNSEND, Henry James 1810-1890
Painter of historical and literary subjects, portraits, genre, animals and landscape; illustrator, etcher and engraver. Born at Taunton, educated as a surgeon, but left that profession to take up art. Made

designs for wood engravings, and was a talented etcher, as is shown by his illustrations to Goldsmith's *The Deserted Village* 1841 and Gray's *Elegy* 1847, produced by the Etching Club of which he was a member. Also illustrated Mrs. S.C. Hall's *Book of Ballads* 1847, Milton's *L'Allegro* 1849, and Thomson's *Seasons* 1852. Won a £200 prize at the Westminster Hall Competition of 1843. Exhib. from 1839-66 at the RA, BI, SS and elsewhere, titles at the RA including 'Sterne and Maria' 1839, 'The Fatal Letter of Charles I Intercepted by Cromwell and Ireton' 1844, and 'Among the Lynmouth Hills' 1849. For some years he was a master in the Government School of Design at Somerset House. The VAM has a study for the prize-winning cartoon of 1843 'Fight for the Beacon' (Descent of the Pirates on the English Coast in the Reign of Henry VI). The AJ reproduces 'Ariel' (RA 1845), now at Osborne House, Isle of Wight.

Probable price range £50-200.

Bibl: AJ 1855 188 (pl.); Bryan; VAM; Maas 27.

TOWNSEND, Miss Pattie See JOHNSON, Mrs. Patty Townsend

TRAVERS, George fl.1851-1859
Painter of landscape and coastal scenes, living in Poplar, who exhib. from 1851-59, at the RA, BI, SS and elsewhere. Titles at the RA include 'The Way-side' 1851, 'On the Coast' 1852, and 'Evening' 1859, 'Whitsand Bay, Devon – Rain Passing off' is in the VAM.

Probable price range £20-60

Bibl. Cat. of Oil Paintings VAM 1907.

TROOD, William Henry Hamilton 1860-1899
Painter of animals, especially dogs. Exhib. at RA 1879-98, SS, NWS, GG, and elsewhere. His pictures usually have sentimental titles e.g. 'A Coveted Bone' 'The Old Man's Darling' 'Home Sweet Home' etc..

Probable price range £50-200

Bibl: The Year's Art 1900 p.297; RA Pictures 1893.

TUCK, Harry fl.1870-1893
London painter of genre and landscape, who exhib. from 1870-93, at the RA (in 1883 and 1884 – both landscapes), SS, NWS and elsewhere.

Probable price range £20-60

TUCKER, Raymond fl.1852-1903
Painter of landscape, portraits, genre and literary subjects, living in Bristol, Sandhurst, Kent and London. Exhib. from 1852-1903 at the RA, SS, NWS and elsewhere, titles at the RA including 'Scene near Eaux Chaudes Pyrenees' 1852, 'Desdemona' 1867, and 'Out of a Friend's Garden' 1903.

Probable price range £30-80

TUDGAY
Family of marine painters, including F.I.J and L. Tudgay. Many of their works were joint productions. For full details see bibl.

Prices during the 1968-9 season ranged from about £50 to £262.

Bibl: Wilson, Marine Painters 78 (pl.39).

TUKE, Henry Scott RA RWS 1858-1929
Genre and portrait painter. Studied at the Slade; in Florence 1880; in Paris 1881-3 under J.P. Laurens. On his return he settled in his native Cornwall, first at Newlyn. already a centre for French-style *plein-air* painting, and later in Falmouth, where he bought a boat. First exhib. at RA 1879, also SS, NWS, GG, NG, NEAC and elsewhere. Member of NEAC 1886, ARA 1900, RA 1914. Most of his works reflect his love and knowledge of the sea. His first work to attract attention was the dramatic 'All Hands to the Pumps' (RA 1889) which was bought by the Chantrey Bequest. Other typical RA titles 'The First Boat in' 'The Run Home' etc. His style, bold and realistic,, was much admired for its feeling of sea and sunlight, and is well suited to his themes of rugged life on the Cornish Coast. He was also an industrious painter of male nudes, usually naked boys posed on sunlit beaches. His many pictures and sketches of this type caused alarm at Victorian exhibitions, and have led more cynical modern observers to dismiss Tuke rather unfairly, ignoring the merit of his other work.

During the last 8 years, pictures have sold for between about £100 and £380, watercolours £50-170.

Bibl: AJ 1907, 358f; Studio Spec. No. 1919 *British Marine Painting;* Mag. of Art 1902, 337-43; M.T. Sainsbury *H.S.T.* 1934; 1934; Reynolds VP; Maas.

TURCK, Miss Eliza b.1832 fl.1854-1886
Painter of genre portraits, literary subjects, landscape, coastal scenes, architectural subjects and miniatures, both in oil and watercolour. Born in London, of German extraction. On her return from school in Germany in 1848, she studied for six months at Cary's School of Art, afterwards took lessons in oil painting from Mr. W. Gale, and in 1852 entered the figure class of the Female School of Art in Gower Street for a further year. In 1859-60 she studied in Antwerp. Exhib. from 1851-86, at the RA (1854-86), BI, SS and elsewhere, titles at the RA including 'Rus in Urbe' 1858, 'Lady Dorothy in Breton Costume' 1880 and 'In St. Mark's, Venice' 1885. 'Cinderella', (1856 RA), was one out of forty pictures selected by Ruskin for criticism in his *Academy Notes:* "Very pretty, and well studied, but Cinderella does not look the lady of a fairy tale. I am rather puzzled myself to know how her relationship to her remarkable godmother could best be indicated so as to leave her still a quite *real* little lady in a real kitchen. But I am glad to see this sternly realistic treatment, at all events". At the International Exhibition, 1871, she exhibited miniatures and an oil 'Painter and Patrons'. An exhibition of her watercolours of Brittany (marines, landscapes, natural objects, street views) was held at the Rogers Gallery, Maddox St. in 1879, about which the AJ wrote "Her colouring is close to nature and full of tender greys, especially in the sky, while her touch is broad, free and Cox-like".

Probable price range £30-100

Bibl: AJ 1879, 79; Ruskin, *Academy Notes* 1856; Clayton II 146-51.

TURNER, Francis fl.1838-1871
London painter of landscape, especially in North Wales, Perthshire and Yorkshire, who exhib. from 1838-71, at the RA (1842-69), BI and SS. Titles at the RA include 'East Sutton Park, near Maidstone' 1842, 'On the River Llugwy', 1851 and 'Roche Abbey, Yorkshire' 1869.

Probable price range £30-70

TURNER, F.C. RBA 1795-1865
London painter of portraits of horses, shooting subjects, and also general portraits and miscellaneous subjects. Exhib. from 1810-46, at the RA (1817-44), BI, SS and elsewhere, titles at the RA including 'Portrait of Master Beecher on the Celebrated Pony Lady-bird, the property of Captain Beecher' 1836, 'A Subject from Æsop's fables' 1840, and 'Foxhounds Going Out' 1844, Paintings by him are in the Walker Art Gallery, Liverpool and the City Art Gallery, Manchester Said to be the father of two other sporting artists.

'A Groom with a Horse and Gig outside a House' sold at Sotheby's 20.11.68 for £5,800. This was an exceptional price, possibly a record. The normal range is still £200-500.

Bibl: Pavière, Sporting Painters (pl.43).

TURNER, George fl.1865-1882

Little-known Bristol landscape painter. Exhib. 19 works at SS between 1865 and 1882.

Prices during the last two years have ranged from about £50 to £160.

*TURNER, Joseph Mallord William RA 1775-1851

Painter and watercolourist. The greatest English artist of the nineteenth century, and one of the most important figures of the Romantic Movement. Born in London, son of a barber. Studied at RA schools 1790-3. First exhib. at RA 1790. From the start, he was encouraged and supported by the RA, who elected him ARA 1799, RA 1802. Professor of Perspective 1807-37. In the early 1790's he worked only in watercolour, in the eighteenth century topographical tradition. In 1790 he made the first of his many sketching tours of England. He met Girtin, and the two artists worked together at Dr. Monro's house, Turner washing in over Girtin's outlines. Turner acknowledged his debt to Girtin in his remark "if Tom had lived, I should have starved". About 1796 he turned to oil painting. His oils of this period represent a romantic reinterpretation of all the current historical styles then in vogue. He painted Dutch-style landscapes and seascapes in the manner of Van der Neer, Cuyp, Teniers, Ruisdael and Van de Velde; classical landscapes in the style of Claude and Wilson; and after his visit to Paris in 1802, grand historical compositions in emulation of Titian and Poussin. In 1802 he also visited Switzerland, where he painted some of his finest early watercolours e.g. 'The Great Fall of the Reichenbach' 'Chamonix' etc. The Alps were to inspire several other works, such as 'The Fall of the Rhine at Schaffhausen' 'The Fall of an Avalanche in the Grisons' and 'Snowstorm, Hannibal and his Army Crossing the Alps' all typical of his "visionary evocation of the cosmic forces of Nature" (Butlin). In 1803 he painted 'Calais Pier' the first of his early works to show individual style, but this and many subsequent pictures were bitterly attacked by the critics as unfinished, or "pictures of nothing, and very like". To defend himself, Turner in 1805 adopted the practise of opening his house as a gallery, and from 1806-19 he produced the *Liber Studorium*, a series of engravings of different styles of landscape. He continued his exploration of natural effects and English landscape in watercolours and sketches, but also produced historical pieces e.g. 'The Battle of Trafalgar'. In 1819 he paid his first visit to Venice. The revelation of light and colour which he found there was soon reflected in the increasingly pale and impressionistic style of his pictures. He returned to Venice in 1835 and 1840. In 1820 he visited Rome, which inspired him to paint another series of Claudian landscapes of Rome and the Campagna. During the 1820's his increasing preoccupation with light and colour resulted in many almost abstract watercolour sketches; best-known are the series of interiors at Petworth. His watercolours undoubtedly influenced his oil painting style. Ideas first tried and experimented with in watercolour were later worked out in oils. Throughout all this, he continued with his Dutch marine pictures, such as 'Port Ruysdael' and the Van Tromp series, and also historical scenes in the Rembrandt style. By the 1830's his style was finally formed, and he produced some of his greatest works e.g. the Petworth landscapes (1830-1), many of his finest Venetian scenes, 'The Burning of the Houses of Parliament' (1834) and other fire subjects, and 'The Fighting Temeraire' (1838) the best of his late, finished works. In the 1840's his style became increasingly abstract e.g. 'Norham Castle' and 'Rain, Steam and Speed' (1844). Many of the swirling, vorticist compositions of this period were never exhibited, and were found in his house after his death. In 1843 Ruskin published his celebrated defence of Turner in the first volume of *Modern Painters*. An enormously prolific artist, he bequeathed over 300 oils and nearly 20,000 drawings to the nation. His style has had many imitators, but no rivals.

'Ehrenbreitstein' sold at Sotheby's 7.7.65 for a record £88,000. Major works by Turner are now very rare, and obviously make large sums. Last season a watercolour of Ely Cathedral sold at Christie's 16.6.70 for £10,500, and 'Geneva and Mount Blanc' sold at Sotheby's 17.6.70 for £31,000, the latter a record for a Turner watercolour. In the last ten years, prices for watercolours have generally ranged from £1,000-10,000. Some watercolours, especially the early topographical ones, can still sell for under £1,000.

Bibl: Main Biographies – G.W. Thornbury *The Life of J.M.W.T.* 1862.
P.G. Hamerton *The Life of J.M.W.T.* 1879
C.F. Bell *List of Works by T. Contributed to Public Exhibitions* 1901
Sir W. Armstrong, *T.* 1902
A.J. Finberg *T's Sketches and Drawings* 1910
A.J. Finberg *T's Watercolours at Farnley Hall* 1912
A.P. Oppé *Watercolours of T.* 1925.
G.S. Sandilands *J.M.W.T.* 1928
B. Falk *T. the Painter* 1938
A.J. Finberg *The Life of J.M.W.T.* 1939
C. Clare, *J.M.W.T. His Life and Work* 1951
Sir J. Rothenstein *T.* 1962
M. Butlin *T. Watercolours* 1962
L. Hermann *J.M.W.T.* 1963
Sir J. Rothenstein and M. Butlin *T.* 1964
John Gage *Colour in T.* 1970
G. Reynolds *T.* 1970
Other References: J. Ruskin *Modern Painters* 1843; ibid, *Academy Notes;* Redgrave, Dict. and Cent.; Roget; Bryan; Binyon; Cundall; DNB; VAM; Reynolds VP; Tate Cat.; Hutchison; Hardie II and III (see p.319-20 for full bibl. and list of exhibitions); Maas.

TURNER, William (of Oxford) ARWS 1789-1862

Landscape painter, mainly in watercolour. Called "Turner of Oxford" to distinguish him from J.M.W. Turner. Studied under John Varley. His early promise was so great that he was elected ARWS at the age of only 18, in 1808. His work of this period can stand comparison with Varley and Cotman, but his "youthful ardour, promise and innocence were to be spoiled by experience and sophistication" (Hardie). In 1833 he returned to Oxford, where he gave lessons, and produced large numbers of landscapes and topographical views. These later works are usually pleasing and professional, but lack the inspiration of his earlier work. He travelled extensively in England, Wales and Scotland in search of subjects; he was most fond of Scotland, the Lake District, Northumberland, West Sussex and the country round Oxford. Exhib. mainly at OWS (455 works), also RA 1807-57, BI and SS. Works by him are in the Ashmolean and the VAM. His studio sale was held at Christie's on March 9, 1863.

During the last ten years, the average has been between £50 and £650.

Bibl: DNB; Bryan; Cundall; Binyon; VAM; Redgrave, Dict.;
A.L. Baldry *W.T. of Oxford* Walker's Quarterly XI 1923
M. Hardie *W.T. of Oxford* OWS IX 1932
L. Hermann *W.T. of Oxford* 'Oxoniensa' XXVI, XXVII, 1961-2.
Hardie II 234-8 (pls. 229-231).

TUSON, G.E. fl.1853 d.1880

Painter of portraits, genre and biblical subjects, working in London, Turkey and South America. Exhibited from 1853-65, at the RA (1854-9), BI and SS, titles at the RA being portraits and 'The Cold Bath', 1854. Painted 'The Reception of a Deputation from the Corporation of Manchester by the Sultan, in Buckingham Palace', 1867, for the Town Hall, Manchester. Afterwards he painted genre subjects and portraits in Turkey, and then in Montevideo, where he died. His portrait of General Sir W.F. Williams, Bart., is in the Guildhall Art Gallery, London.

Probable price range £20-60

Bibl: *American Art Review* II/I 1881 134 (obit); Bryan; Cat. of Engr. Brit. Portraits BM I 1908 320.

TWEEDIE, William Menzies 1828-1878

Portrait painter. Born in Glasgow, the son of a lieutenant in the marines. Entered the Edinburgh Academy at the age of sixteen, and remained there for four years, gaining a prize for the best copy of Etty's 'The Combat'. In 1843 he exhib. a portrait at the RSA. In 1846 he came to London and entered the RA Schools; afterwards he studied for three years in Paris under Thomas Couture. Exhib. from 1847-74, at the RA (in 1847 'Summer', and from 1856-74), BI and SS. From 1856-59 he lived in Liverpool, and in 1859 he settled in London. His pictures were not always accepted at the RA and after 1874 they were invariably refused.

Probable price range £20-60

Bibl: Ottley; Redgrave, Dict.; Bryan; DNB;
R.L. Poole *Cat. of Portraits....Oxford* 3 1925
Cat. of Engr. Brit. Portraits BM 6 (1925) 189

TYNDALE, Walter Frederick Roofe RI 1855-1943

Painter of architectural subjects and topographical landscapes, portraits and genre. Born at Bruges; came to England when he was sixteen; at eighteen studied at the Academy in Antwerp, and then in Paris under Bonnat and the Belgian artist Jan Van Beers. Returned to England, and at first worked in oils, painting portraits and genre, and was chiefly known as a portrait painter until *c.* 1890. Settled in Haslemere and gave lessons, and at this point took up watercolours, being much influenced by Claude Hayes and by Helen Allingham, who was a friend. He never again used oils. He travelled to Morocco, Egypt, Lebanon, Damascus, Sicily, Italy and Japan, and became well-known for his finely detailed watercolours of Egyptian temples, Tunisian streets, Italian townscapes and other topographical subjects. He held many exhibitions : at the Leicester Galleries in 1912 — 'An Artist in Egypt', at Waring and Gillows in 1913 — watercolours of Egypt and Japan; and at the FAS in 1920 and 1924. He was appointed to the Censor staff at Havre in 1914, and later was Head Censor (Despatches) at Boulogne. Exhib. from 1880 at the RA, SS, NWS, GG and elsewhere. He also illustrated many topographical books, chiefly for the publishers A. & C. Black Ltd. : *The New Forest* 1904 (Methuen), *Wessex, Below the Cataracts* 1907, *Japan and the Japanese* 1910, *Japanese Gardens* 1912, *An Artist in Egypt* 1912, *An Artist in Italy* 1913, *An Artist in the Riviera* 1916, *The Dalmatian* Coast 1925 and *Somerset* 1927.

'Sermon at Evening' sold at Christie's 20.11.70 for £126.

Bibl: Studio 31 (1904) 254; 38 (1906) 289-97 (pls.); Connoisseur 32 (1912) 133; 37 (1913) 122; 58 (1920) 244; 68 (1924) 111f; 72 (1925) 190; Who's Who in Art 1934; Who Was Who 1941-1950.

UNDERHILL, Frederick Charles fl.1851-1875

London painter of genre, coastal scenes and biblical subjects. Born at Birmingham. Exhib. from 1851-75, at the RA (1852-67), BI, SS and elsewhere, titles at the RA including 'Sea Coast' 1852, 'The Gipsy Mother' 1855, and 'Hagar and Ishmael' 1863. 'The Dinner Hour' is in Birmingham Art Gallery.

Probable price range £30-100

Bibl: AJ 1859 82 121 168; Birmingham Cat.

UNDERHILL, Frederick Thomas fl.1868-1896

London painter of fruit, landscape and portraits, who exhib. from 1868-96, at the RA (1874-96), SS and elsewhere, titles at the RA being 'Fruit' and 'Pears' 1874, 'On the Ridges, Berkshire' 1877, and 'Andrew W. Levey, Esq.' 1896.

Probable price range £30-80

UNDERHILL, William fl.1848-1870

London painter of genre, sporting subjects, coastal scenes and mythological subjects. Born at Birmingham, brother of F.C. Underhill (q.v.). Exhib. from 1848-70, at the RA (1849-64), BI, SS and elsewhere, titles at the RA including 'Irish Emigrants' 1849, 'Cupid and Psyche' 1851, and 'The Salmon-trap' 1856. In 1859 the AJ reviewed 'The Raft' (at the Portland Gallery, a man helping a woman out of the sea), as "A daring essay, successful in many points". Paintings by him are in Birmingham and Wolverhampton art galleries.

Probable price range £30-100

Bibl: AJ 1859, 121 167; Birmingham Cat; Pavière, Sporting Painters; Wilson, Marine Painters.

URWICK, Walter C. b.1864 fl.1882-1904

Painter of genre and portraits. Pupil at the RA from 1882. Exhib. from 1887-1904 at the RA, NWS and elsewhere, titles at the RA including 'A Stagnant Pool' 1887, 'Sweet and Twenty' 1901, and 'In that New World which is the Old' 1902. Connoisseur illustrates 'Love Hopeth all Things', a painting very much in the style of Frederick Walker showing a mother holding her sick baby, with the note "Wanted — information about a picture by Walter Urwick, 'Love Hopeth all Things', exhib. RA 1896 and sold to a man in the North of England." 'A Kentish Maiden' is in the City Art Gallery, Leeds.

Probable price range £50-150

Bibl: Connoisseur 63 (1922) 229-30 (pl.)

URWICK, William H. RPE fl.1867-1881

London landscape painter and etcher, who exhib. from 1867-81, at the RA (1872-81), SS and elsewhere. Titles at the RA include etchings and 'Mount Pond, Clapham Common' 1872 and 'Windsor, from Burnham Beeches' 1880.

Probable price range £30-80

UWINS, James fl.1836-1871

Landscape and topographical painter. Exhib. at RA 1836-71, BI and SS. Painted English scenery, especially in Devon, also views in Spain and Italy. There seems to be no indication that he was related to Thomas U. (q.v.).

Probable price range £30-100

UWINS, Thomas RA 1782-1857

Genre painter, watercolourist and illustrator. Studied under Benjamin Smith, an engraver, and at RA Schools. At first worked mainly in watercolour, drawing many fashion plates for Ackermann's Member of OWS 1809-18. Also painted portraits and rustic scenes. After 1818 he began to turn more to oil painting, first of French subjects, then following his first visit to Italy in 1824, the picturesque Italian subjects for which he became best known. Exhib. at RA 1803-57, BI, SS, OWS and NWS. Elected ARA 1833, RA 1838. Keeper of the National Gallery 1847-55. Works by him are in the VAM, Glasgow, Leicester, Manchester and Dundee AG.

Probable price range £50-250

Bibl: AU 1847, 312; AJ 1857, 315f (obit); 1859, 28; Connoisseur 52 (1928) 114; 67 (1923) 197; Mrs. Unwins *A Memoir of T.U.* 1859; Studio Spec. No.

1916 Shakespeare in Pictorial Art; Redgrave, Dict. and Cent.; Clement and Hutton; Roget; Binyon; Cundall; DNB; VAM; Hardie I 157 (pl.156).

VACHER, Charles 1818-1883

Watercolour painter of landscape and topographical subjects. Third son of the well-known stationer and bookseller, Thomas Vacher, of 29 Parliament Street. Studied at the RA Schools; in 1839 he went to continue his studies in Rome. Many tours followed, in which he visited Italy, Sicily, France, Germany, Algeria and Egypt, making large numbers of sketches. He was a rapid worker, and, besides over two thousand sketches which he left at his death, he often executed twelve to sixteen highly finished works in one year. He exhib. from 1838-81, at the RA (1838-74), BI, and SS, but chiefly at the NWS (324 works) of which he became an Associate in 1846 and Member in 1850. Titles at the RA include such subjects as 'Attila's Invasion; the First View of Italy' 1859 and 'Thebes during the Inundation' 1874. Ruskin admired Vacher's work and said of 'The Kabyle Mountains at Sunset' (NWS 1857): "The rocks and aloe on the left are very beautifully drawn, the tone of the distant mountains most true, and all the effects more delicately felt than hitherto in this painter's work", and of 'Bardj Acouss' (NWS 1858): "There is great beauty of tone in many of Mr. Vacher's drawings and their impression is often most pleasing; but he should really leave out the figures for some time to come.". His studio sale was held at Christie's on Feb. 21, 1884.

'Pageant in St. Mark's Square, Venice' – a watercolour sold at Bonham's 11.12.69 for £110.

Bibl: Ruskin, Academy Notes (OWS 1857; NWS 1857-8); Bryan; Binyon; Cundall; DNB; VAM.

VACHER, Thomas Brittain 1805-1880

Landscape watercolourist. Brother of Charles Vacher (q.v.). For many years he was in business in Parliament Street with his brother George; with whom he founded a charitable trust called the "Vacher Endowments". His hobby was sketching, and the VAM has many watercolour views made in England, Wales, Scotland, Ireland, Belgium, Germany, Italy and Switzerland.

Probable price range £20-50

Bibl: VAM

VALLANCE, William Fleming RSA 1827-1904

Scottish marine painter; also in his early career painted portraits and genre. Born in Paisley; when his family moved to Edinburgh, he was apprenticed in 1841 as a carver and gilder to Messrs. Aitken Dott. During his apprenticeship he began to paint portraits and genre, but did not receive proper instruction until he was twenty-three. Studied for a short time at the Trustees' Academy under E. Dallas, and later, from 1855, under R.S. Lauder. Began to exhibit at the RSA in 1849, but did not take up art as a profession until 1857. Exhib. only five works at the RA, 1961-73. After 1870 he painted, principally in Wicklow, Connemara, and Galway, a series of pictures of Irish life and character. However, he was eventually best known as a painter of the sea and shipping, and for his atmospheric watercolour sketches of sea and sky. Elected ARSA in 1875, RSA 1881.

Probable price range £50-150

Bibl: AJ 1898 370 f. (pls.); Bryan; Caw; DNB 2nd. Supp. 1912.

VALTER, Henry fl.1854-1864

Birmingham landscape painter, who exhib. from 1854-64 at the BI, SS and elsewhere.

Probable price range £30-80

VARLEY, Charles Smith fl.1839-1869

Landscape painter. Son of John Varley (q.v.). Exhib. from 1838-69, at the RA (1839-56), BI and SS, titles at the RA including 'View from Norwood' 1839, 'Ditchling Village, Sussex' 1850 and 'Landscape Effect' 1856.

Probable price range £50-200

VARLEY, Cornelius 1781-1873

Painter, in watercolour, of landscapes, marines and architectural subjects; inventor of scientific instruments, notably the graphic telescope, Brother of John Varley (q.v.). Trained by his uncle Samuel, a watchmaker and manufacturer of scientific apparatus, but in c.1800 decided to follow his brother's profession and joined him in frequenting Dr. Monro's house. In 1802 he visited N. Wales with his brother John, and again in 1803. In 1804 he became one of the founder members of the OWS. Exhib. from 1803-69, at the RA, BI, SS, OWS and elsewhere, only 62 works in all throughout his long career. This may have been due to his early taste for science: he improved the microscope, the *camera lucida* and the *camera obscura,* and at the Great Exhibition of 1851 was awarded a gold medal for the graphic telescope, which he had patented in 1811. The scarcity of his work has hindered general knowledge of its fine quality.

Usual price range £100-200

Bibl: AJ 1873, 328; Redgrave Dict. and Cent.; Roget; Binyon; Cundall; DNB; Hughes; VAM; B.S. Long *C.V.* OWS XIV 1937; Windsor, Williams; Hardie II 108-10 figs. 90-1; Maas 44.

VARLEY, Edgar John fl.1861-1887 d.1888

Painter of landscape and architectural subjects. Son of Charles Smith Varley (q.v.), and grandson of John Varley (q.v.). Exhib. from 1861-87, chiefly at SS, but also at the RA (1868-87), NWS, GG and elsewhere, titles at the RA including 'Arundel Castle, Sussex' 1868, 'Rue des Damouettes, Guernsey' 1876, and 'Near the Village of Shalbourne' 1887. He was Curator of the Architectural Museum at Westminster. The VAM has 'View from Gosport, Evening' 1867.

Probable price range £50-150

Bibl: Cundall; VAM; Hardie II 110.

VARLEY, John 1778-1842

Landscape and architectural watercolourist. Brother of Cornelius Varley (q.v.), and father of Albert Fleetwood Varley and Charles Smith Varley (q.v.). Apprenticed at first to a silversmith, and later to a law stationer. Subsequently he obtained employment with a portrait painter in Holborn, and studied under J.C. Barrow, a teacher of drawing, from about 1794. He was one of the young artists patronised by Dr. Monro. After visiting Peterborough with Barrow, he exhib. for the first time at the RA in 1798 – 'Peterborough Cathedral'. Exhib. from 1798-1843, at the RA (1798-1841), BI, SS, but chiefly at the OWS, which he helped to found in 1804, and where he exhibited 739 works. His early style is broad and simple, deriving great freshness from pure tints and facility of treatment. Varley published works on drawing, perspective and astrology and had a considerable reputation as an art teacher, numbering among his pupils F.O. Finch, W.H. Hunt, Copley Fielding, Turner of Oxford, David Cox, John Linnell, and Mulready. His life ended in poverty.

The usual price range is £100-300, but an exceptional example could sell for up to £1,000.

Bibl: Art Union 5 (1843) 9 f. (obit); Redgrave Cent. and Dict.; A.T. Story *James Holmes and J.V.* 1894; Roget; Binyon; Cundall 66, 265; DNB; Hughes; The Walpole Society 5 (1915-17) 64; Connoisseur 66 (1923) 73-5 (pl.); 67 (1923) 190, 192, 196 (pl.); 68 (1924 71 (pl.) 75; 70 (1924) 233, 247; B.S. Long 'List of works exhibited by J.V.' OWS II 1925; Studio 90 (1925) 74; VAM; Charles Johnson *English Painting* 1932 B.M. Quarterly 9 (1934-5) 85; RA 1934; A. Bury *J.V. of the 'Old Society'* 1946; Windsor; Williams; Hardie II 98-107, passim (pls), III passim; Maas 44, 47, 171.

VARLEY, John, Junior fl.1870-1895 d.1899

Painter of landscape and oriental subjects (street scenes, genre and landscape in Egypt, India and Japan). Son of Albert Fleetwood Varley (1804-1876), who was a teacher of drawing, and grandson of · John Varley (q.v.). He often causes confusion by using the same signature as his grandfather. Exhib. from 1870-95, at the RA (1876-1895), SS, NWS, GG and elsewhere, titles at the RA including 'The Island of Philae, Nubia' 1876, 'Fishing Boat on the Nile' 1885, and 'A Potter's Shop, Cairo' 1887.

'The Mosque of Olboo Leybeh, Cairo' sold at Christie's 10.10.69 for £116.

Bibl: Studio 32 (1904) 61; 58 (1913) 63.

VARLEY, William Fleetwood 1785-1856

Painter of landscapes and architectural subjects. Brother of John Varley (q.v.). Exhib. from 1804-1818 at the RA. He taught drawing in Cornwall in 1810, and afterwards at Bath and Oxford. At Oxford he was nearly burned to death by the thoughtless frolic of a party of students, and never recovered from the shock; he died at Ramsgate.

Probable price range £50-150

Bibl: AJ 1856, 148; Redgrave Dict.; Cundall 265; DNB; Hughes; Williams; VAM; Hardie II 110 fig. 89.

VAWSER, Miss Charlotte fl.1837-1875

Landscape painter, living in London and Derby, who exhib. from 1837-75, at the RA (1837-65), BI, and SS. Daughter of G.R. Vawser (q.v.). Titles at the RA include 'Effect from Nature in Hampstead' 1837, and 'Eagle Cliff' 1865.

Probable price range £20-60

VAWSER, G.R. fl.1818-1847

London landscape painter, who exhib. from 1818-47, at the RA and SS, titles at the RA including 'View near Bolton, Yorkshire' 1836, and 'Sketch from Nature – the Wind about to Change' 1847.

Probable price range £20-60

VAWSER, G.R. Junior fl.1836-1874

Landscape painter, living in London and Derby, who exhib. from 1836-74, at the RA (1836-65), BI and SS. Son of G.R. Vawser (q.v.). Titles at the RA include 'Effect from Nature' 1836, 'Aysgarth Foss, Yorkshire' 1842, and 'View in Calke Park, Derbyshire' 1865.

Probable price range £20-60

VENABLES, Adolphus Robert fl.1833-1873

London portrait painter. Exhib. 21 works at the RA between 1833 and 1873.

Probable price range £20-50

VERSEY, Arthur fl.1873-1900

Kilburn painter of landscape, river scenes and rustic genre, who exhib. from 1873-1900, at the RA (1880-1900), SS (63 works), NWS and elsewhere. Titles at the RA include 'Measuring Hops in a Kentish Garden' 1883, 'Shrimp Boats on the Yare, Norfolk' 1888, and 'Market Day' 1900.

Probable price range £30-70

VERNEDE, Camille fl.1869-1898

Landscape painter, living in London, Poole and Wimborne, Dorset. Exhib. from 1869-98, at the RA (1873-98), SS, GG, NG and elsewhere, titles at the RA including 'Fir-trees' 1873; 'Near Poole Harbour' 1896, and 'A Grey Day' 1898.

Probable price range £30-100

VERNON, Arthur Langley fl.1871-1897

Genre painter. Exhib. at RA 1873-97, SS, NG and elsewhere. Painted domestic scenes and interiors, with figures often in period costume. Also sometimes painted scenes with cardinals engaged in some humorous activity.

Prices in the 1968-9 season ranged from £126 to £260.

VERNON, William H. fl.1858-1892

Birmingham landscape painter, who exhib. from 1858-92, at the RA (1872-92), BI, SS and elsewhere, titles at the RA including 'On the Ogwen, North Wales' 1872 and 'A Lonely Mere' 1891.

Probable price range £30-60

*VICKERS, Alfred 1786-1868

Landscape painter. A self-taught artist, whose light and sparkling style has been compared to Boudin. Exhib. at RA 1831-68, BI (125 works) and SS. Painted English views, especially river scenes, in a rapid, sketchy style, using a range of pale greens which is very distinctive. Works by him are in Glasgow, Nottingham and Sheffield A.G. His son Alfred Gomersal V. (q.v.), was also a painter.

'A Farm Scene with Figures and Cattle' sold at Christie's 14.11.69 for £2,730, the current auction record. The usual range is £100-600.

Bibl: Connoisseur 66 (1923) 240 f; Redgrave, Dict.; Bryan; Wilson, Marine Painters pl.42; Pavière, Landscape pl.83.

VICKERS, Alfred Gomersal 1810-1837

Landscape painter; son of Alfred V. (q.v.). Like his father, he exhib. mostly at BI, also RA 1827-36, SS and NWS. In 1833 he visited Russia to make drawings for Charles Heath's "Annuals". Painted views in England, France, Switzerland, Poland, and Moscow. Works by him are in the VAM, Leicester and the Nat. Gall. Dublin. He died young, and his output was not large. Unless his pictures are signed "A.G. Vickers" they are often confused with those of his father.

Prices in the last two seasons have ranged from about £100 to 546.

Bibl: see under Alfred Vickers.

VICKERS, A.H. fl.1853-1868

Landscape painter. Probably related to Alfred Gomersal V. (q.v.) and Alfred V. (q.v.), but this is not known for certain. Exhib. at RA once in 1853, BI and SS. Painted landscape views in England, and on the Rhine. His pictures are usually small, and his style a slightly coarse imitation of Alfred Vickers (Senior). Usually signed "A.H. Vickers".

Prices in the last season have ranged from about £100 to 525.

Bibl: Pavière, Landscape Painters.

VINTER, Frederick Armstrong fl.1874-1883

London painter of historical subjects, portraits and genre, who exhib. from 1874-83, at the RA (1879-83), SS and elsewhere. Titles at the RA include 'Mildred' 1879, 'Lady Jane Grey' 1880, and 'From Arabia' 1881. Possibly the son of John Alfred Vinter (q.v.) as listed as living at the same address, 29, Monmouth Road. Also at the same address was Miss Harriet Emily Vinter, still life painter, who exhib. from 1879-80 at the RA and SS.

Probable price range £30-100

VINTER, John Alfred 1828-1905

Portrait lithographer, and painter of portraits, genre, and literary and historical subjects. Exhib. from 1847-1902, at the RA (1848-1902), BI, SS and elsewhere. Many of his lithographed portraits exhibited at the RA were made for Queen Victoria, e.g. 'H.R.H. Prince Leopold George Duncan Albert. After Winterhalter', 1860. Titles of other works exhibited at the RA include 'The Burial of Isabella' 1849, 'The Hamper from Home' 1873, and 'Alone in London' 1881.

'Chelsea and Greenwich Pensioners' sold at Christie's 21.3.69 for £147.

Bibl: The Year's Art 1906, 362; Cat. of Engr. Brit. Portraits BM 6 (1925) 706; Ill. list NPG 1928.

VOS, Hubert RBA b.1855 fl.1885-1892

Painter of portraits, genre and landscape. Born in Maastricht; studied in Brussels, Paris and Rome. Living in England 1885-92. Exhib. from 1888-92, at the RA (1888-91), SS, NWS, GG, NG and elsewhere, titles at the RA including 'A Breton Beggar' 1888, 'A Room in the Brussels Almshouse for Women' 1889 and 'H.E. Mons. de Staal, Russian Ambassador in London' 1890. Later he went to New York, where he became a naturalised American.

Probable price range £50-200

Bibl: J. Martin, Nos peintres et sculpt., 2 1898; American Art Annual 20 (1923) 723; The Art News 23 (1925-6) No.6 2; M. Fielding, Dictionary of American Painters, 1926; Op de Hoogte 25 (1928) 102-05.

WADE, Thomas 1828-1891

Painter of landscape and rustic genre. A self-taught artist, influenced by Pre-Raphaelite techniques. Lived in Preston, Lancs, and after 1879 in Windermere. Exhib. at RA 1867-90, BI and elsewhere. Titles at RA 'The Old Smithy' 'An Old Farmhouse' 'Harvest Field' etc. 'An Old Mill' (RA 1879) was bought by the Chantrey Bequest for £84.

Probable price range £50-200

Bibl: Preston Corporation AG. 1907.

WAGEMAN, Michael Angelo fl.1837-1879

Portrait and genre painter. Presumably son of Thomas Charles W. (q.v.) as they are listed in Graves at the same address during 1836-7. Exhib. at RA 1837-79, BI and SS. Titles at RA portraits and historical genre e.g. 'Amra and Govinda' 'Celadon and Amelia' and 'Nathan Accusing David'.

Probable price range £30-100

WAGEMAN, Thomas Charles 1787-1863

Portrait painter in oil and miniature, and engraver. Exhib. at RA 1816-1848, BI, SS and NWS. Specialised in portraits of famous actors in their leading roles. Appointed portrait painter to the King of Holland. Michael Angelo W. (q.v.) also a painter, was presumably his son.

Probable price range £20-60

Bibl: Redgrave, Dict; Cundall 265; VAM Watercolour Cat. 1908 of Drawings by Brit. Artists BM 4 (1907); Cat. of Engraved Brit. Portraits BM VI 559 f; Burlington Mag. 69 (1936) 251; Binyon; VAM.

WAINEWRIGHT, John fl.1860-1869

Very little-known flower painter. Exhib. four pictures at BI and two at SS between 1860 and 1869.

'Flowers in a Sculptured Vase' sold at Sotheby's 16.10.68 for £3,200 by far the highest recorded price. Usual range £100-400.

WAINEWRIGHT, Thomas Francis fl.1831-1883

Landscape painter. Lived in London. A prolific painter, who exhib. over 200 works at SS, also at RA 1832-62, BI and elsewhere. Titles at RA include many landscape sketches and studies.

'Fisherfolk on Shore at Low Tide' sold at Sotheby's 16.10.68 for £240.

Bibl: VAM Cat. of Watercolours 1908

WAINWRIGHT, William John RWS RBSA 1855-1931

Birmingham painter and watercolourist of portraits, still life and genre; stained-glass designer. Born at Birmingham; educated at Sedgley Park College near Wolverhampton. Apprenticed to Messrs. Hardman, stained-glass designers. One of the founders of the Birmingham Art Circle, 1879. For some time he directed the life academy at the Birmingham School of Art under E.R. Taylor (q.v.). Studied painting at the Antwerp Academy, principally under C. Verlat. Shared a studio with F. Bramley (q.v.). Elected A of the Birmingham Society of Artists, 1881. Lived in Paris, 1881-4; After a period in London, he spent two years at Newlyn with Edwin Harris and W. Langley. Returned in 1886 to Birmingham where he died. Exhib. from 1882, at the RA (only in 1883, 'An Ancient Musician'), RWS, SS, but mostly at the RBSA. Elected RWS 1893. Painted a posthumous portrait of David Cox for the RWS.

Probable price range £50-300

Bibl: Studio 65 (1915) 201; Connoisseur 72 (1925) 50; 75 (1926) 60; 88 (1931) 277 (obit.). Birmingham Cat.

WAITE, Edward W. RBA fl.1878-1903

Landscape painter. Lived in Blackheath, Reigate and Dorking. Exhib. at RA from 1878, also at SS, NG and elsewhere. Titles at RA 'The Felling Season' 'Late Autumn' 'Lingering Autumn' etc. Works by him are in Bristol and Preston AG.

Prices in the 1968-70 seasons ranged from about £180 to £231

Bibl: Bristol AG. Cat. 1910; Preston AG. Cat. 1907.'

WAITE, James Clarke RBA fl.1863-1885

London genre painter. Exhib. mainly at SS (117 works) where he was a member; also at RA 1863-1884, BI, OWS and elsewhere. Titles at RA 'The Torn Dress' 'A Rustic Genius' 'The Cat with Many Friends' etc.

'The Youngest Member of the Family' sold at Christie's 10.7.70 for £147.

WAITE, Robert Thorne RWS 1842-1935

Landscape painter, mostly in watercolour. Born in Cheltenham; studied at S. Kensington Museum. Exhib. at RA from 1870, SS, NWS, GG, NG etc. but mostly at OWS. Elected ARWS 1876, OWS, 1884. Painted pastoral scenes in Yorkshire and Southern England, especially the Sussex Downs; the main influence on his style was Copley Fielding (q.v.).

Probable price range £20-60

Bibl: AJ 1892 p.182-6; 1895, 60, 62; Connoisseur 28 (1910) 315; 54 (1919) 49; 67 (1923) 61; 72 (1925) 50; Studio Summer No. 1900; VAM; Hardie II 233-4 (pl.226).

WALKER, Francis S. RHA 1848-1916
Irish genre and landscape painter, and illustrator. Studied at Royal Dublin Society and RHA schools. Came to London 1868 where he worked for the Dalziel brothers. Later worked as an illustrator for *The Graphic* and *Illustrated London News*. Made his debut as a painter in 1868 at the Dudley Gall. Exhib. at RA 1871-1913, SS and NWS. Titles at RA 'A Lazy Fellow' 'The Little Shepherdess' etc. and many views along the Thames. A work by him is in Leeds AG. He illustrated several topographical books, including 'The Groves of Blarney'.

'Children Resting under a Tree' sold at Bonham's 6.2.69 for £320.

Bibl: Mag. of Art 1904 p.140; Who was Who 1916-29.

***WALKER, Frederick ARA ARWS 1840-1875**
Genre painter and watercolourist. Born in London. First studied from antique sculpture in the British Museum, then at Leigh's Academy, and RA schools 1858. Member of Langham Sketching Club. Worked for T.W. Whymper, a wood engraver, for 3 years. In 1860 he began to contribute drawings to *Once a Week*, in 1861 *Cornhill Magazine*. Before long he had established himself as one of the most talented young illustrators of the 1860's, illustrating for Thackeray and many magazines. In 1863 he began to exhibit at the RA, and in 1864 he scored a great success at the OWS with his exhibits there. His watercolours are similar in spirit and technique to the work of Birket Foster (q.v.) and W.H. Hunt (q.v.). The theme of most of his works is the poetic evocation of simple pastoral life e.g. 'Spring' 'Autumn' 'The Violet Field'. His watercolours of this type were very popular, and made high prices in his own lifetime. His large oils, such as 'The Harbour of Refuge' 'Wayfarers' and 'The Old Gate' reflect the classicism of his early training, with their consciously posed figures in what Ruskin called "galvanised-Elgin" attitudes. Exhib. at RA 1863-75, OWS and elsewhere. Elected ARWS 1864, ARA 1871. Died of consumption at a tragically young age; buried at Cookham-on-Thames, where many of his pictures were painted. His studio sale was held at Christie's on July 17, 1875.

Works by Walker are very rare and do not often appear in the saleroom. 'The Plough' sold at Christie's 16.3.62 for £147, but a good example would be worth more than this at the present time.

Bibl: AJ 1876, 197-300. 1893, 277 f; Portfolio 1870, 35-38; 1875, 117-22; Print Collector's Quarterly 7 (1920) 385f; Redgrave, Dict and Cent; Roget; Binyon; Cundall; DNB; Gleeson White; VAM; J.C. Carr *F.W.* 1885; Sir C. Phillips *F.W.* 1894; J.G. Marks *The Life and Letters of F.W.* 1896; C. Black *F.W.* 1902; J.L. Roget *F.W.* OWS XIV 1937; Hardie III 134-7 (pls. 156-7); Reynolds VS and VP; Maas 235-6 (pl. p. 236).

WALKER, James William 1831-1898
Landscape painter in oil and watercolour. Born in Norwich, where he studied at the School of Design. Later lived in London, Bolton, and Southport. Exhib. at RA 1862-93, SS, OWS, GG, NG and elsewhere. Mainly painted views in Lancashire, Cumberland, Wales and Brittany. Visited Rome and Naples in 1881. Works by him are in Norwich, Liverpool and VAM. His wife Mrs. Pauline W. exhib. still-life pictures from 1870-82 at RA, SS, OWS and elsewhere. Works by her are also in Norwich Mus.

Probable price range £30-100

Bibl: W.F. Dickes *The Norwich School of Painters* 1905; Cundall 266

WALKER, John Eaton fl.1855-1866
Birmingham genre painter. Exhib. at RA 1858-66, BI, SS and elsewhere. Titles at RA 'Venice — a Reverie' 'Abraham Cooper RA' and 'The Earth Hath Bubbles' etc.

Probable price range £30-80

WALKER, John Hanson fl.1869-1902
London portrait painter. Exhib. at RA from 1872, SS, GG and else-

where. Titles at RA also include occasional genre subjects. Portraits by him are in Cheltenham and Derby AG.

Probable price range £30-70

WALKER, John Rawson 1796-1893
Nottingham landscape painter. Lived in London and Birmingham, but is best known in his native town of Nottingham. Exhib. at RA 1817-45, BI and SS. RA titles also include some historical genre subjects. Painted landscape in many parts of England, but especially in the Midlands around Nottingham. Works by him are in Nottingham AG.

'A Classical Landscape' sold at Sotheby's 16.10.68 for £130.

Bibl: AJ 1850 p.65; 1874, 45; Redgrave, Dict; Bryan; Cat. of Drawings by Brit. Artists BM 4 (1907)

WALKER, Miss Marcella M. fl.1872-1901
Genre painter. Exhib. at RA from 1876, also at SS. Titles at RA 'The Sailor's Sweetheart' 'At her Wheel' 'Flowers of the Field' etc.

Probable price range £30-80

WALKER, Mrs. Pauline See under WALKER, James William

WALKER, William Eyre RWS 1847-1930
Landscape painter, mainly in watercolour. Exhib. mostly at OWS (197 works) also RA 1885-98, SS, NG and elsewhere. A prolific painter of landscape views in England and Scotland.

Probable price range £20-50

Bibl: Hardie III 163

WALL, William Archibald fl.1857-1872
London landscape painter. Exhib. at RA 1857-72, BI, SS and elsewhere. Titles at RA 'A Shady Stream' 'The Bridle Path' 'On Bexley Common, Kent' etc.

Probable price range £30-60

WALLER, Samuel Edmund 1850-1903
Genre and animal painter. Studied at Gloucester School of Art. Worked for his father, an architect, and on their farm, making many studies of animals. Exhib. at RA 1871-1902, SS and elsewhere. Titles at RA 'The King's Banner' 'Sweethearts and Wives' 'The Huntsman's Courtship' etc. Also worked as illustrator for *The Graphic*. Works by him are in The Tate Gall. His wife Mrs. Mary W. (q.v.) was also a painter.

'The Wide, Wide World' sold at Christie's 7.11.69 for £262. 'A Special Treat' sold at Sotheby's 16.2.69 for £170

Bibl: AJ 1881, 117-20; 1893, 314-19; 1896, 289-92; RA Pictures 1891-1902; DNB; R.L. Poole *Cat. of Portraits etc. at Oxford* 3 (1925); Cat. of Engraved Brit. Portraits BM 6 (1925); Pavière, Sporting Painters pl. 44.

WALLER, Mrs. Samuel Edmund fl.1871-1916
(Miss Mary L. Fowler)
Portrait and genre painter. Wife of Samuel Edmund W. (q.v.). Exhib. in 1871 as Miss Mary Fowler, and then from 1872-1916 under her married name at RA, GG and elsewhere. Specialised in portraits of children.

Probable price range £20-60

Bibl: see under WALLER, Samuel Edmund

***WALLIS, Henry RSW 1830-1916**
Historical genre painter, in oil and watercolour. Studied in London and Paris. Exhib. at RA from 1854, BI, SS, OWS and elsewhere. During the 1850's he was much influenced by the Pre-Raphaelites, and pro-

duced many important works. The two best-known are 'The Death of Chatterton' (Tate Gall.) for which Meredith was the model; and 'The Stonebreaker' (Birmingham). Ruskin described the former as "faultless and wonderful". The latter is "one of the gloomiest and most intensely felt essays in social realism to which this frequently chosen subject lent itself". (Reynolds). Among his other works of this period are 'Elaine' and 'Andrew Marvell Returning the Bribe'. Wallis's career is similar in some ways to that of Arthur Hughes (q.v.), for after painting a few Pre-Raphaelite works of importance, the quality of his work thereafter declined.

Works by Wallis have not appeared at auction for many years. An important Pre-Raphaelite work would probably make £1000 or more – later works less.

Bibl: AJ 1876, 172; 1878, 180; 1880, 140; Burlington Mag. 30 (1917) 123 (obit.); Faenza 5 (1917) 33 f; Who's Who 1916; Bate; Ironside and Gere; Fredeman; Reynolds VP 65, 68-9 (pl.50); Maas 13, 133 (pl)

WALLIS, Miss Rosa b.1857 fl.1878-1934
Flower painter and watercolourist. Pupil of Royal Cambrian Academy in Manchester. Studied in Berlin. Exhib. at RA from 1881, SS, NWS and elsewhere.

Probable price range £20-60

Bibl: AJ 1905, 159; 1906, 96, 160; Connoisseur 68 (1924) 172, 241; 75 (1926) 64; 93 (1934) 61; Who's Who in Art 1934

WALLS, William RSA RSW 1860-1942
Scottish animal painter and watercolourist. Studied at RSA schools, and in Antwerp. In the Zoological Gardens of Antwerp and London he made many fine studies of wild animals. Exhib. a few works at the RA after 1887; showed mostly at RSA and RSW. Elected ARSA 1901, RSA 1914, RSW 1906. Hardie writes of his work"shows sympathetic and highly skilled craftsmanship......few artists have shown greater appreciation of animal life or of its relationship with its landscape environment".

Probable price range £50-200

Bibl: Studio 1907 The Royal Scottish Academy p.10; Studio 22 (1901) 180; 43 (1908) 137; 68 (1916) 125, 152; 69 (1916) 96; RA Pictures 1896; Caw 441-2 (pl); VAM; Hardie III 109 (pl.241)

WALMISLEY, Frederick 1815-1875
Genre and portrait painter. Pupil of H.P. Briggs and RA schools. Exhib. at RA 1838-68, BI and SS. Lived for a time in Rome, and painted genre scenes of Italian life. Also painted portraits and historical genre.

Probable price range £30-100

Bibl: Bryan

WALTER, Miss Emma fl.1855-1891
London fruit and still-life painter. Exhib. at RA 1855-87, NWS and elsewhere, but mostly at SS (66 works). 1857 member of the Society of Female Artists; 1872 Associate of the Liverpool Society of Painters in Watercolours. Many of her works are entitled 'Fresh Gathered' or 'Just Gathered'. Few can rival this admired artist in brilliancy of colouring or the dewy freshness of her floral groups" (Clayton).

Probable price range £30-100

Bibl: AJ 1859, 84; Clayton II 199-302

WALTER, Joseph 1783-1856
Bristol marine painter. Lived and worked all his life in Bristol, painting mainly ship portraits, also harbour and river scenes. Exhib. at RA (1834-49) and SS. His works can be seen in Bristol AG, also at Greenwich Maritime Museum.

'The Ajax in Bristol Channel' sold at Christie's 15.11.68 for £210

Bibl: Connoisseur 97 (1936) 258; Wilson, Marine Painters 82 (pl.42)

WALTER, Louis fl.1853-1869
Architectural, landscape and genre painter. Exhib. at RA 1857-61, but more regularly at BI, SS and elsewhere. RA titles mostly views of buildings, including several of Chingford Old Church, Essex.

Probable price range £30-80

Bibl: AJ 1859, 143

WALTERS, George Stanfield RBA 1838-1924
Liverpool landscape and marine painter. Son of Samuel W. (q.v.). Moved to London 1865. A prolific artist, he exhib. mainly at SS (over 300 works before 1893), also at RA from 1860, BI, NWS and elsewhere. Titles at RA mostly landscapes or coastal views in Wales and Holland. Elected RBA 1867. Drawings by him are in the BM and VAM.

'Dutch Estuary Scene' sold at Bonham's 9.4.70 for £120

Bibl: Connoisseur 70 (1924) 184 (obit.); Binyon; Wilson, Marine Painters 82

*WALTERS, Samuel 1811-1882
Liverpool marine painter. Father of George Stanfield W. (q.v.). Began to exhibit at Liverpool Academy in 1830; member 1841. Although self-taught, he was a competent painter, and enjoyed the patronage of Liverpool and American shipowners. Exhib. at RA 1842-61, BI, SS and elsewhere. Painted mostly pure marine pictures, but occasionally coastal subjects. Lived in London 1845-7; returned and settled in Bootle, Lancs. Works by him are in the Walker AG, Liverpool and the Bootle AG.

'The Steamship "President" leaving her Berth' sold at Phillips 13.10.69 for £4400, the current auction record. Other prices have ranged from about £300-1000

Bibl: Connoisseur 97 (1936) 258 f; Wilson, Marine Painters 82 (pl.44)

WALTON, Edward Arthur RSA PRSW 1860-1922
Scottish painter of landscapes and portraits, in oil and watercolour. Studied in Dusseldorf, and then at Glasgow School of Art, where he became friendly with Guthrie, Crawhall and others of the emerging 'Glasgow School'. Exhib. at RA from 1883, GG, NEAC, RSA, RSW and elsewhere. Lived in London from 1894 to 1904, where he was a friend and neighbour of Whistler, then settled in Edinburgh. ARSA 1889, RSA 1905, PRSW 1915-22. Like others of his school, his prime concern was decorative quality, achieved by careful design and balanced tones. Although primarily a landscape painter, he enjoyed a reputation as a portraitist, especially for his sympathetic portrayals of children. Although these are at times over-sentimental, and lack the vigour of Guthrie or Lavery, their colour and tone are always beautiful. Both Caw and Hardie also praise his watercolours for their deftness and subtlety.

'Village Street in Ceres, Fife' sold at Morrison McChlery (Glasgow) 22.5.69 for £480. Other prices mostly in £100-200 range

Bibl: AJ 1894, 77 f; 1906, 312 f; Studio 25 (1902) 207 f; 26 (1902) 161-70; 58 (1913) 260-70; 87 (1924) 10-16; Special No. 1917-18, 34 f; Who was Who 1916-28; Caw 370-3 et passim (with pl.); D. Martin The Glasgow School of Painting 1902; Cat. of the Glasgow Boys Exhib. Scottish Arts Council 1968; Hardie III 109-10

WALTON, Elijah 1833-1880
Birmingham landscape painter and watercolourist. Studied at Birmingham School of Art and at RA schools. Travelled widely, visiting Switzerland, Egypt, Greece, the Middle East and Norway. Exhib. at RA 1851-65, BI, SS and elsewhere. Titles at RA include some genre

scenes among his early works, but he turned later to views of the many countries in which he travelled. He is best known for his romantic and colourful watercolours of the Alps, and he illustrated several books on the subject. He lived in London, Staines, and Bromsgrove (Worcs) where he died.

Usual price range £50-100

Bibl: For list of books illustrated by E.W. see Thieme-Becker; Clement & Hutton; DNB; Cundall; VAM; Hardie III 114 (pl.242)

WALTON, Frank RI RBA 1840-1928

London painter of landscape and coastal scenes, in oil and water-colour. Exhib. at RA 1862-1924, BI, SS, NWS, GG and elsewhere. Titles at RA include views on the coasts of England, Wales and the Channel Islands. Member of RI, RBA, and President of the Royal Institute of Oil Painters. Works by him are in the Walker AG. Liverpool. Occasionally collaborated with Heywood Hardy (q.v.).

'Holmbury St. Mary, near Dorking' sold at Bonham's 6.3.69 for £140.

Bibl: Connoisseur 64 (1922) 242; The Year's Art 1928, 546 (obit.); RA Pictures 1890-96; Who Was Who 1916-28.

WALTON, James Trout fl.1851-1867 d.1867

York landscape painter. Brother of Joseph W. (q.v.). Pupil of Etty at York Art School. Exhib. at RA 1851-63, BI, SS and elsewhere. Painted views, especially mountain scenery, in Scotland, Yorkshire, and Switzerland.

Probable price range £30-80

Bibl: AJ 1868, 9 (obit.); Redgrave, Dict; Bryan

WALTON, John Whitehead fl.1834-1865

London portrait and genre painter. Exhib. at RA 1834-65, BI and SS. Titles at RA all portraits. His portrait of Joseph Hume is in the NPG.

Probable price range £30-70

Bibl: Cust., The NPG 2 (1902) 160; Cat. of Engraved Brit. Portraits BM 6 (1925)

WALTON, Joseph fl.1855-1872

York landscape painter; brother of James Trout W. (q.v.). Exhib. twice at RA in 1855 and 1863, BI, SS and elsewhere. A picture by him is in York City AG.

Probable price range £30-80

WANE, Richard 1852-1904

Painter of landscape and genre. Lived in London, Wales, and at Egremont (Cheshire). Studied with F. Shields and at Manchester Academy. Exhib. at RA 1885-1904, SS, NWS, GG and elsewhere. Titles at RA mostly coastal scenes with fisherfolk off the coasts of Wales. President of the Liverpool Sketching Club. Works by him are in Wolverhampton and Walker AG, Liverpool. His daughter Ethel and his son Harold W. (1879-1900) were also painters.

Probable price range £30-100

Bibl: Studio 24 (1902) 136; AJ 1904, 102-3; Bryan.

WARD, Alfred fl.1873-1903

London genre painter. Exhib. at RA from 1873, SS, GG and elsewhere. Titles at RA 'Monastic Recreation' 'Moon Maidens' 'The Horns of Elfland Faintly Blowing' etc.

Probable price range £30-70

WARD, Charles fl.1826-1869

Landscape painter. Lived in London, Cambridge and Manchester. Exhib. at RA 1826-61, BI, SS, NWS and elsewhere. Painted views and buildings in England and Wales. A work by him is in Salford AG.

Probable price range £30-80

Bibl: Connoisseur 44 (1916) 60.

*WARD, Edward Matthew RA 1816-1879

Painter of historical genre. Pupil of RA schools 1835. In Rome 1836-9, visiting Cornelius in Munich on the way. Returned to London 1839. Won a prize in the 1843 Westminster Hall Competition. Exhib. at RA 1834-77, BI, SS, NWS and elsewhere. Painted scenes from English and French history, and literary subjects taken from Goldsmith, Molière etc. His compositions are at times elaborate, but his sure sense of style and period made him one of the most popular of Victorian historical painters. Works by him are in the VAM, Sheffield and other galleries. ARA 1846, RA 1855. His wife Henrietta (q.v.) was also a painter. His studio sale was held at Christie's on March 29, 1879.

Prices from 1968-70 ranged from about £150 to £220.

Bibl: AJ 1855, 45-8; 1879, 68, 72f (obit) 84; J. Dafforne The Life and Works of E.M.W. 1879; DNB; Bryan; Reynolds VP 32, 35, 39, 59 (pl.35); Maas 26 (pl. p.109).

WARD, Mrs. E.M. (Miss Henrietta Ward) 1832-1924

Painter of historical genre. Daughter of George Raphael W. and wife (m. 1848) of Edward Matthew W. (q.v.). Studied with her father, but her style closely modelled on that of her husband. Exhib. at RA from 1849, and occasionally elsewhere. She painted scenes from English and French history, literary subjects, and genre. Works by her are in Bristol and the Walker AG, Liverpool. Her sisters Eva and Flora were also genre painters, exhib. 1873-9 and 1872-4.

'Lady in Pink Holding a Spaniel' sold at Bonham's 7.11.68 for £115.

Bibl: AJ 1864, 357-9; Connoisseur 60 (1921) 115; 70 (1924) 57 (obit.); Clayton II 161-6; Who Was Who 1916-28.

WARD, Edwin Arthur fl.1883-1903

London painter of portraits, who exhib. from 1883-1903, at the RA (1884-1903), SS, GG, NG and elsewhere, titles at the RA including 'Shy' 1884, and 'Mei Suji San, Tokyo' 1898.

Probable price range £20-60

WARD, George Raphael 1797-1879

Portrait painter, miniaturist, and engraver. Son of James W. (q.v.) and father of Henrietta W. (q.v. Mrs. E.M. Ward). Studied with her and at RA schools. Exhib. at RA 1821-64, SS and elsewhere. Titles at RA mostly portraits and miniatures, and also engravings after Lawrence, A.E. Chalon, J.P. Knight, Grant and others. His wife Mary (née Webb) was also a miniaturist, exhib. at RA 1828-49, SS and elsewhere.

Probable price range £20-80

Bibl: AJ 1880, 84 (obit); Connoisseur 70 (1924) 57; DNB; Bryan; Cat. of Engraved British Portraits BM 6 (1925).

WARD, James RA 1769-1859

Animal painter and engraver. Father of George Raphael W. (q.v.) and brother of William Ward (1766-1826) an engraver. Born in London, the son of a fruit merchant. Studied engraving under J.R. Smith, and in 1783 under his elder brother William. He gained some success with his own mezzotints of horses and landscapes, and was appointed Painter and Engraver in Mezzotints to the Prince of Wales. In 1817 he gave up engraving for painting. At first he painted domestic and rustic genre in imitation of George Morland, his brother-in-law. Later, under the influence of Stubbs, Gilpin, and most important, Rubens, he began to paint the romantic, dramatic animal pieces for which he is best known, such as 'Bulls Fighting' 'Fighting Horses' etc. In 1815 he painted the monumental landscape 'Gordale Scar' (Tate Gall.) and this

led him to attempt more ambitious historical subjects, such as 'The Triumph of the Duke of Wellington' 'The Fall of Phaeton' etc. These pictures were little suited to his talents, and were a failure. After 1830, his powers began to decline, and he became embittered by family tragedies, financial hardship, and quarrels with the RA. In 1848 he was forced to apply to the RA for a pension. Exhib. at RA 1795-1855, BI and SS. Elected ARA 1807, RA 1811. He also painted a number of fine romantic landscapes in watercolour; these and his many spirited oil sketches of animals tend to find more favour today than his large exhibition pieces.

'The Rev. T. Levett and his Dogs' sold at Sotheby's 12.3.69 for £11,000, the current auction record. Other major works have sold in recent years for about £1,000-7,000. Less important works, particularly his early rustic scenes, can sell for under £1,000; small works and animal sketches still sell in the £100-400 region.

Bibl: AJ 1849, 179-81; 1860, 9 (obit); 1862, 169f; 1897, 185-8; Connoisseur 11 (1905) 169-71; 24 (1909) 177-82; 35 (1913) 136-42; 91 (1933) 19-13; 95 (1935) 45f; 97 (1936); 3-8 Portfolio 1886 (article by F.G. Stephens); Redgrave, Dict. and Cent; Roget; Binyon; Cundall; DNB; VAM; J. Frankau *William W. and J.W.* 1904; C.R. Grundy *J.W. his life and works* 1909; A. Bury *J.W.* in British Racehorse X, IV, 1958; Arts Council. J.W. Exhibition 1960; Hardie II 141-2 (pls. 117-22); Maas 72 (pl. p.78).

WARD, James fl.1817-1831

Genre and portrait painter. Exhib. at RA 1817-31, SS and elsewhere. Titles at RA mostly portraits, some genre e.g. 'The Village Ballad Singer' 'Jane Shore at the Door of Alicia' etc. Not to be confused with James Ward RA (q.v.). Hardie mentions a James Ward (1800-1885), retired pugilist who took up painting, and exhibited landscapes and sporting subjects; this may be the same artist.

Probable price range £50-150

WARD, James Charles RBA fl.1830-1875

London painter of fruit and landscape, who exhib. from 1830-75, at the RA (in 1836, one work, a study of fruit), BI and SS (178 works).

Probable price range £30-100

WARD, John 1798-1849

Hull marine painter. Son of a master mariner. Apprenticed as house and ship painter. Influenced by William Anderson, who visited Hull. Painted ship portraits, and shipping scenes, mostly on the Humber. Also visited the Arctic, where he painted whaling ships. Published illustrated books of ships. Did not exhib. in London, but for a provincial artist, his work is of remarkably high quality. Another John Ward is listed by Graves as a London painter of sea-pieces, who exhib. 1808-47 at RA, BI, SS and NWS.

The usual range is £200-500, although works by Ward have not appeared in the saleroom recently.

Bibl: G.D. Harbron in the Burlington Magazine October 1941; *Early Marine Paintings* Hull Catalogue 1951; Wilson, Marine Painters 83 (pl.43).

WARD, Sir Leslie ("Spy") 1851-1922

Painter of portraits and architectural subjects; caricaturist; engraver. Eldest son of Edward Matthew Ward RA (q.v.). Studied architecture under S. Smirke RA, and at the RA Schools. Like Pellegrini he drew caricatures for many years for *Vanity Fair*, 1873-1909; his pseudonym was "Spy". He also drew for *The Graphic*, and painted portraits in oil and watercolour. Exhib. from 1868 at the RA, GG and elsewhere, mainly (at the RA) portraits and 'Hall at Knebworth, Herts., Seat of Lord Lytton' 1870, and 'The Mourner; Study in Christ Church, Hants' 1871. Published *Forty Years of Spy* 1915. His portraits are at the National Gallery, Dublin, the Walker Art Gallery, Liverpool, the NPG, and Trinity College, Oxford.

"Spy" cartoons usually sell for a few pounds, depending on the interest

of the character portrayed. In 1970 one of Mark Twain sold for £1000, but this was only because of exceptional American interest.

Bibl: Studio 89 (1925) 202 ff (pls.); Connoisseur 49 (1917) 50; 50 (1918) 237; 53 (1919) 230; 63 (1922); 119; 70 (1924) 57, 59; American Art News 20 (1921-2) No.34, 8; The Year's Art 1923, 340; VAM; Who Was Who 1916-28.

WARD, Martin Theodore 1799 (?) -1874

Animal and sporting painter. Son of William Ward (1766-1826) the engraver; nephew of James Ward (q.v.). Studied under Landseer. Exhib. at RA 1820-25, BI and SS. Titles at RA 'A Terrier' 'Returning from Shooting' 'Portrait of a Favourite Hunter' etc. His work shows the influence of his teacher Landseer; in some of his more ambitious pieces the influence of his uncle James can also be detected. He died in poverty in York. A work by him is in Preston AG.

Prices in 1968-70 have ranged from about £100 to £336.

Bibl: AJ 1874, 154; Bryan; DNB; Pavière, Sporting Painters.

WARD, William fl.1860-1876

Landscape and still-life painter. Exhib. at RA 1863-76, SS and elsewhere. Titles at RA dead birds, English and French landscape views.

Probable price range £30-100

WARD, William H. fl.1850-1872

Birmingham painter of fruit and still life, who exhib. from 1850-72 at the RA, BI and SS, titles at the RA including 'Flowers and Fruit' 1855 and 'Fruit, with Pyefinch's nest' 1860.

'Still Life with Fruit' sold at Bonham's 2.10.69 for £110.

WARDLE, Arthur 1864-1949

Animal painter. Exhib. at RA 1880-1935, SS, NWS and elsewhere. Painted domestic and wild animals, and sporting subjects. Also used pastel and watercolour. Probably his best medium was pastel, in which he made many wonderful studies of animals (see *Studio* article). An exhibition of his work was held at the Vicars Gallery in 1935.

Prices from 1968-70 have ranged from about £100 to £668.

Bibl: Connoisseur 68 (1924) 113f; Studio 68 (1916) 3-14; RA Pictures 1896 f passim; Who's Who; Pavière, Sporting Painters.

WARREN, C. Knighton fl.1876-1892

London painter of portraits, genre and historical subjects, who exhib. from 1876-92, at the RA (1878-92), SS and elsewhere, titles at the RA including portraits and 'Spring-time' 1878, 'An Egyptian Musician' 1881, and 'Rameses the Great and his Queen Playing a Game of Draughts' 1889. His paintings are to be found in Nottingham and Sunderland Art Galleries.

'Portrait of a Lady' sold at Christie's 1.5.70 for £116.

WARREN, Edmund George RI 1834-1909

Landscape watercolourist. Son of Henry Warren (q.v.). Exhib. from 1852, at the RA (1874, 'In the New Forest'), GG and elsewhere, but principally at the NWS (197 works), of which he became A in 1852 and RI in 1856. ROI until 1903. His work had an almost photographic realism, coming very close to Pre-Raphaelitism at times. Ruskin, however, feared his success was mechanical: "Mr. E.G. Warren's 'Lost in the Woods' and 'Avenue, Evelyn Wood', (NWS 1859), are good instances of deceptive painting — scene painting on a small scale — the treatment of the light through the leaf interstices being skilfully correspondent with photographic effects. There is no refined work or feeling in them, but they are careful and ingenious; and their webs of leafage are pleasant fly-traps to draw public attention, which, perhaps, after receiving, Mr. Warren may be able to justify by work better worthy of it."

Probable price range £30 to £150.

Bibl: AJ 1908, 216 (pl.); Ruskin; Academy Notes NWS 1858-9; VAM.

WARREN, Henry PRI KL 1794-1879
Painter of Arabian subjects, genre, landscape and literary subjects.
Studied sculpture under Nollekins, with Gibson and Bonomi as his
fellow students, entered the RA Schools in 1818; painted both in oil
and watercolour. Exhib from 1823-72, at the RA (1823-39), BI, SS,
and NWS (Member 1835 President 1839-73, resigned in 1873). He
turned to watercolours on becoming an RI. Though he had never been
to the East his principal pictures represented Arabian scenes and
incidents —" his camels and dromedaries have been the denizens of the
Regent's Park gardens". The first of these subjects was exhib. in
1840 an 'Encampment of Turkish Soldiers in the Desert of Nubia', in
1841, 'The Dying Camel' and in 1848, 'The Return of the Pilgrims
from Mecca' — "a large composition of numerous figures picturesquely
grouped showing so accurate a knowledge of eastern manners, customs
and dress as almost to make us incredulous about the fact that the
artist had never visited the land of Mahommedan". He also drew
illustrations for annuals and topographical works, wrote humorous
poetry and published a book on watercolours. Knight of the Order of
Leopold and Hon. Member of the Belgian Société des Aquarellistes.

Probable price range £50-200

Bibl: AJ 1861 265-7 (3 pls.); 1880 83 (obit.); Academy Notes NWS 1858;
Clement and Hutton; The Portfolio 1880 36 (obit.); VAM.

WARREN, Miss Sophy S. fl.1865-1878
Landscape painter in watercolour, who exhib. from 1865-78 at the
RA (1869-78), SS and elsewhere, titles at the RA including 'Evening'
1869, 'A Summer Day on the Thames' 1876, and 'Early Morning —
Exeter' 1878. Member of the Society of Lady Artists. Her watercolours
are in the National Gallery Dublin, and in the VAM ('Near Benhill
Wood, Sutton, Surrey' 'A Fort on the Shore', 'Pond and Trees —
Sunset' and Old Mill at Evesham'.)

Probable price range £20-50

Bibl. VAM

WASSE, Arthur fl.1879-1895
Manchester painter of genre and flowers, who exhib. from 1879-95
at the RA and SS titles at the RA including 'Flowers' 1879,
'Lancashire Pit Lasses at Work' 1887 and 'Devotion' 1892.

'The Reverie' sold at Christie's 5.3.71 for £178.

WATERFORD, Louisa, Marchioness of (The Hon.Miss Stuart) 1818-1891
Amateur painter and watercolourist. A friend of Ruskin, Burne-Jones
and Watts, she was one of the most talented of all Victorian lady
amateurs. Most of her work is in watercolour, and was much admired
for its rich Venetian colouring. She painted mythological and biblical
subjects, copies after old masters, and genre scenes, especially of
children. Exhib. at the GG 1877-82 but most of her work was never
exhibited. A celebrated beauty, she married the Marquis of Waterford,
who was soon afterwards killed in a hunting accident. She retired to
live at Ford Castle, Northumberland. In the village school at Ford, she
painted a series of biblical scenes of children, which can still be seen
there.

Usual price range £20-40

Bibl: Fine Arts Quarterly Review 2 (1864) 198 f; Portfolio 1870, 118; Studio
49 (1910) 283-6; Clayton II 338; Cundall; VAM; W. Shaw-Sparrow *Women
Painters of the World* 1905; C. Stuart *Short Sketch of the Life of L.W.* 1892;
A.J.C. Hare *The Story of Two Noble Lives* 1892; H.M. Neville *Under a Border
Tower* 1896; Hardie III 267 (pl.280).

***WATERHOUSE, John William RA RI 1849-1917**
Historical genre painter. Studied with his father, also a painter and
copyist and at RA Schools. At first came under the influence of
Alma-Tadema and painted Graeco-Roman subjects, similar to those
of Edwin Long (q.v.). Exhib at RA from 1874, SS, NWS, GG, NG and
elsewhere. Elected ARA 1885, RA 1895. Later he evolved a more
personal style of the late romantic Pre-Raphaelite type — typical titles
'The Lady of Shalott' 'Circe Invidiosa' 'Ophelia' 'La Belle Dame sans
Merci' etc. He also painted large-scale historical and biblical works.
His studio sale was held at Christie's on July 23, 1926.

*'Mariana in the South' sold at Christie's 5.3.71 for £3,990, the current
auction record. Other prices for important works have ranged from
about £1,500 to £3,000; smaller works and sketches £300—£500.*

Bibl: AJ 1893 126 134; 1909 Christmas No. 1-32; Studio 4 (1894) 103-115;
44 (1908) 247-52; 70 (1917) 88; Reynolds VP 65, 69, 71 (pl.56); Maas 231 (pls.
p.20, 230).

WATERLOW, Sir Ernest Albert RA PRWS 1850-1919
Landscape and animal painter in oil and watercolour. Studied in
Heidelberg and Lausanne, entered RA Schools 1872, winning the
Turner Gold Medal in 1873. Exhib. at RA from 1872 SS, OWS, GG,
NG and elsewhere. Hardie writes "his somewhat idyllic landscapes
found mainly in Southern England, are marked by harmony of colour
and quiet refinement". Elected ARWS 1880 RWS 1894, PRWS 1897;
ARA 1890, RA 1903. Knighted 1902. Works by him are in the Tate,
Birmingham, and the Laing AG, Newcastle. His studio sale was held
at Christie's on Jan. 6, 1920.

'Gathering Seaweed' sold at Christie's 10.7.70 for £200.

Bibl AJ 1890 97-101; 1893, 166; 1896 (pls. see index); 1903, 52-6; Christmas
No.1906; Studio Special No.1898 'A Record of Art in 1898' p.60-65; Studio
Special No 1900 'Mod. Brit. Watercolour Drawings'; DNB; VAM; Hardie II 234
(pl.227).

WATKINS, John fl.1876-1894
Chelsea genre painter who exhib. from 1876-94, at the RA (1884-
94), SS, NWS, GG, and elsewhere, titles at the RA including 'A Puritan'
1884, 'Maternal Counsel' 1886, and 'An Italian Girl' 1893. Not to be
confused with John Watkins, R.E. the etcher.

Probable price range £30-100

***WATSON, John Dawson RWS RBA 1832-1892**
Painter, watercolourist and illustrator. Studied at Manchester School of
Design and RA Schools. Exhib. at RA 1853-90, BI, SS, OWS (267
works) GG and elsewhere. Painted genre scenes, often of children. His
pictures are usually small, painted on panel or board, and show a Pre-
Raphaelite feeling for colour and detail. He was also a prolific and
notable illustrator, producing many designs for books and periodicals.
He worked for *Once a Week, Good Words, London Society* and
others; among the many books he illustrated were *Pilgrims Progress
Arabian Nights,* and Watt's *Divine and Moral Songs.* Works by him are
in the VAM, Norwich, and Liverpool. His brother was Thomas J.
Watson (q.v.).

'Comparison' sold at Christie's 11.7.69 for £147.

Bibl: AJ 1861, 46; Chronicle des Arts 1892, 13; Portfolio 1892 p.VI; Clement and
Hutton; DNB; Bate 90; Cundall; VAM Cat. of Watercolours 1908; Gleeson
White; Maas 237 (pl.)

WATSON, Robert F. fl.1845-1866
Landscape and marine painter, who specialised in coastal views, mainly
in the North of England. Exhib. from 1845-66, at the RA (1845-64),
BI, SS and elsewhere, titles at the RA including 'The *Erebus* and *Terror,*
under the command of Sir John Franklin, leaving the coast of Britain,
on the Arctic Expedition in 1845' 1849, and 'Vale of Coquet, North-
umberland, from the Hill above Lothbury' 1853. The AJ (1860)
comments on 'Shields, the Great Coal Port, Northumberland' BI 1860:

"The view comprehends South Shields, a part of North Shields and the mouth of the Tyne: the subject is treated with too much severity". 'Dutch fishing boats' is in Sunderland Art Gallery.

Probable price range £30-80

Bibl: AJ 1860, 79; Wilson, Marine Painters.

WATSON, Miss Rosalie M. fl.1877-1887

London genre painter, who exhib. from 1877-87, at the RA (1878-87), SS, NWS, GG and elsewhere, titles at the RA including 'Anxiously Waiting' 1878, ' "She took the gift with a mocking smile, In the flush of her maiden pride' ", 1882, and 'Past and Present' 1887. Member of the Society of Lady Artists.

Probable price range £30-80

WATSON, Thomas J. ARWS 1847-1912

Painter of landscape, genre and fishing scenes. Born in Sedbergh, Yorkshire. Studied painting under a private master for a year in London, then a student at the RA Schools. Lived and painted with his brother John Dawson Watson (q.v.), with occasional advice from his brother-in-law Birket Foster (q.v.). Exhib. from 1869 at the RA (from 1871), SS, OWS (122 works), the Dudley Gallery and elsewhere, titles at the RA including 'Waiting for Boats' 1871, 'In a Scotch Fishing Village' 1876, and 'Sunday Morning – Odde, Norway' 1903. A water-colour landscape is in the National Gallery, Melbourne (Cat. 1911).

Probable price range £30-100

Bibl: Who Was Who 1929-1940

WATSON, William fl.1828-1866

London painter of miniature portraits, who exhib. from 1828-66, at the RA (1828-59) and SS.

Probable price range £10-30

WATSON, William, Junior fl.1866-1872 d.1921

Liverpool animal and landscape painter, who exhib. from 1866-72, at the RA (in 1872 only, 'Scotch Cattle') and SS (1). Pupil of Landseer and Rosa Bonheur. Son of William Watson (q.v.). His paintings are in the Walker Art Gallery, Liverpool, the Mappin Art Gallery, Sheffield (Cat. 1908), Art Gallery, Sunderland (Cat. 1908) and in the Thomas B. Walker Art Collection, Minneapolis, U.S.A. (Cat. 1913).

Prices 1968-70 have ranged from £130-209.

Bibl: The Year's Art 1922, 314.

WATSON, William Peter RBA fl.1883-1901 d.1932

Painter of genre and landscape, living in London and Pinner. Exhib. from 1883 at the RA, SS and elsewhere, titles at the RA including 'Topsy' 1883, 'Day Dreams' 1889 and 'High Tide on a Norfolk River' 1899. Born in South Shields, died in Bosham, Sussex; studied at the South Kensington Schools and at the Academie Julian in Paris. RBA in 1890. His wife Mrs. Lizzi May Watson (née Godfrey), was a portrait painter and exhib. at the RA in 1882.

Probable price range £30-100

Bibl: The Art News (New York) 31 (1933) I 8.

WATT, Miss Linnie fl.1875-1908

Genre painter; studied at Lambeth School of Art. Exhib. from 1875 at RA, SS, NWS and elsewhere. Subjects mostly rustic genre and domestic scenes with "children of the Gainsborough, Morland and Constable types" (Clayton). She also painted designs on pottery. An exhibition of her work was held at the Doré Gallery, London, in 1908. Member of the Society of Lady Artists.

Probable price range £30-60

Bibl: Clayton II 249-50; Morning Post 17.2.1908.

*WATTS, Frederick William 1800-1862

Landscape painter. Lived in Hampstead at the same time as Constable, who greatly influenced his work. Exhib. mainly at BI 1823-62, also RA 1821-60, SS and NWS. Although he imitated closely many of the elements of Constable's style, he preserved his own distinctive style and colouring. During his own lifetime and after his death his reputation was eclipsed by that of Constable, but his work is now enjoying a well-deserved revival.

'A River Landscape' sold at Christie's 19.1.68 for £9,975, still the auction record. The usual range 1968-70 has been £1,000-4,000.

Bibl: Pavière, Landscape pl.85; Maas 48 (pl. p.54).

*WATTS, George Frederick OM RA HRCA 1817-1904

Historical and portrait painter. Born in London, the son of a maker of musical instruments. Apprenticed at the age of 10 to William Behnes, the sculptor. Entered RA Schools 1835. First exhib. at RA 1837 'The Wounded Heron'. In 1843 his picture of 'Catactacus' won a £300 prize in the Westminster Hall Competition. With the money he visited Italy, where he stayed in Florence with his friends Lord and Lady Holland. Returned to London 1847, when his composition 'Alfred' won £500 first prize in the House of Lords Competition. Depressed by poor health and lack of commissions, in 1850 he became the permanent guest of Mr. and Mrs. Thoby Prinsep at Little Holland House. He remained there until 1875, when he moved to the Isle of Wight, then to 6, Melbury Road, London. Elected ARA and RA 1867. His pictures were not popular with the critics or the public, and it was not until the 1880's that he began to achieve recognition. Exhibitions of his work were held in Manchester 1880, Grosvenor Gallery 1882 and New York 1884, which quickly established him as a leading Victorian painter. He twice refused a baronetcy, in 1885 and 1894, but finally accepted the Order of Merit. In 1864 he was briefly married to Ellen Terry; in 1886 he married Mary Fraser Tytler, and soon after they built a house "Limnerslease" near Guildford, now the Watts Museum. Exhib. at RA 1837-1904, BI, SS, GG, NG and elsewhere. Watts said of his own paintings "I paint ideas, not things". The titles of his grand historical works are a reflection of this approach e.g. 'Love and Death' 'Hope' 'The Spirit of Christianity' 'Love Triumphant' etc. Although he believed in the moral message of his art, his attempt to revive the dead tradition of grand historical painting was a failure. He remained an isolated figure, and founded no school. Today he is better known for the fine and penetrating portraits he painted of many of his famous contemporaries. He was also a sculptor, and a fine academic draughtsman.

The usual range in recent years has been from about £200 to £1,000, 'Watchman, What of the Night' a portrait of Ellen Terry, sold at Sotheby's 20.3.68 for £980.

Bibl: Main Biographies – C.T. Bateman G.F.W. 1902
 H. MacMillan The life of G.F.W. 1903
 G.K. Chesterton G.F.W. 1904 (repr. 1912)
 Mrs. R. Barrington G.F.W. Reminiscences 1905
 M.S. Watts G.F.W. The Annals of an Artist's Life. 3 vols. 1912
 E.R. Dibdin G.F.W. 1923
 Miss R.E.D. Sketchley W. 1924
 R. Chapman The Laurel and the Thorn 1945
Other References: For full list of periodicals see Thieme-Becker; J. Laver in *Revaluations* by L. Abercrombie 1931; Ellen Terry *Autobiography* 1933; Lord Ilchester *Chronicles of Holland House 1820-1900,* 1937; DNB; Bryan; W. Gaunt *Victorian Olympus;* 1952; Reynolds VS & VP; Maas.

WATTS, James Thomas RCA RBSA fl.1873 d.1930

Liverpool landscape painter, who exhib. from 1873, at the RA (from 1878), SS, NWS, GG and elsewhere, titles at the RA including 'Beech

Trees in Winter' 1878, 'A Bright Day on Barmouth Sands' 1881, and 'The Gipsies' Haunt' 1902. His watercolour 'Nature's Cathedral Aisle' is in the Walker Art Gallery (Cat. 1927). His wife, Louisa M. Watts (née Hughes), was also a landscape painter.

Probable price range £50-100

Bibl: AJ 1905, 353 (pl.); 1907, 375-6 (pl.); Studio 63 (1915) 217; 66 (1916) 214; Connoisseur 87 (1931) 61; Who's Who in Art 1934, 449.

WAY, Charles Jones RCA b.1834 fl.1859-1888

Landscape watercolourist. Born at Dartmouth, Devon; studied at the South Kensington Schools. Worked in Canada in 1859, and was President of the Art Association in Montreal. In 1885 was working in Lausanne, Switzerland. Exhib. from 1865-88, from a London address, at the RA, SS, NWS and elsewhere, titles at the RA including 'The Abbey of St. Sulpice' 1884, 'A Winter's Morning at the Foot of Wetterhorn' 1887, and 'Winter's Snow on the Dent du Midi' 1888. His work is represented at the National Gallery, Ottawa.

'Indian Camp by a River' — a watercolour — sold at Sotheby's 16.10.69 for £350. Canadian subjects, being of greater historical and topographical interest, make much more than his European views.

Bibl: Brun, Schweiz. Ksterlex 3, 1913..

WAY, William Cosens 1833-1905

Landscape, genre and still-life painter, in oil and watercolour. Born in Torquay. Studied for six years at S. Kensington School. Appointed Art Master at Newcastle-upon-Tyne School of Art with William Bell Scott (q.v.), and remained there for forty years. Exhib. at RA from 1867, SS, NWS, GG and elsewhere. Works by him are in the VAM and the Laing AG, Newcastle..

Probable price range £20-60

Bibl: VAM Cat. of Watercolour Paintings 1908; Cat. of Watercolour Drawings, Laing AG, Newcastle 1939, 107-8..

WEATHERHEAD, William Harris RI 1843-c.1903

London painter of genre, who exhib. from 1862 at the RA, BI, SS, NWS and elsewhere, titles at the RA including 'The Market-girl' 1862, 'The Lace Maker' 1871, and 'A Puritan' 1895. RI in 1885 and resigned in 1903. A watercolour 'From my Highland Laddie' is in the VAM.

Probable price range £30-70

Bibl: VAM

WEBB, Archibald RBA fl.1886-1892

London painter of landscape, who exhib. from 1886-92, at the RA (1888-92), SS, NWS and elsewhere, titles at the RA including 'St. Paul's from Waterloo' 1888, 'A Breezy Day off Dort' 1890, and 'Rye, from the Hills' 1892. Possibly the son of Webb, Archibald (q.v.).

Probable price range £30-100

WEBB, Archibald fl.1825-1866

London painter of coastal scenes in England and France, especially fishing scenes. Exhib. from 1825-66 at the RA (1841), BI and SS, the title of the RA being 'The Stranded Coaster' 1841. Member of the Webb painter family, with the London address of Trafalgar Lodge, Chelsea (see also WEBB, Archibald RBA, Byron, and James). Also executed two paintings of the Battle of Trafalgar. Represented at the Maritime Museum, Greenwich.

Probable price range £50-200

Bibl: Wilson, Marine Painters.

WEBB, Byron fl.1846-1866

London painter of animals especially Highland deer in well-painted scenery. portraits of horses, hunting and skating scenes. Member of Webb painter family see WEBB, Archibald. Exhib. from 1846-66, at the RA (1846-58), BI and SS, titles at the RA including 'Red Deer, from Nature' 1846, 'Abdallah' 1854 (the property of Her Majesty), and 'The Pick of the Fair — Coming Storm' 1858.

Probable price range £50-200

*WEBB, James 1825-1895

Marine and landscape painter. Exhib. at RA 1853-88, BI, SS, NWS, GG and elsewhere. RA titles include coastal scenes in England, Wales, Holland and France, and also views on the Rhine. Webb painted in a robust, naturalistic style using a pale range of colours, influenced perhaps by Turner. Works by him are in the Tate, VAM and nearly all the provincial galleries. Sales of his remaining works and his own collection were held at Christie's on March 3, June 13 and July 13, 1868. Other members of the Webb family were artists; see Archibald, and Byron W.

'St. Paul's from the Thames' sold at Sotheby's 18.10.68 for £1,400, the current auction record. Other prices 1968-70 ranged from about £100-950.

Bibl: Burlington Mag. 7 (1905) 328; 10 (1906-7) 341, 347; The Nat. Gall. ed. Sir E.J. Poynter 3 (1900); Wilson, Marine Painters 83 (pl.45); Pavière, Landscape pl.87; Maas 64.

* WEBB(E), William J. fl.1853-1878

Landscape, animal and genre painter. Lived in London; worked in Dusseldorf, and visited Jerusalem and the Middle East. Exhib. at RA 1853-78, BI, SS and elsewhere. Titles at RA include genre, animals, and several Middle Eastern subjects, especially in Jerusalem. He also painted occasional fairy subjects. His painstakingly detailed studies of animals and landscape, and his fondness for painting sheep, reflect the influence of Holman Hunt.

'Poultry in a Barn' sold at Christie's 11.7.69 for £158.

Bibl: H.W. Singer, Kunstlerlexicon 4 (1901); Bate 81 (with pl.); Maas 153-4, 227 (pls. p.154 and 227).

WEBER, Otto ARWS 1832-1888

Painter of portraits, animals, genre and landscape. Born in Berlin; painted in Paris and Rome; exhib. frequently at the Paris Salon, where he won medals in 1864 and 1869; settled in London in 1872. Exhib. from 1874-88 at the RA, OWS, GG and elsewhere, titles at the RA including 'H.H. Prince Christian Victor, Eldest Son of T.R.H. the Prince and Princess Christian of Schleswig-Holstein' 1874, 'A Girl Spinning and her Cow; north of Italy' 1876, and 'Skye terriers: Pet Dogs of H.M. the Queen' 1876. Painted for Queen Victoria; enjoyed a great reputation for his 'Landscapes with Cattle'. Died in London.

Probable price range £50-150

Bibl: *Gazette des Beaux Arts* 17 1864, 8, 27 168; 1870 II 58; 1874 II 286; Clement and Hutton; The Portfolio 1885 105; Cundall; DNB; VAM; Bonner Rundschau 22.1.1957 (pls.); also see Thieme-Becker.

WEBSTER, Alfred George fl.1876-1894

Lincoln painter of genre, architectural subjects and landscape, who exhib. from 1876-94, at the RA (1878-94), SS and elsewhere, titles at the RA including 'Girl Knitting' 1878, 'Bishop Russell's Chapel, Lincoln Cathedral' 1885, and 'The Landward Gate — After Rain' 1893.

Probable price range £30-100

*WEBSTER, Thomas RA 1800-1886

Genre painter. His father, who was a member of George III's household, wanted him to be a musician. As a boy he sang in the Chapel

Royal Choir, but after the death of George III, turned to painting. Following an introduction to Fuseli, he became a student at the RA, and won a Gold Medal in 1824. At first he painted portraits, but achieved his first success at the BI in 1827 with 'Rebels Shooting a Prisoner', a picture of boys firing a cannon at a girl's doll. This led him to concentrate on pictures of schoolchildren at play e.g. 'The Village School' 'The Boy with Many Friends' 'The Truant' etc. which earned him great popularity and prosperity. His style followed that of Wilkie and W. Mulready, who modelled their technique on Teniers and the Flemish School of the 17th century. Most of his pictures are small, and painted on panel. Exhib. at RA 1823-79, BI and SS. Elected ARA 1840, RA 1846 (retired 1876). In 1856 he moved to Cranbrook in Kent, where he remained for the rest of his life. He was the senior member of the Cranbrook Colony (q.v.), a group of artists, who lived and worked there every summer, painting genre scenes of everyday life. Webster forms an important link between Wilkie, and the Victorian tradition of small Dutch-style genre painting, which continued to flourish right through the period. His studio sale was held at Christie's on May 21, 1887.

Prices 1968-70 ranged from about £100 to £368.

Bibl: AJ 1855, 293-6 1862, 138; 1866, 40, 330; Redgrave, Cent.; Bryan; DNB; Reynolds VS 51-2 et passim (pl.8); Reynolds VP; Maas 107, 232 (pl. p.234).

WEEDON, Augustus Walford RI RBA 1838-1908
London landscape painter in watercolour. Exhib. from 1859, at the RA (from 1871), SS (109 works), NWS and elsewhere, titles at the RA including 'An Autumn Evening' 1871, 'Moorland Stream, North Wales' 1876, 'Gathering Peat, Ross Shire' 1898, and 'Stormy Weather, near Sandwich' 1904. Two of his paintings are in Melbourne Art Gallery.

Probable price range £20-60

Bibl: Cundall 268; A. Dayot *La Peinture Anglaise* 1908, 307.

WEEKES, Frederick fl.1854-1893
London painter of battle scenes and contemporary genre, who exhib. from 1854-93, at the RA (1861-71), BI, SS, NWS and elsewhere. Titles at the RA include 'Captured' 1861, 'Home from the War' 1865 and 'Mustering for a Raid over the Border' 1871.

Probable price range £30-100

WEEKES, Henry fl.1851-1884
Genre painter. Son of the sculptor Henry Weekes RA. Exhib. at RA 1851-84, BI, SS and elsewhere. Titles at RA 'A Dairy Stable' 'The Gipsie's Halt' 'Fancy Rabbits' etc. A work by him is in Leeds AG.

'A Setter with a Grey Hen on a Moor' sold at Sotheby's 18.3.69 for £210.

WEEKES, William fl.1864-1904
Genre and animal painter. Probably brother of Henry W. (q.v.) as Graves lists them for a time at the same address. Exhib. at RA from 1865, BI, GG, SS and elsewhere. His speciality was humorous pictures of animals, usually posed in human situations eg. 'You are Sitting on my Nest' 'Prattlers and Cacklers' 'The Patient and the Quacks' 'A Snap for the Lot' etc.

'Dog and Kittens' sold at Bonham's 8.5.69 for £240.

WEEKS/WEEKES, Miss Charlotte J. fl.1876-1890
London painter of genre, historical and literary subjects, who exhib. from 1876-90, at the RA (1878-90), SS, GG, NG and elsewhere. Titles at the RA include ' "Does he Really Mean it?" ' 1878, 'Amy Robsart' 1880 and 'Feeding Pets' 1884.

Probable price range £30-80

WEGUELIN, John Reinhard RWS 1849-1927
Painter of genre, classical, biblical and historical subjects, much influenced by Alma-Tadema. Studied at the Slade School under Poynter and Legros. Exhib. from 1877 at the RA, SS, GG, NG and elsewhere. titles at the RA including 'The Labour of the Danaids' 1878, 'Herodias and her Daughter' 1884, and 'The Piper and the Nymphs' 1897. After 1893 he worked solely in watercolour.

Probable price range £30-70

Bibl: Studio 33 (1905) 193-201 (9 pls.); Connoisseur 78 (1927) 254 (obit.); 79 (1927) 261; Who Was Who 1916-1928.

WEHNERT, Edward Henry RI 1813-1868
German painter of genre and historical subjects; illustrator. Son of a German tailor; born in London. Educated in Germany, where he studied at Gottingen. Returned to England c.1833, in which year he began to exhibit; then he worked for a time in Paris and Jersey, reaching London again in 1837. Exhib. from 1833-69, at the RA (1839-63), BI, SS, but chiefly at the NWS, of which he became a Member in 1837. Titles at the RA include 'The Lovers' 1839, 'The Elopement' 1852, and 'The Death of Jean Goujon' 1863. In 1845 he participated in the Westminster Hall Competition. Visited Italy in 1858. His works, many of which are historical genre scenes, are German in their general character. Also drew book illustrations. A watercolour, 'George Fox Preaching in a Tavern' 1865 is in the VAM.

Probable price range £30-100

Bibl: AJ 1868 245 (obit.); 1869 125; Universal Cat. of Books on Art, South Kensington 2 1870; Redgrave Dict.; Bryan; Cundall; DNB; VAM.

WEIGALL, Arthur Howes fl.1856-1892
Portrait and genre painter. Son of Charles Henry Weigall. Exhib. from 1856-92, at the RA (1856-91), BI, SS and elsewhere, titles at the RA including 'The Nut-Gatherer' 1863, 'A Belle of the Last Century' 1866, and 'The Betrothal Ring' 1884. One of his paintings is in Salford Art Gallery.

'Married Beneath him' sold at Bonham's 7.5.70 for £460. 'The Love Letter' sold at Sotheby's 29.1.69 for £110.

WEIGALL, Charles Harvey RI fl.1810-1876 d.1877
Watercolour painter of portraits, landscape and genre. He also modelled in wax and made intaglio gems. Father of Arthur Howes Weigall and Julia Weigall, both painters of portraits and genre. Exhib. from 1810-76, at the RA (1810-54), SS, and NWS (over 400 works). RI in 1834; Treasurer of RI 1839-41. Titles at the RA include 'Frame Containing Impressions from Intaglio Gems. Portraits of Dogs, after Reinagle, and Birds' 1826, 'The late Rt. Hon. George Canning; Impression from an Intaglio Gem' 1828, and 'Drawing of Ducks' 1851. 'A Disputed Claim' is in the National Gallery, Dublin, and 'Landscape, with Cottage and Figures on a Sandy Road' in the VAM. He also published *The Art of Figure Drawing* 1852, *A Manual of the First Principles of Drawing, with the Rudiments of Perspective* 1853 and a *Guide to Animal Drawing,* for the use of landscape painters 1862.

Probable price range £20-60

Bibl: Universal Cat. of Books on Art South Kensington 2 1870; Cundall 268; The 4th annual volume of the Walpole Society 1914-15, Oxford (1916) 53, 209; Cat. of the National Gallery, Dublin 1920, 198; VAM.

WEIGALL, Henry Junior 1829-1925
Painter of portraits (in oil and miniatures), and of genre. Known in his earlier years as Henry Weigall (Junior) in distinction from his father Henry Weigall, the sculptor (d. 1883). Exhib. from 1846 at the RA, BI, GG, NG and elsewhere. He exhib. 'A Cameo in Pietra Dura' in 1846 at the RA, and subsequently sent in miniatures and portraits on a larger scale, including, in 1852 and 1853, portraits of the Duke of

Wellington. Later works included several royal portraits and a number of presentation portraits commissioned for the Gresham Assurance Society, Society of Apothecaries, Jockey Club, Merton College, Oxford, Wellington College, and the Colony of Victoria (Dr. Perry, 1st Bishop of Melbourne, RA 1875). In 1866 he married Lady Rose Fane, daughter of the eleventh Earl of Westmorland. J.P. and D.L. for Kent. Died at Ramsgate.

Probable price range £50-140

Bibl: AJ 1859 163; 1860 79; Gazette des Beaux Arts 18 (1865) 558; 23 (1867) 91, 216; Ruskin, Academy Notes 1875; Mrs. R.L. Poole *Cat of Portraits etc. of Oxford* 2 (1925); 3 (1925) pls.; Connoisseur 71 (1925) 112f. (obit.); Cat. of Engraved British Portraits BM (Index); Apollo 5 (1927) 45; Who Was Who 1916-1928; Birmingham Cat.

WEIR, Harrison William 1824-1906
Animal painter, illustrator and author. Born at Lewes; educated at Camberwell. Learnt colour printing under George Baxter, but disliked the work and started independently as an artist. Gradually gained a great reputation for his studies of birds and animals. Drew for the *Illustrated London News,* the *Graphic, Black and White* and other periodicals, and for many books on animals, including *The Alphabet of Birds* 1858. He himself wrote many books, including a large work on *Poultry and All About Them,* Exhib. from 1843-1880, at the RA (1848-73), BI, SS, NWS and elsewhere. Elected A. of NWS in 1849, Member in 1851, retired in 1870. He was a friend of Darwin, a keen naturalist, a great lover of animals and champion of their cause.

Probable price range £30-100

Bibl: AJ 1906 95 (obit.) 172; Universal Cat. of Books on Art S. Kensington 2 1870; Supp. 1877; Cundall 168; Who Was Who 1897-1915; VAM; Cat. of Engraved British Portraits BM 6 (1925) 273; Pavière, Sporting Painters.

WEIR, William fl.1855-1865 d.1865
London genre painter, who exhib. from 1855-65 at the RA, BI and SS, titles at the RA including 'The Lesson' 1855, 'Fisher Children on the French Coast' 1858, and 'Teasing the Bairn' 1865. His copy of Wilkie's 'The Blind Fiddler' is in the Walker Art Gallery, Liverpool. (Cat. 1927, 107).

'Freedom' sold at Sotheby's 18.11.68 for £110

WELBY, Miss Rose Ellen fl.1879-1904
London painter of genre and flowers, who exhib. from 1879-1904, at the RA (1888-1904), SS, NWS, GG, NG and elsewhere, titles at the RA including 'Christmas Roses' 1888. 'Waste Ground' 1896, and 'Where Untroubled Peace and Concord Dwell' 1900.

Probable price range £30-70

WELLES, E.F. fl.1826-1856
Animal and landscape painter, living in Earl's Croom, Worcestershire, London, Cheltenham, Hereford and Bromyard, Herefordshire, who exhib. from 1826-56, at the RA (1826-47), BI, SS, and elsewhere. Titles at the RA include 'Manfred, a Race Horse, the property of Lechmere Charlton Esq.' 1827, 'Study of a Horse's Head' 1831, and 'Landscape with Cattle' 1847.

Probable price range £50-150

WELLS, George RCA fl.1842-1888
Painter of genre, literary subjects, portraits and landscape, living in London and Bristol, who exhib. from 1842-88, at the RA, BI, SS, NWS and elsewhere. Titles at the RA include 'A Scene from Kenilworth' 1849, 'The Belle of the Village' 1854, and 'An Autumn Afternoon on the Llugwy, North Wales' 1880.

Probable price range £30-100

***WELLS, Henry Tanworth RA 1828-1903**
Portrait painter and miniaturist. Pupil of J.M. Leigh. Painted miniatures up till about 1860, when the development of photography forced him to take up oil painting. Exhib. at RA 1846-1903 (239 works) BI, SS, and elsewhere. ARA 1866, RA 1870. Painted many official and presentation portraits, numbering many distinguished Victorians among his sitters. His best known work is the group portrait entitled 'Volunteers at Firing Point' (RA 1866), now the property of the RA. His wife, Miss Joanna Mary Boyce, was also a painter, exhib. 1853-62.

Probable price range £50-200

Bibl: AJ 1903, 96 (obit.); DNB; Bryan; Poole *Cat. of Portraits etc. of Oxford* 3 (1925); Cat.of Engraved Brit. Portraits BM 6 (1925); Maas 200, 216 (pl. p.216).

WELLS, John Sanderson RI fl.1895-1914
Genre painter. Exhib. at RA 1895-1914, and SS. Usually painted genre scenes in 18th c. costume, sometimes coaching or hunting subjects.

Usual range about £100-300

Bibl: AJ 1909, 40; Studio 32 (1904) 297; Pavière, Sporting Painters.

WELLS, Josiah/Joseph fl.1872-1893
Marine painter, who exhib. from 1872-93, at the RA (1877-93), SS, NWS and elsewhere, titles at the RA including 'A Steam Carrier Collecting Fish from the Doggerbank Trawl-fleet' 1877, 'Kynance Cove, Cornwall, January 1881' 1881, and 'A Salt-Marsh' 1882.

Probable price range £30-70

Bibl: Wilson, Marine Painters.

WERNER, Carl Friedrich Heinrich RI 1808-1894
German architectural and landscape painter. Born at Weimar; studied at Leipzig and Munich. Travelled extensively for many years in England, on the Continent, in Egypt, Palestine, Greece and Syria, painting views of the places he visited, chiefly in watercolour. Exhib. from 1860-78, at the RA (1877. 'Interior of the Cathedral of Ravello, near Amalfi'), and NWS (139 works), of which he became an A and Member in 1860; resigned in 1883. He was also a member of the Venetian Academy.

'Continental Street Scene' sold at Christie's 13.6.69 for £294.

Bibl: VAM; See also (for long German bibliography) Thieme-Becker.

WEST, Richard Whately 1848-1905
Landscape painter. Born in Dublin, the son of Rev. John West, Dean of St. Patrick's; named after Archbishop Richard Whately. Educated at St. Columba's College, and in 1866 entered Trinity College and graduated in 1870. Went to Pembroke College, Cambridge, and afterwards was a schoolmaster for a few years. Had no special instruction in painting. Exhib. from 1878-88, at the RA, SS, NWS, RHA and elsewhere, titles at the RA including 'A Coal Wharf at Rotherhithe' 1878, 'Piazza and Campanile, Bordighera, Italy' 1885, and 'Summer Day on the Norman Coast' 1888. He went abroad in 1883 on a commission to make sketches in the Riviera for the AJ. in 1885 spent two months in Alassio, and in 1886 was painting in Ireland and in Wales. In 1890 settled permanently in Alassio, but after that date never exhibited any of his works. A gallery was erected to his memory at Alassio, in which are 122 of his works. It was opened in 1907. Three of his paintings are in the VAM.

Probable price range £30-100

Bibl: Strickland.

WEST, Samuel 1810-1867
Painter of portraits and historical subjects. Born in Cork, son of William

West (1770-1854), bookseller and antiquary. Studied in Rome. Lithographed a portrait of his father for William West's *Fifty Years' Recollections of an Old Bookseller*, Cork 1830. Came to London, and exhib. from 1840-67 at the RA, BI and SS, titles at the RA including 'Head of a Roman; Study from Life' 1840, 'Charles I Receiving Instructions in Drawing from Rubens, whilst Sketching the Portraits of his Queen and Child' 1842, and 'Bringing in a Prisoner — Portraits of Viscount Trafalgar, Lady Edith, Hon. Charles and Hon. Horatio, children of Earl Nelson', 1861. He also exhib. at the RHA in 1847 — portraits of the McNeill children and of Sir John and Lady McNeill. He specialised in portraits of children.

Probable price range £50-200

Bibl: Cat. of the 3rd Exhibition of National Portraits VAM May 1868 107; Redgrave Dict.; Binyon; DNB; Mrs. R.L. Poole *Cat. of Portraits etc. of Oxford* I 1912 255, Cat. of Engraved British Portraits BM 6 (1925) 562.

WEST, William 1801-1861

Landscape painter. Born in Bristol, where he worked for most of his life. In the early part of his career he travelled in Norway and produced many Norwegian landscapes. Later he turned to scenes in Devon and Wales, especially river landscapes with waterfalls. For this reason he is sometimes referred to as "Waterfall West" or occasionally "Norway West". Exhib. mostly at SS, where he became a member in 1851; also exhib. at RA 1824-51, and BI. He was in his early days member of the Sketching Club formed by W.J. Muller, Samuel Jackson, John Skinner Prout and T.L. Rowbotham (all q.v.). Works by him are in Bristol AG. and the VAM.

A group of three landscapes sold at Christie's 21.3.69 for £126, £200 and £630.

Bibl: AJ 1861, 76 (obit); J. Ruskin *Notes on the SBA* 1857; Redgrave, Dict.; VAM; Hardie III 12, 57.

WESTCOTT, Philip 1815-1878

Painter of portraits, historical subjects and landscape. Born in Liverpool; left an orphan at an early date, and became apprenticed to the Liverpool picture restorer Thomas Griffiths. Became established as a painter in Liverpool and became an A of the Academy in 1843, and Member in 1844; Treasurer, 1847-53. His portraits were popular in Liverpool, and he had many distinguished sitters, amongst others Mr. Gladstone and Archdeacon Brookes. The Walker Art Gallery, Liverpool, has his portrait of Sir John Bent (Mayor 1850-1). In 1855 he moved to London, and in all exhib. there from 1844-61, at the RA (1848-61), BI and SS. However, he did not have great success in the South, and at the end of his life settled in Manchester. His most important work was an historical picture of 'Oliver Cromwell in Council at Hampton Court, Palace, on the Persecution of the Waldenses', an elaborate composition for which he accumulated a great wardrobe of costumes, wigs, weapons and armour of the period (Cheetham Library). He also painted landscapes, and at one period of his life refused commissions in order to devote himself to it. He rented a cottage at Cookham, where he painted many Thames subjects, and later a house in Norfolk, from which he used to sail for sketching purposes to favourite spots along the Yare and Bure. His landscapes are principally in watercolour. Among his best portraits are those of Lord Sefton, George Holt, and other members of the Holt family.

Probable price range £50-150

Bibl: AJ 1878 124 (obit.); Marillier 226-9, 259.

WESTLAKE, Nathaniel Hubert John 1833-1921

Decorative painter of biblical subjects; stained glass designer; writer. Born at Romsey; studied at Heatherley's and at Somerset House under Dyce and Herbert. At the suggestion of W. Burges RA, went to a firm of glass painters to design; afterwards became Art Manager and partner c.1880; then proprietor. Designed the side windows in St. Martin-le-Grand, and windows in St. Paul's, Worcester, and Peterborough Cathedrals, and other prominent churches; also the glass for the Gate of Heaven Church, South Boston, U.S.A.; painted the roof and 14 stations of the Chapel of Maynooth College; did the mosaics for the Newman Memorial, Birmingham; painted decorations for St. Thomas of Canterbury Church, St. Leonard's-on-Sea, and many other churches, besides various altar pieces. Exhib. from 1872, at the RA (from 1879) and elsewhere, titles at the RA including 'Study for Painting at E. end of St. Mary of the Angels, Bayswater' 1879 and 'Study for a Painting in St. Mary's Abbey, East Bergholt' 1885. Among his publications are *History and Design in Painted Glass*, 4 vols., and *History and Design in Mural Painting*.

Probable price range £100 to £200

Bibl: The Fine Art's Quarterly Review 2 (1864) 198; Universal Cat. of Books on Art S. Kensington 2 1870; supp. 1877; Binyon; Humphry, Guide to Cambridge 46; Who Was Who 1916-1928.

WETHERBEE, George Faulkner RI ROI 1851-1920

Painter of landscapes, genre and mythological subjects. Born in Cincinnati, U.S.A. Educated in Boston; studied art at Antwerp and at the RA Schools. Travelled and lived in the West Indies, France, Germany, Italy, Belgium etc.; finally settled in London. Exhib. from 1873, at the RA (from 1880), SS, NWS, GG, NG and elsewhere, titles at the RA including 'Harvest Idyll' 1880, 'Phyllis and Corydon' 1886 and 'The Pool of Endymion' 1901. An exhibition of his work was held at the FAS in 1903. His work is in galleries in Buffalo, Capetown, and Preston (Cat. 1907).

Probable price range £50 to £150

Bibl: AJ 1900, 187 (pl.); 1901 183 (pl.) 186; 1905 169 171 (pl.) 184; 1907 200 (pl.); 1909 170 (pl.); Studio Special Summer Number 1900 'Modern British Watercolour Drawings' 9, 89 (pl.); Kurtz Illustrations from the Art Gallery, the World's Columbian Exhibition 1893 95 (pl.); RA Pictures 1895 193 (pl.); 1896 64 (pl.); Magazine of Art N.S. I (1903) 105-10; Who's Who in America 7 1912-13; M. Fielding *Dictionary of American Painters* 1926; Who Was Who 1916-1928.

WHAITE, Henry Clarence RWS PRCA 1828-1912

Landscape painter, mainly in watercolour. Born in Manchester. Exhib. mainly at OWS, of which he was a member, also RA 1851-1904, BI, SS, GG and elsewhere. A prolific painter of pleasing, if rather conventional, views in England and especially Wales, where he died. Ruskin commented on his 'Barley Harvest' (RA 1849) "very exquisite in nearly every respect. The execution of the whole by minute and similar touches is a mistake". Works by him are in Blackburn, Cardiff, Leeds, Liverpool, Nottingham and Warrington AG.

Probable price range £30-100

Bibl: AJ 1859, 122, 168; 1894, 267-9 (pls.), 270-1; 1904, 216 (pl.); 1905, 352; Studio 26 (1902) 54; 32 (1904) 61; RA Pictures 1896, 140; The Year's Art 1913, 438; J. Ruskin *Academy Notes* 1859; Cat. of Manchester City A.G. 1908; Nottingham A.G. 1913; Who's Who 1912; Hardie III 163 (pl. 186).

WHAITE, James fl.1867-1896

Landscape painter, living in Manchester, Liverpool, 1875, and Seacombe, Cheshire 1896, who exhib. from 1867-96, at the RA (1870-96), SS, GG and elsewhere. Titles at the RA include 'Mullin's Bay, Cornwall' 1870 and 'The Lledr Valley, North Wales' 1896. A watercolour 'Llyn Idwal' 1867 is in the VAM.

Probable price range £20-60

Bibl: VAM.

WHEATLEY, Mrs. Francis See POPE, Mrs. Alexander

WHEELER, John Arnold 1821-1877

Bath sporting painter. Gained practical knowledge of horses while serving in the army. Retired to take up painting; lived in Bath 1857-77. Painted racing and hunting scenes, and equestrian portraits. Exhib. once at RA in 1875.

Prices 1968-70 ranged from about £100 to 210.

Bibl: Pavière, Sporting Painters 89 (pl. 46).

WHEELWRIGHT, J. Hadwen fl.1834-1849

Painter of biblical, historical and sporting subjects, portraits and genre. Exhib. from 1834-49, at the RA (1842-49), BI, and SS, titles at the RA including 'Cumberland Peasant Girl' 1842, 'Italian Peasant Children in the Neighbourhood of Rome, at a Spring; sketched on the spot' 1846, and 'David Sparing Saul's Life in the Tent' 1849. He also made many copies after paintings in Italy, and several of his water-colours after Fra Angelico, Giotto and Giottino are in the National Gallery Dublin. (Cat. 1920, 198).

'Royal Mail Coach in Winter Landscape' sold at Christie's 19.6.70 for £210.

Bibl: G. Redford *Descriptive Cat. of a Series of Paintings in Watercolour by J.H.W. taken from pictures in the Vatican, Uffizi, Pitti, etc.* 1866; Cat. of Engraved British Portraits BM 4 (1914) 25; Pavière, Sporting Painters.

WHICHELO, C. John M. fl. from 1804 d. 1865

Marine and landscape painter, who painted many views of the coasts, harbours and dockyards of England. Member of a family of four painters. First known as the illustrator of *Select Views of London* 1804. About 1818 he was marine and landscape painter to the Prince of Wales. Exhib. from 1810-65, at the RA (1810-44), BI (1811-49), and OWS (210 works, 1823-65), becoming A of the OWS in 1823. Titles at the RA include 'Morning — Brighton, Fishing Boats Coming in' 1836, and 'A Pilot Boat Going to the Assistance of a Ship on the Goodwin Sands' 1844; and at the BI his large 'Battle of Trafalgar' in 1811. He also worked for a time at teaching. His studio sale was held at Christie's on April 10, 1866.

Probable price range £50-200

Bibl: Redgrave Dict.; Roget; Binyon; Cundall 269; DNB; VAM; Birmingham Cat.; The Print Collector's Quarterly 17 (1930) 329; Williams; Wilson, Marine Painters.

WHICHELO, H.M. fl.1817-1842

Painter of landscapes, marines and architectural subjects, who exhib. from 1817-42 at the RA, BI and SS. Brother of C. John M. Whichelo (q.v.). Titles at the RA include 'South-east View of the Transept and Great East Window of Netley Abbey, Hampshire' 1818. 'View of the Clyde near Stonebyres' 1838, and 'Scene near Ewell, Surrey' 1842.

Probable price range £50-200

WHIPPLE, John fl.1873-1896

London painter of landscape, genre and river and coastal scenes, who exhib. from 1873-96, at the RA (1875-96), SS, NWS, GG, NG and elsewhere. Titles at the RA include Near Streatley-on-Thames' 1875, 'Street in Cairo' 1883, and 'Fisher-folks and their Homes' 1889. His wife Agnes Whipple also exhib. studies of flowers at the RA from 1881-1888.

Probable price range £30-80

***WHISTLER, James Abbott McNeill PRBA 1834-1903**

Painter, etcher and lithographer. Born in Lowell, Mass. the son of an engineer. As a boy lived in Russia and England. 1851 entered West Point Military Academy. Left to work as a cartographer for the Navy, where he learnt the technique of etching. 1855 went to Paris as a student. Met Degas and Fantin-Latour; much influenced by Courbet, as can be seen in 'Au Piano' which was rejected by the Salon in 1859. By 1858 he had completed the 'French Set' of etchings of Paris. 1859 moved to London and began on the first 'Thames Set'. His paintings of this period, such as 'The Music Room' (1860) 'The Coast of Brittany' (1861) and 'The White Girl' (1862) still reflect the influence of Courbet and Manet. Moved in 1863 to 7, Lindsay Row, Chelsea, where he met Harry and Walter Greaves (q.v.), and also Rossetti (q.v.). The influence of Japanese art becomes apparent in his pictures of the 1860's, such as 'La Princesse du Pays de la Porcelaine'. 1866 visited Valparaiso. In the 1870's he began to paint his Nocturnes, and also produced some of his finest portraits, such as those of Carlyle, Mrs. Leyland and 'Portrait of the Artist's Mother', later bought by the Louvre. 1876 painted the Peacock Room (now Freer Gallery, Washington) which led to the break with his patron F.R. Leyland. 1877 exhibited 'Nocturne in Black and Gold — The Falling Rocket' at the first exhibition of the Grosvenor Gallery. The picture was attacked by Ruskin, who accused Whistler of "flinging a pot of paint in the public's face". Whistler retaliated by suing Ruskin for libel. The trial took place in 1878, and Whistler was awarded one farthing damages. The costs of the action led to bankruptcy in 1879, and the sale of the White House in Tite St., built for him in 1877 by E.W. Godwin. 1879-80 visited Venice for the first time, where he produced some of his finest etchings and pastels. 1885 delivered his famous Ten o'clock Lecture. 1886-8 President of the RBA. 1888 married Beatrix Godwin (née Philip)) widow of E.W. Godwin. 1892 settled in Paris. 1897 President of the International Society of Sculptors, Painters and Gravers. 1898-1901 ran his own art school, the Académie Carmen, in Paris. Exhib. at RA 1859-79, SS, GG and elsewhere. As a painter Whistler was primarily interested in the exploration of tones and colour relationships, within a strict and formalised decorative pattern. In this he often shows an affinity with such academic English artists as Albert Joseph Moore (q.v.). The titles of his pictures, Arrangements, Nocturnes, Symphonies etc. reflect his conscious aestheticism, and rejection of the Victorian idea of subject. He was also a watercolourist and pastellist, but perhaps his greatest contribution to the 19th c. was his etching. With justification, he is now classed with Rembrandt and Goya as one of the greatest masters of etching. A wit and dandy, he was one of the most colourful personalities of the 19th c., but his combative nature led him into many feuds and lawsuits, notably those with Ruskin, Oscar Wilde and Sir William Eden. Among his many pupils and disciples were Mortimer Menpes (q.v.) and W.R. Sickert (q.v.)

Important oils by Whistler are very rare, and have not appeared in the sale room for some years. Pastels and drawings have come up more often, and sell for prices in the £1,000 — £3,000 range. Etchings usually make between £100 and £800.

Bibl: Main Biographies — W.G. Bowdoin *J.McN. W. The Man and his Work* 1902
E. Hubbard *W.* New York 1902
E.L. Cary *The Works of J. McN. W.* New York
A.J. Eddy *Recollections and Impressions of J. McN. W.* 1903
A.E. Gallatin *W. Notes and Footnotes,* New York.
T.R. Way and G.R. Dennis *The Art of W.* 1903.
A. Bell *J.A. McN. W.* 1904.
M. Menpes, *W. as I knew him* 1904.
H.W. Singer *J. McN. W.* Berlin 1904.
E.R. & J. Pennell, *The Life of J. McN. W.* 2 vols. 1908.
T.M. Wood 1909.
T.R. Way *Memories of J. McN. W. The Artist* 1912.
J. Laver *W.* 1930 (1951)
J. Laver *Paintings by W.* 1938.
J. Laver *W.* 1942.
H. Pearson *The Man Whistler* 1952.
H. Gregory *The World of J. McN. W.* 1961
D. Sutton *Nocturne* 1963.
D. Sutton *J. McN. W.* 1966.
Catalogues of prints — E.G. Kennedy *The Etched Work of W.* 5 vols. Publ. by The Grolier Club, New York 1910.

T.R. Way *Lithographs by W.* 1914.
Other References – AJ 1887, 97-103; 1905, 107-11; Mag. of Art 1902-3, 577-84; 1903-4, 8-16; Burlington Mag. 14 (1909) 204-6; Studio 4 (1894) 116-21; 29 (1903) 237-57; 30 (1903) 208-18; Cundall; VAM; Reynolds VS & VP; Hardie III 166-8 et. passim (pls. 196-7); Maas 245-7 et passim (pls.).

WHITE, Daniel Thomas fl.1861-1890

London painter of genre, literary subjects and portraits, who exhib. from 1861-90, at the RA (1864-82), BI, SS, GG and elsewhere, titles at the RA including 'Town' 'Country' 1864, 'Dr. Johnson at Rehearsal' 1871 and 'Colonel Newcombe at the Charterhouse' 1878.

Probable price range £30-80

WHITE, Edward/Edmund Richard fl.1864-1908

Painter of landscape, genre and portraits, who exhib. from 1864-1908, at the RA, SS, NWS and elsewhere, titles at the RA including 'A Grave-Digger' 1864, 'A School Board Subject' 1886 and 'A Cottage at Witley' 1890. Living at Walham Green in 1908.

Probable price range £30-70

Bibl: The Year's Art 1909, 613

WHITE, George Harlow 1817-1888

Landscape painter. Exhib. mostly at SS, also RA 1842-73, BI and elsewhere. Painted landscape views in England, Wales and Ireland, rustic genre, and occasional portraits. In 1871 he went to live in Ontario, Canada, where he painted scenes of early Canadian pioneers. In 1876 he moved to Toronto, where he remained until about 1880, when he returned to England. His Canadian pictures are more valuable than his English ones, as they are of historical and topographical interest to Canadian collectors.

'Deer in a Forest, British Columbia' sold at Christie's, Montreal, 16.4.69 for £310. Canadian subjects are more valuable than English ones.

Bibl: J. Russell Harper *Canadian Painting* (Toronto 1966) 191, 430

WHITE, John RI 1851-1933

Painter of rustic genre, landscape, marines and portraits. His parents emigrated to Australia in 1856, and he was educated at Dr. Brunton's School, Melbourne. Entered the RSA in 1871, and won the Keith prize for design in 1875. Came south in 1877. Exhib. from 1877 at the RA, SS, NWS, GG and elsewhere, titles at the RA including 'Labour O'er' 1877, and 'Haymaking in Devon' 1895. 'A Village Wedding, Shere, Surrey' is in Exeter Museum.

Probable price range £20-60

Bibl: Caw 281; Who's Who in Art 1934; Who Was Who 1941-1950; Pavière Landscape

WHITE, J. Talmage fl.1853-1893

London painter of genre and architectural subjects, especially in Italy. Exhib. from 1853-93, at the RA (1855-93), BI, SS, GG and elsewhere, titles at the RA including 'Corner of a French peasant's Court-yard' 1855, 'The Temple of Paestum' 1871, and 'Villa of Catullus, Lago di Garda' 1875. From 1893 living in Capri.

Probable price range £30-70

WHITE, W. fl.1824-1838

London portrait painter who exhib. from 1824-38 at the RA and SS.

Probable price range £30-60

WHITEFORD, Sidney Trefusis fl.1860-1881

Painter of genre, still life, birds and flowers, who exhib. from 1860-81, at the RA (1869-81), SS and elsewhere. Living in Plymouth and London. Titles at the RA include 'Fresh Acquisitions' 1870, ':Study of Flowers' 1876, and 'British Birds' 1880.

Probable price range £30-100

WHITEHEAD, Frederick William Newton 1853-1938

Painter of landscape, especially of Hardy's "Wessex", still-life, architectural subjects and portraits; etcher. Born at Leamington Spa. His first master in art was John Burgess, of Leamington. Studied in Paris at the Académie Julian for three years, and painted at Barbizon and Gretz, studying naturalism. Travelled extensively in France, and worked a great deal in Warwickshire. Exhib. from 1870, at the RA (from 1881), SS, Birmingham Art Circle, and elsewhere, titles at the RA including 'The River near Leamington' 1885, 'Street Scene, Algiers' 1892, and 'Tess of the d'Urbervilles' Ancestral Home' 1893, (his first Wessex picture at the RA). It was not until 1893 that he began to paint in Dorset; he met Thomas Hardy, and after that painted many of his pictures in that county. He was much influenced in his art by Constable, and in the varying conditions of light and atmosphere. In 1895 an exhibition of 35 of his Wessex paintings was held in Bond Street.

Probable price range £50-200

Bibl: Clive Holland 'The work of F.W., a Painter of Thomas Hardy's Wessex' Studio 32 (1904) 105-16 13 pls.; Birmingham Cat.

WHITLEY, Miss Kate Mary RI fl.1884-1893 d.1920

Leicester painter of still-life and flowers. Born in London, daughter of the Rev. J.L. Whitley of Leicester; educated in Manchester. Exhib. from 1884-93, at the RA (1884-92), and NWS, titles at the RA including 'Stones and Fossils' 1884, 'Flowers and Shell' 1885, and 'Cornelians' 1892. Also exhib. in Dresden, Chicago and Brussels. RI in 1889.

Probable price range £30-100

Bibl: Corporation of Leicester, Permanent Art Gallery, Cat. 1899, No.96; Who Was Who 1916-1928

WHITMORE, Bryan fl.1871-1897

Painter of landscape and coastal scenes, living in Chertsey, Shepperton, and Southwold, who exhib. from 1871-97, at the RA (1882-97), SS, NWS and GG. Titles at the RA include 'Cromer' 1882, 'The Flowing Tide' 1887 and 'Bude Sands' 1897.

Probable price range £30-100

WHITTAKER, James William 1828-1876

Landscape watercolourist, chiefly of scenery in N. Wales. Born at Manchester; apprenticed to an engraver to calico-printers; subsequently, having saved some money, he settled at Llanrwst, N. Wales, where he practised as a landscape painter. F.W. Topham saw and admired his work while on a visit to Wales and advised him to stand for election to the OWS. A. in 1862; Member in 1864. Exhib. from 1862-76, at the RA (1870-1), OWS (162) and elsewhere. His work was very similar to that of Thomas Collier (q.v.). He was accidentally drowned near Bettws-y-Coed, by slipping from the rocky side of a steep gorge above the River Llugwy. Two of his watercolours of Welsh scenery are in the VAM.

Probable price range £20-50

Bibl: AJ 1877 38 (obit.); Roget II; Bryan; VAM; Hardie III 151-2

WHITTLE, Thomas, Senior fl.1854-1868

Still-life and landscape painter. Exhib. mainly at SS, also at BI and RA in 1863-4. Father of Thomas W (Junior), (q.v.).

'Still Life of Fruit, Pottery and Bird's Nest' sold at Phillip's 13.1.69 for £150

WHITTLE, Thomas, Junior fl.1865-1885

Landscape painter. Son of Thomas W. (Senior), (q.v.). Exhib. mainly at

SS, also at RA 1866-72 and SS. Titles at RA 'The Moonlight Hour' 'Palmy Days of Spring' etc.

Probable price range £30-70

WHYMPER, Charles RI 1853-1941

Painter, in oil and watercolour, of landscapes, birds, animals and angling subjects; illustrator. Son of Josiah Wood Whymper (q.v.). Exhib. from 1876, at the RA (from 1882), SS, NWS, GG and elsewhere, titles at the RA including 'A Wild Cat Trap' 1882, 'Elephants at Early Dawn' 1884, 'The Old Mill at Houghton-on-the Ouse' 1885, and 'A Snared Hare' 1893. He illustrated books on travel, sport and natural history, and published *Egyptian Birds,* several papers on the Pheasantry of England, *Bird Life,* etc., besides many etchings of shooting and fishing from his oils and watercolours. *The Connoisseur* comments on his bird studies at the RI in 1922: "Mr. Whymper's work relies on an almost scientific presentment, correct to the last detail, of the feathered creatures which he chooses to depict". An exhibition of his Egyptian watercolours was held at the Walker Galleries, New Bond Street, 1923.

Probable price range £50-150

Bibl: Gilbey *Animal Painters in England* 1900; Sketchley *English Book Illustration of Today* 1903; Connoisseur 63 (1922) 50; 65 (1923) 238; Cat. of Engraved British Portraits BM 6 (1925) 434; Bulletin of the Worcester Art Museum 17 (1926) 28; Who Was Who 1941-1950; Pavière Sporting Painters.

WHYMPER, Josiah Wood RI 1813-1903

Landscape watercolourist; engraver. Born at Ipswich, second son of a brewer and town councillor. Apprenticed to a stonemason. In 1829 went to London, where he began wood-engraving, teaching himself and executing shop bills etc. In 1831 he successfully published an etching of London Bridge. Engraved many illustrations for Black, Murray, Cassell and other publishers. Had lessons in watercolour from W. Collingwood Smith (q.v.), and exhib. from 1844, at the RA (1844-54), SS, NWS (414 works), GG and elsewhere. RI in 1854. Died at Haslemere. Ruskin comments on 'The Bass Rock' (NWS 1858), "there is no high power of present execution shown in it; but I think the painter must have great feeling, and perhaps even the rare gift of invention...... I hope this painter may advance far." His son Edward was the well-known Alpinist.

Probable price range £20-60

Bibl: AJ 1859, 175; Ruskin Academy Notes (NWS) 1858; Roget II; Cundall 269; DNE 2 Supp. III; VAM; Pavière, Sporting Painters; Hardie III 137

WHYMPER, Mrs. J.W. fl.1866-1885 d.1886
(Emily Hepburn)

Watercolour painter of flowers and landscape. Married Josiah W. Whymper (q.v.) in 1866. Exhib. from 1870-85, at the RA (1877-8), SS, NWS and elsewhere, titles at the RA including 'Carnations' 1877 and 'Hollyhocks' 1878.

Probable price range £20-60

WIDGERY, Frederick John b.1861 fl. to 1934

Exeter painter of landscape and coastal scenes. Son of William Widgery (q.v.). Studied at the Exeter School of Art, under Verlat at Antwerp, and at the Bushey School of Art under Herkomer (q.v.). Chairman of Exeter Public Art Gallery, and a Magistrate of the City. Painted the landscape of S.W. England, and especially Dartmoor, and the cliffs and moors of Devon and Cornwall.

Probable price range £30-80

Bibl: Studio 66 (1916) 62 f. (pls.); G. Pycroft *Art in Devonshire* 1883, 156; Who's Who in Art 1934

WIDGERY, Julia C. fl.1872-1879

Exeter landscape painter who exhib. from 1872-9 at SS. Daughter

(or possibly wife) of William Widgery (q.v.).

Probable price range £30-70

WIDGERY, William 1822-1893

Exeter landscape and animal painter. Trained as a stone mason, and self-taught as an artist. Made a good deal of money by producing imitations of Landseer's 'The Monarch of the Glen', and then took up art as a profession. He painted the scenery of Devon and Cornwall, (especially Dartmoor), and was "of great local repute", although only exhibited once in London, at SS, in 1866. He also visited Italy and Switzerland. His 'Poltimore Hunt' was engraved by J. Harris.

'Pike's Peak, Colorado' – a drawing – sold at Christie's 8.12.64 for £57

Bibl: AJ 1893 191; G. Pycroft Art in Devonshire 1883 145 ff; Pavière Sporting Painters.

*WILKIE, Sir David RA 1785-1841

Scottish genre, historical and portrait painter. Born in Cults, Fifeshire. Entered the Trustees' Academy, Edinburgh, at the age of 14. In 1804 he painted 'Pitlessie Fair' which showed his natural talent for depicting scenes of Scottish life. 1805 went to London and entered RA schools. 1806 'Village Politicians' was an instant success at the RA. Elected ARA 1809, RA 1811. Exhib. at RA 1806-42 and BI. Continued to paint humorous scenes of Scottish life, such as 'Blindman's Buff' 'The Blind Fiddler' 'Village Festival' 'The Penny Wedding''The Reading of the Will' 'The Parish Beadle' etc. In 1822 'Chelsea Pensioners Reading the Waterloo Dispatch' was so popular that for the first time a rail had to be put up at the RA to protect it. Although Wilkie was undoubtedly influenced by the techniques of such Flemish painters as Teniers and Ostade, his art remained strongly individual and nationalistic. He visited Paris 1814; Holland 1816; and after a severe illness in 1825, was forced to travel abroad frequently for his health. His visit to Spain in 1817-8 was a turning-point in his career. Influenced by Murillo and Velasquez, he turned to grander subjects and a broader technique. Among his later works are 'Guerilla's Departure' 'Napoleon and the Pope' 'Sir David Baird Discovering the Body of Tippoo Sahib' 'John Knox Preaching' etc. Unfortunately works of this scale and subject were not really suited to his genius. Appointed Painter in Ordinary to King George IV; knighted 1836. In 1840 he visited the Holy Land, and in 1841 died at sea on his way home. His death was commemorated by Turner in 'Peace – Burial at Sea'. Wilkie had many followers and imitators; in Scotland, Alexander Fraser, Alexander Carse, William Kidd etc; and in England, Thomas Webster, and the Cranbrook Colony, through whom his style continued to influence genre painting right up to the end of the century. His visits to Spain and the Holy Land also anticipated later developments in Victorian painting. He was also an etcher and watercolourist. Engravings of his works were made in large numbers, and can still be found in many Scottish houses. Exhibitions of his work were held at the Arts Council in 1951 and 1958. His remaining works were sold at Christie's on April 25, 1842; his executors held another sale on June 20, 1860.

'An Interior with a Lady, a Child, a Nurse and a Dog' sold at Edmiston's (Glasgow) 19.2.69 for £3,400. Other prices in recent years have mainly ranged from about £500 to £2,000.

Bibl. Biographies – A. Cunningham *The Life of Sir D.W.* 1843
A. Raimbach *Memoir of Sir D.W.* 1843
Mrs. C. Heaton *The Great Works of Sir D.W.* 1868
A.L. Simpson *The Story of Sir D.W.* 1879
J.W. Mollett *Sir D.W.* 1881
R.S. Gower *Sir D.W.* 1902
W. Bayne *Sir D.W.* 1903
Other References – AU 1840, 10 f; 1841. 115 f; AJ 1859; 233 f; 1860, 236 f; 1896, 183-8; Portfolio 1887, 90-7; J. Ruskin, *Modern Painters;* ibid. *Academy Notes;* Redgrave, Dict & Cent; Binyon; Cundall; Caw 95-104 et passim (2 pls); DNB; VAM; Reynolds VS 7-8, 45-7 et passium (pls. 1-2); Reynolds VP

11-12 (pl.1); Hutchison; Hardie III 175-6 (pls. 202-4); Maas (pls. p.10, 93, 104-5)

WILKINSON, Alfred Ayscough fl.1875-1881
London painter of views in Venice who exhib. from 1875-81 at SS (13 works).

Probable price range £50-150

WILKINSON, Charles A. fl.1881-1892
London landscape painter, who exhib. from 1881-92, at the RA (1883-92), SS, NWS, GG and elsewhere, titles at the RA including 'On the Thames below Medmenham' 1883, 'The Mountain of Clouds (see Arabian Nights)' 1886, and 'An October Evening' 1892.

Probable price range £30-80

WILKINSON, Edward Clegg fl.1882-1904
London painter of genre, landscape and portraits, who exhib. from 1882-1904 at the RA (1884-1904), SS, NWS, NG and elsewhere, titles at the RA including 'Sunny Days' 1884, 'In Loving Memory' 1891, and 'The Mill on the Stream' 1904.

Probable price range £30-80

WILKINSON, Miss Ellen fl.1853-1879
Painter of flowers and genre, living in London and Chelmsford, who exhib. from 1853-79, at SS, RA (1875 and 1876) and elsewhere. Titles at the RA are 'Bon Soir!' 1875 and 'Do you Like Butter?' 1876.

Probable price range £30-70

WILKINSON, Hugh fl.1870-1913
Landscape painter, living in Ealing and Brockenhurst, New Forest, who exhib. from 1870-1913, at the RA (from 1875), SS, GG, NG and elsewhere. Titles at the RA include 'Study in Devonshire' 1875, 'A New Forest Road' 1889 and 'In the Austrian Tyrol' 1903.

Probable price range £30-70

Bibl: Illustrated Catalogue, National Art Gallery, Sydney 1906 No. 49

WILKINSON, R. Ellis fl.1874-1890
Painter of genre and landscape, living in Harrow, Ashburton, Devon, Bath, and St. Ives, who exhib. from 1874-90, at the RA (from 1876-90), SS, NWS and elsewhere. Titles at the RA include 'A Spring Morning; by the Undercliff, Isle of Wight' 1877, 'His Last Resource' 1882, and 'Feeding the Ducks' 1887.

Probable price range £30-70

WILLCOCK, George Barrell 1811-1852
Landscape painter. Born in Exeter. Gave up coach painting to study landscape under his friend James Stark (q.v.). Exhib. at RA 1846-51, BI, SS and elsewhere. Painted most of his works in Devonshire. His style is similar to that of Stark, and it is possible that many of his works have been changed into Starks to enable them to sell for better prices.

Prices 1968-70 ranged from £240-680

Bibl: The Nat. Gall. ed. by Sir E. Poynter 3 (1900); Pavière, Landscape pl.88

WILLES, William fl. 1815-1849 d.1851
Irish painter of landscape, coastal views, architectural, mythological and literary subjects. Born in Cork; educated at Edinburgh High School and afterwards studied for the medical profession. Did not apply himself seriously to painting until he was thirty. Took a prominent part in organizing 'The First Muster Exhibition' held in Cork in 1815. Then he went to London and studied at the RA schools. Exhib. from

1820-48 at the RA and BI, titles at the RA including 'Landscape: Scene from the Palace of Ægithus, from the Electra of Sophocles' 1820, 'The Water-log. "That ship shall never reach a shore" ' 1831, and 'The Round Tower, on the Island of Scottery' 1848. 'The Mock Funeral' was thought to be his best picture. Twenty-one of his drawings were engraved for Hall's *Ireland*. On the foundation of the School of Design in Cork in 1849, he was appointed Headmaster.

Probable price range £30-100

Bibl: AJ 1851 44 (obit.); Redgrave Dict; Strickland

WILLETT, Arthur fl.1883-1892
Brighton landscape painter, who exhib. from 1883-92, at the RA (1883-88), SS, NWS and elsewhere, titles at the RA including 'Sheltered Corner in March' 1883, 'Mill Stream, Arundel, Sussex, Early Spring' 1885, and 'A Bright Day in the Forest, Late Autumn' 1888.

Probable price range £30-100

WILLIAMS, Arthur Gilbert See under GILBERT, Arthur

WILLIAMS, Benjamin See under LEADER, Benjamin Williams

WILLIAMS, Alfred Walter 1824-1905
Landscape painter. Son of Edward W. (q.v.). Exhib. at RA 1843-90, BI, SS, NWS and elsewhere. Titles at RA include views on the Thames, in Wales, Scotland, and Italy. He painted in a style similar to that of his brother Sidney Richard Percy (q.v.), using the same rather hard colours and metallic finish. His wife Florence Elizabeth Thomas was a painter of fruit and still-life; she exhib. from 1852-64 at RA, BI and SS.

Prices 1968-70 ranged from about £50-175

Bibl: T.M. Rees *Welsh Painters* 1912; Pavière, Landscape

WILLIAMS, Charles Frederick fl.1841-1880
Landscape painter. Worked in Exeter, Southampton and London. Exhib. at RA 1845-79, SS and elsewhere. Titles at RA 'View on the Bovey' 'Fishing Boats at Beer' 'Rival Mountains from Carnarvon Bay' etc.

Probable price range £30-100

WILLIAMS, Miss Caroline F. 1835-1921
Landscape painter; lived in Barnes, London. Exhib. mostly at SS, also RA 1858-76, BI and elsewhere. RA titles mostly views on the Thames, also scenes in Wales. Daughter of George Augustus W. (q.v.).

Probable price range £30-70

WILLIAMS, Edward 1782-1855
Landscape painter. Father of the "Williams Family" of painters; his sons were Alfred Walter, Arthur (Gilbert), Edward Charles, George Augustus, Henry John (Boddington) and Sidney Richard (Percy). Studied under James Ward (q.v.), his uncle. Exhib. at RA 1814-55, BI, SS and elsewhere. Titles at the RA mostly views along the Thames, and moonlight scenes. Works by him are in Leeds AG and the VAM.

Prices 1968-70 ranged from about £200-840

Bibl: AJ 1855, 244 (obit.); Connoisseur 67 (1923) 41, 56; Redgrave, Dict; T.M. Rees *Welsh Painters* 1912; Pavière, Landscape, 139; *The Williams Family of Painters*, Exhibition at N.R. Omell Gallery, London, April 1971.

***WILLIAMS, Edward Charles 1807-1881**
Landscape painter. Son of Edward W. (q.v.). Exhib. at RA 1840-64, BI, SS and elsewhere. Like his father, he painted mainly views along the Thames; also coastal scenes. Sometimes collaborated with William Shayer (q.v.) on large village or gipsy scenes.

'A Cottage at the Edge of a Wood' sold at Sotheby's 12.3.69 for £3600, the current auction record. Other prices have ranged from about £100-800

Bibl: Pavière, Landscape pl.89; *The Williams Family of Painters*, Exhibition at N.R. Omell Gallery, London, April 1971.

WILLIAMS, Edwin **fl.1843-1875**
Cheltenham portrait painter. Exhib. at RA 1843-75, BI, and SS Painted many official and presentation portraits. A portrait of General Napier is in the NPG.

Probable price range £30-70

WILLIAMS, Frank W. **fl.1835-1874**
London genre painter. Exhib. at RA 1835-61, BI, SS and elsewhere. Titles at RA mostly historical or literary genre, taken from Shakespeare, Gray, Dickens and others.

Probable price range £30-80

WILLIAMS, Frances H. **fl.1870-1901**
Genre painter. Exhib. mostly at SS, also RA 1884-1901 and elsewhere. Titles at RA 'The Little Mother' 'A Bit of Old Brentford' 'In the Chelsea Pensioners' Garden' etc.

Probable price range £30-70

WILLIAMS, George Augustus **1814-1901**
Landscape painter. Son of Edward W. (q.v.). Exhib. mainly at SS (140 works), also RA 1841-85, BI and elsewhere. A prolific and versatile artist, he painted Thames views, moonlight scenes, coastal subjects and landscapes in Kent, Wales and elsewhere.

Usual price range £50-150

Bibl: Pavière, Landscape pl.90.

WILLIAMS, Harry **fl.1854-1877**
Liverpool landscape painter. Painted landscapes and coastal scenes around Liverpool and North Wales. Came to London, where he died in poverty. Exhib. at RA twice, BI, SS and elsewhere.

'On the Cheshire Coast' sold at Christie's 7.11.69 for £126

Bibl: Marillier 230-1

WILLIAMS, H.P. **fl.1841-1857**
London landscape painter. Exhib. at RA 1841-57, BI and SS. Titles at RA include views on the Thames, in the south of England, Wales and France.

Probable price range £30-70

WILLIAMS, J. **fl.1831-1876**
London landscape painter. Exhib. at SS (71 works) also RA & BI. Graves Dictionary lists four other artists called J. Williams, but only three are in Graves R.A. Exhibitors.

'A Wooded Landscape' sold at Christie's 3.4.69 for £126

WILLIAMS, John Edgar **fl.1846-1883**
London portrait and genre painter. Exhib. at RA 1846-83, BI and SS. Painted mostly official and presentation portraits; also painted several portraits of members of the RA. A work by him is in the Museum of Nottingham.

Probable price range £30-100

Bibl: Cat. of Engraved Brit. Portraits BM 6 (1925) 564; R.L. Poole *Cat. of Portraits etc.* Oxford 3 (1925) 298

WILLIAMS, John Haynes **1836-1908**

Genre painter. Studied in Worcester and Birmingham. Came to London 1861. Exhib. at RA 1863-97, BI, SS, NWS, GG, NG and elsewhere. Painted genre scenes, often of a humorous nature, and Spanish subjects. Works by him are in the Tate and the VAM.

Usual price range .£50-250.

Bibl: AJ 1894, 289-93; 1909, 31 (obit.); RA Pictures 1891-7.

WILLIAMS, Joseph Lionel **fl.1834-1874** **d.1877**
Genre painter and engraver. Son and pupil of Samuel W. (1788-1853). Exhib. mostly at SS, also RA 1836-74, BI and elsewhere. Titles at RA 'Market Day in the Olden Time' 'A Bit of Gossip' 'Ballad Singers' etc. and historical scenes from Shakespeare etc. As an engraver he illustrated Milton, Byron, Goldsmith and other books, and worked for the *Art Journal* and *Illustrated London News*. A work by him is in Sheffield AG.

Probable price range £30-100

Bibl: AJ 1877, 368 (obit.); Bryan.

WILLIAMS, J.M. **fl.1834-1849**
Architectural and still-life painter. Exhib. at RA 1836-49, BI, SS and NWS. Titles at RA still-life, interiors of old buildings, and ruins.

Probable price range £30-100

WILLIAMS, Penry **1798-1885**
Painter of Italian genre. Born in Merthyr Tydfil, Wales. Pupil of RA schools. After 1827 he lived mainly in Rome. Exhib. at RA 1822-69, BI, SS and OWS. Painted Italian landscapes, and scenes of Italian life. His most characteristic type of picture is the view in the Campagna, with peasants in the foreground, and a distant view of Rome beyond. He also painted portraits, including one of his friend John Gibson RA: His studio sale was held at Christie's on June 21, 1886.

Prices 1968-70 ranged from about £100 to £420

Bibl: AJ 1864, 101f; Connoisseur 56 (1920) 126; 77 (1927) 59; C. Eastlake *Life of John Gibson* 1870, 241f; DNB; T.M. Rees *Welsh Painters* 1912, 153-7.

WILLIAMS, Pownoll T. **fl.1872-1897**
London genre and landscape painter. Exhib. at RA 1880-97, SS, NWS, GG and elsewhere. Titles at RA 'A Dying Rose' 'A Corner of a Market Garden' and several Italian genre scenes.

Probable price range £30-100

WILLIAMS, Terrick **RA** **1860-1937**
Painter of shipping and coastal scenes. Studied in Antwerp and Paris. Exhib. at RA from 1888, SS and elsewhere. Painted bright and colourful harbour and coastal scenes in England, France, Holland and the Mediterranean. Elected ARA 1924, RA 1933.

Usual price range £30-80

Bibl: Studio 90 (1925) 110-15; Special No. 1919, British Marine Painting, 34, 132; Apollo 11 (1930) 341; Who's Who in Art 1934

WILLIAMS, Walter **1836-1906**
Landscape painter. Exhib. mainly at SS, also RA 1854-80 and BI. Titles at RA all views in Wales. Son of George Augustus W. (q.v.).

Prices 1968-70 ranged from about £100-500.

WILLIAMS, W. **fl.1841-1876**
Landscape painter. Lived in Bath, Topsham and Torquay. Exhib. at RA 1845-67, BI and SS. Painted landscapes, river and coastal scenes in the West Country, especially Devon and Cornwall.

Probable price range £100-500

Bibl: Pavière, Landscape pl.91.

***WILLIAMSON, Daniel Alexander 1823-1903**
Liverpool landscape and genre painter. Son of Daniel W. (1783-1843) also a painter, and nephew of Samuel W. (1792-1840). Left Liverpool for London c.1847, but continued to send pictures to Liverpool exhibitions. Like his friend W.L. Windus (q.v.) he was much influenced by the Pre-Raphaelites. About 1860 he returned to Lancashire and settled near Carnforth. Here he painted a number of Pre-Raphaelite landscapes, remarkable for their pure colours and minute fidelity to nature. Later he broadened his style and turned mainly to watercolours, firstly in the idiom of David Cox, later of Turner. Between 1849 and 1871 he exhib. occasionally at the RA, SS and elsewhere. A large number of his works were in the collection of Mr. James Smith of Blundell Sands, who left them to the Walker AG Liverpool.

Probable price range £500-1,000 for Pre-Raphaelite style works, less for later ones.

Bibl: AJ 1904, 82f; Yorkshire Post (Leeds) v.14.9.1912; Bryan; Marillier 234-40 (pl. p.238); Maas 237 (with pl.); *The Taste of Yesterday* Exhibition at Walker AG Liverpool 1970 no.64.

WILLIAMSON, Frederick fl.1856-1900
Landscape painter. Exhib. at RA 1864-1900, BI, SS, NWS, GG and elsewhere. Specialised in the painting of English landscapes with sheep. In his early period he used Pre-Raphaelite techniques, painting in great detail on panel. A watercolour by him is in the VAM.

'A Pastoral Landscape' sold at Christie's 11.7.69 for £147.

WILLIAMSON, John Smith fl.1866-1880
London painter of coastal scenes. Exhib. at RA 1866-73, SS and elsewhere. Titles at RA 'Filey Beach' 'Drying Sails – Hastings' 'A Drawn Battle' etc.

Probable price range £30-80

Bibl: Wilson, Marine Painters.

WILLIAMSON, W.H. fl.1853-1875
London painter of coastal scenes. Exhib. at SS, also RA 1853-75 and BI. Titles at RA 'On the Coast of Kent' 'Stormy Weather, Coast of Holland' etc.

Usual price range £50-150

Bibl: Wilson, Marine Painters.

WILLIS, Henry Brittan RWS 1810-1884
Painter of cattle and landscapes, and lithographer. Born in Bristol, the son of a drawing master, under whom he studied. In 1842 he went to America, but returned in 1843 and settled in London. Exhib. from 1844-83, at the RA (1844-61), BI, SS and elsewhere, but chiefly at the OWS (366 works), of which he became A in 1862 and Member in 1863. He painted various picturesque localities in Great Britain, introducing finely composed groups of cattle. His 'Highland Cattle' 1866 was bought by Queen Victoria, and his 'Ben Cruachan Cattle Coming South' was at the Paris Exhibition of 1867. Four of his paintings were engraved in the *Art Union Annual* 1847. The VAM has several watercolour landscapes, e.g. 'Landscape with a Tidal River, Cows in the Foreground', and also drawings of animals. His paintings are also in Bristol, Leicester, Birmingham and York Art Galleries. His studio sale was held at Christie's on May 16, 1884.

'Extensive River Landscape' sold at Bonham's 6.3.29 for £280.

Bibl: AJ 1879 93-6 (3 pls.); Universal Catalogue of Books on Art South Kensington 2 1870; Roget; Bryan; Cundall; DNB; Cat. of Engr. British Portraits BM 6 (1925) 715; VAM; Hardie III 57.

WILLS, Edgar W. fl.1874-1893
Painter of genre and landscape, who exhib. from 1874-93, at the RA (1877-93). SS, GG, NG and elsewhere, titles at the RA including 'A By-road in Autumn' 1877, 'Kine on the Moor' 1888, and 'Spring Blossoms and Flowers' 1892.

Probable price range £30-80

WILLSON, Harry fl.1813-1852
Painter of architectural subjects and landscapes; lithographer. Exhib. from 1813-52, at the RA, BI, SS and NWS, titles at the RA including 'On the Scheldt' 1827, 'View under the North Entrance of the Cathedral of Chartres' 1835, and 'St. Mark's, Venice' 1852. He published *Fugitive Sketches in Rome and Venice* 1838, *The Use of a Box of Colours* 1842, and *A Practical Treatise on Composition* 1851. A letter to *The Connoisseur* asking for information about Willson mentions two of his circular views of Venice noting that they are "like strong Guardis but lack the little flecks of white paint; but the drawing is fine and colour brilliant".

Probable price range £50-200

Bibl: Universal Catalogue of Books on Art South Kensington 2 1870; Connoisseur 63 (1922) 162.

WILSON, Chester fl.1846-1855
London genre and portrait painter, who exhib. from 1846-55, at the RA (1846-53, BI and SS, titles at the RA including 'The Penitent' 1846, 'An Indian' 1850, and 'Venus Reclining' 1851.

Probable price range £30-70

WILSON, Herbert fl.1858-1880
London portrait painter, who exhib. from 1858-80, at the RA (1864, 1874, 1876), BI, SS and GG.

Probable price range £20-60

WILSON, John H. RSA 1774-1855
Scottish marine and landscape painter, known as "Jock" Wilson. Pupil of John Norie and Alexander Nasmyth. Moved to London 1795; worked as a scene painter. Exhib. mostly at SS (301 works) also BI and RA (1807-55). Lived in Folkestone and painted coastal and river scenes there, and in France and Holland. Caw writes that "in spite of obvious defects his art remains a vigorous and vital performance". His son John James W. (q.v.) was also a painter, and their work is often confused.

Usual price range £40-120

Bibl: AJ 1855, 192, 204 (obit.); 1875, 108 (obit.); Portfolio 1887, 71; Studio Special No.1919, British Marine Painting, 25, 38; T. Smith *Recollections of the British Institution* 1860, 88; DNB; Bryan; Caw; Wilson, Marine Painters 87 (pl.47).

WILSON, John James 1818-1875
Landscape and marine painter; son of John W. (q.v.). Studied under his father, and painted in a very similar style. Exhib. at SS (384 works), BI, and RA 1835-73. A work by him is in Sheffield AG.

'The Old Pier at Calais' sold at Sotheby's 18.6.69 for £220.

Bibl: see under John H. Wilson.

WILSON, J.T.
There are two painters of this name listed in Graves Dict.: (1) Painter of portraits and landscape, who exhib. from 1833-53 at the RA; (2) Painter of landscapes and genre, who exhib. from 1856-82 at the RA, BI, SS and elsewhere. Graves RA joins both these into one, exhibiting from 1833-66, and living in London and Witley and Thursley, near

Godalming, titles at the RA including 'Hop Garden, near Tunbridge Wells' 1853, 'The Gardener's Pet' 1860, and 'Where the Stream Runs across the Road' 1864. The Witley address first occurs in 1861. The VAM has 'Stream and Cottage, Thursley, Surrey' 1863, and the Bethnal Green Museum contains six watercolours by, and one attributed to, J.T. Wilson, representing views in that neighbourhood.

Probable price range £100-200

Bibl: VAM.

WILSON, Oscar fl.1886-1893
Blackheath genre painter, who exhib. from 1886-93, at the RA (1888-9), SS, NWS and elsewhere, titles at the RA including 'Reading the Koran' 1889.

Probable price range £30-70

WILSON, Thomas Harrington fl.1842-1886
London painter of landscape, genre, portraits literary and historical subjects. Exhib. from 1842-86, at the RA (1842-56), BI and NWS, titles at the RA including 'Mendicant Boys Resting' 1842, 'Blackgang Chine, Isle of Wight' 1846, 'Wishart' 1849, and ' "Sandy", the Dog of the Sappers — a Crimean hero' 1856.

'Three Boys with Pony and Dog' sold at Christie's 14.11.69 for £137.

Bibl: Cat. of Engraved British Portraits BM 6 (1925) 564, 715.

WILSON, Thomas Walter RI b.1851 fl.1870-1903
Painter of landscapes and architectural subjects; illustrator. Exhib. from 1870-1903, at the RA (1873-76), SS, NWS and elsewhere, titles at the RA including 'The Oldest House in Bayeux, Normandy' 1873, 'Canal au Hareng, Anvers' 1876, and 'Marche au Bois, Anvers' 1876. RI from 1879-1903. One of his watercolours, 'Widowed and Fatherless', is in the National Gallery, Sydney, (Cat. 1906).

Probable price range £30-80

Bibl: The Year's Art 1890 236; J. Pennell *Die Mod. Illustr.* 1895; Cundall 171; Cat. of Engraved British Portraits BM 6 (1925) 564.

WILSON, William A. fl.1834-1865
Painter of landscape and architectural subjects, living in London and Woodford Green, Essex. Exhib. from 1834-65, at the RA (1834-59), BI and SS, titles at the RA including 'On the Coast near Schevening' 1834, 'The Castle from the Market' 1850, and 'Abbeville' 1859.

Probable price range £30-80

WILSON, William Heath 1849-1927
Painter of landscape and genre. Born in Glasgow. Son and pupil of Charles Heath Wilson. Exhib. from 1883, at the RA (from 1884), SS, GG and elsewhere, titles at the RA including 'Sunset from the Shore of Carrara' 1884, 'Time to Go Home' 1886, and 'Winter Evening, Boxhill' 1899. Headmaster of the Glasgow School of Art.

Probable price range £30-100

Bibl: Pavière, Landscape.

WILTON, Charles fl.1837-1847
Painter of portraits and genre, who exhib. from 1837-47, at the RA (1837-46) and SS, titles at the RA including 'A Fancy Portrait' 1837, 'Savoyard' 1841, and 'The Sugar Hogshead' 1846.

Probable price range £30-100

WIMBUSH, Henry B. fl.1881-1904
Finchley landscape painter, who exhib. from 1881-1904, at the RA (1888-1904) and elsewhere, titles at the RA including 'Fleeting Day'

1888, 'Petit Bo Bay. Guernsey' 1889, and 'Grosse Tête, Jersey' 1904.

Probable price range £30-60

WINCHESTER, G. fl.1853-1866
Landscape painter, living in Hastings and Margate, who exhib. from 1853-66 at the RA (1862 only), BI and SS; at the RA 'At Northdown, near Margate' 1862.

Probable price range £30-70

WINKFIELD, Frederic A. fl.1873-1920
Painter of landscapes and marines, working in Manchester and Fulham, who exhib. from 1873 at the RA, SS, NWS and elsewhere. Titles at the RA include 'The Shields' 1873, 'Misty Morning; Oyster Boats Getting under Weigh' 1877, and 'Mouth of the Conway River' 1904. *The Year's Art* lists him as still working in 1920.

Probable price range £30-80

Bibl: The Year's Art 1921, 550; Wilson, Marine Painters.

WIMPERIS, Edward Morison VPRI 1835-1900
Landscape painter and watercolourist. Born in Chester. Studied wood-engraving under Mason Jackson, and worked as an illustrator for *Illustrated London News* and other magazines. Gradually he took up painting in oil and watercolour; exhib. from 1859 at RA, SS, NWS, GG, NG and elsewhere. Elected ARI 1873, RI 1875, VPRI 1895. At first his watercolours followed the minute, stippled technique of Birket Foster, but later he broadened his style under the influence of Thomas Collier (q.v.), his frequent painting companion in the late 1870's and 1880's. Like Cox and Collier, he was fond of black and windswept moorland scenes ". he painted expansive landscapes with breadth and decision; he dealt tenderly with the form and movement of spacious skies, and boldly with fleeting shadows cast over broken ground". (Hardie).

Prices 1968-70 ranged from about £100 to £368.

Bibl: AJ 1901, 63; 1909, 156; Connoisseur 59 (1921) 55; 60 (1921) 120; The Year's Art 1892, 122; Mag. of Art 1901, 173f; Cundall; DNB; VAM; E. Wimperis *E.M.W.* Walker's Quarterly IV 1921; Pavière, Landscape pl.92; Hardie III 156-7 (pl.177).

*WINDUS, William Lindsay 1822-1907
Liverpool Pre-Raphaelite painter. Pupil of William Daniels (q.v.) and the Liverpool Academy. His early works were mostly historical genre e.g. 'Morton before Claverhouse' 'The Interview of the Apostate Shaxton with Anne Askew in Prison' etc. These works show considerable talent, particularly in the strong use of chiaroscuro, something he probably learnt from Daniels. Elected associate of the Liverpool Academy 1847, member 1848. In 1850 he visited London and saw Millais's 'Christ in the House of his Parents' and was converted to the Pre-Raphaelite cause. It was through his influence that the Pre-Raphaelites were persuaded to exhibit at the Liverpool Academy, where they were awarded the first prize at several annual shows. His own first Pre-Raphaelite picture was 'Burd Helen', exhib. at the RA in 1856. A slow and uncertain painter, his next important work was not finished until 1859. This was 'Too Late' exhib. at the RA in 1859. Unfortunately the picture was severely criticized by Ruskin, and Windus was so discouraged that he virtually gave up painting. During the next 40 years he painted only a few sketches and drawings, purely for his own amusement, and did not exhibit at all after 1859.

'Studies for Heads' sold at Christie's 25.3.66 for £157.

Bibl: AJ 1859, 171; 1905, 159; 1907, 360, 382; Mag. of Art 23 (1900) 49-56; Ruskin, Academy Notes, 1856, 1859; DNB; Bate; Marillier 241-54 (2 pls.); Ironside & Gere; Reynolds VS 17, 23, 77 (pl.47); Mary Bennett *W.W. and the PRB in Liverpool* Liverpool Bulletin VII no.3, 19-31; Fredeman Section 65 and index; Reynolds VP 66-7 (pls.44-5); Maas 132-4.

WINGATE, Sir James Lawton PRSA 1846-1924

Scottish landscape painter. Born in Glasgow. Painted in his spare time up to the age of 26, when he first began to study seriously. Exhib. mainly at RSA, also RA from 1880. Painted everyday scenes of country life in Scotland. Because of his lack of early training, his pictures lack good drawing and construction, and depend for their effect on "delicate play of brushwork and subtle modulation of tone and colour" (Caw). His work also reveals a considerable feeling for the poetry of Scottish landscape, especially in his sunsets and moonlight scenes. During the 1880's he worked at Muthill, near Crieff, where many of his best works were painted. Later he turned away from figure painting towards pure landscape. Elected ARSA 1879, RSA 1886, PRSA 1919.

'Two Boys Asleep in a Wood' sold at Sotheby's 29.8.69 for £180.

Bibl: AJ 1896, 73-6 (with pls.); Studio 68 (1916) 124f; also see indexes to Studio Vols. 28, 34, 37, 43, 62, 65, 69, 80; Connoisseur 37 (1913) 55; 69 (1924) 181; Charles Holme *The RSA* The Studio 1907; Caw 318-21 (with pl.); Dayot *La Peinture Anglaise* 1908, 262, 282 (pl.); The Scots Pictorial V. 22.3.1913, 547 (2 pls.).

WINGFIELD, James Digman fl.1832-1872 d.1872

Genre painter. Exhib. at RA 1835-72, BI (94 works) SS and elsewhere. Painted landscapes, rustic genre, historical scenes, and garden scenes with figures in period costume. A work by him is in Nottingham AG.

'The Picture Gallery at Stafford House' sold at Sotheby's 5.11.69 for £820.

Bibl: AJ 1859, 82, 167; Studio 32 (1904) 280, 296; Redgrave, Dict.

WINTER, W. Tatton RBA 1855-1928

Landscape painter. Born in Ashton-under-Lyne. Entered business at an early age in Manchester; studied art at the Board School classes and at the Manchester Academy of Fine Arts; gave up business later. Toured through Belgium and Holland, and studied under Verlat at Antwerp. Exhib. from 1884, at the RA (from 1889), SS, NWS, NG and elsewhere; also at Munich and the Paris Salon. Titles at the RA include 'A Breezy Upland, Sussex' 1889. ' "When Trees are Bare" ' 1897, and 'The West Wind' 1902. The Connoisseur noted his exhibition of watercolours at the Museum Galleries, 1923, "his themes are country glades and suburban heaths, wind-tossed foliage and placid rivers, rendered with a feeling for atmospheric truth and limpidity of colour." In 1925 *The Connoisseur* again noted his "attractive atmospheric style and delicate perception of colour, typically French in feeling with a faint suggestion of Watteau and Corot."

Probable price range £30-100

Bibl: Studio 30 (1904) 42; 63 (1915) 253 (pl.); Connoisseur 18 (1910) 204; 31 (1911) 272; 54 (1919) 180; 66 (1923) 119; 71 (1925) 183; The Athenaeum 1919 II 562; Who Was Who 1916-1928; Apollo 14 (1931) 181; VAM Annual Review 1933 21.

***WINTERHALTER, Franz Xaver** 1805-1873

Portrait painter and lithographer. Studied engraving with his uncle at Fribourg. 1823 studied in Munich under Piloty. Encouraged by the portrait painter Stieler. Settled at Carlsruhe as a portrait painter. He was at once successful, and became Court Painter to Grand Duke Leopold of Bade. 1834 went to Paris, where he painted Queen Marie-Amélie. This launched him on a long and successful career as an international court painter. He painted the royal families of France, England, Belgium, Germany, Austria and Russia. Exhib. at the Paris Salon 1835-68. Chevalier de la Légion d'Honneur 1839; Officer 1857. He only visited England occasionally, mainly to paint Victoria and Albert and their family. These portraits are still in the Royal Collection. He also painted a few portraits of the English aristocracy, mostly members of the Court Circle, and exhib. four pictures at the

RA 1852-67. His career has often been compared to that of Lawrence, but his style remained essentially German. The key to his success was ability to portray his sitters as regal, semi-divine figures, surrounded by the accessories of power, against a grandiose background. His portraits are usually concerned more with status than character. His influence may be detected in the work of some English painters, such as Hayter and Francis Grant (q.v.). Winterhalter also occasionally painted landscape sketches, and watercolours.

'Portrait of Madame Adeline Patti' sold at Sotheby's 18.3.70 for £5500. Other prices in recent years have mostly been in the £1000-£2000 range; less for studio works and replicas.

Bibl: For full bibl. see Thieme-Becker

WIRGMAN, Theodore Blake 1848-1925

Painter of portraits, genre, historical and literary subjects. Exhib. from 1867 at the RA, SS, NWS, GG, NG and elsewhere, titles at the RA being chiefly portraits, but including 'Andrea del Sarto and his Wife Lucrezia' 1871, and '1793 (During the Revolution in La Vendée, the Royalist women had the choice of letting their children perish with them, or of giving them up to the care of the Republicans)' 1893. His most notable subject, never shown at the RA, was 'Peace With Honour', which represented Disraeli interviewing Queen Victoria after the signing of the Berlin Treaty in 1878. An engraving was made of this painting and was very popular. Among his best portraits were Hamo Thornycroft ARA, 1883, Col. Richard Harte Keatinge, 1883, the Bishop of Brechin 1885, the Rt. Hon. Sir James Hannen, 1890, Mrs. Edmund Gosse 1882, and Col. T. Colclough Watson, 1899. Member of the Royal Society of Portrait Painters.

Probable price range £30-100

Bibl: RA Pictures 1891-1896; Connoisseur 41 (1915) 113; 62 (1922) 46; 71 (obit.); La Renaissance de l'Art Francais 4 (1921) 525 f; Cat. of Engraved British Portraits BM 5 (1922) 63; 6 (1925) 565, 715; Mrs. R.L. Poole *Cat. of Portraits etc. of Oxford* 3-11 (1925) 287; The Print Collector's Quarterly 12 (1925) 7; Who Was Who 1916-1928.

WITCOMBE, Miss Margaret fl.1855-1871

Landscape painter, living in Guildford and Swanage, who exhib. from 1855-71, at the RA (1855-63), BI and SS, titles at the RA including 'A Landscape' 1855, 'Woody Meadows' 1862, and 'The Pathway to the Ruin' 1863.

Probable price range £30-60

WITHERBY, Henry Forbes RBA fl. from 1854 d.1907

Painter of landscape and flowers, who exhib. from 1854-1907, at the RA, BI, SS and the old Dudley Gallery. Titles at the RA included 'Study of Spring Flowers' 1854, 'The Harvest Moon; Looking Towards Whitby' 1895, and 'Fresh from the Kitchen Garden' 1900. Lived at Highbury, Croydon, Blackheath and Holmehurst, Burley, New Forest.

Probable price range £30-100

Bibl: The Year's Art 1907-9.

***WITHERINGTON, William Frederick RA** 1785-1865

Landscape and rustic genre painter. Pupil of RA schools. His early works are mostly rustic genre scenes in the Morland and Wheatley tradition. Later he adapted his style to suit Victorian tastes and painted picturesque landscapes and rustic incidents in a manner similar to William Shayer and F.R. Lee (q.v.). Like them he painted much in Devon, the West Country and Wales. Exhib. at RA 1811-63 (138 works), BI and SS. Elected ARA 1830, RA 1840. Works by him are in the VAM.

Usual range £100-300; a pair of rustic scenes sold at Sotheby's 12.3.69 for £700.

Bibl: AJ 1859, 73-5; 1865, 191; Connoisseur 69 (1924) 192; 70 (1924) 107,

113; Redgrave Dict.; Clement and Hutton; Bryan; DNB; VAM; Reynolds VS 51 (pl.7); Maas 53-4 (pl. p.52); Pavière, Landscape pl.93.

WITHERS, Alfred ROI 1856-1932

Painter of landscapes and architectural subjects, very reminiscent of Corot and Diaz. Exhib. from 1881, at the RA (from 1882), SS, GG and elsewhere, titles at the RA including 'The Outer Harbour, Whitby' 1882, 'The Golden Hour' 1884, 'From Hilly Pastures' 1889, and 'Nocturne from Lambeth Bridge' 1890. Member of the Pastel Society; Commander of the Royal Order of Alfonso XII; member of the International Society of Sculptors, Painters and Gravers; member of the Society of Twenty-five English Painters, formed in 1906, (other members including his wife, W. Llewellyn, Sydney Lee, Montague Smyth and Terrick Williams). His wife, Isabelle A. Dods-Withers, was also a landscape painter, painting in a similar style to that of her husband, but in a more purely decorative manner.

Probable price range £30-80

Bibl: AJ 1903, 184, 186 (pl.); 1904, 47 (pl.); 48; 1909, 171 (pl.); Studio 37 (1906) 112 (pl.); 39 (1907) 152 f; 41 (1907) 58 (pl.) 59; 42 (1908) 135; 50 (1910) 27 (pl.); 60 (1914) 145; 65 (1915) 113; 68 (1916) 54; Who Was Who 1929-1940.

WITHERS, Mrs. Augusta Innes RBA fl.1829-1865

Painter of flowers, fruit and birds, who exhib. from 1829-65, at the RA (1829-46), SS, NWS and elsewhere, titles at the RA including 'Flowers and Fruit from Nature' 1829, 'Apples from Nature' 1833, and 'Hens and Chickens' 1846. In 1833 became Flower painter in Ordinary to the Queen Dowager. Member of Society of Lady Artists.

Probable price range £30-100

WIVELL, Abraham 1786-1849

Portrait painter, both oils and miniatures, and inventor of the fire-scape. Exhib. from 1822-59, at the RA (1822-54), BI, SS and elsewhere. From 1841 lived in Birmingham. Published, amongst others, *An Inquiry into the History, Authenticity and Characteristics of the Shakespeare Portraits 1827.*

Probable price range £30-70

Bibl: AJ 1849 205 (obit.); Supp. to the Universal Cat. of Books on Art South Kensington 1877; Redgrave Dict.; Cat. of Engraved British Portraits BM 6 1925.

WIVELL, Abraham Junior fl.1848-1865

Birmingham painter of portraits (both oils and miniatures), and domestic genre. Son of Abraham Wivell (q.v.). Exhib. from 1848-65, at the RA (1848-9), BI and SS — at the RA all miniatures. He contributed twelve portraits to be opening exhibition at Aston Hall, Birmingham in 1858.

Probable price range £20-60

Bibl: Birmingham Cat.

WOLF, Joseph RI 1820-1899

Illustrator and painter of animals and birds. Born at Mörz near Coblenz, Germany. From early childhood he was passionately fond of birds, and would spend hours watching and drawing them. Apprenticed for three years to the Brothers Becker, lithographers, of Coblenz, and subsequently became a lithographer at Darmstadt. In order to obtain practical instruction in drawing, Wolf went to Antwerp, where he painted some pictures of birds, and from Antwerp went in 1848 to London, where he obtained employment at the BM. Drew for a very large number of books on natural history, two of the most important being John Gould's *Birds of Great Britain* and *Birds of Asia;* he drew for the Zoological Society. Exhib. from 1849-81, at the RA (1849-77), BI, NWS and elsewhere; RI in 1874. Many of his drawings of birds and animals are in the VAM.

Recent prices have ranged from about £80 to £300.

Bibl: AJ 1859, 82; Universal Cat. of Books on Art South Kensington 2 1870; Portfolio 1889, 92-99, 152-6, 167-72; A.H. Palmer *The Life of Joseph Wolf* 1895; A.B.R. Trevor-Battye *J.W.* 'Artist' XXV i 1899; W. Gilbey *Animal Painting in England* 1900; Cundall; DNB; *Encyclopaedia Britannica* 1911 ed.; VAM; *Philobiblon* 8 (1935) 78f; Pavière, Sporting Painters; Hardie III 163 fig. 192; Maas 86.

WOLFE, George 1834-1890

Painter of landscapes and coastal scenes, both in oil and watercolour. Lived at Clifton, Bristol. Shared a studio for a time with Samuel Jackson (q.v.). Exhib. from 1855-73, at the RA (1857-67), BI, SS and elsewhere, titles at the RA including 'Beach at Dittisham, on the Dart, Devon' 1857, 'In Leigh woods, Clifton' 1860, and 'A Brig in St. Ives Harbour, Cornwall' 1864. Bristol Art Gallery has two oils and two watercolours, and the VAM has one watercolour 'The Shore at Penzance: Ebbing Tide'.

Probable price range £30-100

Bibl: VAM; Wilson, Marine Painters

WOLLEN, William Barns RI b.1857 fl.1879-1922

Military, sporting and portrait painter. Exhib. from 1879-1922, at the RA, NWS and elsewhere, titles at the RA including 'Football' 1879, 'The Rescue of Private Andrews by Captain Garnet J. Wolseley at the Storming of the Motee Mahal, Lucknow' 1881, and 'The 1st Battalion South Lancashire Regiment Storming the Boer Trenches at Pieter's Hill' 1903. RI in 1888. *The Connoisseur* comments on his exhibits at the RA in 1916: "Mr. W.B. Wollen gives a spirited presentment of what may be called a 'rough and tumble' battle of the old type, with hand to hand bayonet fighting, in his 'Defeat of the Prussian Guard Nov. 11th 1914'. Better, however, is the same artist's 'Canadians at Ypres', painted with equal spirit and with a far greater concentration of interest."

'Britain's Watchdogs' sold at Christie's 8.7.66 for £105

Bibl: AJ 1905 175 (pl.); The Year's Art 1892 122; RA Pictures 1896 193 (pl.); Cundall 173; Connoisseur 45 (1916) 120.

WOLSTENHOLME, Dean, Junior 1798-1882

Sporting and animal painter; son of Dean W. (Senior) (1757-1837). Painted hunting and fishing scenes; also many portraits of horses and dogs. Exhib. at RA 1818-49, BI and SS. His style is very similar to that of his father, and their work is often difficult to distinguish.

'The Halfway House' sold at Sotheby's 20.11.58 for £1600. Other prices were mostly in the £100-300 range.

Bibl: Apollo 7 (1928) 160; 10 (1929) 196; 15 (1932) 96-7; Connoisseur 82 (1928) 137. 141f; Redgrave, Dict; W. Shaw Sparrow *A Book of Sporting Painters* 1931; Pavière, Sporting Painters.

WONTNER, William Clarke fl.1879-1912

Portrait and figure painter. Exhib. at RA from 1879, SS, NWS, GG, NG and elsewhere. Titles at RA mostly portraits. One of these can be seen in Oriel College, Oxford. He also painted many pictures of female figures, usually half-length or head and shoulders, posed against a marble background, in a style similar to J.W. Godward (q.v.).

Usual price range £100-300. 'Anticipation' sold at Bonham's 3.10.68 for £525.

Bibl: AJ 1905, 185; RA Pictures 1892, 150; R.L. Poole *Cat. of Portraits etc. of Oxford 1925.*

WOOD, Miss Catherine M. See WRIGHT, Mrs. R.H.

WOOD, C. Haigh fl.1874-1904

Genre painter, living in London, Bury and Taplow, Bucks, who exhib. from 1874-1904, at the RA (1879-1904), SS, NWS and elsewhere.

Titles at the RA include 'The Harvest Moon' 1879, 'Chatterboxes' 1889, and 'The Old Love and the New' 1901.

Probable price range £30-70

WOOD, Miss Eleanor Stuart fl.1876-1893

Painter of fruit, flowers and portraits, brought up in Manchester, but in 1876 working in London. Exhib. from 1876-93, at the RA (1876-86), NWS, GG and NG, titles at the RA all being of fruit and flowers. In the Walker Art Gallery, Liverpool is the portrait of the novelist William Edwards Tirebuck. Member of the Society of Lady Artists.

Probable price range £30-70

Bibl: The Year's Art 1893, 124; Cat. of the 10th Spring Exhibition of Modern Pictures, Rochdale Art Gallery 1913.

WOOD, Miss Emmie Stewart fl.1888-1910

Landscape painter. Exhib. at RA from 1888, SS, NWS and elsewhere. Painted quiet, poetic landscapes, reflecting the influence of Corot and the Barbizon school. Titles at RA 'The Silent Loch' 'The Reed Cutters' 'The First Breath of Autumn' etc.

Probable price range £30-80

Bibl: The Year's Art 1928, 556

WOOD, George fl.1844-1854

London painter of historical and mythological subjects, genre, still-life, portraits and landscape, who exhib. from 1844-54, at the RA (1844-9), BI and SS. Titles at the RA include 'Ellen Young at the Grave of her Parents' 1844, 'The Bending of Prometheus' 1845, and 'Old Women Boiling Potatoes' 1845.

Probable price range £30-100

WOOD, John 1801-1870

Painter of portraits, biblical, historical and literary subjects. Studied at Sass's School, and at the RA Schools, where in 1825 he gained the gold medal for painting. Exhib. from 1823-62, at the RA (118 works), BI and SS, titles at the RA including mainly portraits, and 'Elizabeth in the Tower after the Death of her Sister Queen Mary' 1836 (which gained a prize at Manchester), 'King Henry VI Taking Refuge in a Cottage after the Battle of St. Albans' 1842, and 'The Entombment of Our Saviour' 1853. He won a great temporary reputation. In 1834 he completed successfully the commission for the altar-piece of St. James's, Bermondsey. During the latter part of his career he painted chiefly biblical subjects and portraits. His portraits of Sir Robert Peel, Earl Grey, John Britton (NPG), and others have been engraved, as well as several of his fancy subjects.

Probable price range £50-200

Bibl: AJ 1870 204; Redgrave Dict.; Bryan; L. Cust NPG Cat. 2 1902 (pl.); DNB

WOOD, Lewis John RI 1813-1901

Painter of landscape and architectural subjects; lithographer. Exhib. from 1831-91, at the RA (1831-72), SS, NWS (205 works) and elsewhere, titles at the RA being chiefly architectural subjects: 'The Old Tower of St. Dunstan's Church, now Pulling Down' 1831, 'Church of Notre Dame at Caen, Normandy' 1855 and 'The Old Church of St. Laurent, Rouen' 1872. After 1836, when he first visited the Continent, he found his best inspiration in the towns and villages of Belgium, Normandy and Brittany. A of RI in 1867; RI 1870; resigned his membership in 1888.

'Limburg on the River Lahn' sold at Weinmuller (Munich) 19.3.70 for £834. Other prices have mostly been in the £50-200 range.

Bibl: AJ 1859 80; Studio 46 (1909) 142; Gazette des Beaux Arts I (1859) 363; 6 (1860) 105 f; Bryan; VAM Cat. of Oil Paintings 1907; Cundall 271; Trafalgar Galleries, London *The Victorian Painter Abroad* 1965 52 (pl.).

WOOD, Matthew 1813-1855

Irish painter of portraits and rural and domestic subjects..Born in Dublin, and exhib. portraits at the RHA from 1826-38. In 1838 he left Dublin and settled in London, where he held a clerkship in the General Post Office. Continued to exhibit at the RHA until 1852, e.g. 'Bashfulness, an Irishman's Failing' 1845, and also acted for some years as agent, collecting pictures in London for its annual exhibitions. Exhib. in London from 1840-55 at the RA, BI, SS and elsewhere, titles at the RA being mainly portraits and 'A Kerry Peasant's Child' 1845, 'Irish Heath Blossom' 1846, and 'A Norman Peasant' 1852. He committed suicide in 1855, due to the disappointment of not obtaining promotion to a post in his office.

Probable price range £30-100

Bibl: AJ 1855, 284; Strickland

WOOD, R.H. fl.1865-1876

London landscape painter, who exhib. from 1865-74, at the RA (1866-74), BI, SS and elsewhere, titles at the RA including 'Near Kirkstall, Yorkshire' 1866, 'The Sunset Hour' 1871, and 'The Old Mill' 1872.

Probable price range £30-70

WOOD, Thomas 1800-1878

Painter of marines, landscapes and architectural subjects. Second son of John George Wood FSA., and brother of John Wood. Chiefly self-taught, but became known for his accurate study of nature. He specialized in views in Wales, Devon, the Isle of Wight, Jersey and at Harrow, where he was drawing master from 1835-71, but also executed marines with careful attention to ship construction, rigging etc. Exhib. at the RA and NWS from 1828-53, titles at the RA including 'Westminster Abbey from Dean's Yard' 1838, 'Harrow church from the N.E.' 1846, and 'H.M.S. *Queen,* 116 — Portsmouth Harbour' 1853. Member of NWS in 1833.

Probable price range £50-200

Bibl: Bryan; Cundall 271; VAM; Wilson, Marine Painters.

WOODMAN, Charles Horwell 1823-1888

Landscape watercolourist. Brother of Richard Horwell Woodman, and son of Richard Woodman. Exhib. from 1842-85, at the RA (1842, 'A Portrait'), BI, SS, NWS and elsewhere. Nine of his watercolours are in the VAM.

Probable price range £20-60

Bibl: AJ 1860 47; *Guide to an Exhibition of Drawings etc. acquired between 1912-14*, BM 1914, 29; Connoisseur 72 (1925) 161, 178.

WOODMAN, Richard Horwell fl.1835-1868

Landscape painter. Son of Richard Woodman, miniature painter. Exhib. from 1835-68, at the RA (1848-58), BI, SS and elsewhere, titles at the RA including 'Evening' 1848, 'A Rugged Path' 1851, and 'Forest Scenery' 1858.

Probable price range £20-60

*WOODS, Henry RA 1846-1921

Painter of Venetian genre. Studied in his native town of Warrington, Lancs, and at South Kensington Schools. At first worked as an illustrator for *The Graphic* and other magazines. Began to exhib. at the RA in 1869, mostly rustic genre, e.g. 'Haymakers' 'Going Home' etc. In 1876, at the suggestion of his brother-in-law Sir Luke Fildes (q.v.), he visited Venice in search of new subjects. He was so taken with life in Venice, that he settled there permanently, and devoted the rest of his life to painting scenes of everyday life in the streets and

canals. Exhib. at RA from 1869, SS and elsewhere. Typical titles 'The Gondolier's Courtship' 'Il Mio Traghetto' 'Saluting the Cardinal' etc. His style is very similar to that of his brother-in-law Fildes, and also shows the influence of other members of the foreign colony in Venice, such as M. van Haanen and Eugene de Blaas. Elected ARA 1882, RA 1893. Works by him are in the Tate, Aberdeen, Liverpool and Leicester AG.

'At the Well' sold at Sotheby's 14.6.63 for £105. Price range today probably £500-1,000.

Bibl: AJ 1886, 97-102; 1893, 192; 1908, 42; Connoisseur 61 (1921) 237f; RA Pictures 1892-3; J. Greig *H.W. RA* The Art Annual 1917; Who Was Who 1916-28, 1929; Reynolds VS 28, 94; See also references under Fildes, Sir Luke.

WOODVILLE, Richard Caton RI 1856-1926
Painter and illustrator, mainly of military scenes. Studied in Dusseldorf and Paris. Painted Napoleonic battle scenes, and episodes from many Victorian campaigns, in Afghanistan, Egypt, Africa and elsewhere. Exhib. at RA from 1879, BI, NWS, NG and elsewhere. Works by him are in Bristol and Liverpool AG, and in the Royal Collection. His work can be confused with that of his father, also Richard Caton W. (1825-1855), an American military artist, who settled in London in 1852.

'Conquered but not Subdued' sold at King and Chasemore (Sussex) 11.2.69 for £540.

Bibl: Illustrated London News 1895 no 144 p. 137, 419; Connoisseur 42 (1915) 248; 51 (1918) 110; 79 (1927) 127; The Times 18.8.27; Who's Who 1924; Who was Who 1916-19; J. Pennell *Modern Illustration* 1895; The Year's Art 1901.

WOODWARD, Thomas 1801-1852
Painter of animals, landscapes, portraits, genre and historical subjects. Born at Pershore, Worcestershire. Pupil of Abraham Cooper, R.A. (q.v.). Exhib. from 1821-52 at the RA, BI and SS, titles at the RA including 'A Child Feeding Rabbits' 1837, 'The Battle of Worcester' 1837, 'Milking Time in the Highlands' 1847, ' "The Wild, the Free". Byron's Mazeppa' 1851, and 'Scene in Westwood Park — Lady Diana Pakington with her Favourites' 1852. His two most important paintings are 'The Battle of Worcester' and 'The Struggle for the Standard'. His landscapes, chiefly of Scottish scenery, are generally made subservient to the cattle in them. Occasionally he was employed by Queen Victoria and Prince Albert to make portraits of some of their favourite animals, and among his other patrons were the Duke of Montrose, the Duke of Newcastle, Sir Robert Peel and the Earl of Essex. A picture of 'The Ratcatcher' is in the Tate Gall.

Girl and a Boy on Ponies' sold at Sotheby's 18.3.70 for £400.

Bibl: AJ 1852 375 (obit.); Redgrave Dict.; Bryan; Cat. of Engraved British Portraits, BM 6 (1925) 325; Pavière, Sporting Painters.

WOOLLETT, Henry A. fl.1857-1873
London landscape painter, who exhib. from 1857-73 at SS and elsewhere.

'Huntsman with Hounds' sold at Sotheby's 19.8.69 for £180.

***WOOLMER, Alfred Joseph RBA 1805-1892**
Genre painter. Born in Exeter, studied in Italy. Exhib. mainly at SS (355 works), also BI and RA 1827-50. Painted pleasing genre scenes, usually Watteauesque gardens with figures in 18th c. costume. Works by him are in Glasgow, Liverpool and York AG.

'Babes in the Wood' sold at Christie's 21.2.69 for £158

Bibl: AJ 1859, 141, 143; Apollo 18 (1933) 205; Connoisseur 100 (1937) 93; Ottley; Maas 168 (pl. p.166)

WORSEY, Thomas RBSA 1829-1875
Birmingham flower painter. Trained as a japanner (painter upon

papier-mâché), but turned to flower painting about 1850 gaining a good practice. Exhib. from 1856-74, at the RA (1858-74), BI, SS, Portland Gallery and in the principal provincial towns. The AJ (1859) comments on two of his paintings: 'Primulas' (Portland Gallery), 'these flowers are painted with much freshness and delicacy, but the sky does not in anywise assist the group''. 'Apple Blossoms' (SS), "This in its way is really charming. The feeling of the little picture is fascinating, and its truth unimpeachable."

'Flowers in a Vase' sold at Spencers (Retford) 1.7.69 for £125

Bibl: AJ 1859 121 143; 1875 279 (obit.); Bryan

WORSLEY, Charles N. fl.1886-1922
Landscape painter, living in London, Sidmouth and Bridgenorth, Shropshire. Exhib. from 1886, at the RA (from 1889), SS, NWS and elsewhere, titles at the RA including 'Lisbon from the Tagus' 1890, 'Almada from Lisbon' 1892, and 'On the Lake of Zurich' 1894. His motives included scenes in Switzerland, Spain, Portugal and New Zealand. One of his paintings is in the National Gallery, Auckland, and four watercolours in the National Gallery, Sydney. (Cat. 1910).

Probable price range £50-150

Bibl: Studio Special Winter Number 1916-17 III 'Art of the British Empire Overseas'; *American Art News* 21 (1922-3) No. 12 3

WORSLEY, D. Edmund fl.1833-1854
London painter of landscape and coastal scenes, who exhib. from 1833-54, at the RA (1836), BI and SS, the title at the RA being 'Sea Coast; a Sketch 1836.

Probable price range £30-70

WORTLEY, Archibald ('Archie') J. Stuart 1849-1905
Painter of portraits and sporting subjects. In 1874 he had practical lessons in painting from Millais. When he first met Millais "his interests seemed to be centred in guns and sketch-books", and Millais offered to teach him how to paint. *(Life and Letters).* His work became very popular, and Ruskin comments on 'Miss Margaret Stuart Wortley' RA 1875 "The rightest and most dignified female portrait here." Exhib. from 1874 at the RA, GG, NG and elsewhere, titles at the RA being mainly portraits but also 'In Wharncliffe Chase — Winter' 1874, 'The Leader of the Pack' 1878 and 'W.G. Grace Esq.' 1890. His work is represented at Lord's Cricket Club.

Probable price range £100-300

Bibl: Ruskin, Academy Notes RA 1875; J.G. Millais *The Life and Letters of Sir John Everett Millais* 1899 II 61; The Year's Art 1890, 233, 1906, 362; Who's Who 1907 (under Lovelace); Pavière, Sporting Painters.

WRIGHT, George 1860-1942
Sporting painter. Lived in Leeds and Oxford. Exhib. at RA and elsewhere from 1892. Painted coaching and hunting scenes, and occasionally other sporting scenes, in a lively and realistic style. His pictures are very often painted in pairs.

'The Bristol, Bath and London Coach' sold at Sotheby's 17.6.70 for £750. Other prices have ranged from £100-300 for single pictures, and up to £1000 for a pair.

Bibl: Pavière, Sporting Painters p.93 (pl.47).

WRIGHT, John Masey 1777-1866
Genre painter, in oil and watercolour. Born in London, the son of an organ builder. First taught by Thomas Stothard. Settled in Lambeth, in the same house as "Jock" Wilson (q.v.). Through him met other artists working for the theatre, and found work as a scenery and panorama painter. Also exhib. at RA (1808-20) BI, SS and OWS (1808-

1866). Member of OWS 1824. Painted historical and literary genre, especially from Shakespeare, Goldsmith and Cervantes. Also worked as an illustrator for many of the Annuals so popular at the time. Hardie writes that "his talent was of the fragile and modest kind which does not lead to any lasting fame".

Probable price range £50-200

Bibl: Redgrave, Dict; Roget; Binyon; Cundall; DNB; VAM; Hughes; Birmingham Cat; Williams; Cat. of Drawings by Brit. Artists BM 4 (1907); Cat. of Engraved Brit. Portraits BM 6 (1925) 567; Randall Davies *Victorian Watercolours at Windsor Castle* 1937; Burlington Mag. 72 (1938) 98; Pavière, Sporting Painters; Hardie III 85, 87-8.

WRIGHT, John William RWS 1802-1848

Painter of portraits and sentimental figure subjects; illustrator. Not related to John Masey Wright, (q.v.), and often confused with him. Son of John Wright, miniature painter; began his studies with a view to portraiture in oil, and then devoted himself to water-colour. Exhib. from 1823-48, at the RA (1823-46) and OWS; chiefly portraits at the RA, and at the OWS studies with such titles as 'Meditation' or 'There's Nothing Half so Sweet as Love's Young Dream'. Elected A of the OWS in 1831 and a full member in 1841. Hardie notes that "..from 1832 to 1851 his lovely, full-breasted, ringleted ladies adorned the pages of such Annuals as *The Keepsake, The Literary Souvenir, Heath's Book of Beauty* and *Fisher's Drawing-Room Scrap-Book.* His work is delicate and pleasing, to be treasured only for its contemporary flavour and association"

Probable price range £50-150

Bibl: AU 1848, 52, 104; Thomas Smith *Recollections of the British Institution* 1860 95; Ottley; Redgrave Dict.; Roget; Bryan; Guide to an Exhibition of Drawings etc. by Old Masters etc. acquired between 1912 and 1914 BM (1914) 24; Cat. of Engr. Brit. Portr. BM 6 (1925) 567; Hardie 88

WRIGHT, Richard Henry fl.1885-1913

Architectural and landscape painter, who exhib. from 1885-1913 at the RA, NWS and elsewhere, titles at the RA including 'Lotos-land' 1889, 'Siena' and 'Verona – Sunset' 1902. Many of his landscapes were set in Egypt, Italy, Switzerland and Greece.

Probable price range £30-100

Bibl: Cats. of RA Exhibitions: 1908, 09, 1910, 1913; for Catherine: 1905, 1909-14, 1916-19, 1922; The Year's Art 1923 556.

WRIGHT, Mrs. R.H. (Miss Catherine Wood) fl.1880-1922

Painter of still-life, flowers and genre. In 1892 married Richard Henry Wright (q.v.). Exhib. from 1880-1922 at the RA, SS, GG and elsewhere, titles at the RA including 'Azalea' 1884, 'A Corner of my Study' 1885, and 'Empty Houses' 1898.

Probable price range £30-70

Bibl: See under WRIGHT, Richard Henry.

*WRIGHT, Robert W. fl.1871-1889

London genre painter. Exhib. mainly at SS, also RA and elsewhere. Subjects mostly domestic scenes and interiors, especially of children at play. Titles at RA 'Making Patchwork' 'Baby's Birthday' 'Mind your own Business' etc. Most of his pictures are small, on panel, and painted in the traditional Wilkie-Webster style. Many of his pictures seem to be painted in pairs.

'Mending the Doll'; and 'The Toy Cannon' – a pair – sold at Christie's 6.3.70 for £284.

WYBURD, Francis John b.1826 fl.1846-1893

Painter of genre and literary and historical subjects. Educated at Lille; placed as a pupil with Thomas Fairland, lithographic artist; in

1845 won the Silver Medal at the Society of Arts; in 1848 entered the RA Schools. Exhib. from 1846-93, at the RA (1846-89), BI, SS and elsewhere, titles at the RA including 'Medora' 1846, 'Amy Robsart and Janet Foster' 1858 and 'The Confessional'. In 1858 Wyburd and George E. Hering, landscape painter, went sketching in N. Italy and the Tyrol, which resulted in several pictures, e.g. 'The Convent Shrine' BI 1862. Most of his pictures are single figures, e.g. 'Lalla Rookh' (little Persian slave), and 'Esther', SS 1875. "The characteristics of Mr. Wyburd's art are principally, a perfect realisation of female beauty, an attractive manner in setting out his figures, and a refinement of finish which is sometimes carried almost to excess." (AJ).

'Undine, the Water Spright' sold at Christie's 2.4.69 for £147.

Bibl: AJ 1877 137-40 (3 pls.); Studio 23 (1901) 118; Clement and Hutton; Studio Year-Book of Decorative Art 1907 74-80.

*WYLD, William RI 1806-1889

Landscape and topographical painter, mainly in watercolour; also lithographer. Pupil of Louis Francia. For a time secretary to the British Consul at Calais. Lived mostly in Paris, where he became a close friend of Bonington. His drawings of Paris are remarkably close to Bonington in style and subject. Exhib. mainly at NWS, also RA 1852-4, and BI. Elected ARI 1849, RI 1879. He painted English and French landscapes and views, and also views in other parts of Europe, especially Venice. He played an important part in the development of watercolour in France. He was awarded two medals at the Salon, and given the Légion d'Honneur in 1855.

'Capriccio View of the Bacino, Venice' sold at Christie's 11.7.69 for £3,675, the current auction record. Other prices have mostly been in the £100-400 range.

Bibl: AJ 1857, 204; Portfolio 1877, 126-9, 140-4, 161-4, 178f, 193-6; Walpole Society 2 (1913) 114f; Connoisseur 87 (1931) 119; Binyon; Cundall; VAM; Hardie II 145 (pls. 127-8); Pavière, Landscape pl.94.

WYLLIE, Charles William RBA b.1859 fl.1871-1920

Painter of landscape and coastal scenes; brother of William Lionel W. (q.v.). Exhib. at RA from 1872, SS, NWS, GG, NG and elsewhere. Like his brother, he painted harbour scenes, views on the Thames, and the English coasts. Two works by him are in the Tate Gall.

'The Pipes of Pan' sold at Bonham's 5.2.70 for £210.

Bibl: Connoisseur 64 (1922) 242; The Year's Art 1890, 231; See also under William Lionel Wyllie.

*WYLLIE, William Lionel RA RI 1851-1931

Painter of marine and coastal subjects in oil and watercolour. Son of William Morison W. (q.v.); brother of Charles William (q.v.). Studied at Heatherley's and RA schools, where he won the Turner Gold Medal in 1869. Exhib. at RA from 1868, SS, NWS, GG and elsewhere. ARA 1889, RA 1907. Painted harbour and dock scenes, especially in London, coastal scenes, and pictures of the British fleet, which were well-known through engravings and reproductions. Works by him are in the Tate, Bristol and Liverpool galleries. His son Harold W. (b.1880) was also a marine painter.

'Shipping in the Pool of London at Sunset' sold at Christie's 6.2.70 for £252.

Bibl: AJ 1889, 221-6; Connoisseur 87 (1931) 335, 400 (obit); Apollo 8 (1928) 105f; Who's Who 1924; Who's Who in Art 1934; F. Dolman *W.L.W. and his Work* 1899; M.A. Wyllie *We Were One. Life of W.L.W.* 1935; Clement and Hutton; Wedmore *Etching in England* 1895, 165; Wilson, Marine Painters.

WYLLIE, William Morison fl.1852-1890

London genre painter. Father of William Lionel W. (q.v.). Exhib. at RA 1852-87, BI, SS, GG, NG and elsewhere. Titles at RA 'The Rustic Oven' 'The Passport Nuisance' 'Landing the Catch' etc.

Probable price range £50-150

Bibl: See under William Lionel Wyllie

WYNFIELD, David Wilkie 1837-1887
Historical genre painter. Great-nephew of Wilkie. Studied with J.M. Leigh. Exhib. at RA 1859-87, BI and elsewhere. Subjects mainly taken from English 16th and 17th c. history. Lived in St. John's Wood, where he was the founder of the St. John's Wood Clique (q.v.). He was also a pioneer photographer, and taught Julia Margaret Cameron, the great Victorian portrait photographer. Died young of tuberculosis. A work by him is in the VAM.

'Return from Market' sold at Bonham's 7.5.70 for £100

Bibl: AJ 1880, 24, 245, 340; Portfolio 1871, 84-7; Clement and Hutton; Bryan; Ottley; B. Hillier *The St. John's Wood Clique* Apollo June 1964.

YARNOLD, J.W. fl.1839-1854
London painter of coastal scenes. Exhib. at RA 1841-52, BI and SS. RA titles include views of coasts of England, Wales, Scotland and N. France.

Probable price range £30-60

Bibl: Wilson, Marine Painters.

*YEAMES, William Frederick RA 1835-1918
Historical genre painter. Born in Southern Russia, where his father was consul. Lived in Odessa and Dresden before returning to London in 1848. Studied in London under G. Scharf; in Italy 1852-8. Exhib. at RA from 1859, BI, SS, GG and elsewhere. ARA 1866, RA 1878 (retired 1913). Specialised in well-known scenes from English history, usually of the Elizabethan or Cromwellian periods e.g. 'Lady Jane Grey in the Tower' 'Amy Robsart' 'Prince Arthur and Hubert' etc. His best-known work is the Victorian favourite 'And When did you Last See your Father?' (Walker AG, Liverpool). Yeames lived in Grove End Road, London, and was a member of the St. John's Wood Clique. Other works by him can be seen in the Tate, Aberdeen, Manchester, Sheffield and Bristol AG.

Probable price range £200-500

Bibl: AJ 1874, 97-100; 1895, 167; Connoisseur 62 (1922) 176; RA Pictures 1891 ff; The Year's Art 1889; Who Was Who 1916-28; M.H.S. Smith *Art and Anecdotes : Recollections of W.F.Y.* 1927; Clement and Hutton; Reynolds VS 83, 100-1 (pl.96); B. Hillier *The St. John's Wood Clique* Apollo June 1964; Reynolds VP 179, 196 (pls. 122, 124); Maas 234-5.

YELLOWLEES, William 1796-1856
Scottish portrait painter. Pupil of W. Shiels in Edinburgh. Came to London about 1829, where he became a protégé of Prince Albert. Exhib. at RA 1829-45. Because of the similarity of his style to that of Raeburn, he was known as "The little Raeburn". A portrait of him is in the Scottish NPG. Caw writes of his portraits "little larger than miniatures, they are distinguished by a fullness and richness of impasto and a beauty of colour one does not usually associate with oil-painting on such a small scale."

Probable price range £30-100

Bibl: Bryan; Caw 90; Cat. of Engraved Brit. Portraits BM 6 (1925)

YGLESAIAS, Vincent Philip RBA fl.1873-1904
London painter of landscapes, especially river scenes. Exhib. mainly at SS, also RA 1874-1904, GG and elsewhere. Titles at RA 'Thames Barges' 'Moonlight at Whitstable' 'The Flush of Dying Day' etc.

Probable price range £30-80

YORKE, William Hoard fl.1858-1903
Very little known Liverpool marine painter. Painted mostly ship portraits off Liverpool and the Mersey, examples of which can be seen in Greenwich Maritime Mus. and Liverpool. Worked only for local patrons, and did not exhibit in London.

Prices in the 1969-70 season have all been in the £200-250 range.

Bibl: Wilson, Marine Painters, 90.

YOUNG, Miss Frances fl.1855-1874
London genre painter. Exhib. twice at RA, in 1862 and 1871, also BI and SS. Titles at RA 'Evening' and 'The Old Priory, Hampstead'.

Probable price range £30-80

YOUNG, Miss Lilian fl.1884-1890
London genre painter. Exhib. at RA 1884-88, SS, NWS and elsewhere. Titles at RA 'An old Pump' 'Wall Flowers' 'Feeding Time' etc.

Probable price range £30-80

YOUNGMAN, Miss Annie M. RI 1860-1919
Genre and still-life painter. Daughter and pupil of John M. Y. (q.v.). Exhib. mainly watercolours at NWS, also RA from 1886, SS, GG and elsewhere. Titles at RA 'Azaleas' 'A Page to Queen Bess' 'A Work of Patience' etc.

Probable price range £30-60

Bibl: Shaw-Sparrow *Women Painters of the World* 1905

YOUNGMAN, John Mallows RI 1817-1899
Landscape painter and etcher. Pupil of Henry Sass. Before settling in London, he was a bookseller in Saffron Walden, Essex. Exhib. mainly watercolours at NWS (110 works) also RA 1838-75, BI and elsewhere. Titles at RA 'Lane, Audley End' 'Lane Scene in Essex' 'In Richmond Park' etc. Drawings by him are in the BM. Elected RI 1841. Father of Annie Y. (q.v.).

Probable price range £30-70

Bibl: AJ 1899, 94; Cundall

ZEITTER, John Christian RBA fl.1824-1862 d.1862
Painter and engraver; of German origin. Exhib. mainly at SS (291 works) also RA 1824-41, and BI. Painted genre, landscapes, flowers, and views on the Continent, RBA 1941. His father-in-law was Henry Alken (q.v.) for whom he engraved Illustrations of Don Quixote, 1831.

Probable price range £20-60

Bibl: AJ 1859, 143; 1862, 163; Connoisseur 87 (1931) 224, 229; Ottley; Redgrave, Dict; Cat. of Engraved Brit. Portraits BM 3 (1912) 428.

ZIEGLER, Henry Bryan 1798-1874
Painter of landscape, portraits and rustic genre. Pupil of John Varley.
Later became drawing-master to Prince George of Cambridge, Edward
of Sachsen-Weimar, and Princess Elizabeth. He was also patronised by
King William IV, and taught Queen Adelaide drawing. Accompanied
the Duke of Rutland on a trip to Norway. Exhib. at RA 1814-1872,
BI, SS and OWS.

Probable price range £30-100

Bibl: Bryan; Cat. of Drawings by Brit. Artists BM 4 (1907).

ZIEGLER, Miss fl.1844-1863
Genre and portrait painter. Presumably daughter of Henry Bryan Z.
(q.v.) as Graves lists them under the same address. Exhib. at RA 1844-
63 and SS. Titles at RA 'Wild Ducks' 'Meditation' 'A Portrait' etc.

Probable price range £30-70

ZIMMERMAN, Henry RBA fl.1871-1889
Landscape painter. Exhib. mostly at SS, also RA 1872-89, GG and
elsewhere. Titles at RA 'The Haunted Mill' 'Haddon a.d. 1650' 'A
Surrey Lane' etc.

Probable price range £30-100

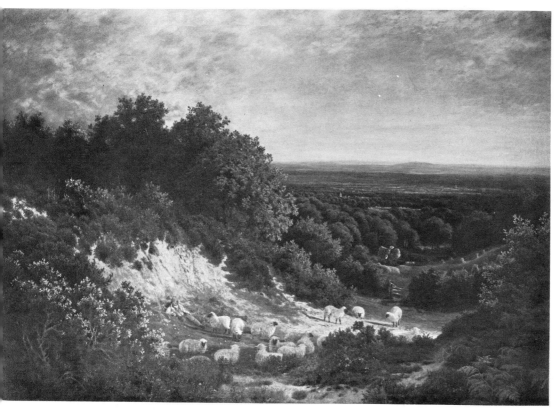

JOHN CLAYTON ADAMS
The Evening Sun — View on Ewhurst Hill, near Guildford
Signed and dated 1878 34½in. x 49½in.

Victoria and Albert Museum

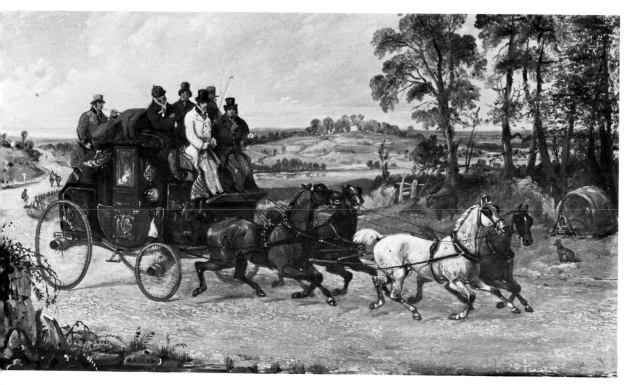

HENRY ALKEN "Summer" *Signed. 7½in. x 12in.*

Richard Green Ltd.

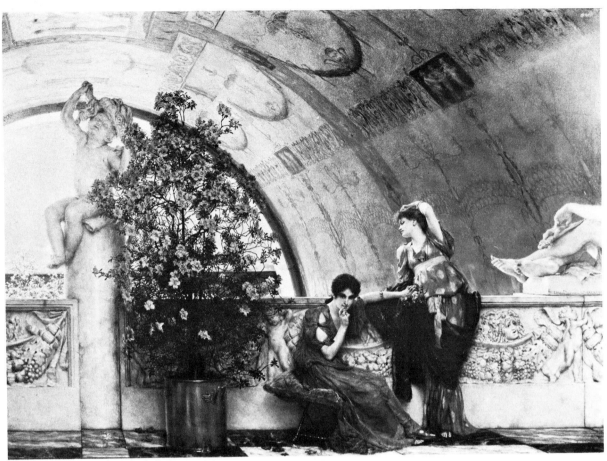

SIR LAURENCE ALMA-TADEMA, RA
Unconscious Rivals *Signed and numbered 321. 17¾ins. x 24¾ins.*

Bristol City Art Gallery

RICHARD ANSDELL RA
The Caledonian Coursing Meeting. *Signed and dated 1844. 60ins. x 119ins.*

Photo: Christie

SOPHIE ANDERSON
No Walk Today
19¾ins. x 15¾ins.

Sir David Scott

JAMES ARCHER

Playing at being Queen *Signed and dated 1862 33ins. x 39½ins.*

The Rt. Hon. The Earl of Stair

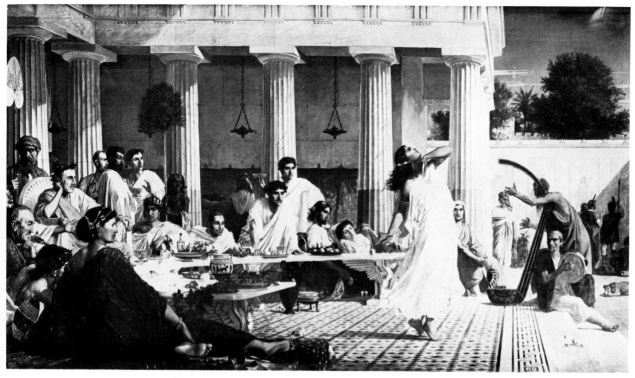

EDWARD ARMITAGE
Guildhall, London
Herod's Birthday Feast *Signed and dated 1868 61ins. x 109ins.*

THOMAS BAKER OF LEAMINGTON
Photo: Christie's
Landscape with Cattle *Signed and dated 1853, 17¾ins. x 24ins.*

WILLIAM AND HENRY BARRAUD
The Beaufort Hunt Lawn Meet at Badminton
80½ins. x 116¼ins.

Major Sir Reginald and
the Hon. Lady MacDonald-Buchanan

JERRY BARRETT
The Mission of Mercy — Florence Nightingale receiving the Wounded at Scutari in 1856
Private Collection, Wales

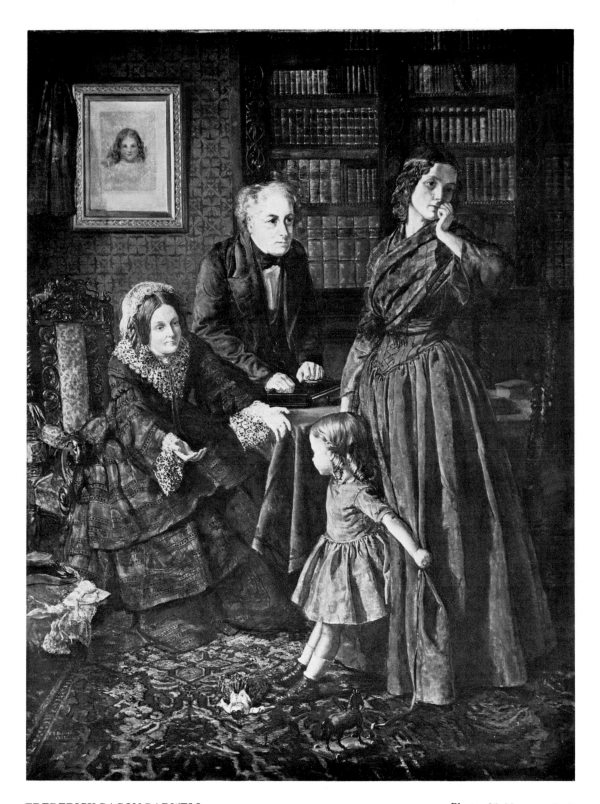

FREDERICK BACON BARWELL
Adopting a Child
Signed and dated 1857
40ins. x 31ins.

Photo: M. Newman Ltd.

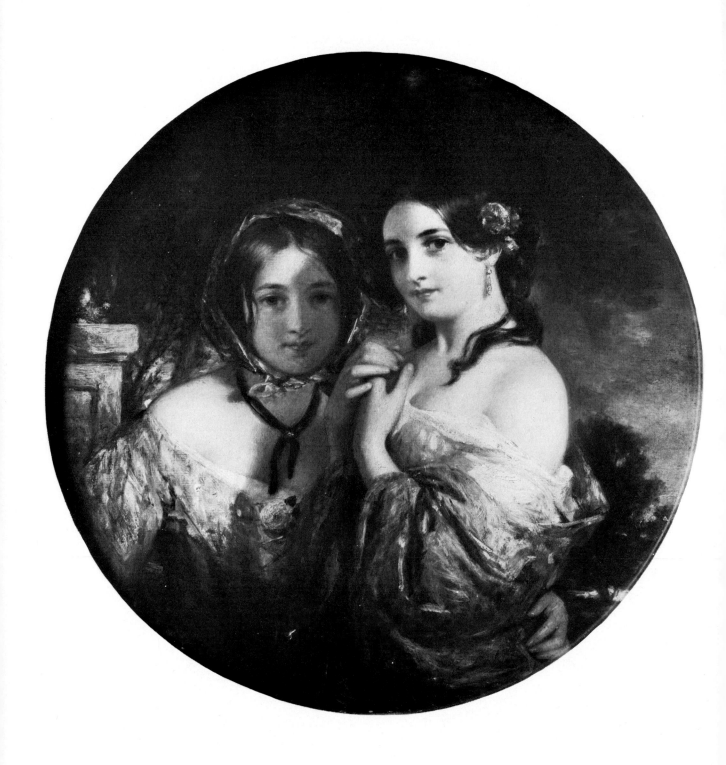

CHARLES BAXTER
The Sisters
Circular
Diameter 12¾ins.

Victoria and Albert Museum

WILLIAM J. J. C. BOND
Raven's Fall, near Hurst Green
Signed, panel, 16½ins. x 12½ins.

THOMAS BLINKS
Photo: M. Newman Ltd.

The York and Ainsty Hounds on the Ferry at Newby
Signed and dated 1898, 32ins. x 50ins.

HENRY JOHN BODDINGTON
N.R. Omell

On the River Lynn, North Devon
Signed and dated 1845, 19ins. x 33ins.

214

SAM BOUGH RSA The Vale of Teith, Perthshire. *Signed and dated 1865, 17ins. x 23½ins.* Mrs. Quinnell

GEORGE HENRY BOUGHTON Walker Art Gallery, Liverpool
The Road to Camelot *Signed and dated 1898, 54ins. x 96¼ins.*

215

JANE MARIA BOWKETT
Preparing for Dinner
Signed

Picture destroyed

216

HENRY A. BOWLER
The Doubt — 'Can these dry Bones live?'
24ins. x 20ins.

JOHN BRETT ARA Walker Art Gallery, Liverpool
The Stonebreaker. *Signed and dated 1857-8, 19½ins. x 26¾ins.*

FRANK BRAMLEY Tate Gallery
A Hopeless Dawn. *Signed and dated 1888, 48¼ins x 66ins.*

FREDERICK LEE BRIDELL Photo: Christie's
The Temple of Vesta. *Signed and dated 1850, 34ins. x 49ins.*

JOHN BRIDGES Photo: Christie's
Three Sisters. *Signed and dated 1849, panel 24½ins. x 29½ins.*

SIR OSWALD BRIERLY
Man Overboard. *Signed, 24ins. x 41ins.*

National Maritime Museum

HENRY BRIGHT
The Old Mill. *41½ins. x 71ins.*

Photo: Chrisite's

HARRY BROOKER

Making a Kite. *Signed and dated 1902, 28ins. x 36ins.*

Photo: Christie's

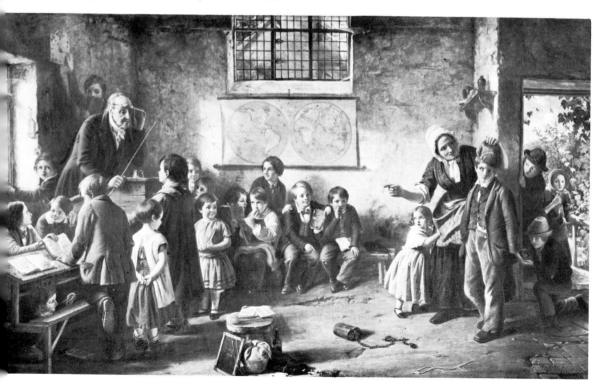

THOMAS BROOKS

The Truant. *Signed and dated 1850, 28ins. x 46ins.*

Mrs. S. Williams

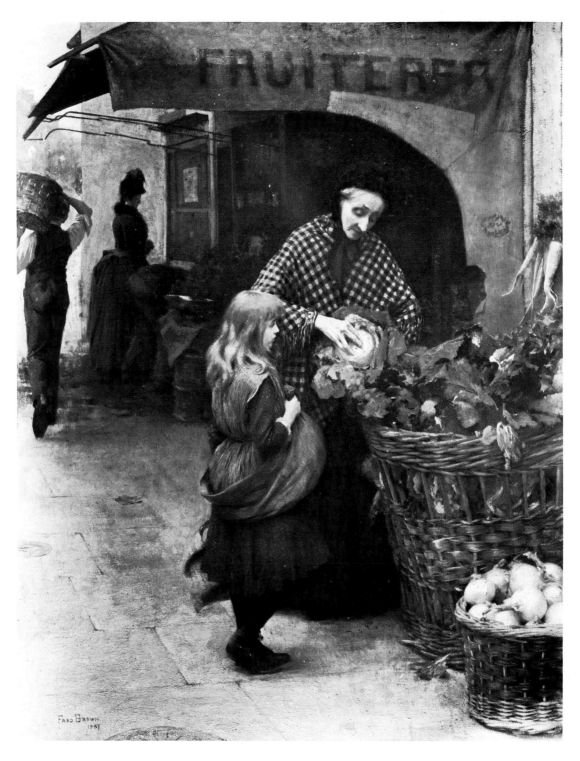

FREDERICK BROWN
Marketing
Signed and dated 1887
53ins. x 39½ins.

Manchester City Art Gallery

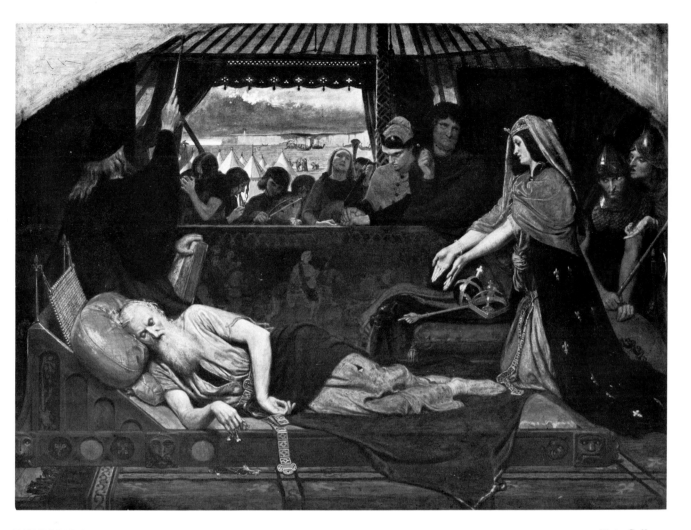

FORD MADOX BROWN
Lear and Cordelia
Signed
28ins. x 39ins.

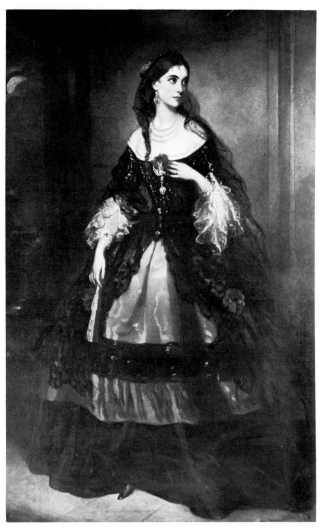

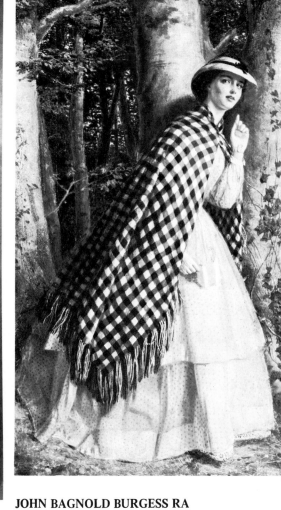

JOHN BAGNOLD BURGESS RA Mrs. Viva King
Waiting
Panel, 12ins. x 9¼ins.

RICHARD BUCKNER Edmund Brudenell, Esq.
Adeline, 7th Countess of Cardigan
Signed, 48ins. x 30ins.

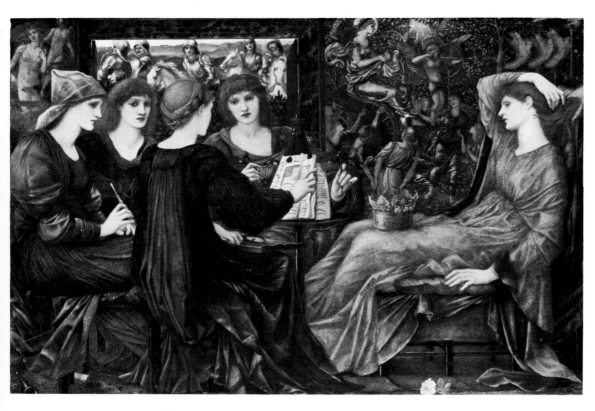

SIR EDWARD BURNE-JONES BT. ARA Lans Veneris. *Signed and dated 1873-5, 48ins. x 72ins.* Thomas Agnew & Sons Ltd.

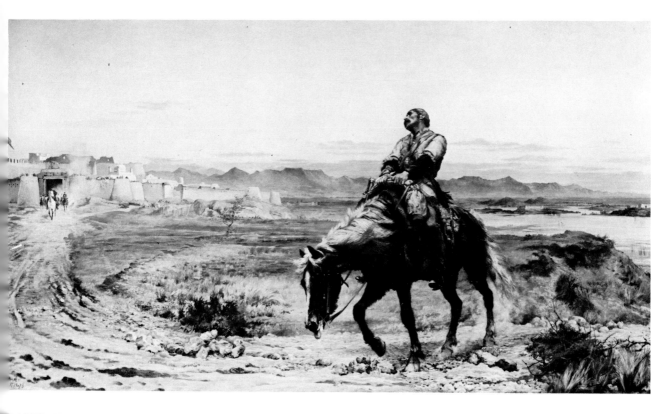

LADY BUTLER The Remnants of an Army *Signed and dated 1879, 52ins. x 92ins.* Tate Gallery

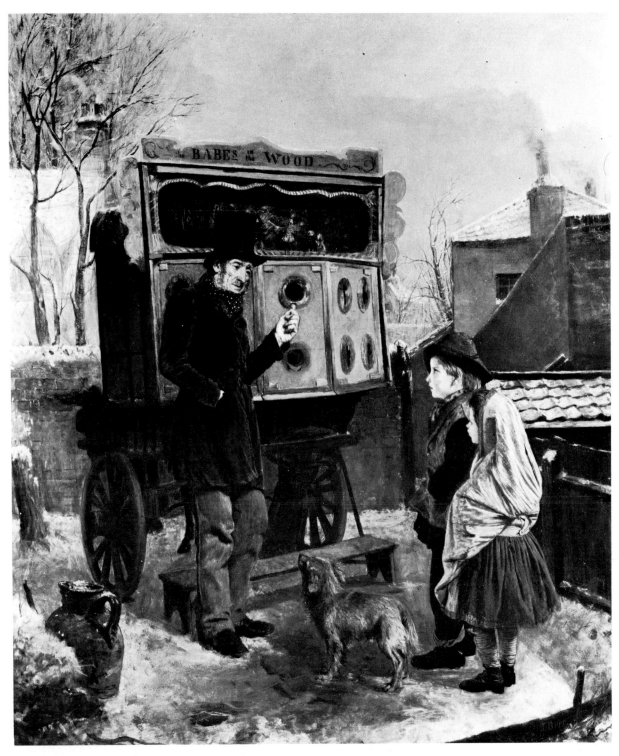

JOHN BURR
The Peepshow. *Signed and dated 1864, 30ins. x 25ins.*

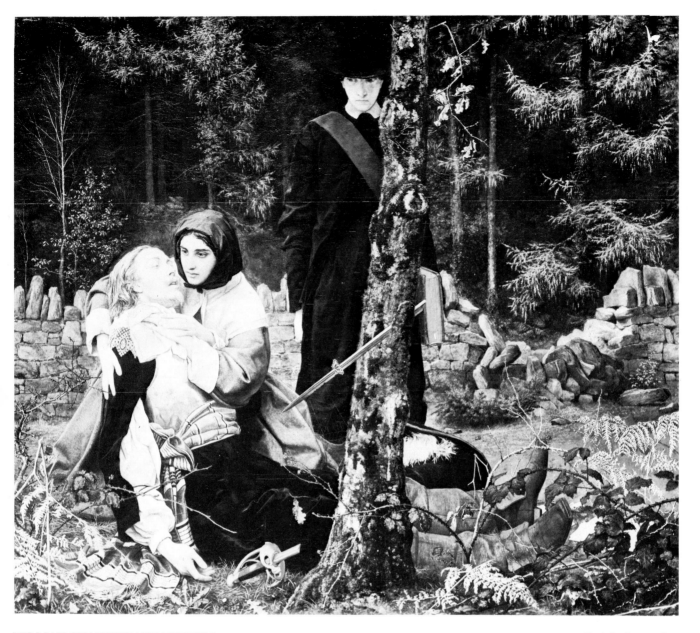

WILLIAM SHAKESPEARE BURTON
The Wounded Cavalier
35ins. x 41ins.

Guildhall, London

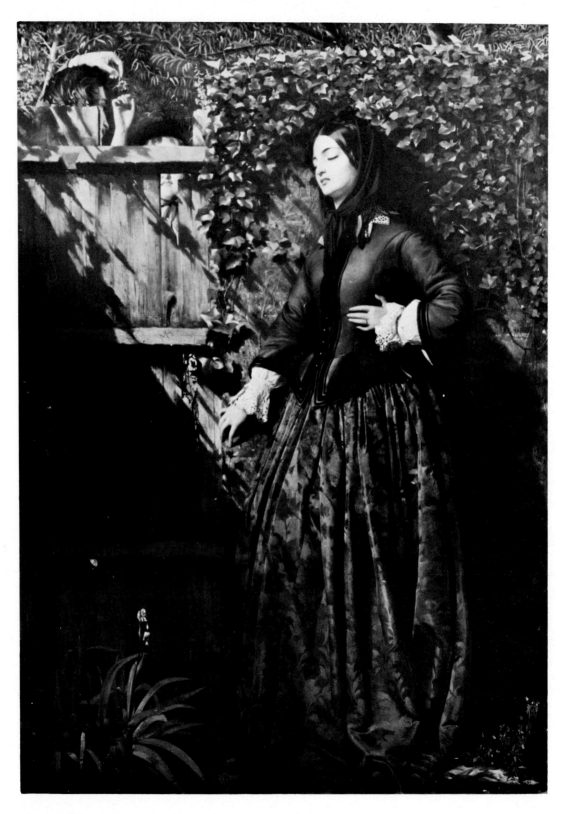

PHILIP HERMOGENES CALDERON RA
 Broken Vows
 Signed and dated 1856, 35½ins. x 26½ins.

Tate Gallery

HUGH CAMERON RSA
Responsibility
Signed and dated 1869
31½ins. x 25⅝ ins.

Aberdeen Art Gallery (MacDonald Collection)

JAMES CAMPBELL
Waiting for Legal Advice
Signed and dated 1857
30ins. x 24½ins.

Walker Art Gallery, Liverpool

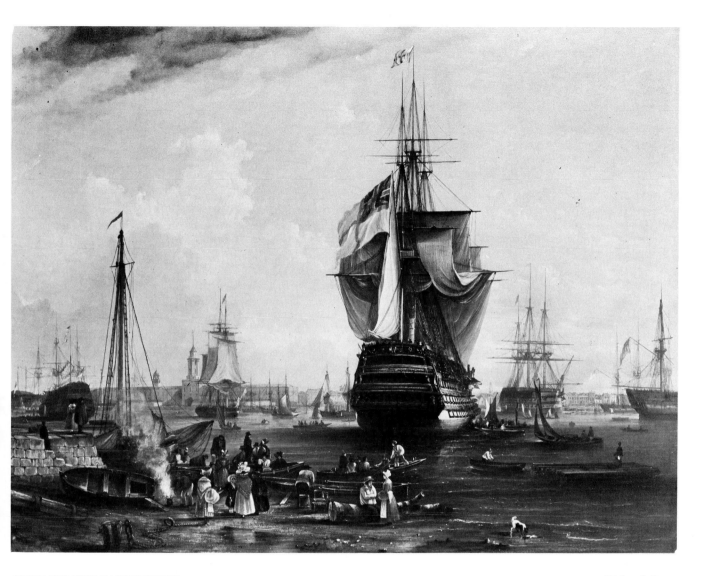

JOHN WILSON CARMICHAEL
H.M.S. St. Vincent in Portsmouth Harbour
Signed and dated 1825
37ins. x 48ins.

Richard Green

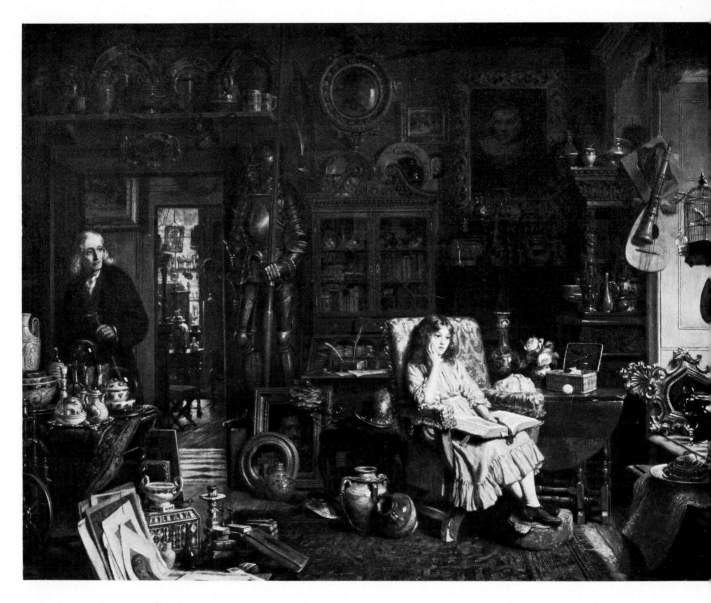

JOHN WATKINS CHAPMAN
Little Nell and Her Grandfather
Signed and dated 1888
28ins. x 36½ins.

H.D. Lyon Esq.

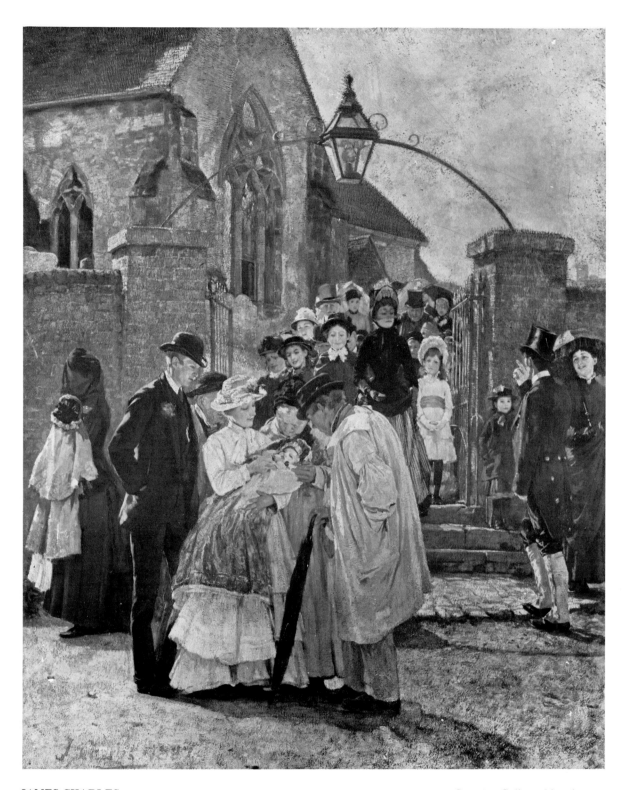

JAMES CHARLES　　　　　　　　　　　　　　　　City Art Gallery, Manchester
Christening Sunday
Signed and dated 1887. 62¼ins. x 49½ins.

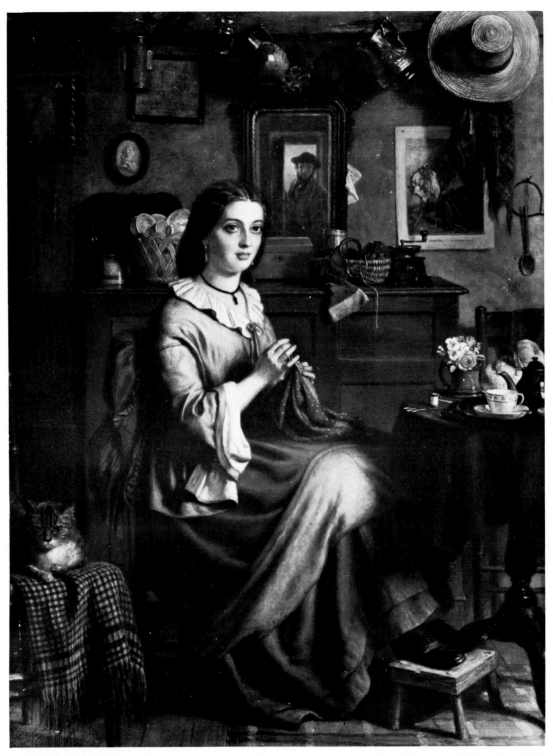

JOSEPH CLARKE
The Labourer's Welcome
30ins. x 21½ins.

The Graves Art Gallery, Sheffield

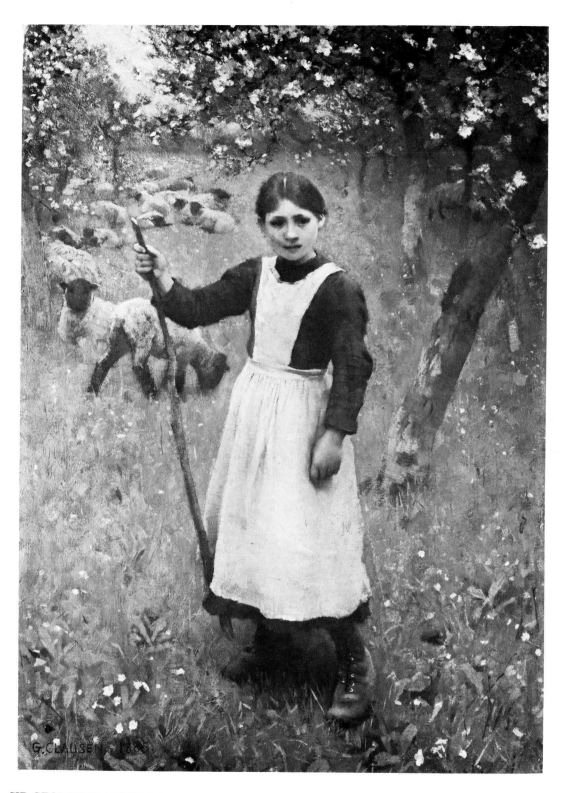

SIR GEORGE CLAUSEN RA
The Shepherdess
Signed and dated 1885
25½ins. x 18 ins.

Walker Art Gallery, Liverpool

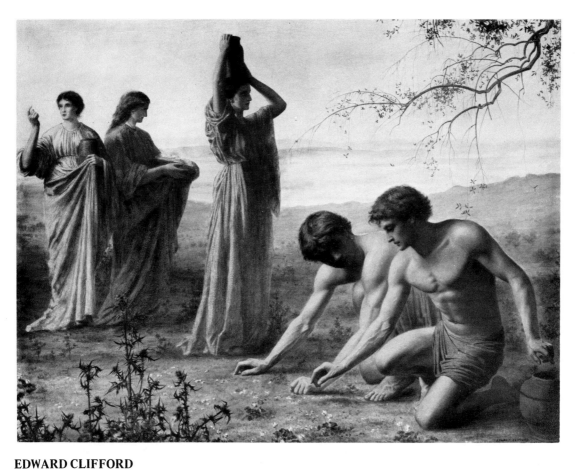

EDWARD CLIFFORD
Israelites gathering Manna. *Watercolour and body colour, signed and dated 1873, 26ins. x 34ins.*

Maas Gallery

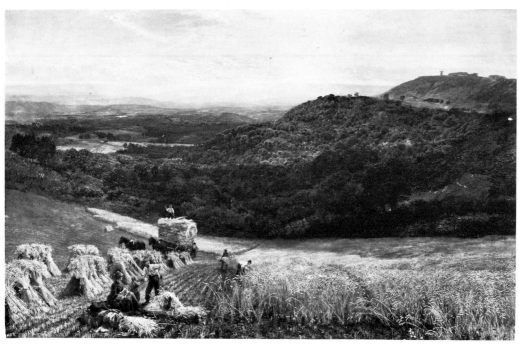

GEORGE VICAT COLE, RA
Harvest Time
Signed and dated 1860. 37ins. x 59½ins.

Bristol City Art Gallery

236

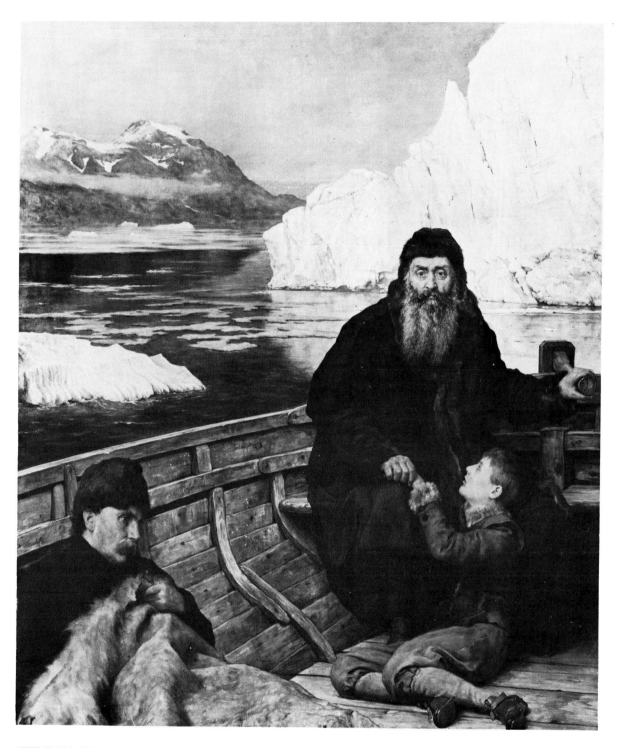

THE HON. JOHN COLLIER
The Last Voyage of Henry Hudson
84½ins. x 72¼ins.

Tate Gallery

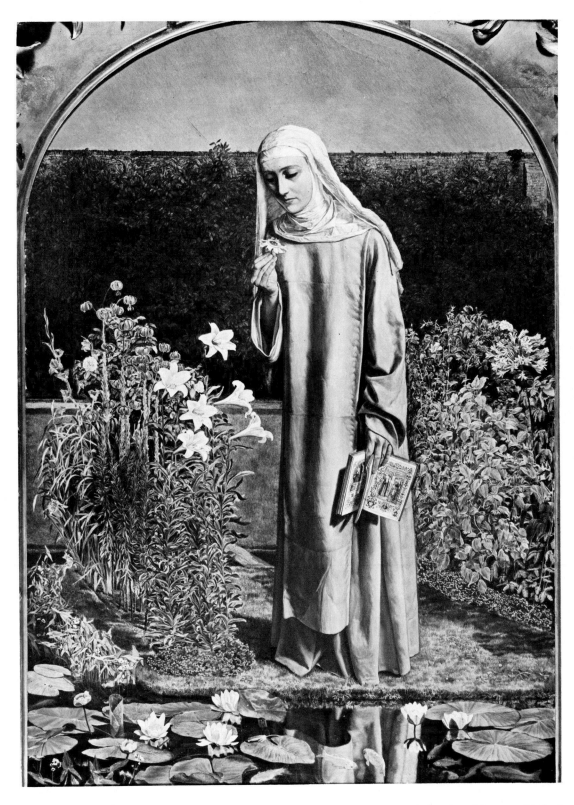

CHARLES ALLSTON COLLINS
Convent Thoughts
33ins. x 23¼ins.

Ashmolean Museum, Oxford.

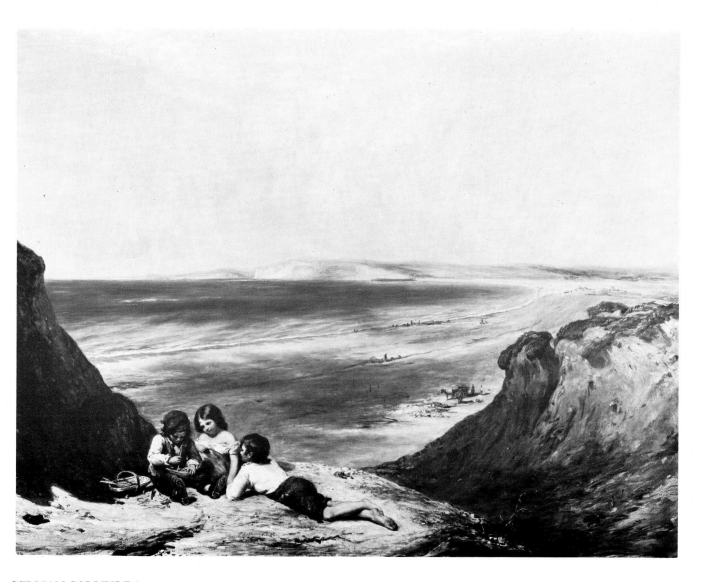

WILLIAM COLLINS RA

Victoria and Albert Museum

Seaford, Sussex
Signed and dated 1844
27½ins. x 36½ins.

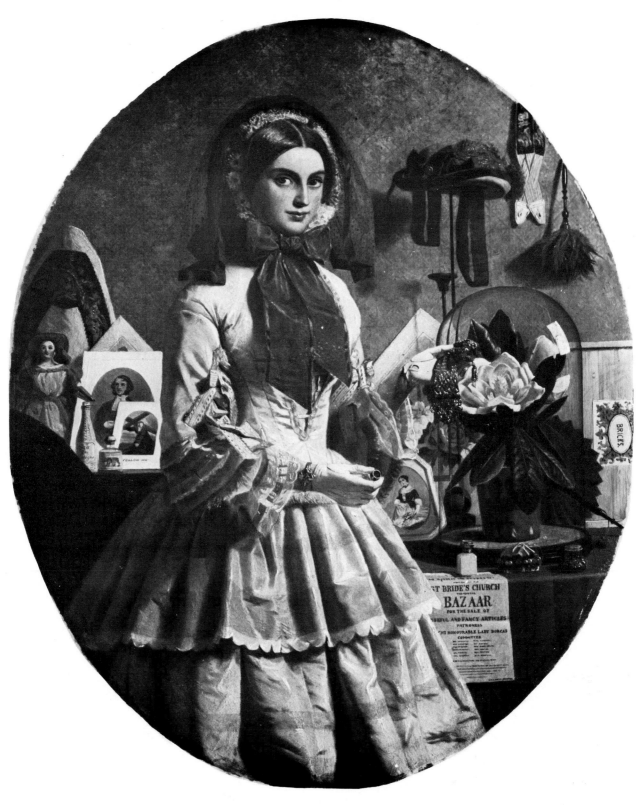

JAMES COLLINSON
At the Bazaar (The Empty Purse)
Signed and dated 1857
24ins. x 18ins.

Graves Art Gallery, Sheffield

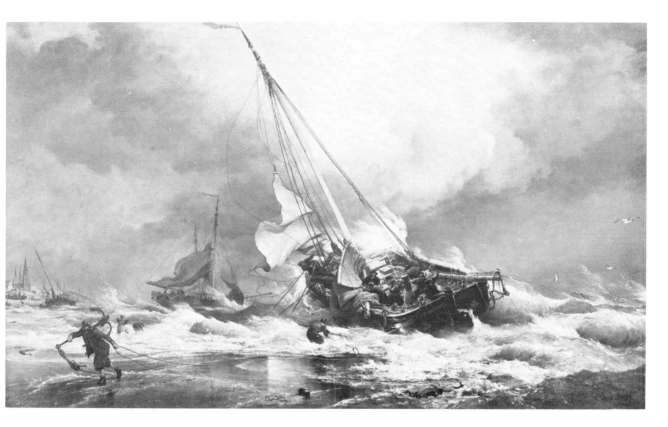

EDWARD WILLIAM COOKE, RA
Beaching a Pink in Heavy Weather at Scheveningen. *Signed and dated 1855, 42ins. x 66ins.*

National Maritime Museum

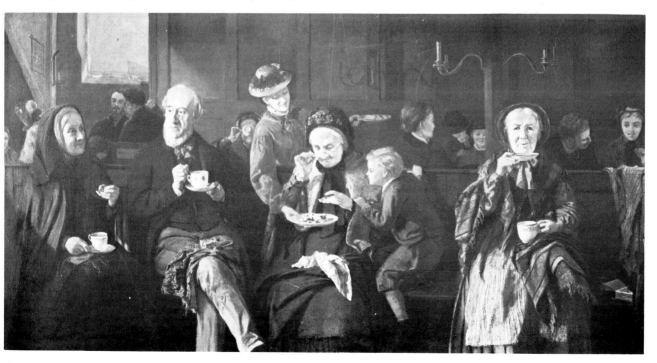

ELLEN CONNOLLY, The Tea Party. *Signed and dated 1877 32½ins. x 61ins.*

Photo: M. Newman, Ltd.

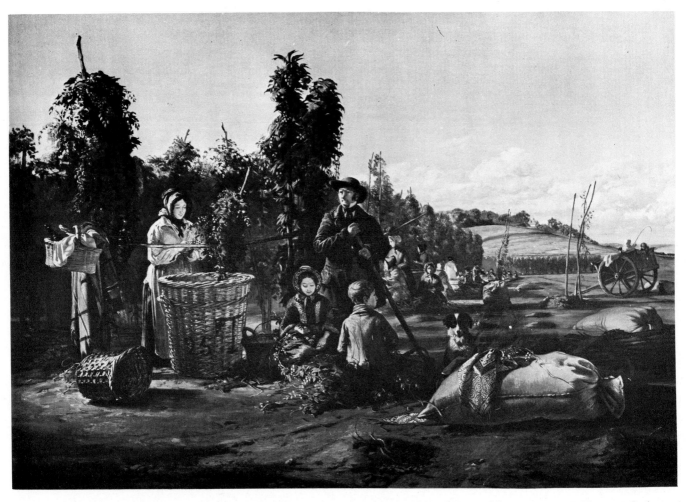

THOMAS GEORGE COOPER, Hop Picking in East Kent. *Signed and dated 1857 — 20ins. x 28ins.* Photo: M. Newman Ltd.

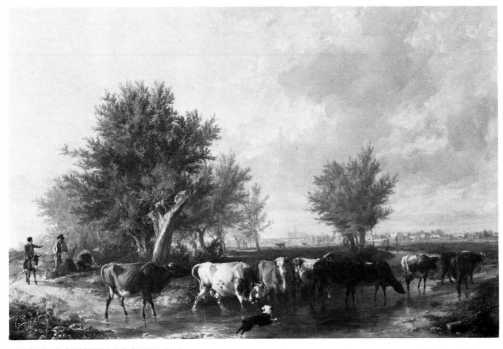

THOMAS SIDNEY COOPER, 'RA
Near Canterbury. *Signed and dated 1861, 37½ins. x 52ins.*

Photo: Christie's

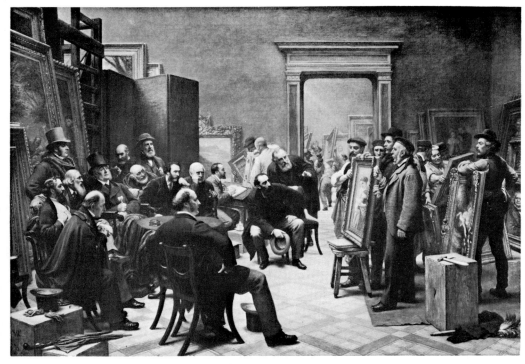

CHARLES WEST COPE, RA Royal Academy, London
The Council of the RA selecting pictures for the Exhibition.
Signed and dated 1876, 57ins. x 86½ins.

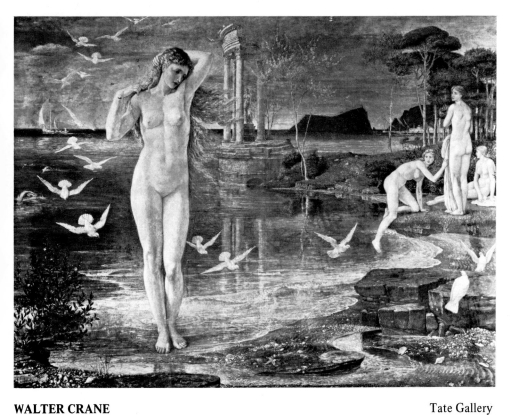

WALTER CRANE Tate Gallery
The Renaissance of Venus. *Signed and dated 1877, tempera, 54½ins. x 72½ins.*

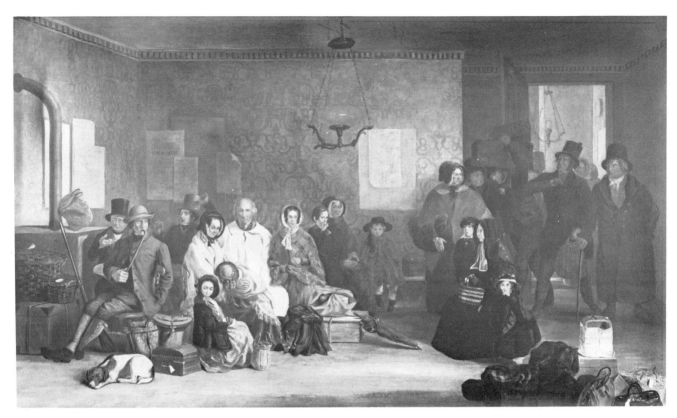

LEFEVRE J. CRANSTON
Waiting at the Station. *Signed and dated 1850, 26ins. x 42ins.*

Photo: M. Newman Ltd.

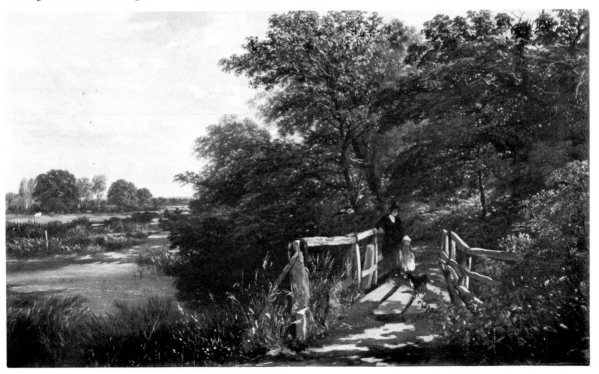

THOMAS CRESWICK RA, Landscape with a Footbridge. *Signed – 15¼ins. x 23½ins.*

Photo: Christie's

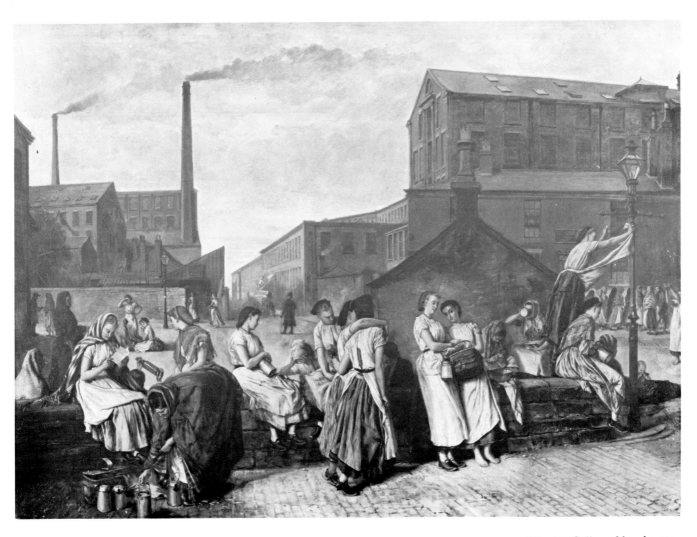

EYRE CROWE
The Dinner Hour, Wigan
Signed and dated 1874
30ins. x 42½ins.

City Art Gallery, Manchester

245

RICHARD DADD
The Fairy Feller's Master Stroke
Signed and dated Quasi 1855-64,
21¼ins. x 15½ins.

Tate Gallery

FRANCIS DANBY ARA
The Wood Nymph's Hymn to the Rising Sun
Signed and dated 1845, 41ins. x 58ins.

Tate Gallery, London

WILLIAM DANIELS. The Goldfish Bowl. *Signed and dated 1868. 27¼ins. x 35ins.* Mrs. Graham Greene

WILLIAM DAVIS. Corner of a Cornfield. *13½ins. x 17½ins.* Walker Art Gallery, Liverpool

248

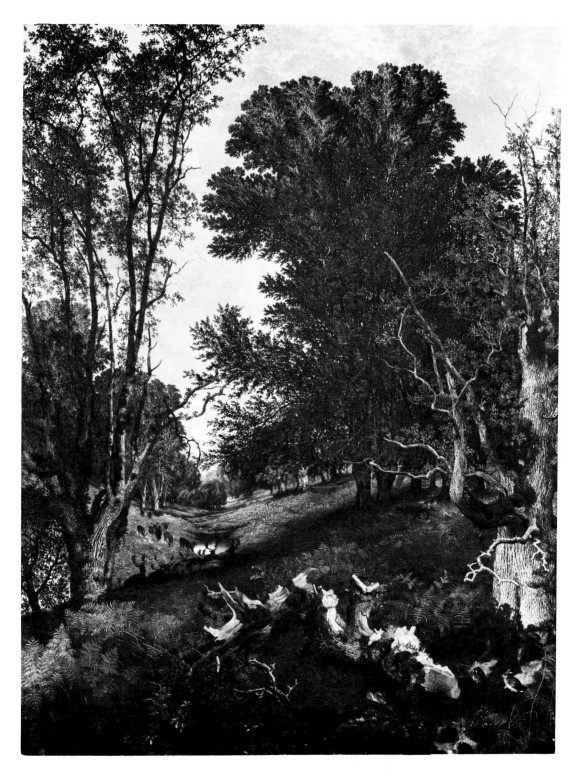

HENRY WILLIAM BANKS DAVIS, RA
Towards Evening in the Forest
Signed and dated 1853, 36ins x 27½ins.

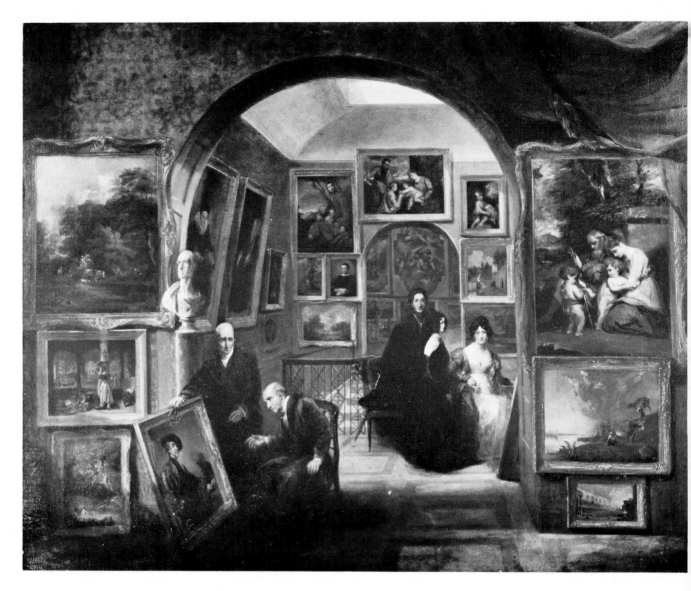

JOHN SCARLETT DAVIS
The British Institution Gallery
43ins. x 55ins.

Photo: Christie's

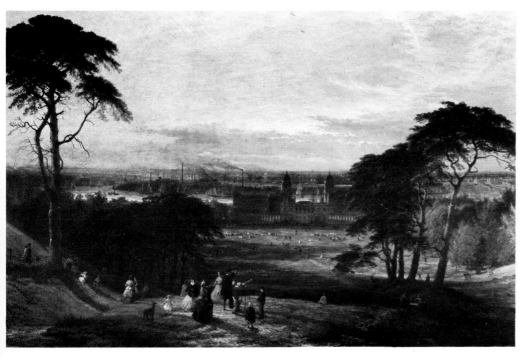

HENRY DAWSON, London from Greenwich Hill. Mr. and Mrs. Paul Mellon

Signed and dated 1869, 70½ins. x 107½ins.

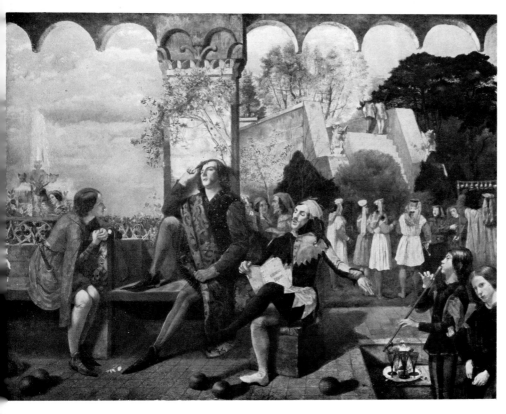

WALTER HOWELL DEVERELL, On Loan to the Tate Gallery, London

Twelfth Night, *40¼ins. x 52½ins.*

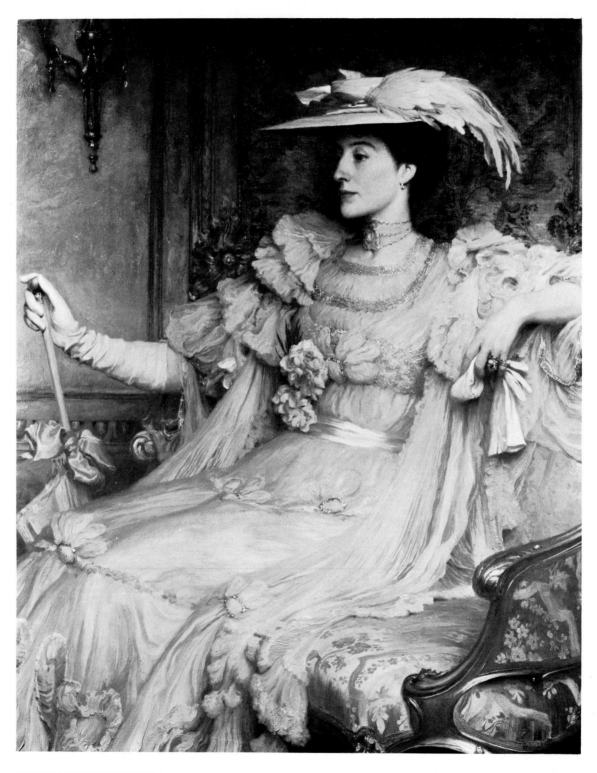

SIR FRANK DICKSEE, PRA
Portrait of Lady Hillingdon
Signed and dated 1904. 40ins. x 50ins.

Private Collection, London

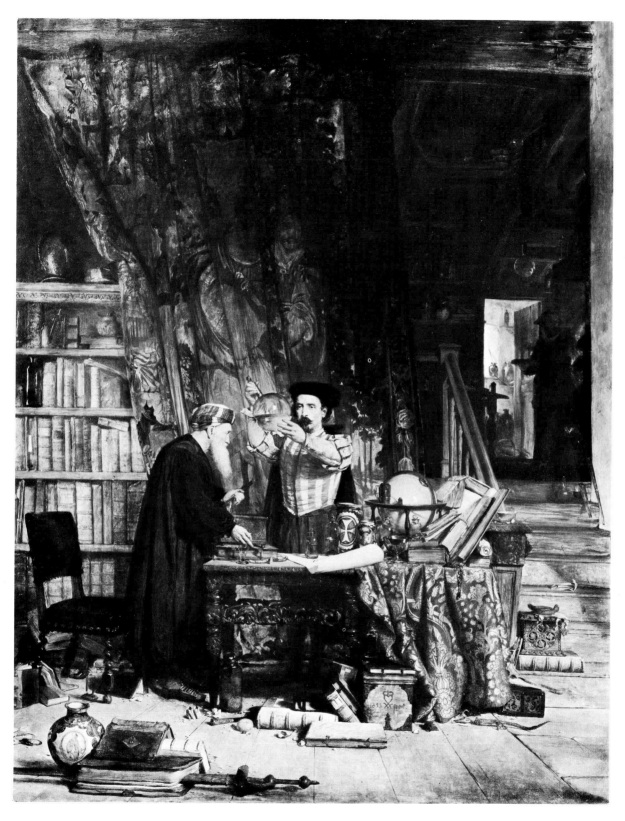

SIR WILLIAM FETTES DOUGLAS PRSA
The Alchemist
Signed and dated 1855
51½ins. x 39½ins.

Victoria and Albert Museum

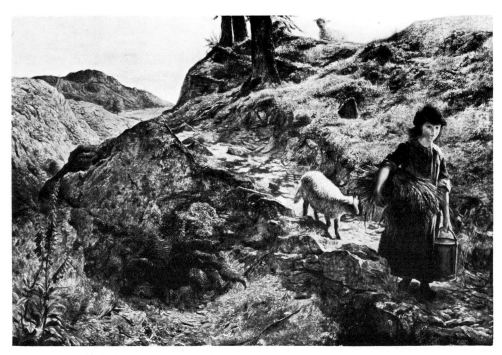

EBENEZER NEWMAN DOWNARD Tate Gallery, London.
Mountain path at Capel Curig, Wales. *13½ins. x 20½ins.*

RICHARD DOYLE Alexander Martin Esq.
The Fairy Tree *Watercolour — 29ins. x 24½ins.*

HERBERT JAMES DRAPER
The Lament for Icarus
Signed. 72ins. x 61¼ins.

Tate Gallery, London

WILLIAM DUFFIELD
A Still Life of Fruit with a Cockatoo
Signed and dated 1858
42½in. x 33in.

Photo: Sotheby's

CHARLES DUKES York City Art Gallery
The Bird's Nest
Signed — 24ins. x 20ins.

WILLIAM DYCE
Pegwell Bay
25in. x 35in.

Tate Gallery

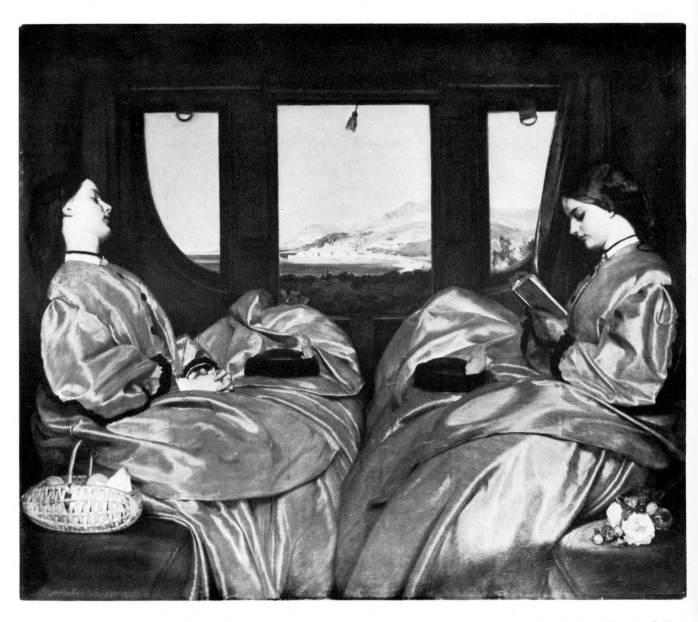

AUGUSTUS LEOPOLD EGG, RA
The Travelling Companions
Signed. 25¼ins. x 30ins.

Birmingham City Art Gallery

WILLIAM MAW EGLEY
Omnibus Life in London
Signed and dated 1859, 17¾ins. x 16½ins.

Tate Gallery, London

ROBINSON ELLIOTT
Strokes of Genius
on panel − 11 ins. x 8¾ins.

Photo: Christie's

ALFRED ELMORE RA
On the Brink
Signed and dated 1865 — 45 ins. x 32¾ins.

Dr. A.N.L. Mumby

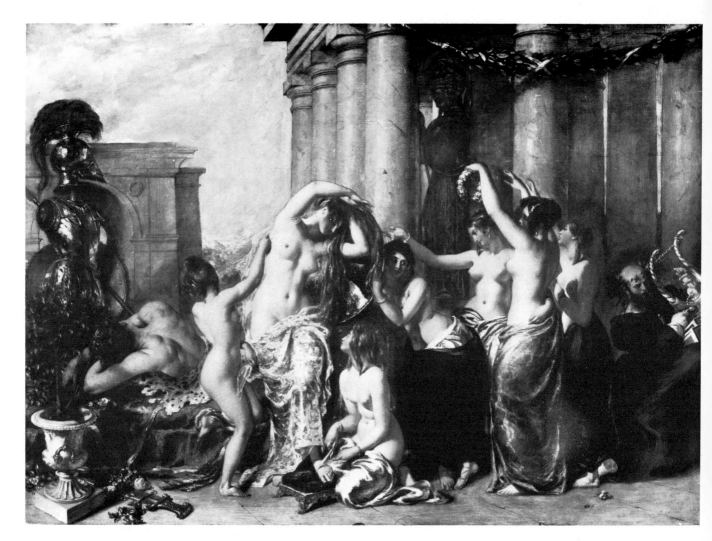

WILLIAM ETTY RA
Venus and her Satellites
on panel – 30½ins. x 42½ins.

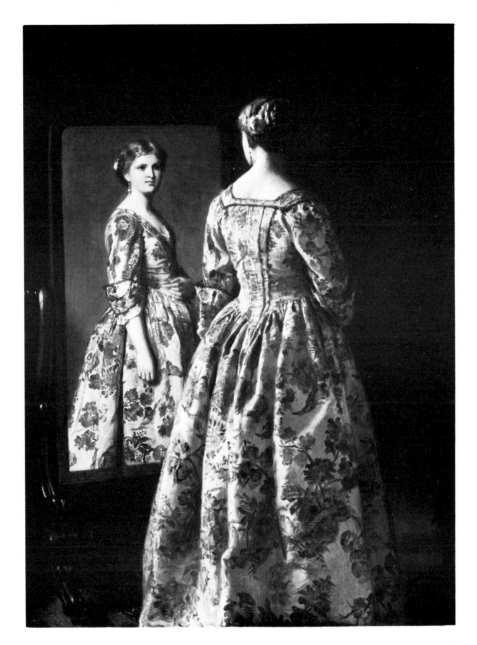

JOHN FAED
The New Dress
12in. x 9in.

Fine Art Society Ltd.

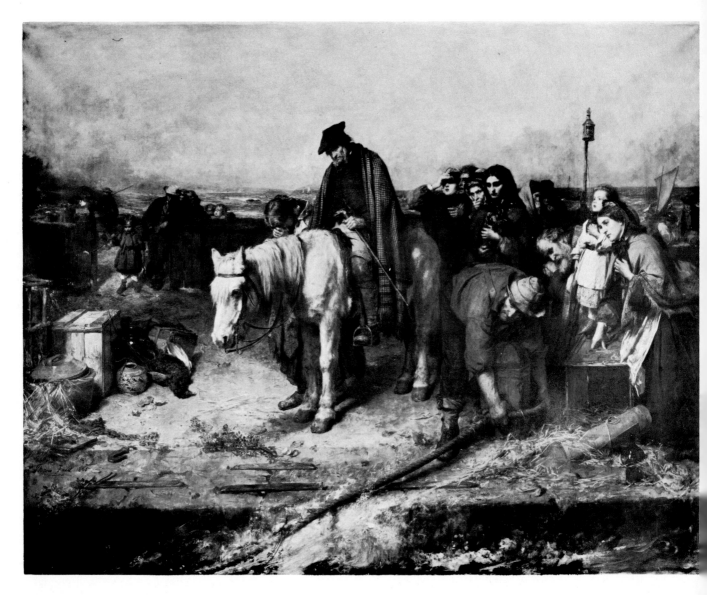

THOMAS FAED, RA
The Last of the Clan
Signed and dated 1865
57ins. x 72ins.

Fine Art Society Ltd.

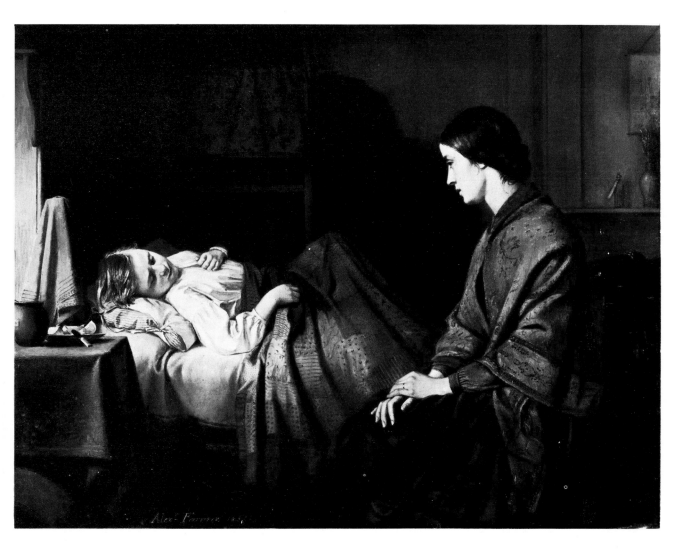

MRS. ALEXANDER FARMER
An Anxious Hour
Signed and dated 1865
On panel. 12in. x 16in.

Victoria and Albert Museum

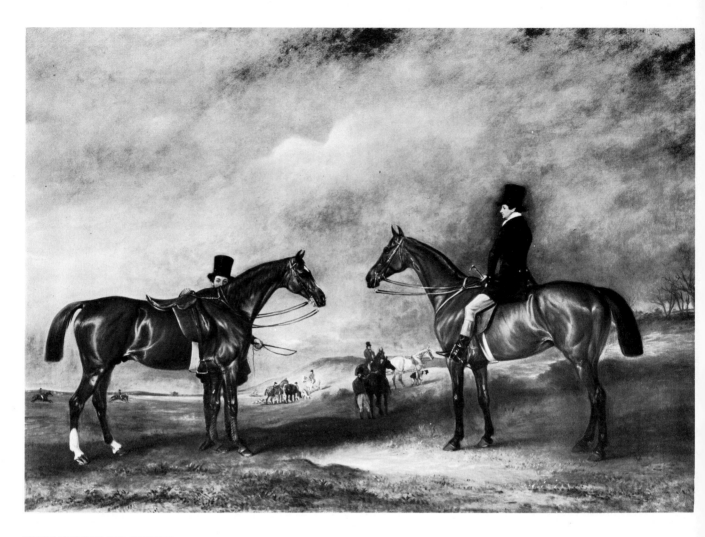

JOHN FERNELEY, SENIOR
Two Hunters with Riders in a landscape
Signed and dated 1814 – 40ins. x 50ins.

Richard Green Ltd.

SIR LUKE FILDES, RA
Royal Holloway College, Egham.
Applicants for Admission to a Casual Ward. *Signed and dated 1874. 56in. x 97½in.*

JOHN AUSTEN FITZGERALD
Sir David Scott
The Stuff that Dreams are made of. *14½in. x 18in.*

MRS. ELIZABETH STANHOPE FORBES
Jean, Jeanine, Jeanette
Signed with monogram
21½ins. x 17½ins.

City Art Gallery, Manchester

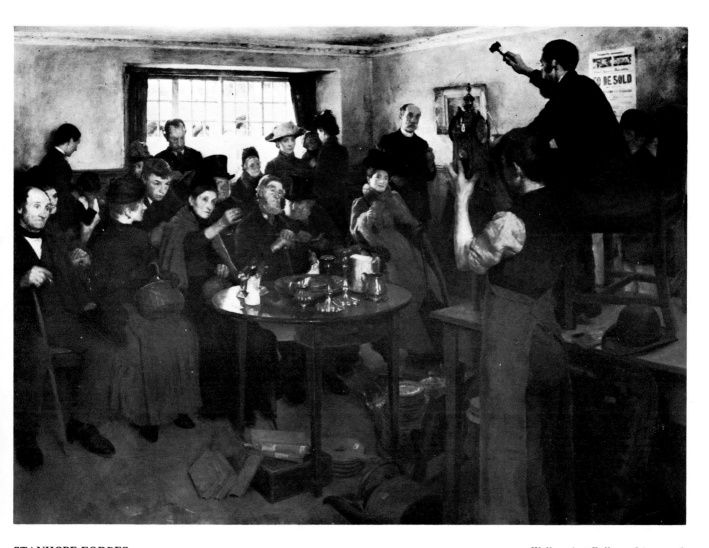

STANHOPE FORBES
By Order of the Court.
Signed and dated 1881 – 60ins. x 80½ins.

Walker Art Gallery, Liverpool.

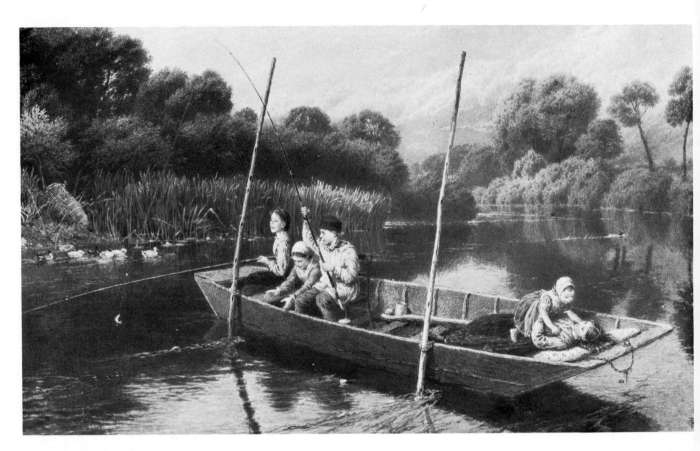

MYLES BIRKET FOSTER,
Children Fishing in a Punt. *Signed with monogram — watercolour — 14ins. x 24ins.*

Photo: Christie's

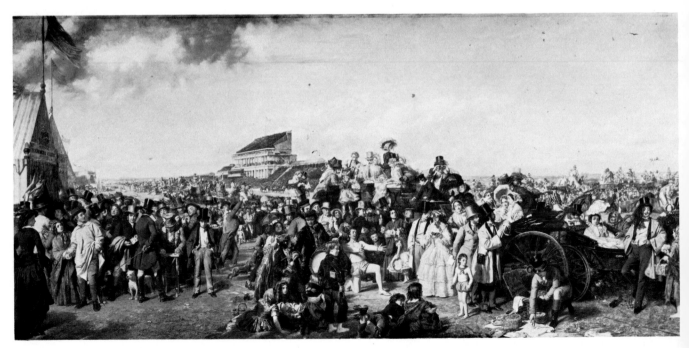

WILLIAM POWELL FRITH RA, Derby Day. *40ins. x 88ins.*

Tate Gallery, London

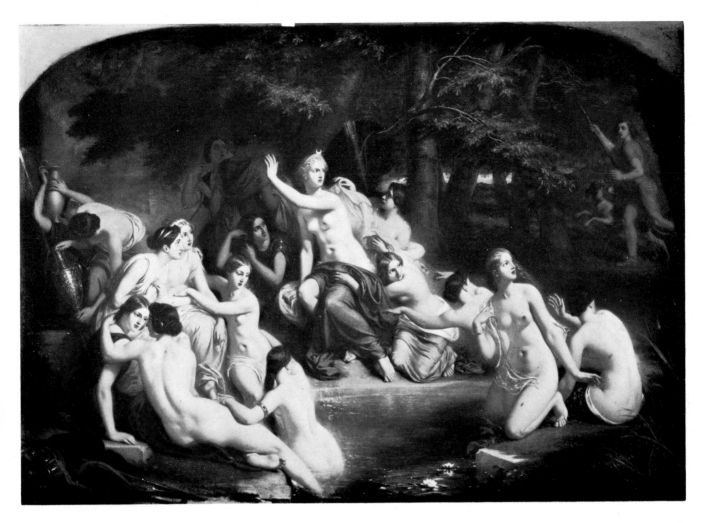

WILLIAM EDWARD FROST, RA
Diana and her Nymphs surprised by Actaeon. *Signed and dated 1846. 48in. x 71¾in.*

WILLIAM GALE
The Confidante
9¾ins. x 6¾ins.

Tate Gallery, London

HENRY GARLAND
Looking for the Mail
Signed and dated 1861 — 20½ins. x 16½ins.

York City Art Gallery

SIR JOHN GILBERT
Ego et Rex Meus
63in. x 41in.

Guildhall, London

T.S. GOOD
Fine Art Society Ltd.

The Morning Newspaper.

Panel, 15½in. x 11½in.

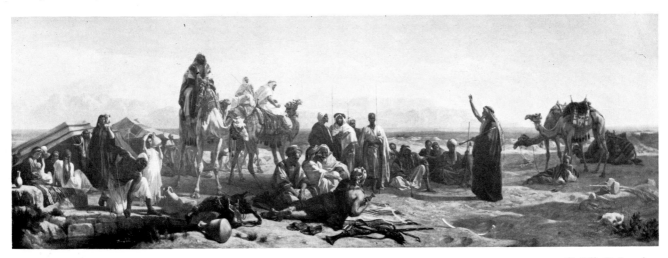

FREDERICK GOODALL, RA
Guildhall, London

Early Morning in the Wilderness of **Schur**.
Signed and dated 1860. 48in. x 120in.

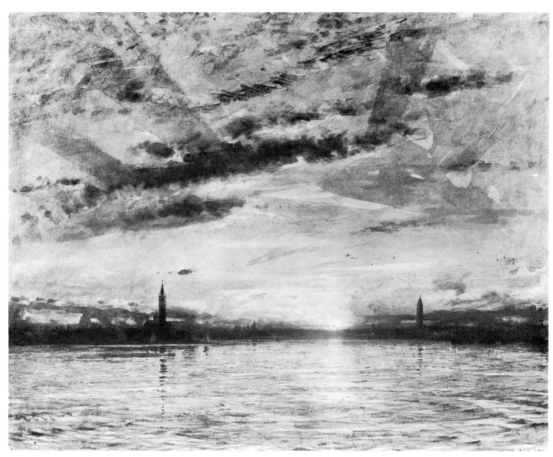

ALBERT GOODWIN Oscar and Peter Johnson **Ltd.**
Sunset over the Sea, Venice. *Signed, inscribed and dated 1902 – watercolour 19½in. x 24¼in.*

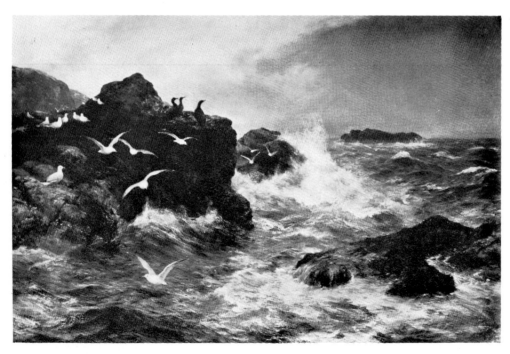

PETER GRAHAM, RA M. Newman Ltd.
Seascape. *Signed and dated 1898. 28in. x 42in.*

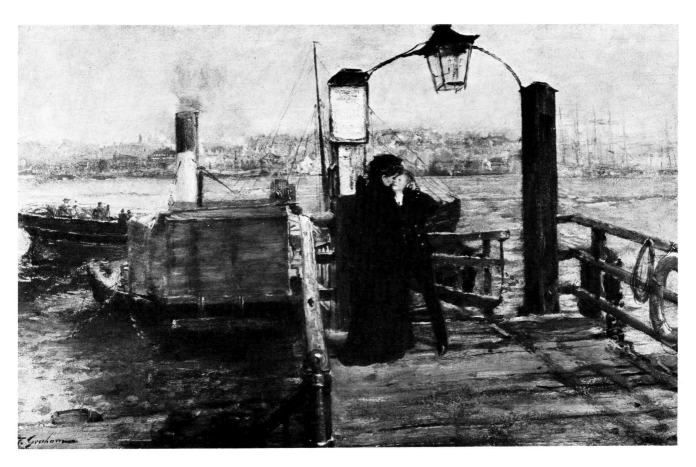

TOM GRAHAM RA
The Landing Stage. *12½ins. x 21ins.*

Victoria and Albert Museum

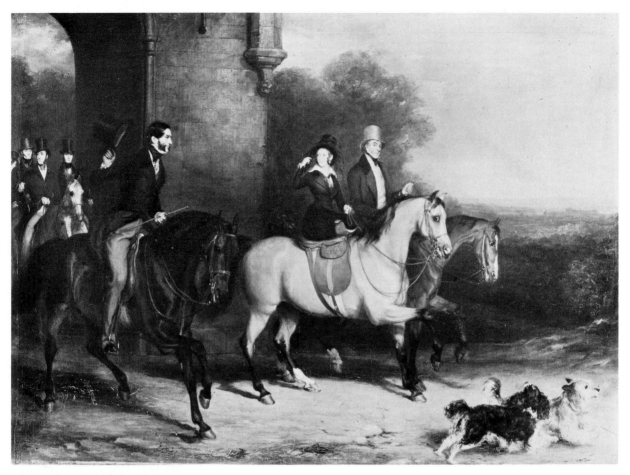

SIR FRANCIS GRANT, PRA
Queen Victoria Riding Out at Windsor Castle
38in. x 53in.

Reproduced by gracious permission of Her Majesty the Queen

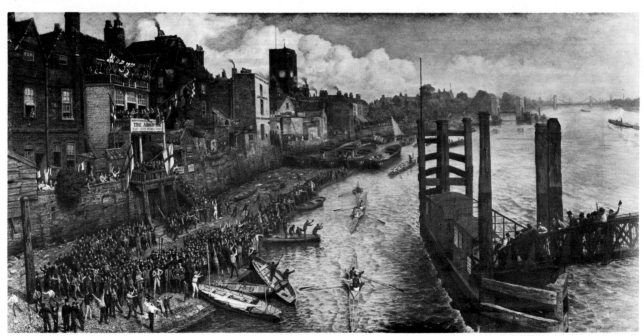

WALTER GREAVES, Chelsea Regatta. *Signed – 35¾ins. x 75ins.*

City Art Gallery, Manchester

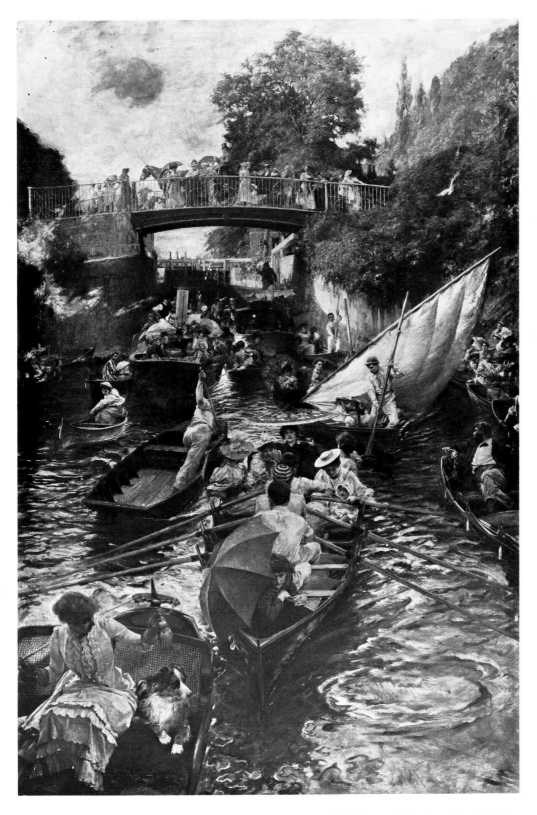

EDWARD JOHN GREGORY, RA
Boulter's Lock
84½in. x 56¼in.

Lady Lever Collection, Port Sunlight

ATKINSON GRIMSHAW Leeds City Art Gallery
'Autumn Glory', The Old Mill, Cheshire. *Signed and dated 1869, panel 24½in. x 34½in.*

LOUIS GRIMSHAW, Trafalgar Square from Whitehall. *On board — 11ins. x 16½ins.*

280

HARRY HALL Photo: Christie's

Mr. Richard Sutton's 'Lord Lyon' and 'Elland' with jockeys on a racecourse.
Signed and dated 1867-8 – 31½in. x 47½in.

THOMAS P. HALL N.R. Omell

One Touch of Nature makes the Whole World Kin.
Signed and dated 1867 – 25ins. x 30ins.

FREDERICK DANIEL HARDY York City Art Gallery
The Volunteers. *Signed and dated 1860 – on panel – 25ins. x 44½ins.*

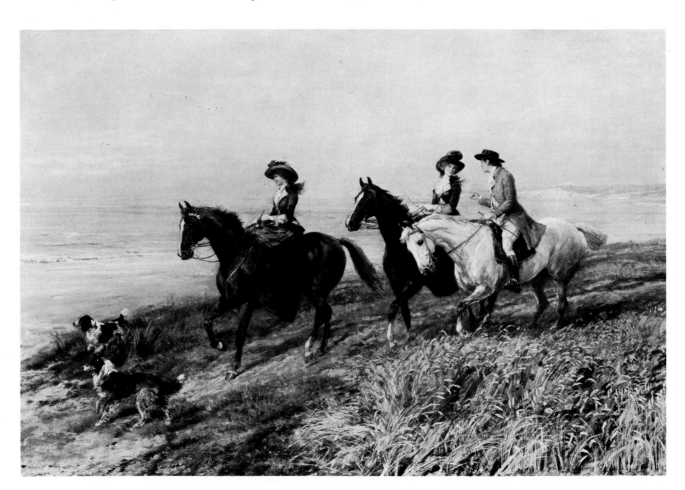

HEYWOOD HARDY, A Summer Morning. *Signed – 22¾ins. x 35½ins.* Richard Green Ltd.

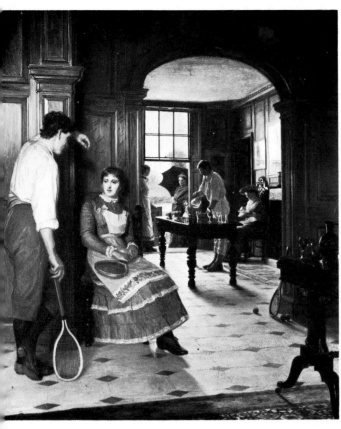

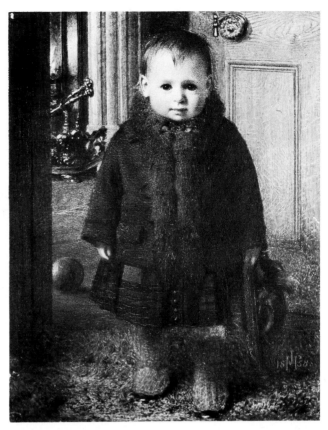

EDITH HAYLLAR Photo: Christie's

A summer Shower.

Signed and dated 1883 – board – 20ins. x 16¾ins.

JAMES HAYLLAR Mrs. Viva King

A Boy in a Kilt. *Signed and dated 1858 – 9ins. x 7ins.*

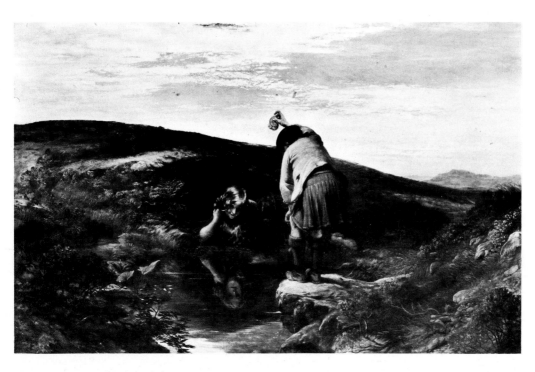

SIR GEORGE HARVEY PRSA Fine Art Society Ltd.

The Mountain Mirror. *On panel – 32ins. x 48ins.*

JOHN WILLIAM HAYNES York City Art Gallery

The First, the Only One.

Signed and dated 1859 – circular – 16ins. diameter.

WILLIAM HEMSLEY
The Bird Catchers
Signed. On board, 11½in. x 9¼in.

Photo: Christie's

CHARLES NAPIER HEMY RA Mrs. Charlotte Frank
Among the Shingle at Clovelly. *Signed and dated 1864 – 17¼ins. x 28½ins.*

JOHN HENRY HENSHALL, The Public Bar. *Signed – 24½ins. x 43¾ins.* Photo: M. Newman Ltd.

286

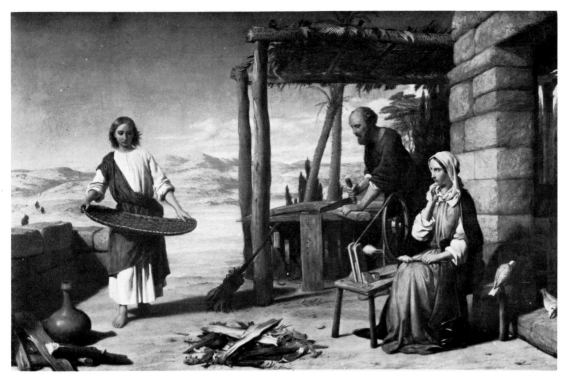

JOHN ROGERS HERBERT RA Guildhall, London
Our Saviour subject to his Parents. *32ins. x 51ins.*

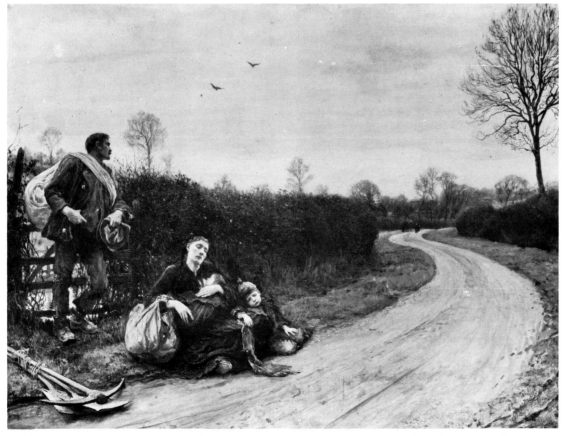

SIR HUBERT VON HERKOMER RA Manchester City Art Gallery
Hard Times. *Signed with intials and dated '85 — 33½ins. x 43½ins.*

287

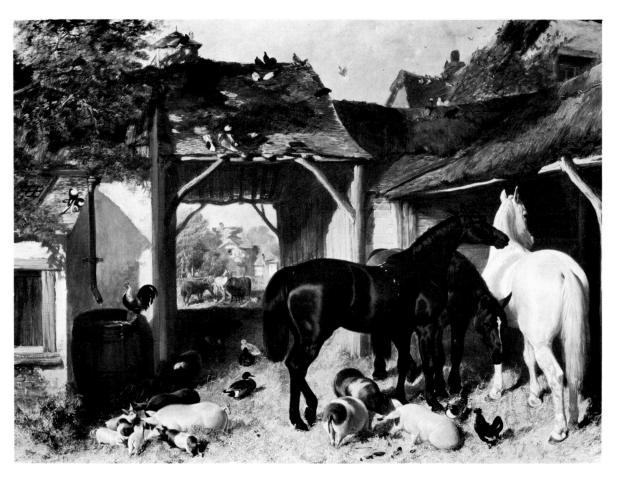

JOHN FREDERICK HERRING, Senior Richard Green
Summer, *28in. x 37in.*

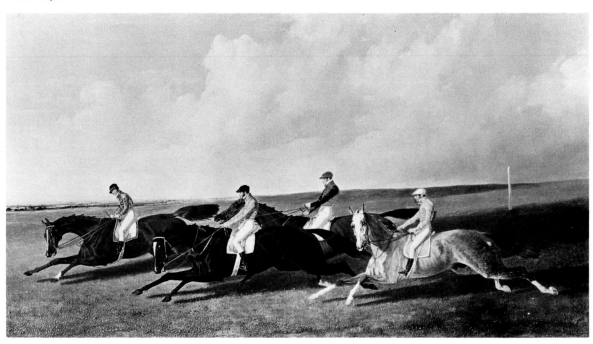

JOHN FREDERICK HERRING, Senior Richard Green
Four Racehorses with Jockeys Up. *Signed, inscribed and dated 1841. 24in. x 42in.*

288

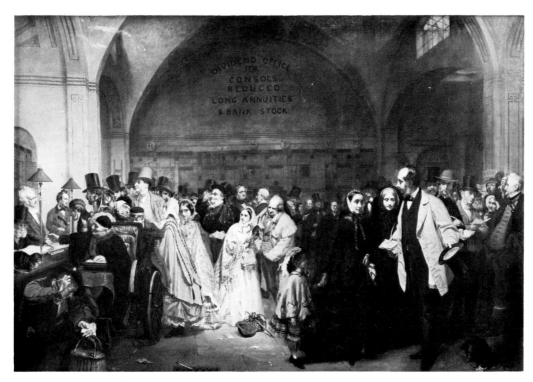

GEORGE ELGAR HICKS The Bank of England
Dividend Day at the Bank of England. *Signed and dated 1859. 35½in. x 53in.*

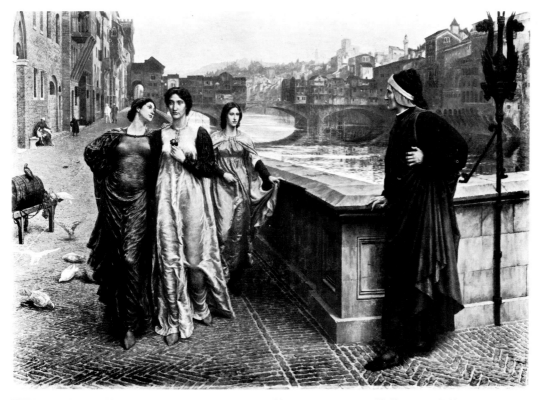

HENRY HOLIDAY. Dante and Beatrice. *55ins. 78½ins.* Walker Art Gallery, Liverpool

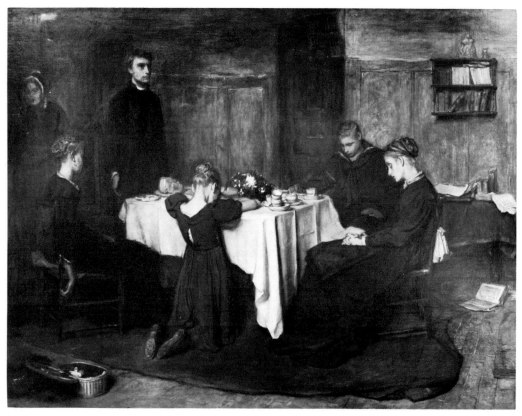

FRANK HOLL, RA
Guildhall, London.
The Lord Gave, The Lord Hath Taken Away. *36in. x 49in.*

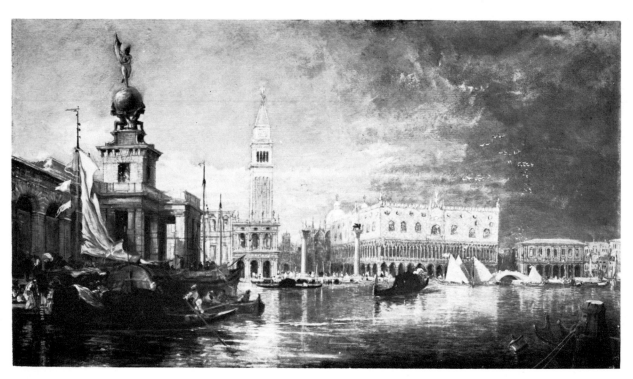

JAMES HOLLAND
Tate Gallery, London
The Grand Canal, Venice. *16in. x 29in.*

JAMES CLARKE HOOK RA Guildhall, London
Word from the Missing.
Signed with monogram, dated '77 – 30½ins. x 51ins.

EDWARD HOPLEY Maas Gallery
An Incident in the First Indian Mutiny.
Dated 1857 – 24¾ins. x 30¼ins.

JOHN CALLCOTT HORSLEY RA
Showing a Preference
26½ins. x 20¾ins.

Sir David Scott

ARTHUR BOYD HOUGHTON
Punch and Judy
14in. x 10in.

Tate Gallery, London

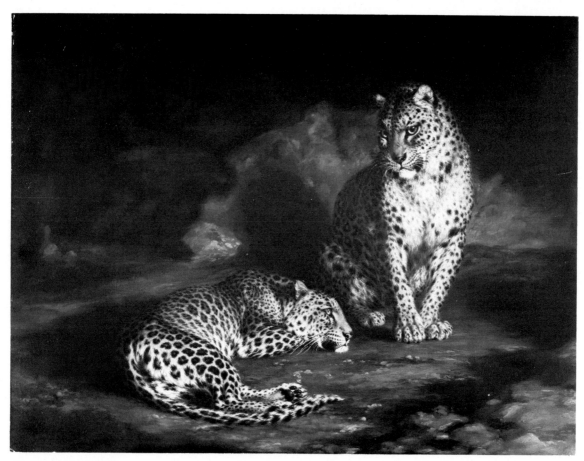

WILLIAM HUGGINS
A Pair of Leopards
Panel, 17¼in. x 21¼in.

Oscar and Peter Johnson Ltd.

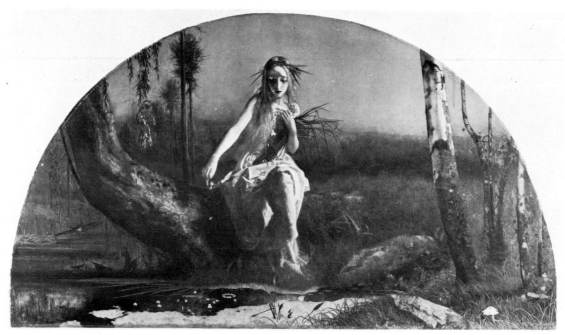

ARTHUR HUGHES, Ophelia. *Signed – 27ins. x 48¾ins.*　　　Manchester City Art Gallery

ALFRED WILLIAM HUNT
Brignal Banks, *11¼in. x 18in.*

Walker Art Gallery, Liverpool

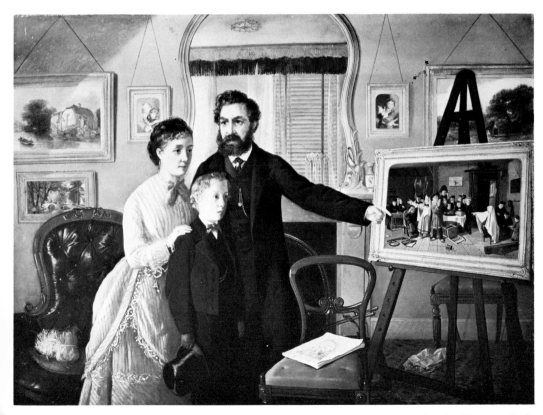

CHARLES HUNT
My Macbeth. *Signed and dated 1863. 20in. x 26in.*

Photo: M. Newman Ltd.

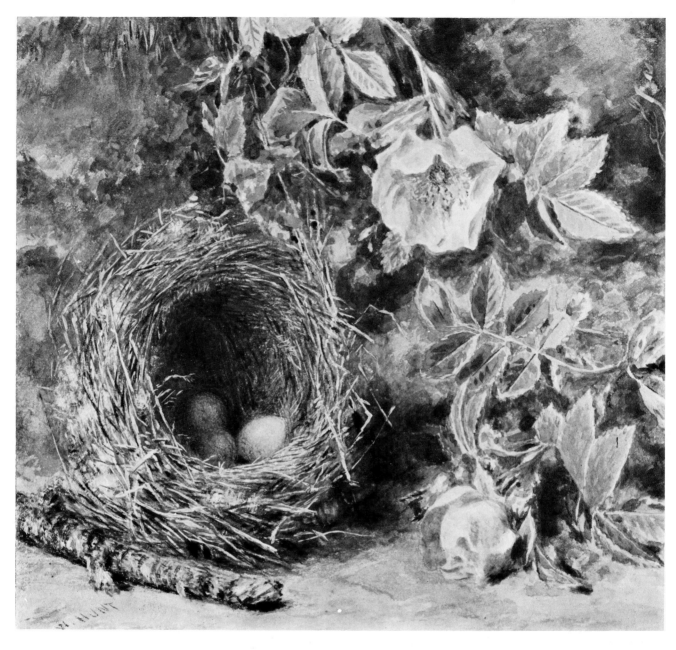

WILLIAM HENRY HUNT

Bird's Nest with Briar Rose. *Watercolour, 7¼in. x 8¼in.*

Mr. and Mrs. Cyril Fry

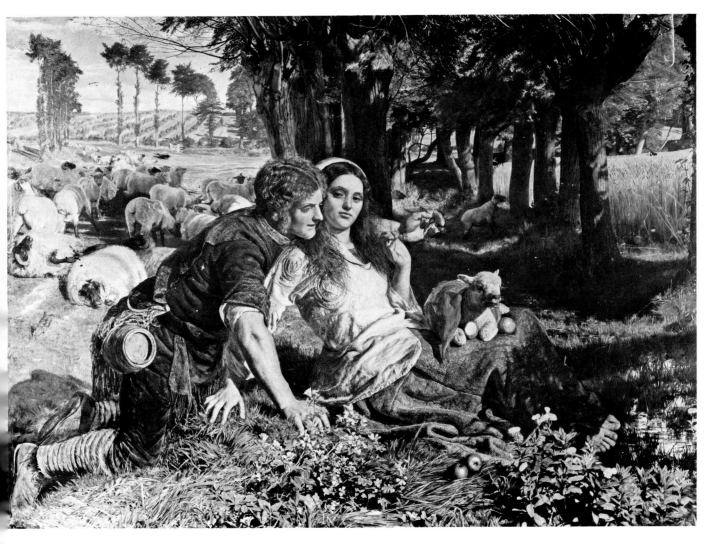

WILLIAM HOLMAN HUNT
The Hireling Shepherd
Signed and dated 1851 - 30ins. x 43ins.

Manchester City Art Gallery

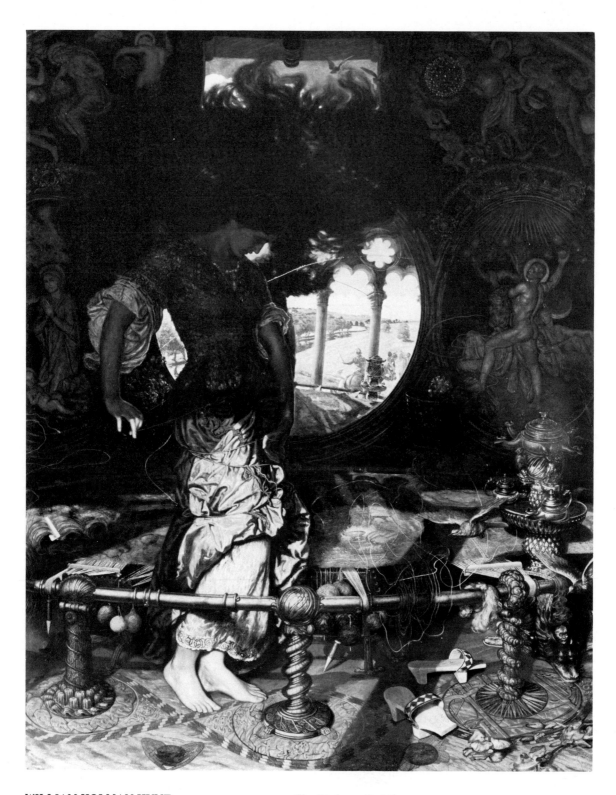

WILLIAM HOLMAN HUNT
The Lady of Shalott
Signed with monogram
Panel, 74in. x 57in.

The Wadsworth Athenaeum,
Hartford, Connecticut.
(Ella Gallup Sumner and Mary Catlin Sumner Collection)

298

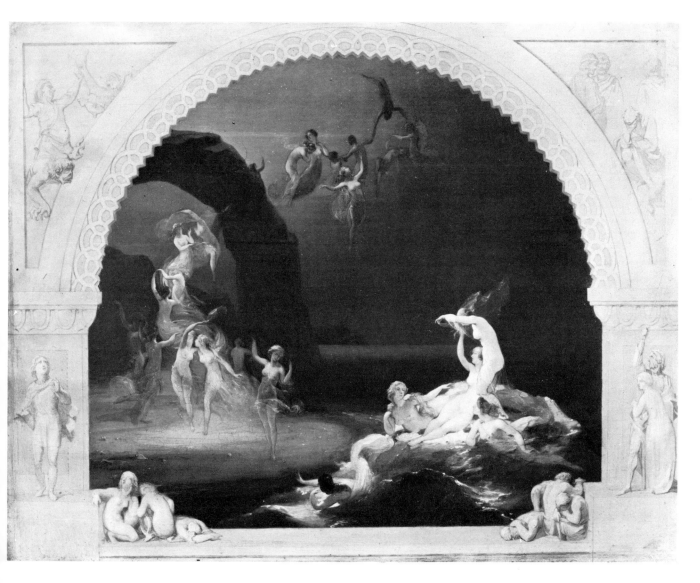

ROBERT HUSKISSON
Come Unto These Yellow Sands
On panel, 13½in. x 17½in.

Maas Gallery

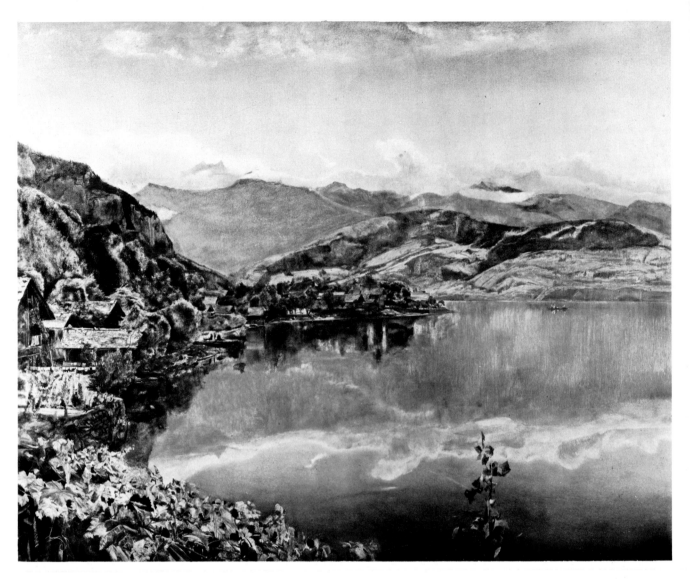

JOHN WILLIAM INCHBOLD Victoria and Albert Museum
Lake of Lucerne, Mount Pilatus in the Distance
Signed and dated 1857. On board, 14½in. x 18½in.

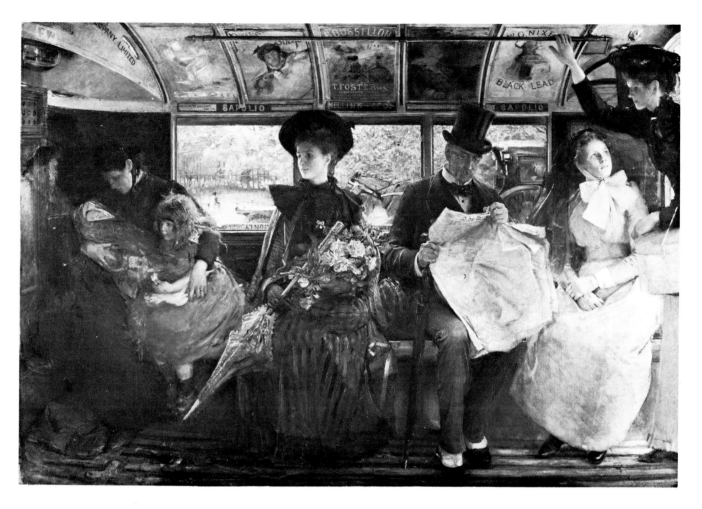

GEORGE WILLIAM JOY
The Bayswater Omnibus
Signed and dated 1895
48¼ins x 69ins.

London Museum

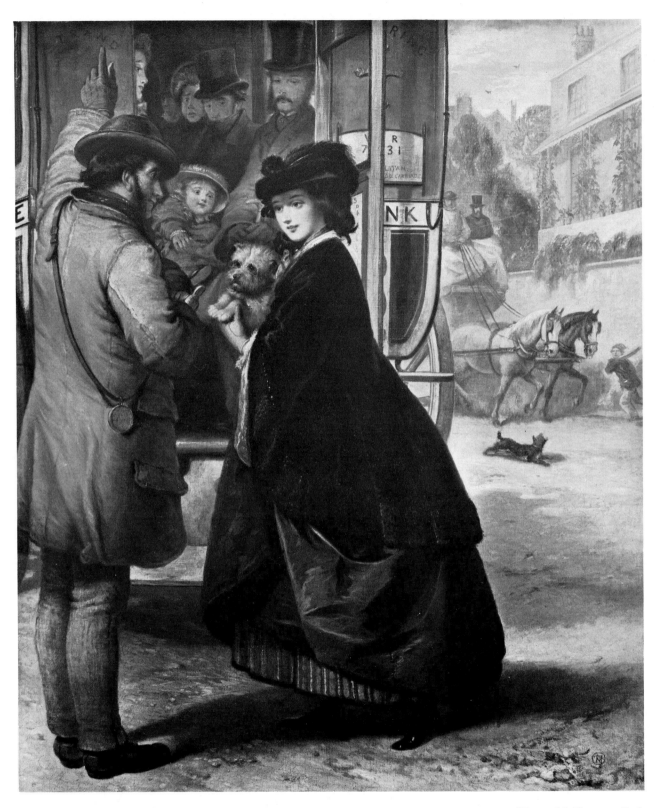

THOMAS MUSGROVE JOY
The Charing Cross to Bank Omnibus
Signed with initials
30ins. x 25ins.

Photo: M. Newman Ltd.

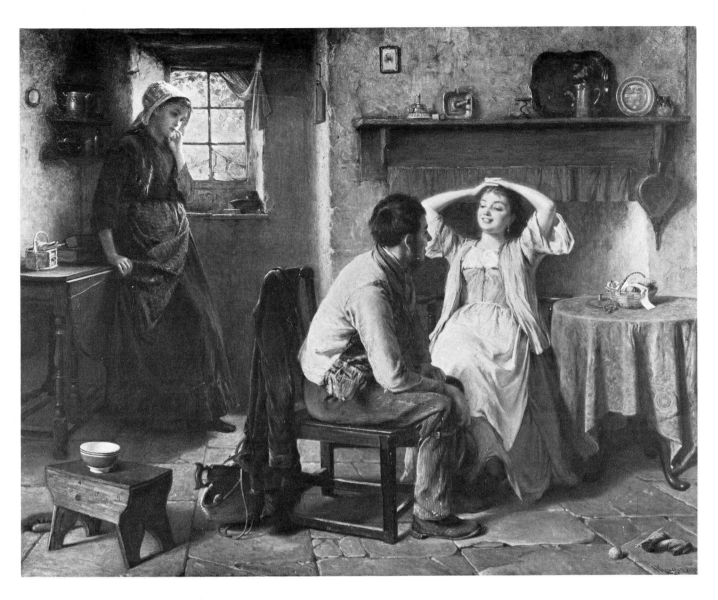

HAYNES KING
Jealousy and Flirtation
Signed and dated 1874. 27¾in. x 35¾in.

Bethnal Green Museum, London

WILLIAM ADOLPHUS KNELL
H.M.S. Queen in Portsmouth Harbour
Signed. 27in. x 39in.

EDWARD LADELL
Still Life
Signed with monogram
16½in. x 13½in.

Photo: Christie's

THOMAS REYNOLDS LAMONT
At The Pawnbroker's
Signed. 31in. x 25in.

Private Collection, London

GEORGE LANCE Photo: Sotheby's
Still Life with Fruit. *27½in. x 35½in.*

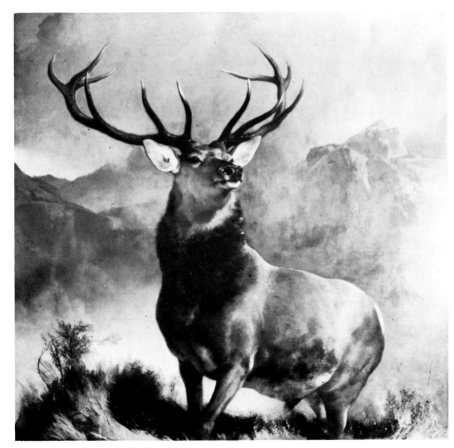

SIR EDWIN LANDSEER, RA John Dewar and Sons Ltd., London
The Monarch of the Glen, *80½in. x 78½in.*

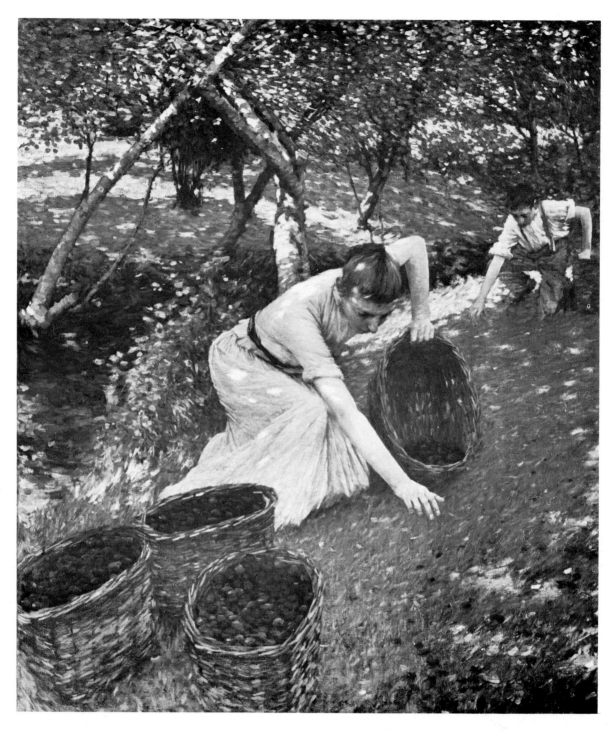

HENRY H. LA THANGUE
Gathering Plums
Signed. 42in. x 36in.

Manchester Art Gallery

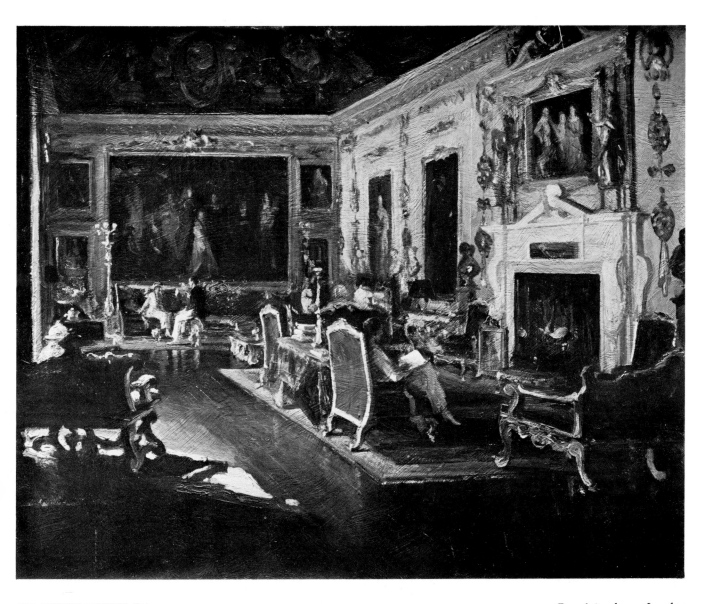

SIR JOHN LAVERY, RA
The Van Dyck Room, Wilton
Signed. 24½in. x 29½in.

Royal Academy, London

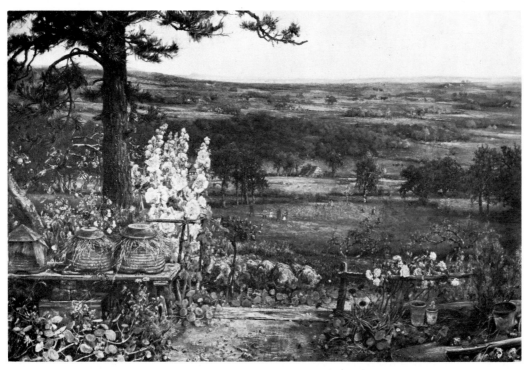

CECIL GORDON LAWSON Manchester City Art Gallery
The Minister's Garden, *71in. x 107in.*

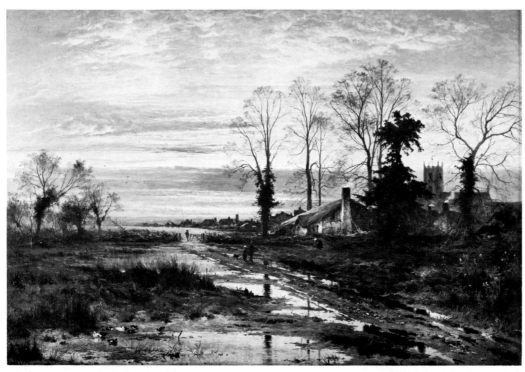

BENJAMIN WILLIAMS LEADER, RA Birmingham City Art Gallery
February Fill-Dyke. *Signed and dated 1881. 47in. x 71½in.*

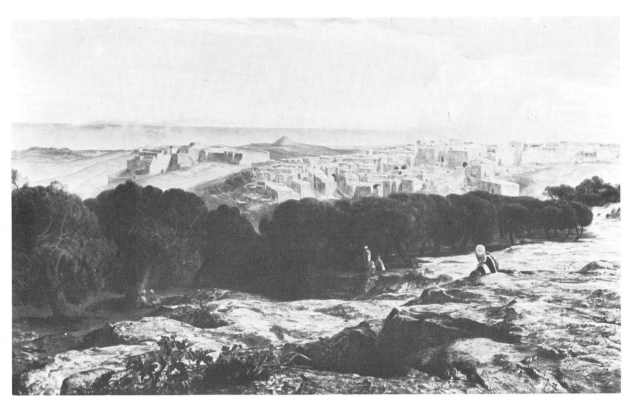

EDWARD LEAR
Bethlehem. *Signed. 27¼in. x 45in.*

Walker Art Gallery, Liverpool

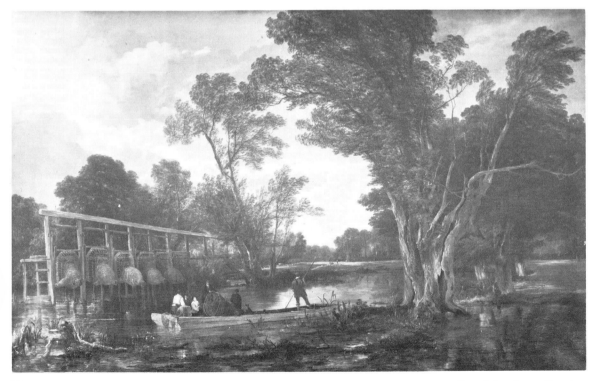

FREDERICK RICHARD LEE, RA
Morning in the Meadows. *43in. x 71in.*

Royal Academy, London

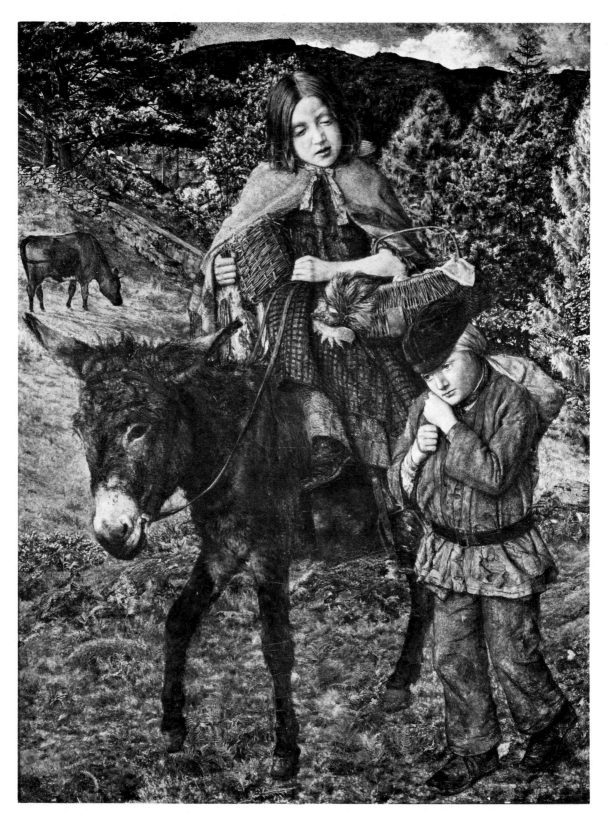

JOHN LEE
Going to Market
Signed and dated 1860. 17½in. x 14in.

Walker Art Gallery, Liverpool

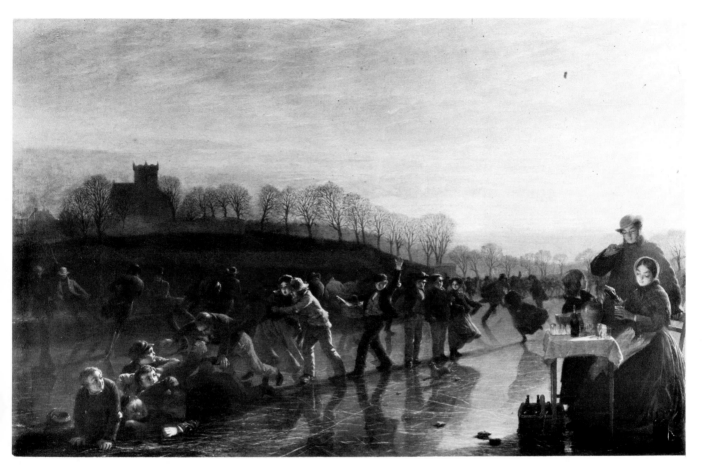

CHARLES LEES, RSA

Mrs. Quinnell

Sliding on Linlithgow Loch. *Signed and dated 1858. 30in. x 49in.*

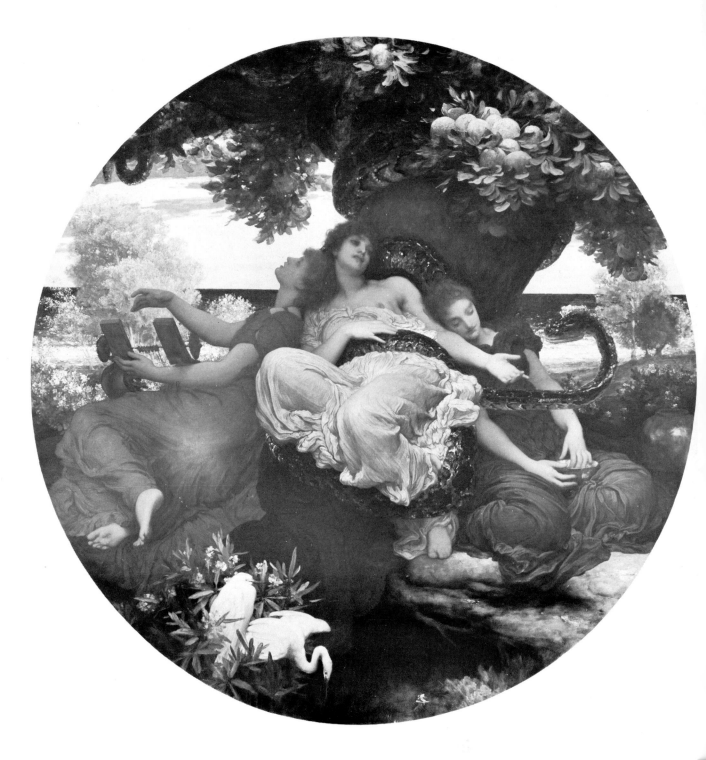

LORD LEIGHTON, PRA
The Garden of the Hesperides
Diameter 66in.

Lady Lever Collection, Port Sunlig▮

314

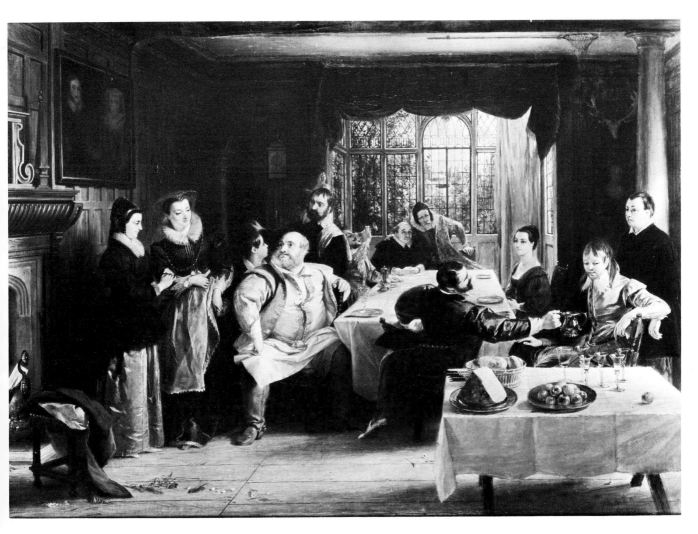

CHARLES ROBERT LESLIE, RA
A Scene from 'The Merry Wives of Windsor'
36¾in. x 52½in.

Victoria and Albert Museum

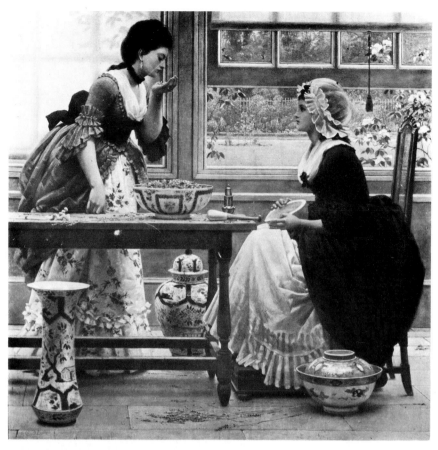

GEORGE DUNLOP LESLIE, RA
Pot Pourri. *Signed. 38in. x 38in.*

Photo: Christie's

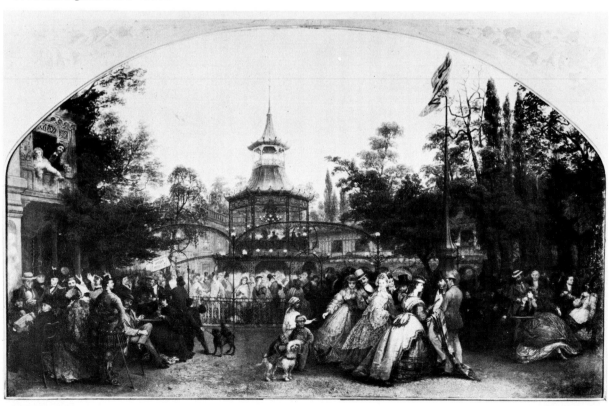

PHOEBUS LEVIN
The Dancing Platform at Cremorne Gardens. *Signed and dated 1864. 26½in. x 43in.*

London Museum

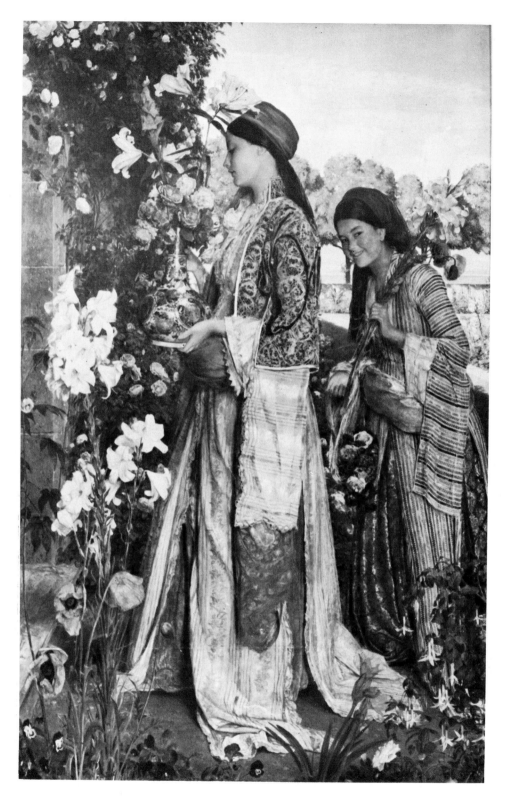

JOHN FREDERICK LEWIS, RA
Lilium Auratum
Signed and dated 1871. 54in. x 34½in.

Birmingham City Museum Art Gallery

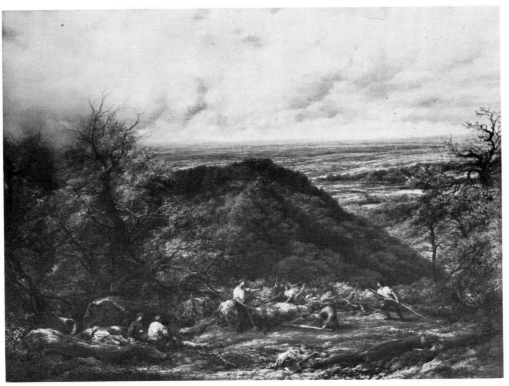

JOHN LINNELL
Photo: Christie's
Surrey Woodlands. *Signed and dated 1868. 39in. x 54in.*

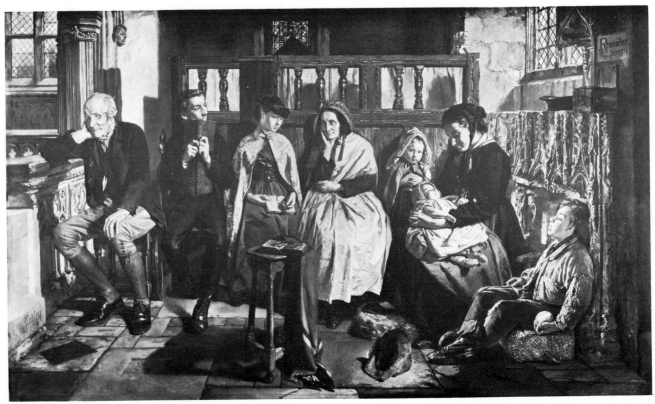

JAMES LOBLEY
Birmingham City Art Gallery
The Free Seat. *Signed and dated 1869. On panel 21¾in. x 37in.*

WILLIAM LOGSDAIL Guildhall, London
The 9th of November : Lord Mayor's Day, 1888. *Signed and dated 1890 – 73¼in. x 107¼in.*

EDWIN LONG, RA Holloway College, Egham
The Babylonian Marriage Market
Signed and dated 1875. 68in. x 120in.

CHARLES F. LOWCOCK
Victorian Interior
20in. x 24in.

Fine Art Society Ltd.

JOHN SEYMOUR LUCAS, RA
Flirtation. *22in. x 30in.*

Guildhall, London

HORATION MacCULLOCH, RSA
Loch Maree. *Signed and dated 1866. 44½in. x 72in.*

Glasgow Art Gallery and Museum

321

WILLIAM McTAGGART, RSA
A North Wind, Kilbrennan Sound
Signed. 32in. x 48in.

JOHN MACWHIRTER, RA
June in the Austrian Tyrol
Signed. 48¾in. x 73in.

Tate Gallery, London

DANIEL MACLISE, RA
Noah's Sacrifice
Signed and dated 1847-53.
81in. x 100in.

Leeds City Art Gallery

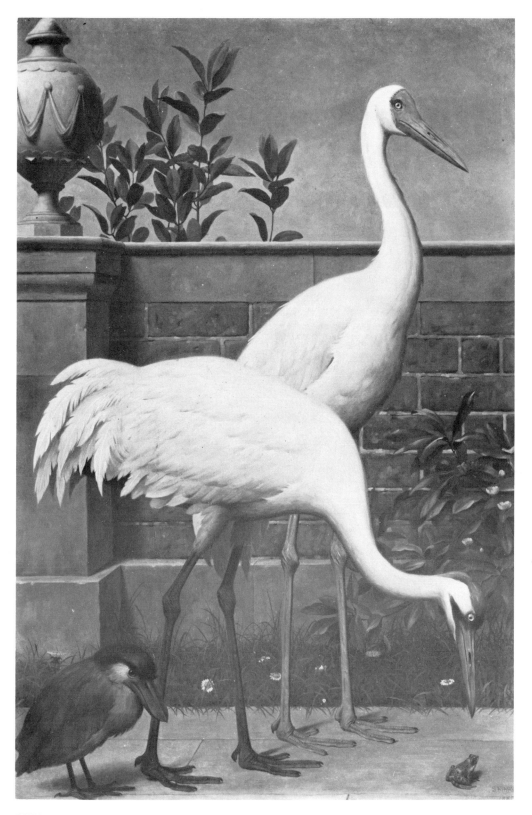

HENRY STACY MARKS RA
White Cranes
Signed and dated 1880. 48in. x 32in. One of a pair.

Photo: Christie's

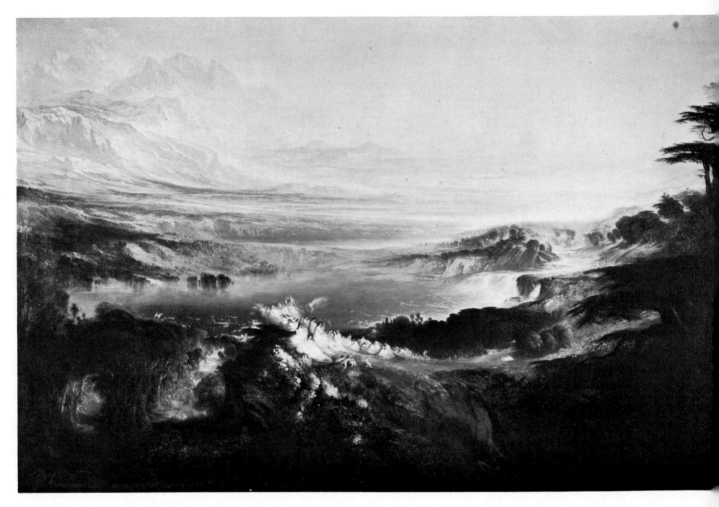

JOHN MARTIN
The Plains of Heaven. *Signed and dated 1853. 78in. x 120in.*

Mrs. Charlotte Frank

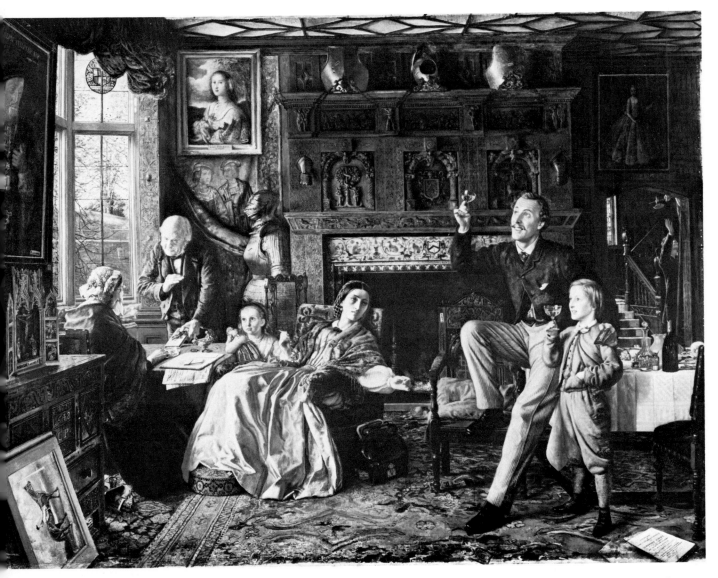

ROBERT BRAITHWAITE MARTINEAU
The last Day in the old Home
Signed and dated 1861. 42½in. x 57in.

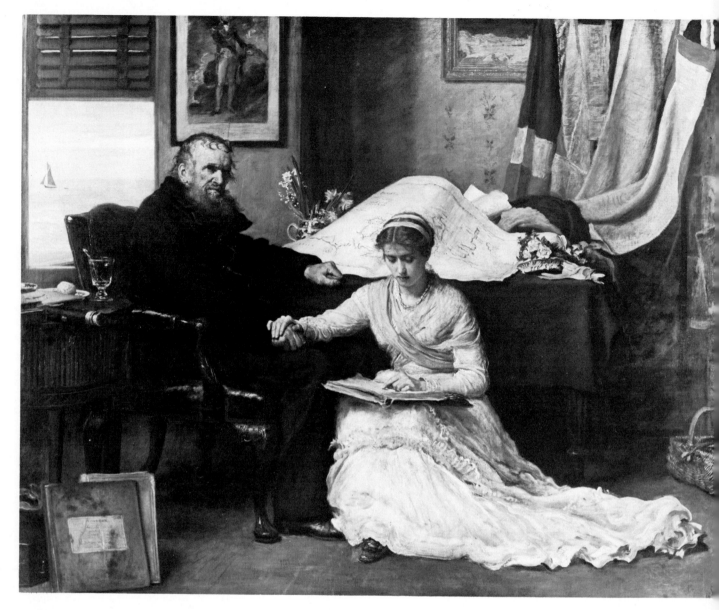

SIR JOHN EVERETT MILLAIS, Bt PRA
The North-West Passage
Signed with monogram and dated 1874. 69½in. x 87½in.

Tate Gallery, London

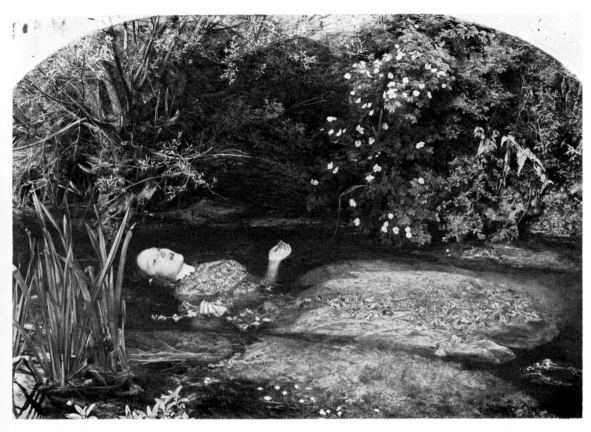

SIR JOHN EVERETT MILLAIS, BT, PRA
Ophelia. *Signed with monogram, dated 1852. 30in. x 40in.*

Tate Gallery, London

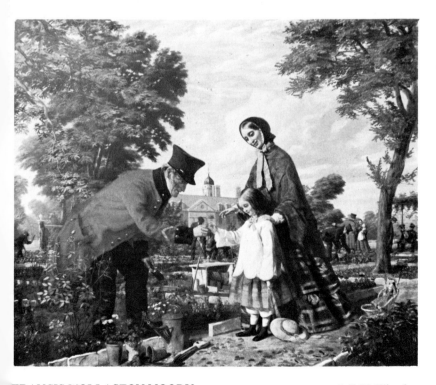

FRANCIS WOLLASTON MOODY
In Chelsea Gardens 1858
25in. x 30in.

A.E.W. Wheeler

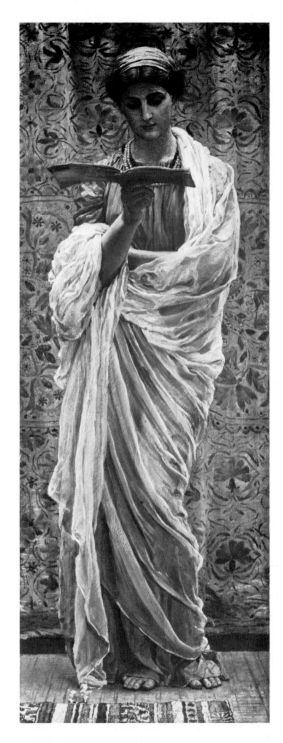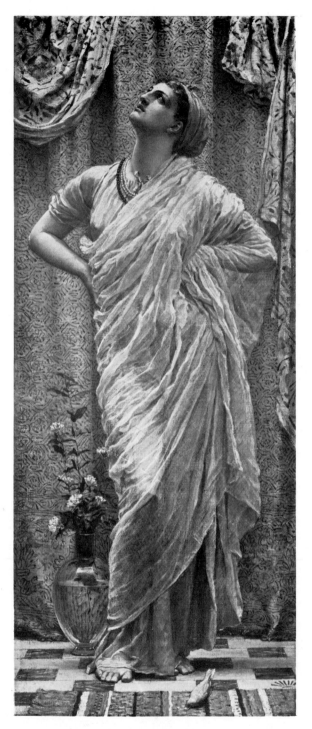

ALBERT JOSEPH MOORE
A Reader and Birds of the Air – a pair
Both signed with monogram. 34in. x 12in and 33¼in. x 13½in.

Manchester City Art Gallery

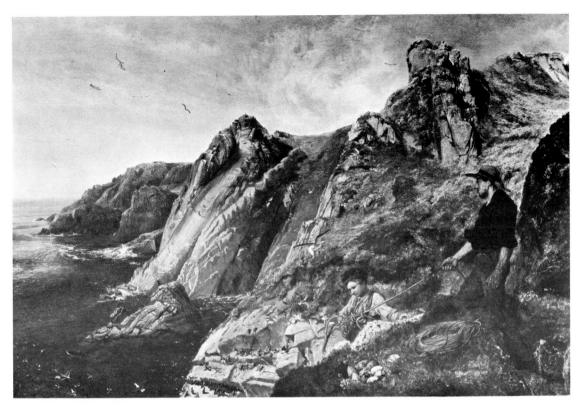

HENRY MOORE, RA
A Rocky Coast, with a man and a boy gathering birds' eggs. *Signed. 24in. x 36in.*

David Carritt, Esq.

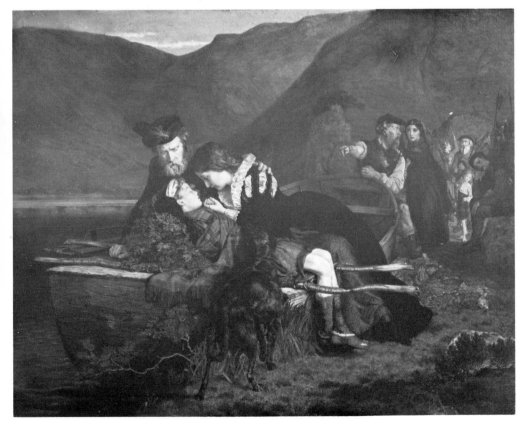

PHILIP RICHARD MORRIS, ARA
The Return of the Hostage
Signed and dated 60. 33½in. x 43in.

The Hon. David Bathurst

GEORGE WILLIAM MOTE
Children at Play. *Signed and dated 1865. 20in. x 30in.*

Photo: M. Newman Ltd.

WILLIAM JAMES MULLER
The Grand Canal, Venice. *Signed and dated 1837. 52¼in. x 90¼in.*

Photo: Thos. Agnew and Sons

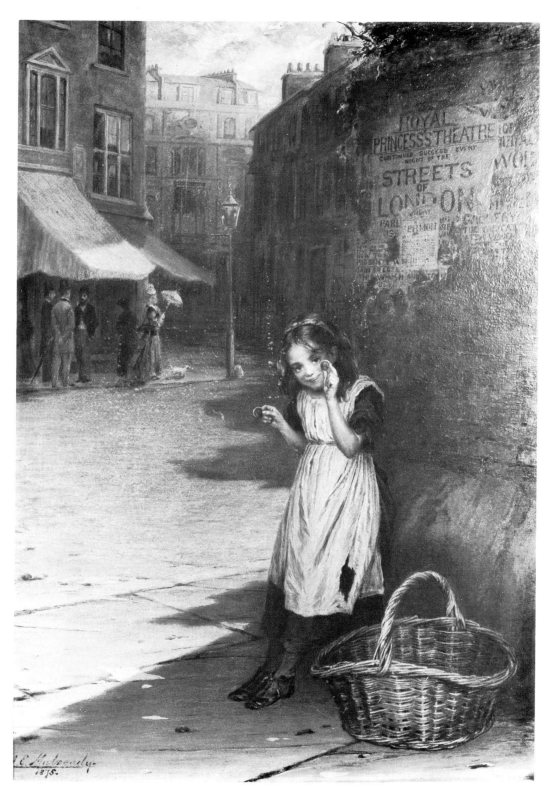

AUGUSTUS E. MULREADY
Her First Earnings
Signed and dated 1875. 16in. x 11½in.

Photo: Christie's

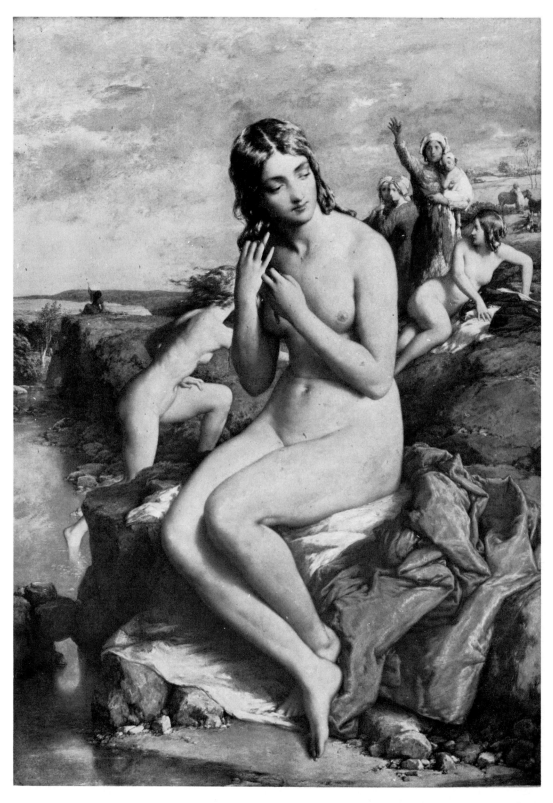

WILLIAM MULREADY, RA
Bathers Surprised
Panel 23¼in. x 17¼in.

National Gallery of Ireland

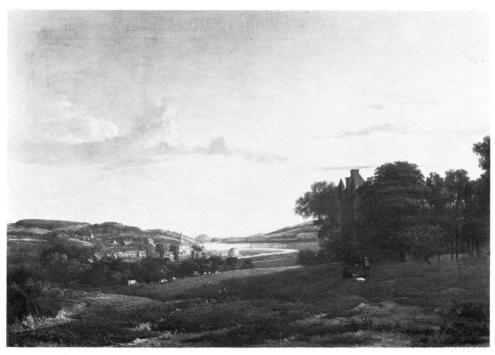

PATRICK NASMYTH Photo: Christie's
A View of Teviotdale
Signed and dated 1813. 23in. x 33½in.

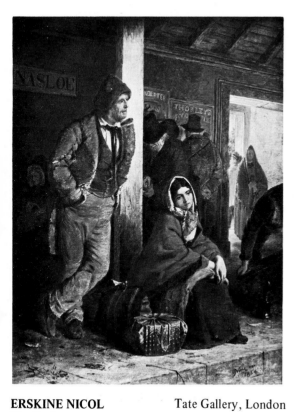

ERSKINE NICOL Tate Gallery, London
The Emigrants
Signed and dated 1864. 18in. x 13¾in.

JOHN WATSON NICOL
Lochaber No More
Signed and dated 1863

Photo: Fine Art Society Ltd.

WILLIAM W. NICOL
Quiet
Signed with initials and dated 1860
18in. x 15¼in.

Burton Collection, York City Art Gallery

EDMUND JOHN NIEMANN
Richmond, Yorkshire
Signed. 21in. x 26in.

Richard Green

JOHN WILLIAM NORTH
Halsway Court, North Somerset
Watercolour, 13in. x 17½in.

Robin de Beaumont, Esq.

JOHN WRIGHT OAKES
A Devon Footbridge. *Signed and dated 1872. 48¼in. x 66in.*

Victoria and Albert Museum

JOHN O'CONNOR. Pentonville at Sunset. *Signed and dated 1884. 36in. x 60in.*

London Museum

340

HENRY NELSON O'NEIL
Eastward Ho! August 1857
53½in. x 42½in.

Sir Richard Proby

GEORGE BERNARD O'NEILL
Manning the Navy. *Dated 1880. 30in. x 46in.*

National Maritime Museum

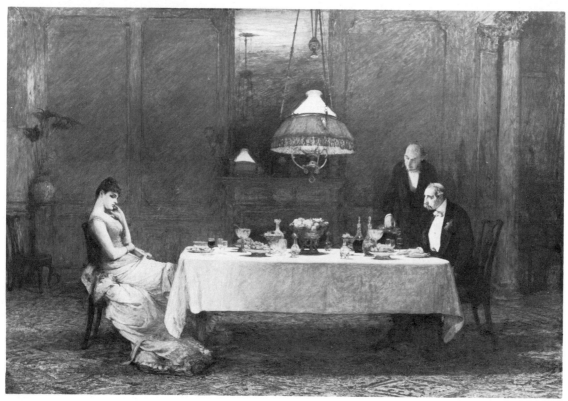

SIR WILLIAM QUILLER ORCHARDSON, RA
Mariage de Convenance. *Signed and dated 1883. 41¼in. x 60¾in.*

Glasgow City Art Gallery and Museum

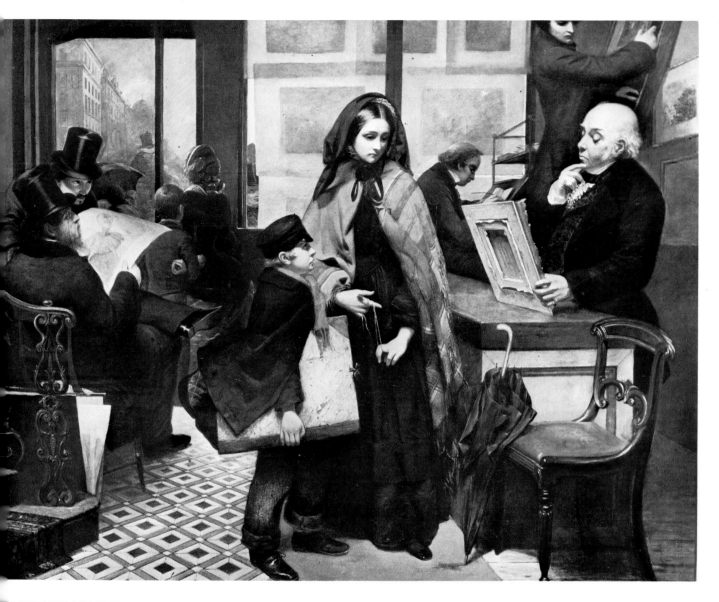

ILY MARY OSBORN
neless and Friendless
. x 44in.

Sir David Scott

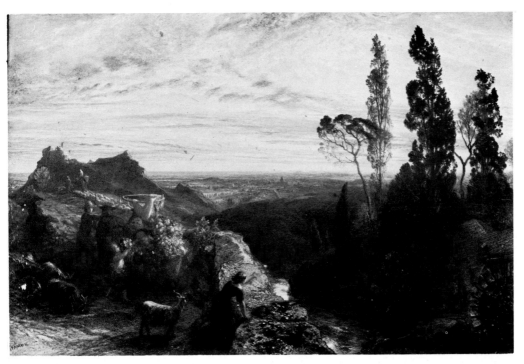

SAMUEL PALMER Tate Gallery, London
A Dream in the Appenine. *Gouache. 26in. x 40in.*

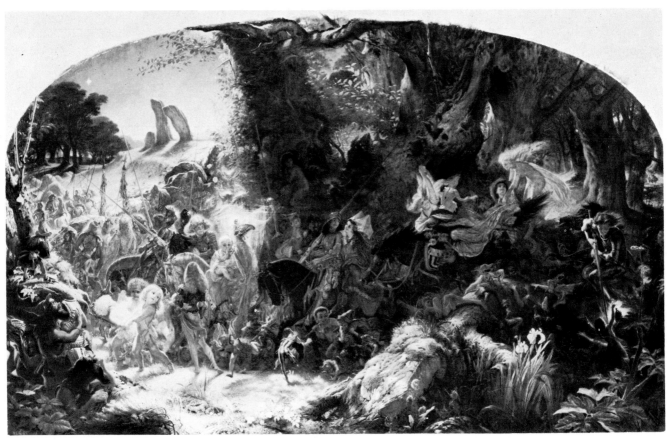

SIR JOSEPH NOEL PATON, RSA Glasgow Art Gallery and Museum
The Fairy Raid. *Signed with monogram and dated 1867. 34in. x 57¾in.*

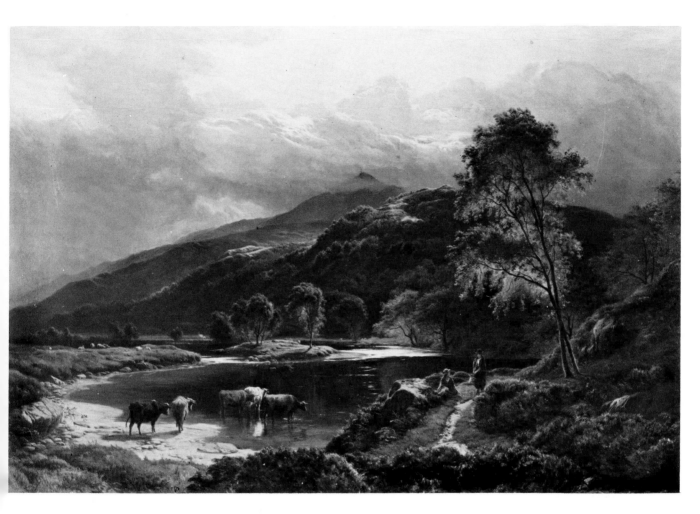

SIDNEY RICHARD PERCY
Moel Siabod from Capel Curig
Signed and dated 1865. 23½in. x 37in.

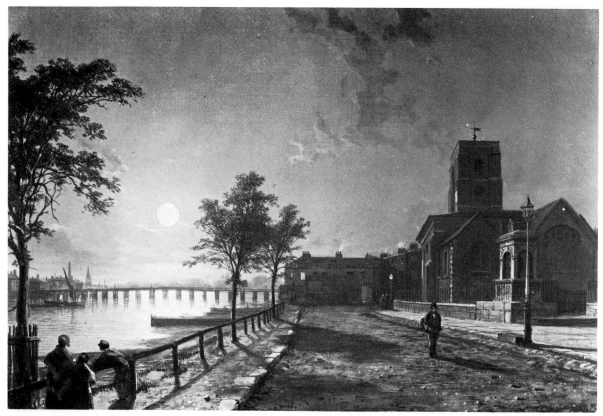

HENRY PETHER O. & P. Johnson Ltd.
Chelsea Old Church. *Signed. 12in. x 18in.*

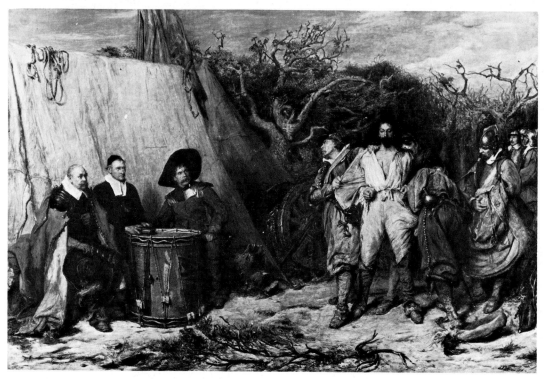

JOHN PETTIE, RA Graves Art Gallery, Sheffield
The Drumhead Court-Martial. *Signed and dated 1865. 27½in. x 41¼in.*

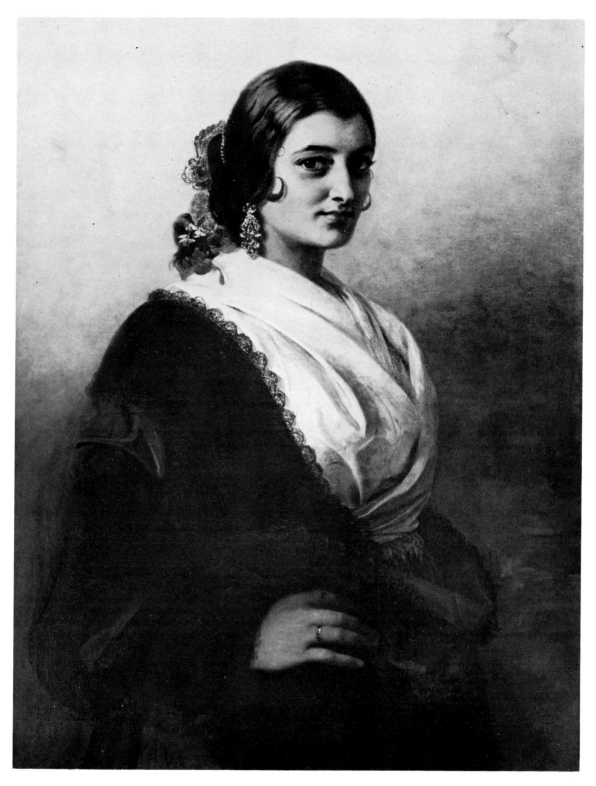

JOHN PHILLIP, RA
The Gypsy Queen of Seville
Signed and dated 1852. 40in. x 30in.

Aberdeen Art Gallery

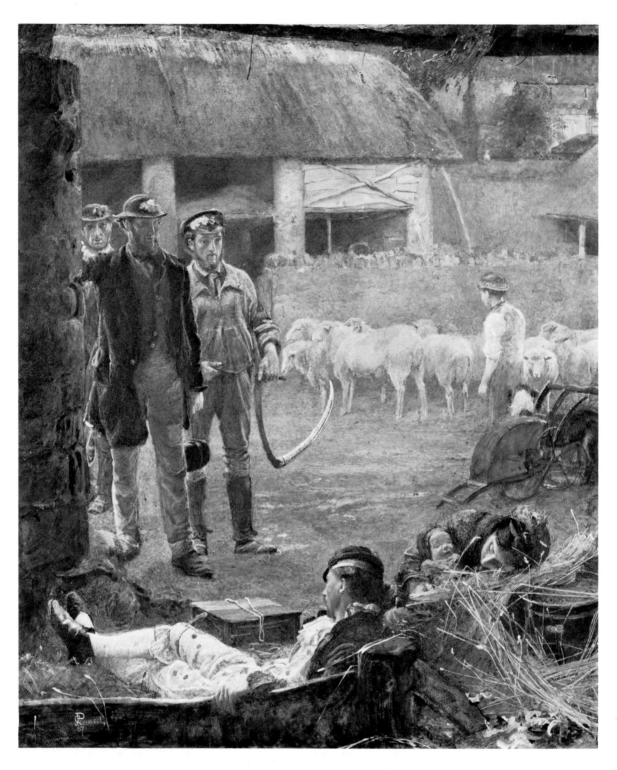

GEORGE JOHN PINWELL
The Strolling Players
Watercolour, signed and dated '67
17¾in. x 14½in.

Robin de Beaumont, Esq.

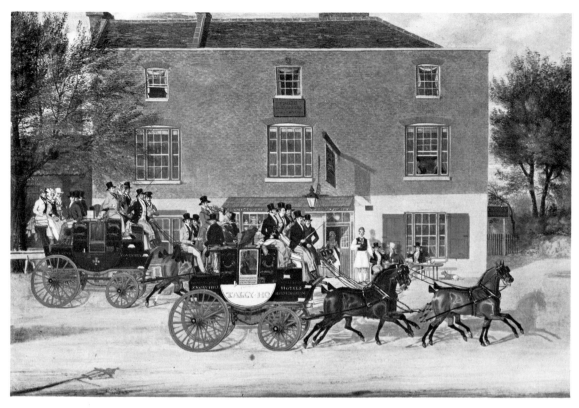

JAMES POLLARD N.C. Selway, Esq

The Birmingham Tally-Ho Coaches Passing the Crown at Holloway. *20in. x 30in.*

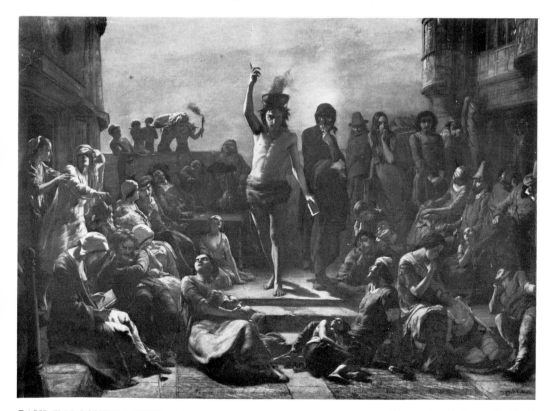

PAUL FALCONER POOLE, RA Graves Art Gallery, Sheffield

Solomon Eagle. *Signed and dated 1843. 60¾in. x 88in.*

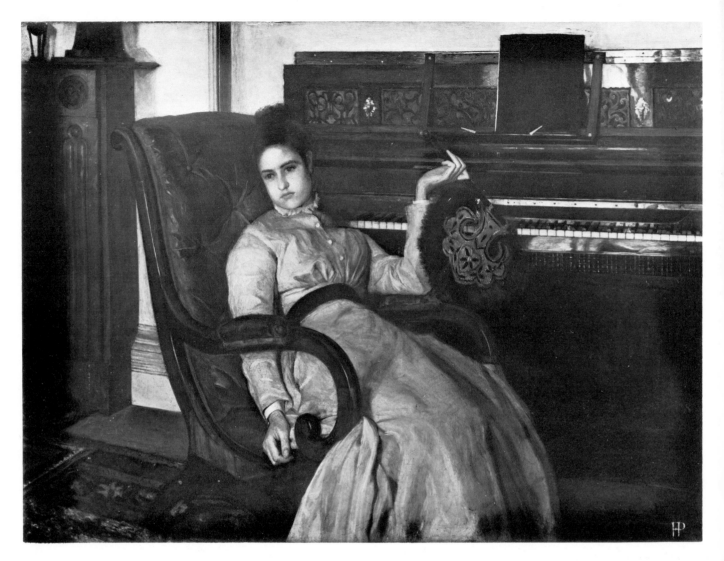

FRANK HUDDLESTONE POTTER
Girl Resting at a Piano
Signed with monogram. 20¼in. x 28in.

Tate Gallery, London

SIR EDWARD JOHN POYNTER, Bt. PRA Leger Galleries Ltd., London
When the World was Young. *Signed with monogram and dated 1891. 30in. x 47½in.*

EDWARD PRITCHETT Photo: Christie's
Doges Palace, Venice. *25in. x 38in.*

ALFRED PROVIS
The Blacksmith's Forge
16¼in. x 24in.

Aberdeen Art Gallery

JAMES BAKER PYNE
Berne
Signed and dated 1854 and numbered 348
48in. x 72½in.

Walker Art Gallery, Liverpool

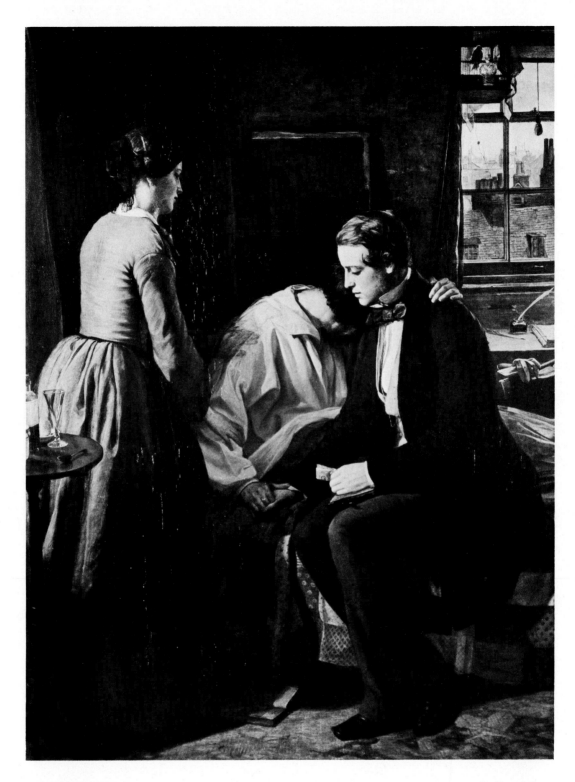

ALFRED RANKLEY
Old Schoolfellows
Signed and dated 1854. 36¾in. x 28in.

Sir David Scott

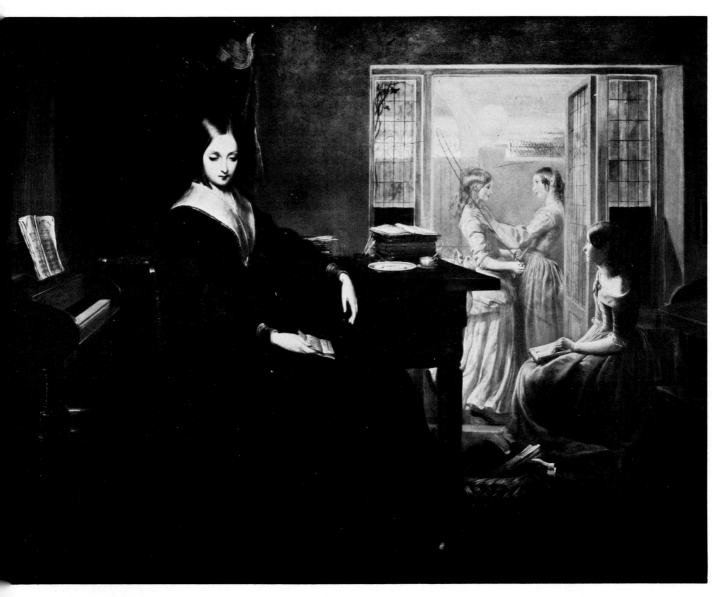

RICHARD REDGRAVE, RA
The Governess
Signed and dated 1844. 36in. x 28in.

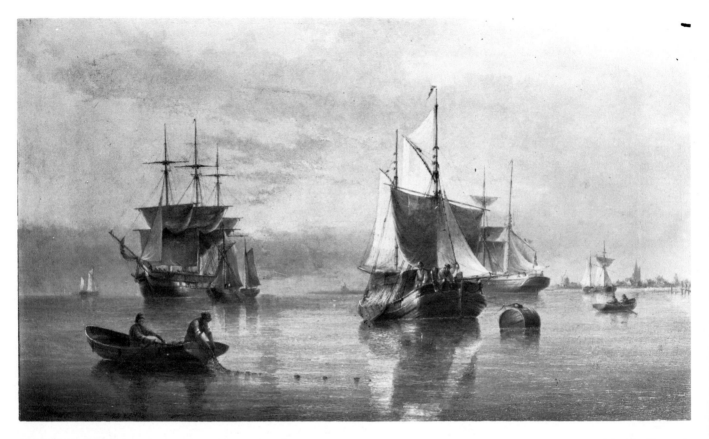

HENRY REDMORE. Shipping Scene. *Signed and dated 1882. 17½in. x 29½in.* Photo: Christie's

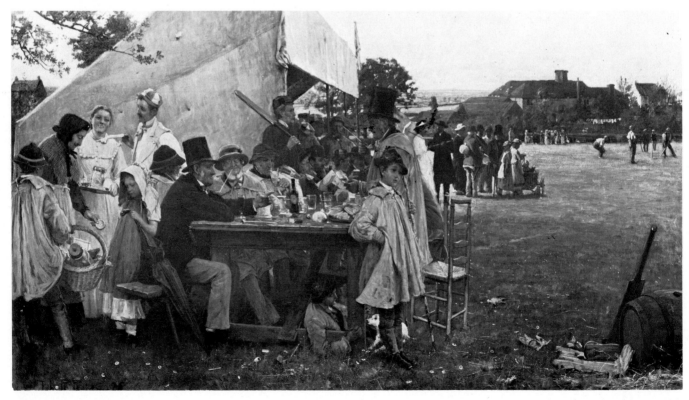

JOHN ROBERTSON REID Tate Gallery, London
A Country Cricket Match, Sussex. *Signed and dated '78. 42in. x 71½in.*

THOMAS MILES RICHARDSON, SENIOR
Newcastle upon Tyne. *Signed and dated 1831. 38¼in. x 55¾in.*

JOHN RITCHIE
A Summer Day in Hyde Park. *Signed and dated 1858. 30in. x 51in.*

BRITON RIVIERE, RA
Fidelity
Signed and dated 1869. 31½in. x 45½in.

Lady Lever Collection, Port Sunlight

DAVID ROBERTS, RA
The Doge's Palace, Venice
Signed and dated 1853. 47½in. x 72in.

THOMAS E. ROBERTS
The Opinion of the Press
Signed. 24¾in. x 29¾in.

MATTHIAS ROBINSON
The Battle of the Bolsters
Signed with initials. 11¾in. x 17½in.

ROBERT THORBURN ROSS, RSA
The Fisherman's Home
Signed and dated 1866. 34½in. x 44in.

DANTE GABRIEL ROSSETTI
The Bower Meadow
33½in. x 26½in.

Manchester City Art Gallery

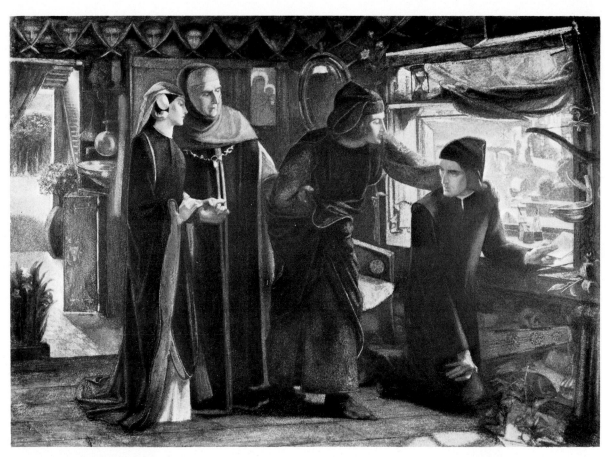

DANTE GABRIEL ROSSETTI Ashmolean Museum, Oxford
Dante drawing an Angel on the Anniversary of Beatrice's Death. *Signed and dated 1853. Watercolour. 16½in. x 24in.*

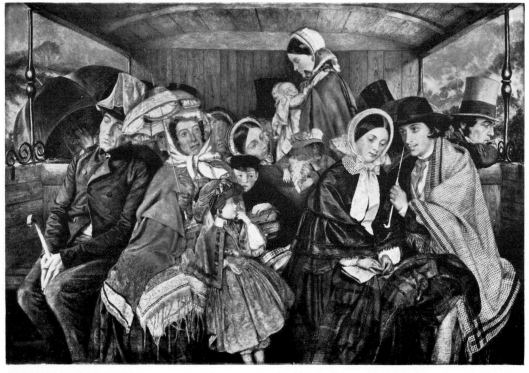

CHARLES ROSSITER Birmingham City Art Gallery
To Brighton and Back for 3/6. *Signed and dated 1859. 24in. x 36in.*

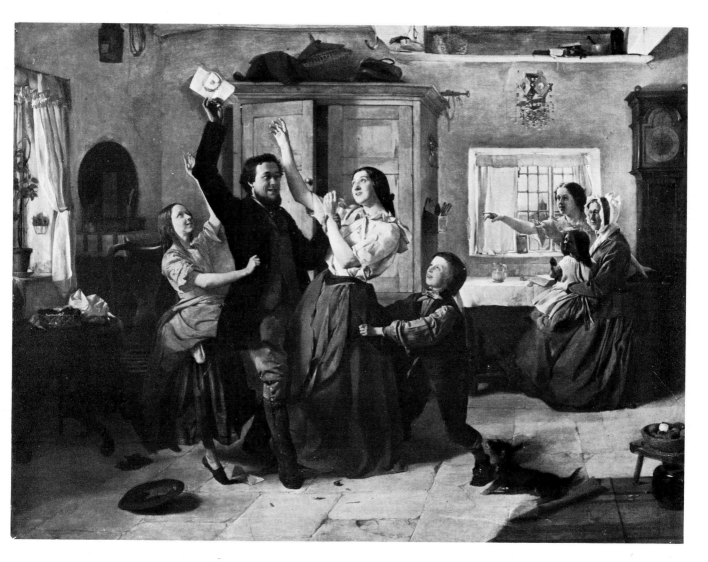

HENRY BENJAMIN ROBERTS
The Valentine
Signed and dated 1877. 27in. x 35in.

Photo: Christie's

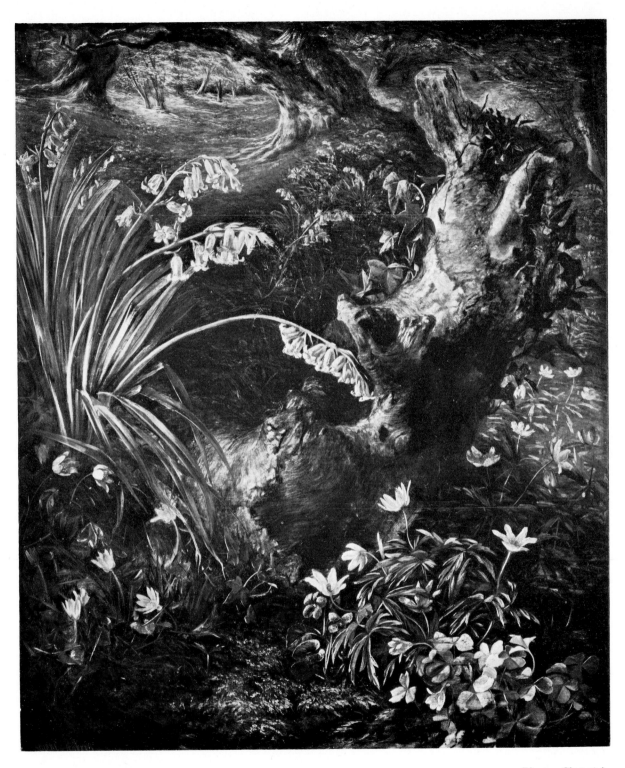

H. LARPENT ROBERTS
Bluebells and other Flowers growing round a Tree Stump
Signed. 23in. x 19in.

JOHN RUSKIN
Whitworth Art Gallery, University of Manchester
La Mer de Glace, Chamonix. *Watercolour, gouache and pencil. 15¼in. x 12in.*

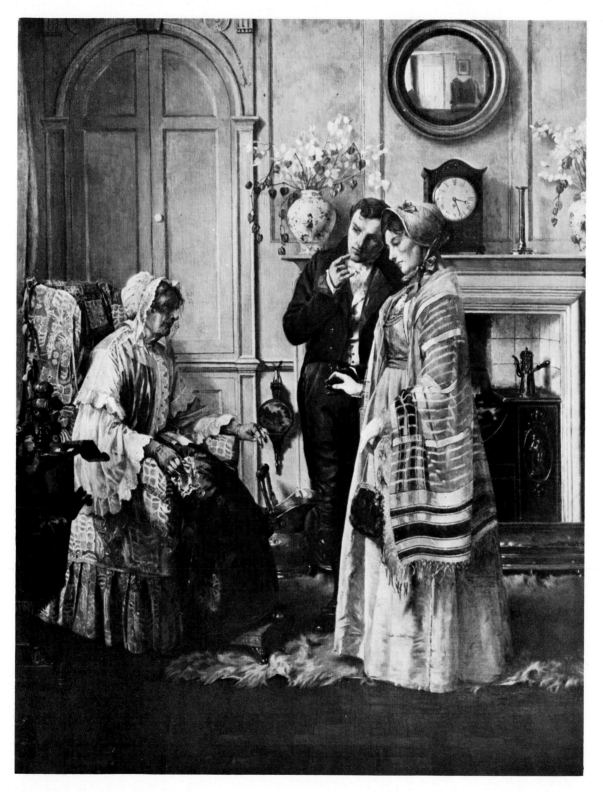

WALTER DENDY SADLER
Sweethearts
Signed and dated 1892. 34in. x 26in.

Guildhall, London

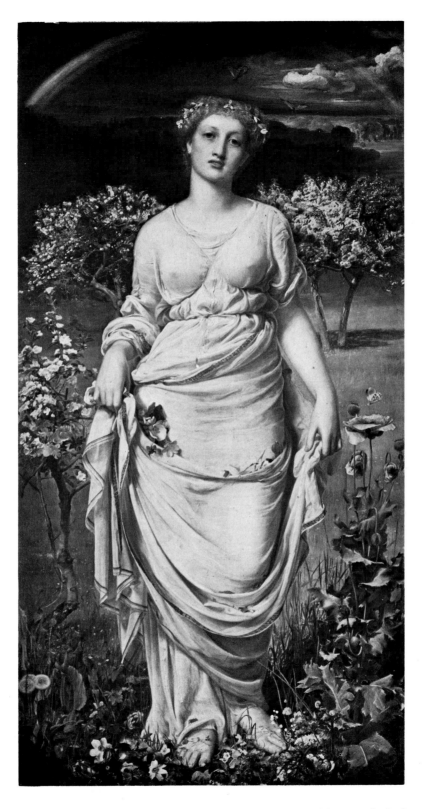

FREDERICK SANDYS
Gentle Spring
47½in. x 25¼in.

Ashmolean Museum, Oxford

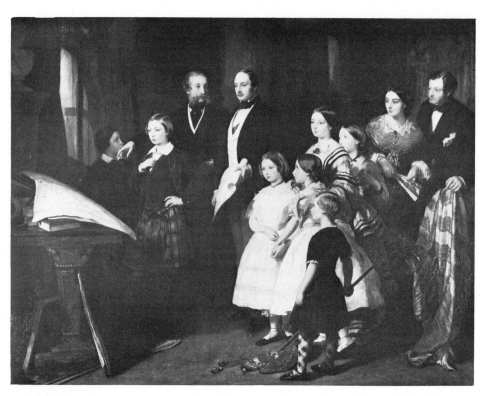

JAMES SANT, RA Edmund Brudenell, Esq.
Lord Cardigan relating the story of the Cavalry Charge of Balaclava to the Prince Consort
and the Royal Children at Windsor. *72in. x 96in.*

JOHN SINGER SARGENT, RA Graves Art Gallery, Sheffield
The Misses Vickers. *Signed and dated 1884. 54¼in. x 72in.*

JOHN CHRISTIAN SCHETKY National Maritime Museum
H.M.S. Columbine. *Signed and dated 1831. 25in. x 42in.*

DAVID SCOTT National Gallery of Scotland
The Traitors' Gate, *53¾in. x 71¾in.*

WILLIAM BELL SCOTT
Keats' Grave in the Old Protestant Cemetery at Rome
Signed with initials and dated 1873, 19in. x 13in.

Ashmolean Museum, Oxford

THOMAS SEDDON Tate Gallery, London
Jerusalem and the Valley of Jehoshaphat. *25in. x 32in.*

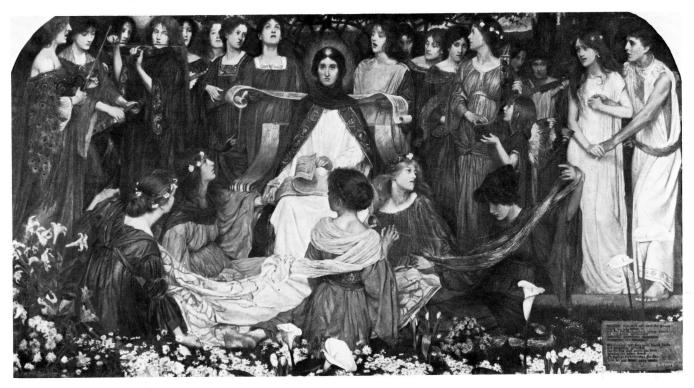

BYAM SHAW Guildhall, London
The Blessed Damozel. *Signed and dated 1895. 37in. x 71in.*

WILLIAM SHAYER. Landscape with Country Figures. *Signed. 27in. x 35in.* Photo: Christie's

BENJAMIN SHIPHAM. Harvesting near Nottingham Castle. *30in. x 50in.* Fine Art Society Ltd.

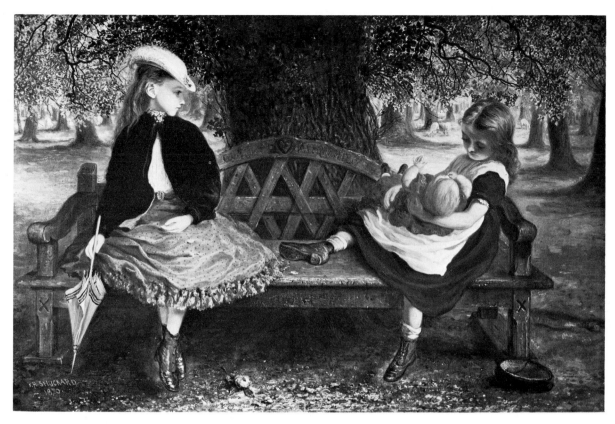

FREDERICK P. SHUCKARD
The Park Bench. *Signed and dated 1870. 12in. x 18in.*

Photo: M. Newman Ltd.

WALTER RICHARD SICKERT, RA. Noctes Ambrosianae, The Mogul Tavern
Signed. 25in. x 30 in. Nottingham City Museum and Art Gallery

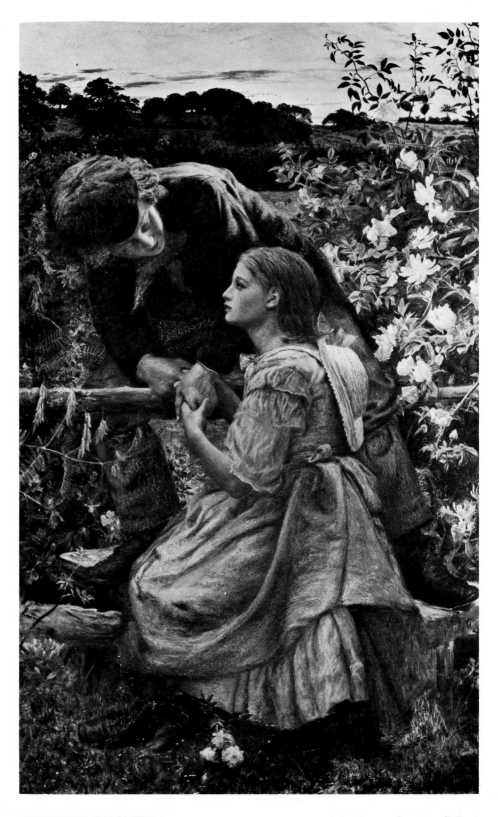

FREDERICK SMALLFIELD Manchester City Art Gallery
First Love
Signed and dated 1858. 30in. x 18in.

JAMES SMETHAM
Naboth's Vineyard
Panel – 8¾in. x 6¾in.

Tate Gallery, London

GEORGE SMITH
Temptation – A Fruit Stall
Signed and dated 1850. On panel – 25in. x 30in.

Victoria and Albert Museum

ABRAHAM SOLOMON
Waiting for the Verdict c.1857.
14in. x 16in.

Tunbridge Wells Museum

SIMEON SOLOMON
Youth reciting Tales to Ladies. *14in. x 21in.*

Fine Art Society Ltd.

SOLOMON JOSEPH SOLOMON, RA
Samson and Delilah. *Signed. 96in. x 144in.*

Walker Art Gallery, Liverpool

380

JAMES STARK
A wooded river landscape with a fisherman and his dog in the foreground
17½in. x 23½in.

Richard Green

CLARKSON STANFIELD, RA. The Bridge at Avignon. *53½in. x 102in.* Photo: Christie's

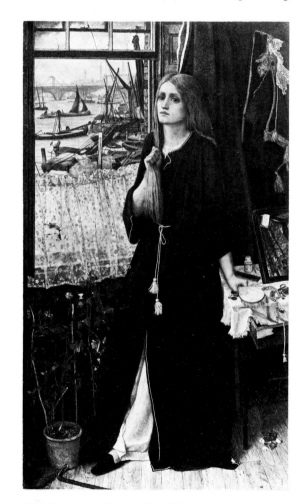

JOHN R. SPENCER STANHOPE
Thoughts of the Past
34in. x 20in. Tate Gallery, London

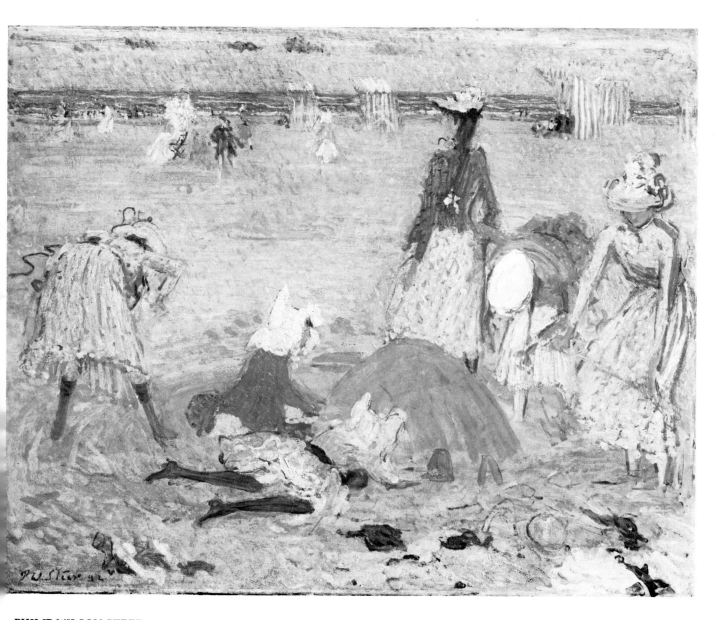

PHILIP WILSON STEER
Boulogne Sands
Signed and dated '92. 24in. x 30in.

Tate Gallery, London

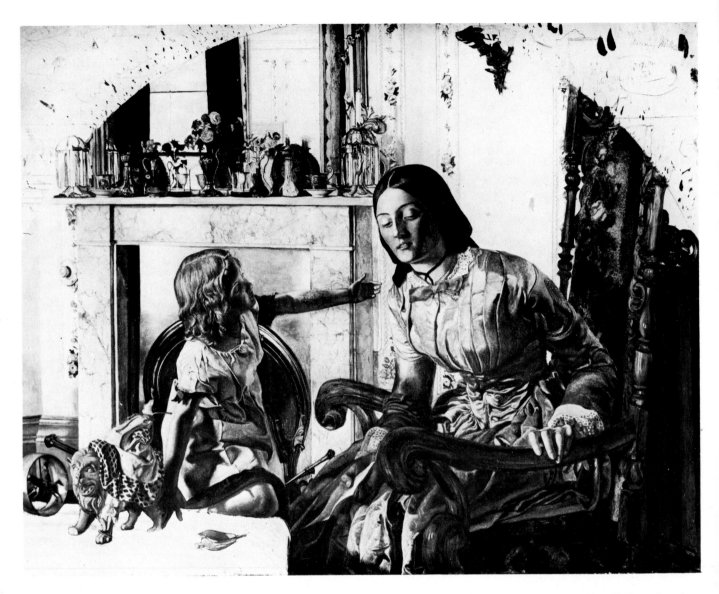

FREDERICK GEORGE STEPHENS
Mother and Child (unfinished)
18½in. x 25¼in.

Tate Gallery, London

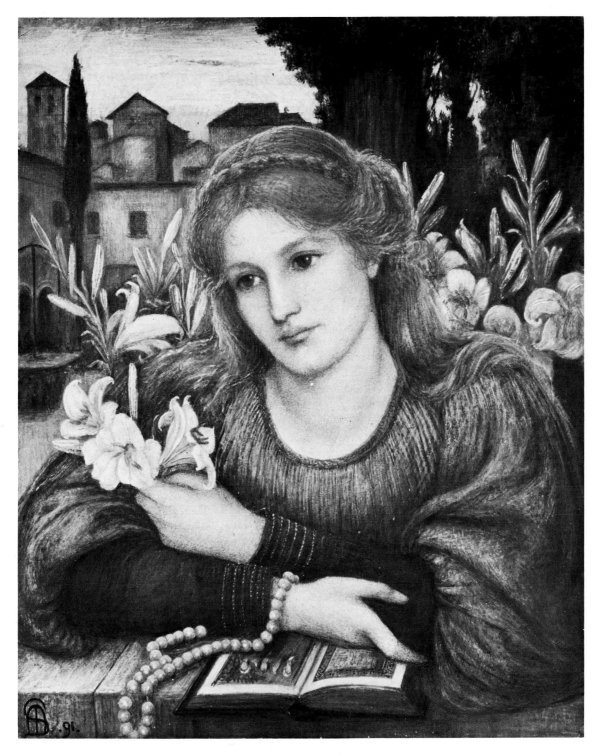

MARIE STILLMAN
Ashmolean Museum, Oxford
Cloister Lilies
Signed with monogram, dated 91. 17in. x 13½in.

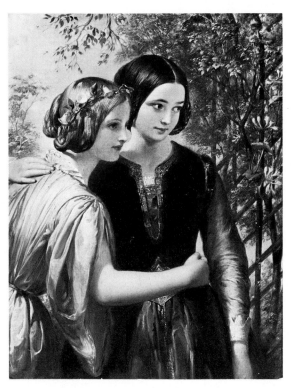

FRANK STONE ARA Alan Class Esq.
The Sisters. *20¼in. x 16in.*

MARCUS STONE, RA Private Collection, London
Summer Punting. *Signed and dated '64. 8in. x 15in.*

EDWARD STOTT, ARA
The Inn, Evening
Signed. 22in. x 28½in.

Fine Art Society Ltd.

WILLIAM STOTT OF OLDHAM
The Ferry
43in. x 84¼in.

Fine Art Society Ltd.

JOHN MELHUISH STRUDWICK
When Apples were Golden
30in. x 18¾in.

Manchester City Art Gallery

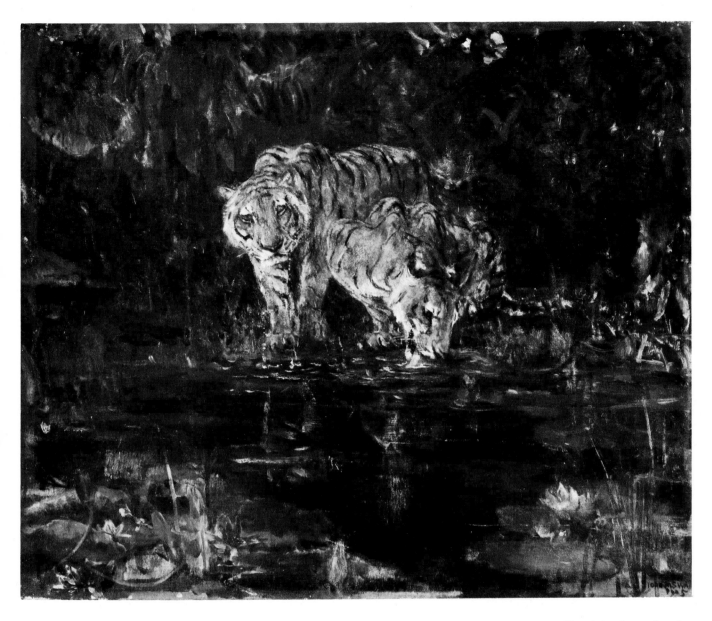

JOHN MACALLAN SWAN, RA
Tigers drinking
Signed. 21in. x 25½in.

Royal Academy, London

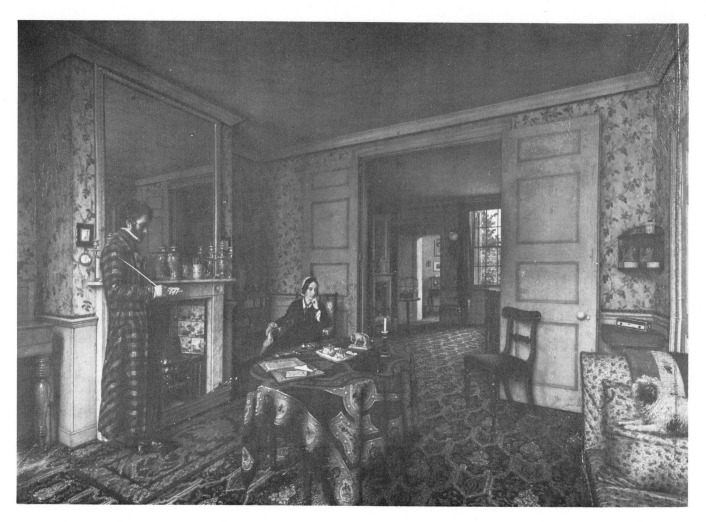

ROBERT S. TAIT
A Chelsea Interior – Thomas and Jane Carlyle in their House in Cheyne Row
22in. x 34in.

The Marquis of Northampton

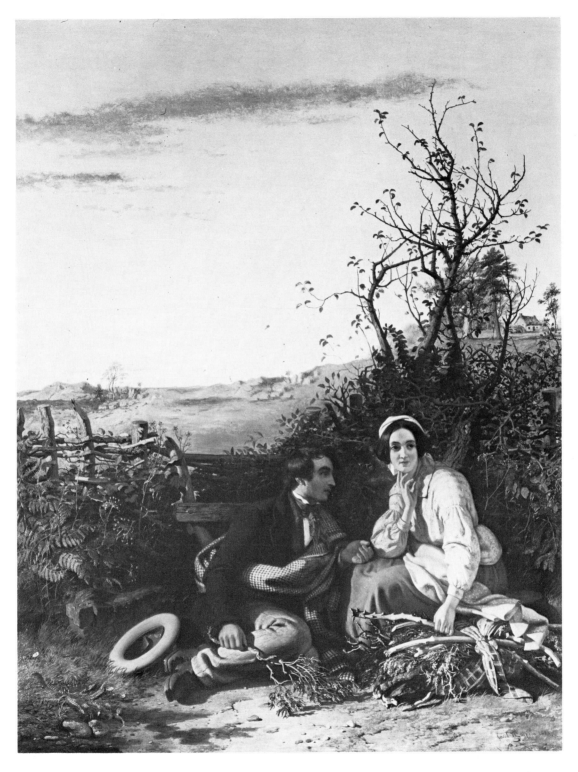

JACOB THOMPSON
The Course of True Love never did run smooth
Signed and dated 1854. 35½in. x 27½in.

Sir David Scott

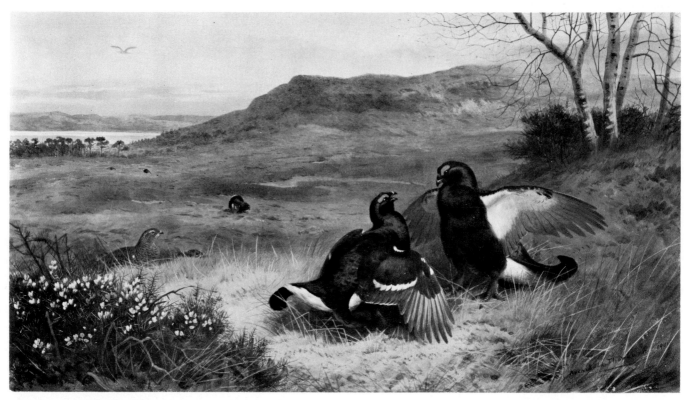

ARCHIBALD THORBURN Tryon Gallery, London
Blackcock Fighting
Signed and dated 1901, watercolour. 17in. x 30in.

JAMES TISSOT Guildhall, London
The Last Evening
Signed and dated 1893. 28½in. x 40½in.

FREDERICK WILLIAM TOPHAM
Rescued from the Plague
Signed and dated 1898. 72in. x 45in.

Guildhall, London

JOSEPH MALLORD WILLIAM TURNER, RA
Calais Pier, an English Packet arriving
67¾in. x 94½in.

Tate Gallery (On loan from National Gallery, London)

JOSEPH MALLORD WILLIAM TURNER, RA
The Fighting Temeraire
35¾in. x 48in.

National Gallery, London

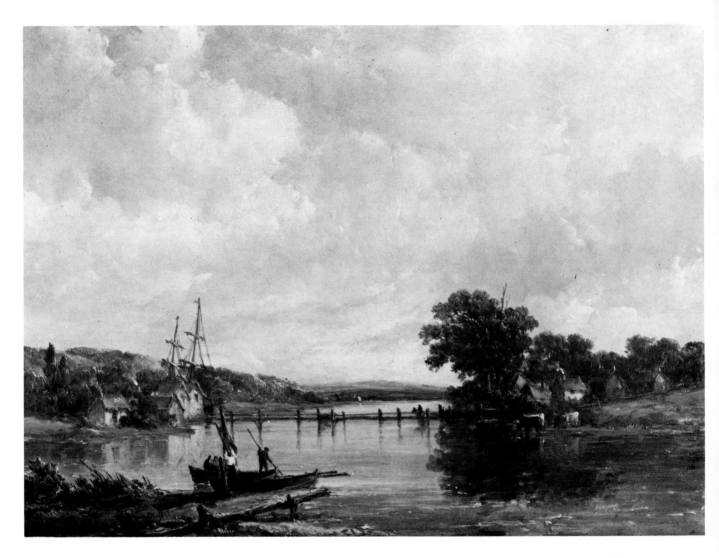

ALFRED VICKERS
A River Landscape
Signed. 11in. x 16in.

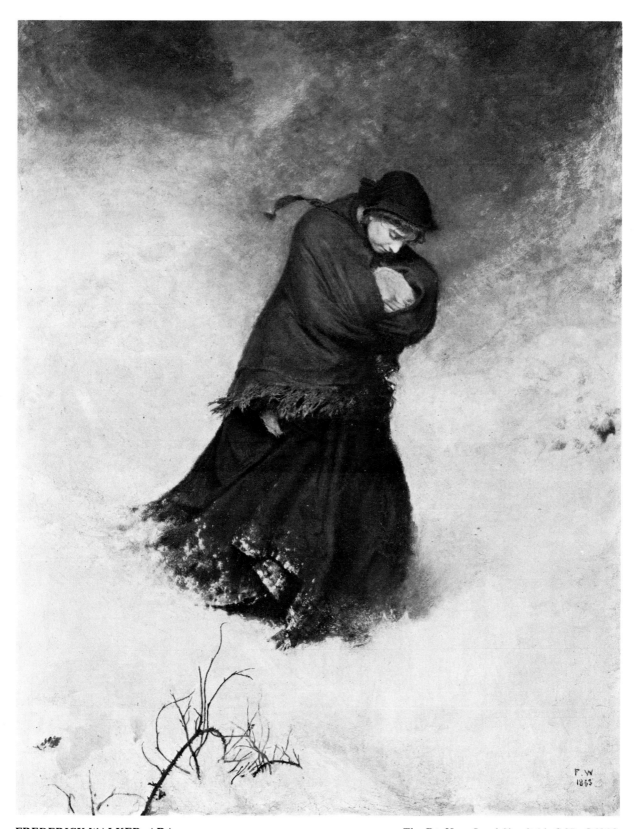

FREDERICK WALKER, ARA
The Lost Path
Signed and dated 1863. 36in. x 28in.

The Rt. Hon. Lord Sherfield, GCB, GCMG

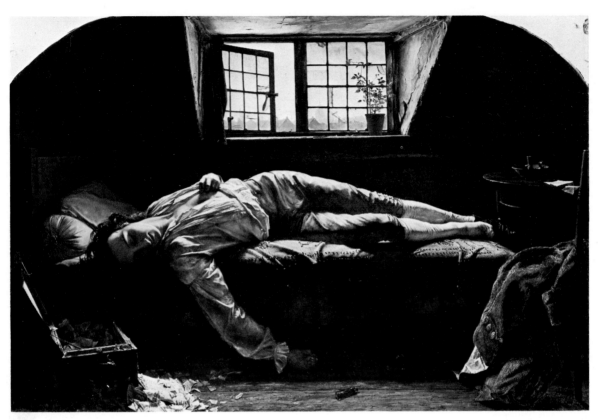

HENRY WALLIS. Chatterton. *24½in. x 36¾in.* Tate Gallery, London

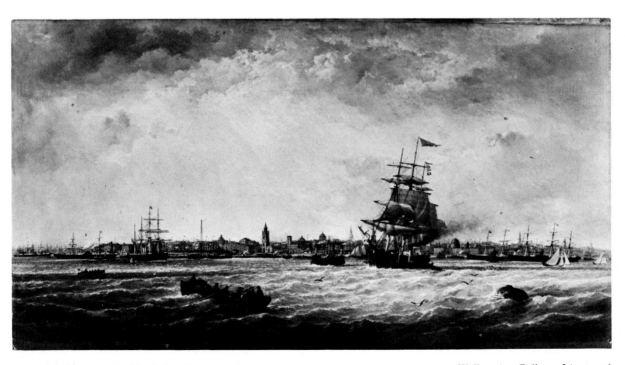

SAMUEL WALTERS. The Port of Liverpool. Walker Art Gallery, Liverpool
Signed with initials and dated 1873. 27¾in. x 51in.

EDWARD MATTHEW WARD, RA. The Fall of Clarendon. Graves Art Gallery, Liverpool
Signed and dated 1861. 25¾in. x 35¼in.

JOHN WILLIAM WATERHOUSE, RA Maas Gallery
St. Cecilia. *48½in. x 78½in.*

JOHN DAWSON WATSON
Children at Play
On board. 14in. x 17¾in.

Private Collection, London

400

FREDERICK WILLIAM WATTS
edham
)in. x 32in.

Richard Green

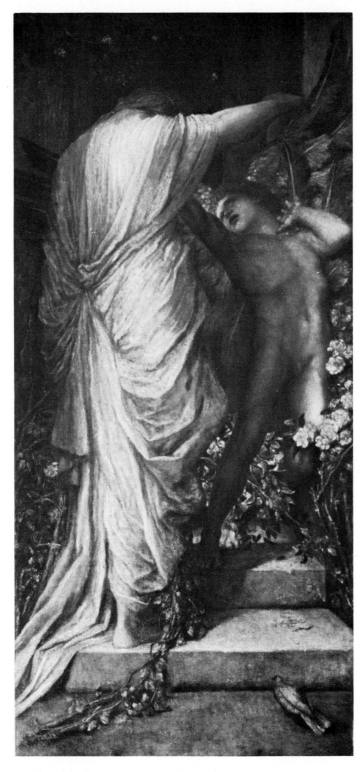

GEORGE FREDERICK WATTS, RA
Love and Death
97½in. x 46in. Tate Gallery, London

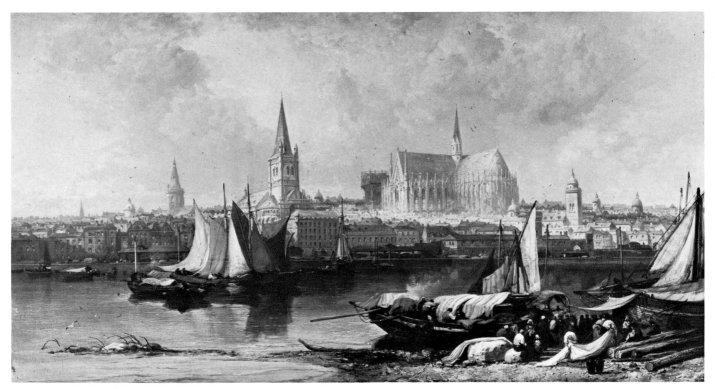

JAMES WEBB. A View of Cologne. *Signed and dated 1872. 26in. x 50in.* Photo: M. Newman Ltd.

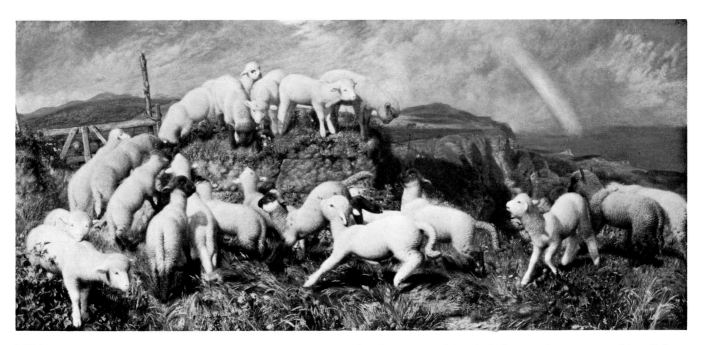

WILLIAM J. WEBBE. Sheep on Mount Zion - from nature. *Signed with initials and dated 1862 – panel* Maas Gallery

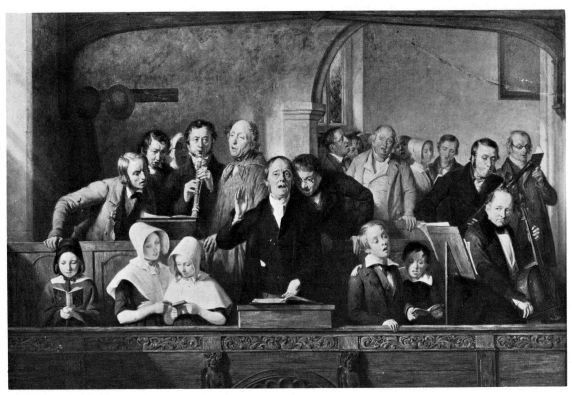

THOMAS WEBSTER, RA. A Village Choir. *Panel – 24in. x 36in.* Victoria and Albert Museum

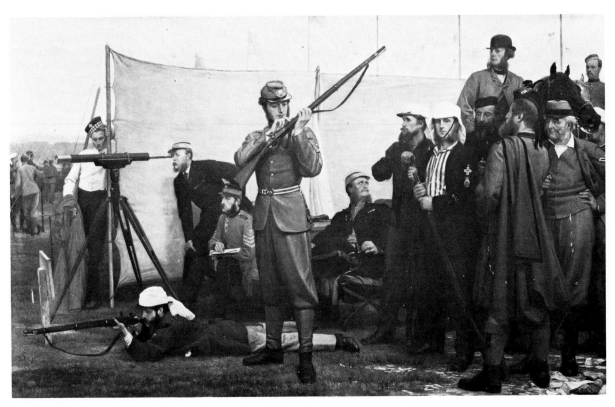

HENRY TANWORTH WELLS, RA. Volunteers at Firing Point. Royal Academy, London
Signed and dated 1866. 73¼in. x 114¾in.

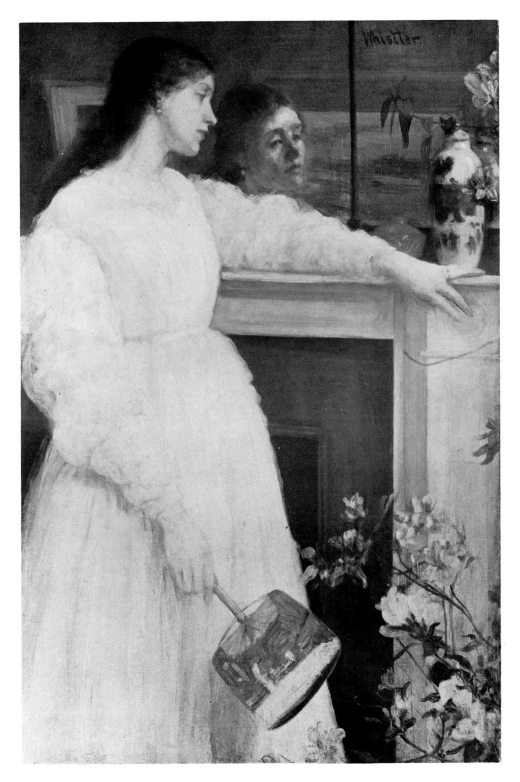

JAMES ABBOTT MCNEILL WHISTLER
The Little White Girl : Symphony in White, No. 11
Signed. 30in. x 20in.

Tate Gallery, London

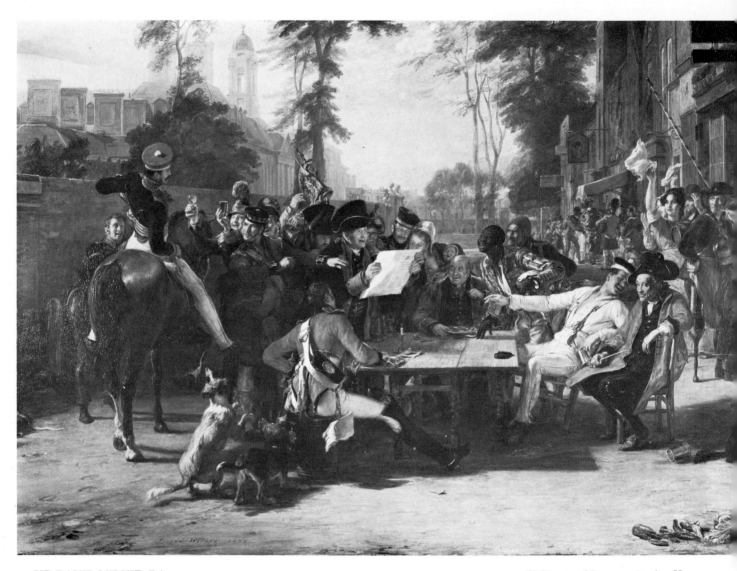

SIR DAVID WILKIE, RA
Chelsea Pensioners reading the Waterloo Despatch (detail)
Signed and dated 1822. 36½in. x 60½in.

Wellington Museum, Apsley House

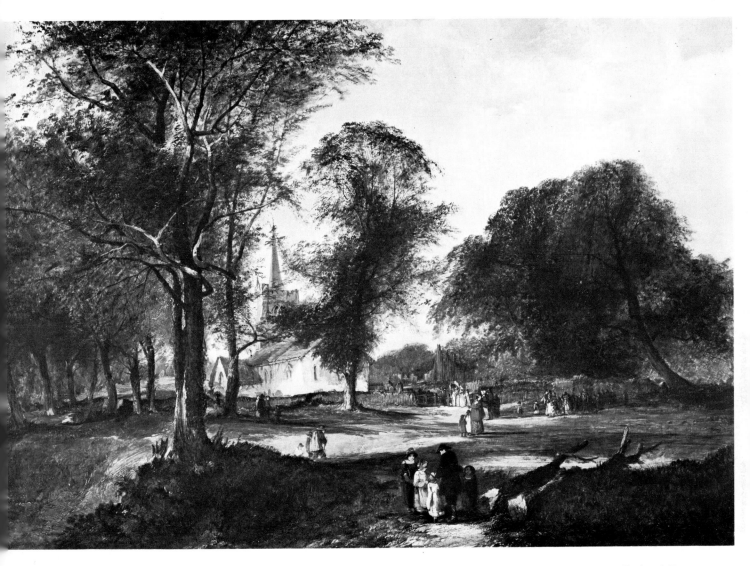

EDWARD CHARLES WILLIAMS
Sunday Morning
18¼in. x 25¼in.

Richard Green

DANIEL ALEXANDER WILLIAMSON
Spring, Arnside Knot and Coniston Range of Hills from Warton Crag
Panel – 10in. x 16in.

Walker Art Gallery, Liverpool

WILLIAM LINDSAY WINDUS, 1823-1907
Burd Helen
Signed with monogram and dated 1856. 33¼in. x 26¼in.

Walker Art Gallery, Liverpool

FRANZ XAVIER WINTERHALTER
The Duke of Wellington presenting a Casket on Prince Arthur's Birthday
42¼in. x 51in.

Reproduced by gracious permission
of Her Majesty the Queen

410

WILLIAM FREDERICK WITHERINGTON, RA
A Fete in Petworth Park
Dated 1835. 33in. x 47½in.

HENRY WOODS, RA
Cupid's Spell
Signed and dated 1885. 46¾in. x 29½in.

Tate Gallery, London

ALFRED J. WOOLMER
Fete Champetre
23in. x 35in.

Fine Art Society Ltd.

ROBERT W. WRIGHT
The Passing Column
Signed and dated 1886. Panel – 9¾in. x 14in.

WILLIAM WYLD
Venetian Capriccio
Signed. 37in. x 57in.

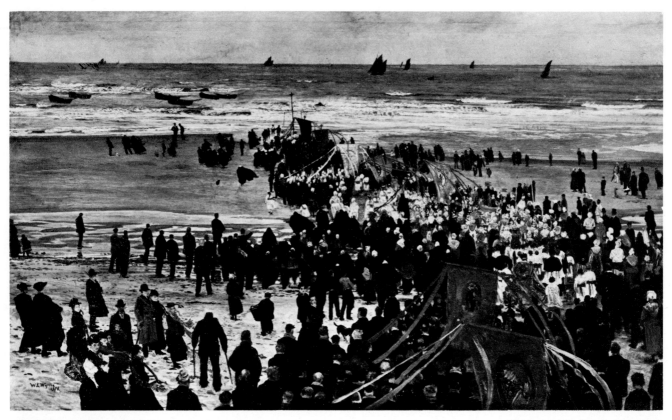

WILLIAM LIONEL WYLLIE, RA. Blessing the Sea. Walker Art Gallery, Liverpool
Signed and dated 1876. 29in. x 49in.

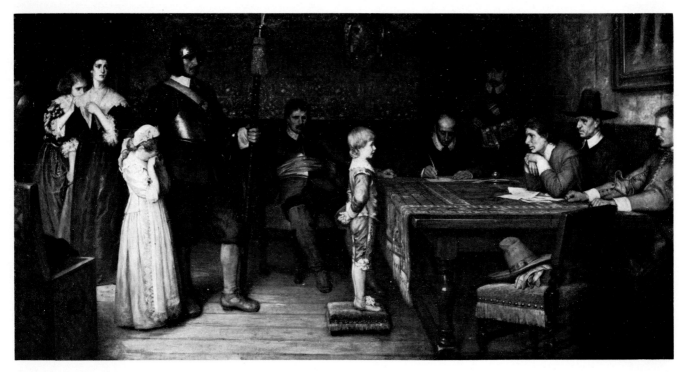

WILLIAM FREDERICK YEAMES, RA. And when did you last see your Father? Walker Art Gallery, Liverpool
Signed and dated 1878. 48in. x 98in.

Index of

Artists Monograms

The Index of Artists' Monograms is arranged in two parts –

1. **The Monogram Index**. In this section, monograms and initials are listed alphabetically under the *first* letter of the monogram or initials which are being looked up. For example, Edward Burne-Jones, who used the initials EBJ, will be found under the letter E. Some artists, like Whistler, used a symbol or emblem instead of a signature. These are listed in a section at the end of the monogram index.

2. **Index of Artists**. This is an alphabetical list of the artists included in the monogram index, and indicates in which section or sections each artist's monogram can be found.

Monogram Index

AA

ABBEY, Edwin Austin

AAG

GLENDENING, Alfred A. Junior

AB

BROWN, Sir John Arnesby

DE BREANSKI, Alfred

ABH

HOUGHTON, Arthur Boyd

AC

CLAY, Sir Arthur Temple Felix, Bt.

AE

EAST, Sir Alfred

AGW

WEBSTER, Alfred George

AH

HACKER, Arthur

HAVERS, Alice (Mrs. Fred Morgan)

HUGHES, Arthur

AKB

BROWN, Alexander Kellock

AML

MERRITT, Anna Lea

AP

PENLEY, Aaron Edwin

AR

RACKHAM, Arthur

AR

RANKLEY, Alfred

ARQ

QUINTON, Alfred Robert

AST

STRUTT, Alfred William

AT

ARMSTRONG, Thomas

THORBURN, Archibald

AW

ALLAM, Robert Weir

WARDLE, Arthur

AW

WITHERS, Alfred

AWS

STRUTT, Alfred William

(see also AST)

B

BRANGWYN, Sir Frank

SHAW, Byam

BF

BRAMLEY, Frank (see also FB)

BP

PARSONS, Beatrice

PRIESTMAN, Bertram

BWL

LEADER, Benjamin Williams

C

CRANE, Walter (see also WC)

CA

COOPER, Abraham

CAC

COLLINS, Charles Alston

CAG

GOW, Andrew Carrick

CAW

WILKINSON, Charles A.

CB

BRANWHITE, Charles

CEC

CLIFFORD, Edward C.

CEH

HOLLOWAY, Charles Edward

CG

GOLDIE, Charles (see also G)

GREEN, Charles

CGL

LAWSON, Cecil Gordon

CH

HAAG, Carl

HUNTER, Colin

CHS

SHANNON, Charles Haslewood

CJ

JONES, Charles

CJS

STANILAND, Charles Joseph

CK

KEENE, Charles

For details of all monograms used by **Keene**, see G.S. Layard, *The Life and Letters of C.S. Keene*, 1892-3.

420

CM

MONTALBA, Clara

CNH

HEMY, Charles Napier

CP

PERUGINI, Charles Edward

PETTITT, Charles

CR

ROBINSON, Charles

CRL

LESLIE, Charles Robert, RA

CS

SHANNON, Charles Haslewood

(see also CHS)

CSL

LIDDERDALE, Charles Sillem

CSM

MOTTRAM, Charles Sim

CTB

BALE, C.T.

CW

CALLOW, William

WHYMPER, Charles

CWC

COPE, Charles West

CWE

COOKE, Edward William

DA

DAWSON, Alfred

DE

DOUGLAS, Edwin

DGR

ROSSETTI, Dante Gabriel

(see also GR)

DH

HARDY, Dudley

EA

ALEXANDER, Edwin

EAG

GOODALL, Edward Alfred

EB

BARNES, E.C.

BARCLAY, Edgar

BRICKDALE, Eleanor Fortescue

(see also EFB)

BUTLER, Lady (see also ET)

EBJ

BURNE-JONES, Sir Edward Bt.

OM ARA (see also EJB)

EBL

LEIGHTON, Edmund Blair

ED

DOUGLAS, Edwin

EFA

FORBES, Mrs. Elisabeth Stanhope

EFB

BRICKDALE, Eleanor Fortescue

(see also EB)

EH

HALE, Edward Matthew

HARGITT, Edward

EJB

BURNE-JONES, Sir Edward Bt.

OM ARA (see also EJB)

EJG

GREGORY, Edward John

EL

LADELL, Edward

LANDSEER, Sir Edwin, RA

EMW

WIMPERIS, Edward Morison

EN

NICOL, Erskine RSA ARA

END

DOWNARD, Ebenezer Newman

EP

PATRY, Edward

PICKERING, Evelyn (de Morgan)

(see also EWM)

ERH

HUGHES, Edward Robert

ERT

TAYLOR, Edward Robert

ES

STOTT, Edward

ESK

KENNEDY, Edward Sherard

ET

BUTLER, Lady (see also EB)

TAYLOR, Edward

EW

WILLIAMS, Edward Charles

EWM

DE MORGAN, Evelyn and William

(see also EP)

EWW

WAITE, Edward William

F

FOSTER, William

FAS

SANDYS, Frederick Augustus

FB

BARNARD, Fred

BRAMLEY, Frank (see also BF)

FOSTER, Birket

FD

DADD, Frank

DICKSEE, Sir Frank PRA

FG

GOODALL, Frederick, RA

FH

HALL, Fred

HOLL, Frank ARA

FHP

POTTER, Frank Huddlestone

FL

LEIGHTON, Lord PRA

(see also L)

FM

MEYER, F.W.

MOODY, Fanny

MORGAN, Fred.

FMB

BROWN, Ford Madox

FS

SMALLFIELD, Frederick

FSW

WALKER, Francis S.

FW

WALKER, Fred.

WILLIAMSON, Frederick

FWB

BURTON, Sir Frederick William

G

GOLDIE, Charles (see also CG)

GA

GOODWIN, Albert

GAS

STOREY, George Adolphus

GAW

WILLIAMS, George Augustus

(see also GHW)

GBG

GODDARD, George Bouverie

GC

CATTERMOLE, George

GREGORY, Charles

GEH

HICKS, George Elgar

GFW

WATTS, George Frederick RA

WETHERBEE, George Faulkner

GGK

KILBURNE, George Goodwin

GH

HARVEY, Sir George PRSA

GHB

BOUGHTON, George Henry

GHW

WILLIAMS, George Augustus

(see also GAW)

GJP

PINWELL, George John

GPJH

JACOMB-HOOD, George Percy

(see also PH)

GR

ROSSETTI, Dante Gabriel

For a complete list of the initials and monograms used by Rossetti, see Virginia Surtees *The Paintings and Drawings of D.G. Rossetti A Catalogue Raisonné* 1971 Vol. 2 p. 238. (see also DGR)

GSW

WALTERS, George Stanfield

GW

GALE, William

H

HOOK, James Clarke RA

HBR

ROBERTS, Henry Benjamin

HC

COULDERY, Horatio Henry

HD

DAWSON, Henry

DICKSEE, Henry Thomas

HH

HERKOMER, Sir Hubert Von, RA

HHL

LA THANGUE, Henry Herbert RA

HIF

FORD, Henry Justice

HJ

JOHNSON, H.J. (Harry)

HJL

LE JEUNE, Henry

HMP

PAGET, H.M.

HMS

MARKS, Henry Stacy RA

(see also HSM)

HO

HALL, Oliver

HP

PILLEAU, Henry

HR

ROBERTSON, Henry Robert

RYLAND, Henry

HRS

STEER, Henry R.

HS

SELOUS, Henry

HSM

MARKS, Henry Stacy RA

(see also HMS)

HST

TUKE, Henry Scott RA

HTS

SCHAFER, Henry Thomas

HW

HAYNES WILLIAMS, John

WOODS, Henry RA

HWB

BREWER, Henry William

425

IEH

HODGSON, John Evan RA

(see also JEH)

IMS

SWAN, John Macallan RA

(see also JMS)

IMWT

TURNER, Joseph Mallord William

RA (see also T)

JA

ARCHER, James

JC

CHARLES, James

CHARLTON, John

JDB

BATTEN, John Dickson

JDH

HARDING, James Duffield

JDL

LINTON, Sir James Dromgole

JDW

WATSON, John Dawson

WINGFIELD, James Digman

JEH

HODGSON, John Evan RA

(see also IEH)

JF

FULLEYLOVE, John

JG

GILBERT, Sir John RA

JH

HAYLLAR, James

JHL

LEONARD, John Henry

JJM

JOPLING, Joseph Middleton

JJT

TISSOT, John James

JL

LAVERY, Sir John RA

LEECH, John (see also symbols)

LINNELL, John

JMB

BOWKETT, Jane Maria

JMS

SWAN, John Macallan RA

(see also IMS)

JN

NASH, Joseph

JN JN

NEWTON, John Edward

N

JP

PARKER, John

JP JP

PASMORE, John F.

P

PEDDER, John

JP JP

PHILLIP, John RA

JP P

PRICE, James

JP

JR

RUSKIN, John

JR

JRR

REID, John Robertson

J.R.R.

JRW

WELLS, Josiah R.

JRW

JS

SANT, James RA (see also S)

JS

JT

TENNIEL, John

JT JT

JT

JTN

NETTLESHIP, Hohn Trivett

J.T.N.

JW

WATKINS, John

JW

WHITE, John

JW

WOLF, Joseph

JW

JWR

JWS

WARD, James RA

JWS

SMITH, J. Wells

JS

KW

KEMP-WELCH, Lucy
(see also SEKW)

K.W

L

LEIGHTON, Lord (see also FL)

L

LAT

ALMA-TADEMA, Sir Lawrence
OM. RA

SAT

LF

FILDES, Sir Luke RA
(see also SLF)

L.F.

427

LH

HAGHE, Louis

LMB

BROWN, Lucy Madox

LS

SAMBOURNE, Linley

SMYTHE, Lionel Percy

LW

WATERFORD, Louisa, Lady

Mac W

MACWHIRTER, John RA

M

MENPES, Mortimer (see also MM)

MILLAIS, Sir John Everett Bt. PRA

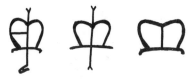

For a full list of all signatures and monograms used by Millais, see J.G. Millais: *The Life and Letters of Sir J.E. Millais* 1899 Vol 2. p. 465

MURRAY, Sir David RA

MG

GREIFFENHAGEN, Maurice William

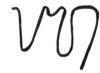

MHN

NISBET, Mrs. M.H.

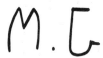

ML

LINDNER, Moffat P.

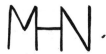

MM

MENPES, Mortimer

MST

STONE, Marcus RA

NW

NORTH, John William

OW

WILSON, Oscar

P

PEPPERCORN, Arthur Douglas

PH

JACOMB-HOOD, George Percy

PHG

HAMERTON, Philip Gilbert

PM

MORRIS, Philip Richard, RA

PN

PATON, Sir Joseph Noel, RSA

R

MACBETH, Robert Walker

(see also RM)

ROBERTSON, Charles

RANB

BELL, Robert Anning

RB

BEAVIS, Richard

RIVIERE, Briton, RA

RBM

MARTINEAU, Robert Braithwaite

RCW

WOODVILLE, Richard Caton

RD

DOYLE, Richard

RF

FOWLER, Robert

RG

GALLON, Robert

RJ

JOBLING, Robert

RL

LITTLE, Robert

RM

MACBETH , Robert Walker

(see also R)

MORLEY, Robert

ROOKE, Thomas Matthew

(see also TR)

RP

PEACOCK, Ralph

RSC

CHATTOCK, Richard S.

RW

WAY, Thomas R. (see also TRW)

S

SANT , James, RA (see also JS)

STAPLES, Robert Ponsonby

SA

SADLER, Walter Dendy

(see also WDS)

SC

CARTER, Samuel John

SEKW

KEMP-WELCH, Lucy (see also KW)

SJS

SOLOMON, Solomon Joseph, RA

SL

LUCAS, John Seymour, RA

SLF

FILDES, Sir Luke, RA (see also LF)

SM

METEYARD, Sidney

SR

READ, Samuel

SS

SOLOMON, Simeon

SW

WORTLEY, Archibald Stuart

T

TISSOT, James Joseph

(see also JJT and symbols)

TOPHAM, Frederick William

 Warwick

TURNER, Joseph Mallord William,

RA (see also IMWT)

TBW

WIRGMAN, Theodor Blake

TD

DAVIDSON, Thomas

TENNANT, Dorothy (Mrs. Stanley)

TE

ELLIS, Tristram J.

TG .

GRAHAM, Thomas

GREEN, H. Towneley

TMJ

JOY, Thomas Musgrove

430

TP

THOMAS, Percy

TOWNSEND, Patty

TPH

HALL, Thomas P.

TR

ROOKE, Thomas Matthew

(see also RM)

TRW

WAY, Thomas R. (see also RW)

TSB

SMITH, James Burrell

TW

WEBSTER, Thomas

TWW

WILSON, Thomas Walter

VC

COLE, Vicat, RA

W

WINGATE, Sir James Lawton, PRSA

WB

BALL, Wilfred W.

BAYES, Walter

BURTON, William Shakespeare

WC

CRANE, Walter (see also C)

SYMONS, William Christian

WD

DYCE, William

WDS

SADLER, Walter Dendy

(see also SA)

WH

HUNT, Walter

WHH

HUNT, William Holman

WHP

PATON, Waller Hugh

WJW

WEBBE, William J

WL

LANGLEY, Walter

LUKER, William, Junior

431

WLL

LEITCH, William Leighton

WLW

WYLLIE, William Lionel, RA

WM

MILLNER, William Edward

WP

PADGETT, William

PAGET, Walter

WQO

ORCHARDSON, Sir William
Quiller, RA

WS

SMALL, William

WSS

STACEY, Walter S.

WWL

WINDUS, William Lindsay

WWO

OULESS, Walter William

SYMBOLS

DOUGLAS, Sir William Fettes, PRSA

GRAHAM, Peter, RA

LEECH, John (see also JL)

MOORE, Albert Joseph

TISSOT, James Joseph

(see also JJT and T)

WHISTLER, James Abbot McNeill

(Whistler used many variations of these monograms — some of these can be found in his book *'The Gentle Art of Making Enemies'*.)

Index of Artists
in the
Monogram Index

This index shows the group or groups in which each artist's monogram can be found.

ABBEY, Edwin Austin AA
ALEXANDER, Edwin EA
ALLAN, Robert Weir AW
ALMA-TADEMA, Sir Lawrence LAT
ARCHER, James JA
ARMSTRONG, Thomas AT

BALE, C.T. CTB
BALL, Wilfred W. WB
BARCLAY, Edgar EB
BARNARD, Frederick FB
BARNES, E.C. EB
BATTEN, John Dickson JDB
BAYES, Walter WB
BEAVIS, Richard RB
BELL, Robert Anning RANB
BOUGHTON, George Henry GHB
BOWKETT, Jane Maria JMB
BRAMLEY, Frank BF FB
BRANGWYN, Sir Frank B
BRANWHITE, Charles CB
BREWER, Henry William HWB
BRICKDALE, Eleanor Fortescue EB' EFB
BROWN, Alexander K. AKB
BROWN, Sir J. Arnesby AB
BROWN, Ford Madox FMB
BROWN, Lucy Madox LMB
BURNE-JONES, Sir Edward Coley EBJ EJB
BURTON, Sir Frederick William FWB
BURTON, William Shakespeare WB
BUTLER, Lady EB ET

CALLOW, William CW
CARTER, Samuel John SC
CATTERMOLE, George GC
CHARLES, James JC
CHARLTON, John JC
CHATTOCK, Richard S RSC
CLAY, Sir Arthur Temple AC
CLIFFORD, Edward C. CEC
COLE, Vicat VC
COLLINS, Charles Allston CAC
COOKE, Edward William CWE
COOPER, Abraham CA
COPE, Charles West CWC
COULDERY, Horatio H. HC

CRANE, Walter C WC

DADD, Frank FD
DAVIDSON, Thomas TD
DAWSON, Alfred DA
DAWSON, Henry HD
DE BREANSKI, Alfred AB
DE MORGAN, Evelyn EP EWM
DICKSEE, Sir Frank FD
DICKSEE, Henry Thomas HD
DOUGLAS, Edwin ED
DOUGLAS, Sir William Fettes SYMBOLS
DOWNARD, Ebenezer Newman END
DOYLE, Richard RD
DYCE, William WD

EAST, Sir Alfred AE
ELLIS, Tristram J. TE

FILDES, Sir Luke LF SLF
FORBES, Elizabeth Stanhope EFA
FORD, Henry Justice HIF
FOSTER, Birket FB
FOSTER, William F
FOWLER, Robert RF
FULLEYLOVE, John JF

GALE, William GW
GALLON, Robert RG
GILBERT, Sir John JG
GLENDENING, Alfred A. Jun. AAG
GODDARD, George Bouverie GBG
GOLDIE, Charles CG G
GOODALL, Edward Alfred EAG
GOODALL, Frederick FG
GOODWIN, Albert GA
GOW, Andrew Carrick CAG
GRAHAM, Peter SYMBOLS
GRAHAM, Thomas A.F. TG
GREEN, Charles CG
GREEN, H. Townley TG
GREGORY, Charles GC
GREGORY, Edward John EJG
GREIFFENHAGEN, Maurice W. MG

HAAG, Carl CH
HACKER, Arthur AH
HAGHE, Louis LH
HALE, Edward Matthew EH

HALL, Frederick FH
HALL, Oliver HO
HALL, Thomas P TPH
HAMERTON, Philip Gilbert PHG
HARDING, James Duffield JDH
HARDY, Dudley DH
HARGITT, Edward EH
HARVEY, Sir George GH
HAVERS, Alice AH
HAYLLAR, James JH
HAYNES WILLIAMS, John HW
HEMY, Charles Napier CNH
HICKS, George Elgar GEH
HODGSON, John Evan JEH
HOLL, Frank FH
HOLLOWAY, Charles Edward CEH
HOUGHTON, Arthur Boyd ABH
HUGHES, Arthur AH
HUGHES, Edward Robert ERH
HUNT, Walter WH
HUNT, William Holman WHH
HUNTER, Colin CH

JACOMB-HOOD, George Percy GPJH PH
JOBLING, Robert RJ
JOHNSON, Harry John HJ
JONES, Charles CJ
JOPLING, Joseph Middleton JJM
JOY, Thomas Musgrove TMJ

KEENE, Charles CK
KEMP-WELCH, Lucy KW SEKW
KENNEDY, Edward Sherard ESK
KILBURNE, George Goodwin GGK

LADELL, Edward EL
LANDSEER, Sir Edwin EL
LANGLEY, Walter WL
LA THANGUE, Henry Herbert HHL
LAVERY, Sir John JL
LAWSON, Cecil Gordon CGL
LEADER, Benjamin Williams BWL
LEECH, John JL SYMBOLS
LEIGHTON, Edmund Blair EBL
LEIGHTON, Lord FL L
LEITCH, William Leighton WLL
LE JEUNE, Henry HJL
LEONARD, John Henry JHL
LESLIE, Charles Robert CRL
LIDDERDALE, Charles Sillem CSL
LINDNER, Peter Moffatt ML
LINNELL, John JL
LINTON, Sir James Dromgole JDL
LITTLE, Robert RL
LUCAS, John Seymour SL
LUKER, William WL

MACBETH, Robert Walker R RM
MACWHIRTER, John MacW

MARKS, Henry Stacy HMS HSM
MARTINEAU, Robert Braithwaite RBM
MENZIES, Herbert M. HMM
MENPES, Mortimer M MM
MERRITT, Anna Lea AML
METEYARD, Sidney SM
MEYER, F.W. FM
MILLAIS, John Everett M
MILLNER, William Edward WM
MONTALBA, Clara CM M
MOODY, Fanny FM
MOORE, Albert Joseph SYMBOLS
MORGAN, Frederick FM
MORLEY, Robert RM
MORRIS, Philip Richard PM
MOTTRAM, Charles Sim CSM
MURRAY, Sir David M

NASH, Joseph JN
NETTLESHIP, John Trivett JTN
NEWTON, John Edward JN
NICOL, Erskine EN
NISBET, Mrs. M.H. MHN
NORTH, John William NW

ORCHARDSON, Sir William Quiller WQO
OULESS, Walter William WWO

PADGETT, William WP
PAGET, H.M. HMP
PAGET, Walter WP
PARKER, John JP
PARSONS, Beatrice BP
PASMORE, John F. JP
PATON, Sir Joseph Noel PN
PATON, Waller Hugh WHP
PATRY, Edward EP
PEACOCK, Ralph RP
PEDDER, John JP
PENLEY, Aaron Edwin AP
PEPPERCORN, Arthur Douglas P
PERUGINI, Charles Edward CP
PETTITT, Charles CP
PHILLIP, John JP
PILLEAU, Henry HP
PINWELL, George John GJP
POTTER, Frank Huddlestone FHP
PRICE, James JP
PRIESTMAN, Bertram BP

QUINTON, Alfred Robert ARQ

RACKHAM, Arthur AR
RANKLEY, Alfred AR
READ, Samuel SR
REID, John Robertson JRR
RIVIERE, Briton RB
ROBERTS, Henry Benjamin HBR
ROBERTSON, Charles R
ROBERTSON, Henry Robert HR

ROBINSON, Charles CR
ROOKE, Thomas Matthew RM TR
ROSSETTI, Dante Gabriel DGR GR
RUSKIN, John JR
RYLAND, Henry HR

SADLER, Walter Dendy SA WDS
SAMBOURNE, Linley LS
SANDYS, Frederick Augustus FAS
SANT, James JS S
SCHAFER, Henry Thomas HTS
SELOUS, Henry HS
SHANNON, Charles Haslewood CHS CS
SHAW, Byam B
SMALL, William WS
SMALLFIELD, Frederick FS
SMITH, James Burrell TSB
SMITH, J. Wells JWS
SMYTHE, Lionel Percy LS
SOLOMON, Simeon SS
SOLOMON, Solomon Joseph SJS
STACEY, Walter S. WSS
STANILAND, Charles Joseph CJS
STAPLES, Robert Ponsonby S
STEER, Henry R. HRS
STONE, Marcus MST
STOREY, George Adolphus GAS
STOTT, Edward ES
STRUTT, Alfred William AST AWS
SWAN, John McAllan IMS JMS
SYMONS, William Christian WCS

TAYLER, Edward ET
TAYLOR, Edward Robert ERT
TENNANT, Dorothy TD
TENNIEL, John JT
THOMAS, Percy TP
THORBURN, Archibald AT
TISSOT, James JJT T SYMBOLS
TOPHAM, Frank William Warwick T
TOWNSEND, Patty TP
TUKE, Henry Scott HST
TURNER, Hoseph Mallord William IMWT T

WAITE, Edward William EWW
WALKER, Frederick FW
WALKER, Francis S. FSW
WALTERS, George Stanfield GSW
WARD, James JWS
WARDLE, Arthur AW
WATERFORD, Louisa, Lady LW
WATKINS, John JW
WATSON, John Dawson JDW
WATTS, George Frederick GFW
WAY, Thomas R. RW TRW
WEBBE, William J. WJW
WEBSTER, Alfred George AGW
WEBSTER, Thomas TW
WELLS, Josiah Robert JRW

WETHERBEE, George Faulkner GFW
WHISTLER, James Abbott McNeill SYMBOLS
WHITE, John JW
WHYMPER, Charles CW
WILKINSON, Charles A. CAW
WILLIAMS, Edward Charles EW
WILLIAMS, George Augustus GAW GHW
WILLIAMSON, Frederick FW
WILSON, Oscar OW
WILSON, Thomas Walter TWW
WIMPERIS, Edmund Morrison EMW
WINDUS, William Lindsay WWL
WINGATE, Sir James Lawton W
WINGFIELD, James Digman JDW
WIRGMAN, Theodore Blake TBW
WITHERS, Alfred AW
WOLF, Joseph JW
WOODS, Henry HW
WOODVILLE, Richard Caton RCW
WORTLEY, Archibald Stuart SW
WYLLIE, William Lionel WLW

75018